Aesthetics of Ugliness

Other translations available from Bloomsbury

Aesthetics of Ugliness

A Critical Edition

Karl Rosenkranz

Edited and translated by Andrei Pop and
Mechtild Widrich

Bloomsbury Academic
An imprint of Bloomsbury Publishing Plc

B L O O M S B U R Y
LONDON · OXFORD · NEW YORK · NEW DELHI · SYDNEY

Bloomsbury Academic

An imprint of Bloomsbury Publishing Plc

50 Bedford Square
London
WC1B 3DP
UK

1385 Broadway
New York
NY 10018
USA

www.bloomsbury.com

BLOOMSBURY and the Diana logo are trademarks of Bloomsbury Publishing Plc

First published 2015
Paperback edition first published 2017

British Library Cataloguing-in-Publication Data
A catalogue record for this book is available from the British Library.

ISBN: HB: 978-1-47256-885-4
 PB: 978-1-35002-292-8
 ePDF: 978-1-47256-887-8
 ePub: 978-1-47256-886-1

Library of Congress Cataloging-in-Publication Data
A catalog record for this book is available from the Library of Congress.

Typeset by RefineCatch Limited, Bungay, Suffolk
Printed and bound in Great Britain

Contents

Figures

Guide to Frequently Translated Words

abscheulich – abominable (*as in 'snowman'*)
albern – silly
Anschauung – experience, *rarely* intuition
aufheben – cancel (out)
Auflösung – dissolution (*of harmony or disharmony*), resolution (*of a contradiction*)
Bedingung – condition (unbedingt – unconditional)
Bestimmung – determination, definition
Beziehung – relation, connection
bloß – mere, sheer, plain, brute
Dasein – existence, being, entity
Einheit – unity, unit (*pl.* units)
ekelhaft – disgusting
Empörung – outrage
entsetzlich – terrifying
Entzweiung – rupture, break
Erscheinung – appearance, *rarely* phenomenon
Existenz – existent (being)
Fratze – grimace
furchtbar – frightful, *rarely* terrible
Gebilde – entity
Gegensatz – opposite, opposition
Geist, geistig – spirit(ual), *in some contexts* intellect(ual), *rarely* mind/mental
gemein – mean, *rarely* common
Gesetzmäßigkeit – law-likeness
Gestalt – shape, *rarely* form, figure
Gestaltung – design, formation (*respectively if context is art or reality*)
gleich – same, *rarely* equal
gräßlich – gruesome, atrocious
Grauen – horror
grell – glaring, lurid
hinausgehen – supersede or go beyond
Kraft – force
Komik – the comical, *more fluently* humour
komisch – comical, *more fluently* funny
Macht – power
Mannigfaltigkeit – multiplicity
Maaßlos(igkeit) – immoderate(ness)
nichtig; Nichtigkeit – null and void; nullity

niedlich – cute
niedrig; Niedrigkeit – low, the low *but sometimes noun* baseness
Pietät – (filial) piety, family feeling
Regelmässigkeit, Regularität – regularity
Reiz, reizend – charm, charming
roh – crude
scheußlich – hideous
sinnlich – sensible, sensuous (*depending on English usage*)
Sitte – custom
sittlich, Sittlichkeit – moral, morality
Tendenz – tendency (*in the political sense, as in 'tendentious'*)
übergehen – turn (into), pass (over) to
Übergang – transition
ungeheuer – tremendous, *as noun* monster
Unterschied – difference, *rarely* distinction
Verbildung – disfiguration (*not strictly facial, broadly as flawed figuration*)
Verhältnis(se) – circumstance(s) connection(s), relation (*singular only*)
Verkehrung – reversal, *rarely* perversion
Vernunft – reason
Verschiedenheit – differentness
Verständigkeit – reasonableness
Verstand – common sense, *rarely* understanding
verzerrt – distorted
Vorstellung – (mental) image, notion, imagination (*when the faculty is being discussed*)
wahrhaft – genuine
Wechselbeziehung – interrelation
Wechselwirkung – reciprocity, interaction
Wechselspiel – interplay
widrig – repulsive
Zerrbild – distorting mirror, distorted picture
Zerrissen(heit) – torn(ness)
zierlich – delicate

Approaching Ugliness

Karl Rosenkranz's Contribution to Philosophy

Introduction

God doesn't have a sense of humour? If not, how could the world persist?
Karl Rosenkranz, notebook entry, 1836[1]

Less than a century ago, a prominent mathematician could assert that, 'Like the word "beautiful" in aesthetics and the word "good" in ethics, "true" gives logic its direction.'[2] In the present day, these subject matters are no longer taken for granted in these fields. In particular, aesthetics, that eighteenth-century coinage that awkwardly combines art, pleasure, and the senses in one single word, may have gained by turning from the clouds of beauty to the soil of art and its functions. And there is no doubt that artists themselves have played a key role in debunking simple identifications of aesthetics with the beautiful. Whether one takes as a paradigm Edouard Manet's *Olympia*, Alfred Jarry's *Père Ubu*, Marcel Duchamps' *Fountain*, Andy Warhol's *Brillo Box* or the Sex Pistols' *Never Mind the Bollocks*, it is an article of faith in modern art that rejecting old recipes for aesthetic success is tantamount to securing the same.[3] When a twentieth-century philosopher of art like Nelson Goodman declares, 'the symptoms of the aesthetic are not marks of merit', this sounds less like a fact and more like confident avant-garde self-avowal. Goodman continues:

> Folklore has it that the good picture is pretty. At the next higher level, 'pretty' is replaced by 'beautiful', since the best pictures are often obviously not pretty. But again, many of them are in the most obvious sense ugly. If the beautiful excludes the ugly, beauty is no measure of aesthetic merit; but if the beautiful may be ugly, then 'beauty' becomes only an alternative and misleading word for aesthetic merit.[4]

The points, taken individually, are fair. Not all good artworks are good-looking. And not by accident: in a Jenny Saville portrait, it may be that an artwork's very intent, and

[1] Karl Rosenkranz, *Aus einem Tagebuch: Königsberg Herbst 1833 bis Frühjahr 1846* (Leipzig: Brockhaus, 1854), 5. All translations, unless otherwise noted, are by the editors.
[2] Gottlob Frege, 'Der Gedanke', *Beiträge zur Philosophie des Deutschen Idealismus*, 1:2 (1918), 56.
[3] Mechtild Widrich, 'The "Ugliness" of the Avant-Garde', in *Ugliness: The Non-Beautiful in Art and Theory*, ed. A. Pop and M. Widrich (London: Tauris, 2014), 69–81, discusses this tradition and its relation to the view of beauty and ugliness as optional in art.
[4] Nelson Goodman, *Languages of Art* (Oxford: Oxford University Press, 1968), 255.

its achievement, are to be aesthetically unsettling. Goodman, who in his youth ran an art gallery and collected art all his life, knew this. On this basis he posed a dilemma for aesthetic theory. If beauty excludes ugliness, it is useless as a mark of merit, since some ugly pictures are good. If, on the other hand, a beautiful picture can be ugly, beauty is not an informative concept, for presumably to be one thing, it should exclude its opposite. This 'presumably' shows the circularity of the argument. Perhaps ugliness is outweighed by beauty, somehow exploited or subverted by it, in good art. On the other hand, if the second horn of the dilemma is right and beauty is just a synonym for merit, then it is strange that 'ugliness' for Goodman should not be just be a synonym for aesthetic failure. But if it is, the first horn of the dilemma could not arise, for no good art could be ugly. The passage, far from posing a challenge for classical aesthetics, shows Goodman fumbling with two formulations of the same contradictory notion: namely, that beauty is only a word for aesthetic merit, while ugliness is a real phenomenon.

The result is not the isolated failing of a consistent thinker, but rather a distinctly modern experience: only try to meet Saville's gaze on the cover of this book, or recall T.S. Eliot's 'patient etherized upon a table'.[5] To call either beautiful seems wilful, to admit ugliness in art or in the world, a platitude. But how can ugliness be real if beauty is not? Should not the two terms, fundamental or derived, enjoy the same status? Such questions moved Karl Rosenkranz, in the *Aesthetics of Ugliness* (1853), to disagree with his master Hegel, who, following Goethe, had called the devil a 'highly prosaic person', useless for art. This Rosenkranz met with Goodmanian disbelief: 'Is then the drawing of evil so easy that every bungler can succeed at it?'[6] Granting Hegel and the Neo-Platonists that evil may be a mere privation of good, Rosenkranz argued not only that ugliness is an indispensable feature of its salient representation, but that such salience can make an ugly work, *as* ugly, aesthetically valid, even beautiful. To deny this is to demand from art only 'moral exhibitions', not insight into our imperfect world.

The quarrel between Rosenkranz and Hegel about the possibility of representing negativity in aesthetic terms is still of interest today for the light it casts not only on aesthetic notions, but on their relation to one another and to the more alarming real world. More recent students of Hegel, driven by Modernist ideas about the autonomy of art and its values, have seen in relational accounts like Rosenkranz's a theological impulse linking ugliness with evil, in contrast to Hegel's putatively value-free science of aesthetics.[7]

[5] The notorious third line of 'The Love Song of J. Alfred Prufrock', following the lyrical couplet: 'Let us go then, you and I / When the evening is spread out against the sky / Like a patient etherized upon a table'. T.S. Eliot, *Prufrock and Other Observations* (London: The Egoist Ltd., 1917), 9.
[6] Karl Rosenkranz, *Ästhetik des Häßlichen* (Königsberg: Gebrüder Bornträger, 1853), R 357. We quote from our translation, but provide the original German pagination as (R #).
[7] This has been the case following Hans-Robert Jauss's influential edited volume on 'the no longer fine (beautiful) arts', *Die nicht mehr schönen Künste. Grenzphänomene des Ästhetischen* (München: Wilhelm Fink, 1968). Jauss's point that, in modernity, ugliness becomes autonomous from beauty and its cognates has been applied retroactively by Hegelian scholars like Otto Pöggeler, Annemarie Gethmann-Siefert, and more recently Bernadette Collenberg-Plotnikov and Francesca Iannelli, who distinguish rather starkly between the genuine, fragmentary aesthetics of Hegel (as found in student notes) and the more systematic aesthetics of the Hegelians. For a Jaussian approach to Rosenkranz in art history, see Jeffrey Hamburger, '"To Make Women Weep": Ugly Art as "Feminine" and the Origins of Modern Aesthetics', *RES: Anthropology and Aesthetics* 31 (Spring 1997), 19.

But for what other reason should ugliness have no relation to beauty, if not the denial that the two may be correlated with extra-aesthetic values that make art morally, politically, or otherwise practically interesting? As Goodman and Rosenkranz suggest, such assertions should be tested not only against our experience of art, but in light of the commitments they impose on us. For Rosenkranz, at least, the correlation of beauty and ugliness, though it mirrors that of good and evil, is not a matter of morality, but of art's orientation to other things that we value and reject. This commits him in turn to a view of ugliness as dependent on beauty that many readers find incompatible with its real existence. It might help to compare Goodman's allergic reaction to beauty with a neatly parallel reaction to ugliness by Rosenkranz's illustrious contemporary, the Swiss novelist Gottfried Keller. On receiving a copy of the *Aesthetics of Ugliness*, Keller complained:

> The title is already absurd and romantic. Beautiful is beautiful, and ugly is ugly, in all eternity. There is nothing else to do, but what the physicists do with heat: they know no positive coldness and do not use this concept, but only less heat. So it must be with beauty. The manner of presenting much of art history as intentionally applied, beautifully executed ugliness is a creeping irrationality; for to be precise, this never happens in true art (degeneracy is not to be taken into account), and what one wants to point out in fact is nothing but pure beauty. Here too we must hold on to the ever more normative procedure of the natural sciences and not assume, against general and absolutely singular beauty, an opposite of positive ugliness, like a devil, but only a lower degree of beauty.[8]

Keller's appeal to scientific method might have been applauded by the nominalist Goodman. And his point that beauty and ugliness are one subject matter is sound; but one cannot on this basis dismiss ugliness by calling it 'lesser beauty'.[9] Quantitative talk of heat obscures the fact that 500 ugly pictures do not add up to a beautiful one – beauty and ugliness play different roles in aesthetics, despite their relationship to one another, just as differing states of a physical system may do. Keller is left desperately denouncing ugly art as degenerate (*Ausartung*, a cousin of *Entartung*), which does not tell us how to distinguish it from 'purely beautiful' depiction of ugly objects. Goodman, at any rate, is clearer about the ugliness of some great art.

Why should philosophers, art historians, artists, and readers in general care about beauty and ugliness as substantive aesthetic terms? Well, the general reader comes first, since these terms are ensconced in social life, where they are unlikely to go away any time soon. Think only of the large, if increasingly covert, role they play in sexuality and

[8] Jacob Baechtold, *Gottfried Kellers Leben: 1850–1861* (Hertz, 1894), 224, discussed in Werner Jung, *Schöner Schein der Häßlichkeit oder Häßlichkeit des schönen Scheins* (Frankfurt: Athenäum, 1987), 201.

[9] In 'The coexistence of beauty and ugliness', in *Ugliness: The Non-Beautiful in Art and Theory*, 165–79, I tried to do justice to both insights (that beauty and ugliness have one subject matter, but are irreducible) by presenting them as converse two-place relations holding between all objects, so that for every 'A is lovelier than B', there is a 'B is uglier than A'.

its social exploitation.[10] But the artist and writer have an equal stake in the matter, as the production of beauty and ugliness in the service of very specific moral, political, economic and other interests has been an explicit task or motivation in many cultures over millennia.[11] Even if advocates of the avant-garde are right to say that the connection has become contingent or optional, it can only be ignored at the cost of ignoring art of the past, and indeed some signal achievements of the avant-garde itself.

Deeper than this 'inclusiveness argument' is the link between aesthetic qualities, art's content, and the role it plays in human society. Beauty and ugliness are after all intra-aesthetic categories that, informed by the anthropological and sociological study of their historical formations, can account for the role that art and artefacts play in economic, moral, religious, and political life – why a ruler would expend considerable resources for certain monuments, say, or imprison a caricaturist. Without aesthetic force of a positive and a negative nature, all of these functions are relegated to art's content, to be extracted from written documents and the iconographic decoding of symbols. Such a didactic view of how art functions is rejected by practically everyone today – but so is a formalism according to which the content of art is irrelevant to its function.[12] The middle ground, which is not a compromise but only honesty about the data to be explained, is that there are both sensual and intellectual aspects of works of art; it is denial of one or the other that fuels indifference to the aesthetic categories which can coordinate them.[13] If this is right, substantial accounts of beauty and ugliness are fair game, and a legitimate goal, for the philosophy, criticism, history, and practice of art.

To give Modernist scepticism its due, Goodman is surely right that a theory of beauty ignoring the phenomenon of ugliness will not be convincing. It is regrettable if not surprising that the recent enthusiasm for beauty makes little provision for ugliness. Thus, beauty theorist Elaine Scarry reluctantly concedes the beauty of 'Japanese noise guitar', which an interviewer was worried would be missed by opera lovers.[14] The noise guitarist might respond as Arnold Schönberg did to film producer Louis B. Mayer: 'My music isn't lovely!'[15] It is a hard-won Modernist achievement to insist that ugliness

[10] As Henri Zerner once replied to Ernst Gombrich's insistence on the possibility of pure decoration: 'Is the present use of lipstick ever "pure design"? That it has aesthetic value (for better or worse) is beyond question. If a woman were asked by an anthropologist, she might indeed reply that she uses it just for aesthetic and decorative reasons. But let a man wear lipstick, and the cultural implications come quickly to the foreground.' In 'The Sense of Order: An Exchange', *New York Review of Books* (28 June 1979), 62.

[11] Whether or not the concepts are universal, their salience to many cultures is shown in research by Claude-François Baudez, 'Beauty and Ugliness in Olmec Monumental Sculpture', *Journal de la Société des Américanistes* 98(2) (2012): 7–31; see also the essays in our anthology *Ugliness*, and its annotated bibliography (275–99).

[12] For example, Alois Riegl in his study of ornament, according to which a historical development of form itself dictates what was made when. Late in his *Spätrömische Kunstindustrie* (1902), Riegl conceded that culture and form are connected by aesthetic categories.

[13] These may be explained in biological, sociological, or idealist terms – or left as basic.

[14] David Bowman, 'Does Beauty Really Equal Truth?', interview with Elaine Scarry, *Salon*, 9 Nov. 1999, available at: http://www.salon.com/1999/11/09/scarry/ (accessed 18 August 2014). The work of Alexander Nehamas is an exception in taking account of ugliness.

[15] Friedrich Torberg, *Die Tante Jolesch; oder, Der Untergang des Abendlandes in Anekdoten* (München: Langen-Müller, 1975), 286.

should not be aesthetically transmuted. On the other hand, whether the truth of Schönberg's self-assessment is compatible with the success, force, and other (further or synonymous) aesthetic features of his art is a matter of theory and observation. Consider the analogy with logic: from the fact that some logical properties apply when sentences are true, others when false, still others in any case, one may hold that logic is the science of truth (with falsity explained as non-truth), or of something more general (inference), but it would be silly to conclude that truth and falsity have no bearing on it.[16]

Truth and falsity do matter in logic, and most people can see that. But the subjective tone of aesthetics makes the existence of both its positive and negative terms seem exotic. Rosenkranz, in introducing and defending the very publication, not the specific content, of his *Aesthetics of Ugliness*, makes recourse to a kind of *scientia oppositorum:* 'No one is amazed if biology also concerns itself with the concept of sickness, ethics with that of evil, legal science with injustice, or theology with the concept of sin.'[17] His point is not merely that ugliness deserves study, but that it is central to *aesthetics:* 'To say "theory of ugliness" would fail to bring out so clearly the scientific genealogy of the word.' To work out this aesthetics, in art and everyday life, and in a systematic rather than in a historical way, is the task that Rosenkranz pursued in this book. Its stand-alone publication provoked much head scratching, and not just from Keller.[18] Even Rosenkranz's best friend among the older Hegelians, the statesman and soldier Karl August Varnhagen von Ense, asked gently why ugliness should be separated from its better half.[19] Rosenkranz replied that he provided what was missing, but a deeper answer might flow from the Hegelian insight developed at length in the book's middle section, on incorrectness in art: modern art achieves its greatest triumphs through the conquest of resistant material, which involves either the breaking of rules in the service of genius or the confrontation of disorder in the world. 'Simple beauty' of the Keller kind, Rosenkranz declares in his most iconoclastic mood, is dull and in the end ugly. Genuine modern beauty, by contrast, has always an admixture of ugliness, whether tragic and pessimistic in nature or comical and optimistic. This is because, while beauty is conceptually self-contained, ugliness as its negation always points to beauty. In notes that predate the writing of the book, Rosenkranz is still bolder, claiming that humour, the distorting principle of caricature, is the *metaphysical* basis of all beauty, because it 'plays with the serious', being able to cross all the registers of the aesthetic from the

[16] For example, Michael Dummett, *Frege: Philosophy of Language* (London: Duckworth, 1981), 433, insists logic is not really about truth, but about 'the relation of logical consequence'. Note the circularity: consequence is logical in that new sentences preserve truth or falsity.
[17] Rosenkranz, *Aesthetics*, R iv. Cf. R 4: 'It is appropriate that finally the dark side of the luminous form of beauty should become of central moment to the science of aesthetics, as illness is to pathology, and as evil is to ethics.'
[18] Notable is the anonymous review by Julian Schmidt, in *Die Grenzboten* 28 (July 1853), 1–9. A former student of Rosenkranz but pronounced foe of Hegel, Schmidt is not always fair, but often pertinent, in his criticisms. We return to them below.
[19] Arthur Warda (ed.), *Briefwechsel zwischen Karl Rosenkranz und Varnhagen von Ense* (1926), 199. Alexander von Humboldt endorsed Rosenkranz's project in correspondence that has unfortunately been lost. See Holger Funk, *Ästhetik des Hässlichen: Beiträge zum Verständnis negativer Ausdrucksformen im 19. Jahrhundert* (Berlin: Agora, 1983), 245.

ridiculous to the sublime.[20] The *Aesthetics of Ugliness*, then, *is* Rosenkranz's positive aesthetics, and the additional texts we have translated bear witness to the fact that he never wrote about beauty and the sublime more probingly than in this volume devoted to their opposites.

To see why the book took on the form it has, and advanced the theses it does with the examples it contains (Rosenkranz boasted having amassed twice as much evidence as he printed), it will be necessary to look briefly at the author's life and philosophy. We then return to the most distinctive and challenging theses of the book, without neglecting its problems. Some of these, regarding the ethical implications of his doctrine, must have become obvious to Rosenkranz himself just a few years after publication, as artists such as Courbet and Baudelaire expanded the range of what might be seen as good in art by leaps and bounds, assimilating much that, in Rosenkranz's eyes, schooled by Romantic painting, poetry and caricature, had at best the negative virtue of bringing vice and evil to light. From a contemporary perspective, other aspects of Rosenkranz's presentation may cause offence – passages that now read as racist or misogynist, and which, even given a charitable historical context, reveal the limits of Rosenkranz's attempt to apply aesthetics not just to art and the realm of the aesthetic (which he pointedly and explicitly identifies with a realm of appearance), but to whatever this shares with reality in general.[21] That his apparent retrogression from Hegel's limitation of aesthetics to art makes Rosenkranz's ideas timely will be emphasized in the final section of this introduction, on thinking about ugliness today. A brief note on the language of the original, and its translation, concludes this prefatory material.

Rosenkranz's life and work

As with Karl Marx, there is a recurrent myth that Karl Rosenkranz (1805–1879) studied with Hegel. In one case, the myth is silly, as Hegel died when Marx was aged 13; in the other, the confusion is such that it would be equally wrong to say, as some scholars do, that Rosenkranz did *not* study with Hegel. He did in fact attend some of Hegel's classes in the late 1820s in Berlin. But he found the master's laboured speech, regularly interrupted by coughing and the taking of snuff, incomprehensible.[22] Two Hegelian teachers, Carl Daub and Hermann Hinrichs, impressed Rosenkranz more with their

[20] Rosenkranz, *System der Wissenschaft: ein philosophisches Encheiridion* (Königsberg: Bornträger, 1850, excerpt translated in this book; pp 296–306), 615. In 1850, Rosenkranz had not yet begun writing the *Aesthetics*. Cf. R 170–1 on caricature and the ideal.

[21] Schmidt complains that Kant and even Hegel had rightly emphasized this distinction, which Rosenkranz, Theodor Vischer, and other mid-century aestheticians had forgotten, and which he sums up as: 'beauty is only for humans' (*Die Grenzboten*, p. 4). Rosenkranz would agree, if this is rightly understood. He would not agree that Hegel had banished natural beauty, whatever Hegelians might have done: see his *Studien* (Berlin: Jonas, 1839), ix–x.

[22] Karl Rosenkranz, *Von Magdeburg bis Königberg* (Berlin: Heimann, 1873), 187. Most of his early biography is based on this amusing autobiography, which ends with the move to Königsberg (and the embrace of philosophy). As a student, Rosenkranz was a devotee of the more eloquent Friedrich Schleiermacher; on turning Hegelian, he published friendly criticism of Schleiermacher (1831, printed in book form in 1836).

earnestness than their theories, convincing him to study and finally to meet Hegel.[23] Meanwhile, as a junior faculty member in Halle, he attended Hegel's final lectures and birthday party, before his death of cholera in November 1831. By this time Rosenkranz had behind him a dissertation on German literary history and a habilitation thesis on Spinoza, and had struggled his way free of Romanticism and to an appreciation of the Middle Ages and their art, a learning experience he was to remember as being most difficult.[24] Being the youngest and most historical of the Hegelians, he was taken on to work on the massive editions of Kant and Hegel, providing the concluding biographical volumes of both, focussing on the dissemination of Kant's philosophy in the former, and on Hegel's life and its relation to his philosophy in the latter – an apt arrangement for the prophet and the Messiah of idealism.[25]

With his appointment in 1833 to Kant's chair in philosophy in Königsberg, occupied in the intervening years, first, by Traugott Krug (who left it to fight against Napoleon!) and then Johann Friedrich Herbart, Rosenkranz took up perhaps the most famous teaching post in German academia, but he also left Berlin for a backwater. His colleague Karl Ludwig Michelet joked about Rosenkranz disappearing into the mists of the Baltic, and in fact the alienation from the Hegel circle grew gradually over the following two decades to a breaking point in the mid-1850s, despite Rosenkranz's brief return to Berlin in July 1848 to serve in the liberal government of Rudolf von Auerswald, and as a Congressman in the first chamber of the Prussian Landtag. This political experience left him disappointed but not embittered, and while there is some justice in editor Dieter Kliche's picture of the aesthetics of ugliness as a work of political resignation, Rosenkranz's motto from Fourier (calling the aesthetics, like picking up rubbish and similar tasks, *works of devotion*) suggests rather a renewed commitment to the political dimension of everyday life.[26]

However political experience may have coloured the work, Rosenkranz, as Kliche notes, had worked on ugliness for at least 15 years. A letter of 1837 mentions patient preparations, including the building up of a collection of caricatures, which was to

[23] Hinrichs published a Hegelian reading of tragedy, *Das Wesen der antiken Tragödie* (Halle: Ruff, 1827), which was censured by Goethe for its turgidity, but may have inspired Nietzsche. Daub, with whom Rosenkranz studied only a semester in Heidelberg, proved more central to Rosenkranz's development: his *Judas Ischariot*, 2 vols. (Heidelberg: Mohr und Winter, 1816–18), in arguing that evil is the cause of natural ugliness, provoked Rosenkranz's resistance in an 1836 essay (collected in *Studien*, 155–205), to which he returns in his twelfth endnote of the *Aesthetics* (cf. R 24, R 439).

[24] *Magdeburg*, 361–63, gives an account of his turn to Spinoza, motivated by Hegel's critique of the latter's concept of substance, which Hegel identified with the Absolute, and thus the Subject, and thus, for Rosenkranz, a theistic God. Puzzled, he read Spinoza.

[25] Bernhard Bolzano 'learned to love and respect the man, whom I cannot warm to as a philosopher' on reading Rosenkranz's biography of Hegel. Wolfgang Künne, 'Goethe und Bolzano', in *Abhandlungen der Akademie der Wissenschaften zu Göttingen*, vol. 18 (Berlin and Boston: Walter de Gruyter, 2012), 84. Rosenkranz, in turn, was one of the few Hegelians to have read Bolzano's *Wissenschaftslehre. Aus einem Tagebuch*, 44–5.

[26] Dieter Kliche, 'Pathologie des Schönen', in Karl Rosenkranz, *Ästhetik des Hässlichen*, ed. D. Kliche (Stuttgart: Reclam, 2007), 477–81. Margaret A. Rose, 'Karl Rosenkranz and the "Aesthetics of the Ugly"', in *Politics, Religion, and Art: Hegelian Debates*, ed. Douglas Moggach (Evanston, IL: Northwestern University Press, 2011), 231–52, rightly insists that Rosenkranz's politics were more liberal (and leftist) than most historians suggest, and that his emphasis on the comic belies Kliche's account of his pessimism.

shape the finished volume, written in seven months in 1853.[27] That Rosenkranz, married and father of three children, engaged in such collecting, whose cost in remote Königsberg must have been considerable, suggests the importance of the project for him. The first decade of his activity in the Baltic city was a flurry of literary activity, with many polemical pamphlets defending Hegelian philosophy, important articles on political science, comparative religion, and German literary history, and a textbook of psychology that went through several editions and whose concept of fear fascinated Kierkegaard. Besides this, there were important reviews (including one of Hegel's *Aesthetics*, which we reprint in part), poems and a play, literary sketches of Königsberg and its denizens, a critique of duelling, and so on. Little wonder that intellectual exhaustion, coupled with impatience, set in. In a reply to the distinguished historian of philosophy, Eduard Zeller, Rosenkranz declines some writing opportunity, saying that he has put journalism and polemics behind him for the time being in order to devote himself to systematic work.[28] Informed readers might expect him to have meant his own *System der Wissenschaft*, which appeared just before the *Aesthetics*, in 1850, but that book is modestly subtitled *A philosophical enchiridion* (manual), and is no more than an update of Hegel, revising the psychology, logic, and above all the natural history and aesthetics in ways Rosenkranz had done in his apologetics, and above all in light of the science of the first half of the nineteenth century.[29] This book contains the author's considered thoughts on *everything*, including aesthetics (reprinted in this volume), but it is hardly the new systematic work for which he gave up controversy.[30] A reply to his critic Friedrich Dorguth is telling:

> I am heartily fed up with all dispute over principles. I would be satisfied if I were to succeed in constructing for a few disciplines a finer profile, a more solid foundation and a more natural context. One may argue over whether I have done this by thinking with 'abstract Spirit' or if it was only a mindless 'cerebral movement' – in God's name, let it only be true. On page 3 you ridicule my opting for a 'wholly new thinking'. What a weakling I must be, if I aimed at 'newness' in thinking, and indeed *ex arbitrio!*'[31]

[27] *Briefwechsel*, 59. In 1850, as the notes to the *System* translated by us make clear, he thought of the project as an *Aesthetics of Caricature*. He also intended it to be extensively illustrated. But a constitutional aversion to finishing things made the project seem far off: 'Must one not hold everything in oneself in continuous flux, can one then conclude or settle any element of spirit, of study, once and for all?' *Studien* (Berlin: Jonas, 1839), viii.
[28] Karl Rosenkranz, *Briefe 1827 bis 1850*, ed. Joachim Butzlaff (Berlin: Walter de Gruyter, 1994), 353 (no. 293). It is regrettable that Butzlaff was not able to publish a second volume of Rosenkranz's letters; these can be pieced together in part from the Varnhagen volume, Paul Herre, ed., *Karl Rosenkranz. Politische Briefe und Aufsätze 1848–1856* (Leipzig: Dieterich, 1919), and the appendix to Lotte Esau, *Karl Rosenkranz als Politiker* (Halle: Max Niemeyer, 1935).
[29] Rosenkranz, nephew of the mathematician Grüson, was more aware of these failings than other Hegelians, having debated the respective merits of Hegel and Newton with his uncle.
[30] Perhaps most interesting of Rosenkranz's 'systematic' efforts is his political geography in *Die Topographie des heutigen Berlin und Paris* (Königsberg: Bornträger, 1850).
[31] Letter to F.L.A. Dorguth, 30 July 1845, in Butzlaff, *Briefe*, 247 (no. 287).

There is a bracing modesty to this even today, as debates continue to rage about the reduction of *Geist* to brain states. But how on earth could this come out of the mouth of a mid-nineteenth-century Hegelian?[32] Even in his orthodoxy, Rosenkranz took on a more worldly attitude than was usual among Hegelians: in the first volume of his *Logic*, he styles himself 'a declared enemy of all abstraction that cannot legitimate itself in the concrete', insisting that the few traditional examples philosophers have 'chewed on' since Aristotle and Bacon should be richly supplemented.[33] This 'realistic tic', as he called it, may explain his agnosticism about ontology, especially those shadowy reaches that cannot be based on example. It also issued in a theoretically interesting revision of the key Hegelian concept of the idea (*Idee*).[34] For Hegel, this 'unity of the concept and reality' was one with the Absolute, and comprised everything, all substance: there is no 'idea of *some thing*', as he dismissively puts it, but concepts and material things are just limited, finite shavings of the whole of truth and reality, which is ideal.[35] Rosenkranz holds on to the formulation in terms of the identity of concept and reality, but dispenses with any hint that there is *one* idea: an idea is simply the 'objective and absolute form of the subjective concept', of which of course there are many.[36] Indeed, a subtle change in the inherited definition points to this: the idea is 'the existence of itself as the unmediated unity of the concept and its reality'.[37] Its reality: the idea is whatever is independent of thinkers that comes into play when they succeed in thinking (of things). As such, it is self-determined and prior to whatever objects it embraces. Rosenkranz's own examples are suggestive: life is not the same as its organic causes, freedom is not the same as its social causes. Simpler examples would work too: to borrow one from Socrates, if I use the word 'horse' to think of a horse, and you use it to think of a man, then the ideas involved in my and your thinking are the ideas of horse and man respectively. The objects could be destroyed, and the subjective concepts die with us, but the ideas of man and horse would remain. The resulting view of the rationality of all reality (because it can all come under concepts), which Rosenkranz calls both *Realidealismus* and *Idealrealismus*, is meant to do justice to both realism and idealism. It is also supposed to generate the whole majestic Hegelian panorama of

[32] Throughout his life, Rosenkranz held Hegel's improvement on Kant to consist of stating the ontological presuppositions of formal logic. *Magdeburg*, 361–2.

[33] Rosenkranz, *Wissenschaft der logischen Idee: Metaphysik* (Königsberg: Bornträger, 1858), vii–viii. At R 177, Rosenkranz defends his rich use of examples against Schiller.

[34] The advertisement for the *System* in the back of the *Aesthetics*, probably by the author, notes that in it, 'the teaching on the idea has been substantially changed and raised to a new doctrine', which, as we will see, is accurate despite the retention of Hegel's definition.

[35] G.W.F. Hegel, *Wissenschaft der Logik* (Nürnberg: Schrag, 1812), I: p. 55, where the definition is only mentioned casually; in the *Enzyklopädie* (1817, §161, pp. 111–12; 1845 §213, pp. 182–3), we learn that 'the idea is the true *in and for itself, the absolute union of the concept and objectivity*' (all italics are original). Hegel goes on to equate the idea with the absolute, with truth, and, warning that 'the idea itself is not to be taken as the idea *of some thing*' (*irgend Etwas*, literally *some something*, important because 'something' was taken to be the widest concept available, applicable to all objects), ends by suggesting that there is just *one* idea, and that is the 'one, general substance'.

[36] In *Magdeburg*, p. 361, Rosenkranz complains of Hinrichs' logic that it mixed up the subjective (conceptual) and objective (ontological) halves of Hegel's.

[37] *System*, 117 (§236) and 119 (§238). At *System*, 466 (§711), Rosenkranz uses the plural, *Ideen*, without giving an impression of carelessly relapsing into an everyday usage.

natural and human science, a *system* whose schematic inadequacy Rosenkranz was in no position to reject.[38] But it is typical of him that he explains the ideality of reality in down-to-earth terms as the joy of recognition, the grasp of the idea in the awareness that an object falls under a concept. This process, as he puts it, is also an ethical and an aesthetic one. 'The unity of the idea with itself as *reunion* gains a yet greater intensity and sensitivity, like the rejuvenation of a convalescent; like the comicality that results from ugliness, and so on. There is more joy in heaven over a sinner that repents than over ninety-nine just men.'[39]

No wonder that Rosenkranz's old colleagues turned against him as Neo-Kantian resistance to the Hegel School intensified. In 1860, articles by the conservative Michelet and the revolutionary Lassalle tore into Rosenkranz: the official complaint was a theological one, since Rosenkranz insisted that Hegel had been a theist, not a pantheist, but the critics, after praising Rosenkranz's literary style, pulled out all the stops, accusing him of the cardinal sin: a regression to Kant. In response, Rosenkranz defended his theology and embraced the Kantian label, which he identified above all with an open attitude in philosophy and courtesy in debate.[40] The polemics that followed unfortunately overshadowed the *Aesthetics*, which in its way signalled a more decisive break with Hegel, at least as he was then worshipped in Berlin.[41] Rosenkranz did in the end retreat somewhat from philosophy, following up his volume on Goethe (1847) with a two-volume study of Denis Diderot, his autobiography (whose 487 pages end with his move to Königsberg), and a second Hegel biography, *Hegel als deutscher Nationalphilosoph*.[42] The predicate of that title had by this time come to have a bitter ring for Rosenkranz: the son of a French mother and himself a Francophile (he spent two months in Paris in the summer of 1846), and a patriotic German (see the rant in this book about the neglect of German novels), he could not accept the nationalist vitriol of the Franco-Prussian War, particularly the blanket rejection of French art and thought. Retiring from teaching in 1873 on account of blindness, he lived his final years in obscurity, his aesthetics carried on by a few of his students, notably the poet-critic

[38] Two decades after the *Aesthetics*, Rosenkranz in fact re-edited Hegel's *Enzyklopädie* in Kirchmann's *Philosophische Bibliothek* series of great works of philosophy (Berlin: Heimann, 1870), sharply deploring the 'randomness' of the reasoning in all the books that carry 'inductive method' proudly on their title pages. He hopes against this that Hegel, for all his empirical obsoleteness, will prove a discipline of thought, quoting loosely from Hegel's review of Jacobi: 'one has to know what one has said; but this is not as easy as one thinks' (p. xxii) The part after the semicolon is in any case Rosenkranz's.

[39] *System*, 137 (§258).

[40] In *Der Gedanke*, vols 1 and 2 (1860 and 1861). Joachim Butzlaff, in the *Neue Deutsche Bibliographie* (Berlin: Duncker & Humblot, 2005), vol. 22, 71 (also available online), mistakes Rosenkranz's complaint that he had been 'solemnly de-Hegelized' as a confession that he had been refuted: he was only complaining of his social exclusion from the Berlin cabal. His philosophical reply is in *Epilegomena zu meiner Wissenschaft der logischen Idee. Als Replik gegen die Kritik der Herren Michelet und Lasalle* (Königsberg: Bornträger, 1862), which led to further replies in *Der Gedanke* for 1862.

[41] His loving parody in 1836 of the 'vulgar opinion' of Hegel has more than a whiff of iconoclasm, especially the image of the end of art as 'the world spirit ascending the peak of the cultural pyramid in his philosophy'. See Rosenkranz's review of Hegel's *Ästhetik*, *Jahrbuch für wissenschaftliche Kritik*, January 1836, 8 (excerpts translated in this book, see pp. 287–96).

[42] He did not wholly give up controversy: his discussion of Moriz Carrière's aesthetics is in the final volume of his *Neue Studien*, printed in 1878, two years before his death.

Rudolf Gottschall and the aesthetician Maximillian Schasler.[43] His own papers, and what he had of Hegel's were dispersed or burned, some in San Francisco after the 1906 earthquake, some in Königsberg in 1945.[44]

Realism in aesthetics

The brief account of his life is not given for its own sake, but for the light it throws on the aesthetics of Rosenkranz. His interest in caricature, the metropolis, medieval and non-Western cultures (not placed, as in Hegel, on lower rungs of intellectual development) will be obvious to the reader: more subterranean, but no less decisive, is his break with the idealist aesthetic tradition of Kant, Hegel, and contemporaries like Arnold Ruge. This break, which issues in a realism about the existence of aesthetic properties, and which Rosenkranz, as we have seen, was to declare in his *Logic*, published five years after the *Aesthetics*, remains in this book to some extent implicit. Rosenkranz aims to correct, not supplant, writers he rightly thought greater than himself: but his realist tendency becomes explicit just where he starts rebelling against Kant, around the middle of the book. As it informs his diverse views of ugliness, it is worth sketching before diving into the detail.

But, first, just what can realism in aesthetics mean? That beauty, ugliness, and whatever other aesthetic properties exist are to be found *in the objects themselves* and only trivially in the perceiving subject who takes account of them.[45] This position might sound alarming to the art historian or institutional art theorist, but of course sociological and cultural theories of aesthetic judgement also have to appeal to empirical realities and not just subjective conditions of the possibility of aesthetic experience. The fact of spectators, even of consciousness, does not render an aesthetics idealist or conventionalist: it is the claim that consciousness *constitutes* the aesthetic object that does so.[46]

[43] Schasler's monumental two-volume *Kritische Geschichte der Ästhetik* (Berlin: Nicolai, 1882), dedicated to Rosenkranz, adapted many of his distinctions to an intellectual history of aesthetic systems, rather in the style of Hegel's lectures on the history of philosophy. Also like Hegel and Kant, Schasler denied that ugliness aesthetically applied remains ugly. More interesting from an art historical standpoint is Rudolf Gottschall's article, 'Glossen zur Aesthetik des Hässlichen', *Deutsche Revue über das gesamte nationale Leben der Gegenwart*, 3 (July–September 1895): 38–54, which adapted Rosenkranz's categories to art of the late nineteenth century. The one substantial discussion of Rosenkranz in English, siding rather with Schasler, is Bernard Bosanquet, *A History of Aesthetic* (London: Swan Sonnenschein/New York: Macmillan, 1892), 400–9.

[44] Butzlaff, *Briefe*, 11, notes that Russian libraries did not appear to have saved any of this, but remained optimistic because of then-recent discoveries of Kant material.

[45] R 178 lists Schiller among the subjectivists, as he was in the *Letters on Aesthetic Education*; but in unpublished notes on the 'aesthetic estimation of quantities' (*Von der ästhetischen Größenschätzung*), Schiller conceded that objects cause the 'phenomenon' of the sublime in subjects, and that we predicate it of the objects. *Schillers Sämmtliche Schriften. Historisch-kritische Ausgabe*, ed. Karl Goedeke (Stuttgart: Cotta, 1871), vol. 10, 201. This position might be called an 'internal realism' like Hilary Putnam's.

[46] Such a position, traditional to German aesthetics, is revived by Juliane Rebentisch. Intermediate positions are possible, though perhaps less interesting than full-blooded realism and idealism. Realism too, to be clear, has to account for conscious experience.

Such a focus on the subject had been Kant's great innovation, and much has been claimed for it: not only the inward turn of German idealism, but the whole critical tenor of modern theory of knowledge with its focus on mental acts. It might seem strange for a Hegelian to attack *this* aspect of Kant, on which Hegel built in limiting aesthetics to art. And Rosenkranz does not attack the actual arguments of the *Critique of the Power of Judgement* that purport to show taste to be both subjective and universal. Rather, he bluntly rejects the doctrine where it is most implausible: where it refers to the sublime, which Kant had made out to be *more* subjective than judgements of beauty, tracking not form in nature but our inability to conceive it, and reflecting feelings of pleasurable fear, respect, and inadequacy in our response to it. That post-Kantians had done away with even this tenuous link to nature frustrates Rosenkranz:

> We know very well, where the sublime in it exists; we seek it out, in order to enjoy it; we make it the goal of troublesome journeys. When we stand on the snow-covered peak of smoking Aetna and see Sicily before us between the coasts of Calabria and Africa, washed by the sea's waves, the sublimity of this view is not our subjective act, much rather the objective work of nature, which we already expected before we reached the peak. Or when the Niagara Falls, its spray rising into the heavens, thunders over the shaking walls of stone for miles round, it is in itself sublime, whether a human witnesses this theatre or not.[47]

Rosenkranz characteristically combines crisp examples (of what we would now call tourist sites), psychology (our expectation of the sublime effect of the view), and realist argumentation concerning the persistence of objects of perception. If this reads like an anticipation of G.E. Moore's arguments against the idealist doctrine that to be is to be perceived, it provoked similar charges of naïveté. Rosenkranz's former pupil Julian Schmidt, for instance, in his organ of 'programmatic realism', *Die Grenzboten* [The border messengers], called this passage 'school-boyish', pointing out that a change in size makes mincemeat of Rosenkranz's argument: 'a Gulliver from Giant-Land would find the Niagara Falls, on wading them, no more sublime than a sluice.'[48]

It is easy to ridicule realism in this manner by singling out the contribution of the spectator to aesthetic experience. An aesthetic realism that dispenses with people is indeed silly. But Rosenkranz, who was talking only about our anticipation of a sublime view, never denies this. And a moment's thought suggests that Schmidt's counterexample plays into Rosenkranz's hands: he has not shown the sublime to be the product of 'the power of one's own soul', in which case we would be ill-placed to understand the giant's view, but only that the relation of one's bodily size to that of the object (a plainly physical one) plays a role in the sublime. One cannot disprove realism about aesthetics thus. But the challenge remains pertinent to the extent that it prompts the realist to specify what the perceiving subject contributes to aesthetic experience. This is in fact what Rosenkranz does in the body of the book, turning from putative cases of ugliness in form (in physical nature, inanimate and animal) to intentional ugliness in aesthetic

[47] R 178–9.
[48] Schmidt, *Die Grenzboten*, p. 5.

and moral rule-breaking.[49] Neither the interest in natural ugliness, nor the ascent from the physical to the moral world, is unusual among the post-Hegelian aestheticians, as Schmidt notes. What makes this development unique in Rosenkranz, and will be discussed more closely in the next two sections, is an identification that concedes to idealist aesthetics their main insight: that what makes *objects themselves* ugly is the recognition of the subject that they fail to conform to some ideal. Thus the kind of naïve-Hegelian criticism of, say, amphibians as neither land- nor sea-dwellers becomes an attribution of ugliness in light of a teleology assumed by observers of animals (Rosenkranz, not seeing the point of a long neck, finds giraffes ugly). This step, far from abandoning realism about aesthetic qualities, extends it to observers: it only makes sense to find some pieces of nature, some living things, some humans and artworks and writings, beautiful, ugly, or indifferent if a relation between these objects and the judging subject is the real object of the aesthetic judgement. This leads to the refutation of a lot of accusatory aesthetics which equate ugliness with matter, primitive states of *Geist*, evil (notably, by Rosenkranz's teacher Daub), and a variety of other imperfections: as Rosenkranz ironically points out in the Preface to the section on deformation, which is probably the most philosophically rewarding ten pages of the book, the devil can make himself pretty if need be, so that any theory that just happens to make ugliness the same as some moral or other non-aesthetic failing cannot be the whole truth. The truth in such speculation, Rosenkranz suggests, depends on intention, both that of the artist who renders the world in beautiful or repulsive ways, and that of the observer of art or nature who interprets what is encountered in aesthetic terms.

What it means to interpret the world aesthetically is precisely the formal aspect of cognition, its phenomenal character emphasized by Kant:

> Aesthetics may rest content with illusion. When the jet of a fountain squirts through the air, the resulting appearance is a purely mechanical product of the height from which the water must first fall, but the violence with which it shoots out lends the water an illusion of free movement. A flower waves its petals back and forth. The flower does not really turn itself this way and that, back and forth; the wind pushes it. But illusion makes the flower appear to be moving on its own.[50]

Aesthetics as the province of appearance is formal through and through, but the account remains realist precisely because the appearance, as illusion, may be true or false. It is here that Rosenkranz offers his substantial account of what beauty and ugliness track, which is freedom, understood very broadly:

[49] As Schmidt notes, the backtracking from Hegel's 'culture only' position is obvious already in the long introduction, which treats in sequence the 'naturally ugly', the 'intellectually ugly', and the 'artistically ugly'. Of course, a Hegelian might go through this trichotomy to conclude that the artistically ugly alone is fundamental. That is not what Rosenkranz does in the body of the book, which shuffles the order of the elements: while the first section, on formlessness, deals in great part with natural phenomena, art examples crop up too, and they predominate in the second section, on incorrectness, only to take their place among natural, moral, and religious examples in the third and longest section, on 'disfiguration or distortion', which ends with an enthusiastic account of caricature as the reunion of intentional ugliness with the ideal.

[50] R 166–7. For stylistic reasons we have removed the definite article before 'illusion' in the first line.

In fact, the ultimate ground of beauty is nothing but *freedom*; this word is meant here not in the brute ethical sense, but in the general sense of spontaneity, which is indeed perfectly consummated in moral self-determination, but which also becomes an aesthetic object in the game of life, in dynamic and organic processes. Oneness, regularity, symmetry, order, natural truth, psychological and historical accuracy cannot yet by themselves satisfy the concept of the beautiful.[51]

Freedom, as Rosenkranz understands it, is no purely subjective state found only in a thinking subject, though its (possibly illusory) recognition by a subject explains aesthetic judgements. Freedom in the sense of dynamic process can be found throughout nature, and some of its most interesting applications are indeed in the natural substrate of human subjects. A revealing passage finds flatulence objectionable because it is a bodily process that escapes our conscious control: this obviously and elegantly explains why it is found particularly offensive in company, say, in a meeting. But this lack of control also makes flatulence funny, because it is felt to represent a freedom of the body asserting itself against our conscious regulation. As such, it reminds us that we are, despite social and other hierarchies, alike at least 'in this non-arbitrary humbleness of our nature.'[52]

What Rosenkranz here appreciates about low bodily humour has not just been overlooked but often actively suppressed. Take Rembrandt's *Rape of Ganymede* in Dresden, painted in 1635 for a Protestant client. As Rosenkranz pungently puts it, in this down-to-earth interpretation of the myth, the eagle's claws 'pull up [the boy's] shirt to reveal his round behind', while 'he pees in fright in the manner of children'.[53] This, Rosenkranz allows, is really funny, and his account of freedom – of which Ganymede is deprived, while his bladder seems to exercise it – can help us see why without assuming a desire to parody the myth. But all this is to assume that what Rembrandt painted Ganymede *doing* matters: an assumption not shared by the English etcher Anthony Cardon (or more likely by his employer Colnaghi) who in 1795 published an impeccable reproductive etching that left out the urine (Figure 1). Such cleaning up of Rembrandt's bodily fluids was not undertaken in all reproductions of the period.[54] But the censored print, for all its silliness, conveys an important insight: not only is content as central to aesthetic value as formal properties, but the refusal to think on it is liable to lead to all kinds of distortion and 'counterfeiting' of art, as Rosenkranz pointedly put it in his Preface.

[51] R 166. *System*, 562, defines beauty as 'harmonious-appearing freedom of spirit in sensuous form'. He seems to have formulated this principle first in his criticism of C.H. Weiße's book on Goethe's *Faust*: 'Without seeing freedom as the principle of the Faust poem, much in it must seem arbitrary, as it does to Mr. Weiße.' *Jahrbücher für wissenschaftliche Kritik*, 80 (October 1837), 606.
[52] R 234.
[53] R 232. Margarita Russell, 'The Iconography of Rembrandt's *Rape of Ganymede*', *Simiolus* 9(1) (1977), 5–18, discusses the critical puzzlement over this work.
[54] The 1770 engraving in the *Recueil d'estampes d'après les plus célèbres tableaux de la Galerie Royale de Dresde* has the urine, above the coat of arms of the Elector of Saxony!

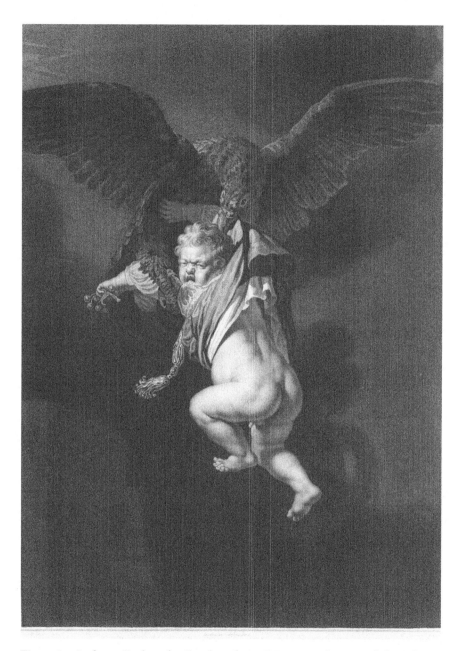

Figure 1 Anthony Cardon after Rembrandt van Rijn, *Rape of Ganymede* [1635], etching and engraving, 1795, The British Museum, London.

Source: © The Trustees of the British Museum.

Problems of ugliness

Rembrandt's peeing Ganymede bears witness to a key aspect of Rosenkranz's thinking: its tendency to slide casually, without warning, from artwork to its subject matter, or from representation to reality. This tendency, we contend, is one of the book's strengths when it comes to drawing attention to cultural and psychological aspects of art.[55] Its unsettling nature is most obvious in those passages where Rosenkranz's judgement diverges sharply from our own. Not long after he warns us that aesthetics deals in illusion, we come across this passage: 'Dwarf size is the normal dimension of the Laplander. A bushman, on the other hand, whose head is big, whose thigh is thin, whose legs are almost fleshless, wanders already into the apelike mode and thus becomes a caricature of the human form.'[56] A reader today is likely to either ignore this or put down the book in disgust. But can we learn anything from it? After all, Rosenkranz has just told us that aesthetics' real basis in freedom may be illusory. Do proportions, thought of as purely phenomenal and thus formal, avoid this? Note that Rosenkranz, like Hegel, distrusts physiognomy and nowhere relies on it to cement transitions from ugliness to inferiority.[57] But, according to Kant, aesthetics delivers judgements concerning the purposiveness of natural objects that rely on nothing but perceived form. That this led even the great cosmopolitan to dodgy remarks about the inhabitants of New Holland and Tierra del Fuego should warn us about the pitfalls of moving from phenomenal to real qualities.[58] The passage then may make a good cautionary tale about such ventures.

For starters, we may note that the views are racist, but not unusual of his era: the Sami people of Northern Europe, then called Lapps or Laplanders, were themselves subject to much tendentious ethnography, and exhibited in Hagenbeck's human zoo in Hamburg. Nor does Rosenkranz attack Africans in general: early in the *Aesthetics* he praises the 'blacks of Dahomey and Benin', especially the 'bodyguard of several thousand amazons' of the Dahomey king.[59] This is in line with German taste of the

[55] Werner Röcke, 'Karl Rosenkranz (1805–1879)', in *Wissenschaftsgeschichte der Germanistik in Porträts*, ed. Christoph König, Hans-Harald Müller and Werner Röcke (Berlin: Walter de Gruyter, 2000), 33–40, argues that despite its rejection by philologists like Karl Lachmann and Jakob Grimm, Rosenkranz's work on medieval German literature presaged a later turn to cultural and social history in the discipline.

[56] R 173–4. Cf. R 32, where it is said that the bushman, 'like the cretin, is ugly by nature'.

[57] On Hegel's critique of physiognomy in the *Phenomenology*, see Alasdair MacIntyre, 'Hegel on Faces and Skulls', in *Hegel: A Collection of Critical Essays*, ed. Alasdair MacIntyre (Notre Dame, IN: University of Notre Dame Press, 1976), 219–36; Steven De Caroli, in 'The Greek Profile: Hegel's Aesthetics and the Implications of a Pseudo-Science', *Philosophical Forum* 37:2 (2006), 113–51, points out that Hegel nevertheless relied on physiognomic ideas in his aesthetics. Hinrich Lichtenstein, *Reisen im südlichen Afrika*, vol. 2 (Berlin: Salfeld, 1812), 86, ridicules phrenological attempts to locate 'the organ of murderousness' in a Bushman skull, relying instead on environmental factors.

[58] Immanuel Kant, *Kritik der Urtheilskraft*, 3rd edn. (Berlin: Lagarde, 1799), 300 (§67).

[59] R 28. Rosenkranz thinks all 'races and social classes' obey the rule that 'with growing freedom, the beauty of the appearance grows as well'. On German enthusiasm for the female bodyguard of the King of Dahomey, see Suzanne Preston Blier, 'Meeting the Amazons', in *Human Zoos: Science and Spectacle in the Age of Colonial Empires*, ed. Pascal Blanchard, Nicolas Bancel, Eric Deroo, and Sandrine Lemaire (Liverpool: Liverpool University Press, 2009), Chapter 13; for more on the Amazons, see Blier, 'Mort et créativité dans la tradition des amazones du Dahomey', *Ethnocentrisme et création*, ed. Annie Dupuis (Paris: Éditions de la Maison des sciences de l'homme, 2013), 67–80.

time, as is the skewed account of the San peoples (called Bushmen), persecuted by Dutch settlers and routinely said to occupy a state between the human and the animal.[60] If Rosenkranz relied on this kind of travel literature, his description of San proportions as 'a caricature of the human form' is not a purely formal judgement. Indeed, one of the lessons of Rosenkranz's third section is that our perception of ugliness is never simply formal, but relies on our standard of beauty. The imputation of an inferior state to the Bushmen cannot be justified on such a basis, unless we have established a biological standard of beauty as the superior state: it is interesting that, even in repeating the racist remark about being like an ape, Rosenkranz draws no biological conclusion on its basis. And we can see why, on a realist construal of aesthetics: whether a formal negation corresponds to a real characteristic is a matter of fact about the world, which an aesthetic representation, as an intentional human act, either captures or fails to capture. That the Bushman 'becomes a caricature', says, as we would expect, more about Rosenkranz than about his subject.

The processual nature of such judgements (stating that persons or things *become* ugly or beautiful), and its problematic relation to real qualities of their subjects, are deeply connected with Rosenkranz's view of caricature, which distorts its subject in representing it justly. Although he speaks of caricatures *in the world*, there is no doubt that caricature, as in the case of a suite depicting the French colonization of the Marquesas (see Figure 16 on p. 253), is a vehicle of social criticism and reporting. Could Rosenkranz express this duality without making reality contain walking caricatures? Not, it seems, without losing some of the force of his exposition of caricature as both a creative process and (in the truthful case of a fit target) the amplification of real problems in the world. This merit is often connected with the naïve tendency of sliding from a discussion of pictures and narratives to one of the persons or events they represent.[61] The most striking such ambiguity is probably Rosenkranz's long quote from George Catlin's *Indians of North America*, which retells the tragic end of Wi-jun-jon, an Assinneboine who journeyed to Washington, returned to his tribe with Americanized dress and habits (above all, drinking), and was murdered, ostensibly on suspicion of having become too powerful a witch doctor.[62] Catlin himself tells the story in an ironical dialogue with a Frenchman, full of stereotypical interjections in French. He also obligingly provides before-and-after images of Wi-jun-jon, whom he had painted on other occasions, in 'the full regalia

[60] See the discussions in *Archiv für Geographie, Historie, Kriegs- und Staatskunst*, 7 (1816): 54; *Der Sammler* 99 (18 August 1831), 395; *Das Panorama des Universums*, vol. 10 (Prague, 1843), 300. Even sympathetic accounts like Lichtenstein and Robert Moffat, *Missionary Labours and Scenes in Southern Africa* (London: John Snow, 1842), stress the bushmen's abjectness. Moffat, for one, quotes Gibbon to the effect that South Africans were 'the connecting link between the rational and irrational creation' (p. 6). The phrase is not in Gibbon, but inspired by Chapter 25 of the *Decline and Fall of the Roman Empire*, where Gibbon, despite hating slavery, attributes its success to Africans' weak intellects. Such contradictory attitudes were the rule in European writing about Africa.

[61] Rosenkranz admits 'a distinction between caricatures that belong to the world of real phenomena, and those belonging to the world of art' (R 393). Among the former are knights of industry, precocious children, pedants: a whole cast of Biedermeier types.

[62] R 418–19.

of his magnificent national costume' and then as 'the horrible, ridiculous grimace' he had become (see Figure 15 on p. 251).[63] Rosenkranz seems blissfully unaware of the role Catlin plays in *making* this caricature, but then, as literary scholars have pointed out, Catlin himself resorted to indirect discourse, irony, and hyperbole in recounting the story because of his own anxiety about not being believed by his public.[64] But just as he may have exaggerated or even distorted Wi-jun-jon's final appearance and behaviour to suit his needs, it is possible for such distortion not to be only a parody or travesty, which would invert some positive attribute for the purpose of ridicule, but a kind of disciplined distortion meant to draw attention to the corrosiveness of what is being criticized. In Rosenkranz's concluding words on the case, 'If art should handle such contradictions, it must have the irony to ridicule the shortcomings of culture itself.'[65]

This aphorism launches into the discussion of colonial caricature in the French Marquesas. The impression that caricature can face up to modern political problems in a way that neither tragedy nor didactic propaganda can certainly links Rosenkranz to contemporaries like Charles Baudelaire (in his writings on caricaturists) and even recent advocates of the graphic arts like Art Spiegelman. Unlike these writers, Rosenkranz prefers to give a quasi-logical account of caricature as the negation of ugliness itself, a 'contradiction of the contradiction' (R 42), able to rise to the same ideal that the most ambitious kind of art pursues. True, Rosenkranz distinguishes three kinds of caricature, viz., portrayal, symbolization, and idealization, with the last being the highest. The Catlin kind (portrayal), being most akin to the world's own caricature, is the lowest. But in all cases, whether an aesthetic or a moral or a political ideal is being made conspicuous by its absence, for Rosenkranz, 'caricature points restlessly beyond itself, because with itself it represents at the same time something else' (R 414). The realist point of the untruth of caricature is to bring us closer to reality. In doing so, it is also aesthetically delightful, as Rosenkranz noted in comparing the laughter ugliness can unleash with the feeling of recovering from illness. It is this kind of thoughtful hedonism that Rosenkranz finds in a Viennese farce, wherein a misanthrope trades roles with the mountain king, only to complain bitterly that the latter exaggerates his misanthropy. 'How true, how deep, how philosophical, we want to say, is this humour! If we all could see ourselves once so truly objectively, would we not also be of the opinion that we indeed appear to ourselves, but not quite how we really are, rather a trifle exaggerated?' (R 428).

[63] Catlin's oil painting is in the Smithsonian Museum of American Art, Washington, DC. It and the English book show 'before and after' scenes, posing Wi-jun-jon in Assinneboine attire before the cupolas of Washington, and then as a Yank back home. The German edition Rosenkranz knew only has the latter image, an interesting decision in itself.
[64] Brian W. Dippie, *Catlin and his Contemporaries: The Politics of Patronage* (Lincoln, NE: University of Nebraska Press, 1990), 322, and Laura L. Mielke, *Moving Encounters: Sympathy and the Indian Question in Antebellum Literature* (Amherst, MA: University of Massachusetts Press, 2008), 13–16.
[65] R 419.

Ugliness today

We hope that some of the interesting features of Rosenkranz's text, and its limitations, have emerged in our quotations and discussion, and entrust the further exploration of both to the reader: in concluding, we only mention several avenues of research that Rosenkranz does not pursue but which might benefit from acquaintance with his work. The first may be seen by a quick art-historical examination of the modern editions of Rosenkranz. The 1968 German facsimile edition (contemporaneous with Jauss's volume on the '*no longer fine arts*') and the 1984 Italian edition have plain covers, as befits sober Hegeliana; the 1984 Romanian edition, translated by an art historian interested in computer art and systems aesthetics, features Bosch's late, livid *Carrying of the Cross*; the 1992 Spanish edition has a detail from Brueghel's *Fall of the Rebel Angels*, while both the German reprint of 1996 and the French edition of 2004 feature Jeff Koons' polychrome sculpture of angels driving a pig.[66] In brief, whether the emphasis is on Renaissance monsters or contemporary kitsch, new editions of Rosenkranz address themselves to the art world's fascination with the disgusting and the abject, which dominated painting and sculpture in the 1980s before undergoing feminist and identity-cultural transformations in riot girl, grunge, Young British Art, and other 1990s tendencies. That Rosenkranz, with his own parade of aesthetic deformities and diagnoses, should interest theorists of the abject and the grotesque as a historical precursor is not surprising; they could, however, probably learn also from his coordination of positive and negative aesthetic features that the attempted separation of the latter into autonomous, utopian markers of avant-garde identity is problematic. And, in another spirit altogether, nominalist debunkers of aesthetics as social capital in the tradition of Pierre Bourdieu, as much as Kantian transcendentalists trying to reconstruct the aesthetic judgements of ugliness, might gain from Rosenkranz's explorations of aesthetic rule-following and rule-breaking.[67]

Less straightforward, but perhaps deeper, is the book's value to those trying to apply aesthetic methods to ethics. We are no longer, like Jauss and Goodman and their peers, so confident that aesthetic features can exist independently of one another, and of substantial worldly commitments. Despite this, recent efforts to explore the subjective and moral dimension of habitat destruction through environmental aesthetics are plagued by a certain arbitrariness, as if the authors are merely convinced ad hoc of the applicability of aesthetic attributes (the sublime, the beautiful) to landscapes and living things, coupled to the notion that our societies value aesthetic objects more highly than certain natural ones. There is a flourishing conservationist literature that argues that endangered species (or individual animals) have the same kind of aesthetic value as

[66] The 1996 Reclam edition (reprinted with a new cover in 2007) reprints the 1990 text, one of the last books published by Reclam Leipzig, the East German branch of the venerable publishing house. Though the 1996/2007 version of Kliche's afterword adds page references left missing in 1990, there was no error-checking of Rosenkranz's text: the error at R 4, for instance, is still to be found in the 2007 reprint.

[67] In particular, his view of the pleasant and the sublime as species of the beautiful, with corresponding opposites within the ugly, simplifies the logic of aesthetic judgement.

works of art.[68] Here the difficulties Rosenkranz had in moving from formal qualities of representations to the content represented, and the ways he tried to justify such moves, are pertinent. Furthermore, more general aesthetic and affective reasoning in moral discourse, like appeals to the 'yuck factor' in bioethics, could gain from Rosenkranz's articulation of the kinds of negative reactions evinced and their justification.

In thus commending Rosenkranz to contemporary ethicists and social activists, we do not want to give the false impression that he had ready answers to all questions. Indeed, attempts to understand nature or society in aesthetic-moral terms are hardly new. But when Theodor Adorno, in the 1960s, saw in the revulsion caused by polluted landscapes nothing but bourgeois bad conscience about domination, or Alois Riegl, writing at the turn of the twentieth century, conjectured that the same sentimentality informs animal rights, the preservation of historic buildings and of rock faces, it is the idealist, subject-oriented face of aesthetics that asserts itself.[69] An industrial landscape is more than a prod to conscience; it is a bad place to live, even if often a visually striking one, and our discomfort, as well as the split between our visual appreciation of things like photographs of factories and our aversion to living in their vicinity, must reflect this to some extent. But to what extent? Already the significance of something *looking* ugly is less clear: as Rosenkranz put it, so much of our aesthetic attitude to landscape depends on how it is lit.[70] Formal qualities matter after all, *even in reality*. The passage on Mary Shelley's *Frankenstein* (R 349–51), though ambivalent, is exemplary: Rosenkranz notes the curious fact that though the professor feels no compunction about destroying the monster's companion (an act which would doom his own), he nevertheless feels a thrill of murder in doing so. Aesthetics is more than an epiphenomenon of moral or material processes: it is one of the active domains in which life, humanity, right and wrong, are decided. Its pursuit may prove more than its own reward: it may let us 'look through the struggle of phenomena', like the book's closing image of the maenad, feet planted on the ground, eyes turned to the stars.

A note on the text

In translating a book on ugliness steeped in Hegelian terminology but dealing mainly with works of art and literature, two reader constituencies matter: the philosopher and the general reader. Unfortunately, the history of philosophy has calcified a number of bad translations of key words, some as old as the seventeenth century. Perhaps the slipperiest, *Vorstellung*, the standard German word for a subjective conception, sensory

[68] For criticisms of these views, and an improved analogy of species with *genres* of art, see Alan Carter, 'Biodiversity and All that Jazz', *Philosophy and Phenomenological Research*, 80(1) (January 2010): 58–75.

[69] Theodor W. Adorno, *Ästhetische Theorie*, ed. Gretel Adorno and Rolf Tiedemann (Frankfurt: Suhrkamp, 1970), 76; On Alois Riegl, 'Das Denkmalschutzgesetz', *Die Neue Freie Presse*, 27 February 1905, 6, see Mechtild Widrich, 'The Willed and the Unwilled Monument', *Journal of the Society of Architectural Historians* 72(3) (September 2013): 382–98, on the analogy with the protection of animals, p. 389.

[70] R 18, 26.

or internal, visual or aural or linguistic, is usually rendered 'idea' after Locke's eccentric usage.[71] The result is that *Idee*, a common word, is capitalized as 'Idea', giving it a Platonic ring. Rosenkranz indeed uses *Idee* to stand for an objective concept, but that only makes it all the worse to use English 'idea' for subjective *Vorstellung*. We therefore, according to context, alternate 'image', 'thought', 'imagination' and other clear markers of subjective conceiving. On the other hand, the philosophical classic *Anschauung* since Kant has been translated as 'intuition', leading to much confusion with mathematical intuitionism, biological instinct, and supposed sources of pure insight in philosophy. We have used 'view', whenever the derivation from 'look' (*anschauen*) seems to demand it, but for general purposes, as Max Black and Peter Geach once suggested, it is best translated as 'experience', which does not impose a visual interpretation. We have done this where we could, and it not only makes lovely sense of what Rosenkranz is saying, but it rightly highlights the Kantian heritage. The distinction between *das Schöne* and *Schönheit* (the beautiful and beauty), and the corresponding words for ugliness, though it usefully distinguishes object from concept, we have not followed strictly, because the style would have suffered, and Rosenkranz does not draw this distinction. Because Germans capitalize *all* nouns, we have not: even if the book had talked a lot about *das Absolute*, we would still have translated it as: 'the absolute'.

This brings us to Hegelian terminology, on which Rosenkranz particularly relies to find terms for strife and fragmentation. Thus, for *Entzweiung*, we prefer the physical 'rupture' over received jargon like 'diremption', which, like the pretentious Latin of the Standard Edition of Freud, gives a false sense of what it is like to read the author in German. Among Hegelian terms of art, only *Aufhebung* is frequent in Rosenkranz, but *never* in the famous equivocal sense of at once conserving, destroying, and elevating: in Rosenkranz, to be *aufgehoben* is to be univocally destroyed or invalidated, and though the use may be neutral about a superseded thing's continued existence, this is clear enough in each context. We therefore use plain English 'cancel' throughout, which is similarly neutral about a cancelled thing's continued existence. An interesting case, because it deviates from Hegel more subtly, is Rosenkranz's use of *Verstand*. Though he too, like Hegel, unfavourably contrasts this with *Vernunft* (reason), in Rosenkranz, it is not mathematical or purely discursive 'understanding' that is denigrated, but common sense. Rosenkranz's own terminology, that of ugliness, tends to come from everyday discourse, so we stick with etymologically transparent words (mean for *gemein*, which matches both current and ancient usage; but 'common' is the better reading in some contexts, and there we have used it). Most terms are self-explanatory, others are explained in our foot-of-page notes. Rosenkranz's own, at times self-indulgent and often fascinating endnotes are printed, as in the original, at the back.

One oddity of nineteenth-century typography deserves mention: long dashes are not always parenthetical, but often function as subparagraph breaks, a sign that a new point is being addressed within the larger topic. This is useful, so we have left it untouched. Most translations, to maintain consistency, are ours: we give the original where Rosenkranz does and it is not too long. Original page numbers are bold and

[71] Rosenkranz himself, *System*, 228 (§118), notes that in the Romance languages the word 'idea' is used both in the subjective sense of *Vorstellung* and in that of abstract thought.

bracketed, e.g. **(5)**. In all doubtful cases, we followed the conviction that this is not, as some German historians say, the definitive text on ugliness, but a good starting point: to paraphrase Austin, not the last word, but one of the first.[72]

The book is illustrated with prints that Rosenkranz explicitly discusses. A few paintings are likewise illustrated in the form of reproductive prints, as was usual in publishing at mid-nineteenth-century. This should enhance reading and appreciation of the book's engagement with visual material. And though in his Preface Rosenkranz inveighs against lavishly illustrated but prudish texts, his own 1850 notes call for an atlas of illustrations to 'really put paid to tender sensibilities'. Instead of doing this, he quickly wrote and published the present book. We cannot provide the atlas – Umberto Eco has done this to some extent in his anthologies – so we focus on some of the less familiar pictures, and some famous ones about which Rosenkranz makes specific points.

<div align="right">

Andrei Pop

Basel

September 2014

</div>

[72] J.L. Austin, 'A Plea for Excuses', *Proceedings of the Aristotelian Society* 57 (1956–57), 11. Schmidt calls Rosenkranz a preamble to any future aesthetics of ugliness (p. 7).

Aesthetics of Ugliness

Karl Rosenkranz

Translated by Andrei Pop and Mechtild Widrich

Foreword

An aesthetics of ugliness? And why not? Aesthetics has become the collective name for a large group of concepts, which is in turn divisible into three particular classes. The first has to do with the idea of beauty, the second with the notion of its production, that is to say, art, the third with the system of the arts, with the representation of the idea of beauty through art in a specific medium. We tend to gather concepts of the first class under the rubric of the metaphysics of beauty. But if the idea of beauty is to be considered, an investigation of ugliness is inseparable from it. The concept of ugliness, of negative beauty, thus is a part of aesthetics. There is no other science [iv] to which it could be assigned, and so it is right to speak of the aesthetics of ugliness. No one is amazed if biology also concerns itself with the concept of illness, ethics with that of evil, legal science with injustice, or theology with the concept of sin. To say the 'theory of ugliness' would fail to bring out so clearly the scientific genealogy of the word. As for the name, the handling of the subject itself will have to justify it.

I have taken pains to develop the concept of the ugly as the midpoint between that of the beautiful and that of the comical, from its first beginnings to the fullness it gives itself in the form of the satanic. In a way, I reveal the cosmos of ugliness from its first chaotic patches of fog, from shapelessness and asymmetry, to its most intensive formations in the endless multiplicity of disorganizations of beauty that is called caricature. Formlessness, incorrectness, and the deformity of disfiguration[1] are the distinct levels of this self-consistent series of [v] metamorphoses. The attempt has been made to show how ugliness has its positive presupposition in beauty, which it distorts to create the mean[2] instead of the sublime, the repulsive instead of the pleasant, and instead of the ideal, the caricature. All the arts and all the epochs of art among the most diverse peoples are hereby invoked to clarify the development of the concepts using apposite examples, which should also provide raw material and reference points for future students of this difficult province of aesthetics. Through this work, whose imperfections I believe I know best, I hope to fill a gap that has until now been all too tangible, for the concept of ugliness has until now been handled only in a fragmentary and incidental fashion, or else with great generality, which risks affixing the subject within very one-sided definitions.

The well-meaning reader who really seeks self-instruction may grant all this, and still ask: Should such an unpleasant, disgusting object be so thoroughly

[1] *Verbildung* meant broadly as negative figuration, not narrowly as destruction of faces.

[2] Rosenkranz's *gemein* is an everyday word with connotations of social status (gross, common, vulgar, coarse, base, vile) and ill will (petty, vicious, the modern use of 'mean'). But it is also a technical term indicating a distortion of the sublime. *Widrig* likewise spans a range of phenomena of resistance, from the abstract (adverse or unfavourable: *widrige Umstände*, unfavourable conditions) to the visceral (repugnant, repellent).

investigated? Undoubtedly, for science has in recent times touched on this problem
again and again, and it requires [vi] resolution. Naturally I do not wish to advance
a claim to having accomplished this. I am satisfied if here, as in other areas, it is
granted that I have at least made a step forward. The individual may well think of
this subject[3]:

—down there it's terrible
And man should not challenge the gods
And desire never, but never, to behold
What they kindly conceal in night and horror![4]

The individual may think thus and set aside the science of ugliness unread. Science
itself, however, follows only its own necessity. It must go forward. Charles Fourier,
under the rubric of the division of labour, defined one type that he called the *travaux
de dévouement* [works of devotion], to which no one is predisposed by nature, but
which men do out of resignation, because they recognize their necessity for the
common good.[5] The attempt to satisfy such a duty is made here as well.

But is this business really so terrifying in practice? Does it not also contain points
of light? Does not a positive content also lie in hiding for the philosopher, for the
artist? I certainly think so, for ugliness [vii] can only be grasped as the midpoint
between beauty and the comical. The comical is impossible without an ingredient of
ugliness, which it dissolves and re-forms in the freedom of beauty. This cheering and
universal consequence of our investigation will excuse the undoubted pain of some
sections.

In the course of the treatise, I excuse myself at one point, in a way, for thinking so
much through examples. But it is obvious to me that I did not need to do so; for all
aestheticians, among them Winckelmann, Lessing, Kant, Jean Paul, Hegel, Vischer, and
even Schiller himself, who recommends the sparing use of examples, proceed in the
same manner. Of the material that I have accumulated for this purpose over a span of
years, incidentally, I have made use of only a little over a half, and may thus consider
myself to have been quite parsimonious in this respect. Through my choice of examples
I have only aimed to be many-sided, so as not to impose through examples a limitation
on general validity which has plagued the history of every science.

[viii] The way I handle the material might seem old-fashioned and perhaps too
precise. Modern writers have invented for themselves a striking method of citation,
namely to sprinkle their texts liberally with inverted commas. Where they find the
citation remains mysterious. It is a lot for them to add a name. But it seems to them
pedantic to then add to the name of an author the name of a book. Doubtless it would

[3] The 1853 edition has *Gestande*, which is not a word. We follow the Reclam edition's reading.
[4] From the ballad, 'Der Taucher' [The Diver, 1797], by Friedrich Schiller, *Gedichte* (Stuttgart and
 Tübingen: Cotta, 1852), 304, with the full stop turned into an exclamation mark.
[5] See Charles Fourier, *Théorie de l'unité universelle*, vol.4 (Paris: Société pour la propagation et la
 réalisation de la théorie de Fourier, 1841), 150, 161. Fourier thinks this a domain for child labour,
 especially those involving 'répugnances industrielles' (p. 138).

be petty to always want to document generally known or irrelevant things with citations. But those points less common, less often touched upon, more remote, still debated, require, in my opinion, more precision of statement, so that the reader may, should it please him, go to the sources in person, and compare and judge for himself. Elegance can never be the goal of scientific discourse, only the means, and a very subordinate one at that; thoroughness and precision must stand above it.

With trepidation I see, after the printing, that among the examples quite a number have pressed forward out of the recent past, because they were freshest in my memory, [ix] because they occupy me with the same lively interest I take in their authors. Will these authors, among whom I count some friends, take this badly, will they regard me with bitterness? That would be quite painful for me. But the revered will have to ask themselves above all whether what I say is true. If it is, no wrong has been done to them. Then they will see from my mild way of complaining and in other places of praising, when it is earned, that my friendly disposition toward them has not changed. Yes, I even recall having made most of my censures first through letters. They cannot then wonder that I express the same opinion in print. I would leave out this entire observation, did I not know from experience how excitable modern minds are, how little disagreement they can tolerate, how much they wish to be eulogized and not lectured, how sharp they are, but only in critiquing others, and how especially and, above all from critics, they demand only sympathy and devotion, that is to say, admiration.

[x] I believe that my text is also readable to the general public, not just the educated. Only through the nature of the material does this accessibility have certain limits. I have had to touch on abominable things and call things by their true name. As a theoretician I have held myself back from the descent into certain sewers, and have contented myself with suggestion, as in the case of the Sotadic inventions.[6] As a historian this course would not have been open to me; as a philosopher I was free to decide. And despite my extraordinary caution, some will judge that I need not have been so honest. But then, I may assure you, the investigation ought not to have been done at all, nor could it have been done. It is sad that for us a certain prudery creeps even into science, in that one makes discretion the only criterion for objects of animal nature and of art. And how does one best achieve discretion nowadays? One simply does not discuss certain phenomena. One decrees their non-existence. One secretes them away unscrupulously so as to remain socially acceptable. For example, one publishes [xi] woodcuts—for without woodcut illustrations modern scientificity is not really possible any longer—with microscopic detail in the service of a physiology, a doctrine of life, lectures held before a circle of ladies and gentlemen in a capital city, and one says not a single word about the generative apparatus and above all about

[6] The word 'inventions' suggests that Rosenkranz is not referring to Sotades of Maronea, a Hellenistic poet writing lewd verse and comedy in Alexandria around 280 BCE (few fragments have survived), but rather to the neo-Latin erotic discourses published by Nicolas Chorier under the pseudonym Aliosia Sigea, *Satyra Sotadica de Arcanis Amoris et Veneris* (Lyons?: 1665?). A French translation of the *Satyra Sotadica* circulated widely as *L'Académie des dames*, and impressed Sade among others. On Chorier, see the recent study by James Turner, *Schooling Sex: Libertine Literature and Erotic Education in Italy, France, and England, 1534–1685* (Oxford: Oxford University Press, 2003), Chapter 4.

sexual function. Certainly very discreet. Our German literature has already been castrated through this tidying up for girls' boarding academies and finishing schools for noble daughters, all this to bring out for tender virgin and lady souls the beautiful, the sublime, the refreshing, the comfortable, the mellow, the edifying, and all the other catchphrases. An incredible counterfeiting of the history of literature has taken place, going beyond narrow pedagogical considerations to deface opinion; this counterfeiting is supported through extremely one-sided anthologizing of literary masterworks. What luck, that a work like that of Kurz should appear at this moment, which through its independence will force the [literary] factory workers at least once again to touch on other objects, in another sequence, with another judgement [**xii**] than those found in the ruts they have been treading *ad nauseam*.[7] Every perceptive reader will understand that I, by all decency, could not write such a consumptive boarding-school style, and that in the present case I may apply Lessing's words:

> I do not write for little boys,
> That go to school so full of pride,
> Carrying the Ovid in their hands,
> That their teachers don't understand.[8]

<div align="right">Karl Rosenkranz, Königsberg, April 16, 1853</div>

[7] Probably Heinrich Kurz, *Geschichte der deutschen Literatur mit Proben aus den Werken der vorzüglichsten Schriftsteller*, 3 vols (Leipzig: B.G. Teubner, 1851–1853).

[8] Gotthold Ephraim Lessing, 'Für wen ich singe' [1751], in *Sämmtliche Schriften*, ed. Karl Lachmann (Berlin: Voss, 1838), 81. Rosenkranz has changed 'sing' to 'write'.

Contents

Introduction

—and take my advice, don't
Love too much the sun or stars,
Come, follow me down into the dark realm!

Goethe[9] **[2]**

[3] Great investigators of the heart have plunged into the frightful abyss of evil and have represented the awful forms that confronted them in its night. Great poets like Dante have further sketched these shapes; painters like Orcagna, Michelangelo, Rubens, and [Peter] Cornelius have given them sensuous presence, and musicians like [Ludwig] Spohr have allowed us to hear the dreadful tones of perdition, through which evil screeches and howls the conflict of its torn spirit.

Hell is not simply ethico-religious, it is also aesthetic. We stand in the midst of evil and general wickedness, but also in the midst of ugliness. The fright of non-form and the deformed, of vulgarity and atrociousness, surround us in endless shapes, ranging in dimensions from the pygmy to those giant distortions out of which infernal evil grins at us, baring its teeth. It is into this hell of the beautiful that we wish to descend. But descent is impossible without also gaining admittance into the real hell, the hell of evil, since the **[4]** ugliest ugliness is not that which in nature repels us in swamps, crippled trees, newts and toads, in gaping sea monster jaws and massive pachyderms, in rats and apes; it is the selfishness[10] that reveals itself in spiteful and frivolous gestures, in the furrows of passion, in crooked glances and—in crime.

We are familiar enough with this hell. Everyone has a share of its pain. It touches on the emotions, on the eye, and on the ear in manifold ways. The delicately constituted, the well-educated, often suffer unspeakably on this account, since brutality and vulgarity, the monstrous and the amorphous, all antagonize the nobler sensibility in a thousand guises. Still, a fact can be itself familiar enough without its full significance, its full extent, being properly recognized. This is the case with ugliness. The theory of the fine arts, the legislation of good taste, the science of aesthetics, have been propagated among the civilized peoples of Europe for over a century, until they have educated themselves in it to a great extent, but despite this, the concept of ugliness, though one brushed up against it everywhere, remained in comparison very far behind. It is appropriate that finally the dark side of the luminous form of beauty should become a central moment[11] of the science of aesthetics, as illness is in pathology, and as evil in

[9] This Faustian motto is spoken by Orestes to Iphigenie in *Iphigenie auf Tauris*, li.1232–4.
[10] The Reclam editions make a typographical error here: *Selbstflucht*, self-evasion.
[11] Here as throughout, 'moment' is used in the Hegelian sense to mean a key point in a larger conceptual system of any kind, rather than specifically a point in time.

32

ethics. Not, as we said, as if the unaesthetic in its individual manifestations was insufficiently known. For how could this be possible, since nature, life, and art remind us of it at every moment? And yet, a full exposition of its context and a more [5] explicit understanding of its organization have until now not been attempted.

German philosophy, in any case, deserves praise for having first had the courage to recognize ugliness as the aesthetic non-idea, as an integral moment of aesthetics, and also of recognizing that beauty passes through ugliness into the comical (* NOTE 1). Never again will we be able to deny this discovery, through which negative beauty has come into its own right. But the handling of the concept of ugliness has not advanced, in part due to a cursory and incurious generality, in part due to a one-sided spiritualist attitude. This attitude was too exclusively aimed at explaining some of the characters of Shakespeare and Goethe, Byron and Callot-Hoffmann[12] (*NOTE 2).

An aesthetic of ugliness might sound to some like a wooden iron, since ugliness is the opposite of beauty. Except that ugliness is inseparable from the concept of beauty, since the one contains the other in its development as perpetual aberration into which it can lapse with just a modicum of too little or too much. All aesthetics are forced, with a description of the positive parameters of beauty, to somehow touch also on the negative ones of ugliness. One finds at least the warning that, should things not be carried out as they demand, beauty would be missed and in its place ugliness would be produced. The aesthetics of ugliness should represent its origin, its possibilities, and its modes, and can thus be of utility even to artists. To them, it will naturally always be more creative to represent perfected beauty, rather than to turn [6] their talents to the service of ugliness. To seek out the form of a god is endlessly more satisfying and elevated than the presentation of a devilish grimace. But the artist cannot always avoid ugliness. It is even often the case that he needs it as a foil, or as a point of passage in the manifestation of an idea. Finally, the artist who produces the comical cannot completely avoid ugliness.

On the side of the arts, we can, however, only approach those which, as free arts, are their own ends, and as theoretical arts work on the eye and the ear. Those that serve the practical senses of touch, taste, and smell are here excluded. Herr [Carl Friedrich] von Rumohr in his *Geist der Kochkunst* [Spirit of Cookery[13]], Anthus in his interesting *Vorlesungen über die Eßkunst* [Lectures on the Art of Eating; Leipzig: Wagand 1838], [Eugen Baron] von Vaerst in his astute work on gastronomy [*Gastrosophie*, 2 vols, Leipzig: Avenarius und Mendelssohn, 1851], which is of lasting value especially from an ethnographic perspective—all of these works have raised the sybarite aesthetic to a high level. One can convince oneself on the basis of these works that the general laws that apply to the beautiful and the ugly hold equally for the aesthetic of fine eating, which for many people is most important. We, however, cannot agree with this. It is self-evident that a science like ours, which requires full seriousness of mind, cannot be treated assiduously if one takes one's cue from the frail elegance of a coffee

[12] E.T.A. Hoffmann was so attached to Jacques Callot's fantastic etchings (he even subtitled his 1815 *Fantasiestücke* 'in Callot's manner') that the nickname stuck.

[13] The book appeared as Joseph König, *Geist der Kochkunst* (Stuttgart and Berlin: Cotta, 1822), with Rumohr listed as editor, but he in fact wrote it, as was widely known.

table[14] aesthetic, for then the principal thing itself would have to be omitted. The aesthetics of ugliness makes it our responsibility to also deal with concepts whose discussion or even mention [7] might well otherwise be regarded as an offence to good manners. If someone picks up a book on the pathology and therapy of disease, then they must anticipate the disgusting. And that is also the case here.

That ugliness is a concept that can only be understood relative to another concept is not difficult to understand. The other concept is that of beauty, since ugliness can only be insofar as beauty is, which constitutes its positive presupposition. If there were no beauty, then there certainly would not be any ugliness, since the latter only exists as the negation of the former. Beauty is the godlike, original idea, and ugliness, being its negation, has as such only a secondary existence. It generates itself in and out of the beautiful. It is not as if beauty, while being beauty, could simultaneously be ugly, but rather in the sense that the same conditions that make up the causal necessity of beauty turn into its opposite.

This intimate connection of beauty and ugliness as its self-annihilation accounts for the possibility of ugliness transcending itself in turn, that is, in its existence as negative beauty, a dissolving of its opposition to beauty and the return to oneness with it. Beauty reveals itself in this process as the power that once again subdues the revolt of ugliness. In this beautification an endless mirth arises, which arouses in us smiling and laughter. Ugliness frees itself in this movement from its hybrid, self-involved nature. It confesses its powerlessness and becomes comical. All that is comical [8] comprehends within itself a moment that relates negatively to the pure, simple ideal; but this negation is reduced in the comical to an appearance, to nothing. The positive ideal is confirmed in the comical, because, and insofar as, its negative aspect disappears in itself.

The study of ugliness is thus precisely limited by the very essence of its object. The beautiful is the positive condition of its existence, and the comical is the form through which it delivers itself from its purely negative character relative to the beautiful. The simply beautiful always stands against the ugly in negative fashion, since it is only beautiful insofar as it is not ugly, and the ugly is only ugly insofar as it is not beautiful. It is not as if the beautiful, in order to be beautiful, owed something to the ugly. It is beautiful also in the absence of its foil, but ugliness is the danger that threatens it from inside itself, the contradiction that it poses to itself through its essence. With ugliness it is different. It is what it is indeed *empirically* through itself; that it is ugliness, however, is only possible through its reflexive relationship to the beautiful, in relation to which it finds its measure. Beauty, like goodness, is thus an absolute, and ugliness, like evil, is only something *relative*.

One should not conclude from this, by any means, that what is ugly in a specific case might be doubtful.[15] This is impossible, because the necessity of the beautiful is

[14] Rosenkranz has *Theetischästhetik*, but a German 'tea table' is in English a coffee table.
[15] As the rest of the paragraph makes clear, this should not be taken to mean that people always agree on the ugly or have incorrigible judgements of it: only that the beauty-relativity of ugliness does not put the reality of ugliness into doubt. See our Introduction.

self-determined. On the other hand, ugliness is relative, since it cannot be measured by itself, but only through beauty. In everyday life each might follow their personal taste, according to which one finds beautiful what another finds ugly, and considers ugly what another finds beautiful. [9] Should we, however, wish to move this contingency of the empirical-aesthetic judgement out of its uncertainty and lack of clarity, we must expose it to critique and thus put into practice the highest principles. The province of the conventionally beautiful, fashion, is full of phenomena that, judged according to the *idea* of the beautiful, could only be called ugly, and yet are allowed to pass temporarily for beautiful, not as if they were beautiful in and for themselves, but rather because the spirit of a time finds precisely in these forms the most fitting expression of its specificity, and grows accustomed to them. Through fashion, spirit seeks particularly things that correspond to its mood, which ugliness can also serve as a means of adequate representation. Past fashions, particularly those that have recently gone out of style, are thus as a rule judged ugly or comical, since the change in mood can only develop through opposites. The Romans of republican times, who subjugated the world, were clean-shaven. Even Caesar and Augustus did not wear beards, and only beginning with Hadrian's romantic epoch, as the Roman Empire succumbed more and more to mounting barbarian hordes, did the full, rich beard become fashionable, as if men, feeling weak, wanted to assure themselves of a certainty of manhood and boldness through the beard. The aesthetically most memorable metamorphoses of fashion are offered by the history of the first French Revolution. They have been philosophically dissected by Hauff (*NOTE 3).

Beauty is thus the limit on the entrance side of ugliness, while the comical is the limit on the exit side. Beauty excludes ugliness from itself, while the comical fraternizes with it; but in doing so [10] neutralizes its disgust through the fact that, in comparison with beauty, it recognizes its relativity, its nullity. An investigation of the concept of ugliness, an aesthetics of it, thus finds its road precisely set out. It must begin with a recollection of the concept of beauty, not, however, for the purpose of expounding it in the fullness of its essence, as the metaphysics of beauty would be obliged to do, but only insofar as the basic conditions of beauty must be given, out of which and out of whose negation ugliness emerges. This investigation must then end with the concept of transformation, which ugliness experiences in becoming a means of humour. Naturally the comical is also not presented in its full extent, but only touched upon insofar as the analysis of the transition demands it.

The Negative in General

That ugliness is something negative is sufficiently clear from what has been said. The general concept of the negative, however, does not stand in any relation to that of ugliness besides the simple one that ugliness also expresses a negative. The thought of the negative as such in its pure removal has no sensible form at all. What is incapable of sensible manifestation itself cannot become an object of aesthetics. Out of concepts of nothingness, of the other, of the immoderate, of the inessential, of the negative in

general, as in the case of logical abstractions, no general experience or image can be given, because as such they are never capable of being perceived. [11] Beauty is the idea, as it works on the element of the sensible in the design of a harmonious totality. Ugliness, as the negation of beauty, shares with it the element of the sensible, and can thus not crop up in a purely ideal region, in which being exists only as the idea of being, with the reality of being as one of filling space and time foreclosed.

And as little as the concept of the negative in general may be called ugly, just so little is the term applicable to that other negative, the imperfect.

――――――――

The Imperfect

In the sense in which the beautiful is essentially idea, it can also be said of it that it is the perfect. And in this way it happens often enough, notably also in the aesthetics of Baumgarten in the past century, that the concepts of beauty and perfection are taken to be the same. But perfection is a concept that does not correspond directly with that of beauty. An animal can be very well adapted, it can be very perfectly organized as a living thing, and for that very reason be extremely ugly, as are the camel, the sloth, the squid, the toad, etc. A mistake in subjective thought, an incorrect concept, an error, a false judgement, a faulty conclusion, on the other hand, are imperfections of the intelligence which cannot, however, be assimilated into the category of the aesthetic. Virtues that have just been acquired, that is to say, which are not yet practised with the virtuosity of habit, make ethically [12] speaking an impression of imperfection, but may be aesthetically almost endlessly charming in their purposeful pleasure of becoming. An ugly character, on the other hand, means just as much as an evil one.

The concept of imperfection is relative. It always depends on the standard by which we proceed to measure it. The leaf is imperfect in comparison to the flower, the flower to the fruit, if one weighs the value of the flower against the fruit as the mode of existence of the plant. But the flower, which is counted imperfect in a botanical or better yet economic register, generally ranks higher than the fruit aesthetically. Imperfection is in this connection so little related to ugliness, that it can even outrank what according to reality and totality is more perfect. If the drive of the authentic, the true, and beautiful is active in what is imperfect, then it might also be beautiful, if not as beautiful as it might have been in its perfection. The first works of a true artist, for example, will betray many deficiencies, but already radiate a genius capable of greater accomplishment. The youthful poems of Schiller or Byron are still imperfect, but betray nevertheless the future of their makers, often precisely in the manner of their imperfection.

The word imperfection in the sense of incipience should thus not be confused with the concept of the bad, for which we do at times euphemistically employ it. The imperfect as a necessary step in development is after all a stage on the way to perfection; the bad, on the other hand, is a reality which does not [13] simply leave something to be desired, which does not simply awake a longing for greater perfection, but is something which gets caught up in positive contradiction to its concept. The imperfect

in a positive sense lacks only the further formation that would allow it to show itself to be wholly what it already is in itself. The bad, however, is something imperfect in the negative sense, comprising something else altogether, something that should not be. A drawing can be still imperfect and yet beautiful; a bad drawing is a faulty one, which contradicts the laws of aesthetics.

Foremost for our investigation is the correct understanding of the *comparative* sense of beauty, which is to be found in art itself, and which can be expressed thus: just because something is more beautiful than something else, it does not follow that the less beautiful something is ugly. Rather, this is a gradual difference, which does not yet alter the quality of beauty in itself.

First and foremost, one has to remember that every *species* is *coordinated* to some genus, even if among themselves they can stand in a relationship of subordination.[16] From the point of view of the genus, all species are equal, and yet this does not exclude the possibility that in direct comparison one should stand objectively higher than another. Architecture, sculpture, painting, music, and poetry are as species of art all perfectly equal, and yet it is true that in the order here given they also express a progression, in which the next art surpasses the previous in its range of possibility of adequately representing the essence of spirit, freedom.

In the individual arts the same consideration holds, for the qualitative differences in an art behave [14] in relation to the whole as species. If one considers this, one rises above all the disputes as to which species should be preferred, because one will never, through subordination, forget the coordination of them all. Poetry, for example, is objectively perfected as dramatic poetry; lyric and epic are in this respect subordinate to it; but from this it does not follow that lyric and epic, which are necessary forms of poetry, do not enjoy the same absoluteness. Seen relatively, the art of building is less perfect than sculpture, sculpture less perfect than painting, and so forth. And yet within the peculiarity of its material and form every art can achieve absoluteness. In other words, this means emphatically that subordination as such stands in absolutely no relation to ugliness. When one designates, as we must, an art or genus of art as lower or less perfect than another, this implies no aesthetic demotion of it. But it is so only relatively, without involving the concept of a somehow necessary ugliness emerging from this hierarchy. In the case of individual works of art, it is common to express the comparative of beauty through simple ascriptions of quality. One says, for instance, that *Münchhausen* is Immermann's greatest work, and one wants in any case also to say that it is thus his most beautiful. Less beautiful, on the other hand, is by no means the same as ugly.

[16] Rosenkranz conflates quantitative ranking under the concept/genus (e.g., under beauty: first gods; then mortals) with subordination, wherein a wider concept contains narrower concepts as sub-ranks (e.g., under beauty: beautiful living things; under beautiful living things, beautiful animals; etc.). But the point is sound however one construes the arts.

[15] The Naturally Ugly

In nature, to whose idea[17] existence in time and space is essential, ugliness can already take on innumerable forms. Becoming, which is basic to all things in nature, perpetually makes possible through its process excess and disproportion, thus disturbance of the pure form which nature in itself pursues, and thus ugliness. The individual natural existences, which in heterogeneous chaos push through to real being (*Dasein*), often impede one another in their morphological processes.

The geometric and stereometric forms—triangle, square, circle, prism, cube, sphere, etc.—are in their simplicity, through the symmetry of their relations, really beautiful. As general forms in abstract purity, they indeed only exist ideally in the imagination, since *in concreto* they only appear as the forms of certain natural patterns found in crystals, plants, and animals. The way of nature here is the transformation from the rigidity of straight line and flat surface relations to the suppleness of the curve and a wonderful fusion of the straight and the sinuous.

Brute, raw mass, insofar as it is only governed by the law of gravity, offers us in aesthetic terms an indifferently neutral state. It is not necessarily beautiful, but also not necessarily ugly; it is accidental. If we take, for instance, our planet Earth, in order for it to be beautiful as a mass, it ought to be a perfect sphere. But it is not. It flattens at the poles and bulges at the equator, and besides, its surface is of the greatest [16] inequality of elevation. A profile of the Earth's crust, regarded only stereometrically, shows us the most casual disorder of elevations and depressions in erratic outlines. In the same way we cannot say of the surface of the moon with its confusion of highs and lows that it is beautiful. The silver disk of the moon, seen from a distance as a simple luminous body, is beautiful; but this agglomeration of cones, rills, and valleys is not. The lines which describe the planets in their motion as multiple ellipses in spiral orbits cannot be regarded as aesthetic objects, for they only appear as lines in our drawings. The infinity of the mass of stars, on the other hand, works on our sense of sight, not through mass, but through light. For some admirers of the twinkling night sky, a certain illusion of fantasy also creeps in through the naming of constellations: the Lyre [Lyra], the Swan [Cygnus], Berenice's Hair [Coma Berenices], Hercules, Perseus, and so on, doesn't that sound pretty! Modern astronomy has become very prosaic in its nomenclature, in that the sextant, the telescope, the air pump, the printing workshop and other important inventions are glorified with constellations.

That mechanical actions, pushing, throwing, falling, swinging, can become beautiful, is not directly conditioned by the form of the movement, but also through the composition of the objects and their velocity. A swing, for instance, is not exactly ugly as it swings, but not beautiful either. If one were to imagine, however, a young girl on a swing, gracefully rocking back and forth through the bright spring air, the [17] scene is one of carefree beauty. The bold launch of a rocket, which lights up the dark

[17] See our Introduction for a discussion of the Hegelian word *idea*, which is the objective, true application of a concept, or in Hegelian language, the unity of a concept and reality. Nature in this view has *existence* in space and time as components of its *idea*, even if both philosophers would concede to Kant that existence is not a predicate and thus no part of a *concept*.

and explodes at its zenith, seemingly fraternizing with the starry sky, is beautiful not just through the mechanical motion, but also through its light and speed.

The dynamic processes of nature are in themselves neither beautiful nor ugly, because in them form does not attain to any expressiveness. Cohesion, magnetism, electricity, galvanism, chemistry are in their effectiveness simple in themselves. But their results can be beautiful, like the sputter of electrical sparks, the zigzag of a lightning bolt, the majestic roll of thunder, the change in colour of chemical processes, and so on. A huge field is here opened up by the fantastic images that develop out of gas in its elastic mobility. Its great freedom brings out not only beautiful but also ugly forms. The basic form of gas expansion is in any case spherical, pushing outward in all directions simultaneously. But because gas expands into the immeasurable it loses its spherical shape immediately where it meets solid bodies, or other gases, with which it mixes and dissolves chaotically. What an endlessly rich, inexhaustible play of twilight forms, reminiscent of everything and of nothing, the clouds offer us! (*NOTE 4)

For organic nature, the principle of its existence consists in closure of form. It follows that beauty here frees itself of the dreamy contingency to which, in inorganic nature, it adheres. The organic entity has a definite aesthetic character right away, because it is a real individual. [18] For this very reason ugliness is possible in a much more definite way. It is the task of the specialized study of natural beauty to follow nature's progress in this regard. We cannot go into particular detail, and refer here to the fine works of Bernardin St. Pierre, Oerstedt, and von Vischer (*NOTE 5). In general, the eurhythmia, symmetry, and harmony of form in nature rise from the simple crystalline entities through the struggle of the straight and sinuous lines of the plant world, to the countless configurations of the animal world, wherein with thousand-sided oscillations and hybridizations the curve triumphs; a process, which at the same time involves an endless metamorphosis and gradation of colour.

Individual crystals, on their own, are beautiful. In an aggregate state with many of them massed together, they often appear in fantastic combinations, as can be seen from the handsome exemplars in Schmidt's *Mineralienbuch* (* NOTE 6).

The great aggregate masses on the Earth's surface are of the most varied and often indefinite form. Mountains can look beautiful, when they stretch out in gently sloping, pure lines; sublime, when they tower like colossal ramparts; ugly, when they divert the eye by their jagged outline in the desert and their characterless tangle; comical, when they tease our fantasy with bizarre and grotesque digressions. In immediate reality, these forms acquire other, peculiar attractions through lighting. How moonlight augments the wonder of the Au-ma-tu or Five Horseheads [Wu-ma t'ou, part of wu-ma kuei ts'ao-shan, The five horses who return to eat[18]], the Bohea Tea Hills [Wuyi Shan], the Tsi-Tsin [Qixing] or Seven Star Mountain in China (* NOTE 7)! [19] Between the chemical composition and the form another correlation takes place, which von Hausmann in a classic treatise has shown to hold also for the relation of terrain type to vegetation and plant life. The cooling of the once incandescent crust,

[18] A favourite for European travellers: see Donald F. Lach and Edwin J. Van Kley, *Asia in the Making of Europe* (Chicago: University of Chicago Press, 1993), vol. 3, book 4, 1730.

and the play of water and air, have drawn the broad lineaments of the Earth's physiognomy (* NOTE 8).

Plants are almost all beautiful. Poisonous plants, according to ancient theology, ought to be ugly, and it is precisely they who offer us an exuberant bounty of delicate forms and exquisite colours. Their narcotic power can indeed bring death to living things; but, of what concern is this to the plant? Is killing part of its concept? Narcosis can well have lethal effects, but it can also delight through intoxication; indeed, it can save life from illnesses. Poison is a very relative concept, and the Greek word *pharmakon* designates poison as well as remedy (* NOTE 9).

But because the plant is alive, it can also become ugly. Life, as freedom of formation, necessarily introduces this possibility. In groups, plants can overgrow and crowd one another, and thus grow ugly in self-caused deformation. They can be violently attacked from the outside, arbitrarily moulded and botched. But they can also wither and degenerate from the inside through illness. With illness, a crippling and discoloration can develop, and indeed be felt as ugly. In all these cases, the natural cause of ugliness is quite obvious. It is, for life and the plant, no [20] foreign, satanic principle at work, rather, the plant itself, that as a living thing sickens and, as a consequence of sickness, forfeits its normal form in tumours, desiccation, dwarfing, and fusion,[19] and its normal complexion through bleaching and discoloration. In itself alien to the plant is the violence that is done to it by storm, water, fire, animals and humans. This violence can make the plant ugly, but it can also beautify it. This depends on the specific nature of the action. The storm can scatter the foliage and splinter the branches of an oak, thus crippling the proud tree. But it can also, as it blows with rhythmic strokes through the leafy branches, really bring to light the pith and energy of the tree's beauty in movement. Normal changes in the metamorphosis of a plant are free of ugliness, since because they are necessary, they are in no way pathological. The passage of bud to blossom, of blossom to fruit, is accompanied by a silent, unspeakable delight. When in autumn the chlorophyll drains from the leaves and these dye themselves in a thousand yellow, brown and red tints, countless picturesque effects result. And how beautiful is the view of the golden crop when the nourishing grains ripen and yellow, that is, when they dry up!

Greater than with plants is the possibility of ugliness in the animal kingdom, because here the richness of forms grows towards infinity, and life becomes more energetic and self-centred. To understand the ugliness of animal form correctly, we have to ponder the fact that nature above all aims to protect life and the species, [21] and that for this purpose treats beauty and the individual with indifference. This explains why nature spawns some truly ugly animals, that is, animals that do not become ugly through mutilation or age or disease, but for which an ugly form is constitutive. For our aesthetic judgement, there creep in here many errors, partly through familiarity with a type which we then tend to call beautiful, and deviations

[19] *Verwachsung* is a term used in many fields. In botany, it is 'adnation' or 'connation', the fusion of plant parts, e.g. of stamen and petal, not necessarily pathological. In medicine, however, 'adhesions' are dangerous scar tissue: perhaps that is what is meant here.

from it ugly; partly through the isolation of an animal in the abstract manner shown to us in an etching or a specimen in a collection. How entirely different an animal seems to us when viewed alive, in its natural surroundings, the frog in water, the lizard in grass or in a crevice, the ape climbing a tree, the polar bear on the ice floe, and so on.

Crystals with their rigid regularity, when constrained in the act of formation, can develop in ways that are empirically imperfect, but in their concept resides the beauty of stereometric form. Plants can become maimed, or wilt from the inside out and lose their form, but in accordance with their concept they are beautiful. If they seem ugly in some instances, the formlessness is instantly softened through a comic expression, like the face of the cactus, the beet, the cucurbits [gourds, pumpkins], the latter of which are indeed often used to produce fantastic-comical figures in painting (* NOTE 10). With animals, on the other hand, it is undeniable that there are forms of original ugliness, whose horrid visage cannot be cheered up by any comic expression. The real motive for these forms is the necessity of nature [22] to incorporate the animal organism into the various elements, zones, and soil types, and to lead it through the various periods of the Earth. Subjecting itself to this necessity, it must vary each type, for instance, the dog, infinitely. Certain jellyfish, squid, caterpillars, spiders, rays, lizards, frogs, toads, rodents, pachyderms, apes, are positively ugly (* NOTE 11). Some of these animals are important to us, or at least interesting, such as the electric ray. Others impress us in their ugliness through their size and strength, like the hippopotamus, the rhinoceros, the camel, the elephant, the giraffe. At times, the animal world takes a comic turn, as with some egrets, toucans, penguins, and with some mice and primates. Many animals are beautiful. How beautiful are some conches, butterflies, beetles, snakes, doves, parrots, horses! We see that ugly forms originate primarily in the transitions of the animal kingdom, because through them a certain contradiction, a fluctuation between disparate types, manifests itself in outer form. Many amphibians, for instance, are ugly because they are at once land and water animals. They are still fish and they aren't: an amphiboly[20] that comes to light, inwardly and outwardly, in their structure and behaviour. The monstrous shapes of prehistory came to be thus, namely the giant organisms had to adapt to extreme states of terrain and temperature. Ichthyosaurs and flying lizards, giant reptiles equipped with fins: these alone could endure those boundless swamps and that blazing, steamy, scorching atmosphere. The variety of those [23] terrestrial conditions had to take shape also in the variety of animal form. And still we find such hybrid beings, in places where the terrain is still not fully developed and the vegetation virginal, as with the Australian platypus.

The animal can thus be ugly in its very type. The individual can also, in the case of an originally beautiful type, become ugly. Through crippling or illness, it can be subject to exterior or interior deformation respectively, as are plants. In both cases its ugliness far exceeds that of plants, because its organism is far more united and sealed, while the plant grows and entwines itself in undefined space and thus its form is liable to a certain contingency. By contrast, the structure of the animal is in and for itself definite.

[20] *Amphibolie* (Greek: both + throw) is a grammatical term used since Kant to denote ambiguous expressions whose words are themselves unambiguous (e.g. 'Every boy loves a mother' taken distributively and taken to be about *one* mother).

As a consequence, should a limb be wounded or taken away, the animal would become immediately uglier. An animal can dispense with no part of its organism, with the exception of the vegetative excess of hair, horns, etc., which it can regrow. From a rosebush, one can pluck a rose without harming the plant or its beauty. One cannot cut away the wing of a bird or hack off the tail of a cat without detracting from its form and its enjoyment of life.—On the other hand, due to this *a priori* articulation of the animal form, closed in itself, ugliness can also occur through an excess alien to its concept. The limbs of the animal organism are precisely defined as to number and position, for they must interact harmoniously. A limb more or placed elsewhere than where the concept [24] would have it contradicts the basic form and makes it ugly. For instance, should a sheep be born with eight legs, this doubling of the number necessary to it is a monstrosity and ugly.

This careful development of the animal form, which develops definite proportions from the inside out, results in the fact that each member has its normal size, decided by the so-called balance of the organs, and also that when this size is increased or decreased, a disproportion results which is necessarily of an ugly kind. Such excessive size or excessive smallness is, however, usually already the result of illness, whose origin can also be an inherited condition developing from the very depths of its life. Deformation can begin already in the egg, in the sperm, in the uterus, in the foetus. Disease first destroys the organism partially, then totally, and discoloration and disfiguration are usually correlated with this destruction. The more beautiful an animal is in its concept, the more ugly will be the appearance of its wizened, emaciated, swollen, pallid, ulcerated form. The horse is undisputedly the most beautiful animal; for this very reason it is the one that through disease, age, rheumy eyes, hanging belly, protruding bones, visible ribs, and spotty baldness looks particularly repulsive.

From what was said thus far, it follows that the ugliness of animal form, whether we regard it as original or produced through accident and illness, is for us sufficiently explicable, so that we do not need like Daub in his *Judas Ischarioth* (* NOTE 12) to entertain the hypothesis of [25] something unnatural in nature as its cause. The necessity of nature to unite contrasts in one organism, throwing mammals such as whales and seals into the water, others such as bats into the air, and preparing chelonians, saurians, and batrachians as much for a stay on land as in water, is just as clear as the necessity of chance that violently cripples an animal from the outside or deforms it from the inside through illness. That the lust for blood of the carnivores and the poison of some animals, including the stink which some disseminate for their defence, has as little to do with their beauty or ugliness as the poison of a plant does with its form, hardly needs to be noted. Were the supernaturalist hypothesis of the origin of ugliness through an evil that has corrupted nature true, then the predators and poisonous snakes would also have to be ugly on principle, which is so little the case, that on the contrary the poison-fanged snakes and the wild cats are distinguished through beauty, indeed through splendour. The unnatural, however, has in fact no application to nature, since, lacking freedom of consciousness and will, nature is unable to break a law intentionally. For animals, there exists no law of self-respect and filial piety, and thus also no crime against it. Self-dirtying, incest, and infanticide are concepts that only

belong to the world of minds, and it is false sentimentality to be appalled by the misdeeds of the animal world, which does not judge them as such.

Ordinarily, we also do not have such items in mind when we speak of natural beauty and ugliness, [26] but rather, usually, what we imagine is the beauty of landscape, which gathers in itself all natural forms into a characteristic unity. Landscape is monotonous where one of the natural forms rules it elementarily: the mountain, the stream, the forest, the desert, and so on. Or it is full of contrast, where two forms oppose one another in it; or it is harmonious, where an opposition dissolves into a higher unity. Each of these basic forms can go through an endless multiplicity of phases, through the cycle of hours and seasons. What aesthetic impression a landscape can make depends above all on lighting. A desert can be sublime, terribly sublime, when the tropical sun burns through[21] it as if through the deep-lying Sahara; melancholically sublime, when the moon of the temperate zones with its silver light shimmers over it as if over the high Gobi. But each of the basic forms of landscape can appear ugly as well as beautiful. Monotony, though reputed to be ugliness, reaches it first through the indifference of absolute shapelessness, like the leaden, flat, stagnant sea under a grey sky with no wind.

The Intellectually Ugly[22]

If we move from nature to spirit, we shall have to begin by saying that the absolute aim of spirit is truth and good, to which it subordinates beauty, just as organic nature had subordinated it to its absolute aim, life. Christ, the ideal of freedom, [27] we do not imagine as ugly exactly, but also not as beautiful in the Greek manner. What we call the beauty of the soul is the concept of the goodness and purity of the will, and such a thing can live in a common, indeed an ugly, body. The will in and for itself, in the seriousness of its holiness, exceeds the aesthetic element. Conscience with its practical content does not inquire about the form in which it appears. The intimacy of a loving mind lets one forget the rough manners, poor dress, possible errors in speech, etc., of the one acting. But it is natural that truth and goodness of the will result in a dignity of personal bearing which pushes outward all the way to sensible appearance, insofar justifying Lichtenberg's saying that all virtue makes beautiful, all vice makes ugly.[23]

This saying, true in itself, could be expressed yet more generally by saying that all feeling and consciousness of freedom make beautiful and all unfreedom makes ugly.[24] We want to take freedom here only in the sense of an unlimited self-determination, abstracting from the truth of its content. The organism is once and for all determined

[21] The verb *durglühet* is a misspelling of *durchglühet*, to shine or burn through.

[22] *Geist* means spirit *and* mind, as in Hegel's *Phänomenologie des Geistes*. The contrast here being that with nature, it is the intellectual dimension that bears emphasizing here.

[23] Georg Christoph Lichtenberg, 'Über Physiognomik', §7, in, e.g., *Vermischte Schriften*, vol. 4 (Göttingen: Dieterich, 1844), 66. Lichtenberg warns in the same breath that 'every Neapolitan thief may nonetheless be more beautiful than every honest German peasant'!

[24] *Unfreiheit* might be more fluently rendered as 'bondage' or 'constraint', but since these suggest outside forces, not self-willed negation, we stick with the literal 'unfreedom'.

to mean nothing for itself, but only as the tool of the spirit that shines through it. We can observe the truth of this concept in the races and social classes. With growing freedom, the beauty of the appearance grows as well. Aristocratic houses become more beautiful because they feel freer, because they are emancipated from the bondage of nature, because they have more leisure and fill this with play, love, armed exercise, and poetry. The islanders [28] of the South Seas were beautiful, as long as they lived in the dance, in combat, in love, and in the enjoyment of sea bathing. The blacks of Dahomey and Benin are beautiful, because they combine martial courage and mercantile enterprise with sensuous well-being. For this reason, they also take an interest in beauty. The king has a bodyguard of several thousand Amazons, truly beautiful and brave girls, of whom A. Boué has given us drawings.[25] Whoever receives a gift from the king expresses his thanks through a dance, that is, through an aesthetic act, in public before the assembled people.

Even the person who from a moral point of view is in part bad or even evil can nevertheless show beauty, inasmuch as beside his vices and non-virtues, he can still possess virtues, even a soul. Namely, he will often possess formal freedom, cleverness, prudence, sobriety, self-control, perseverance, through which criminals may even stand out with a certain knightly flair and nobility. In this province, strange wonders can be found. A Ninon de l'Enclos was certainly beautiful and no less gallant than beautiful; but she was free of petty considerations; she was gallant with feeling and grace and thus remained beautiful.[26] She gave out her favour freely after inclination, but she did not sell it.

Because the body in relation to mind can only lay claim to a symbolic value, it is possible that a person, in the body, can even be ugly, lopsided, of irregular facial features, pockmarked, and yet he can make us not only forgot all this, but further, that he can animate these unhappy forms from the inside out with an expression [29] whose charm draws us irresistibly,—as the ugly Mirabeau knew how to passionately captivate the most beautiful women, as soon as they allowed him to speak; as Shakespeare's Richard III, in a spirited and sovereign fashion is able to obtain at the bier of Henry VI the love of Anna, who had at first cursed him; as Alcibiades in Plato's *Symposium* says of Socrates that silent he is ugly, but on speaking, he is beautiful.

That evil as the intellectually ugly once it becomes habitual must make a human physiognomy ugly lies in its essence, since it is that unfreedom that originates in the free negation of veritable freedom. The habitus and physiognomy of happy primitive peoples can be beautiful, because they enjoy a freedom that is, at least initially, natural. The unfreedom that consists of knowing that evil is evil and wanting it nevertheless contains the deepest contradiction of the will with its idea; a contradiction that must betray itself outwardly as well. Individual wrongs and vices achieve their own physiognomic specificity. Jealousy, hate, lies, greed, and lust work out their own strange forms. One thus notices in female thieves an unsure, sideways look, whose movement

[25] Ami Boué (Hamburg, 1794–Vienna, 1881), a doctor, geologist and ethnographer.
[26] Ninon de l'Enclos (Paris, 1620–1705), French courtesan. Rosenkranz has in mind her many and public affairs with men of state, conducted with humour and independence.

the French call *fureter* from Latin *fur* [cf. English furtive], and which in its cursory sharpness, its secretively conspicuous groping, has something terrible about it. If one has visited large prisons and stepped into halls where sixty to a hundred female thieves sometimes sit and stew together, one recognizes this specific gaze of the prowling, restless eye as almost the gaze of the species. Ugliness becomes even greater, naturally, when evil is wanted in and for itself. But as paradoxical as it sounds, through [30] the fact that evil in this case fixes itself as a systematic totality, a certain harmony of the will is regained and an appearance generated that aesthetically softens the form. The aberrations of individual vices can often have a more disagreeable, cruder expression than absolute evil, which in its negativity is once again whole. A coarse vice is conspicuous in its one-sidedness, absolute evil in the depths or rather shallows[27] penetrates with its intensity both face and habitus in analogous ways, and can exist without offering to criminal justice any particular material it can use. Rich salon denizens thoroughly licked by culture, indulging every profligacy, wallowing in the finest refinements of egoism, flirting with the seduction of women, in the torment of their nonchalance tormenting their servants, often fall into the bottomless being-in-itself of evil.—Comparing them retrospectively with nature, we recognize here an escalation: nature may generate ugliness in some animals directly and positively, but a human being is capable of defacing and distorting the natural beauty it possesses from inside out, through evil, an accomplishment of self-destroying freedom of which the animal is incapable.

The cause of evil and of the ugliness it can convey in the outward appearance of a person is thus freedom itself, and in no way a transcendent being outside it. Evil is man's own act and so its consequences also belong to man. Since man has a natural part essentially, it follows that those determinations of ugliness that we found in organic and especially animal nature [31] are also possible in man. It is true that the type, according to its idea, leads us to expect a beautiful human appearance, but empirical reality, whose necessary factors include chance and arbitrariness, shows us also ugly forms and indeed not purely in the form of particular individuals, but in inherited diffusion over large groups. But such forms are not species in the sense in which there are animals that are ugly by birth, whose concept already contains ugliness, distortion, and what is contradictory. Held up to the idea of man, they remain accidents, which empirically are only relatively necessary. These may be of the singular or of the particular type. The singular type occurs when a human organism is deformed through individual illness, for example, scrofula, scoliosis, fracture, and so on; the particular type, when deformity comes into being because the organism must adapt itself to a particular locality. In this case the adaptation to a certain soil type and climate exposes man to the same processes as it does the plant and the animal. The diversity of telluric conditions expresses itself in the diversity of habitus and physiognomy, the more so as they also produce a diversity of modes of life. The inhabitant of mountain range and plain, the woodland hunter and fisherman, the herdsman and the farmer, the inhabitant of the polar zone and of the tropics, receive necessarily a different anthropological

[27] A play on words, *Untiefe* (un-depths), means shallows, but also dangerous reefs.

character. Even cretinism is thus explicable, since it seems to correspond to certain localities, namely to certain mountain streams in which lime deposits are dissolved. The cretin is much uglier than the black [**32**], because he has the added disadvantage of a formless figure with stupidity and mental weakness. His dull eyes, his low forehead, his protruding lower lip, his indifferent gluttony and sexual brutality place him below the black and in the vicinity of the ape, which has the aesthetic advantage over the cretin of not being human.

In the concept of the human, thus, there is no ugliness. This concept, as the concept of reason and freedom, demands its realization in exterior appearance through the regularity of form, in the distinction between feet and hands, and in upright posture. If a human being, like the bushman,[28] like the cretin, is ugly by nature, his malformation represents also a local and relatively inheritable unfreedom. Illness causes ugliness in every case in which it results in a deformation of the skeleton, of the bones and muscles, for example, in syphilitic bone protrusions and in cases of gangrene. It is ugly in every case in which it discolours the skin, as in jaundice; when it covers the skin with rashes, as in scarlet fever, the plague, certain forms of syphilis, in leprosy, in rashes and matted hair,[29] and so on. The most awful deformities are undoubtedly those due to syphilis, which produces not only disgusting rashes, but also rotting and the destruction of bone tissue. Exanthems [rashes] and abscesses are comparable with the itch mites that burrow under the skin;[30] they are to some extent parasitic individuals, whose existence contradicts the essence of the organism as a unity, and because of which it falls apart. The experience of such a contradiction is thus acutely ugly.—Disease is generally the cause [**33**] of ugliness when it alters the form of the body abnormally. Dropsy, tympanitis,[31] etc., belong to this category. But illness is not ugly in cases like phthisis, mania, or states of fever, when it gives the organism a transcendent tincture that makes it appear downright ethereal. Emaciation, a burning gaze, the pale or fever-blushed cheeks of the patient can even make the essence of the spirit more directly visible. The spirit is at this point on the verge of separating from its organism. It still inhabits the body, but only to make it, in effect, into a pure sign. The entire body in its transparent morbidity[32] no longer means anything for itself and has become through and through the expression of a spirit that is leaving, independent of nature. Who has not seen on a deathbed a virgin or youth who, as a victim of consumption, offered a truly transfigured sight! No animal can offer such a sight.—For the same reasons it follows that death must not necessarily result in the ugliness of the face, but can just as easily leave behind a beautiful, blessed expression.

[28] On these problematic claims and their probable sources, see the editors' Introduction.

[29] *Weichselzopf*, polish braid or elflock, an aggregate of hair and organic matter caused by poor hygiene: in Rosenkranz's time there were efforts to eradicate it in Germany. See Axel Bauer, 'Der "Weichselzopf" in medizinhistorischer Perspektive. Eigenständige Hautkrankheit oder mythologisches Konstrukt?' *Aktuelle Dermatologie* 30 (2004), 218–22.

[30] *Krätzmilbe*, Latin *Sarcoptes scabiei*, an insect that burrows into skin and causes scabies.

[31] A by now obsolete designation for *Otitis media*, middle ear infection.

[32] Rosenkranz probably means morbidity, but uses the Italian word *morbidezza*, which literally means softness, one of the synonyms of beauty in Renaissance aesthetics.

If illness can even, under certain circumstances, beautify a person, it can so much more become a source of beauty in its disappearance. The gradual return of health gives the gaze a free clarity, the cheeks a gentle ruddiness. The refilling of veins and muscles and the play of strength, which begins to stir again in search of pleasure, convey an exceptionally potent beauty and shower the human form with that ineffable charm, in which the appeal of rejuvenation still has in itself its opposite, infirmity, as life still has [34] death. A convalescent is a sight for the gods!

But we cannot leave spirit just at this point, for there are other ways in which it can generate ugliness than ordinary disease. Namely, it can become ill itself, and as a result express in its outward appearance the contradiction in which it has fallen with itself as spirit. Or more correctly, the disturbance of the soul is in itself true ugliness of spirit, as much as evil is. This inner ugliness can, however, also translate itself into the exterior. Idiocy, folly, insanity, and rage make a person ugly. Drunkenness as an acute, artificially generated self-estrangement of the mind also belongs here. The sobriety with which the self-aware spirit considers all of its relations and knows itself while individual to be simultaneously the general essence of reason: this gives the spirit the needed presence [of mind] and accordingly also the needed sovereignty over its organism. In disturbances of the soul, however, the person loses the generality of his sense of self as an idiot, or he divests himself of it limitedly as a fool, or as madman he feels himself annihilated by the force of a contradiction, and rescues himself from this contradiction only through the fiction of another being or through going berserk. In all these cases, the patient ascribes false values to the real as well as to the imaginary. The idiot sinks more and more into animal apathy, the fool develops a strange look that turns from reality and present things and persons to stray into the undefined, a nauseous grimace, a repulsive animation or rigidity, and even in the insane, who suffer from a deeper raggedness [35] of the mind, one notices in the ceremoniousness of their conduct, in the hollowness and incoherence of their pathos, the betrayal of a broken sense of self.

The Aesthetically Ugly

The realm of ugliness is, as we see, as large as the realm of sensible appearance itself; of sensible appearance, because evil and the unfortunate self-estrangement of the spirit only become aesthetic objects through the mediation of exterior representation. Because ugliness comes only through beauty, it can generate itself as the negation of each of its forms, making use of the necessity of nature just as well as of the freedom of mind. Nature mixes the beautiful and the ugly by chance, or as Aristotle would say, καταβεβηκώς [*katabebekós*, going down, descending[33]]. The empirical reality of spirit does the same. To thus enjoy the beautiful in and for itself, spirit must first bring it forth and enclose it in a peculiar world for itself. This is how art originates. Outwardly it too

[33] The best-known use of this verb is Pausanias, *Description of Greece* (X.28), to describe a painting in Delphi of Odysseus καταβεβηκώς ἐς τὸν Ἅιδην, 'descending into Hades'.

links up with human needs, but its one true motive remains the mind's longing for pure, unmixed beauty.

If making beauty is the task of art, must it not appear as the greatest contradiction when we notice that art also produces ugliness?

Should we wish to answer here that art does produce ugliness, but as something beautiful, we would obviously only be adding to the first paradox [36] a second and seemingly greater one, for how is it possible that the ugly should become beautiful?[34]

Through these questions we see ourselves bogged down in new difficulties. Since they urge themselves on us, one usually defends oneself by repeating the trivial sentence that beauty needs ugliness or can at least make use of it in order to appear more beautiful;—similarly, one makes vice the precondition of virtue. Over against the dark foil of the ugly, the pure image of the beautiful is supposed to show itself all the more clearly.

But can one really rest content with this sentence? Its truth, namely, that compared to the ugly, the beautiful must be felt all the more as beautiful, is only relative. Were it absolute, all beauty would have to wish for the accompaniment of ugliness. Only next to a Thersites would then the beauty of an Achilles be entirely what it ought to be. But such an assertion is clearly incorrect. The beautiful, as the sensibly appearing expression of the idea, is absolute in itself and needs no foothold outside itself, no amplification through its opposite. It will not be more beautiful through the ugly. The presence of the ugly beside the beautiful cannot increase the beautiful as such, but only the stimulus of pleasure, in that, faced with it, we feel the excellence of beauty so much more vividly;— as for instance many painters show Danaë as with sweetly languorous desire she receives the gold rain in her beautiful lap, and beside or behind her, a wrinkly, sharp-chinned old woman.

But, in fact, the beautiful and sublime in general make us wish its exclusive and unmodified presence. [37] It is sufficient in itself to such a degree that not only can it dispense with any foil of ugliness, but any such foil would be found disturbing. Absolute beauty has a calming effect and, for the moment, makes one forget everything beside itself. Why, out of its blessed fullness, be distracted by something else? Why spice up its enjoyment through reflection on its opposite? Beside the statue of the god in the adyton,[35] is there room in the temple for a malicious demon? Will the worshipper be satisfied with anything other than the features of the god?

We must then discard the unqualified validity of the thesis that the ugly in art is there for the sake of beauty. In architecture, sculpture, music and lyric poetry, one would be particularly troubled to maintain it. The contrast which art often requires need not be generated through the opposition of ugliness; beauty is sufficiently multifaceted to contrast with its own forms—as, for instance, in Goethe's *Iphigenia* so many beautiful characters appear, or in Raphael's Sistine Madonna only majesty, grace,

[34] It is an article of faith of idealist aesthetics from Kant to Bernard Bosanquet that ugly content is somehow rendered beautiful in art. How this is accomplished is not explained.
[35] The small rear room of the interior (*cella*) of a Greek temple, where the cult statue was kept. Only temple personnel entered, hence the name (which means 'no entry').

elegance, dignity, gentleness and by no means something ugly can be found, and despite this the work does not lack in contrast, but, as beautiful, produces that endless delight which belongs to the absolute as the flawlessly divine. The teleological interpretation of ugliness thus has no comprehensive justification. In the case of nature, we convinced ourselves that, speaking teleologically, it is concerned essentially with life and only secondarily with beauty. We also saw that for the mind truth and goodness take priority over all aesthetic demands. It is nice[36] when the true and the good also seem beautiful [38], only it is not necessary. That from this it does not follow that truth and goodness, if they cannot appear in ideal beauty, must appear ugly, has been stressed. Unselfconscious ugliness has no purpose external to itself, in mind or in nature. Nature warns us of poison in metals, plants, and animals not through frightening form and colour, and the spirit most worthy of love can have the fatal destiny of having to carry out its life with an Aesopian hump, with a Byronic clubfoot.

How can art, whose goal can only be beauty, come to create ugliness? Obviously the reason must lie deeper than in that superficial relation of reflection. It can be found in the essence of the idea itself. Art indeed has of necessity a sensuous element—this is its limitation, against the freedom of the good and the true—but in this element it wants and should express the appearance of the idea in its totality. It belongs to the essence of the idea to leave open the existence of its appearance and thus to allow the possibility of the negative. All forms that can spring from chance and arbitrariness realize their possibility factually as well, and the idea proves its divinity above all through the power with which, in the welter of intersecting phenomena, in the division[37] of accident and accident, of drive and drive, of arbitrariness and arbitrariness, of passion and passion, it conserves on the whole the unity of its law. If art then wishes to give more than a merely one-sided experience of the idea, it cannot avoid the ugly. The pure ideals present [39] to us, however, the most important moment of beauty, the positive. But should nature and mind come to be represented in their entire dramatic depth, then natural ugliness, evil and the diabolical cannot be absent. The Greeks, as much as they lived in the ideal, nevertheless offered to the world *Hekatocheires* [hundred-handers], Cyclops, satyrs, *Graiae* [the grey sisters], *Empusas* [blood-drinking female demons], harpies, chimeras, a limping god, and in their tragedies crimes of the most abominable kind (Oedipus, Orestes), madness (Ajax), disgusting illness (Philoctetes's pus-filled foot), and finally in their comedies vice and indignities of every sort. But with Christian religion, which preaches the recognition of evil at its root, and its fundamental overcoming, ugliness has been introduced fully into the world of art.

For this reason of rendering the appearance of the idea in its totality, then, art cannot avoid making ugliness. It would be a superficial understanding of the idea to limit it to what is simply beautiful. But from this integration, it does not follow that the ugly has the same aesthetic rank as the beautiful. The secondary origin of the ugly makes a difference here as well. The beautiful, resting as it does in itself, can be brought

[36] *Schön*, literally pretty or beautiful: a wordplay on the casual use of this word in German.

[37] *Entweizung*, split or rupture (see below) seems to refer here to the individuation of events, amidst which a Hegelian idea (as objective unity of concept and reality) persists.

forth by art with no connection and without any further background, while the ugly is incapable of this aesthetic self-reliance. Empirically, it is indeed self-evident that the ugly can also appear on its own, but aesthetically speaking, no abstract fixing of the ugly is possible, because aesthetically it must always reflect itself in the beautiful, which is the condition [40] of its existence. We can henceforward take up again the thesis discussed in relation to beauty and say that ugliness, which does not rest in itself, has in beauty its necessary foil. Next to a Danaë we may well enjoy the ugly old woman, but the painter would not have painted her for us alone, unless as a genre picture, wherein the situation constitutes the aesthetic element, or as a portrait, which then falls directly into the category of historical correctness. Now, quite naturally, the dependence of the ugly on the beautiful is in turn not to be understood as the ugly being allowed to take the beautiful as its means. That would be an absurdity. The ugly may thus appear in the vicinity of the beautiful, under its patronage as it were, accidentally;[38] it can remind us of the danger to which the beautiful is always exposed through the freedom of its mobility, but it cannot become the direct and exclusive object of art. Only religions can posit the ugly as absolute object, as shown by so many hideous idols of ethnic religions, but also of Christian sects.

In the totality of a worldview, ugliness, like evil and disease, constitutes only a vanishing moment, and in the labyrinthine nature of this great context we not only tolerate it, but it can become interesting for us. Taken out of this context, however, it becomes aesthetically inedible. Gazing, for instance, on van Eyck's *Last Judgement* triptych in Danzig,[39] on the wing to one side of the central panel which represents the horrible forms of Hell, the despair of the damned and the mockery of the devils busy with their punishment, it is obvious that the painter showed this sinister knot [41] of repulsive grimaces only in connection to the opposite panel, which contains the entry of the saved into the bright halls of Heaven, and he painted both only in relation to the large central picture, the Judgement itself, which alone explains the extremes of the side wings and marks a passage to them in symmetrical groups and wondrous up-and-down gradations of colour. But Hell alone or even a devil alone he would not have painted. For didactic reasons, we isolate the ugly as well, naturally, but an artist who reproduced it in portrait-like fidelity would never believe that he had created an artwork in the process. The Head of Christ is exhibited everywhere without hesitation; not so the mask of a Mephisto. Such individualization would entitle ugliness to a self-sufficiency inconsistent with its concept, whereas beauty can be isolated in painting all the way down to a still life. For this reason all works of poetry which have taken as subject something simply ugly have been unable to achieve the slightest popularity, whatever the exertion of spirit. No one can take real pleasure in such works. The French possess didactic poems concerning pornography and even syphilis, the Dutch, concerning flatulence and so forth, so that even the owners of such poems are ashamed to have them found in their possession. The Prince of Pallagonia of whom Goethe tells

[38] *Accidentell* is not an everyday 'accident' (*Unfall*), but the accident of scholastic logic, an attribute that an individual has contingently rather than necessarily (as its essence).

[39] Hans Memling's *Last Judgement*, once in the Marienkirche, now the Nationalmuseum Danzig (*Muzeum Narodowe w Gdańsku*), was once attributed to Jan van Eyck.

us (* NOTE 13) wanted to render ugliness through art itself, which bristles decisively against its design, to represent it through sculpture in a certain systematic perfection, and managed to produce for all his trouble nothing but a confused, sadly ridiculous [42] curiosity. Only in combination with the beautiful does art allow the ugly its existence; but in this connection it can bring about great effects. Art needs it not only for a complete grasp of the world, but primarily for the transformation of an action into the tragic or the comical.

If art does represent the ugly, then, it seems against the very concept to beautify it, for in that case the ugly would no longer be ugly, quite independent of the question whether an attempt to beautify the ugly, the sophistic dressing up of an aesthetic lie, does not in fact produce one more piece of ugliness through the inner contradiction of making out the ugly, which is the negation of the beautiful, to be beautiful, thus passing it off as something positive, which is against its nature and in the end gives rise to a caricature of the ugly itself, a contradiction of the contradiction. So it seems, to repeat, though it is true that art must also idealize ugliness, that is, must treat it according to the general laws of beauty, which it transgresses through its very existence; not as if art should hide, disguise, falsify the ugly, decorating it with finery alien to it, but rather that it should form it, its truth intact, according to the parameters of its aesthetic significance. This is necessary because it is how art deals with all reality. The nature art shows to us is real nature and yet not ordinary empirical nature. It is nature as it could be if its finitude permitted it such perfection. Likewise, the history which art gives us is real history and yet not ordinary empirical history. It is history according to its [43] essence, according to its truth, as idea. In ordinary reality there is never a lack of the most looming and most repugnant forms of ugliness; art cannot take these up without further ado. It must show us ugliness in the full compass of its mischief, but it must do this nevertheless with the ideality with which it handles the beautiful. There art dispenses with everything in the content that belongs only to its contingent existence. It emphasizes the significant in a phenomenon, erasing in it the inessential features. It must do the same with ugliness. It must display just those conditions and forms that make the ugly ugly, but it must remove from it all that intrudes into its existence only accidentally, weakening or confusing what is characteristic in it. This purification of the ugly through removal of the undefined, accidental, characterless, is an act of idealization which does not consist of adding to the ugly an alien beauty, but in a pithy dredging up of those elements which stamp it as the opposite of beauty, and where, so to speak, its originality lies, that of aesthetic contradiction. The Greeks, however, reached in this idealization at times a point wherein the ugly is cancelled and turned into the positively beautiful, as in the *Eumenides* and the Medusa (* NOTE 14). For if one has so often imagined that the Greeks sought ideal beauty primarily in cheerful calm, and avoided the mobility and intensity of expression as ugly, this is far too narrow a conception of their art based on a few sculptures. Concerning poetry, one will admit this promptly enough on reflection; [44] concerning sculpture, Anselm Feuerbach in his fine work on the Vatican Apollo has proved that they did not shy from the terrible and from dramatic vitality (* NOTE 15); concerning painting, we learn this not only from deeper penetration in the wall painting of Herculaneum and Pompeii, but also from the description of Polygnotos's paintings in the *Leschen* at Delphi and Athens, as Goethe

feels compelled to emphasize in his discussion of them, despite being himself an admirer of good cheer, calm, and restrained liveliness (* NOTE 16).

The ugly therefore must be freed through art of all its heterogeneous excess and disturbing accident, and once again submit to the general laws of the beautiful. For this very reason, an isolated representation of the ugly would contradict the concept of art, for it should appear through art as an end in itself. Art must make the secondary nature of ugliness visible and remind us that it does not exist originally through itself, but only in and out of beauty as its negation. Even if it is brought into view in this accidental position, still it must be given all the consideration due to it as a moment in a harmonious totality. It cannot be idle, but must prove itself necessary. It must group itself properly and subordinate itself to all the laws of symmetry and harmony that it violates in its own form; it may not pull itself out of the proportions allowed by its context, and it must possess a force of individual expression which makes its meaning unmistakable.

[45] Taking up, for example, visual art, the appearance of a person defecating or vomiting is certainly disgusting. Nevertheless, painters have not balked at presenting such things in the context of great feasts. It is after all the way of the world, that people, when something tastes particularly good to them, overeat. In the interest of completeness of description, the artist did not wish to leave out this moment, he has only aesthetically softened it through his form of representation. Paul Veronese has famously painted the Wedding at Cana thus.[40] In the foreground he painted a small boy pissing in childish innocence. A child in this situation is tolerable in the foreground, the more so as he shows his dainty calves and haunches, lifting his robe with a smile. The adult who vomits, however, a man who had enjoyed too much good food and drink, is placed in the background, leaning his wine-heavy head against a wall.

Dissonance, taken musically, is the destruction of music, non-music. The musician may not introduce it arbitrarily, but only there, where its entry has been prepared, where it is necessary, where through the dissolution of the discord, it is the basis of the triumph of a higher harmony.

The poet who presents us with a Caliban does this on an island in the ocean, ruled by a wizard, a context in which his presence loses its oddness. He is the original barbaric inhabitant of the wild island, over whom the educated intruder has made himself master—the fate of all primitive peoples who come into contact with civilized peoples.[41] [46] Caliban thus has against Prospero an original claim of ownership, and knows this too. He is thus no simple monstrosity, but expresses a world-historical idea. But there is more. As aesthetic compensation Shakespeare appended to him Ariel, who, on one hand, makes the oafish and brutish side of the untamed monster more clearly evident,

[40] Paolo Veronese's 1563 painting, taken from Santa Maria Maggiore in Venice in 1797 by Napoleon, must have been seen by Rosenkranz in the Louvre on his 1846 Paris visit.
[41] A Caliban reminiscent of postcolonial interpretations. The opposition *Culturvolk* and *Naturvolk* (the latter coined by Herder, according to the Grimms, the former probably derived from his theory of *Culturen*) is flexible around 1850, especially applied to the past. For example, Wilhelm Heinrich Riehl, *Land und Leute* (Stuttgart & Augsburg: Cotta, 1856), 129: 'The frequently mixed German (*deutsch*) cultured people of the Franks still stands opposed in the North to the Germanic (*germanisch*) primitive people of the Saxons ...'

and, on the other, makes us feel lifted above his clumsy bulk through the contrast of the delicate air spirit.

Architecture might raise a particular question here through its ruins. The demolition of a building leads us to expect ugliness; only, whether this is the case depends in part on the building, in part on the mode of its destruction. A beautiful building, namely, will still show as a ruin the grandeur of its plan, the boldness of its proportions, the richness and elegance of its execution, and our fantasy will involuntarily try to produce the whole out of these suggestions. The ugly building can benefit from demolition; its fragments may be thrown fantastically together, quite apart from the fact that destruction of the ugly affords us aesthetic satisfaction. Surely it also matters how the ruin is produced, how the fragments are thrown together, what remains are left over. A diminutive pile of stones, a few bare walls, provide as yet no picturesque perspective. The ruins of a barn or a cattle stall would not interest us even in the moonlight; a palace on the other hand, a cloister, a knight's castle will seem romantic. That a ruin can appear beautiful, finally, is not determined alone by the original proportions of the [47] building and the mode of its destruction, but also according to whether the work of architecture grows together with surrounding nature and takes on itself the character of a work of nature. In that roof and windows and doors hang open, in that all seclusion ceases, in that moss makes the stones green, plants take root between them, birds build their nests and the fox peeks through the broken window, the building becomes sort of a production of nature, often coming very close to its basalt formations.

Ugliness in Relation to the Individual Arts

For the general possibility of falling into ugliness, the arts are in the same position. Each can produce it, and indeed to the point where we can no longer bear it. Despite this, the qualitative temperament of this general possibility depends on the peculiarities of each art. According to its nature, the content, extent, and modality of each art differ. We may see the various arts as a path to aesthetic self-liberation of the spirit, upon which, in poetry, it finally and fully reaches itself. The passage through the varied materials of realization of the beautiful represents for us the particular steps of this liberation. In matter, in space, in experience, that is, in visual art, spirit is still outside itself. With sound, with time, with feeling, that is, in music, spirit steps into itself. With the word, with consciousness, with [48] image and thought, in the art of poetry, spirit reaches perfect inwardness and the full ideality of form. In this progress, with increasing freedom, greater ease and acute effortlessness of representation, there grows also the possibility of ugliness.

In architecture at any rate one can build abominably, which is shown not just by countless buildings that spring out of limited needs, but also many public buildings, indeed, buildings that are meant to be architectonic marvels. But it is difficult in the art of building to be entirely hideous. When Goethe said that mistakes should not be built, because through their size and durability they offend the aesthetic sense too painfully, he hinted that the works of architecture are too serious and valuable to be taken in any

way lightly. Through its material, that of massive matter, building always provokes deliberation. It must at the least provide safety and somewhat fulfil its purpose. These two motives of utility always bring of themselves a certain eurhythmy in the work. A building is that much more beautiful, the more it pronounces outwardly the solidity of its proportions in a reassuring manner, the more it already symbolically announces in its form the purpose to which it is dedicated. Some houses, particularly those built in the first half of the eighteenth century, indeed look as if someone had first provisionally built four walls, then by necessity a roof, and finally, as is the case with Schöppenstedt's City Hall,[42] carved out windows large and small without any symmetry from the inside outward according to whim. A larger building will, however, always betray some reflection, [49] and a mishmash of incompatible building styles belonging to distinct centuries will not make so much an ugly as a fantastically imposing impression.

Sculpture also limits ugliness exceptionally through the brittleness and preciousness of its material. To be sure, as the most lurid facts can make themselves felt, even the most miserable statues can be carved or cast, but at least the sumptuousness of the material and the tedium of the work will always rein in its productive flippancy. A block of Carrara marble or even old gunmetal for a statue is not to be had so inexpensively. Only very slowly does the block give in to thousands of hammer blows; only in a very involved procedure, often requiring years, does the ore get poured into the cast, and then it is still chiselled month after month. This is why there is no art in which tradition is so powerful as in sculpture. The new risks its appearance seldom, for in the case of failure there is too much at stake. A mistake carved in stone or cast in bronze is far more obvious in its plastic reality than if it were merely drawn or painted. The result is that, thanks to the ideality forced on it by the persistence of its forms, there is no other art that has so little the disposition to represent the negative in disease, pain, and wickedness.

Painting, on the other hand, among the visual arts falls victim most easily to ugliness, for it has to simulate individual animation as well as the appearance of perspective. Sculpture can make individual mistakes, small or great, in the making of a statue, mistakes in form, position, and drapery, and still offer something entirely worthy of respect. [50] But painting can through the affordability of its materials and the ease of its production much more easily be tempted to bungling. The extent of its possibility is already infinitely greater than sculpture's: landscape, the animal, the person; nothing that can be visibly perceived is closed to it. At the same time, it is determined from many sides: the contours of the shapes, the palette, the perspective—what a multitude one has to take into account, if it is to appear as a unity! For this reason, incorrectness of drawing, untrue colour, false perspective creep in so quickly. A foreshortening, how quickly it is botched! A hue, how quickly missed! A shadow or a highlight, how quickly forgotten! And so there are doubtlessly far more bad paintings than statues, even if one does not exclude the Indian and Egyptian, which are ugly according to religious principle.

[42] The medieval German town of Schöppenstedt, located in Lower Saxony near Wolfenbüttel, has a distinctive *Rathaus*, equipped also with a tower with a pointed pyramidal roof.

With music the ease of production grows, and with it, as with the distinctive subjective inwardness of this art, the possibility of ugliness. Though this art in its abstract form, in measure and rhythm, is founded in arithmetic, yet in melody, which first makes it the true, soulful expression of the idea, it is exposed to the greatest vagueness and contingency, and a judgement of what is and is not beautiful in it is often infinitely difficult. Thus, due to the ethereal, volatile, mysterious, symbolic nature of sound, and due to the uncertainty of criticism, ugliness gains even more ground here than in painting.

Finally, in the most free of arts, in poetry, the possibility of ugliness, through the freedom of spirit, and [51] the word with its utter ease of speaking and writing as medium of representation, reaches its pinnacle. To do justice truly to the idea, poetry is the most difficult art, because it can least of all imitate the empirically given directly, and must much rather work it out, condense it, out of the depth of the spirit. Once it is there, however, once it has won a literary existence, once it has worked out a poetical technique for itself, there is no other art that is so easily misused as poetry, because then, according to the well-known judgement of a great poet, language already writes and thinks for us.[43] In epic, in lyric, in drama and didactic poetry, the same material undergoes a superficial modification, in content as in form, but the material's structure only seems to change. It is then up to a taste that is educated and enriched through many-sided experience, and made tranquil through deep knowledge, to discover ugliness. To this must be added the interest that can be taken in poetry in a tendentious vein, so that it is not poetic value, but revolutionary or conservative, rationalistic or pietistic pathos that decides a poem's fate, as our epoch proves only too often. For us, party ideals often overshadow the divine ideal, if they do not make it disappear altogether. In poetry one can sin most easily and imperceptibly, and surely in it the greatest proportion of ugliness is produced.

[52] The Pleasure in Ugliness

That ugliness might produce pleasure seems as absurd as the claim that illness or evil might. Despite this, it is possible, in healthy as well as pathological ways.

In a healthy way, when the ugly justifies itself as a relative necessity in the totality of an artwork and is cancelled out by the counteraction of the beautiful. Not the ugly as such causes our pleasure then, but the beautiful overcoming its apostasy, which also appears. We have already discussed this above.

In a pathological way, when an era is physically and morally depraved, powerless to register true but simple beauty, still wishing to enjoy in art what is piquant in frivolous corruption. Such an era loves mixed sensations that have a contradiction as their content. To tickle dulled nerves, one assembles the most unheard-of, the most disparate,

[43] Friedrich Schiller, in the couplet 'Dilettant' [1797], wrote: 'If a verse comes off true, in a sophisticated language / that writes and thinks for you, do you think you're a poet?'

the most repulsive things. The torn spirits feed on ugliness, since it becomes for them in a way the ideal of their negative state. Animal baiting, gladiatorial games, lewd *symplegmas*, caricatures, sensually effeminate melodies, colossal instrumentation, in literature a poetry of faeces and blood (*de boue et de sang*, as Marmier said[44]) are peculiar to such periods.

[53] Division of the Work

Turning our attention, after the solution of these preliminary questions, to the development of a classification of the concept of ugliness, we have already above given its general place in the metaphysics of beauty. We have said that it constitutes the negative middle between the concept of the beautiful in itself and that of the comical. This position differs from that which does not see the ugly as any particular moment of the idea of beauty, but treats it only as a subordinate determination of the sublime in the form of the frightful and terrible, or of the comic in the form of the farcical and low comedy. Many of today's aestheticians, namely, take the comical as the opposite of the sublime and would like to see absolute beauty regarded as the union of the sublime and the comical. The comical, however, does not simply stand opposed to the sublime, it is opposed to the beautiful in general, or more correctly, it does not stand opposed to it, but is the cheering up of the ugly into the beautiful. Ugliness stands opposed to beauty; it contradicts it, whereas the comical can at the same time be beautiful, beautiful not in the sense of simple positive beauty, but certainly in the sense of aesthetic harmony, the return out of contradiction into unity.[45] In the comical something ugly is co-posited as the negation of the beautiful, which it in turn negates. Without a contradiction that is resolved through an appearance, since it is itself only an appearance, the comical cannot be thought. Aristotle and after him Cicero have already presented the matter thus (* NOTE 16b). The concept of the sublime is also not to [54] be separated from that of the beautiful, but rather to be seen as a peculiar form of the same. Since the ugly is nothing absolute, but much rather only something relative, its conceptual definition requires a return to the idea of the beautiful, which gives it its condition.

The beautiful in general, we have presupposed here, where only the ugly concerns us, is the sensible appearance of natural and intellectual freedom in harmonious totality.

The first condition of beauty is therefore manifestly the need for a limit; it must posit itself as unity, and its differences as organic moments of the same. This concept of the abstract fixity of form constitutes in a way the logic of the beautiful, in that it still

[44] Xavier Marmier, *Lettres sur l'Amérique*, vol. 1 (Ixelles: Delevigne et Callewaert, 1851), 165: the actual phrase is in reverse order, 'cet homme couvert de sang et de boue ...' Marmier's Chapter 9, on Niagara, may have inspired Rosenkranz's use of the example (R 179).

[45] The relation between beauty, ugliness, and the comical might be said to be a circular one for Rosenkranz, with ugliness lying between the other two (as he had written often before writing this passage), and the comical being in turn closer to beauty than non-comical ugliness.

abstracts completely from its particular content and posits for all beauty, in whichever material it realizes itself and whatever its spiritual gratification may be, the same formal necessity.

The negation of this general unity of form is thus formlessness. The pure absence of all form is not beautiful, likewise not yet ugly. Space in its boundless extension cannot be called ugly; the black of night, wherein no form can distinguish itself, also not; a uniformly sounding tone just as little, and so on. Formlessness becomes ugly only where some content ought to have a form and lacks one, or where there is a form but it is not yet shaped as it should be to match the concept of the content. Insofar as with the expression 'formlessness' we also mean the indefiniteness of the boundary, formlessness can well be the necessary form of a content, as [55], for example, the infinity of space calls for, for to have a form, thus a boundary, would be against the concept of absolute space, that is, it can only have formlessness as a form. If, however, some content should have a certain form and this form is not there, we compare it with this form that has been presupposed for it and by it, and we feel this deficiency as ugliness. Taken metaphysically, it is in any case entirely correct that no content can exist without some form, but relatively we can articulate formlessness, just as we can a lack of content. Say we imagine a landscape painter who wished to paint a location, and, pressed for time, can only add to his fugitive contours a few streaks of colour to jog his memory: the landscape has a very imperfect form. Instead of the real coloration, we are only offered formless points of colour, which refer exclusively to the future execution, and this aggregate of colour would still be formless and ugly as a result. Now, we can also imagine the picture as completed, but misconceived and botched; then the execution would be the completed form and yet not that which it should be. Instead of it, there would have come into being a form that is more or less foreign to the concept of the thing, thus a form not matching the content. There would thus be a positive contradiction of form and content, and this formlessness of form would be ugly once again.

The beautiful thus demands unity of form and content in determined relations or, speaking abstractly, proportions. But the beautiful also has a sensible side that is essential, for precisely as form [56] does it enter nature. To be beautiful, intellectual content also needs the mediation of sensible manifestation. From this standpoint, nature can be said to contain the truth of concrete individualization, into which the existence of beauty must enter. In its reality it [beauty] is also something determined ideally, but this determination is somehow bound to nature, for only through nature can the idea make itself finite and realize itself as a particular phenomenon. Without nature no single beautiful formation can exist, and art thus needs to study nature in order to master its forms; art should in this respect imitate nature and indeed with conscientious fidelity, for it is here dependent on it.—This proposition is just as true as that which asserts that art should not imitate nature, insofar as we understand by imitation a plain, however precise, copying of contingent empirical objects. Just as the formalism of abstract proportions is as yet insufficient to create beauty, neither is abstract realism. The simulation of crude appearances is not yet art, which should begin with the idea; but nature, which in its existence is exposed to all exteriority and contingency, can often not live up to its own concept. It remains the business of art to realize the ideal of natural form, a beauty which nature pursues but which its being in

space and time often makes impossible. But to make possible the ideal truth of natural forms, empirical nature must in any case be studied assiduously, something all real artists do and upon which only the false idealists heap scorn. The truth of natural forms gives the beautiful its correctness. [57]

Accordingly, correctness in general consists in no mistake being made in the representation of the necessary natural form. The beautiful cannot dispense with this. Thus, if a form trespasses against the regularity of nature, the contradiction infallibly produces ugliness. Nature itself becomes no longer beautiful when it lapses from its law through some aberration. With art this is even more so the case, because here the excuse that nature gives in its defence is lacking, namely that of not being able to avoid the context in question, through which monstrosities, cockroaches, hydrocephaly, etc. come into being. Say we imagine that a sculpture meant to depict a female elephant with a suckling calf, as pendant to Myron's nursing cow; abstract proportions would have to be applied in the ordering of the group, but the moment of natural correctness would consist in the fact that the calf is nursed just so as is naturally possible for the mother. The udder of the female elephant, namely, is borne between the front feet, rather like human breasts, and the calf does not suckle with the trunk, with which it sucks up water to squirt it into its gullet, but rather, it suckles with the lips of the lower jaw. If this were not observed, an incorrectness and consequently ugliness would result, for all the formal proportions of the elephant are calibrated to this form of suckling. It is evident that a superficially so-called beautification of nature that alters its ideal truth also comes under the concept of incorrectness [58] as easily as the slavish correctness that through awkward diligence fails to attain to ideal truth, and in its turn requires aesthetic correction.

But it is also evident that a self-conscious deviation of art from the forms given by nature in the service of a particular aesthetic impulse or in fantastic images should not be counted as incorrect. Conventional proportion constitutes a peculiar sphere of correctness, which fixes itself as the historical expression of a form of spirit. In its origin, such a form corresponds more or less with a natural proportion, or at least with a real need. With the passage of time, however, it can distance itself considerably from nature: man, to make his freedom really and visibly real, even does violence to nature. The savage demonstrates through barbaric mutilations and changes of his body, through bones and rings, which he affixes to his nose, earlobes, or lips, through tattooing and so forth, the drive to distinguish himself from nature. He is not satisfied with nature as given, like the animal; he wishes qua man to show his freedom against it. The peoples acquire after some duration a quite distinct habitus, and a firmly pronounced mode of behaviour. They produce, according to local and national character, peculiar forms of dress, habitation, and equipment. Should art have a historical object as subject matter, it must in order to be correct represent it according to its positive, historically given form. Here too what matters is not a scrupulous accuracy, but rather a sense of how form through the exaggeration of [59] peculiarity can become an aesthetically more individual object. The wide, downward-stretched lower lip of the Botocudos,[46] the potbellies and shrunken feet of Chinese ladies; the

[46] The Aimoré of Brazil, called 'Botocudos' by the Portuguese for their *botoques* (plugs).

boyish faces and small waists of women in the Styrian Alps, and so on, are certainly ugly. A transgression against these forms would thus have aesthetic priority. But if the intention were precisely to represent a lady as a Chinese beauty, there would be no alternative to doing this in the Chinese manner and thus neither the potbelly not the shrunken feet could be spared. Art can soften such forms, but may not ignore them. For they belong in this case to the individual characteristics of a historical model. Indeed, the naïve period of an art concerns itself little with such historical precision, and holds on above all to the universally human, but art that has reached a stage of reflection cannot do away with attention to historical correctness. As is well known, the French theatre under Louis XIV and XV played Greek and Roman heroes and heroines in wigs and hoop skirts with rapiers at their side. The actors stood closer to the public, insofar as the public must have more easily understood action in this costume. But eventually this freedom led to unease. One wanted the past and the foreign to come into their rights. A separate periodical provided with truly instructive copperplates, the *Costumes et annales des grands théâtres de Paris*, published under Louis XVI,[47] made it its goal to depict Celtic, Greek, Roman, Jewish, Persian, and medieval costume with historical accuracy, and to reconcile it with theatrical praxis. [60]

Formlessness would thus be the first and incorrectness the second principal form of ugliness. But there still remains that form which really and truly contains the motive for the first two, the inner deformation that also breaks out in external disharmony and unnaturalness, because it is in itself murky and convoluted. For beauty, namely, freedom is the real content, freedom in the general sense, which includes within it not only the ethical freedom of the will but also the spontaneity of the intelligence and the free movement of nature. The unity of form and its individuality become perfectly beautiful only through self-determination. One must take this concept of freedom generally, for otherwise the aesthetic domain is unnecessarily limited. The metaphysics of beauty apply not only to art, but also to nature and to life. In modern times it has become customary regarding beauty to speak of the spiritual content of sensible form. This may be meant in the sense that, insofar as nature in and for itself is also descended from spirit, it too as a work of the creative spirit radiates this, and the spirit in its contemplation also contemplates its own freedom. This sense, as I said, may be thus expressed. But if it limits itself solely to art, as often happens, the result is a groundless and unjust contraction of the concept of the beautiful and thus also of the ugly. The concept of freedom is not thinkable without that of necessity, for the content of the self-determination that is its form is found in the essence of the individual self-defining subject. We should avoid here digression into those difficult, frequently aired investigations of the origin and [61] goal of freedom. They may as well be relegated to other sciences. If we satisfy ourselves here with the aesthetic point of view, it follows that freedom as self-determining necessity constitutes the ideal content of the beautiful. Freedom has in its essence the possibility of a double movement, in that it can either exceed the measure of appearance as the infinite, or it can enter it as the finite. In and for itself, it is the unity of the infinity of its content and the finitude of its form, and as

[47] A journal published by Levacher de Charnois and Hilliard d'Auberteuil, Paris, 1786–89.

this unity it is beautiful. Should it annul the finitude of its self-limitation, it becomes with this act sublime; by contrast, if it pursues its finitude, limiting itself, it becomes with this comprehensibility pleasant. Absolute beauty persists in its own infinity, neither reaching out into the boundless, nor losing itself in the miniscule.

The true opposite of the sublime is not the ugly, as Ruge and Kuno Fischer claim, nor the comical, pace Vischer, but the pleasant. In the idea of beauty we must distinguish the opposition between beauty in general, the sublime included, and ugliness as negative beauty, from the positive opposition between the sublime beautiful and the dainty and delicate forms of the pleasantly beautiful. Through the mediation that the ugly brings forth for the comical, it is indeed possible for the comical to be relatively opposed to the sublime, but it is worth considering that the comical, being capable of humour, can merge once again with the sublime. What was said at the fall of Napoleon I: *du sublime au ridicule il n'y a qu'un pas* [from the sublime to the ridiculous there is but a step]; and what was said on the coronation of Napoleon III: *du* [**62**] *ridicule au sublime il n'y a aussi, qu'un pas!* [From the ridiculous to the sublime there is also but a step!] can be taken as universal aesthetic rules. Aristophanes is often so sublime that every tragedian might envy him for it.

Within the ugly therefore the principle shall consist in unfreedom, from which the individual aesthetic or rather the unaesthetic character flows; unfreedom is also taken in a general sense, since not only art, but also nature and life in general are pulled this way. Unfreedom as the lack of self-determination or as a contradiction of self-determination against the necessity of the essence of a subject gives rise to the ugly in itself, which further, as appearance, becomes the incorrect and the formless. If we observe, for instance, the living thing in a state of illness, the possibility of it becoming ill is indeed necessary, but it is by no means for this reason necessary that it should become ill in reality. Through illness it is disturbed in the freedom of its movement and development; it is also thus bound by illness, whose results finally, after they have crept through its innards, must reveal themselves also in its outer deformation and uglification.—Or if we observe the will, it becomes positively unfree through frivolous negation of its necessity; it becomes evil. Evil is the ethically ugly and this ugliness will also have aesthetic ugliness as a consequence. And how could theoretical unfreedom, dumbness and narrow-mindedness, help but reflect itself in stupid and flaccid faces? True freedom is in all ways the mother of the beautiful, unfreedom of the ugly. The ugly, however, like the [**63**] beautiful, whose negative double it is, can reveal its unfreedom on two sides: on one side, unfreedom that sets a boundary where according to the concept of freedom there should be none; on the other side, unfreedom that removes a boundary that according to the concept of freedom should be there. In the one case it generates meanness, in the other repulsiveness. Finally, the unfreedom that in the way of an apodictic judgement compares itself with its essence, that is with the necessity of freedom, which it inverts into a nuisance,[48] becomes the distortion of

[48] *Unwesen*, nuisance, means etymologically 'non-essence'. The analogy with apodictic or self-evident judgements like 'this is a sentence' remains sketchy here, but it seems that the positing of an ideal ugliness in caricature implicitly posits beauty as the true ideal.

freedom and beauty, caricature. In its origin this is ugly, for in both form and content, it is the explicit contradiction of freedom and beauty with itself. But in caricature the determinate reflection of its prototype breaks again the power of ugliness; it can turn back relatively to freedom and beauty, for it recalls not only the ideal that it contradicts, but can indeed do this with a certain self-satisfaction, that in the appearance of the positive contentment of absolute nullity with itself becomes comical.

The opposite of the sublime is thus the mean; that of the pleasant the repulsive; that of the beautiful caricature. This last concept is in any case a very sweeping one, for we use it, since it concentrates in itself all inflections of the ugly, almost synonymously with the ugly as generic concept, and rightly oppose caricature to the ideal, which is inverted in it. Due to this determinate connection to the beautiful, the comical is capable of passing into the beautiful, running through all the tonalities of appearance, for there are flat [64] and deep, cheerful and grim, mean and sublime, ghastly and charming, ridiculous and terrible caricatures. But however they may be determined in themselves, they also always point through themselves to their positive background, allowing their opposite to appear immediately together with them. Of every case of ugliness, however, it must be said that in itself it also establishes a connection to that beauty which it negates. The formless for itself provokes form; the incorrect recalls immediately its normal proportion; the mean is mean in that it contradicts the sublime, and the repulsive the pleasant. Caricature, on the other hand, is not only the negation of universal aesthetic determinations, but rather reflects, like a distorting mirror[49] of a sublime, pleasing, or beautiful prototype the qualities and forms of the same, in an individual manner that causes it, as noted, even to appear relatively beautiful, and in its lost state to bring about an even more energetic effect. Take. for example, Cervantes's *Don Quixote.* The noble Manchego is a dreamer, who thanks to an artificial, pathological effort manages to pose as a medieval knight, after the entire environment has already worked itself out of this state and set itself in contradiction with such an adventurous mode of acting. Already, giants, castles, and sorcerers do not exist; the police have already taken on a part of the knightly duties; the state has already made itself the lawful protector of widows, orphans, and the innocent; individual force and courage have already become indifferent qualities, faced with the violence of firearms. Nevertheless, Don Quixote acts as if all this did not yet exist, embroils himself thus necessarily in a thousand conflicts and turns through them into a [65] caricature, for they reveal the inevitable helplessness of his conduct that much more, the more he reaches out for justification and support of his ways to the glorious models of an Amadis of Gallia, a Lisuarte or others called by similar circumstances. The real presuppositions under which these flowers of knighthood acted are precisely no longer there, and the fiction of their existence falsifies the worldview of our Hidalgo all the way to madness. Only, this fool really possesses in his fantasy world all the qualities of a real knight. He is brave, generous, compassionate, ready to help, a friend of the

[49] The word *Zerrbild* was introduced in 1789 by J.H. Campe as a Germanic neologism for caricature, which, however, soon gained the ascendancy; Grimm records a sense of a 'distorting mirror' as having stuck. We alternate between the more general 'distorted image' and the metaphorical 'distorting mirror', but keep in mind that no actual mirrors are discussed.

oppressed, in love, faithful, a believer in miracles, addicted to adventure. In his subjective virtues we must admire him and hear with pleasure the poetry of his speech, as it overflows with philanthropic sublimity. In the Middle Ages he would have been a worthy comrade of King Arthur's Round Table, a dangerous rival to all 'errants'. Precisely through his positive elements does he become a more significant caricature, because these attributes, which are excellent in themselves, come out in him as an inversion that annihilates itself, that spends its courage in foggy excitement on a mill taken to be a powerful giant, that frees chain-gang convicts taken as oppressed innocents, that lets a lion out of a cage because it is a kingly beast, that worships a barber's basin as the helmet of the immortal Mambrin, and so on. Having reached this point of the self-destruction of the sublimity of his pathos, we laugh at him; humour erupts from the caricature, moving us even to melancholy. Don Quixote, miserable, thin, mistaken, is never mean or detestable, but he does become [66] formless; his Rocinante is a very incorrect warhorse; his archetype, ideal knighthood, metamorphoses into its distorted reflection precisely through the practical nullity of its method, and yet at the same time, Cervantes has understood the great art of depicting in the fantastic knight and his sensible companion eternal directions of human nature in a general manner; he has understood the art of making this distortion, in which the noblest feelings and attitudes capsize, into a critique of the deficits of civil society—and not simply the Spanish version, in whose centre the lovable Don lives. We must concede to the poet that, despite the state, despite the police, despite the Enlightenment, the voluntary intervention of a strong, good-hearted personality would often be a benefit in these rotten circumstances. This is how big, how manifold, how significant a caricature can become—through genius.

Formlessness

The abstract fundamental definition of all beauty is, as we saw above, unity. As a sensible appearance of the idea, it requires limits, for only in it lies the power of distinction, distinction however being impossible without a unity that detaches itself. All beauty must represent itself as unity, but not simply as a unity closed off from the outside, but much rather it must also distinguish itself in itself and from itself as a unity. The difference, as definite, can lead to rupture;[50] the rupture, however, being the struggle of the unity with itself, must be able through its process to return to unity, even if the empirical course of events does not in fact always get that far. The unity through the creation of its difference and its dissolution makes itself a harmonic unity.

These are lemmas of the metaphysics of beauty. We must recall them, because from them it follows that the ugly as negative beauty: (1) consists in the non-unity, non-closure, indefiniteness of form; (2) that the difference, when it occurs, is produced either as a false irregularity, or as a false equality and inequality; and (3) that instead of the reunion of form with itself, it much rather produces the transition from rupture to a tangle of false contrasts. [68] These different forms of the formless can be labelled in plain language as *shapelessness*, as *non-form* and *disunity*. For scientific technique it will, however, be more comfortable to use Greek expressions that we Germans share with the Romance languages and that through the range of their use possess a greater precision. We can, namely, call the opposite of form, *amorphism*; that of the rational ordering of differences, *asymmetry*, and that of living unity, *disharmony*.

A. Amorphism

Unity in general is beautiful, because it gives us a whole that refers to itself; for this reason, unity is the first prerequisite of all design.

[50] *Entzweiung* (tear, rip, split) is a key term in Hegel, debated by the Young Hegelians. See, e.g. Karl Philipp Fischer, *Speculative Charakteristik und Kritik des Hegel'schen Systems* (Erlangen: Carl Heyder, 1845). Rosenkranz deals with the concept in, e.g., *Kritische Erläuterungen des Hegel'schen Systems* (Königsberg: Gebrüder Bornträger, 1840), 35, 153, 157. We have sought as direct and physical a term as the original.

The opposite of unity as abstract disunity would thus at first be the absence of an outward limit or interior differentiation.

The *absence of limitation* toward the outside is the aesthetic shapelessness of a being. Such boundlessness can be necessary for an essence, as space, time, thinking, willing in itself must be thought of as being without boundary. It first makes itself sensibly felt, however, where according to the concept an external differentiation ought to take place and is not there. Boundlessness in [69] general cannot be called either beautiful or ugly. In comparison with it, however, the bounded is the more beautiful, because it represents a unity that refers to itself, as Plato famously favours the πέρας [*péras*, boundary] over the ἄπειρον [*ápeiron*, unbounded] (* NOTE 17). It is thus in itself not ugly in general, since it in its nothingness offers the possibility of limitation. Since this limitation is not real, however, it is also not beautiful.

From this absolute lack of form we can distinguish that formlessness we call relative, insofar as it indeed has a form, so that unity and limitation are there, this, however, is in itself without any differentiation. Such a form is thus within itself formless through its *non-differentiation*. This lack of distinction becomes boring and drives all the arts to arm themselves against it. Architecture, for example, reaches out for ornament in order to bring about, through zigzags, meanders, rosettes, loops, serrations, egg-and-dart pattern, inward and outward curls, and so on, differences where otherwise the monotony of a simple surface would be present. Bare, undifferentiated identity is in itself not yet positively ugly, but it *becomes* so. The purity of a particular feeling, a particular form, a colour, a sound can even be immediately beautiful. If the same should appear before us again and again without interruption, however, without change or contrast, there results a sad poverty, uniformity, monochromy, monotony. Empty indefiniteness, which might still be the nothing of all design, has already dissolved itself here; out of the still undifferentiated abyss of the possibility of design it has already [70] arrived at a reality and definition of form, colour, sound, image. As it now leaves it at this single defining feature, a different ugliness is generated through the fixation of mere identity. At first we still receive such an impression, definite in itself, with pleasure, since unity and purity, at least when joined with energy, create something gratifying. Should it remain within this abstract unity, however, it would become through its lack of difference ugly and unaesthetic. What Goethe said of life in general, that nothing is harder to bear than a succession of good days, is also true of the aesthetic. That repetitive purism of a single shape and colour, a single tone, and single image that is undifferentiated in itself, and only distinguishes itself against the nothing of outer shapelessness, becomes ugly, indeed unbearable. Green is a pretty colour, but just green, without the blue sky above it, with no twinkling water among it, without a fleecy white flock of sheep on it, without a red tile roof, peeking out between trees, becomes boring. *Le parti des ennuyés* [The party of the bored: the dandies] in Paris was thrilled in 1830, as the rifle fire and the cannon thunder interrupted the monotony of the eternal carriage noises on the boulevard. But as the battle continued on the second day and even as on the third the shooting never seemed to want to end, the same just-unbored persons cry: *Oh, que c'est ennuyant!* [Oh, how boring!]

The unity that is an only-unity thus becomes ugly, because it is in the concept of true unity to differentiate itself from itself. Now shape can in itself confront unity with the difference of its *dissolution*. It can cancel itself out and disappear towards one side, or

indeed as shape in general. Such a **[71]** dissolution can be beautiful, because with it is bound becoming as perishing, thus as a differentiation, even though this differentiation turns into nothingness. What is attractive in this phenomenon consists of the fact that with the form there is present simultaneously the becoming of shapelessness, the pure passage into the other. Imagine a mountain range whose tree-crowned heads dawn dreamily in the perfumed distance. Or if one imagines the foam of a crashing wave, whose spraying, fluttering froth is thrown into the air by the whirlwind with raging cheer, the gradual sinking of the barely formed water columns is beautiful. Or if one imagines a tone that, as tone ever-same, gradually rings out, this ringing out is beautiful. Compared with the dreariness of changeless equality, all movement, even that of perishing, is beautiful. But what is beautiful in these ways becomes ugly if dissolution enters where it should not be, where we had much rather expected the definiteness and closure of shape, where thus shape, instead of attaining itself through such a suspension, is disturbed, weakened and fades. What comes into being then is what we call in art the *nebulistic* and the *undulistic*, the lack of definition, of differentiation, where it ought to be. In epic and dramatic poetry this comes to light through *planlessness* as well; in music we call it euphemistically *wildness*; what is wild can naturally also be beautiful, as in the case of a battle song, but as criticism it refers to formlessness. Wavering and uncertainty of boundaries contradict the concept of shape, and this contradiction is ugly. Resourcelessness and powerlessness hide **[72]** themselves often behind such loose forms and barely suggested outlines. One should not confuse these mollusc-soft, amorphous shapes with the sketch. The real sketch is the first attempt at an execution. It is not yet satisfying, because it is still lacking in execution, but it may still make us feel perfectly the possible beauty, as do the drawings of great painters and sculptors, in its preparatory lineaments. Goethe, in the dialogue *Der Sammler und die Seinigen* [The collector and his circle], has weighed and treated all the distinctions that belong here most finely (*NOTE 18).

The nebulistic is thus not the beautiful perfume wherein a shape can conceal itself; the undulistic not the gentle wavy line in which a form can float; not the muffled tone in which a sound can float away. It is rather the flattening of delimitation, where a decided delimitation would be necessary; the lack of clarity of a distinction, where it should be emphasized; the incomprehensibility of expression, where it ought to be marked. In sculpture and painting it is primarily *symbolic* and *allegorical* forms that seduce one to such a treatment. And even with the best intentions artists are often unable to reach any characteristic definition, when they have to represent such abstractions as *la patrie, la France, le choléra morbus, Paris* and the like.[51] One can be very satisfied when in such a case we are if anything given a beautiful female form. The older Düsseldorf School[52] of painting suffered for a while from such formlessness,

[51] Homeland, France, morbid cholera: the sardonic list is typical of Napoleonic art.
[52] Kliche suggests that Rosenkranz means the Nazarenes, who revived religious painting with allegorical overtones; but they were only dominant at Düsseldorf's Art Academy during the directorship of Peter Cornelius (1819–1824), who was anything but vague. The nickname 'Düsseldorf School' stuck with the directorship of Wilhelm von Schadow (1826–1859), who, beside Nazarene pastiches of Renaissance art, experimented with single symbolic figures, landscapes, and genre scenes that better fit Rosenkranz's criticism.

because through the dominance of a sentimental album manner it was misled over the difference between the painterly and the poetic, and, attaching itself to the poets, [73] it relied too much on these to come to its aid with the explanatory word for its wavering, problematic forms.—In poetry, we very often find after the appearance of great geniuses a period of imitators, in whom shapelessness is rampant. In epic this follows [Friedrich] Schlegel's theory that plot, being the mere fragment of a greater context, may run over into the infinite without inner unity.[53] In lyric, it distinguishes itself usually through the excess of predicates with which it furnishes its subjects. In that one predicate always suppresses the other, this overstuffing generates, instead of the desired rich picture, a completeness that says nothing, that mixes the essential with the inessential. In drama, it renders homage to the so-called dramatic poem, which anyhow abstracts *a priori* from the possibility of being staged, and thus dispenses on principle with real plot, consistency of characters, and plausibility and often contains only a loose series of lyric monologues. Among us Germans, since we do not feel like a nation and as a consequence have no national stage, unfortunately two-thirds of our dramatic productions consist of such theatrically impossible *pure* dramas, and so it is unnecessary to name special offenders here. If Goethe is often blamed for having fathered this beast by composing *Faust*, this is a mistake, for *Faust* withstood the theatrical test dazzlingly in its first part, and the second will withstand it as well if only the required music is composed to accompany it, for it is no less theatrically thought out and operatically fashioned. [74]

Now that we have observed the origin of ugly shapelessness, we must also investigate its passage into the comical. The comic effect is here caused in part by the fact that, instead of the clear difference that one expects, the same keeps returning; in part by the fact that a form, from the beginning of its movement, is suddenly thrown around to another and quite opposite ending.[54] Indefiniteness of design, consisting of the fact that in empty infinity there is as yet none can be neither called positively beautiful nor positively ugly, since *non entis nulla sunt prädicata* [no predicates attach to nothing]. As the still-neutral ground, we can also not call it comical.

The uniform determination of shape, on the other hand, which is found in the unending return of the same phrase, can give rise to a comic effect. Instead of going on to another predicate, it keeps on falling into the same. A simply endless extension of identity would bore us. Even if we should at first laugh over it, it would soon repel us and become ugly, an experience we have with bad comedies, when the author's inadequacy puts into a person's mouth some tasteless mode of speech which, being applied everywhere *à tort et à travers* [far and wide], stimulates us a few times to dry laughter, but soon uses itself up and makes the most miserable impression of mindlessness wishing to be witty. The real artist knows how to use the comic effect of repetition (by which of course I don't mean the refrain, which follows other laws), as for example Aristophanes in the *Frogs*, where, to prove the wretchedness of Euripides' prologues

[53] For example, in the famous 'Über das Studium der griechischen Poesie' [1795–1796], in *Fried. v. Schlegel's sämmtliche Werke*, 2nd edn, vol. 5 (Vienna: Ignaz Klang, 1846), 97: 'A plot is only completed in time; therefore the visual artist can represent no complete plot.' The theme is Lessingian, but Schlegel characteristically exaggerates it into a fragment-theory.

[54] See the following discussion (R 76) for some concrete examples of such inversion.

[75], he gets Aeschylus to append to all opening trimeters a word like ram's-wool, ointment-jar, or nosebag, making them ridiculous in the process. One expects here after every opening a different continuation, but to each the pitiless Aeschylus appends the annihilating ointment-jar. Droysen [*Aristophanes Werke*, Berlin: Veit, 1838] has translated freely: 'fell flat with the old lyre', which does identify the intent, but in reality is only an abstract pronouncement of Aristophanes' desired result. After Voss, vol. 3, 185ff:

> Euripides:
> Aegyptos, as all around expands the call,
> With his fifty sons, through rudder turns,
> Steering for Argos —

>> Aeschylus:
>> — broke in two his ointment-jar.
> — — — — — —

> Euripides:
> Dionysus who with thyrsus and beautifully spotted
> Stag skin decorated, in torchlight through Parnassus' grove
> Hops up in a circle dance—

>> Aeschylus:
>> — broke in two his ointment-jar.
> — — — — — —

> Euripides:
> There is no man alive anywhere who in all things is happy:
> For whether of noble origins, he lacks the good;
> Whether of low parentage, —

>> Aeschylus:
>> — broke in two his ointment-jar.
> — — — — — —

[76]
> Euripides:
> Cadmus, once having sailed away from Sidon's high castle,
> The son of Agenor —

>> Aeschylus:
>> — broke in two his ointment-jar.
>> etc. etc.

The constant appending of a changed form, and the constant fall back into the form that explicitly has already been, is the *via comica* here, of which farce knows how to

make a happy and strong use, as one can see in any tomfoolery[55] of acrobats and riding teams. Shapelessness can also consist in a transition to the positive opposite of the initial design. It announces to us a form, but instead of the expected, the opposite appears, a dissolution of the original form into an opposite ending. Naturally, this will also have some form, but in relation to the first, this form will be its destruction. For instance, the Bajazzo [clown] takes a gigantic head-start to jump over a *barrière*. We already see, anticipated in our fantasy, the daring leap, just as he, right before the goal, restrains himself suddenly and calmly ducks under it or turns aside with a saunter. We laugh because he has deceived us. We laugh because the perfect opposition of great intensity of movement and phlegmatic peace surprises us. Or say that the Bajazzo tries to learn horse riding. He plays stupid. Tediously one shows him what he has to do and convinces him to mount. Finally he swings onto the horse, but—backward, so that he takes hold of the tail instead of the reins, and so on. The art of the conjurer too [77] is able to entertain us supremely in this fashion, for it knows how to enchant something out of nothing. Common sense tells itself that nothing can come out of nothing, and still despite it we see the magician take bouquet after bouquet out of an empty hat. We gape, but we laugh, because our common sense, even in being so publicly contradicted, still tells itself silently that it is right after all. The very contradiction of being self-consciously duped thrills us.—Also the passage of a drunk from speech to sheer slurring, to inarticulate sounds, the reflex of confusion in which intelligence sinks, can be comic to a certain degree. The actor Gern der Sohn[56] in Berlin could with mastery and unfailing effect bring out these form-seeking, humming, squeaking, gurgling, meowing tones, with the occasional word fragment interspersed.

B. Asymmetry

Amorphism is simply the total indefiniteness of shape. This cancels itself in the unity of a shape, which, however, is lacking in difference within itself, so that it is shapeless through a lack of differentiation in itself. Or the difference appears in the shape, but in such a way that it consists in its dissolution.

The unity of a shape can repeat itself in simple differences; it can extend itself according to a certain rule. [78] This is regularity. But between regularity and unity there still lies the immediate being-otherwise of existences, *differentness*, whose colourful multiplicity can be very enjoyable aesthetically. For this reason, all art strives quite instinctively for variety, so as to interrupt the sameness of formal unity. This multiplicity, which in itself has a pleasant effect when opposed to abstract identity, falls into ugliness whenever it becomes the sterile confusion of the most disparate existences.[57] If out of the

[55] Hanswurst, literally Hans-sausage, is a traditional figure in travelling comedy troupes in Germany.

[56] Albert Leopold Gern (1789–1869), called 'the son' (i.e., Jr.) to distinguish him from his father, Johann Georg Gern (1757–1830), 'the father' with whom he often played.

[57] *Existenzen*, plural of 'existence' means existents or existing things. Cf. Rosenkranz, *Hegel als deutscher Nationalphilosoph*, p. 103: 'In natural religion, spirit still sees the absolute in natural existences, in the essence of light, in the plant, in the animal . . .'

mass of the same a certain grouping does not arise again, it soon irritates us. Art thus concerns itself early on with mastering the chaotic, whose diversity falls apart so easily, through abstraction of *the same relations*. We have already had occasion to point out how popular taste in the visual arts early on made efforts to enliven the emptiness of a large surface. At first this taste helps itself to forms that are little more than loops and points, colourful lines and flecks; but soon thereafter it begins to organize this material. The rectangle, the zigzag, the leaf tendril, the dentil, the braided band, the rosette, become the fundamental forms of all ornamentation, which still exercises our tapestries and carpets.

Ugliness in diversity thus lies in the lack of a commonsensical connection that can bring together the pullulating fullness of its individual elements to some relative formation. Only from the point of view of the comical can lawless commotion once again become satisfying. Ordinary reality swarms with *confusions* that would insult us aesthetically, did they not, [79] fortunately, make us laugh instead. We peer at them through the eye of a Jean Paul or of Dickens's Boz and they immediately gain in comic appeal. We cannot cross the street without finding ceaseless material for such humoresque observations. There we are met by a furniture waggon on which sofas, tables, kitchenware, beds, paintings have ended up in a proximity that, by their usual distribution, would be thought impossible. Or that house over there shows us in its ground floor a smart shoemaker, above it in the parterre a cigar store with attendant beer hall, above it a Parisian tailor and far above in the attic an Oriental flower painter. How stimulating is this disorder thrown together by chance! Or we step into a book shop and see on the display table classics, cookbooks, children's texts, brochures raging one against the other, jostling in the comical combinations of the kind that a Washington Irving or Gutzkow could dream of in one of their satirical moods.[58] As for the junk! What a master of humour he is in the innocence with which he [presumably Irving or Gutzkow] mixes up yellowed family portraits and moth-eaten furs, old books and night stools, sabres and kitchen brooms, suitcases and bugles![59] Markets, inns, battlefields and post coaches swarm with such improvizations of whimsical confusion. The heterogeneity of manifold existences in contact changes the usual value of things through the connections imposed on them for our view.[60] Chance can indeed be very prosaic and mindless, but it can also be very poetic and witty. Things that otherwise lie far apart [80] and which might be thought profane in each other's company find themselves brought into surprising proximity by chance. The moderns have cultivated

[58] On Rosenkranz's enthusiasm for the scatological realism of Karl Gutzkow, see Olaf Briese, 'Biedermeierliche Vermittlung. Karl Rosenkranz "Aesthetik des Häßlichen"', in Briese, *Konkurrenzen: Philosophische Kultur in Deutschland 1830–1850. Porträts und Profile* (Würzburg: Königshausen & Neumann, 1998), 54–64. Rosenkranz read Irving in German translation, since he spells him *Irwing*, as do the translations by H.S. Spiker published by Duncker & Humblot in Berlin in 1825. Spiker appended Irving's name to the pseudonymous *Sketch Book of Geoffrey Crayon, Gent* (1819, *Gottfried Crayon's Skizzenbuch*) and *Tales of a Traveller* (*Erzählungen eines Reisenden*) of 1824.
[59] Night stool is one of several euphemisms (close stool, necessary stool, convenience, night commode, toilet chair) for the furniture enclosing a chamber pot. *Schleppsäbel*, literally dragging or hanging sabres, refers to the impractical trailing belts and sheaths of military pomp.
[60] This account of juxtaposition should be compared with Roland Barthes' 'L'Effet de Réel', *Communications* 11 (1968), 84–9. A source Rosenkranz may have read is Edgar Allan Poe's story 'The Assignation' (1834), which links such disparities to the sublime.

this *quodlibetarian* wit very widely and often very felicitously;[61] the great empirical fullness of a contemporary consciousness has made it possible to produce innumerable connections, which in their accidental togetherness delight us in their mutual reflection. The British islanders, sea-ploughing London, the Elizabethan era, Shakespeare's world-imagination have excited this play of fantasy most of all. Hogarth introduced this into painting, and despite the aptness, particularly physiognomic, of his character studies, [his art is] not entirely innocent of a certain premeditation, betraying an exaggerated, intrusive anxiety lest some aspect of his calculation be overlooked. In more recent poetic literature, this manner has been the province especially of the humoristic novelists, who are not just comfortable with it, but have driven it, through affectation, to the point of absurdity. A plain muddle of images is ugly. Some of our forced humorists are often no better than the patients in insane asylums who suffer from free association.[62]

Free multiplicity is beautiful, insofar as it embraces a certain sense of grouping. If we think of the tendency to order diversity as abstract, self-repeating unit in the multiple, we arrive at the concept of the *regular*, that is, the renewal of diversity according to a fixed rule, which binds its loose differences. Thus the equal time intervals of rhythm, the equal distance between the trees of an **[81]** *allée*, the equal dimensions of the similar parts of a building, the return of the refrain in a song, and so on. Such *regularity* is beautiful in itself, but it satisfies only the needs of abstract common sense, and is on its way to *becoming ugly* as soon as an aesthetic formation limits itself to it, offering nothing else that might express an idea. Regularity tires through its *stereotypical sameness*, which presents to us difference always in the same manner, so that we long to get out of its *uniformity* and into freedom, even if *in extremis* it is a chaotic freedom. Tieck in the introduction of his *Phantasus* defended the Dutch manner of gardening from this perspective, saying that with its flower beds [*plates-bandes*, in German, *Rabatten*] enclosed by hedge-walls, shorn trees and boxwood, it is very conducive to the conversation of strollers.[63] Where sociability is its own goal, in a brilliant court, these broad, sand-strewn paths, these green walls, these trees marching in parade step, these grotto-like *bosquets* are just right.[64] This manner was in fact brought to perfection by Lenôtre under Louis the Great.[65] He was then copied by the imitators in Schönbrunn,

[61] A *quodlibet* is a musical composition containing superimposed melodies not originally meant to appear together. Beloved from the medieval motet to Bach and Mozart, this form of musical wit made a comeback in Biedermeier, particularly in the Viennese farces of Johann Nestroy, which feature servants and masters harmonizing unwittingly.

[62] *Gedankenflucht* is 'flight of ideas', a term still used for excessive, disorganized speech.

[63] Ludwig Tieck, ed., *Phantasus: Eine Sammlung von Mährchen, Erzählungen, Schauspielen und Novellas* [A collection of fairy tales, stories, plays, and novellas] (Berlin: Realschulbuchhandlung, 1812–17), vol. 1, 65.

[64] A *bosquet* is a formal planting of trees in close, parallel rows, creating the impression of an orderly wood (hence the French Renaissance word, derived from Italian *bosco*, forest).

[65] André Le Nôtre, chief gardener of King Louis XIV of France, famous for the garden of Versailles and the Tuileries (he laid the groundwork for the Champs-Élysées), as well as divine formal gardens like Saint-Cloud and Sceaux, parks on the outskirts of Paris which Rosenkranz likely saw in summer 1846. See Rosenkranz, *Magdeburg*, 24.

Kassel, Schwetzingen, and so on.[66] Nature is not meant to appear here in its free natural vigour, but rather confine itself in the presence of majesty, presenting itself as on its best behaviour, an airy salon in which silk robes and golden uniforms swish by. But in small dimensions and without serving as the stage for court actions, between cubic hedges and trees, which shears have cut down to spheres and pyramids, [82] we are overcome by a feeling of force and precise measure, in whose dreariness we long for the irregularity of an English garden or, better still, a wild wood.

We find ourselves here in the middle of nothing but dialectical determinations. A simple articulation and stipulation of the conditions are insufficient; they merge into one another. As one moment, regularity is warranted and can be beautiful; as absolute rule, in which the aesthetic object is realized, it can become ugly. One cannot, however, conclude that the opposite of regularity, irregularity, must be beautiful in every case. It can be, in the right conditions; put in the wrong place or allowed to degenerate into confusion, thus it too will become ugly. A nice example of stimulating irregularity in the architectonic field is the Château Meilhant in the Department Cher, built with no symmetry in a kind of Renaissance style (* NOTE 19). In the representation of that careless irregularity we *par excellence* call *negligée*, and in which servant girls tend to appear more attractive than their mistresses, the poets and painters have been successful enough that no examples are needed on my part. During the past century, ostensibly in imitation of Hebrew poetry, ancient chorus, the lays of the Scalds and Ossian, free rhythmic song came to Germany, emancipating itself in its irregular wildness from metric closure. Some of it was splendid, above all some of Klopstock's bardic poems and some of Goethe's compositions. Yet how miserably this irregularity failed in some others, who moved not just in a barrage of hollow words, but in entirely arrhythmic, unmusical, stumbling masses of sound. [83]

Regularity, like irregularity, may for this very reason become comic through its juxtaposition. The former becomes so e.g. in pedantry, the second in ridiculing it. Pedantry would like to tie up life in its rules, and would not even allow a thunderstorm to arrive at any but the opportune time to pay its courtesy visit. Because its compulsion is an impractical and self-willed one, it becomes comical, and the irregularity with which a mischievous sprite disturbs his painstakingly drawn circles, becomes comical as the justified mockery of such foolishness, which undertakes to handle life, against its concept, as a machine.

Should unity be joined with difference, this may happen so, that a shape is repeated, but in this repetition it is *turned around* to form an *inversion*. The repetition of a shape is the *equality* of regularity; the reversal of an order is the *inequality* of irregularity. This form of the equality that is nevertheless identical in inequality is real *symmetry*. Thus the ancients showed the two Dioscuri in beautiful symmetry, each holding a rearing horse, one with the left, the other with the right hand; the one stepping forward with the left, the other with the right foot; the heads of the horses turned inward, or outward. On

[66] Schönbrunn in Vienna was in fact designed by a student of Le Nôtre, Jean Trehet. But the Bergpark in Kassel's Wilhelmshöhe and the garden of Schwetzingen Castle in Baden-Württemburg are original attempts to compete with the French paradigm. Schwetzingen's ponds especially recall English gardens and their Orientalism: there is even a 'mosque'.

both sides the same is present and yet it is different; it is not a mere other, but rather the one is the reverse of the other and thus a relation to the same thing. Symmetry thus represents not a simple unity, not a simple plurality or a simple difference; not a simple regularity or irregularity [84], but a unity that in its equality contains inequality. Despite this, symmetry is not yet the perfection of form; the higher formation of beauty orders it under *itself* as well as only a moment, which, under certain circumstances, it exceeds.— Should symmetry *fail*, where we are right to expect it, such a deficit injures us, at least, for instance, if it was already present and has been destroyed, or if it is advertised and not carried out. Symmetry, taken abstractly, is only equilibrium in general; more precisely it is an equilibrium which contains oppositions of up and down, right and left, large and small, high and deep, light and dark; or more precisely still, one that in the repetition of the same comprises the reversal of position, which we call nothing but inversion, as the eyes, ears, hands, and feet of the human organism, in this manner symmetrical, stand to one another. The doubling of the same may be related to a *point that is the same for both sides,* as are window positions in relation to a door; or two semi-circles of columns in relation to two passages which intersect them; or in a distich the rising and falling half of the pentameter in relation to the hexameter, and so on.[67] All of these are symmetric orderings, which we specify in sculpture, painting, music, the art of dance, and poetry on the basis of the peculiar content of these arts. Should symmetry be negated in such cases, a *disproportion* that is ugly results.

If symmetry is missing in general, if it is not there at all, its *absence* in such a case is more tolerable than a positive injury would be.—If in an essentially [85] symmetrical relation, one side of the same is missing, the existence of symmetry therein is *incomplete.* There our fantasy functions as a supplement, adding in imagination the missing side from that already present, so that this *half-symmetry* remains just tolerable as conceptually existent, though not carried out in reality. We feel this of many Gothic churches of which often only one tower was built, whereas the other is missing altogether or only made it to the lower storeys. In overlooking the façade with the towers, the missing tower is an obvious aesthetic defect, for, in the design of the building, it should be there. But since it belongs to the concept of the tower as a structure that advances a claim of sublimity that it may stand by itself, we tolerate the fault rather easily, and we complete it as well, if it is conspicuous, in our imagination.— Should symmetry be fully there, but with *inconsistencies* in its very fabric, our fantasy is deprived of its room to play, for we are obstructed by something positive. We cannot then put something else in the place of the given, completing the present ideally and idealistically;[68] on the

[67] A distich (German *Distichon,* from Greek *distikhos*) is a self-contained couplet, used in elegy and other epigrammatic poetry. Rosenkranz has classical usage in mind, consisting of a hexameter followed by a pentameter, not the isometric, rhyming modern form. See T.V.F Brogan's entries in *The Princeton Encyclopedia of Poetry and Poetics,* ed. Roland Greene and Stephen Cushman (Princeton, NJ: Princeton University Press, 2012), 370, 396.
[68] See the discussion of 'idea' in the editors' Introduction. Rosenkranz's *System* presents both idealism and materialism as legitimate but one-sided approaches to the *ideal* (idea-based) nature of the world, which consists of the fusion of concept and reality. None of this, he is saying here, matters when faced with real asymmetry: we cannot correct the flaw mentally or logically, because it is the flawed material object we are concerned with.

contrary, we must submit to the empirically existent, and take it as it is. Equality can be there in a perverse rather than an inverse way. What offers itself is then not the symmetrical, symphonic correlate, but rather the same, which should correspond, presents itself in a qualitatively different way. Let us imagine, for instance, that a Gothic church, according to the original plan, ought to have had two towers, that only one of them [86] was carried out at first, that later a second tower, only in a different style, was added: symmetry would surely be there, for there should indeed be two towers, but present at the same time in a way inconsistent with the concept of the whole, contradicting it rather qualitatively. In theatre, through shortcomings of costume, asymmetries of this form can often be very funny.— Or symmetry may be a qualitative match for the unity of the shape, but transgress against *quantitative* equilibrium, a formlessness that is also ugly. In the visual arts very many mistakes of this kind are made. Conceptually, of two parallel towers, one should not be taller than the other; of two wings of a building, one should not be longer than the other; of two rows of windows divided by a door, the number of windows of one should not exceed the other; a statue not have one arm longer than the other, and so on. *Cripples* represent for us this lack of symmetry, as, for instance, when an arm or foot is shrunken or crooked.

Asymmetry is not simply shapelessness, it is definite non-shape. Byron, in a fantastic drama, *The Deformed Transformed*, has portrayed the agonies of a strong-spirited hunchback.[69] After even the mother has spurned him, Byron lets him seek his death, and at this moment he is interrupted by a mysterious stranger, who offers him as a present any other form, saying:

Were I to taunt a buffalo with this
Cloven foot[70] of thine, or the swift dromedary
With thy sublime of humps, the animals
Would revel in the compliment. And yet [87]
Both beings are more swift, more strong, more mighty
In action and endurance than thyself,
And all the fierce and fair of the same kind
With thee. Thy form is natural: 'twas only
Nature's mistaken largess to bestow
The gifts which are of others upon man.

But Arnold, as the deformed is called, feels the whole weight of beauty. He says further on:

[69] Rosenkranz gives the title erroneously as *the transformed disformed*. His quotations are from 'Der umgestaltete Ungestalte', trans. A. Hungari, in *Lord Byron's Sämmtliche Werke*, ed. Johann Valentin Adrian (Frankfurt am Main: Sauerländer, 1831), 364, 375–6. There is a rival edition of *Lord Byron's Sämmtliche Werke* (Stuttgart: Hoffmann, 1839), Vol. 5 of which renders the play under the title 'Der Verwandelte' [The Transformed]. We give Byron's original, noting minor deviations in Rosenkranz's version (italics are his).

[70] Rosenkranz (Hungari ed.) has *Klumpfuß*, clubfoot, Byron's own deformity. This spoils the buffalo image, but is in keeping with Thomas Moore's popular interpretation of the play as autobiographical: see John Golt, *The Life of Lord Byron* (London: Henry Colburn and Richard Bentley, 1832), 34, 251.

I ask not
For Valour, since *Deformity is daring.*[71]
It is its essence to o'ertake mankind
 By heart and soul, and make itself the equal—
Aye, the superior of the rest.

Because ugliness in its negativity is something positive, it feels itself *alone* and this feeling is its greatest pain. Arnold says:

Had no Power presented me
The possibility of change, I would
Have done the best which Spirit may, to make
 Its way, with all Deformity's dull, deadly,[72]
Discouraging weight upon me, like a mountain,
In feeling, on my heart as on my shoulders—
A hateful and unsightly molehill to
The eyes of happier man. I would have looked
On beauty in that sex which is the type
Of all we know or dream of beautiful
Beyond the world they brighten, with a sigh—
Not of love but despair; nor sought to win;
Though to a heart all love, what could not love me
In turn, because of this vile crooked clog
Which makes me lonely.

[88] So bleak is the pain of the deformed. Despite this, it can be a great means for humour. Though in the absence of symmetry there is as yet nothing comic, confusion already gives rise to it, because in it one shape displaces and erases another. In half-symmetry also, the impulse to a realization that is not achieved has a comic veneer, quite irrespective of content. Positive asymmetry, on the other hand, which in its congruence is not congruent, which in the equality of its parts is nevertheless unequal, this asymmetrical symmetry is in fact already funny in itself, insofar as the ridiculous is the contradiction of the impossible as something empirically real, possessed of the reality which correspondence with a concept demands. Indeed, it is true that, in accordance with the concept, it should be impossible for an arm to be longer than its counterpart; but should one in fact be longer than the other, a reality which should not be, one that contradicts the concept, is real, and this contradiction is funny—just like, with regard to the feet, a limp has something funny about it. The comic makes use of human activities that result in a bending or apparent shortening of the arm, representing the writer, tailor, cobbler, carpenter and so forth in their comical movements.

[71] Rosenkranz (Hungari ed.) has *Häßlichkeit ist kühn*, 'ugliness is bold'.
[72] Rosenkranz (Hungari ed.) has instead of 'Deformity', *Scheusal*, literally 'monster'.

A particularly beloved comic quality arises in drama in the comic sequence of a side plot that is symmetrically opposed to the tragic sequence of the main plot. All positive processes of the serious sphere are repeated in the nullity of the comic, and the effect of their pathos rises through this parallelism. In the English theatre, but above all in the Spanish, [89] this manner rules. Shakespeare has kept it out of high tragedy, but Calderón, since he has nothing but moral-conventional exercises to solve, applies it almost everywhere. Even in a theological drama like the *Magico prodigioso* [The Wondrous Magican], he allows the tragic development to be reflected in the foil of humour.

The same determinations of asymmetry we call ugly, addressed to a positive character, become comical, if the pretention is only an appearance. We need not follow humour any further here, where we are occupied with the ugly, and its dissolution into the ridiculous only needs be suggested. We do have to show, however, how asymmetry through *false contrast*, the antagonistic lever of symmetry, turns into disharmony. In symmetry, as in asymmetry, the relation of the inverse members is in general a restful one. But if the opposition turns into tension, this relation turns to contrast. This is, as is well known, one of the most excellent aesthetic means. Qualitatively it can only consist of intrinsically contradictory determinations, quantitatively it may have many degrees, be weak and strong, dull and glaring. The specific conditions explain which contrast is necessary in a given case. For one and the same being, different contradictions are possible according to its different aspects; but each has also by virtue of its peculiarity an absolute contradiction in itself, which contains its total negation; as absolute contradiction to life stands death, to death life, to truth the lie, to the lie truth, to beauty ugliness, to ugliness beauty, and so on. To life, on the other hand, illness, to truth error, [90] to beauty the comic stand only as relative contradictions, and for that reason these determinations have yet others as their absolute contradiction in itself.[73] Illness is indeed a constraint and diminution of life; and contradicts it insofar as life according to its concept ought to be healthy; the absolute contradiction of illness is therefore, in life, health. So is error absolutely opposed to objective certainty; the comic to the tragic. Thanks to such distinctions it becomes possible to contrast determinations also that do not in themselves, be it relatively or absolutely, stand in contradiction with one another, but between which a contradiction can only be *concocted* and presented one time as absolute, another as a relative. Taken formally, the absolute may end up in contradiction

[73] The phrase translated in this passage as 'contradiction in itself', *Widerspruch an sich*, with or without an 'absolute' appended, appears to be of Hegelian vintage, but not used precisely in Hegel's manner: There, in the second book of his *Logic*, we read: 'The difference in general is already the contradiction *in itself* [*an sich*, emphasis Hegel's]; for it is the *Unity* of such, as are, only insofar they are not *one*— and the *separation* of such, that are only separated *in the very same relation*.' *Georg Wilhelm Friedrich Hegels Werke: Wissenschaft der Logik*, 2nd edn (Berlin: Duncker und Humblot, 1841), 56 (Bk.2, Pt.1, Ch.2, C). This seems to mean nothing more than that a sentence like 'Blue is not green' contains two distinct things (*unifies* what is not *one*) and makes *one* statement of their difference. Rosenkranz means nothing so ponderous, but only that absolute opposites are equivalent to the negation of their opposite. Thus, death is identical to non-life, and non-beauty is identical to ugliness, though some have doubted this (e.g., Frege).

with the absolute, but also with the relative, and the relative with another relative. Concretely such conditions can wear a variety of expressions.

This is not the place to investigate these general concepts, some of which belong directly to metaphysics and logic, and others especially to a metaphysics of aesthetics. We only have to recall them to the extent necessary to distinguish the false contrast as ugly from the apt contrast as beautiful. False contrast comes into being whenever, instead of the opposition which should be posited, the merely different appears; for this is only an indistinct difference, which is as yet incapable of any tension. The colourful multiplicity of the different can be perfectly justified aesthetically; but if it is offered where a contrast should be set to work, it remains inadequate. All difference, [91] however it is heaped up, is unable to replace the interest stirred in us by a precise opposition. When in a novel a crowd of persons is presented, when an abundance of incidents is developed, when, however, no contrasting of the actors and their destinies cuts through the mass of situations, the multiplicity tires us soon, if it does not in the end disgust us. Or if a painting flaunts a great many colours, but there is no decided colour contrast, our eye is soon numbed by the sheer jumble. With no injury to the charms of multifariousness, opposition may assert itself very well out of it.

Positive and negative opposition first produces a contrast. In other words, *sameness* must come to *differ from itself* and this may progress to conflict and collision. What is distinguished must then in some way be identical all the same; it must through its unity stand in mutuality with itself. The more it presents itself as something *interdependent*, the more beautiful it is. Should, however, a distinct difference appear, and on one side instead of the identical negative only something different be placed, something indeed capable of a relation, but not an immanent one, the result is purely something *different*. So, for example, in the opera *Robert le diable*,[74] the devil is only distinct from his son, for as devil he should hate him, only this 'Stranger' loves the son, against the nature of the devil, but according to the nature of the father; that is to say, with the love for the son, the idea of the diabolical is cancelled out. He cannot contrast with the good, though he always should; a sentimental devil is ridiculous. It is a *failed* contrast. The place of the opposition that should be [92] is taken by mere difference. This contrast is not just dull, it is exhausted.

Contrast as ugly is also, however, produced whenever opposition outpaces tension. We call this form of contrasting sides *straining after effect*. This art puts no trust in simple truth, but raises to an extreme so as to goad mind and feeling. It wants to force an effect at any cost and cannot allow the one who enjoys any freedom. He should and must be overcome, and for his defeat—for a victory for art would be the wrong expression here—contrast is the chief means. But the worry that it might be overlooked or overheard by a satiated and desensitized race leads to renewed efforts, as one would say today, to *grab*. Contrast becomes *glaring, garish*. The limit of natural truth is crossed

[74] Giacomo Meyerbeer's (1831) grand opera *Robert le diable*, written by Eugène Scribe and Germain Delavigne, with its ballet of undead nuns (see Edgar Degas' 1876 painting in the Victoria and Albert Museum) was a first in many respects: e.g., *en pointe* dancing by soloist Marie Taglioni and the use of gas footlights for the ballet. The run ended in 1893.

giddily, so as to excite our nerves infallibly through overexcitement (*surexcitation*).[75] Design of this kind in art, such as it disfigures our modern music, is ugly. Voltaire traded in this non-taste in adapting Shakespeare's *Julius Caesar* for the French stage. It was not enough for him that Brutus as a Republican contrasted with Caesar, the consul and dictator who sought sole power; he made Brutus into Caesar's son; he let both of them know it; he amplified the murder of a political opponent to patricide and, to crown his work, left out the Battle of Philippi, wherein Caesar's ghost comes into its world-historical right against Brutus.

The true contrast, we said, contains opposition as the non-identity of the same.[76] So red and [93] green are identical in being coloured;[77] white and black in being colourless; good and evil in their freedom; rigid and liquid in being matter, and so on. False contrast, on the other hand, starts from qualitative generality and brings *apparently* opposed things, such as when to the large is opposed not the small or another large thing, but only the slight or the weak. For to the slight stands opposed the significant, the distinguished, the dignified, and to the weak the strong, the powerful. That such forms also have a certain affinity, in that they can become synonyms for one another, explains also why a mishandling can slip by even the best artists. Our modern lyric poetry, following the linguistic direction given to it by the polished, facetted brilliance of Anastasius Grün, has brought forth many such hybrid contrasts. One can, however, find their origin in Grün himself, and indeed in his best poems. Such fabrications have crept even into the fine, rightly beloved poem *Der letzte Dichter* [The Last Poet], for instance:

As long as the wood still rustles
And someone tired cools.[78]

To tiredness rest stands opposed, to the cool the burning. Tiredness and cooling do not fit together. The rustling, with which the wood is introduced, contrasts with the silence of the treeless plain or else with its own. One sees that Grün wanted here to sum up much. The forest should provide one tired by the heat of the open plain with coolness, fanned by the rustling of its twigs; only this idea is imperfectly expressed. [94]

The glaring contrast on the other hand increases tension through means that turn the legitimate, present tension aside, opening the path to another interest, and distracting us in the process from the substantial connection, instead of strengthening

[75] Rosenkranz gives in parenthesis the French term, likely from Adrien Joseph Gaussail, *De L'influence de l'hérédité sur la production de la surexcitation nerveuse, sur les maladies qui en résultent, et des moyens de les guérir* (Paris: Germer-Baillière, 1845).

[76] Rosenkranz's terms, *Ungleichheit des Gleichen*, as on p. 91, suggest a second meaning, 'the inequality of the equal', which he would not distinguish from that we gave in the text, since he takes identity and equality as the same relation.

[77] Rosenkranz says literally 'in colour' (*in der Farbe*), etc., but he does not mean these obvious absurdities. Rather this is the Hegelian strategy for finding 'real' contradictions by calling objects that share an attribute identical *in that respect*, then pointing out how else they differ. The antidote is to insist that identity is not a relative concept.

[78] 'So lang der Wald noch rauschet / Und einen Müden kühlt.'

this as intended. *Mole ruit sua*—it collapses under its own weight—one can say of its effect. When Brutus vows Caesar's death, because he wants to hold on to the republic as the necessary form of the Roman state, we are thus presented with the whole, great political crisis of the time. Brutus has to sacrifice his affection, his personal sympathy for Caesar, in order to remain true to his duty to the fatherland—as the first Brutus had to sacrifice his sons to the republic when they sided with the Tarquins. When Voltaire, however, makes Brutus into Caesar's son, he thus becomes a virtuous monster; a breach of reverence of this sort is so horrid in itself that it suffices to freeze our blood. For there are two elements here that demand our allegiance: Roman civic virtue and filial piety. In Shakespeare this piety is not lacking in Brutus, and must make his decision to murder Caesar difficult; only it does not necessarily deter in Brutus the conspirator, and the chief accent remains on the political.

Glaring contrast can under certain conditions become aesthetically beautiful; but it becomes ugly, when it is not borne by the unity of the self-same. Such a transcendence of the homogeneous basis is meant to make it *piquant*; the piquant is the virtuosity that corrupts all genuine art in Scribe and Sue.[79] The grand *opéra* in Paris is only ruled by the attempt to be new through the synthesis of *heterogeneous opposites*. The [95] impossiblity of this occupies reason through its untruth and surprises the imagination— not with the naïveté of the fairy tale, whose childlike inexperience still plays with the limits of the possible, but with the refinement of jaded lunacy. We have already cited Bertram from Scribe and Delavigne's *Robert the Devil* to show that the same fails to represent a real contrast to his son; he also does not contrast to Alice, for she is 'a young girl from Normandy' and no demon, as he is; but the *piquant* is supposed to be precisely that the devil has a son whom he loves tenderly and whom, because he loves him, he wishes to make into a comrade in hell. This love makes him sing, for instance in Act III No. 9 (following the standard translation of Theodor Hell) thus:

O my son, o Robert! For you,
The greatest of goods for me,
I defy even heaven,
I defy even hell.—
For the fame, now gone away,
For the lustre, faded today,
You were my only solace,
Through you I found peace![80]

[79] Eugène Scribe, as mentioned, was Meyerbeer's librettist for *Robert le diable*, for whom he also wrote the hit *Les Huguenots*; he also wrote for Rossini, Donizetti, and even Verdi (*Les Vêpres siciliennes*, 1855). Eugène Sue, who will reappear, was a kind of prolix French Dickens, famous for the serial novels *Les Mystères de Paris* and *Le Juif errant* (1842–1845), which fascinated the avant-garde, e.g. Isidore Ducasse in *Chants de Maldoror*.
[80] Rosenkranz erroneously says 'scene 9', otherwise his text is that of *Robert der Teufel, Nach dem Französischen des Scribe und Delavigne von Theodor Hell, Musik von Meyerbeer* (Münich: H.J. Rösl, 1834), 28, leaving out only a demon chorus which is not in the original. The French is, if possible, even more sentimental: the last line is 'C'est par toi que j'aimais' [It's through you that I loved]. Interestingly, the lines about heaven and hell also differ slightly: Bertram has defied heaven ('J'ai bravé...') and would defy hell ('Je braverais...') *Robert le diable, opéra en cinq actes* (Paris: N. Tress, 1850), 10.

This entirely undevilish devil ought to become interesting precisely through paternal sentimentality. A loving devil, who finds solace and peace in his son, indeed has not been spotted yet! (*NOTE 20)

It is understandable that the critics can often be embarrassed by such productions, for the falsity of the contradiction may be able to conceal itself. We **[96]** in Germany have in the debate over Hebbel's *Maria Magdalena* a very interesting example of the extent to which false contrasts can be regarded as the maximum of beauty. Certainly this dramatized story is sad enough.[81] It can happen, unfortunately, on any day, and our newspapers are full of this putrescent stuff. But this story is not tragic, as Hebbel in his Foreword and as his fanatic adherents think; what is sad in the incident is *made* into a tragic contrast and adulterated by the claim to such dignity, which results indeed in the dazzling peculiarity of Hebbel's dramaturgy. A gruff man, the carpenter Anton, refuses to drink a toast with a bailiff, says rude things to him instead and the bailiff denounces his son as a thief. The son is thrown in prison; the father believes he is guilty; the mother dies of horror. The daughter, Clara, loved a young man, who seems to have forgotten her while at university. She takes up with Leonhard, a common, calculating, matter-of-fact person. Deliberately, to force fidelity upon herself, she sacrifices her virginity to him and becomes pregnant. But Leonhard, because he can fulfil his luck to the utmost by another marriage, leaves her. In the meantime the innocence of the son is discovered—who emigrates to America as a sailor. Clara's earlier lover returns, loves her still, would like to marry her—but unfortunately she is pregnant.

'No man can get over that!'

He himself exclaims this. In vain, Clara begs Leonhard to marry her; because she did not give herself to him in the thrall **[97]** of love and loves another in her heart, he rejects her contemptuously. Her earlier lover, holder of a doctorate, duels with the clerk [Leonhard], and they shoot one another dead.[82] The old Anton, who is very generous with stinging Catoesque speeches, must nevertheless not have had faith in the moral rigour of the daughter. He utters the threat that, should she disgrace him, he would cut his throat. The daughter, certain of her misery, throws herself thus into a well out of love for the father. He does not slit his neck with a razor, as one might expect the Cato of bourgeois tragedy to do, does not go insane either—he is too reasonable for that— but rather ends the piece with the sarcastically contentless phrase:

'I don't understand the world any more.'

[81] Hebbel's bourgeois tragedy (*bürgerliches Trauerspiel*), named after the Biblical figure at the publisher's behest, ends with the unhappily engaged pregnant heroine's suicide. The book is famous now for Hebbel's Foreword 'concerning the relation of dramatic art to time and related points'. See Friedrich Hebbel, *Maria Magdalene. Ein bürgerliches Trauerspiel in drei Akten* (Hamburg: Hoffmann und Campe, 1844).

[82] Rosenkranz is not quite fair: the lover, though mortally wounded, is onstage and speaks through the last scene, and is led away by the brother. Also, the heroine's name in Hebbel is spelled Klara, and the play has only three acts, not, as Rosenkranz goes on to say, five.

This drama is a real rat king of false contrasts.[83] Son and mother, son and father, daughter and father, lover and beloved, all stand in false connections. There is also no circumstance, be it domestic tyranny, theft, fall of the innocent, infidelity, infamy, duel, suicide with obligatory infanticide, which does not present us with an ugly twist. The midpoint of the whole should be Clara. Only, how can we allow her to count as tragic, when she throws herself into the arms of such a subject as the heartless Leonhard! Had he been a noble human being, then a tragic contrast between him and the doctor would have been possible. As it is, however, their relation to Clara has no unity. Or Clara could contrast with him. But how can she do so, since she has betrayed the true love of her heart to him, indeed sacrificed her virgin purity to him on a frivolous whim? With whatever sophistry she might [98] cover this up, it is and remains common. Unhappy enough she is, to be sure! But when we watch a girl cry in secret or moan with pathos for five acts, and when she tells us, that it is not out of love, nor intoxication of the senses, but out of a truly infernal calculation that she gave herself to a person that in her deepest self she despises, so it is impossible for us to feel anything but sorry for her. Hebbel has rendered the hapless story, which can take place again and again every day in our neighbourhood, with grand genre-pictorial accuracy, in warm, living, singularly visual language, and all this has as effect only that out of its misery we long more deeply for the sublime shudder of tragedy, *purifying* through fear and pity.[84]

That the ugliness of the false contrast turns very easily into humour can in fact already be read between the lines of what has been said so far. The heterogeneity must only be taken a bit further, the sought-for effect only a bit exaggerated, and the ridiculous is ready;—as certainly for instance many will have had the happy experience of laughing heartily over the pains of the devil Bertram in *Robert le diable*, despite Meyerbeer's music.

The false contrast is already the inner break of a symmetric arrangement, the passage into a disharmony filled with contradiction.

[99] C. Disharmony

Symmetry is among the formal conditions of beauty not yet the last, for in the sameness of its repetition lurks a reasonableness, which in itself is indeed beneficial, but as such alone is also superficial and, like the distinctions of mere regularity, boring. Egyptian art paints us a grand picture of Egyptian monotony, which from regularity and symmetry fails to rise to freer forms. For instance, because hieroglyphic figures require an index to indicate whether they should be read from right to left or the other way around, in any inscription they must all correspond in direction. Thus these wide stretches of wall,

[83] A rat king is an entanglement of black rats' tails, documented in Europe since the seventeenth century. This is at times conflated with the myth of a rodent king, picked up most memorably by E.T.A. Hoffmann and Tchaikovsky in 'The Nutcracker'.

[84] Rosenkranz's *Angst und Mitleid* is the standard German form for Aristoteles' famous ἐλέος καί φόβος [*eleos kai phobos*, pity and fear], *Poetics* 1449b. This kind of deep pity is in contrast with sentimental 'feeling sorry' (*Bedauern*) that Hebbel's heroine provokes.

upon which all figures, often in the thousands, stand arranged in profile from one and the same side; an extraordinarily tiring view, contrasted only by the colossi sitting *en face* at the entrance gate. Thus nature and art strive with a certain force to overcome the stiffness of symmetry. To reach and maintain the harmony of great circumstances, bold genius sacrifices unhesitatingly the regularity and symmetry of subordinate relations, as we can see in ambitious architectonic conceptions, for instance, the admirable Marienburg Castle (* NOTE 21), in musical compositions, for instance in some of Beethoven's sonatas, in poetry, for instance in Shakespeare's historical dramas. Beauty can develop difference up to the rupture of a contradiction, insofar as the contradiction [100] dissolves itself again in unity, for through the *dissolution of the rupture* harmony first emerges. The simple unity is indeed also beautiful in itself, because it fulfils the first condition of all aesthetic design, that of representing a whole. But we have seen how bare unity remains flawed, and becomes ugly, in part through lack of distinctions, in part through confusion of distinctions, that is, through nebulous vagueness. A distinction can, as differentiation, turn into free and beautiful multiplicity; but through lack of grouping, bare differentiation as superficial, external difference turns into wilderness and barrenness, against whose formlessness beauty tries to react through subordination of the different under a common rule. Thus arises, as we saw, regularity as the equal return of the same differences, only this regularity can itself become ugly in turn, as soon as it becomes the exclusive form of an aesthetic whole, for which reason, beauty must elevate difference to determinate difference. Positive and negative become genuine symmetry through inversion of moments that are in themselves equal, enjoying an interrelation that is beautiful in and within itself. Were it missing altogether where, according to the concept of the form it should have been, or were it there, but flawed, disturbing the presumed equality of unified, coordinated differences through inner contradiction, ugliness again ensues. To posit contradiction does not contradict beauty. True contrast of relative with relative, relative with absolute, or absolute with absolute, is beautiful. In all that is [101] dynamic aesthetically, collision constitutes the high point of development; false contrast on the other hand becomes ugly in positing an opposition which is not, in the unity of its essence, capable of contradiction itself. The true contradiction must contain the rupture of a unity, for such a rupture carries the possibility of its dissolution in itself; dissonance allows unity to be glimpsed through the collision as the ἐν διαφερουν ἑαυτῶ [*hen diapheroun heauto*, differently identical].[85] That the ugliness which emerges from unity, differentness, regularity, symmetry, and contrast can turn into the comic, has been shown on all points.

 Unity achieves its aesthetic completion only thus: that the differences are born as *living* moments of the whole and stand to each other in *free interaction*. Not just the unity must appear to determine itself in its differences; the differences themselves must

[85] The term, used by Plato in *Symposium* 187a and by the German Romantics (Hölderlin, *Hyperion*) is adapted from Heraclitus' Fragment 51 (our italics): 'They do not understand how, while *differing from, [it] is in agreement with itself*. [There is] a back-turning relation, like [that] of a bow or lyre.' Heraclitus, *Fragments*, ed. T.M. Robinson (Toronto: University of Toronto Press, 1987), 37. Or more comprehensibly: 'They do not apprehend how *being at variance it agrees with itself*. There is a connection working in both directions, as in the bow and the lyre.' G. S. Kirk, *Heraclitus. The Cosmic Fragments: A Critical Study* (Cambridge: Cambridge University Press, 1962), 203.

possess this characteristic of self-determination. This is the concept of *harmonious* unity. Harmony is not just abstract, self-sufficient unity; it is also not a unity that falls apart into merely external, mutually indifferent distinctions; it is much rather a totality that creates its own differences freely and takes them back into itself, which we thus are pleased to call *organic*, on the example of nature. It has the force to overcome through itself the contradiction into which its differences could get mixed up. For the ancients, harmony had such high status that they thoroughly subordinated to it the individuality of the differences, whereas the moderns have a tendency to sacrifice harmony to the individually characteristic. One [102] may look at, for instance, the Pompeian frescoes, wherein the harmony of the colours is so essential that in one room the ground tone rules all, even into the smallest detail. Hettner, in his *Vorschule der bildenden Kunst bei den Alten* [Introduction to the Visual Art of the Ancients] (* NOTE 22) has well shown that only this high harmonic sensibility can explain the anomalies against truth to nature in the frescoes, as when animals or humans are shown in a coloration that is unnatural to them. On closer inspection we find such deviations from nature to be determined by the harmony through which the ground colour of the wall and the central painting corresponds to the side pictures and ornaments. The ancients made the wall a living optical unity, of which all that is particular to it may be taken from its colouring.

As in all similar cases, the word harmony is used already for those values or gradations within the unity that are only its moments. The purity of a simple certainty, a colour, a tone, a surface, we already call harmonious. No less so the eurhythmy of a happy symmetrical composition. Strictly speaking, we can only call harmonious a unity whose differences have a *genetic* character. It is not just the proportionality of ratios, but also the activity of relating, which harmony demands. The more varied the differences of the whole are, the more self-sufficient each of them seems, and the more intimately they interlock to bring about a thoroughgoing homologous unity, the more harmonious is the impression made. A harmonious work [103] repeats the essence of the whole in each of its differences, lending each of these nevertheless a soul of its own. This work does not shy away from dispersing itself into the plurality of differences, for it knows how to consolidate these again under the synthesis of the whole as moments, which in their independent existence need one another just as much as they need the whole. Disharmony thus springs out of harmony as its self-reversal, for without being able to postulate harmony of a shape, one will also not be able to speak of disharmony. The empty, dead, non-contradictory, only-identical gives it no material to work with; only with the interrelation of unity and plurality, of essence and form, of generality and specificity does it appear.

Harmony will be missed whenever we expect a living unity and come upon only an abstract one; but in this case, there is as yet no positive disharmony. The absence of a free multiplicity is not beautiful, but by itself it is not rupture of unity.—Should unity advance on to differences, but these remain external to one another, so that they do not melt one in the other, we will miss the soul of harmony. In this case there is as yet still no positive disharmony, but already *non-harmony* present, because the differences as unarticulated, by simply standing one after the other, decompose unity into a plurality. The differences become themselves units that do not interact. Unity appears for this

reason not harmoniously but in the dryness of a mere state of aggregation. Nowhere do we feel this malformation more keenly than in the theatre, when the actors do not play well together. Each person then forces [**104**] its own essence around the stage for itself alone, as if the others were indifferent to it. The play of the individuals does not interlock; the plot falters continuously and the lack of ensemble playing makes, particularly in a poorly cast theatre, a lonely, frosty impression; yes, sometimes, when the actors depend too much on the prompter and simply repeat what one has already heard him whisper hoarsely in his hellish voice [literally, a Hades voice], the impression is not too far from that made by the inmates of an insane asylum, who also play their roles recklessly and in perpetuity.

If the unity of the differences should destroy itself by changing into contradiction, without returning to unity, that rupture comes to be what we generally and rightly call disharmony. Such a contradiction is ugly because it destroys unity, that fundamental condition of all aesthetic design, *from the inside out*. Disharmony is indeed in itself ugly, but one must distinguish right away between that which is necessary and thus beautiful and that which is accidental and thus ugly. *Necessary* disharmony is the conflict into which the so-to-speak esoteric differences within a unity can fall through their justified collision; the *accidental* is the as-it-were exoteric contradiction imposed on a unity. The necessary kind reveals the entire depth of a unity in the monstrous rip it tears open. The force of harmony seems to us greater, the greater the disharmony over which it triumphs, but the rupture must not only [**105**] share a homogeneous element with the unity, but it must be in fact the negative relation of the unity with itself; for only under this precondition is the recovery of the unity possible. Rupture then is beautiful not through the negative as such, but through the unity, which in the rupture proves its energy as that which is internally efficacious, cohesive, saving, renewing power.

Kant says with justice that the beautiful is what without interest is liked universally; the ugly, then, is what without interest is disliked universally. The disharmonious can very well excite our interest, without being beautiful; we then call it *interesting*. We will not call interesting what does not carry a contradiction in itself. The simple, the light, the transparent, are not interesting; the great, the sublime, the sacred, on the other hand stand too high for this expression; it is more than just interesting. But the convoluted, the contradictory, the amphibolic, and thus also the unnatural, the criminal, the strange, even the insane, are interesting. The bubbling unrest in the witch's cauldron of contradiction has a magic force of attraction. There are writers who often confound the *interesting* with the *poetic*, and are able thus to idealize it through the richness of their minds, through the artfulness of their execution, that it approaches the ideal. Such authors always grasp of all things best the contradiction: like Voltaire and Gutzkow. But in the genesis and in the dissolution of paradox, they are not so happy, which explains the fact that they employ their acumen and fantasy more than they are swept up by feeling, that the whirlpool of disharmony indeed [**106**] shakes them, but they wish rather to be carried by the victorious current of harmony. True disharmony is a redemptive entry point of unity; false, ugly disharmony is a pseudo-rupture, an artificially injected contradiction. Such a thing presents us not with the appearance of a genuine essence, but rather of a genuine non-essence, and becomes thus embarrassing

to us. In Hebbel's *Maria Magdalena*, which we have discussed, we feel, as often as Clara stalks the boards, the permanent contradiction of what she is factually and what she wants to be and indeed should be. Whatever she says that is noble and beautiful, her words have all had their sharp points broken off, for we must always reply: but you are indeed pregnant and—you wished it so! This North German Clara is fundamentally no different from the Fleur de Marie in Sue's *Mystères de Paris*. This *Gouaieuse*, a born princess, with her fresh silvery voice, with her naïve girlishness, her sense of nature, her angelic demeanour, should be an ideal. Only, the more her sweetness unfolds, just the more decidedly do we feel the disharmony in meeting this sweet child first in a *tapis franc* [slang for dive bar] in the Parisian Cité, that despite being the friend of the brave, pure Rigolette, out of want of money, being out of work and having spent her last penny, she has surrendered herself to a *licentious idleness*. She let the *ogresse* make her drunk and cajole her into prostitution. A born princess in an urban *repaire* [hole, lair]! Interesting to high heaven, but not one whit poetic. We do not get over the defect that attaches to her moral stance from here on in; she does not either, and Sue has at least had enough tact [**107**] to let her die unwed of consumption at the court of her father, the German allegorical prince Rudolph (* NOTE 23).

A genuine disharmony *becomes* ugly if its *resolution* is *false*, for in this case, obviously, a *contradiction is the source of a contradiction*. In the consistent development of a contradiction, the unity at work in it, like a law, could have gradually emerged, and this experience of inner necessity could have given us satisfaction, in that we find the decline of disharmony through the harmony in which it dissolves itself, instead of a distraction through a resolution inconsistent with the beginning, which is obviously ugly. This happened, for example, to the otherwise so lucid Prutz in his *Karl von Bourbon*. Instead of obeying the poetry of the story, instead of letting him fall from the walls of Rome, a victim of Benvenuto Cellini's bullet, in the struggle against the Pope, Prutz lets him die some years earlier on the battlefield of Pavia, poisoned by a capsule in a ring served to him by a lover who had escaped from a cloister and strolled into the din of battle *à propos*. Wounded, exhausted, delusional, wishing to fortify himself with the drink, the great *Connetable* dies slowly with long, hyperventilating speeches. What a sad, sentimental contrast with his first bold entrance, in which he pleads for France's well-being and honour before the kings of France. What disharmony! What a false harmony, that the miserable poisoner, an unfortunate, romantic creature, naturally poisons herself as well. A quick bullet in the heat of battle through the bold heart, true to history, that alone would have been harmonious and poetic here.—Romanticism often allowed itself [**108**] to give, instead of an objective, self-profiling resolution of a paradox, a subjective and fantastic one that disappoints our expectation.—That said, one ought to remember that in contemplating beauty, whether of nature, whether of art, one cannot proceed liberally enough. The more certain the great aesthetic principles must be for us, and the more steadfastly we have to hold on to their eternal truth, all the more forbearing we can be to the concrete formation of beauty, when it often combines in itself what is the most varied and contradictory. We have before, rightly, distinguished between the interesting and the poetic; but to prevent misunderstanding we note that naturally the genuinely poetic can be *at the same time* extremely interesting. There are rock formations so terribly jagged, so wonderfully fissured, that they are not beautiful and not ugly in the

sense of the pure ideal and its negation, but which certainly can be called interesting, and as interesting a wild, eerie, strange poetry can breathe through them. There are buildings, wherein the style of different centuries has merged so wonderfully, that by all heterogeneity of the specific components they still add up to a most interesting, disharmonious-harmonious whole. There are poems that belong to no certain genre, and for this reason are not capable of exercising aesthetically a perfectly pure effect, but possess a fullness of authentic poetry. Byron's *Childe Harold's Pilgrimage* is not an epic, not a lyric (*Melos*), not a didactic-descriptive poem, not an elegy—it is all of these together in an interesting association. [**109**]

Because disharmony rests on the rupture of an essence with itself, and because it gathers together all moments of the formally ugly in its false justification and false resolution, naturally it provides a far stronger means for the production of the comic than the previous transitions into ugliness. Every mere removal, every expired resolution, every fantastic ending of a contradiction, in the place of the necessity of its immanent self-development, is already on its way to being comic. In works of this sort, wherein the comic as concept is present not in the works themselves, but in another consciousness that finds itself deceived by their deception, the contradiction is too serious in nature to be able to arouse our full hilarity with its perverse complication and irresolution; the comic must be free of all dubiousness if it is to dissolve all troubled ill humour in the sunbeams of laughter, which is why such works, wholly against their will, become ugly. Hebbel, the poet of pessimism and the bizarre, as Henneberger aptly called him (* NOTE 24), ought to allow us to prove through his *Julia* how the tragic, when the knots of its contradictions are neither tied nor loosened correctly, already begins to tip into the comic, but because it remains too serious and weighty, remains for the present ugly. A chief of robbers, Antonio, wishes to avenge himself, or rather his father Grimaldi, executed for being a chief of robbers, on the rich man Tobaldi, because he holds him to be the cause of his father's original exile. How does he go about this? He decides to dishonour Tobaldi's daughter. He approaches her, naturally without her suspecting he is a robber [**110**]; she falls in love with the pretty young man; he rapes[86] her in contempt of the father. More than diabolically Italian! In the act of violation, however, his hate turns to love and as a result of this love his whole attitude changes. He disappears and tries to free himself from his robber band and become a respectable member of bourgeois society, and emigrates to America with his Julia—thoroughly un-Italian. Only, he is so unreasonable that he tells the girl nothing about his future plans, though he has the additional misfortune to be lying ill in his hideout. Time passes. Julia feels herself to be pregnant, but is supposed, as the chastest girl of her city, to play the queen of virgins on the feast of Saint Rosalia. She cannot bear this contradiction; she runs away, wanders around the country, hopes to die somewhere. Instead of jumping into the water to drown herself, like Hebbel's Clara in *Maria Magdalena* does after all, instead of shoving a dagger into her heart like Lucretia,

[86] Here and later, Rosenkranz uses the old word for rape, *nothzüchtigen*, not the modern *vergewaltigen*. There is a broader connotation of 'to force' (which the Grimms attest in Lessing) but there is no romantic air as in English 'to ravish': the Grimms cite a 1414 lawbook according to which a *Nothzüchtiger's* neck should be cut with a knife.

instead of letting herself be killed by her father, like Virginia, or at least taking a sleeping potion like Shakespeare's Juliet, she meets a bandit in a forest—alone—offers her purse and talks strangely, until it dawns on the bandit that she might appreciate not living any longer. At that moment an unheard-of catastrophe rears its head. In the thicket cowers a rich young German count, extremely smug, possessed of exceptional love for mankind in general; he has ruined himself so thoroughly, that with mathematical certainly he cannot live much longer. But since he is in fact a very good human being, as is confirmed by his old servant Christoph, he would very much like to [111] dedicate the remainder of his life to a useful, if possible, to a noble deed. Alas the 'how' remains obscure to his ingenious brain, but dramatic providence looks also after fools. With surprise he had witnessed the original murder scene, and at the right moment he chases away with a forcefully uttered 'Boy!' the honest bandit Pietro, then promptly learns from Julia the state of affairs, and is thrilled to find in her a perfect opportunity to turn around his nothing of a life. He decides as a matter of fact to marry the pregnant Julia. What Clara's earlier lover in Hebbel's *Magdalena* could not bring himself to do, because supposedly no 'man' could, is not a problem for the emaciated count. His perspective is higher, freer, for, before his imminent death, he thirsts after a virtuous action and a fallen girl to snazzily help back to her honour—is that not extraordinarily virtuous? Meanwhile, the old father has found his daughter missing and deceives the town with an empty coffin, pretending she is dead, a farce in which he is assisted by the old family doctor Alberto, who, as a friend of the family, loved, from a modest distance, first, Julia's mother, then her. Count Bertram arrives with Julia and the father gives, happily or not, his blessing to the noble son-in-law. But the very handsome robber Antonio, reformed through love into Philistinism, comes too and is at first naturally furious, until Bertram's wondrous, not exactly chaste so much as really impotent, intentions are made clear. In a castle of the count's in Tyrol we find in the last act Julia with her husband, her lover, and the Platonic [112] Alberto peacefully together. Bertram indeed feels the endless beauty and kindness of his young wife; he promises, however, to behave. He wants to hunt mountain goats in the Alps—and then? But he must be quite familiar with George Sand's *Jacques*, for it takes hardly more than a month—and then, turning to Julia and Antonio: 'promise me both'—

Julia: Then—
Antonio: Then, should we ask ourselves, whether we yet may be happy?
Julia: We should ask ourselves, whether we yet can be happy?
FINIS

Thus ends this tragedy, distorted through the talent of its composer all the way down to the smallest detail; we have given its content straightforwardly, without being able to prevent comic highlights falling on it. We do not doubt in the least the subjective seriousness of the ethical disposition, which Hebbel proclaims with great pathos in the Foreword. But let us not be seduced, but rather recognize that this tragedy, through its form of disharmony, is basically a gruesome comedy, a monster of illusory contrasts. Let us turn a blind eye to the crasser motives that crop up often in this tragedy and often have a highly comical constitution; if we concentrate on the fundamental

circumstances, these are not tragic, but comical. That a girl who has secretly been made pregnant [113] should appear as the queen of virgins in a procession is certainly comical. That a father, whose daughter he thinks has run off with her lover, tricks the town through a fake death and a fake coffin is certainly comical. That a German count, after rakishly spending his life suffers a hypochondriac fit of virtue and wishes to do his satiated corpse the additional honour of serving something useful, even noble, is certainly comical. That a pregnant girl traipses without impediment through a country that after all has *gendarmes* of its own, and, longing for death, convinces a bandit in a dark wood to kill her by waving a purse in front of him, instead of him, as one might expect, procuring the purse without murder and forcing the girl, a pretty prize, to do his bidding: that is certainly comical. That Bertram and Julia undergo a marriage, which is not one; he, to do some good before he dies; she, to rescue her honour; that is certainly comical. That finally all three lovers, each accepting, even admiring, the others from their own standpoint, get along marvellously in the castle in Tyrol, and that the count offers Antonio and Julia the pleasant prospect of his permanent disappearance for their comfort, well, that is certainly comical. Comical? Yes, in the Aristophanic sense, insofar as this also encompasses ethical nullity, but not in the broader, also Aristophanic sense of the cheerful exuberance of absolute nullity, which is without pretension. Rather, these corrupt circumstances are handled with stately seriousness and speeches full of long words, so that instead of blessed smiling, we feel only the gloom [114] of having before us a failed tragedy.

If contradiction is not of an ideal nature in accordance with its content, and if the subject caught up in it does not feel it as contradiction, but seems rather perfectly satisfied in it, the resulting disharmony is comical. Recall, for instance, Strepsiades in Aristophanes' *Clouds*, a reputable Athenian who wants to study philosophy with Socrates. But to what end? So that he can sophistically rid himself of his creditors. This goal he sets for philosophy contradicts its essence. But in being taken thus, it is funny. And thus Strepsiades finds himself at first quite comfortable in the earnestness of his faith that philosophy will rid him of his debts, that is until his son over-sophisticates [*übersophistet*, a wordplay on sophism] him and proves to him dialectically his right to beat his father.

Part Two

Incorrectness

The abstract determinations of formlessness are applicable to all ugliness. But ugliness *in concreto* is partly natural, partly mental. The generality of amorphousness, asymmetry and disharmony becomes in nature, and in the mind, a real existence. As such, it is subject to the necessity of realizing in its appearance the general concept that makes up its essence. The correspondence of reality with the concept, the objective satisfaction of law-likeness, makes up correctness. This consists, then, in that aesthetic shape is represented according to its normal particularity, that is, that nothing is left out that belongs to it according to its concept, that nothing is added that is foreign to its essence, that nothing is changed in its normality. In these negations lies the concept of incorrectness.

Incorrectness leads into the domain of the individual arts. But if one wanted to follow it there, one would end up embroiled in endless and extraneous details. Namely, one would have to add to every positive determination of the canon that its transgression is incorrect. What a tiring bore it would be if one had to list all the rules of art and repeat for each one the litany that a failure of the same [116] is not correct. It is then enough to show in our context how the ugly enters into incorrectness and how incorrectness too can become a source of the ridiculous.

We will thus have to first articulate the concept of incorrectness in general; then we will have to go through the particular modifications that incorrectness can take in the peculiar types of styles of the nations and the schools, and in individual ideal forms of expression; for the design process, however, which has the same character in the individual arts, the giving of general characteristics will suffice.

A. Incorrectness in General

Correctness as such consists in the *rightness* with which a shape represents those forms that inhabit it by dint of its essential content, be it natural or historical. In the language of formal logic, one could say that it equips an object with all the traits that distinguish it essentially from others. Only through the definition and clarity of its fundamental rightness can a shape separate itself from others aesthetically as well. Correctness thus

demands, for instance, that in a landscape picture the kinds of trees are distinguishable by their natural type, that in a work of architecture the columns are ornamented and tapered in accordance with the law of their order, that in a poem the character of its [117] genre is preserved, and so on. This definition is entirely required, because without it the individuality of the shape cannot appear. In this it is beautiful. But since it is based first of all on the formal correspondence of the individual shape with its generic similarity to a law, it is not in itself absolutely beautiful, but constitutes only the satisfaction of a necessary condition of the beautiful. The ideal swing, the blessing of a higher poetry does not yet lie in it, and it alone cannot yet satisfy aesthetically.

If we said of a work of art that it is fully correct, that is certainly praise and that not inconsiderable, for we recognize thus that it fulfils the rules of art. But if we said nothing more of it, this praise turns nearly into blame, for though it is correct only, it can also be dry, soulless, without the fizz of original invention. We see this best in the works of that tendency in art we call *academic*. Formally they are generally right, but insofar as their merit is limited to the *absence of individual mistakes*, they do not fail to bore us promptly despite their correctness, for they do not grab hold of us through the enthusiasm, which in the right proportions, delights us with that excess of godly character, ideal truth, original freedom, which first makes a work of art a classic. The academic, well-schooled correctness, which is nothing else, with its often embarrassing precision, comes to appear in comparison with the creative breath of genius cold and lacking—indeed, ugly. Not the correct as such is ugly, but ugly is the beautiful, as long as it remains at the level of sheer correctness [118] and does not make it to a means of soulful manifestation. A work that in points of detail is incorrect can nevertheless, despite these offences against drawing, musical texture, arrangement, verse structure, and so on, be beautiful, if the whole is carried by an ideal force, which makes us forget the flaws in the details. The newness of the invention, the audacity of the organization, the power or gentleness of the execution, make us forgive, in the name of genius, any inconveniences, errors, and blunders. Thus, for instance, Platen is extraordinarily correct, but less peculiar and self-creative; Heine, in contrast, is often incorrect, sometimes even consciously so, only his productive force, his originality, is much greater. As a result of this difference, his influence on our literature is much stronger and more widespread than Platen's.

That incorrectness in itself, inasmuch as it negates a necessary determinacy of form through omission, heterogeneous addition or modification, falls into the category of ugliness, is without doubt. Art must demand correctness and may not in bad faith exercise tolerance toward incorrectness. The necessity, in accordance with which art must submit to correct execution in general, is a *physical, psychological*, and *historical-conventional* one. Here the concept of imitation comes to the fore, because here art holds itself to a given which it must follow. It must observe the forms of appearing of nature and mind, for only in these forms can it individualize its shapes. Imitation, however, as is well known, does not have [119] the sense of a brute copying of the contingently empirical, but rather through devotion to the same, through exact replication of its shape, comes to know the ideal form, the general proportion. Nature and mind often prevent themselves, through the contingency and arbitrariness that are attached to them, from reaching the form they strive for as the adequate appearance of their essence. Their reality often remains behind the tendency of their concept, because

unintentionally they often interfere with their necessity as well as their freedom. Art liberates aesthetic design from this predicament, removes from it all that is corrupt and inessential, takes out the pure kernel from the shell and gratifies us with the eternity of the flawless ideal. This could not be accomplished through an only empirical eclecticism, for the more exact its productions, as in wax figures, automata, daguerreotypes, and so on, the more they distance themselves from the freedom and truth of the ideal. A daguerreotype portrait does not give us the whole person, but only the person as he finds himself in just this moment in very particular circumstances, in the thrall of a passing mood, and so on. The artist has to produce the ideal in the final instance out of spiritual experience, for which obedience to the empirical can only furnish him with the material. Praxiteles would never have brought forth his ideal statue of Aphrodite, had he wished to limit himself to an accurate composite of the excellent beauties of those hetaerae the Athenians put at his disposal.[87] If we imagine that he borrowed the breasts of one, the arm of another, [120] the foot of a third, and so on, and then superficially bound these individual parts, so he would certainly have made a beautiful monster, but no goddess of beauty, worthy of prayer; from his own interior thoughts he had to conceive the triumph of female beauty. That is precisely why those hetaerae were not useless to him, for studying them made correctness possible for him, so far as he could see in each a relatively true appearance of the ideal. How palpable it is, on the other hand, with our modern sculptors and painters, that they create naked female shapes only on the basis of *grisette* models who have corrupted the pure forms of nature by pouring them into corsets.[88] To be correct, art should adopt the essence of natural and mental reality, but it should not *naturalize* any more than it should idealize in the service of a false transcendence. We shall have to concede to the artist a *relative remodelling* of mere rightness, insofar as he needs it for the production of the objective truth of the ideal, and we shall not be able to scold such an over-reaching of empirical forms as incorrectness; only subjective idealizing that deflates the specific force of individuality into abstract potentialities will have to be criticized.

Physical correctness can be verified most certainly, because the comparison of artistic production with the given is here easiest and most accessible. We use the expression *after nature* figuratively in a general sense as well, in that we understand by it the immediate in general. We say, for instance, even of an architectural representation, though the building be the work of the mind, that it is painted after nature. Just [121] so we say also: from life.[89] Now, although the experience of nature offers itself willingly at all times as the right conception of the same, it is by no means as infallible as it might seem. A purely objective seeing and hearing are by no means such a generally enjoyed ability. On careful observation we thus usually discover, to our amazement,

[87] Athenaeus, *Attic Nights*, 13.590a, reports that the courtesan Phryne was Praxiteles' model for his famous Knidian Apollo: Rosenkranz is mixing up this story with that of Zeuxis, who used five models for his painting of Helen, as reported in Pliny, *Natural History* 35.61–6, Cicero, *De inventione*, 2.1.1–3, and picked up by Alberti and Raphael, the latter of whom recommends the ideal method favoured by Rosenkranz.

[88] Rosenkranz echoes a complaint about dress from his hero Diderot's 'Salon de 1761'.

[89] 'After nature' (*nach der Natur*) and 'from life' (*nach dem Leben*) share a preposition.

more incorrectness than we would have thought possible. And other instances of incorrectness spring from the solidification of manners, such as for instance the overlong shapes, hands and feet in Byzantine painting (* NOTE 25).

Psychological correctness we often call also natural truth. It includes the sphere of the mental in its desires, tendencies and passions; the right expression of the same in gestures, facial expressions, words; no less than the right motivation of the emotions. The connection of feelings in accordance with their content, the form of appearing of the same in a mimicking, pathognomic, and physiognomic sense, the representation of the same in sound and word, opens up an infinite field for the injury of objective truth, whose correction is much less simple than that of physical incorrectness. In poetry, music and painting, psychological error will be more definitely demonstrable than in sculpture, because the latter, working toward generic expression, often has to soften the decidedness of the characteristic in order to represent the abstractly allegorical. Thus, the French have a concept in their poetics called *la poésie légère*. Pradier has represented this concept in a statue, which caused the French critics to gush in flowery phrases and [122] poets to celebrate in enthusiastic verse. A beautiful dancing woman holds in her left hand a little harp, while stretching the right over her head. She stands on the toes of her left foot; the right is lifted in a light swinging motion and taps the floor behind with its point. That the shape, in accordance with French notions of the *poésie fugitive*, has a certain fullness, we will readily admit; but must the head too, which turning heavenward ought to breathe out enthusiasm, should the mind express a pleasantly satisfied *embonpoint* [plumpness]? Must the eyes be so small, so heavily closed as from opium? Does this physiognomy not go too far into the Phryne-like?[90] Should Pradier not have considered, that his light poetry should indeed have some lascivious features, but also show more marks of the spiritual in eye and chin? Such reservations flow from the question whether the concept of the jesting, witty, zestful, erotic muse is correctly expressed in these forms. Pradier, who next to Canova among modern sculptors, most perfectly commanded the expression of sweetness, might have defended himself by saying that a less round chin, a larger eye would in turn have been too noble, too Apollonian (* NOTE 26).

In *historical-conventional* rightness, freedom of the spirit remains the essential point, to which respect for the given has to subordinate itself. Should the psychological expression of the mind be correct, the real substance of a historical process rightly grasped, then the outer morphology of the appearance is less important. Thus the incorrectness of the latter is given greater room to play. The [123] historical spirit displays its peculiarity as well in the way we live, its clothing, in the form of its paraphernalia, in the character of its mores. In all these manifestations an infinity of determinations are seen, which, though expressions of its essence, are in fact accidental to its depths. When we observe such things as a whole, we enjoy the consistency with which individuality penetrates every last detail, but in art we must recognize that the multiplicity of specific forms in which individuality expends itself can claim only a

[90] The famous Athenian *hetaira*, whose exploits (serving as model for Apelles and Praxiteles, swimming naked in the sea at Eleusis in honour of Poseidon, being prosecuted for impiety and acquitted for her beauty) are recounted by Athenaeus (XIII, 59–60).

secondary value beside the pathos of freedom, which is its essential content. The ancient study of minutiae may not claim aesthetic primacy for itself. A sword, for instance, remains in the end just a sword, though it is true that every nation and even the same nation in different epochs show the most individual variations of blade and hilt. Clothing, which changes according to climate and culture and still more according to the dictates of fashion, retains nevertheless always and everywhere the necessity of providing a neck hole for the head and two side openings for the arms, and so on. And so art must, in the representation of history, be authorized to emphasize above all things the generally human, the mental content, the inner nature of action and its externalization in gesture, facial expression, and word, for this truth, in contrast to the rightness of conventional forms, constitutes poetry, on which beauty directly depends. Assuming then that the substantial interest that we take in spiritual phenomena is satisfied, we need be [124] far less punctilious in historical fidelity than in matters physical and psychological. Learned precision in historical superficies can never be the purpose of art, for art wants to do more than to instruct. Where ancient fidelity coincides with poetic stimulation, as in Walter Scott, it is very agreeable, but the poetry must not be sacrificed to erudition; when productions are written outright in this didactic spirit, such as Barthélemy's *Voyage en Grèce*, Becker's *Charikles* and *Gallus*, it is at once conceded that we are dealing with only a pleasant covering for the useful, and the pretension to art falls away. To the artist we grant unconditionally a certain commercial skill in all the outer reaches of a historical composition, as long as he brings us the human. Even *anachronisms* do not offend us, as long as they do not become absurd or fail to generate any artistic effect that might justify them.

Great artists have handled history with just this freedom, and we have not counted the liberties they took as incorrectness. This is the way Shakespeare handled not just English, but also Roman history. His Romans are in a certain sense Englishmen, but above all they are real people, plebeians, aristocrats, full of eternally true emotions and passions. What nit-pickers have called historical incorrectness shows itself to the more acute critic to be poetically motivated. In the *Winter's Tale* he makes the sea surge against the coasts of Bohemia. What ignorance! pedantry cries out here. But it is after all a tale, and [125] the geography of fairy tales is fantastic. For the English of that time Bohemia was a foreign land and nothing else, as historical as the tale's kings and wizards. In Gutzkow's *Richard Savage* [on the other hand] we come across an anachronism that deserves to be called an incorrectness. Savage converses with the famous journalist Steele. Steele wants to cheer up the melancholic thinker and says to him: 'You know, I pity you and myself, that you should be kidnapped from the suffocating air of London; but Botany Bay, my friend ([*aside:*] I have to try to console him)—it really repays careful study. For my journal it is tremendously valuable to have a correspondent there.' Gutzkow gives in the cast of characters the year in which his drama is set as 172* [that is, some date in the 1720s –trans.]; he is too well educated not to know that Oceania at that time had not yet been discovered; furthermore, for the humanitarian thoughts that Steele utters, Botany Bay was not at all suitable; the anachronism is therefore entirely unmotivated and this deliberate slip makes it incorrect.

Though art may behave indifferently towards correctness in such matters, it may not do so in those matters where the poetic nerve lies. A deviation from that

correctness which expresses the truth of the plot, and its corresponding physiognomic, pathognomic, and rhetorical appearance, would be at the same time a destruction of the ideal essence without which the work of art cannot remain beautiful. Painting gives us very interesting examples of how [in the service of] admirable composition, historical incongruence of the forms can be overlooked. The van Eyck [126] School, for instance, has painted Mary as a German girl, kneeling in a wood-panelled room before a nut-brown console bed to hear the angel's annunciation. Carpets adorn the floor; a flower vase with lilies is resplendent in a corner; through a window we look upon the castle-crowned banks of the Rhine. This whole decoration is objectively impossible, for naturally Palestine before Christ's birth could not have looked like a Rhenish burgher's parlour in the Middle Ages. Insofar this whole environment, this costume, this leather belt, this gold-blonde hair, these blue eyes, this German profile are not historically accurate and are incorrect. But, we ask, are humility, virgin aloofness, longingly pious devoutness contained in that shape poured into a prayer, in the features of the face, in the look of the eye? If we find this, and find it represented in natural and psychological correctness, historical convention becomes a side issue; the virginity of the Conception, that Christian reversal of the lustful fertilization of a Danaë, that is the idea of the picture, and that idea is realized.

In the interest of beauty we must permit the artist also the adaptation of myth and history, insofar as he thus profiles the poetic content of the same more ideally, and does not produce a deformation through his changes, as Euripides did. No great artist has feared incurring blame on the basis of such adaptations, because such blame has the virtue of being an aesthetic corrective of historical tradition. Shakespeare, Goethe, Schiller have all changed history in ways that do not injure historical truth in its essence. [127] Schiller's *Don Carlos* is not fully the historical man, but at the same time he is, for not only does Schiller make the tragic situation of a prince so unfortunate as to draw upon himself through talent and sensitivity the ire of a tyrannical father, and to love his young stepmother, who had initially been intended as his own spouse; more, Schiller renders this tragic state also in the way he individualizes the Spanish mind and its court etiquette.[91] Fouqué, in his *Don Carlos*, has given us the correct detail, the empirically true, the historically correct Don Carlos—insomuch as we know him, that is—but this Infant of Spain is as good as unknown to the world, because he lacks in history that which is its element—Spirit.—Although art, in striving after ideal truth, enjoys a certain freedom in its historical dimension, it must nevertheless be said that the genuine artist will trouble himself with historical fidelity for no other reason than that it offers him such happy means of individualization. He will only discard that which positively constrains him in his aesthetic purposes, and only modify that which damages the harmony of ideal truth. Pore over the works of great masters, and see if you can chastise them for neglecting historical colour. How historically precise is Raphael in his Loggia, without any trace of fearful meticulousness! Ask yourself whether Shakespeare in his Roman tragedies held on to historical truth only in the

[91] Frege in his unpublished (1897) *Logik* also contrasts the real Don Carlos with Schiller's. This poetic figure, it seems, impressed German philosophers as particularly far-fetched.

whole, or achieved it in even the most individual connections? Ask yourself whether, for instance, his Cleopatra is nothing but a beautiful, hot-blooded, lustful, imperious woman, or whether she is not also [**128**] the Egyptian woman, the 'old snake of the Nile'? One has only to listen to how historians like Gervinus (* NOTE 27) discuss the historical content of this tragedy. Or take apart Schiller's *Wallenstein*: is the fissure of the European world at the time of the Thirty Years' War not painted there in historically saturated colours? Or look at Schinkel's pictures for stage sets: has he not there made historical individuality agree with the aesthetic ideal and the practical needs of the theatre? — But always we will be able to concede art the free handling of nature and *a fortiori* of mind only on the condition that ideality in the objective sense of the word gains by it, for without this gain, which liberates the tendency of the essence itself to come to the clarity of appearance, it will fall into the category of the incorrect, or else become comic.

As always and everywhere, the comic lies here also in that what is conceptually impossible seems to become real, and mocks our common sense through its empirical reality. If, as mentioned above, the Greek and Roman heroes and heroines once appeared on the Parisian stage in long powdered wigs, crinolines, high heels, swords and fans, we should find in this costume today a ridiculous incorrectness. How little these externalities really affected the thing itself can be seen, however, in the fact that today these tragedies of Corneille, Racine and Voltaire are played in the *Théâtre français* no longer in that court gala costume of the absolute monarchy, but in true antique dress, without [**129**] causing any kind of tension with the content through this change. If we imagine, on the other hand an *intentional* historical incorrectness, this must have a comic effect, because it must appear as parody. For instance, in a puppet play by Glasbrenner, *Paradise*, Adam enters with the following words:

> I am very happy that I was created. One cannot know what for. (*looks around*) A lovely botanical garden! That blue ceiling and the warm lantern in it are also not without their uses. Apart from the fact that one has to take it as *fait accompli*, there all of a sudden, it really is rather well done. The producer has earned the public's applause. At the very least, a start was made, the initiative for creation was seized, which through appropriate measures taken by a strong administration might still develop into a nice place. (*glances all around*) In six days, really all that was possible? (*shakes his head*) But that only one guy could have put this all together, I don't believe that. It must have been more: a team. In any case, Radowitz must have helped, for without that guy no creation gets made . . .

Impossible, we want to interject, Adam wouldn't have spoken like that! But this Adam of the puppet theatre really speaks in this way. We see that here Creation begins with a jaded boozer from Berlin, and we have to laugh over the contradiction between the concept of the prototype and the reality of an argumentative philistine beer drinker.

The correct consists in general in the faithful observance of the positive normality of nature and [**130**] mind. But the freedom of art, as we have seen, is never able to satisfy itself sufficiently if limited to the correct; it may even under certain circumstances become incorrect, without thus contradicting beauty. In deliberate parody, it can

become comic. But what about the *fantastic*? How should we judge compositions that seem physically and mentally impossible and nevertheless through the mediation of art stand before us with the whole energy of the real? How do these dream shapes stand in relation to the concept of ugliness? Art may indeed have no other law for itself than beauty, but beauty has a necessary relationship to the true and the good, which even in the freest productions of art may not be broken. This identity is by no means a negative limitation of art, quite the opposite, for first through it does, the positive consummation of the beautiful become possible. But rightness must be distinguished from this relation, which in its relativity allows fantasy to play a dreamy game with the shapes of empirical reality. Fantasy enjoys itself greatly in its play-drive,[92] in that it, so to speak, frees itself from the limits that must be respected in the reproduction of the positive, and it does this through a boundless production of shapes that belong only to its own creative force. Fantasy confirms its freedom through the Saturnalia of its arbitrariness. It jokes with its exuberance. It makes up plants that belong to no class of flora, animals that belong to no type of fauna, circumstances that belong to no time in history. Can one still talk about correctness faced with this fantastic essence? It does not seem right; with which [131] positive natural forms should these figments be compared?

At this point we have to remember that nature and history themselves are rich in fantastic productions. If only common sense had been at work in them, then indeed these things would not have been found there, but chance and arbitrariness indulge in the cheekiest frivolity; it is literally true that empirical combinations can shamelessly rival the inventions of subjective fantasy. Common sense alone could hardly have conceived animals whose covering is indistinguishable from that of plants, like the large group of Phytozoa.[93] Common sense alone could not have produced the contradictory forms [of] the antediluvian giant nautilus. Even in the present organic epoch of the Earth it would not have tolerated any flying fishes, winged lizards, flying mice, lizards with long, skewer-like mouths, rodents with scaled tails, warm-blooded mammals that tease us as fishes from out of surging sea, and so on. Nature, more than sensible, rational, is witty and fantastic enough in its freedom to combine the apparently contradictory. Only the apparently contradictory, for in the interior of the organism there can be no contradiction, for then it would not be able to live; but in outer form it can appear contradictory. Fantastic art, then, when it invents bull-lions, eagle-bulls, griffons, sphinxes, centaurs and the like, is like nature. And no less in history, for the freedom of spirit produces in combination with chance the most monstrous, fabulous phenomena, which surpass the fantasy of nature incomparably. [132] The mind recalls numerous fantastic shapes and circumstances, whose brightly glittering existence the artist could hardly have dared to invent in his boldest phantasmagorias. The life of Napoleon I—the life of an artillery lieutenant, a general, a statesman, a conqueror, an exile—what fantasy would have had

[92] The *Spieltrieb* (play drive) was central to Enlightenment aesthetics, from H.R. Reimarus to Kant and finally Schiller, who in his *Letters* enshrined it as a moral principle as well.
[93] Corals and other plant-resembling marine animals were called in the mid-nineteenth century *Phytozoa* by Blainville, *Hydrozoa* by Owen, and *Polypifera* (polyps) by other scientists.

enough force to devise such a wonder poem? The life of *gold miners* in the mines of California and Australia, who a decade ago would not have called it a fairy tale? The journey of the Mormons from Nauvoo[94] through the desert to the Great Salt Lake in Utah—while barricades were being built in old Europe, who would have expected such Old Testament poetry in commonsensical North America? Othello played by Ira Aldridge, a real Moor—how could Shakespeare have dreamed this?[95]—But we will cease the introduction of further facts; facts which belong to our century, to our immediate present; facts which have not taken on a fantastic shimmer through distance, grey antiquity, or the layering of tradition.—Spirit casually goes beyond commonsensical purposefulness, beyond brute necessity, beyond bald usefulness, when the point is to create space for its particularity. But it cares nothing also for the pure contours of beauty, in following its urge to mark its individuality. What wondrousness do we not come across in the fashions of the various peoples? Recall for instance those beaked medieval shoes whose upturned horns ended in a bell. Did the shape of the foot demand such a form? No. Did it provide especial comfort? Certainly [**133**] not. Should these horns seriously make a claim on beauty? Impossible. Why then did they exist? Obviously only to satisfy a crazy mood of mischievously playful spirit. Recall the costumes of the Directory, as Wattier painted them so aptly in that picture in the Galerie Moreau.[96] While the women, as *merveilleuses*, displayed bare necks, breasts, arms, and yes, through the tunic's side slit more than just calves, while they thus unveiled nature, we see the dandies as *incroyables* doing just the opposite, making nature practically unrecognizable through stupendous bulges of hair, through overstuffed cravats,[97] and strangely pointed coat-tails. One should recall such shapes, and then confess that history with its fantastic formations can often, in broad daylight, overshoot the world of dreams.

Returning to art, we have to recognize for its fantastic side an aesthetic limit that concerns not so much the rightness as the *truth* of the figures. They have to work in us the illusion that they have a certain reality, even if no direct empirical counterpart. We call this state of affairs *ideal probability*. They contradict our common sense, and yet they must conform to it through the unity in contradictions, through the naturalness of their unnaturalness, through the reality of their impossibility. We must concede that fantastic creatures like chimeras, hekatonchires, centaurs, sphinxes, and so on are anatomically and physiologically impossible, and yet they must appear to us in such harmony with themselves that in looking at them, a doubt concerning [**134**] their reality should not directly trouble us at all. What is derived from the difference must be constructed in accordance to its truth.[98] If this demand were not met, we would have to

[94] Settled by John Smith in 1839–1840, Nauvoo had for a time a bigger population than Chicago. The Mormons left in 1844, and Étienne Cabet's Icarians settled in 1849.

[95] Ira Frederick Aldridge (1807–1867), the most prominent black Shakespearean of the nineteenth century, was born in New York of free Senegalese stock: Rosenkranz, if one takes 'Moor' to mean 'African', as Shakespeare did, is less imprecise than he seems.

[96] Presumably Émile Wattier (1800–1868), notable for his illustrations to Rousseau (1845) and colour lithographs of fashionably dressed youth.

[97] *Kinntuch* (or *Backentuch*: Grimm), literally chin-scarf (or cheek-scarf).

[98] An odd sentence: Rosenkranz might have had in mind Descartes' claim that fabulous creatures are constructed from real sense experiences of their various real components.

regard the fantastic as incorrect. This correctness of unity, symmetry and harmony in the heterogeneous, bound together by the arbitrariness of fantasy, must be present, failing which, the design will make an ugly or comical impression. An Egyptian sphinx combines a human head with a woman's breasts and the body of a lioness. Anatomically and physiologically such a unity is impossible; but sculpture shows it to us with such determinacy and clarity that in the moment of seeing we hardly think of this natural scientific scruple. How calmly the body rests after all stretched out on its paws, how straight and erect the neck, how thoughtfully the eye commands its view! And we should not categorically grant this existence in our fantasy? Indeed, if the woman's head were not welded to the lioness in a natural-seeming progression, were the one stuck upon the other in a merely aggregate fashion, did the heterogeneous parts not fraternize in such an unforced manner, we would find the sphinx ugly. The same holds of similar half-animals, of fantastic plants and even arabesques. A fantasy flower must simulate the appearance of natural truth in its leaf form, its leaf position, its cup; its proportions must be aesthetically possible.—From the mind too we will demand, however fantastically it should rove, probability in the *sense of the idea*; in the sense of the idea, for fantasy can contradict without ado the commonsensically empirical without transgressing higher laws. [135] The eccentricity must maintain a certain possibility within its vortex; that is, one should not confuse the absurd with the fantastic, as so many today are content to do. Some authors of the older Romantic school in Germany have let their healthy beginnings devolve into a tasteless muddle, which they took for the heights of poetic profundity, while in fact they had only achieved absurdity and a mindless nihilism. Arnim's great *Dolores*, Brentano's *Godwi or the petrified picture of the mother*, are examples of this (*NOTE 28).—Among the modern painters Grandville has proven himself a giant of fantastic art. How wonderfully in his *Fleurs animés* the female forms are woven together with flower forms, so that one doesn't know whether to say that the girls have become flowers or the flowers girls! The flower is only a decoration, but one thus botanically correct, that its drapery shows a character identical with the human form (* NOTE 29). In his work *Un autre monde*, without doubt the culmination of his genius, however, he has risked images whose contradictions tear our fantasy to bits. We stand with them at the border of madness and are hardly able to bear the experience. Why are some of these pictures so agonizing? We believe in them, for within the bounds of the fantastic, Grandville not only remains true to aesthetic probability, but despite his absolutely unleashed poetic caprice retains a frightening degree of natural truth. 'Hell-Bruegel', Teniers and Callot have invented in their *Temptations of St. Anthony* highly fantastic figures, which, however, [136] abstract from all natural fidelity, possessing only a fantastic aplomb. Grandville, by contrast, in his distortions has not just painted a turtle with a poodle's head, a bear with a snake's, a grasshopper with a parrot's; he has not just painted machines as people, people as machines; but among other things, he has painted an animal cage that would horrify even antediluvian monsters, for we see in it double beasts which are not merely syntheses of split forms, but rather constructions that preclude one another, which destroy the illusion of unity in a frightful manner. We see, for instance, a buffalo whose tail ends in a crocodile-like snake, so that two hooves of the buffalo point forward and two paws of the crocodile backward, a split tendency that crazily disturbs unity. Or we

see a lion leaping down from a climbing pole, its tail a pelican's head and neck, busy swallowing a fish (see Figure 2). This is really ugly, and too awful to have a comic effect. With a comic twist, indeed, the most extreme contradictions become tolerable. Grandville, in the same work, has painted a menagerie, before whose cages a variety of curious animal folk perambulates (see Figure 3). There we see the English unicorn-leopard in a cage, and standing before it a dog shape with the head and hat of a sailor, smoking a short pipe. Before a doubled Napoleonic eagle we see a sphinx cowering, bearing the head of an Alsatian wet nurse, which, instead of the Egyptian kalantika [veil], is decorated with her well-known bonnet. That sailor dog, this sphinx nurse, that is fantastic and funny, [137] without being ugly.—To mock the bad improbability of a false fantasy, humour invents the impossible as well, conveyed in the tone of the most doctrinaire sincerity, as Lucian in his *True Stories* so splendidly skewered both the braggadocio of travellers and the pedantry of scholars. (*NOTE 30)

One could well introduce the fairy tale as a genre in whose essence contradiction sits beside the normality of nature and history. Does it not swarm with things and circumstances that are a slap in the face to positive law-likeness, that is: impossible, incorrect? The true fairy tale, however, will never be incorrect in the sense that its impossibilities fail to be *symbolically* probable. Its flowers will sing; its animals will speak; humans will turn into animals, animals into humans, and wonder after wonder will take place: but through all this fantasy a deeper, one would like to say, more sacred, accord between natural and historical truth will be sifted; the artificial envelopes, with which civilization coats all states of affairs, are broken open by the unconditional nature of the fairy tale world. This remains, as in the store of Oriental and Old Nordic tales (less so in the Celtic), correct to the idea, and retains the natural innocence of childlike fantasy. If it lets a man turn into a donkey, it lets him still think and act like a man, though he eats straw and thistles like a donkey. It will not fall into the absurdities that our most recent fairy tale poetry offers us. In [Oscar] Redwitz's *Märchen vom Tannenbaum* [Tale of the fir tree; Mainz: Kirchheim, 1850], [138] the fir tree is supposed to be the symbol of God. The tree loves dry sandy earth; despite this, Redwitz lets its roots dip into a mountain spring—that is supposed to be man, following the natural force of gravity to lose himself in the big wide world, until he is finally in danger of stagnating and drying out. But the tree sends him a saving branch—and so the stream flows upstream to its source! Man's saviour—symbolized by a current-buffeted fir branch! What sterile conifer poetry! A backward-flowing stream! What profundity!

B. Incorrectness in the Particular Styles

Art has in the idea of nature a general norm for the correctness of its entities. But it also produces for itself out of its inner necessity norms to which it must submit in the realization of its works. We call the specific forms of its typical procedure style. A work of art is only correct when it carries through the peculiarity of a specific style. Neglect of this identity becomes incorrectness. This is not the place to derive the different directions in which the ideal has realized itself by becoming style. We have only to pay

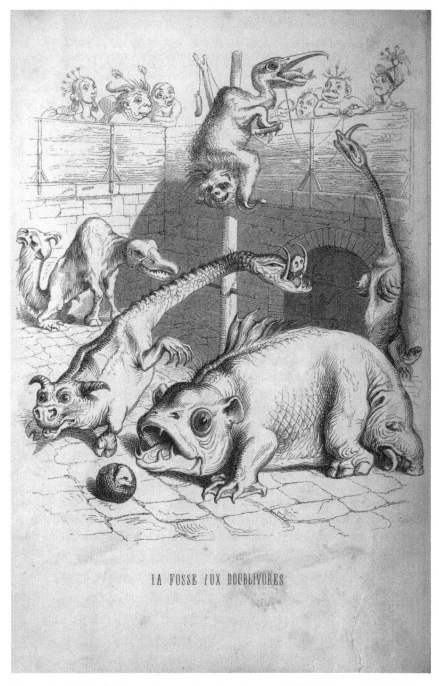

LA FOSSE AUX DOUBLIVORES

Figure 2 J.J. Grandville, wood engraving, *Un autre monde* (Paris: Fournier, 1844), 112.

Figure 3 J.J. Grandville, wood engraving, *Un autre monde* (Paris: Fournier, 1844), 111.

attention to this to the extent that it is required to explain a particular form of ugliness that originates in negation of the individuality of a style.

Out of the idea of beauty itself it follows that the representation in a work of art is possible in a *high* and [**139**] *strict*, or in a *middle*, or in a *light* and *low* style. The artist must decide on one of these modes. Each contains within it gradations that constitute transitions to the others, but each has an aesthetic quality peculiar to itself. Art must insist that its products remain decidedly in one or another of these stylistic modes. Should these be mixed, as it happens especially in novel form, then nevertheless within the mixture the differences must stand out in their purity. The high style excludes phrases and forms that are allowed in the middle; the middle, those which the low style can and must make use of. The high style aims for the sublime; the middle moves proudly and gracefully; the low turns into the ordinary, and even more into the burlesque and the grotesque. It is thus incorrect when a work of art does not carry through the style demanded by its essence. The gravity of the hymn, the enthusiasm of the dithyramb, the swing of the ode, for instance, exclude words and expressions that are innocuous in the simple sociable song. On the other hand, it would be no less incorrect if this gushed forth pomp and grand expressions that only belong in the high style. The history of art offers up analogous phenomena with regard to the purity of style as does the history of science with regard to method. There are very few scientific works that display consciousness regarding their own approach. The majority of scientific studies are not clear whether they treat their object analytically, synthetically, or genetically. And so we recognize in many works of art a [**140**] similar unconsciousness of the artist concerning his relation to the tone he ought to have adopted from the start. In addition, contradictions arise from the fact that motives other than aesthetic ones influence the representation. The grimaces, for instance, which appear on gothic column capitals and which, as is known, often contain very cynical objects, can be tolerated as a luxury of fantasy, which is incapable of weakening the power of the total impression; but they had their origin not in aesthetic reasons, but in other relations, which belonged in part to the social status and traditions of the individual builders' guilds. They cannot be derived from the style of the whole, and to the harmonic sense of a Greek they would appear inappropriate. The trespasses are often not glaring, but certainly palpable. Hölty's *Trinklied* [Drinking song] ('A Life, as in Paradise, grant us Father Rhine') is composed in the middle style, which modulates into the light style. But when Hölty finally sings:

> Long live every German man,
> Who his Rhine-wine drinks,
> As long as to hold his glass he can,
> And then to the ground sinks!

this last turn of phrase goes from the middle and light tone into the lower. To drink until one sinks to the floor—that is brutal. If life in Paradise, which Father Rhine should grant us, ends with this result, it is not very inviting. And to raise another toast to such a reveller is also not too appealing. In the same verse Hölty toasts the female vintner, and declares her queen. How easy it would have been on this basis to arrive at a quite

different, nobler conclusion [141] than that raw joviality which makes the song in the end far too German.

The unintentional mixing of the stylistic modes, the unconscious jumping from one into the other becomes ugly; it will only become comical, when it is done in ironic parody. In the seventeenth and eighteenth centuries, the interiors and exteriors of Gothic churches and city halls were repaired, supplemented, modified in a would-be antique style whose cheerful beauty was not at all in harmony with the German style's tendency to the sublime; a contradiction, which one cannot find comical but only ugly, above all since most of these supplementary constructions were themselves only monsters of the style they were meant to express. But when the falling out of a mode into the other is produced on purpose, it can become a chief source of humour. The great Napoleon reminded his warriors that forty centuries looked down upon them from the pyramids. In a picture we see Faustin I haranguing his half-naked guard in the sparse shadow of some palm trees: 'Soldiers! From the heights of these palms look down upon you—forty monkeys!' The solemn beginning of the speech is contradicted by its ending—but comically.

The general laws of the aesthetic ideal are often individualized to a characteristic particularity through a *national* style originating in the race, locale, religion, and the main occupations to which a nation devotes itself. The more the genius of a nation expresses itself in deeds, the more spiritual content enters into its sense of self and the more individual can [142] become its style in art. A nation does not freely determine its destiny; it is embedded in the tremendous context of the entire life of the world, and is often limited in its existence by conditions that remain hidden to it for the longest time, which sometimes even become clear to it only in the tragic epoch of its fall. For this reason, forms can develop in a national style that indeed correspond to the peculiarity of the nation, but which nevertheless are so entangled with the inevitable, specific limitations of its sense of self that they fail to correspond to the absolute demands of the ideal and, once become habit and general prejudice, hold its art nailed to an imperfect standpoint. A nation then silently assumes in its artists the obedience to these *habitual norms*; insofar as time consolidates their dominion, they become an empirical ideal according to which correctness is measured. Whatever is not brought out within its bounds counts for that people as incorrect. To designate what is problematic in the judgements thus generated, we rightly apply the expression *national taste* for what is individually typical in the art of a nation.

It is obvious that the national taste can correspond to the demands of the ideal; but just as likely the opposite can occur. In this case it is possible that an artist, to the extent that he is correct in the higher sense of the word, becomes incorrect in the sense of the national style. The artist, true to the absolute commandments of art, through this obedience ends up in conflict with the empirically fixed idea. In China, for instance, architecture has developed as building in wood. To [143] protect this wood, which the Chinese regards as the fifth element, against weathering, it has been covered with porcelain tiles, coated with varnish, and painted garishly to break the monotony. The glossy colour of the lacquer, amplified by gilding, has become national, and from that point on, only what corresponds to this bright multiplicity of colours has appeared correct in the Chinese sense. Or recalling that the French supposedly held the abstract

unity of time, place, and plot in the drama to be Aristotelian, and that they raised this theory to their own absolute norm, one will understand readily that to them a violation of any of the three unities must have appeared incorrect. They had thought themselves, lived themselves, so intensely into that abstract unity, that a deviation from the same, however poetic it may have been, was felt by them to be ugly. One has only to remember one of the famous verdicts on the English stage as barbaric that Voltaire delivered from his national standpoint, because in the English theatre the opposite national ideal had developed, with changes of place and time and the passing from the main action to a free multiplicity of episodic side plots, which the French only allowed in the epic.— Should the specificity of a national style become bound up with religious views, this can, in case it is incorrect in the sense of the absolute ideal, hold up for a long time the pure fashioning of the beautiful. Art may have reached higher levels of development, not only in its technique and in its ideal striving, but also in domains that have no direct relation to religion, and yet see itself [144] forced on the religious level to reproduce perpetually the typical shape, however ugly this might be; Gutzkow in his humoristic novel, *Mahaguru* [Stuttgart: Cotta, 1833] has illustrated this in the case of the brothers Hali-Nong, who are tried for heresy in Tibet for having dared to beautify the image of God, and for having modified in their God factory the space between the mouth and nose in the statue of the Dalai Lama to produce a more aesthetic dimension than the holy tradition permitted. So we find in the sphere of Islam painting and sculpture blocked by the Koran's interdiction on the representation of beings with souls; it remains constrained to the field of ornamentation and has had to pour its plastic force of production into the exuberant richness of the same.

We have in the various national styles at the same time various objective forms of the aesthetic ideal. They are insofar the adequate means to express certain conditions, feelings, moods. It is thus part of correctness to find the style corresponding to a particular task and execute it consistently, following its inherent idiosyncrasies. For instance, it may be in accordance with aesthetic truth to render an object in Chinese or Greek or Moorish style. In such a case one would be incorrect in not using the right forms of the respective national style. Recall Montesquieu's exchange of letters between Usbek and Rica, done up in Persian costume; Voltaire's Zadig; Lessing's Nathan; Goethe's *West-East Divan*; Rückert's *Eastern Roses* and so on, compositions ruled thoroughly by the Mohammedan Oriental style. [145]

In a nation, the style in turn tends to run through various epochs or *Schools* of development. A School fixes for a time a peculiar taste, occupying a certain stage of realization of the ideal and therefore, like the national style, able to become a relative aesthetic canon. In general, the direction of a national style will emerge most purely within a school. The ideal of a national spirit will correspond with the ideal of a School; the other Schools of the same nation will appear as departing or emerging moments of development of the dominant School. Such a style will be able to become a lasting organ of art according to the universality to which it raises itself, as when we say today that a picture is painted in the Italian or Dutch style, and at the same time specify that it is conceived in the manner of the Florentine or Roman or Venetian or Sienna School, and so on. Once such an assumption is made, the artist will be incorrect if he fails to conform to the idiosyncrasies that constitute that specific school taste. It is not

impossible that some of these are not correct in the sense of natural truth; the artist would be incorrect in the sense of the School, should he not wish to realize with its individuality also its errors, for without these most likely he will be just as unable to achieve the virtues which distinguish the style of the school.

Here is the place to mention a concept that much exercised Goethe, namely *dilettantism*. [146] Goethe, in his adaptation of Diderot's *Essay on Painting* criticized the latter insofar as Diderot confused the pragmatic necessity of rightness with the aesthetic truth of the ideal. In the well-grounded polemic he addressed to the pedantry of academic stiffness, he became an unguarded apologist of nature, which, according to him, makes nothing incorrectly, for as he says, each shape, be it beautiful or ugly, has its cause, and among all existent beings there is none that is not as it should be. Goethe, the apologist of art produced according to rules, in his turn goes so far as to assert that one should rather say: nature is never correct! 'Nature works on life and being, on the conservation and reproduction of its creature, unconcerned whether it appears beautiful or ugly. A shape meant from birth on to be beautiful can by some accident be injured in one of its parts: with it suffer other parts. For nature needs powers to heal the injured part, and so something is taken from the others that must surely disturb their development. The creature is no longer, what it *should* be, but rather what it *can* be.' Emphasizing the cultivation of a School and the inestimable value of its experience, Goethe exclaims: 'What genius on earth could of a sudden through direct observation of nature, without tradition, decide on proportions fit to grasp real forms, choose the true style and create for himself a method to encompass all!' He followed this tendency in the plan of a work of 1799, of which it may be regretted that it was not carried out, not even by a Goethe [147] enthusiast. With us Germans, if something is ever carried out completely, then it will get repeated until it is shabby, but to make a small step forward and to work further at it oneself is far more rare. The comfortable manner of letting fragments be printed together and making a literary name for oneself with this kind of anthologizing, is certainly not so much in vogue in any nation but ours. The essay we mean can be found in the *Works*, Vol. 44: 'Über den sogennanten Dilettantismus oder die praktische Liebhaberei in den Künsten' [On the so-called dilettantism or practical amateurship in the arts].[99] It contains an exhaustive, often very detailed outline, whose development we would like to recommend or even entrust to a younger force. Goethe first exhibits the concept of dilettantism in general, sets it in parallel to botching in handiwork, specifies it in the individual arts, gives its uses and finally its disadvantages. We would like to extract from these observations that which has to do with the production of ugliness. 'Art dictates to its time, dilettantism follows the inclination of its time. If the masters in art follow a false taste, the dilettante believes all the quicker that he is on the level of art. Because the dilettante receives his vocation to self-production first of all from the effects of the work of art on him, he confuses these effects with the objective causes and motives and believes that he can make the state of feeling in which he is itself productive and practical; as if one wished to produce a flower itself through the smell of the flower. That which means emotion, the final effect

[99] *Goethe's Sämmtliche Werke*, vol. 31 (Stuttgart and Tübingen: Cotta, 1840), 422–46.

of all poetic organization, which, however, presupposes the effort of the whole art, is seen **[148]** by the dilettante as the essence of art and thus he wishes to produce it himself.—What he, in fact, lacks is architectonics in the highest sense, that practising force that creates, constructs, constitutes. He only has a kind of suspicion of it, and he thus gives himself wholly to the material, instead of commanding it. One will find that the dilettante goes in the end above all for *tidiness*, the consummation of what is present, which causes the misunderstanding that the present is worthy of existence. It is the same with the *accuracy* and all other final conditions of form, which could *just as well accompany non-form.*—The dilettante skips steps, insists on staying on certain steps which he regards as the goal, and thinks himself justified in judging the whole from there, thus preventing its perfectibility. He submits to the necessity to act according to *false rules*, because without rules he cannot even seem dilettantish, and after all he does not know the real, objective rules. He gets further and further away from the truth of the object and loses himself on subjective blind alleys. Dilettantism takes from art its element and makes its public worse, by taking away its seriousness and its rigour. All compromise destroys art, and dilettantism introduces indulgence and favour. It pays attention to those artists who stand close to dilettantism, to the detriment of the real artists.—Poetic dilettantism neglects either the indispensable mechanical element and thinks it has done enough in showing spirit and feeling; or it seeks poetry simply in the mechanical with which it can achieve the aptitude of an artisan, and is without spirit and content. Both are harmful, but the former is more harmful to art, **[149]** the latter more to the subject himself.—All dilettantes are *plagiarists.* They enervate and obliterate every original already in language and in thought, in that they repeat it, ape it and thus patch up their hollowness. Thus language after a while gets filled up with plundered phrases and formulas, which no longer say anything, and one can read whole books that are nicely styled and contain nothing at all. In short all truly beautiful and good in real poetry is profaned, dragged around and degraded by dilettantism taking the upper hand.'[100]

C. Incorrectness in the Individual Arts

In general, then, incorrectness consists in falseness, in the deviation from the legitimacy that is immanent in nature and in the mind. More specifically, it consists in infidelity and opposition to the ideal determinacy of a style, against the style of a nation, against the style of a school. If one applies Kant's distinction between ideal and normal existence (*NOTE 31) to the concept of incorrectness, one can say that the aesthetic ideal within the taste of a nation, a School, is developed and fixed into a particular normal existence. A School or a nation then identifies the normal existence that has come to be through an empirical historical process with the absolute ideal. Correctness

[100] Rosenkranz's selection is heavy on the 'Dangers of dilettantism in general' (Goethe, 440), and ends with a passage from the 'Dangers of dilettantism in lyric poetry' (444).

can thus, as we have convinced ourselves, become a negative bound to aesthetic production. [150] But fortunately each art has already in the formation of its means of representation a drive peculiar to itself that breaks through such constriction and produces indubitable incorrectness in the sense of the conventional style, for otherwise it could not satisfy the specific necessity of the correctness required by its art. Here lies the secret that explains why general directions, even if they have won legislative authority, are never able to fully ruin artistic production. It is the individual correctness of the single art that produces this highly objective effect.

All arts should represent the beautiful, but each can do so only within its specific medium. Aesthetics has to develop the rules of the resulting procedure in the system of the individual arts. As previously noted, it would be flat-footed of us to go into detail here, because it could only consist in a litany adding to each positive determination that a deviation from it would result in a transgression against correctness. We have thus to be satisfied with a few general points, on the basis of which such incorrectness will be apparent, as threatens each art in its peculiarity with a form of ugliness specific to itself.

The visual arts allow the appearance of beauty in space, in mute matter. The art of building has the task of raising and supporting matter through matter. It must thus pay attention above all to the centre of gravity. Should it miss this, it becomes incorrect, and all other ornamental or picturesque beauty cannot make good this fundamental error of architectonics. Gravity [151] corrects the error itself, that is, the building collapses; an expensive form of correction, but one very beloved in our time. Apparently the centre of gravity can be moved, but not in reality. Thus the Leaning Tower of Pisa is only apparently in tension with the fundamental law of architecture; it is a masterpiece of technical daring; but no one will find it beautiful, for the art of building must even in the greatest daring of its conditions create a feeling of safety and of permanence.[101] Only when this primitive demand is met can other architectonic consequences be satisfied. A building must rest on the earth, but should, unless it is subterranean, stretch itself over the earth into the air, for matter should indeed carry matter—the wall bears the roof. This carrying force that strives from Mother Earth to the sky gives every building its own characteristic momentum, its freedom. Thus observance of the centre of gravity can be named inner, centripetal correctness, and observance of the ascent out of the earth outer, centrifugal correctness. Thus, for instance, Klenze's otherwise excellent Glyptothek in Münich is incorrect in that it rises so little above its foundations.

The incorrectness peculiar to sculpture arises out of the neglect of the natural proportions of living things, especially of the human form. Works of sculpture stand for us in the fullness of all spatial dimensions as lasting phenomena and thus hurt our sensibility most acutely through lack of mass, too much mass, false construction, impossible positions. The famous *Kanon* of Polykleitos owes its origin to the necessity of art to fix as a reference the normal proportions of the human [152] body. But precisely in sculpture we find deviations from positive natural proportions that, taken

[101] Rosenkranz seems under the impression that the Pisa bell tower was built to lean on purpose; what he says about feelings of safety being required for architectural beauty recalls David Hume's *Treatise of Human Nature* (1740), part III, section 1.

only empirically, could be called incorrect. They are those that are justified through the need for a higher harmony, as was already noted with regard to the general concept of the incorrect. A substantial norm, indeed, may never be transgressed, but surely permissible are those mild, quiet deviations from natural rightness that make possible the full realization of the intellectual content, as in the well-known example of the belly of the Vatican Apollo [Apollo Belvedere], which may not be anatomically entirely correct; we are not, however, aware of this as an error, for the slenderness of the form receives from the slightness of the hips a peculiar elasticity reaching from the ground into the heavens, which harmonizes with the enthusiasm of the head. Colossal forms too would not be correct in the sense of empirical rightness; but for certain goals of bringing about sublime effects they can become entirely correct for art. Nevertheless, in them the degree of proportion and the individuality of the object make a difference. Proportion, for the object cannot be so large that the perception of the unity of the shape suffers; the object, for it must itself have a noble form in order to be beautiful. The colossal bulls and lions in the palaces of Nineveh are beautiful, for bull and lion offer in themselves noble forms; if we imagine, however, an artist wanting to construct in a plastic work a rat sitting on its hind legs, however perfectly, the result would be hideous under any conditions. The [153] same is true of miniaturization, which just the same has its limits in size and the object. Sculpture will also permit itself a tempering of natural normality in the individual members of the body, only of course it may not in the process rove into the abnormal. In order to accentuate a relation, it may swell a muscle more tautly, or allow it to contract more smoothly, than nature makes possible, but it will have to give it the right place and form, for an infraction against basic anatomical truth would avenge itself right away. The Greeks, as is known, exaggerated the natural formation of the orbit (eye socket), but only within sculpture, so as to give the colourless statue the force of possessing a gaze through the deeper-lying eye; optic appearance thus balances osteological incorrectness.[102]

The specific energy of painting lies in colour and lighting; on the other hand drawing as a plastic moment takes a step back. The outlines of the figures must in any case be correct; because painting has to provide the individual shape in the liveliness of its characteristic colouring, in the interplay of light and shade and in the proportional changes of perspective illusion, errors of drawing are more tolerable in it than in sculpture, which offers us its shapes as well-formed, which have their own immediate colour and receive their lighting from outside. In sculpture, then, colour is inessential, for the shape as such matters; to the rigidity of the plastic work [154] individualizing colour stands in opposition; its application is an incorrect procedure, as one feels in the presence of painted statues and wax figures. In cloisters and on the so-called Stations of the Passion of Christ, on Calvaries, one finds sometimes statues, through application of real hair and clothes, approaching naturalness even more than through painting,

[102] Rosenkranz's friend, Franz Kugler, *Über die Polychromie der Griechischen Architektur und Skulptur und ihre Grenzen* [On the polychromy of Greek architecture and sculpture and its limits] (Berlin: Gropius, 1835), 73, agrees with Winckelmann on this cause for exaggerated orbitals; Kugler thought only the clothing of Greek sculpture was coloured.

and the statue receives through such appearance of real life something ghostlike. If one, for instance, climbs in Salzburg the Stations of the Kapuzinerberg up to the Good Shepherd, how gruesomely one meets the glare of the lurid shapes of Jews, soldiers and the martyred Christ behind the wire grates in the rock chamber.[103]

The correct is in fact that beauty which can be learned, aesthetic technique. This can be seen best in music, for although this art represents the most intimate stirrings of the mind, it is nevertheless bound through the nature of sound to the rules of a strict arithmetic, and can for this reason be most exactly controlled in its incorrectness.

In poetry, correctness is less definite, because in it more than in the other arts the depth of the intellectual content is important, and also because this content more than elsewhere can forgive potential incorrectness. Aristotle, Horace, Bouileau[104] and Batteux have tried to specify the rules of poetry and with them the concept of incorrectness. Purity of language, metric rightness, rhetorical perfection and separation of the genres are demands that must be directed at every poetic work. [155] That incorrectness from which our time suffers is due above all to the final point of the list, for we have been getting more than enough epics without struggle, songs without feeling, dramas without plot, and above all the title 'novella' is beloved even when applied to the most characterless mongrel products.

A distinct type of incorrectness is generated through the inappropriate mixture of the arts. They can and should support one another, for they are of sociable nature, and opera has the working together of all the arts to thank for its incomparable power. It is something else when individual arts go forward or backward over their own sphere, wishing to bring forth effects that by virtue of their own specificity must remain beyond their reach. Each art has its strength only within its qualitative determinacy. When it leaves this to seek out effects that are not possible through its medium but only through that of another art, it contradicts itself and falls into ugliness. An artwork can thus only be correct insofar as it holds to the limits that lie within the particular medium of an art.[105] If it overstretches, it will certainly make an effect precisely with this gamble, for it will bring about in such a case something it should not bring about, a strange phenomenon that can in any case be interesting, but which nevertheless violates the bounds of true art. This must be understood aright. That an art supports another is beautiful; that an art extinguishes the individuality of another is ugly. Thus architecture, for example, can be supported by sculpture and even by painting, only this may not happen in such a way that the art of building does not hold on to its self-sufficiency, and that what sculpture and painting [156] contribute to its work retains only the rank of an ornament. The polychromy of the ancients, as it seems from the

[103] The eleven *Kalvarienbergkapellen* (oratories) on the hill *Kapuzinerberg* in Salzburg were built by the Franciscan monks in graphic Counter-Reformation style in 1736–44.

[104] Rosenkranz has Brileau, clearly a typographical error (corrected in the Reclam ed.).

[105] This passage is an enthusiastic echo of Gotthold Ephraim Lessing's *Laokoon: Oder über die Grenzen der Mahlerey und Poesie* (Berlin: C.F. Voß, 1766), which famously distinguished between the arts of time, especially poetry, and the visual arts of space. But Lessing did not make much of 'medium': the word occurs once in his section X, where the 'medium of imitation' is discussed; the contrast of space and time is more important.

reports of Semper and Kugler (*NOTE 32), paid careful attention to this limit. Architecture prepares a site for sculpture and painting; but in order for the acts of these arts not to be crushed by the masses of the architecture, it must take special care and modify the built organism for this purpose, preparing the pedestal for the statue, the wall surface for the picture. Music and poetry can support each other just as well, and poetry can even be sung, but here too it is important that music as instrumental accompaniment does not make the work inaudible and, as in some modern operas, forces the singer to scream and to roar, which can be marvelled at as physical force, but offers nothing beautiful to love.

Lessing has famously tried to draw the borders of painting and poetry in his *Laokoon*. He has sketched out all the incorrectness that comes about from painting forgetting its fundamental condition, coexistence, and poetry its own, succession. He has called the resulting errors in poetry *the addiction to describing* and in painting *allegorizing*: 'in that one wanted to make the former into a speaking painting, without really knowing what it could and should paint, and the latter into a silent poem, without having reflected to what extent it can express general concepts without distancing itself from its calling and becoming an arbitrary notation.'[106] In this investigation, [157] Sections 33 to 35, Lessing excluded ugliness from painting and vindicated it in poetry. But this is a mistake and in his fine way Lessing himself comes to express a doubt, for may not painting in search of the ridiculous and the terrible make use of ugly forms? 'I do not dare to answer roundly with a no here.' He distinguishes in any case a *harmless* ugliness for the ridiculous and a *harmful* one for the terrible and asserts that in painting the first impression of the ridiculous and the terrible disappears promptly and only the unpleasant and the formless remains. In his discussions, however, he takes all the material for his proofs from works of poetry, not from painting, and for this reason, as we will see in the next part of this book in treating the concept of the disgusting, he has defined painting too narrowly.

An inner connection shows itself between the arts, one that represents to us the immanent passage of one into the other. In its noblest organ, the column, architecture announces already the statue, but this does not make the column into a statue. In relief, sculpture already announces painting, but the relief in itself has as yet no painterly principle, for it has as yet no perspective and no shading other than accidental lighting.[107] Painting already expresses the warmth of individual life with such power, that the sound seems to be missing only by accident, but the play of light, the paint tones are not yet real sound. Only music renders in its sounds our feelings. We feel it in the symbolism of its tonal balance, but we long [158], the more it expresses our inwardness, to get from its mystic depth to poetry, and through the definiteness of imagination and the word to reach clarity. The sisterly help that the arts grant one another, and their inner progression from architecture to poetry, are something quite different from the false grasping of the arts after one another, for this does not consist in a natural intensification, but rather in

[106] This passage is from Lessing's Preface (*Vorrede*).
[107] Rosenkranz must be referring to antique relief, since Renaissance relief, e.g., of Bramante and Donatello, is very concerned with linear perspective.

that an art through *usurpation* or *degradation* tries to force out effects which due to the quality of its element are inaccessible or should in any case remain so. If an art acts prematurely without justification, it usurps; or if it sets itself up on a lower level than it deserves in accordance with its concept, it degrades itself; but usurpation and degradation have monstrosity in their train, as the science of the idea shows in one of its general laws.[108] Just a few examples for illustration should suffice. For architecture, falling back on another art is not possible; going forward, it should not weaken its great circumstances through sculpture or painting. Sculpture going backward should not take over the role of the column for architecture. Compared to delicate girls carrying baskets of fruit on their heads, herculean Atlantids[109] indeed make more appropriate caryatids or supports of beam and ceiling; nevertheless, never will such carriers make decisive architectonic members, but always a degradation of the human form, which is too noble to serve as the support of a ceiling beam. To carry the world like the giant Atlas has a poetic sense, for it presupposes quite simply endless strength; but to achieve what a column could do just as well if not better, is against the dignity of the human body. On the other hand, when [159] real columns, such as the Egyptian, have a head instead of a capital, be it the head of Isis herself, that is from the side of column formation an usurpation, that is an aesthetically unwarranted anticipation of the statue. When music tries to paint what can only be seen, it strains its means in vain. The famous passage in Haydn's *Creation,* 'let there be light and there was light!' can never represent light as light, but always only the tremendous movement brought into the universe by its appearance. In *The Seasons* the differences of the natural events and human occupations, themselves equipped with sound, come to Haydn's aid to make the sound itself painterly; the horn's call characterizes the hunter, the charming tone of the pan pipe the shepherd; the dance step of the flute, the field worker. The bubbling of the waterfall, the roar of the storm, the rumble of thunder can be imitated by music; emotions, however, can only be given symbolic expression. One constantly cites as an example of tone painting the scene from Mozart's *Marriage of Figaro* where the 'small, hapless needle' is searched for; but one ought to consider that without this word and the onstage mimicry hardly anyone would get from the music the thought 'here someone is searching for a needle'. Just the same, painting cannot represent what can be expressed only musically or only poetically or even only prosaically. Poetry can indeed through the medium of the word represent everything; nothing can escape its descriptive force; but painting can represent only that which is able to enter the domain of the visible. It is very difficult [160] to lay down something general here that will be valid for all time; for a definite judgement, whether painting oversteps its bounds or not, one will have to stick to the concrete case. The purely inward, lyrical, indeed intellectual, ceases to be painterly; painting has to place subjectivity in a situation, in order to make it painterly.

[108] See Rosenkranz, *Wissenschaft der logischen Idee,* vol.2: *Logik und Ideenlehre* (Königsberg: Gebrüder Bornträger, 1859), 332–42.
[109] Also called atlas, atlantes, and telamons (in Rome), these are decorative elements in the shape of muscular men, usually on façade columns. The older caryatids are freestanding columns, e.g. in the late fifth-century BCE Porch of the Maidens of the Erechtheion, Athens.

A Parisian painter, [Aimé] de Lemud, depicts a painter sitting on a bench, casting a bleak look at a stone pot, while brushes and other stuff are strewn about on a raised platform; beside him with an encouraging gesture, a key in hand, stands a middle-aged dame; both in medieval costume (see Figure 4).[110] What in all the world does this picture want? Without the inspiration of the catalogue we would never guess. It is supposed to represent Jan van Eyck and his sister Margarethe inventing oil painting after many headaches. If only M. de Lemud had read Lessing's *Laokoon*! The invention or rather the discovery of gunpowder can be painted, for one can paint the monk B. Schwarz stepping back in fright from the exploding mortar. Here the explosion makes the scene clear; but the discovery of oil painting cannot be painted, only recounted, as Madame Schopenhauer has done.[111]

Incorrectness within the individual arts can, like every determination of the ugly, turn immediately into the comic, the moment it is exercised on purpose by an artist. In architecture and sculpture indeed little is possible because of the strict simplicity of these arts, as in music because of its arithmetical base; more is possible in painting, and most in poetry. Since the latter represents through language, the incorrectness [161] of the latter becomes a supreme means of humour. *Mistakes of speech, jargon,* and *language clumping* are from the point of view of beauty certainly incorrect. But if they are used on purpose, they can most wonderfully represent the contradiction of the mind with itself, and at the same time its humoristic escape from this state, since language remains always only a means. The otherwise ugly thus becomes most ridiculous, and dramatic poetry thus makes great use of this form of incorrectness. Shakespeare has followed mistakes of speech through all the tones of its tremendous scale with endless wit (*NOTE 33). Of mistakes of speech one can also count *stuttering*, whose comic production the Italians especially enjoy, so that among the Neapolitan masks there is always a Balbutore. Dialect, although in itself correct, can appear incorrect in the context of a cultivated literary language; comics use it thus for contrasts, as did Aristophanes, Shakespeare, and Molière. How lovingly Shakespeare renders Captain Fluellen and Pastor Evans in their dialects! The shepherd's song of the latter makes one laugh even in Tieck's translation[112]:

At quiet prooks, py deir falls
Ring out the birts' magrikals
Let us a pet with roses strew,
And thousand ar'matic plowers too!

[110] Lemud's print illustrated Samuel-Henri Berthoud's 'Légende des frères van Eyck' of 1839, on which see Marc Gottlieb, 'The Painter's Secret: Invention and Rivalry from Vasari to Balzac', *Art Bulletin*, 84: 3 (September 2002), 469–90, at pages 480–3.

[111] Johanna Schopenhauer, *Johann van Eyck und seine Nachfolger* (Frankfurt am Main: Wilmans, 1822), vol.1, 44–7, discusses the invention, without any mention of the Eyck sister Margaretha, whose death is briefly noted on page 52.

[112] Both Captain Fluellen in *Henry V* and Sir Hugh Evans in *The Merry Wives of Windsor* are Welshmen. Above we attempt to Anglicize Tieck's version. Shakespeare's runs: 'To shallow rivers, to whose falls / Melodious birds sings madrigals; / There will we make our peds of roses, / And a thousand fragrant posies.'

Figure 4 Aimé de Lemud, *Légende des frères van Eyck*, 1839, lithograph, Rijksmuseum, Amsterdam.

Jargon differs from dialect in being plundered from various domains of a language and yet reaching a kind of unity of its own, like thieves' cant, the argot of the *bagno*,[113] as well as the linguistic chaos of the big city rabble. [162] Bulwer, Sue, and others have made ample use of this at times for effects of terror as well, for such a language apart makes us fall out of well-behaved, educated bourgeois society. We shudder to hear the language of barbarity that lives among us in the darkness of secrecy and is for us the language of our enemies. For this very reason the Berlin jargon has experienced such a broad expansion for the past few decades, because it contains a certain element of cheerful self-irony that domesticates it, so to speak. In Glasbrenner it has found its classic, and Tenant Strumpf, Herr Buffey, Madam Pisecke, Buffey's son, Willem, and so on have become as popular as before Bäuerle had made the Viennese dialect with his Herr Staberl. That jargon also makes mistakes of language goes without saying.

Distinct from jargon and mistakes of language is language-clumping. Since each language should be a harmonious whole, strictly speaking all words borrowed from another language should be criticized. Only purism should not be pushed this far. Where mixed languages are born, such as today's Romance languages, or where the cosmopolitanism of universal civilization, as in Europe and America, drives the nations to the most intimate interaction, purity of language has become an impossibility. Indeed it may even become a mistake in a specific case not to use the foreign word that is best understood. The clumping of languages becomes ugly when it destroys aesthetic unity, as in our literature at the middle of the seventeenth century; a mistake, that among us Sealsfield also commits often, [163] in outing the characteristics of different nations by a mixture of their typical phrases. But language clumping becomes comical as soon as it seems to express an inner contradiction, as in the *Gryphius Horribiliscribrifrax*, or as soon as it makes the ridiculous attempt of making a whole new independent language arbitrarily out of two existing ones, as this happens in so-called *macaronic* poetry (* NOTE 34). But precisely the history of the latter shows that it can only be brought forth successfully where the languages have a certain relatedness, as do the Italian with the Latin. For this reason Theophilo Folengo will always remain the greatest macaronic poet.—The word clumping of the *Epistolae obscurorum virorum* is not macaronic, but in truth only, to use what one calls a Germanism in Latin, *vulgo* kitchen Latin.

[113] *Bagno* or *bagnio* could designate many things in eighteenth- and nineteenth-century Europe, from the slave prisons of the Ottoman Empire to London brothels and French forced-labour camps. Given the context, Rosenkranz seems to have the latter in mind.

[164] Part Three

Disfiguration, or Deformation

Ugliness is no mere absence of beauty, but rather a positive negation of it. What does not fall by definition into the category of the beautiful also cannot be subsumed under that of ugliness. An arithmetical exercise is not beautiful, but also not ugly; a mathematical point that has no length or breadth is not beautiful, but also not ugly; the same goes for an abstract thought, etc. Since the ugly positively negates the beautiful, it should not be taken for a tyranny of the sensuous over the spiritual, as some aestheticians myopically define it. For the sensuous as such *is* the natural, and the natural, as we saw earlier, is indeed not necessarily beautiful by definition, since above all things it strives to be purposeful, so that teleological unity subordinates aesthetic form. Nor is the natural by definition necessarily ugly: on the contrary, it can be beautiful without contradicting its concept, as inorganic nature in its elemental form already shows us. What beauty can be found in a mountain, a cliff, a lake, a river, a waterfall, a cloud! If the proposition that the sensible is the principle of ugliness were right, everything that is only natural would have to be ugly. —[165] On the other hand, the spiritual can just as little be maintained to be the principle of beauty, because, for starters, sensuousness belongs to beauty as one of its constitutive moments. The spiritual in its abstract isolation from nature, in its interiority with its negativity toward the sensible, is no aesthetic object. It only becomes one where through the mediation of nature or art it steps into the circle of finite, sensibly perceptible appearance. — Thus one also cannot say that evil with its feeling of damnation is the principle of ugliness, for though evil and its sense of guilt can be the cause of ugliness, this is also not downright necessary. Religious imagination expresses this popularly by saying that the devil can also disguise himself as an angel of light—which is after all what he originally was. Ugliness, for its part, can come into being without recourse to evil. As for the sense of guilt, as long as it is not the hair-raising fear of punishment, it can lend a face to the unearthly beauty of true contrition that painters try to give to the penitent Magdalene. When a sculptor makes a bad statue, a composer a bad opera, or a poet a bad poem, the ugliness of his production need not derive from an ugliness of his heart, from his very badness. They may be the best people in the world, who despite this suffer in matters of talent and skill. Goodness itself can become the cause of ugliness, as we see in some difficult, dangerous, and dirty human labour. Workers in arsenic mines, white lead factories, and sewers, chimney sweepers,

etc. are certainly most worthy [**166**] of admiration for their effort; but are they beautified by it?

We have convinced ourselves that the possibility of ugliness first manifests itself through injury to the general clarity of proportion found in unity, difference, and harmony; a negation which as such does not yet have anything to do with oppositions between nature and spirit, good and bad. — We have further convinced ourselves that ugliness can originate whenever the particular definition of form possessed necessarily by the natural and the spiritual is negated. The correctness of an appearance consists in the unobstructed correspondence between the individual and the genus, in the completeness and rightness with which the appearance conforms to its essence. Should this norm be infringed, this results in incorrectness, in an ugliness which suffers from many limitations, because bare correctness has to subordinate itself to ideal truth. — In fact, the ultimate ground of beauty is nothing but *freedom*; this word is meant here not in the bare ethical sense, but in the general sense of spontaneity, which is indeed perfectly consummated in moral self-determination, but which also becomes an aesthetic object in the game of life, in dynamic and organic processes. Oneness, regularity, symmetry, order, natural truth, psychological and historical accuracy cannot yet by themselves satisfy the concept of the beautiful. This demands, in addition, the imparting of a soul through self-activity, through a life that streams from beauty.[114] We must admit that this self-activity can be a truth from the aesthetic point of view, but it can also be pure illusion from the point of view of reality. Aesthetics may [**167**] rest content with the illusion. When the jet of a fountain squirts through the air, the resulting appearance is a purely mechanical product of the height from which the water must first fall; but the violence with which it shoots out lends the water an illusion of free movement. A flower waves its petals back and forth. The flower does not really turn itself this way and that, back and forth; the wind pushes it. But illusion makes the flower appear to be self-moving.

Without freedom, thus, no real beauty; without *unfreedom* or constraint, no real ugliness. Formlessness and incorrectness reach their pinnacle, their genetic ground, only in constraint. From this origin the deformation of forms can develop. Beauty in general becomes in the particular case a distinction between the sublime and the pleasantly beautiful; this distinction is overcome in absolute beauty through the marriage of dignity and grace. In what strikes us as a natural classification of the subject, the sublime is not opposed to the beautiful, as is customary since Kant, but is treated as itself a form of beauty, as one extreme of its manifestation, through which it turns into the infinite. For the very same reason, this classification treats the pleasant as a positive, essential form of the beautiful, as the other extreme of its manifestation, the passage of beauty into finitude. The sublime and the pleasant are beautiful, and, as beautiful, as opposed to each other, they are coordinated; but they are subordinated to

[114] The end of this sentence is an interpretation. Rosenkranz literally writes: 'through a life that streams from it'. His 'from it', 'ihm', is masculine, and thus cannot refer either to the imparting of life or to self-activity (*Beseelung* and *Selbstthätigkeit*), both feminine. The only male noun in this discussion is in the previous sentence, 'the concept of beauty'.

absolute beauty, which, as their concrete unity, for this very reason is just as much sublime as pleasant, since it is not one-sidedly one or the other. Ugliness as the negation of beauty must therefore positively invert the sublime, the pleasant, *and* beauty pure and simple; through this inversion [**168**] it comes into being. Paradoxically, one could say that the sublime, the pleasant, the worthy and the graceful are beautiful, but they can *become* ugly; but such paradoxical statements are dangerous to right understanding, because they lend themselves to being taken without qualification. In our case, that would be as if the sublime and the pleasant were not beautiful, as if absolute beauty did not exclude from its domain all ugliness. Weiße in his *Aesthetics* is even so bold as to assert, in the dialectical course of his argument, that the immediately beautiful is the ugly (* NOTE 35a). Abstract understanding nowadays rewards such boldness, which was not at all uncommon among the Greek philosophers, only with ridicule, since it fails to dive into the depth of things, because it does not, like Faust, descend to the Mothers, who nurse all becoming in their darkness. To understand ugliness we must grasp it not as simply endowed with being but as becoming. The sublime is negated when it shows not the endlessness of freedom but the finitude of unfreedom. Not the unfreedom of the finite, which is aesthetically harmless. But the finitude that lies in unfreedom becomes a contradiction to freedom, whose essence is endless in itself. In this contrast we call the result mean. Meanness only has a sense as long as it should not be, since it contradicts essence as something that should be free. The concept 'sublime' determines the concept 'mean.' For example, we call a physiognomy mean when it reveals its owner's dependency on some vice—because such a dependency is against the concept of the human, which as such should be above it. — The pleasant allows freedom [**169**] to appear in subordinated determinations, in finite relationships. It binds us through the charm possessed by the self-restraint of freedom. The pleasant is therefore really and genuinely the socially beautiful; and the most sociable nation, or better yet the most social nation, the French, articulates its own recognition of the beautiful more in the predicate *joli* than in that of *beau*. Freedom's negation, which plays with its finitude, is the cancellation of freedom through an unfreedom that contradicts itself. Such a thing is repulsive because it negates limits that freedom necessitates, and sets limits which freedom does not permit. Freedom in a state of unfreedom is repulsive, and for that reason the repulsive is opposed to the pleasant; for it manifests freedom in a contradictory state, the finite, which should only be a moment and means of its movement, giving it a limit which is not overcome while dissolving limits that should belong to it. Why for instance is the decay of living matter a repulsive sight? Surely because in decaying it falls prey to elementary powers, over which it ruled as long as it lived. Decaying, it still shows us the form in which we were accustomed to seeing it as a self-determining essence in control of its basic presuppositions; only now we see this same form dissolve itself, we see it surrender to precisely the powers it dominated in life. This is repulsive because that which is free by definition ends up in a state of unfreedom disintegrating into finitude, which dissolves the necessary limits of a living thing. The decaying falls apart and runs together, and however necessary [**170**] the process might be under the circumstances, it is repulsive nonetheless, since we make for ourselves the aesthetic fiction that the form still carries in itself the forces of life.

Meanness and repulsiveness naturally go together, but they are also distinct. The mean generally becomes repulsive as well. Someone overdoing eating and drinking is a case of meanness. But if he throws up as a result, meanness crosses over into repulsiveness. The finitude of unfreedom becomes a condition of unfreedom in finitude. Excess inverts the orderly progression of nature and degrades the mouth into an anus.

In absolute beauty the sublime becomes nobility and the pleasant becomes grace. The endlessness of the former becomes thus a power of self-determination, and the finitude of the latter becomes the softening of self-limitation. The ugly analogue of absolute beauty is therefore the aesthetic configuration which brings the finitude of unfreedom into a state of the unfreedom of the finite, but represented in such a way that unfreedom takes on the *appearance* of freedom and finitude that of the endless. Such a form is ugly, for the truly ugly is the free which contradicts itself through its unfreedom, and sets itself a limit in finitude which should not be. Through the appearance of freedom, however, ugliness is tempered; we compare it with the form that constitutes its ideal counter-image. This comparison carries the ugly phenomenon over into the comical. The self-destruction of the ugly through the appearance of freedom and endlessness, which erupts precisely out of the distortion of the ideal, is comical. We call this peculiar form of ugliness [171] caricature. In Italian, *caricare* means to overload, and from this we usually define caricature as an exaggeration of the characteristic. In general, this definition is correct; in getting down to specifics, it requires more precise definition of the context in which the phenomenon occurs. The characteristic is the key element in individualization. If this exaggerates the individual, the general disappears as a result, in that the individual, so to say, spreads itself out to stand for the whole species. Precisely thus does the need make itself felt to compare the high contrast of hyperindividualization against the measure of necessary generality; precisely in this reflection lies the essence of caricature. Absolute beauty positively balances the extremes of the sublime and the pleasant in itself; caricature on the other hand sends forth the extremes of the mean and the repulsive, but in such a way that at the same time caricature allows us to look through to the sublime and the pleasant, equating the sublime with the pleasant, the pleasant with the sublime, the mean with the sublime, the repulsive with the pleasant, and the nullity of the characterless void with absolute beauty.

This illuminates the impressive many-sidedness of the concept of caricature, and even the possibility of its extension to the concept of ugliness. For this reason the merely formless or incorrect, just as much as the merely repulsive or mean, is not yet caricature. The unsymmetrical, for example, is no caricature; it is simply the negation of symmetry. Only with an exaggeration of symmetry to where it no longer really belongs does the distortion of the same become caricature, a going beyond the thing's concept as required by the proportions of the symmetrical. Or, if someone mixes proverbs in his speech, [172] that is not yet incorrect; but when someone, like Sancho Panza, ends up speaking only in proverbs, the resulting aggregate of proverbs becomes a distortion, through which the sententious force of the judiciously applied proverb trickles away through overuse. An unpleasant physiognomy is as such not a caricature; but when a face seems to sprout forth as just one of its parts—when it seems to be all jaw, all nose,

all forehead, etc.—there distortion arises; a person with a so-called strawberry nose makes us search, so to speak, for the other parts of his face.[115] And just the same, the repulsive by itself is in no way caricature. When repellent circumstances force a person to yield unwillingly, this is likely to evoke our most intimate sympathy, as in the case of epilepsy. But when, in Aristophanes' *Ekkleziazusen* [Council of Women], we see Blepyros step out of his house early one morning to defecate, wearing his wife's hastily thrown-on robe, the repulsive is comedized into caricature, since Blepyros thinks he acts unobserved (* NOTE 35b).

A great artist like Aristophanes adds to such goings-on an exuberant multitude of allusions, quite aside from the fact that he thus naturally motivates the early rising of Blepyros through the pressure of 'Master Kothios', [Shitus] as Voß translates. Where in particular is caricature to be found here? Obviously in the fact that Praxagora, the wife of the honorable Athenian petit bourgeois, has already gone to the market in her husband's clothes to take part in a council of women, and while Blepyros flails about executing nature's call, in the other place a different [173] executive body of the community sets itself to legal reform. The men, we are meant to gather, are no longer men; the women are here men. For this reason does Blepyros equip himself with his wife's underfed little jacket and her Persian shoes; his neighbour steps up, and the two respectable citizens converse exclusively about Blepyros's bowel movement, which had suddenly 'been blocked in its course by a wild pear'. Witty conversational material, surely, that Aristophanes instantly turns satirical, attaching to the scene not only a number of political allusions but also ridiculing those poets who sought in their comedies to replace for the public the 'Attic salt' they lacked through such an excess of crude cynicisms.[116]

Caricature drives the particular over and above the proportionate, generating thus a disproportion; in reminding one of its ideal opposite, caricature becomes comical. It *becomes* comical in this way, for in itself it is not necessary for any caricature to have a comic effect, since as distortion it is really just as possible for it to be simply ugly or frightful. For example, uniform enlargement or shrinking of an object of normal size would not yet produce a caricature, because in such stepping over or falling behind the norm, the unity of all relations would be preserved. Napoleon's Statue on the Vendôme Column is colossal and must be, to match the proportions of the surrounding houses and the column itself. A replica of this statue made of cast iron, in finger-size, which we put on our writing desk, is no caricature. A Lapp, four feet high but perfectly proportioned, is as little a caricature as the dwarf birch that grows on his pastureland. Dwarf size is the [174] normal dimension of the Lapp. A Bushman on the other hand, whose head is big, whose thigh is thin, whose legs are almost fleshless, wanders already into the apelike and thus becomes a caricature of the human form.[117] A particular

[115] *Rhinophyma* (German *Pfundnase*) is a severe form of the chronic skin irritation *Rosacea*. Rosenkranz may have in mind Ghirlandaio's *Old Man with Child* of 1488.
[116] 'Attic salt' is a pedantic way to say 'dry wit', common in English and German authors of the eighteenth century. A relevant use is Jean Paul's in the preface to *Blumen-, Frucht- und Dornenstücke oder Ehestand, Tod und Hochzeit des Armenadvokaten F. St. Siebenkäs im Reichsmarktflecken Kuhschnappel*, vol.1 (Berlin: Matzdorff, 1796), xxiii.
[117] An extended examination of this passage is found in the editors' Introduction to this vol.

moment in his unilateral overgrowth first brings to the form that rupture that deserves to be called caricature, while we also tend, as we just reminded ourselves, to regard all ugliness as a distortion of beauty. For instance, we are not prepared in daily life to call Phorkyas a caricature just because, in contrast to the beautiful Helen, she represents ugliness in general or aesthetic evil. In a narrower sense, however, these toothless jaws, wrinkles, fleshless arms, flat and withered breasts, these hurriedly sluggish gestures, are just simply ugly and almost veering into the horrible. To be caricature, there would have to be in Phorkyas a particular point of deformation tending toward the abnormal; but one doesn't find it, unless it is her extreme, skeletal thinness. On the other hand, the giant ladies of the New Year's Fairs tend to seem distortions of form not through their size, but through their unformed thickness. For the break in form to amount to caricature, it must have finitude for its form and unfreedom for its content, only it must at the same time possess the appearance of freedom, for without this the phenomenon sinks back partly into sheer meanness, partly into sheer repulsiveness. The greater this illusion of freedom becomes, the more is caricature comically animated. The exaggeration of the characteristic, the overflow of the disproportionate, must appear to be its own act. Comedy loves for this reason to make use of the contradiction of people's opinions [175] and their real qualities and circumstances, because through the freedom that they gain through ignorance of their true colours the stimulus to ridiculousness is amplified. A hunchback, for instance, can be ugly; he can despite this consider himself very handsome; indeed, he can, as one may have observed with many hunchbacks, be hardly aware that he is a hunchback. He then entertains a pretension to beauty, to normal formation, and only thus does he become a caricature and indeed a comical one, since his own deportment invites us to compare him with his normal form.

But that is enough of such preliminary illustrations. They should only need to make us recognize that the final cause of ugliness as disfiguration, as the mean and the repulsive, lies in unfreedom. Unfreedom is no straightforward absence of freedom, but a positive negation of actual freedom. But if we posit unfreedom and the negative aesthetic form that results from it as a product of freedom, then just through this— apparently—unfreedom is overcome. We can perhaps express this difficult dialectic more precisely thus: the mean, the repulsive, and emptiness are products of freedom, which in such circumstances unfolds itself as unfreedom. But when this unfreedom forgets its conflict with real freedom, when it wallows in self-satisfied comfort, when it finds satisfaction in the mean, repulsive, or empty and ignores in them the existence of the ideal, then the phenomenon formally fills itself in this manner with freedom. This makes caricature funny. Unfreedom is thinkable without being mean or repulsive. Epictetus as slave, Jan Huss, Columbus, Galileo in [176] prison, all these were outwardly in an unfree condition, which did not however stain them with meanness. Because inwardly they remained true to freedom, their situation does not strike us as mean or repulsive, but sadly sublime. Even so is a cancellation of real unfreedom possible, without any uglification, but on the contrary through a passage to real freedom as beautification. But the freedom that we are here trying to describe is the spontaneity of self-immersed unfreedom. This free unfreedom makes absolute the characteristic as a finite side of individuality, thus splitting itself off from the ideal, remaining however in

harmony with its seeming reality, and affording the viewer through such contradiction the stuff of laughter.

————

A. The Mean

The scientific presentation of ugliness cannot forget that it can only extract its logical guidelines out of the positive ideal of beauty, for ugliness can only arise in and out of beauty as its negation. The concept of ugliness is in the same situation here as the concept of illness or of evil, whose logic is likewise given through the nature of the healthy and the good. Now it would seem that the needs of science could be met most thoroughly through the greatest logical precision, for as Schiller says, whoever wants to contribute to knowledge must dig deeply, distinguish sharply, connect on many sides, and persist firmly. No one will deny this. Only, the [**177**] writer will also have to elucidate the concept through examples, especially in a domain that has been less cultivated; only with the example will he often be able to dispel the doubt clinging still to his abstract definitions. With the example, however, he runs into a new danger, for, being a specific case, it limits the generality of its truth and threatens a mixture of the accidental with the necessary. Thus Schiller says rightly (*NOTE 36) [']that a writer interested in scientific rigour will make for this very reason very unwilling and very sparing use of examples[']. Despite this we will in what follows have to transgress this generally correct rule, because we have here to deal with an object belonging to experience, whose abstract conceptual definition we have to test, as it were, on the example. The impatience of people when it comes to applying the general to something specific, the lack of practice of most readers in remaining long among pure conceptual definitions, forces the contemporary writer, as soon as he wishes to present his subject to a larger circle than that of the schools, to the concession of thinking much in examples. One need only think of the history of a concept, and see how its traditional conception is dependent on one example, to acknowledge the extraordinary importance of the same. Lessing was certainly a man of precise, conceptual definition. But observe in our field how often it has been repeated after him that we can indeed imagine Thersites as composed by Homer, but that we could not see one painted; a thought to which Lessing himself first came through the Comte Caylus, who in [**178**] his drawings to Homer had left out Thersites. Schiller in his essay on the use of the mean and the low in art goes further while following in Lessing's footsteps, asserting that we would be unable to tolerate a painting of Homer's Odysseus disguised as a beggar, for with such a view too many low subsidiary images are connected. An entirely groundless opinion, concerning which painting fortunately has never worried.

The truly beautiful is the happy middle between the sublime and the pleasant; the happy middle, namely, which fills itself to the same degree with the infinitude of the sublime and with the finitude of the pleasant. Sublime beauty is a form of beauty that is definite in and for itself. Kant, in the *Critique of the Faculty of Judgement*, has set the definition of the sublime entirely within the subjective, for according to him it should be something that proves a power of the mind going beyond the sensible in its bare

thinkability alone. This theory has not just been extended in Schiller's famous distich, which denies the sublimity of infinite space,[118] but has been taken so far that, as in Ruge and Kuno Fischer (*NOTE 37), nature is debarred from the sublime in general. This is a mistake, for nature is, among other things, also sublime in itself. We know very well, where the sublime in it exists; we seek it out, in order to enjoy it; we make it the goal of troublesome journeys. When we stand on the snow-covered peak of smoking Aetna and see Sicily before us between the coasts of Calabria and Africa, washed by the sea's waves, the sublimity of this view is not our subjective act, much [179] rather the objective work of nature, which we already expected before we reached the peak. Or when the Niagara Falls, its spray rising into the heavens, thunders over the shaking walls of stone for miles round, it is in itself sublime, whether a human witnesses this theatre or not.—As for what concerns the sensible, this is not in the least a counter-argument to the sublime. Neither nature nor art can abstract from the sensible. Kant had also only spoken of the power of mind which transcends all that is sensible; later authors have eliminated the sensible entirely from the sublime, placing the latter exclusively in the moral and the religious. The sublime has the finite, sensible, in itself, in that it at the same time goes beyond it. Not only we think the infinite, but the infinite realizes itself, and this experience relieves us of the bounds of the finite.[119] The elevation of our mind only repeats what is objectively present. When standing upon ice-crowned Aetna we look upon sky, earth, and sea in such grand circumstances that what is otherwise the boundary of the horizon lies deep below us, this experience liberates us from all subjective narrowness and raises us to the gods ruling outer space, as Hölderlin in his *Death of Empedocles* so wonderfully put it.

One could spare oneself a deal of misunderstanding of the concept of the sublime also by observing its distinctions, instead of identifying them all with the general concept, as is often done, for the sublime is on one hand that form of the beautiful that is the negation of freedom through the cancellation of its bounds, [180] whether they be real or ideal, realized in such a way that its infinity becomes an object for us: in other words *greatness*; on the other hand it is that form which represents the infinity of freedom in the *power* of creation or destruction; finally the power abiding in itself with quiet self-certainty in the greatness of its creation or destruction: in other words, *majesty*. In greatness freedom rises over its bounds; in power it unfolds, positively or negatively, the strength of its essence; in majesty it appears equally great and powerful. From this it follows that the mean as the negation of the sublime is 1. that form of the ugly which reduces an existence within and under the boundaries that belong to it: that is, *pettiness*; 2. that form that makes an existence fall behind that quantity of force

[118] Which poem? Kliche (2007 ed., 438) suggests 'Schön und Erhaben', which, however, neither denies sublimity to anything, nor is it a couplet. Likelier Rosenkranz had in mind 'Das Kind in der Wiege' [The child in the cradle, 1795], which in English goes: 'Happy infant! An infinite space is still your cradle / Become man, and narrow will be the infinite world.' This is not very decisive, but perhaps it may be read as making infinite space too comfortable to be sublime. For evidence that Schiller stood closer to Rosenkranz than the latter thought, see the text cited in the editors' Introduction, note 45.

[119] Thanks to Kant, few philosophers in the early nineteenth century believed in real (as opposed to potential) infinity. In Rosenkranz's time Bolzano offered the only sustained defence of this view, which became orthodox only through the efforts of Georg Cantor.

that should reside in it by its essence: *feebleness*; 3. that which combines limitation and impotence with the subordination of freedom under unfreedom: *baseness or the low*. Thus on the side of the sublime and the mean, there stand as opposite concepts the great and the petty; the powerful and the feeble; the majestic and the low; opposites that *in concreto* according to their fine shadings are also labelled with many other names.

I. The Petty

Greatness of size (*magnitudo*) in itself is not yet sublime; twenty million dollars (*Thaler*) make a great inheritance, one probably very pleasant to own, but there is certainly nothing sublime in it. Even smallness [181] (*parvitas*) is in itself not yet mean. An inheritance containing only ten dollars is very small, but it is nevertheless an inheritance, and by no means contemptible. An 'Our Father' written very small on a cherry stone, is not for that reason ugly, it is nothing more than written very small. Smallness can in the right place and time be aesthetically as necessary as greatness. Even extreme smallness, like extreme greatness of size, can be justified in a given case. The petty, however, is the concept of a smallness which should not be, namely that which degrades an existence below its necessary limits. The sublime in dimension cancels through its infinity the bounds of space and time, of life and will, the differences of education and class; it thus realizes freedom. The petty by contrast reasserts these bounds beyond the degree of necessity that is rightfully theirs; it becomes, in making them absolute, the reversal of greatness. Schiller says everything is mean that does not speak to the mind and wherein one can only take a sensuous interest. With these words he wanted to hint at the element of unfreedom that characterizes the mean. Pettiness is only mean in that it limits the freedom of an existence in a domain where that is not at all necessary. For instance, we call a person petty in daily life if a pedantic observance of the inessential hinders the realization of the essential; such a person is unfree with regard to the inessential, he cannot elevate[120] himself above it.

Of nature and its single entities pettiness can be predicated only seldom and relatively; [182] but in connection with landscape this concept will be applicable to it only too often. There are neighbourhoods stamped with unfreedom. *There* are cliffs, which do not impose on us either through mass or height; *there* is a waterfall, but so light that it hardly suffices to drive a millwheel; *there* are trees and bushes, but small and thinly strewn; *there* are valleys, but really only trough-shaped erosions between modest hills; *there* creeps a river and even forms an island, which, however, is only a small, weakly green sandbank—how petty all that is!

In art, pettiness lies either in the object or in the handing; in the object, if this is unworthy of representation through the nullity of its content; in the handling, if this busies itself with the broad execution of secondary features and forgets to bring out the essential; or even when, taking on the large in itself, against its concept it comes out small. The object of art should not be petty; that is, not that art should not represent the

[120] *erheben* (to raise), the verb form of the German for 'sublime', *erhaben*. This makes Rosenkranz's argument neater, for he sees in unfreedom a failure of elevation.

simple as it appears in certain circumstances. By no means. Genre in painting and the idyll in poetry show us that art knows how to find beauty even in the huts of the poor. George Sand in her newer stories, in *Jeanne*, in *La Mare au diable* [The Devil's Pool], in the *Petite Fadette*, has rendered the peasants of Berry; the greatest simplicity of character and situation and the highest fidelity in the emulation of reality has not impeded her from propounding the whole richness of the human mind with such admirable depth that at the end of such a [183] story one asks oneself involuntarily whether one has really only been reading about simple peasants and in part, even, in their own naïve language. Thus far is the apparently mean material ennobled by the handling. A shepherdess like Jeanne, a farmer like Marie, a gooseherd like Fadette, without any affected fiddling apropos their rural condition, seem to us, through the purity of their souls, through the height of their spirits, truly great. But when a poet takes a wholly indifferent matter as his object, as a kind of *Diminutivum*, it becomes petty and further on even repulsive. In Rückert's *Gedichte* [Poems], 1836, Vol. 2, p. 145, No.38, for instance, we find the following verses:

Last night I brought from visiting my sweetheart,
(What a nagging little love-memento!)
Ah, a little flea back home with me, which now,
Missing its virginal appointments,
Hopping, digging, quails me the whole day long.
At evening, on my sofa laying,
As the hour comes, when I thought
To go out and the little flea to take with me;
I hear how outside the rain is pattering,
And I say: well, I cannot go out today!
The little beast cavorts on me tremendously.

One can only find such stuff petty. A lover who sings the little flea of his beloved; a lover that lets himself be stymied from going to his beloved by rain; a lover who very comfortably stretches on the sofa with his affect, only to study the criss-crossing progress of the beloved little flea—is tremendously prosaic.—Pettiness can, however, also lie in the handling. [184] Art falls into this error when it immerses itself so deeply in the secondary that it is thus completely distracted from the essential. It grants then the subordinate a breadth of space it does not deserve in relation to the main point. In an epic, for instance, it is true that the locale, clothing, weaponry, and so on should be presented. But if this goes beyond the poetic purpose, describing them to us as is done in the newer novels, wherein plants are treated with scientific precision, even with the addition of the Latin name; describing clothes with the care of a fashion journal, furniture and household goods with technical accuracy; such explicitness becomes petty and thus ugly.[121] Even better writers, like Balzac among the French, or among us

[121] One wonders whether Rosenkranz knew Herman Melville's *Moby Dick*, published in 1851. A large part of the book paraphrases treatises on whaling; Ch. 25 of the American edition, for instance, details the use of sperm oil in British coronation ceremonies!

Max Waldau in the first edition of his novella *Nach der Natur* [After Nature], suffer often from these petty traits. In the same way poetry can become petty in dealing with the intimate side of the spirit, as for instance when it exposes feelings to rambling analysis, and develops the reports of psychological pragmatism to us, without any objective justification, into hair-splitting distinctions. Even an aptitude for great feeling can be swept away by such handling with its subtlety of dissections. This was the error of Richardson in his *Clarissa* and *Pamela*; this the error—one may well say it today, without being anathemized—the error of Rousseau in his *Nouvelle Heloïse*. The pettiness of handling can also consist in a great design being executed in too tiny a fashion, and, against its concept, becoming dwarfed in all its circumstances. The small, as already noted, εὔτοπος καὶ [185] εὐκαίρως [*eútopos kai eúkairos*, in the right place and time], justifies itself. But if we think of a great content, miniaturized not only in one aspect of its execution, but conceived the whole way through in too small a fashion, it would become necessarily an ugly phenomenon. The smallness of forms in which it is represented contradicts then the greatness of its essence. For instance, should a church be built, such a building must pronounce the great purpose it serves unambiguously. It should express the unity of a national congregation (*Volksgemeinde*) and thus give an experience in its walls, doors, windows and so on, which goes beyond the private life. If instead we should look upon a characterless building that could as easily be a horse stall, a garden house, or depot (*Ressourçe*), that is, in contrast to the sublimity contained in the concept of a temple, petty and thus mean. A church can, naturally, also be small; a chapel is indeed just a small church; but its style must be noble and express the greatness of its purpose in its totality. Our time calls such churches, which could just as well be factories, train stations, and so on, polka-churches.

That the petty as parody of the great, namely also of the falsely great, can become comical, is obvious, for through its exaggeration it then annihilates itself. Thus Gutzkow in his *Blasedow* has wonderfully portrayed an old man, whose image of the ten dollars he lacks fills his entire consciousness, and everything reminds him of the ten dollars, until they are inflated by his fantasy into a monster. The little flea in Rückert's poem had to seem to us a petty object; the same little beast as object [186] of an epic descriptive poem makes us laugh, as in that macaronic *Floïa* that begins thus:

Deiriculos canam, qui bene huppere possunt etc.
[See, little Deira, how well I can hop etc.]

In the handling of an object, a humorist like Dickens' Boz [i.e., the fictive author of Dickens' 1836 *Sketches by Boz*] may without any danger dwell on the most minute details, as in *David Copperfield* for instance the most prolix description of the solemn ceremony with which Micawber prepares punch; or the pains the little woman goes through in keeping her household account book, and so on, is not too long for us.

An object large in itself can with premeditation be handled in a small way; it is then travestied, as with the *pius Aeneas* in Blumauer's *Aeneide*, or it will be mercilessly satirized, as the enthusiasm of the heroic Jeanne D'Arc in Voltaire's *Pucelle d'Orléans* (* NOTE 38) is derived from a variety of petty, indeed scandalous motifs.

II. The Feeble

The petty can be at the same time the feeble, just as the feeble is generally also petty. Nevertheless, there is a difference between the two. The petty demotes an existence under certain bounds, which it should instead exceed; the feeble lets the force of an existence fall below that quantity which it should possess according to its essence. The sublime as the dynamic sublime[122] expresses its infinity in creation and destruction. It appears as force or violence and can also become frightful and [187] atrocious. The feeble, on the other hand, reveals its finitude in the impotence of production, in the passivity of tolerating and suffering.

Weakness in itself is not yet ugly, just as little as the small in itself is ugly. It first becomes so when it appears where force is expected. Freedom as the soul of all true beauty manifests its power in creation and destruction, or in resistance against a power; weakness shows its lack of force in the unfruitfulness of its doings, in giving way to violence, in absolute docility [*Bestimmtwerden*—literally, being determined]. A feeble fantasy, a feeble joke, a feeble palette, a feeble tone, flat diction, are something other than a delicate fantasy, a fine joke, a smooth palette, a soft tone, or light diction. The dynamic-sublime expresses its power absolutely, it is the source of its own activity. Self-determination can be mere appearance as far as its real efficacy is concerned, but aesthetically it must represent itself as such. On seeing how a great crane lifts a great weight from a ship's hold, we find nothing sublime there, for the sight of the machine dispels any thought of a free movement. Should a volcano, on the other hand, throw up lava flows, stones, and ashy rain from its insides, it is a sublime piece of theatre, because here is present a free elementary process; the elastic tension of the gases in the interior of the earth functions mechanically as well, only with a spontaneous violence. Now it would be very clumsy to deduce that a machine, only because it does not make a sublime impression, must make a feeble one. This is not the case; the machine appears even in its greatest [188] feats not sublime only because it is dependent on another power, the intelligence and will of a person, and thus does not take its origin and the beginning of its movement from itself, as the concept of the sublime demands. On the other hand, the mind that thus masters a tremendous force of nature that its necessity is to that extent subordinated to that mind's freedom, will seem to us sublime. It can lend its machines the appearance of self-sufficiency, and then it will depend on the specific circumstances whether it is not in fact capable of generating an impression bordering on the sublime; but only bordering on the sublime, for our consciousness of the precision of mechanical calculation in turn cancels out part of the aesthetic effect, as we feel, when a great train flies by us on the railway.—Organic life will be able to appear sublime when it realizes its power as violence. Without further ado we will not be able to call any animal sublime. Let us look at the eagle, how he unfolds his arcs and swings with calm beatings of his wings over woods and mountains, indeed over clouds; let us look at the clumsy elephant, as he crushes a tiger with the columns of his feet; or the lion, as with a confident, giant leap he lands on the gazelle: thus will these animals seem sublime to us, because they express outwardly as violence the power that dwells

[122] Despite rejecting the Kantian opposition of sublime and beautiful, Rosenkranz keeps the Kantian distinction within the concept between a dynamic and a quantitative sublime.

in them in its infinity. For the eagle, no boundary seems to exist in flight; for the elephant and lion, no bounds in the resistance of another animal.

Mind seems sublime when it, opposed to the necessity of nature and the freedom of other minds, [189] holds on to its freedom as to its own necessity, even when it is subject to violence. To the absolute power of freedom even nature with its most terrible frights cannot compare. The human being can be overwhelmed by nature, but if in his fall he preserves his dignity, he cannot be conquered. He remains against nature free in himself; therein lies the sublimity of Stoic wise men, who could without fear suffer burial under the ruins of the collapsing universe. One does not need to imagine freedom as abstract lack of feeling; the limits of life, the bitterness of pain can be felt and freedom nevertheless preserved. The victim becomes more sublime, the harder necessity is, whose violence he overcomes through his freedom, and the deeper the feeling of opposition is felt. A Curtius,[123] jumping into the bowels of the earth, in broad daylight, in full armour, surrounded by his fellow citizens, could feel the whole worth of life most intimately—and despite this he jumped, to master nature, in the dark depth with his free bravery.—In the conflict of freedom with freedom, the sublimity of attitude will also appear primarily through elevation over the inevitable pain of the mind—so we will find nothing ugly in the relative weakness of small animals, of woman, the ill, the child, the inexperienced and unpractised, for it is a wholly natural one. Where this unself-consciousness ends, and an existence claims force but does not possess enough, weakness turns into feebleness, which becomes ugly because it contains a contradiction. Here a borderline shows itself that we do well to respect. As soon as the sublime with its absolute violence steps in, in comparison with it even [190] that can appear relatively weak, which otherwise is indeed a power itself. Such weakness is then not yet feebleness in a negative sense. Against the supremacy of elemental nature, for instance, all force of life, all energy of freedom, however great they be, become impotent. The quaking earth, the onrushing flood, the firestorm unleashed, are this kind of merciless powers. The shaking, yawning earth which swallows up animals, people, and cities is sublime, but in its ruthlessness towards everything that sprung out of its womb and enjoyed life on its back, it is atrociously sublime. The living in its fear, as it flees and in its desperation snatches at every shadow of salvation, seems powerless against it; but because the relation is an incommensurable one, one cannot accuse it of feebleness. When the sea's waves play with the largest ships, demolish its masts, fling it against cliffs, they appear frightfully sublime and the humans vainly struggling to be rescued seem powerless; but feeble only insofar as they give in to an inappropriate desperation. An inundation like the Deluge can represent the fruitlessness of the individual's efforts, but also its freedom, which even in death shows itself superior to violence. Thus Girodet painted his famous picture in the Louvre, *A Scene of the Deluge* (see Figure 5), which lets us look upon a family in the midst of destruction, which still holds fast to its piety.[124]

[123] According to Livy (VII.6), to appease the gods, a young soldier, Marcus Curtius, sprang in full armour and on horseback into the bottomless pit in the Roman Forum caused by an earthquake in 362 BCE. The pit closed, and is still marked today (the Lacus Curtius).

[124] Rosenkranz means piety in a familial rather than religious sense. Rosenkranz may have seen Girodet's painting in the Louvre, but the precision of detail (not found in all his accounts of French paintings; cf. Biard at R 214) suggests he owned a lithograph as well.

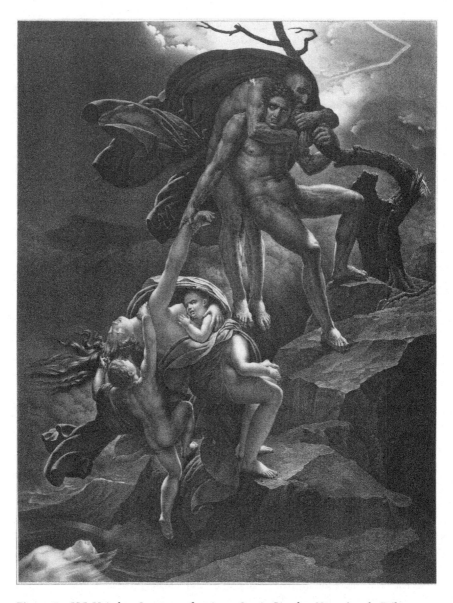

Figure 5 H.L.V. Aubry-Lecomte after Anne-Louis Girodet, *Une scène du Déluge* [1804], lithograph, 1825, The British Museum, London.
Source: © The Trustees of the British Museum.

The man has his elderly, already half-dead father hanging from his shoulders. With the left hand he clutches a barren, broken-off tree trunk; with the right he tries to pull his wife from the waves. But as **[191]** mother she does not want to leave the children; the one, a newborn, clasps her breast; the other hangs by the mother's hair; she has

already set foot on the precipice, but the load is too great, the branch will break entirely—and all will find their grave together; even in death the family will be one. An animal in such circumstances can only allow the instinct of self-preservation to govern without any other consideration, as a modern German painter, for instance, has painted a forest fire. With insatiable vengeance the fire devours trees and bushes and drives the animals from their hiding places; in thick herds with hair standing on end, with terror-enflamed eyes, with panting tongue, they leap forward and seem to have forgotten their ordinary natures, in that bear and buffalo, panther and deer, wolf and sheep cheek-by-jowl in a great knot breathe a peacefulness forced on them by the common danger. In the horror of these fleeing beasts is painted the fury of the infernal element.

Animals fighting with one another can only become sublime if they are large. A small animal can be very strong and courageous, only its force cannot ever gain the illusion of a self-creating and self-renewing infinity. A cockfight is nothing sublime. Just as little can the struggle of smaller and weaker animals against larger and stronger. The mouse in the cat's paws, the hare in the vulture's claws, the pigeon between the marten's teeth tremble against their certain end. One also cannot call them ugly, for the struggle is unequal.—Faced with the power of nature the human should preserve his freedom, [192] opposing to nature the force of his consciousness and his will. Should he submit to it, in that he trembles before its violence, he will appear weak. But whether weakness should already be called ugly depends on the concrete circumstances, on the degree of his fright and the form in which it is expressed. The person who has the courage to attack a predator with a club, or to circumnavigate the inhospitable wave on a hollow tree trunk, elates us just as much as a reversed behaviour mortifies us. Faced with the animosity of the power of nature, even for the highest heroism all struggle can be in vain; then nothing remains to the freedom to preserve oneself other than, amidst outer defeat, to preserve in one's interior unbowed, undying courage.

The cast of mind which remains equal even before the hardest sufferings is sublime, as that of the Aeschylean Prometheus, like that of Calderón's *Steadfast Prince* [*El príncipe constante*, 1629]; weakness which allows itself to be forced is ugly, where it is not ridiculous. In general, this is true; but specifically, history produces an endless multiplicity of situations wherein coercion takes on the sweetest, most seductive forms, indeed, forms based on a calling to sacred duties. Here, in the domain of moral collisions, situations become possible wherein weakness through personal amiability obtains the appearance of freedom, or through sophism usurps the form of force, the familiar theme of so many novels. Indeed, in the amiability of such sentimental heroes the artist has a means of softening the appearance of ugliness to make it interesting. [193] Levity, indecision, inconsistency, hesitation, forgetfulness,[125] inopportune compliance, premature action cannot in any case be presented as things that are right or amiable in themselves. The amiability must be placed in the mind, in fantasy, in personal conduct; the feebleness of the will must be excused through the quality of the temperament, the difficulty of circumstances, with the possibility of doing ill

[125] Rosenkranz has *Vergessenheit*, 'oblivion', but from the context of character flaws, it is clear he meant to write *Vergesslichkeit*, forgetfulness or absent-mindedness.

by acting decidedly in a different way, but it cannot be justified by these means. The light-heartedness of moral weakness always threatens to fall into baseness, becoming real crime; as [Goethe's] *Xenien* say, it all depends on the opportunity. It becomes sophistic in the attempt to present itself (to itself) as noble, but in this sophistry it will often help bring about what is most abominable. Out of complacency, inertia, lack of courage, vanity, it sinks according to the circumstances into the mean, and suffers dependency on an alien will that it perhaps despises but which it acknowledges out of other, egoistic motives. It hides this degradation to itself through psychological rationalization, through fictional illness, through the conjecture of a cruel destiny against whose necessity the individual is helpless. One must, however, distinguish between weakness as an object of representation and feebleness as an error of aesthetic handling. To represent weakness must be allowed. The Werthers, the Weislingens, the Brackenburgs, the Fernandos, the Edwards as rendered by Goethe; the Woldemars of Jacobi, the Roquairols as Jean Paul paints them; the Andrés and [**194**] Stenios as George Sand one might say daguerreotypes them, have a right to be represented. But it is something else altogether when the representation itself is feeble, that is, when precisely where force should be expected, powerless, weak, dull forms appear. This is a decided mistake, leading to that dissolution of aesthetic form that we earlier come to know as the undulistic and the nebulistic, and which can be specified for each art according to the peculiarity of its element.

Since strength and feebleness in the negative sense are opposed, it can be appealing for art to represent the passage from one to the other. To do this with psychological truth is a very difficult task, at which as a rule only great artists really succeed. Iffland and Kotzebue, the dramatic champions of weakness, have given us many illusory transitions of this sort. Byron has curiously dedicated to Goethe two dramas whose object is weakness, *Sardanapalus* and *Irner*.[126] In *Sardanapalus*, a nature in itself noble, but too soft, humane, but too lenient, rises from careless, cheerful dedication to the enjoyment of life to really royal dignity, heroic courage, bravery, and the sublimity of martyrdom; a soul-painting of such incomparable depth and beauty that it is a riddle why no stage presents it to us. In *Irner*, on the other hand, the poet has shown how another nature, itself noble, through its weakness is pulled down to meanness and stifles the remainder of its life in the shameful reminiscence of its misdeed. Irner, in great adversity, steals from his sleeping nemesis a hundred [**195**] ducats. Before himself, his wife, his son he wishes to justify himself by saying that he only stole when he could have murdered his arch-foe. But Schiller already showed sufficiently that murder, because it requires more force, stands higher aesthetically than theft. Irner would have been guiltier in his action, but less mean, had he murdered Stralenheim. His weakness

[126] *Sardanapalus, A Tragedy*, published with *The Two Foscari, A Tragedy* and *Cain, A Mystery* (London: John Murray, 1821), is really by Byron; *Irner*, a rambling two-volume novel, supposedly translated and adapted by Gustav Jördens, was printed by Lauffer in Leipzig in 1823; it is identified as a forgery in J-M. Quérard, *La France Littéraire, ou Dictionnaire Bibliographique*, Vol. 1 (Paris: Firmin Didot, 1827), 581, and more recently in Richard A. Cardwell, ed., *The Reception of Byron in Europe*, vols 1, 2 (New York: Continuum, 2004), xxiv. Most German readers at mid-century thought it authentic.

only allowed him to steal, and the sophistry that the money is in fact his property does not assuage his conscience. His son Ulrich carries out the murder without the father's knowledge. As Irner makes this horrifying discovery, he has to hear as defence the doctrine of weakness that he had himself taught his son:

> Who has told me, the
> Opportunity excuses certain vices?
> That passion be our nature? That from
> The joys of luck those of heaven follow?
> Who told me that his humanity depended
> Only on his nerves? Who took all my power
> To defend myself, to show myself
> In open battle, through his disgrace, which
> Stamps me perhaps even with bastardy,
> With the mark of the culprit? He, who is warm
> And weak at the same time, who excites one to deeds,
> Which he wills but dares not. Is it so strange
> That I carry out what you think?

How weakness and feebleness unsuspectingly—indeed, fancying themselves quite good—turn into evil, George Sand has shown in masterly fashion in *Fadette*. Fadette enlightens Sylvain about himself, how he is weak, sentimental, tyrannical against his surroundings, sophistic and [196] egoistic; 'weakness engenders falsity and that is why you are an egoist and ingrate.'[127] Sylvain understands himself finally and in the end this mother's boy, this home-body, becomes an entirely different person, who tries to forget his love of Fadette in the din of battle of the Napoleonic Wars.

Feebleness must appear at its ugliest, obviously, when it is bound to power itself. Power should not cover itself in it; it degrades itself the more it does so. For nature this makes no sense, because it lacks free will. When the giant elephant breaks into a cold sweat in the vicinity of the tiny mouse, it is no feebleness of the former, but a very right instinct, for should the mouse creep into its trunk, its crawling around would drive him raving mad. Should, however, a prince, a hero, a high priest indulge his temper, his weaknesses, he falls into a meanness that contrasts the more glaringly with his essence. That, for instance, King David traitorously does away with Uriah in order to enjoy his wife Bathsheba undisturbed is especially for a king a weakness in the tendency of his character, wherein he sinks to meanness and criminality. If [Alfred] Meißner's *Weib des Urias* [Uriah's wife; Leipzig: Herbig, 1851] is a failed drama, half the blame lies on the choice of subject.

The feeble falls over into the comic when it behaves as strength. Nevertheless this contradiction will only become ridiculous if the content of the weakness does not injure the demands of virtue too acutely. Thus it is intellectual weaknesses, weaknesses [197] of a harmless kind, dependent more on nature or circumstances, that fit the bill,

[127] 'La faiblesse engendre la fausseté et c'est pour cela, que vous êtes égoïste et ingrat.'

as we see especially in comedy. Should the development of the weakness be connected with the fiction of destiny, and thus surrounded with the appearance of necessity, the comic effect increases accordingly. A shining masterpiece of this humour will always remain Diderot's *Jacques le fataliste et son maître*. That the gentleman cannot live without his servant is a weakness that hurts no one; that the gentleman likes to hear stories about everything is a weakness that gives others an occasion to unfold their talent for storytelling; that the gentleman wants to convince the servant who rules him openly that his fatalism is false is a weakness that is likeable. With what unforgettable humour does Diderot bring Jacques' fatalism into play! All happens 'because it is written above, on the great wheel'.[128] But Diderot would not have been Diderot had he not known how to make contact with the deepest problems of human existence in the chatter of the servant and the waitress, in the fatalism of the servant and the gentleman's criticisms. One errs greatly in following certain widespread expositions, according to which *Jacques* has only a frivolous tendency (*NOTE 39). Its ground text is much rather the idea of fate, and Diderot has indicated this himself through the predicate 'fatalistic'.

III. The Low

The sublime in its boundlessness is great; in the unresisted expression of its power it is mighty; in the [198] unconditional self-determination of its infinity it is majestic. Majesty combines absolute magnitude with absolute power. The opposite of the sublimely great is the petty, which falls under the bounds necessary to its essence; the opposite to the sublimely powerful is the feeble, which falls below the amount of force possible to it; the opposite of the majestic is the low, which in its self-determination is determined by accidental and limited motives, by petty and egoistic ones. 'Low' is in any case an expression that is also relative; but should it be used not comparatively but positively, it identifies the imperfect, the inferior, the mean in general. The majestic is alone in its calm magnitude and in its action it is absolutely sure, as it is not determinable from outside or by chance. Thus it can indeed, insofar as it belongs to the world of appearance as a particular phenomenon, have sides that are vulnerable to an attack form the outside, it can suffer, it can feel pain, but inside it will remain identical with itself and, in the fall of that which is ephemeral in its existence, remain certain of its infinity. Thus is explained the apparent contradiction that the majestic is capable of revealing its greatness and power precisely in suffering. The low [199] on the other hand is: 1. directly the everyday, ordinary, trivial; 2. relatively the changing and restless, the accidental and the arbitrary; 3. crudeness as the degradation of freedom under a necessity alien to it or even as the bringing forth of such a degradation. All these concepts are also called many other synonyms, just as we call majesty according to its gradual differentiation by another name, be it noble, high, dignified, imposing, grandiose and so on.

[128] Given in the text without italics: 'parce que c'étoit écrit là en-haut, sur le grand rouleau'.

a) The Ordinary

The ordinary, insofar as it constitutes the empirical existence of the general, is not yet insofar ugly; this predicate can only be given to it relatively; it *becomes* ugly under certain conditions. The phenomenon of the majestic sublime is unique insofar as it takes up a whole world in itself, for unique in the sense of not having another thing like to itself empirically is after all according to Leibniz's *principium indiscernibilium* every existence, even the most ordinary.[129] Majesty, however, does not differ from other phenomena just empirically, but it is unique as without comparison within a given sphere. If we imagine a mountain range, this can be sublime through sheer size. Now if we imagine that from its ridge, one mountain raises its head still higher into the ether, this would appear not just sublime, but majestically sublime, for it gives the colossal mass something of a personal expression. Thus shines the light of the moon under the stars uniquely in gentle majesty and so on. These are examples in the domain of space; but also [200] time can appear majestic in the spatial, when it reminds us of the endless sequence of years it has persisted as something that has come to be. To come to be is also to pass away. Something that has come to be that in the passage of time remains the same wins thus the appearance of eternity, from whose infinity the stream of time flows. In steppes east of the Dead Sea hang the great rock gates, through which the Moabite kings of Basan entered and left four thousand years ago, they are still on the same hinges. Now it is only poor goatherds who pass by them, but the gates are the same. It's clear that the object, in order to seem sublime, must be large and powerful; duration alone would not make it sublime, even should it exist unchanged for millennia, as, for instance, in the Neues Museum in Berlin a roof tile is displayed that the Jews had to paint in Egypt. Even an eternal roof tile will not become sublime. In history, there are persons, acts, events full of majesty, if they are positively unique and concentrate a genus, a whole world in themselves. A Moses, an Alexander, a Socrates are majestically sublime personalities, because they are unique in a positive sense. That Socrates did not flee, that he did not try to corrupt the judges through rhetorical art, that he awaited death in prison with cheerful seriousness—namely, all that persons of an ordinary stripe would not have done—gives him a majestic nimbus. So is the burning of Moscow a terribly majestic event, because the resistance of the Russians in this sublime burnt offering concentrated itself in a world-historically unique way. If persons [201] and acts do not express such uniqueness based on affirmative ideation, they are not majestic; a uniqueness characterized by its negativity can make no claim on the predicate of majesty; on the contrary, it falls into ugliness. A Commodus, a Heliogabalus, though lords of the world are moral abnormalities, who distorted majesty the more they, with their boyish madness, tried to exercise it in temperamental tyranny; they are unique in this distortion, but this uniqueness is the sad one of colossally debauched, crazed

[129] Leibniz's principle of indiscernibles, according to which two things that cannot be distinguished in any way (they share all properties, even simultaneous spatial location) are the same thing, is found in his *Discourse on Metaphysics*, Section 9. This principle was disputed by Kant, who for some reason thought that two raindrops (why not other things?) could be identical. Obviously it remains controversial.

arrogance. Herostratus, as he threw the torch into the temple of Ephesian Artemis, had reached his goal, but this unworthy action is in its frivolous uniqueness the opposite of all majesty. True majesty naturally appears in contrast to its feeble copy the more unique, as Christ led before the miserable, curious King Herod, veiled his endless majesty in withering silence. Herod, a king, questions an imprisoned, convicted Jew— and he is not honoured with an answer; to the dissipated shadow-king these otherwise so friendly, love-breathing lips do not open; this silence—what terrible majesty!

As already said, the ordinary is by no means already the ugly. No one can prove this necessity in its concept, and it can be, if not beautiful, at least pretty. Only as that which is present in many exemplars, which does not stand out in any way, does it seem aesthetically meaningless. It lacks characteristic individualization. Beauty should represent for us in any case the general truth of things, [202] only it should do this in the form of individual freedom, which individuates the necessity of the general in its peculiarity. The ordinary or everyday becomes through its lack of differentiation senseless, boring, or mean, and turns thus into ugliness. This should not be misunderstood. It is not beauty that becomes unbeautiful, which is impossible, but the frequency of repetition, the broadness of a mass existence, allows it to become indifferent, because another exemplar as sheer tautology lacks any charm of newness. Every art must move in a certain circulation of *motifs*. Insofar its invention has a bound. But this repetition, which is contained in the concept of the thing, is no objection to art; what matters is that it makes the motifs, which in themselves are always the same, appear new through individualization. One should recall, for instance, that all tragic collisions have been thought out in advance; more than twenty-eight are not possible according to Benjamin Constant;[130] these will then always offer themselves, however the poet may begin; he has in them an ethical limit of his production, only he must understand how to handle this inevitable sameness of content that the one chosen will appear as a new, unique case. Pure repetition with only a superficial, formal difference does not satisfy us. We understand the impossibility of changing the idea itself and its necessity; from appearance, however, we demand with justification that the artist represent it in yet another, surprising way. If on reading works like Valentin Schmidt on Romantic poetry, Dunlop's *History of the Fiction*, von der Hagen[131] [203] on the short stories of the Middle Ages, Wolff on the history of the novel and others, one gains the insight that certain materials remain the same through a variety of peoples, epochs, and languages, the fantasy of the poets can seem very poor as a result; only this is a mistake, for the fruitfulness and the creative force of fantasy is shown much rather in the fact that they were able to achieve such a great multiplicity of execution within the bounds determined by the nature of the subject matter. If we take, for instance, a

[130] Rosenkranz may have in mind Benjamin Constant, 'Réflexions sur la tragédie', *Revue de Paris* 7 (1829), 5–21, 126–40, translated into English by Barry Daniels as 'Reflections on Tragedy', *Educational Theatre Journal* 23:3 (October 1971), 317–34.

[131] The other authors are cited by Rosenkranz in detail, but Friedrich Heinrich von der Hagen is known for his histories and anthologies of medieval German literature. Rosenkranz probably meant *Geschichten, Mährchen, und Sagen* [Stories, Fairy Tales, and Sagas], ed. with E.T.A. Hoffmann and Henrich Steffens (Breslau: Josef Max, 1823), or his own second volume, *Erzählungen und Mährchen* (Prenzlau: Ragoczy, 1826).

relationship like that of master and servant, right away we find in this determined boundaries, determined motifs. Master and servant make up a great part of the material of ancient comedy. Master and servant, that is the formal theme of the *Don Quixote* of Cervantes, of Diderot's *Jacques*, of the *Pickwick Papers* of Boz [Dickens], and so on. But as different as the masters are in these writers, Don Quixote, the Maître and Mr. Pickwick, just as different are the servants Sancho, Jacques, Samweller. In this diversity the sameness of motifs remains, because it is inseparable from the general situation. The masters, like the servants, thus possess a certain family resemblance;[132] only within this they diverge again through their individuality, and here lies the originality of the creative fantasy. Diderot's Maître, the way he looks at his watch, takes a hand of cards, and gives Jacques another nudge to tell the story of his love affairs, is a unique figure, which indeed as a genus has something in common with Don Quixote or Mr. Pickwick, but not individually, nor do these with him. Imitation as mere copying, as formal, superfluous repetition, indeed as [204] plagiarism, annoys us, and we shout at it with Rabbi Akhiba in Gutzkow's *Uriel Acosta* [Leipzig: Carl Lork, 1847]: it's all been done before! We can distinguish the permitted identity of the motifs from the undesirable sameness of handling by labelling the latter as the *commonplace*. All arts have their commonplaces; all epochs have theirs. The commonplace is the triviality already known, recognized, and stamped as such. The commonplace was once also new and interesting; but with frequent repetition it got used up, drained of spirit. It thus becomes ridiculous the moment it steps forth with the pretension of newness. In poetry, however, one ought not to count among the commonplaces occurrences of perpetually reoccurring images like the great objects of nature, sun, sea, mountain, forest, flower, and so on, or Greek myths. Both have become eternal symbols, wherein educated humanity expresses itself in a way understandable to all. As nature and the gods are always beautiful and inexplicable, every other image source can be reused and rejuvenated. Have not Schiller and Hölderlin, with universal spirit, taken up where the Greek myths left off, giving them romantic souls?

Lessing opposed the usual to the unusual,[133] and one can on first hearing hardly bring up any counterexamples, for this distinction is only a limiting judgement. If he, however, explains the usual as the natural, it would follow that the unusual should not be allowed to be natural. 'If the poet brings nothing to the theatre other than what he finds in simple nature, he will thus give his spectator nothing to see and to hear beside what one sees and hears every day. But who visits [205] the theatre only so that he can come across the same thing he finds outside it, and more than often enough? He must thus mix unusual features into his characters, if he wishes to capture the attention of the spectators. But what is the unusual other than a deviation from nature?'[134] Deviation

[132] This seems the philosophical debut of a term made much of by the late Wittgenstein.

[133] In German, the two words are related by a prefix: *gewöhnlich* (ordinary, usual) and *ungewöhnlich* (unusual). Doing this to 'ordinary' in English results in 'extraordinary'. (*außerordentlich* in German). One cannot trust grammar to ground opposite concepts.

[134] 'Untersuchung, ob man in Lustspielen die Charaktere übertreiben sollte? [An inquiry on whether one should exaggerate characters in comedy] in an early volume co-written with Christlob Mylius, *Beyträge zur Historie und Aufnahme des Theaters* [Contributions to the history and reception of theatre], vol.1 (Stuttgard: Metzler, 1750), 268.

from nature should characterize the unusual here. Consistently one finds magic and miracle, or affectation and the unnatural, since there are the strongest deviations from nature. Only Lessing did not mean it so, but rather, as the context shows, he only wanted to say that art is not yet art if it only transcribes mean reality, contrasted to which all poetry, all art even is the unusual. One ought also not to confuse ordinariness with *reproduction*. Beauty as such cannot be altered through its reproduction, for it is infinite in itself; just as we never tire of enjoying with ever fresh thankfulness the blue of the sky, the green of the earth, the blooms of spring, the song of the nightingale. In the theatrical revival of Sophocles' *Antigone* we have experienced in our days a quite curious example of the undying force that, without aging, inhabits the truly beautiful.[135] It is one of the most significant aspects of modern technology that its perfection makes possible ever faster and yet accurate reproductions of works of visual art, and with them their ever more general enjoyment. Such reproduction is something else than the flat reproduction of typical models in the uninventive imitation of unproductive weakness. What [206] ordinariness in the Minnesang of the Middle Ages, which provoked Schiller to observe sarcastically that they contain only the spring, which comes, the winter, which goes, and boredom, which stays; he thought if the sparrows could write an almanac of the muses, roughly the same would result. Thus are thousands of sonnets of the Petrarchans, hundreds of tyrant-tragedies of the older French stage, thus the factory wares of our children's tale silliness, thus the army of our novels of resignation, thus in contemporary German painting the endless family of mourning royal couples, Jews, mothers (Hauser's *Massacre at Bethlehem*) (* NOTE 40), Toggenburgers[136] and so on have become the status quo. The imitators often think of themselves as classical artists, because they seem able to bring forth, to a hair, what recognized authorities have also produced. But precisely the extraordinary likeness to their models is what makes them so boring, what keeps away from their works the public they scold unjustly. Had they brought forth what they offer as something new, out of themselves, they could have a justified claim to applause; as it is they should not blame us if we find their prettily chiselled, brightly coloured, correctly contrapuntal, nicely styled works trivial. A real artist who strives after the ideal with religious seriousness will indeed represent even one idea in ever-different idioms. But because he will thus be trying to get ever closer to the ideal, he will not tire us in the process. Each of his creations will reveal his Ur-picture from a different side. For Petrarch, the sonnets and canzone in which he rendered his passion for Laura in every [207] height and depth were as little bad tautologies as were for Raphael his Madonnas, for Byron, his gloomy heroes, for Lysippus, his statues of the godly Alexander, and so on. Mediocrity or even real impotence repeats the already made without progress, without productive deepening, and depresses us through its own unconscious ordinariness as much as the true genius enthuses us through the simple originality of his compositions.

[135] See Helmut Flashar, *Inszenierung der Antike* (Münich: C.H. Beck, 1991), 60f, on the 1841 revival of *Antigone*, in Potsdam and Berlin, for which Mendelssohn wrote striking choruses. The Prussian revival of Greek tragedy died out after the 1848 Revolution.
[136] Inhabitants of the picturesque Thur valley in eastern Switzerland.

When mediocrity has a suspicion, even one it does not admit, of the ordinariness of its achievements, it decks these out in heterogeneous means of excitation to hide its flatness. The result of their application is, however, only to make the flatness of conception and the poverty of execution that much more palpable. These days, poetasters deceive themselves above all with the dangerous praise that is rightly paid to them of being *spirited*. Real richness of spirit, won from the breadth of many-sided experience, from the depth of great struggles, how seldom that is! On the other hand, how ordinary has become that half-mixture of experience and reflection, poetry and philosophy whose confused motley one tends to call spirited today. Impotence now has in dialectical reflection the means of faking for a moment the appearance of creative production.

That the ordinary judges itself, in that it becomes comical through its exaggeration, should be obvious from what was just said. Only, one must distinguish the humour that afflicts it objectively and non-arbitrarily from the humour that consciously parodies the emptiness of the ordinary. If [208] the ordinary makes efforts to spread out the nullity of its content through the bombast of a false pathos, that is unintentional ridiculousness. Our laughing over ugliness means in this case its condemnation. However, if ordinary content is presented in the form of the sublime, or contrarily if what should be sublime content is presented as the ordinary, a comic effect ensues. The first is the case in travesty, as when the frogs in the *Batrachomyomachy* speak the language of Homeric heroes;[137] the second is the case of parody, as when the idea of fate as in itself a sublime power is turned to a futile object. Thus Natalis parodied with his wool-stocking-drama, thus [August] Platen parodied with his fork[138] the confusions of our fatalistic school; thus [Jens] Baggesen parodied with his *Adam und Eva* [Leipzig: Göschen, 1826] the pompousness in which the religious epic has fallen with us. The first persons are certainly a naively sublime object. The study of French and theology are certainly very ordinary occupations of today's world. Baggesen lets Adam study theology until twelve o'clock. All the while, Eva strolls around the Garden of Paradise, where the animals pay her court very politely, and flatter her by licking her dainty foot. Particularly fine is the behaviour of the brightly glittering snake. It makes itself highly interesting to Eve by being able to speak French and having much to report about Paris. Adam, who like a good bourgeois eats luncheon at 12 with Eve, for a long time has no idea of this perilous acquaintance, until he comes across it accidentally on one of his promenades together with his wife, and so on. This whole handling makes [209] the prototypes into modern people; in that to all the ordinary occupations, like studying theology, eating lunch at noon, learning French, or going on a walk for one's digestion, the fantastic presuppositions of the paradisiacal state are added, wherein the animals still live peacefully and the snake speaks, a delightful contradiction is generated, giving the poet the opportunity to make many clever satirical moves, among which not the

[137] *The Battle of the Frogs and Mice*, attributed in antiquity to Homer, and by Plutarch and the Byzantine encyclopedia *Suda* to the Greek-speaking Persian Aechemid poet Pigres of Helicarnassus (fifth century BCE); he may have also composed the *Margites*.
[138] *Die verhängnißvolle Gabel* [The Fatal Fork] (Stuttgart and Tübingen: Cotta, 1826).

worst is that the snake poisons little Eve's innocent fantasy with stories of Paris and flatters her with the language of this Babel.

The ordinary can also turn into the comical if handled with irony about itself. It has already been hinted above that what we aesthetically avoid as ordinary can be very important in reality. Does not necessity, to which we all submit, come to the fore there? Is it not the element wherein the prince meets the beggar? Mustn't we all eat and drink, sleep and digest? Mustn't we all work, at least at doing nothing? Mustn't children be born? Can an empress decree away the pains of childbirth? Can't we all take ill, despite wealth and education? Mustn't we all die in the end? Is then this everydayness not also very serious and honourable? Don't its situations make up the epic element of history in its stable sameness? If art approaches them from this side, all meanness disappears from them. And thus in fact have sculpture, painting, and poetry rendered divine [210] sleep, human labour, the shared meal, wedding, birth, and death, according to the nobility of their positive and universal significance. One may recall how Homer on the shield of the warrior Achilles had Hephaistos depict the whole cycle of peace celebrations and feasts; one may recall the *Works and Days* of Hesiod; one may recall the idyll, the social, skolic lyric; one may recall how the antique relief, antique vase painting, or Pompeian wall painting present our ordinary situations with naïve cheerfulness; how Christian poetry, sculpture and painting have constructed out of the history of Christ and the Patriarchs all the ordinary occurrences of human life in accordance with their ideal value; one will recognize what a great precinct in art the ordinary can take up with a perfectly affirmative character. Only, just because these epic elements of life in the world in their infinite practical importance are at the same time the most everyday, which also betray the dependence of humans on nature and contain in their perpetual return the boredom of our existence, of always having to eat and drink, work and sleep, give birth and die, because of all this there is already in them an ironic tinge. Art has only to emphasize more sharply the point of our connection with nature, our bond to the finite, and humour is suddenly there. Thus arises another *genre picture*, but one that wins a smile from us, because it shows us freedom in its natural limitation. In the great totality, a single situation is only a moment; whatever satisfaction a situation grants relatively and momentarily, it must [211] nevertheless dissolve itself in the general context; to hint at this transition is to make it ironic. Without being serious and worthy in the epic sense, without being comic in the ironic sense, picturesque and poetic genre-pictoriality becomes common and boring. Lessing's advice to the comic poet to break away from ordinariness by deviating from pure, crude, everyday nature could with profit be commended to our genre painting, for we have in it the entirely vacuous portrait of our limited empirical states, an only too true depiction of female cooks and fruit sellers, schoolboys, sock-darning mothers, boot-mending shoemakers, pastors meditating in their nightgowns, idlers hanging around pubs, and so on, without the least ideal transfiguration, without an atom of wit. That we Germans have no shared great story, no unified, god-moving enthusiasm, explains why our art is so embarrassed for worthy objects and why it falls so easily into insubstantial chatter and whining about the ordinary. Despite this, Hegel and Hotho (*NOTE 41) have rightly emphasized that the insignificance of the objects in genre painting makes all the more possible the pleasure of a brilliant execution, only, one is

unfair to these philosophers if one takes their enthusiasm for genre in the Dutch School as a concession that the bare impression of an empirical reality can already satisfy them, and that ideal compositions in their detail would not be so advantageous for the brilliance of virtuosic technique. Such a notion, made into a general prejudice, would fully ruin the aesthetic sense of the nation, for it [212] would allow us to worship limitation as a final thing, desensitizing us with a flat comfortableness, in an idyllic daze, making us ever more incapable to grasp the real pain of life, feeling and knowing which is first capable of giving our existence the blessing of true cheerfulness. The lack of ideality, the triviality of content, lead in all arts to breadth of detail, whose polishing is already taken for poetry; a disproportionate lingering in the ordinary results, because one does not want to miss anything, and with this tendency to a bad completeness, a terrible boredom. Voltaire has famously said that all genres are good and allowed, *except for the boring genre*; but the very same author said: *the secret of being boring is to say everything*.[139] One ought not to wonder if in such epochs it is precisely the higher natures and ambitious minds, who out of disgust with the idol-worshipping of the mean and the ordinary, in their turn exaggerate irony against the finite and fall soon enough into frivolity, piety, or craziness. The right artist will thus represent the ordinary either by putting forth its positive justification as a necessary form of the general run of things, or by ironically reflecting the limitation of a situation into a freedom that transcends it; or he will turn it directly into the comical. Why have Murillo's beggar boys become so famous? Because their misery does not embarrass them and because from their rags the happy feeling of a soul unconcerned about all external privation looks out. Murillo has grasped the affirmative side of their existence. Why has Biard come to such a great reputation? Because he knows how to evoke the ironic moment in the ordinary. [213] His famous *Travelling Actors*[140] wait in vain today for visitors, due to the streaming rain. The light by the waxen figures, among which we notice even some Olympic deities, burns down in vain. The directors of the company, gathered around an astute, wise old lady, convince themselves thoroughly of the bare bottom of the cash register. The one explaining the wax figures, a whip under the arm, looks dejectedly down the bleak street, upon which the umbrella-covered people flit by like shadows. One sees in the people that, experienced in life, used to duplicity, trained in hunger as they are, they do not lose their spirits quickly, and yet the circumstances at this moment are extremely dispiriting. But there in the foreground on the floor, what lovely apparition is that? A young girl in a boyish suit sits occupied with a violin, untouched by all the misery around her. She will share this misery; she will eat and drink badly and little; she will freeze in her thin clothes; but she will love art for its own sake. This black hair, these longing feature, these fiery eyes reveal to us genius and excite us out of all ordinariness. Among the Düsseldorf painters the humour of Hasenclever deserves

[139] Rosenkranz gives the French of these two phrases: *hors le genre ennuyeux*, and *le secret, d'être ennuyant, c'est de tout dire*.

[140] François Auguste Biard, *Les Comédiens ambulants*, 1833; now in the Musée national du châteaux de Fontainebleau, in Rosenkranz's day it was found in the Musée du Luxembourg. In any case, there is hardly one detail in Rosenkranz that corresponds to the oft-reproduced painting: for example, the girl looking at the spectator wears a dress and plays a flute.

to be distinguished; his *Dance Lesson*, his *Painter's Studio*, his *Company for Tea*, his *Jobs as Nightwatch*, what delicious pictures!

The ancients opposed to *megalography*, the painting of gods and heroes, *rhypparography or phypography*, or also, as Friedrich Welcker thinks, *rhopography*, because the dirty also belongs with the ordinary and the low. [214] W. Gringmuth in a separate essay (*NOTE 42) and Hettner in a section of his *Vorschule der Kunst* have taken on the more detailed description of this ancient genre painting. From the works of art that have remained we see that the ancients counted among its objects cupids who drag weapons around, cobbler's huts, painting dwarves, battles of pygmies with cocks and cranes, fruit still-lifes, birds and vases.

b) The Accidental and the Arbitrary

The mean is in its limitation just as ordinary as the sublime in its uniqueness is majestic. In its creative, directly self-conditioning condition, the majestic acts indeed suddenly, but not accidentally, indeed freely, but not arbitrarily. In the desert Moses strikes at a rock with his staff and of a sudden there flows from its arid breast a stream of living water. This majestic action is neither accidental nor arbitrary; not accidental, for Moses is the god-sent leader of the people, who must thus care for it; not arbitrary, for the people was near its extinction. Majestic action is in itself, as creative, absolutely sure, and reaches its goal without especial external mediation; fundamentally through the simple act of pure willing. The Vatican Apollo has scared away from his temple walls some monstrosity, whether it be Python or the Erinyes. He indeed still holds the bow in his hand, only his position and mien express decisively the fact that the far-shooting god was certain of his success in advance. He wishes to kill the monstrosity and he kills it. No doubt, [215] shakiness or hesitation can appear in a being that claims majesty. Should the majesty in its acts fall victim to accident and arbitrariness, it would thereby become ugly. Its acts must be effortless, and yet in its lightness necessary, in the right place, at the right time, which is why a so-called *deus ex machina* and everything resembling it fails of the impression of majesty.—Should an existence that ought to be majestic fail to even achieve in its action that which it intends, this contradicts the sureness assumed on its behalf, and it becomes ugly or comical. Let us imagine a lion leaping upon a gazelle from some hiding place, but overreaching in his leap, so that he leaps over it, while it runs away from under him; thus will the king of animals appear ridiculous. Also, majesty may not hasten in the form of its action, for its autonomy must enter solemnly. The absolute sureness present in the interior must represent itself in the calm and appropriateness of the exterior. Trees incline their crowns majestically, when they slowly bend down and back up; a tone is solemn, when it holds itself and interrupts the silence again with appropriate pauses; a step is solemn, when, since walking is a cancelled falling, the foot drags more from behind than it lets fall in front. Thus all movements that make an individual who should be majestic appear agitated, hurried, pulled this way and that, are ugly, because they contradict the unconditional self-certainty that is the essence of majesty. Even the language of majesty will have to be brief, lapidary, lasting, proportioned. Prolixity, limiting formulas, are not adequate to it; much rather a humoristic play [216] with the joke, because in play mastery over

something shows itself. A quicksilver, nimble, stumbling and bumbling prince, who does not remain master of his emotions, and reveals in his behaviour that he is not over the annoyances that bother the common man, is on the verge of being ridiculous.

In contrast to the unreflected, self-sufficient action of majesty, meanness is characterized by chance and arbitrariness. Chance in itself is as little mean as arbitrariness. They are in themselves thus also not yet ugly; they only become so when they take the place of necessity and freedom. Beauty has as its content not compulsion, but certainly necessity, not lawlessness, but freedom. The necessity of freedom is its soul, and chance as well as arbitrariness can only turn it in a tragic or comic direction. Should necessity together with the appearance of freedom become a whim, with it fate will become accidental and arbitrary, whereas as the objective self-established boundary for the excesses of chance and arbitrariness it makes a majestic impression. So-called chance is found in a tragic development only in the form wherein absolute necessity wraps itself. Fate should not be a bare boundary, but precisely one that we recognize as necessary through the essence of freedom, from which standpoint even the collisions of the ancient fatalistic tragedy are of a moral nature, even when the absence of this latter is not yet taken as an ethical contradiction, but only as a morally unwanted activity whose motivation reaches even into the lap of the gods. But the guilt that in our [217] sense does not exist morally, is nevertheless acknowledged by ancient tragedy, as the famous Sophoclean verses put it in such unsurpassable fashion:

ἀλλ᾽ εἰ μέν οὖν τάδ᾽ [ἐστίν] ἐν θεοῖς καλά [*all' ei mén oun tad' en theois kalá*]
παθόντες ἄν ξυγγνοῖμεν ἡμαρτηκότες [*pathontes an cuggnoimen hemartekotes*][141]

For humour, naturally, chance no less than arbitrariness are the absolute driving forces, because they alone are able to parody the ugliness of bad arbitrariness and chance through subjective excessiveness. It is in the *bizarre* and *baroque*, the *grotesque* and *burlesque*, that the accidental and the arbitrary rise from ugliness to transfigure it into the comical. None of these forms is beautiful in the sense of the ideal; in each a certain ugliness exists, but in each also the possibility of going into the most riotous comedy.

The bizarre is the stubbornness of mood. The word comes from the Italian *bizza*, which means fury and also malice. Since malice is something singular, it has been applied to the unique, the strange, in whose production mood enjoys itself. When one considers that beauty is concerned with the representation of the ideal, one cannot expect the bizarre to be beautiful. Rather it tends to the comical, yet, thanks to its content it is seldom purely ridiculous. Bizarreness so exaggerates individualization that it seems ugly or at least borders on the ugly. In its mood it binds what one usually separates, it separates what one usually binds. English spleen is rich in bizarre inventions. Pregnant women and developing girls often have bizarre cravings, for

[141] Sophocles, *Antigone*, lines 925–6, as Antigone bravely steels herself to be closed in the tomb. Sir Richard Jebb renders them: 'Well, then, if these events please the gods, once I have suffered my doom I will come to know my guilt.' The first line says literally 'if the gods find these things beautiful (*kalá*)', which underscores the aesthetic dimension of the moral conflict. Rosenkranz may be citing from memory, for he leaves out the *estín*.

instance, to ingest tobacco ash. Hypochondriacs torture themselves [218] with bizarre fantasies. Love as passion stimulates bizarre actions, such as those of the troubadour Peire Vidal from Toulouse have remained so memorable. We can set his sentimental nonsense side by side with that of the German minnesinger Ulrich von Lichtenstein (* NOTE 43). In architecture and sculpture, the bizarre can assert itself but little, because the seriousness and specificity of the material of these arts hem its excesses. In painting, it already gains a significant room to play, namely through its very own colour tones. In music, it can naturally develop the incomprehensibility of its metamorphoses according to its whim in the soft, yielding, undetermined-determined element of sound, and music expressly names some of its most wonderful creation caprices. In poetry, finally the manifold representation of the *indefinissable* that lies in the bizarre is self-explanatory. Shakespeare has let it grow in some of his comedies to brilliant elaborations. Among the recent French, Balzac distinguishes himself in the art of idealizing the bizarre. He has written a novel depicting Swedenborgianism. The heroine of the same appears to the men, due to her angelic nature, as a virgin, as *Seraphita*, to the women as a young man, as *Seraphitus*. This psychological hermaphroditism leads to bizarre situations. Among recent German authors Gutzkow has a remarkable talent for the invention of bizarre characters and situations. His *Mahaguru*, his *Nero*, his *Prince of Madagascar*, his *Blasedow*, his Hackert in the *Knights of the* [219] *Spirit* are bizarre in the most eminent sense, and touch for this very reason often the sublime as well as the ridiculous. In the creation of the sleepwalking, secret-policing, ugly-spirited, malicious-good Hackert, Gutzkow has rendered the bizarre in the most fitting way possible. In the *Prince of Madagascar* he has located the bizarre particularly in the situations. What bizarre predicament the prince is in, to be imprisoned and sold into slavery by his own servants! In the smaller stories of Gutzkow also, one finds the taste for the bizarre a main ingredient, for instance, in the deliciously told story of that canary which strangely fell in love with its own mirror image and died of melancholy over the unreality of its *vis-à-vis*. Gutzkow even pulls off character studies of this art succeed very well, as in his portrait of Schottky, to which only [Karl] Schall's portrait by [Heinrich] Laube could be held up as a pendant.[142]

The pointed adventurousness, the fantastic mobility of the bizarre make it the irony of the ordinary and, in this direction, it touches on coquettish affectation. How easily the same can fall into decided ugliness we see from time to time in Tieck, who is so rich in really bizarre forms. In the novella, *Eigensinn und Laune* [Stubbornness and Whim], he has his heroine Emmeline step forth finally in the role of a bordello madam. This caprice is ugly, and the poet elides its motivation, whereas he represents the other wanderings of Emmeline in such a way that one can more or less grasp them. Emmeline could want to marry a coach-driver, could let herself be made pregnant by a careless assistant clerk, could marry an aristocrat of money, could run off with an officer who is in fact no other than the coach-driver Martin, found again—needed [220] she sink so low as to make a career in prostitution, a career not just for herself, but in the most abominable manner, as head of a bordello? This conclusion is more than bizarre.

[142] Heinrich Laube, *Moderne Charakteristiken* (Mannheim: Löwenthal, 1835), vol.1, Ch. 3.

Emmeline shows until then stubbornness and caprice, but not this outrageous meanness.—From the bizarre, the baroque is hard to distinguish. One could well say that it consists in giving the ordinary, the accidental and the arbitrary significance through extraordinary form. One derives the name from a well-known syllogistic figure with the name *baroco*; according to others it ought to signify something like 'askew' and apply to the sunken frames, which meet the picture or mirror in a diagonal surface and are still called Baroque frames.[143] Should it not, however, derive from *baro*, in Latin, a stupid person, in Italian a swindler, a rogue? Should not the baroque have extended the concept of false play to that of all play with chance? In it, there lies the cheekiness and abruptness of a self-surpassing arbitrariness, which can leap on into the comic, but also into the cruel or the sombre, as we find it in the punishments of the various nations, which were often both brutal and baroque—and unfortunately are so still. There is a Syrian pasha who even found an obviously very baroque pleasure in adapting the faces of criminals most single-handedly and artistically with a knife, in order to give noses, ears and lips a form pleasant to himself. Eugène Sue has at times known how to represent the baroque with much spirit, but always along its gruesome side. In *Mathilde*, his most perfected novel, he has drawn the deep malice of Mademoiselle de Maran very characteristically through [**221**] bizarre moods and baroque turns of phrase. The arbitrariness of this satanic person outs itself namely also in the creation of words which are only to be found in her lexicon, as for instance when she finds something very peculiar, she says: *c'est pharamineux!*

Related to the baroque, as to the bizarre, and yet distinct from them through an individual paradox is the grotesque. It got its name—after it had already existed for a long time in all humour—in Italy at the time of Cellini from a particular kind of gold and silverwork, wherein different materials were thrown together in a strange mixture; then the word was carried over to the chequered manner in which grottoes and garden halls, water bowls and so on were decorated with coloured stones, corals, mussels, layered ores and so forth. From this farrago the name went over to all forms, wherein a strange confusion of unpredictable flourishes and unexpected leaps captures as well as distracts our attention. Thus even the dancers, who, in wondrous contortions make us forget that they, like ourselves, have bones, are called grotesque dancers. Their sprawling legs, their teetering, their swaying, turning, frog-hopping, belly-crawling, is indeed

[143] This derivation from the Scholastic mnemonic *baroco*, standing for a deduction from a general affirmative and a particular negative premise to a particular negative conclusion ('All cats have whiskers; some animals have no whiskers; therefore, some animals are not cats'), was held by Erwin Panofsky: 'Either the word, or the peculiar roundabout fashion of thought denoted by it, or both, must have struck later generations as particularly funny and characteristic of the pedantic formalism to which they objected in medieval thought; and when humanistic writers, including Montaigne, wished to ridicule an unworldly and sterile pedant, they reproached him with having his head full of "Barbara and Baroco", etc.; Thus it came about that the word *Baroco* (French and English *Baroque*) came to signify everything wildly abstruse, obscure, fanciful, and useless (much as the word *intellectual* in many circles today). (The other derivation of the term from Latin *veruca* and Spanish *barueca*, meaning, originally, a wart and by extension a pearl of irregular shape, is most improbable both for logical and purely linguistic reasons.)' *Three Essays on Style*, ed. Irving Lavin (Cambridge, MA: MIT Press, 1997), 19. But Panofsky is too confident, for as Pierre Galet, *Cépages et vignobles de France; L'amphelographie française* (Montpellier: C. Déhan, 1990), 38, points out, the white wine grape *baroque* was probably brought to Southern France by pilgrims visiting Santiago de Compostela.

anything but beautiful; it is also not comical; but, as an arbitrariness that seems to ridicule all laws, it is grotesque. Flögel, in a sequel to his history of comic literature, has left behind collections that have been published in 1788 under the title of *Geschichte des Grotteskkomischen* [History of the Grotesque-comical]. In this history he studies after the satyr-play of the Greeks primarily the *Hanswurst*, the marionettes, feasts of fools and **[222]** societies of fops, and understands under the grotesque-comical especially low comedy, above all as this turns into the grossly sensual, the lewd, and the crude. Already in 1761, Möser wrote his *Harlequin oder Vertheidigung des Groteskkomischen*,[144] and explained that concept primarily through the Italian masques of [Luigi] Riccoboni. He also takes it as synonymous with low comedy, with buffoonery, with double entendre. His *Heirath Harlequins oder die Tugend auf der Schaubühne* [*Harlequin's Wedding or Virtue on Stage*] (printed in the *Sämtliche Werken*, ed. Abeken, Berlin 1843, Pt. 9, p. 107ff) is nevertheless kept rather tame. The grotesque is in many ways the taste of children, and the Chinese aesthetic.

The bizarre, baroque, and grotesque can turn into the burlesque. *Burla* means ridicule in Italian and Spanish. From Italy, the burlesque manner came to France and was thus disseminated through Scarron's travesty of the *Aeneid*, that the short verses used in that poem came to be known simply as burlesque verses, and even the story of Christ was reworked, quite seriously, but as the title already indicated (*NOTE 44), in burlesque verses. The burlesque is the parodic abundance of arbitrariness, which is extraordinarily well suited to the execution of light-hearted caricatures. That is why it constitutes the soul of Italian masked theatre and all related forms of humour. Silent acting, which we call *lazzi* or the corrupted *aczioni*, belongs to the burlesque as its genuinely classic form of representation. Creative presumption with it crazy bubbling spirit must bring forth these indescribable gestures, bendings, jumps, shenanigans, and grimaces, which only in the moment of their movement and in contrast with their **[223]** environment have any interest. In today's comic vaudeville it has cooked up a finer existence for itself. The French namely have at their disposal in the parody of the English an endless treasure of burlesque inventions, as for instance in the vaudeville [characters] Sport and Turff. But they love it precisely for its parodic quality, and one can observe how much their actors are able to discover in and to develop out of a role. One takes, for instance, a vaudeville, like the cook Vatel, ambitious in the kitchen,[145] such a role, in which Seydelmann was so classical, would only be half of what it should be without the creative whim of the actor in burlesque faces and gestures. Vatel wants to murder himself with the kitchen knife over a failed pudding. Vatel, dressed in the white apron, in the white hat of the chef, large-bodied, swinging the cooking knife, holds a moving monologue that almost makes us suffocate with laughter—when the genius of the actor has the burlesque in its power. One cannot dictate such stuff. In the vaudeville *Les vieux péchés* [Old Sins][146] we see a former Parisian dancing master settle

[144] Justus Möser, *Harlekin: oder Vertheidigung des Groteskkomischen*, second rev. ed. (Bremen: Johann Heinrich Cramer, 1777). The English translation by Joachim and Friedrich Warneke, *Harlequin: or, a Defence of Grotesque Comic Performances* (London: W. Nicoll, 1766), was appropriately dedicated to David Garrick.

[145] Scribe and Mazères, *Vatel, ou le petit-fils d'un grande homme* (Paris: Pollet, 1827).

[146] Mélesville and Philippe Dumanoir, *Les vieux péchés* (Paris, 1833).

under another name as a prosperous retiree in a provincial town, win the respect and trust of his fellow citizens and finally get named mayor. As soon as this excellent man is moved by deep emotion, he falls predictably into symbolic dancer attitudes, so that the pathos of magisterial dignity and the frivolous enjambment of the ballet contradict one another most burlesquely. Only the whim of the actor, [224] only his burlesque grace can prevent this contradiction from becoming an intolerably ugly one. Or one should recall that vaudeville in which an old retiree follows Fanny Elsler in her travels,[147] and in his hotel room, as he attends to his morning toilette, is so enchanted by the thought of her nearness that, lost in blessed memory, with shaving towel around his neck and razor in hand he imitates the amiable dancer's graceful, seductive cachucha in the most horrifying but ridiculous manner.

Such is burlesque. If we have lost ourselves in the dramatic domain with these illustrations, we must note that this only happened because this domain makes possible the maximum of burlesque energy, but by no means because other forms of art were incapable of the burlesque. Poetry even possesses certain stereotyped means of generating the burlesque, as in *forced rhyme*, in the mixture of languages, in jargon, which we have already discussed in another connection (* NOTE 45). Wherein lies here the aesthetically acceptable? Obviously it is that, in what we would have to judge ugly in itself, freedom asserts itself as a cheerful game and transfigures ugliness into ridiculousness through the conscious excess of arbitrariness. An incorrect rhyme for instance will not be found beautiful by anyone. A forced rhyme distorts a word to make it rhyme. This mishandling of language is also not beautiful; but because it originates in a freedom that has created language itself and according to which the word could also have this form, we must laugh. The same is the case with the word-monsters of Fischart[148] and others. When a well-known parody [225] of the Mignon-song goes: 'To Italy, to Italy, ol' man, I would like to gonce!', in it the verb 'to gonce' is unheard of, impossible.[149] But the burlesque mood springs out with it and courts our laughter.

Due to the relation of the bizarre, baroque, grotesque and burlesque to one another, farce, comic opera, and the comic novel present themselves to us in the most manifold transitions imaginable. Cramer, Jean Paul, and Tieck among us, Smollet and Stern among the British, Scarron and Paul de Kock among the French, have given us such fusions. Incidentally, Tieck is more successful at this in detail than in the conception of the whole. What a baroque idea, in the novella *Die Gesellschaft auf dem Lande* [The Rustic Party] to represent the accusative as a graceful, friendly, forthcoming youth and the dative as a sitting, bearded, old man staring morosely into his lap. With it, however, comes the burlesque justification, carried out in a pathetic tone, that with this invention

[147] Fanny Elssler or more accurately Elßler (Rosenkranz misspells her name) was a famous Austrian ballerina, who in her 1840s heyday toured Europe and the United States. The *cachucha* is a Spanish dance made famous by Elssler in her 1836 hit, *Le Diable boîteux*.

[148] Johann Baptist Fischart (1545–91) was the leading German Counter-Reformation satirist.

[149] Goethe's ingénue Mignon in *Wilhelm Meisters Wanderjahren* sings the famous tourist poem 'Kennst du das Land, wo die Zitronen blühn', which is being parodied here. The original refrain 'There, there, my lover, with you I'd like to go', turns at the end into the dutiful 'There, there, o father, let us go!' The wordplay in the parody turns on *einmalig*, 'unique, one-time', which sounds like the verb phrase *einmal gehen*, 'go once/one day'.

a whole new field is opened to the fine arts, after Antique, Nordic, and Christian mythologies have been exhausted. What a future in which the princely infinitive, the sovereign imperative were also honoured by sculptors and painters! This speech is a masterpiece of the finest burlesque. Paul de Kock is reputed to be frivolous. He is too, only he is nevertheless far less dangerous than some well-tolerated writers, namely because he is comical, because above all things he is grotesque and burlesque. Thus, for instance, in one of his novels he lets a young man hope to rendezvous finally with his [226] lover in a garden pavilion. He comes to the pavilion too, but gets lost and ends up in another room, and, cowering under a sofa, must endure the endearments of a married couple, who lie down to sleep, then crawls after they have fallen asleep out of the room, finds the stairs, finds the right room, finds his lover. But hardly has he delivered himself to her bed that fire breaks out. Noise ensues, he must flee, grabs in his hurry the clothes of his lover, flies with them through a window and escapes successfully over the garden hedge. There he wants to dress, finds to his horror feminine attire, must in his desperation force himself into it, and experiences in this grotesque disguise a thousand adventures on the short way to Paris. Not arbitrariness, but chance, is here burlesque.

c) The Crude

Meanness as such is the degradation of freedom under a necessity which is not its own. As crudeness it is a devotion to dependence on nature, which cancels out freedom, or a bringing forth of force against freedom, or a ridiculing of the absolute ground on which all freedom rests, the belief in God.—The majestic can also fall victim to suffering, but only on its finite and mortal side, which it must surrender to outer violence, while it asserts itself in itself as free and thus is able to preserve all the more energetically, precisely in suffering, an infinity in its action unbothered by the same, as Rückert says so beautifully:

> The dirty wave does not stain the pure pearl,
> Even as its furious foam breaks on its shell. [227]

Freedom does not yet contradict itself if it at first expresses itself imperfectly, as we have already said in the introduction. Held against the higher, against the final step of the possible development, the first, unripe shapes can appear unbeautiful, and insofar as the force in becoming pushes forward violently, they can have a crude form. Such an existence then does not yet, in its reality, correspond perfectly to its concept, only this not-yet-corresponding is by no means a contradiction, but much rather a step along the way to real congruence of the essence to its appearance. The crudeness that we then testify to is not an ugliness that is opposed contrarily to beauty.[150] There are lower, often

[150] In logic, contraries cannot both be true, but both may be false. Rosenkranz tacitly allows for things that are neither beautiful nor ugly, as he did explicitly in the Introduction.

inevitable stages, which an existence must go through successively in order to realize its concept entirely. The crude construction is a preliminary state, which does not exclude beauty positively from itself, and to which we oppose the state of polish, of smoothing and refinement. In this sense, crudeness, insofar as an abundance of fermenting productive force drives it, can even be a guarantee of future competence. The main content of a conception can appear in pithy sketches, from whose crudeness their possible, inherent beauty shines forth. Hand drawings of sculptors and painters, building plans, dramatic sketches, can, in their embryonic state, already reveal to us the whole infinity of real art. In the first works of national art movements we often find bound with the crudeness of the representation already a type of genuine beauty, whose struggle with the imperfection of the appearance can be deeply gripping. Without any reservation [228] one may even speak of a crude majesty, because it is possible that its magnitude and power still lack fine execution, but this latter is already visible in the free, independent, bold pitch of the whole design.

This kind of crudeness thus concerns the fineness of form and the execution of the individual details. From it we must distinguish the crudeness that contains a contradiction of freedom with itself and indeed first of all in the fact that it makes itself dependent upon the *sensuous*, which should be subordinated to it as a means.[151] The mind should enjoy the sensuous, without coming undone completely in this enjoyment and sacrificing to it its free command over it. The ugliness of gluttony, alcoholism and debauchery lies in a bondage of freedom that is against its concept. Neither nutrition nor reproduction as such are, as pure necessity of nature, unbeautiful. They first *become* so insofar as they subjugate the freedom of the mind. Thus, for the animal world this shape of ugliness, one that is mediated through moral concepts, cannot exist. The animal lacks the freedom of reflexion, of comparing its state with a concept of what should be. But if we foist on animals the image of our freedom, as happens in fables, an animal can by dint of this fiction come to present an ugly view. The hyena, for instance, can then appear horrible in its voracity, in that its greed does not spare graves and its insatiable maw swallows corpses too. An ethical moment enters here then, determining our judgement. But because nutrition and [229] reproduction are in themselves necessary acts of nature, humour can find extraordinary means precisely in them, in that the human, in falling away from the strict law-likeness of freedom and giving himself comfortably to sensual enjoyment, discharges the guilt from himself to nature, to whom he pays his tribute only as a *homuncio* [little man], as French levity has invented a phrase for this: *c'est plus fort, que moi* [it is stronger than me!]. But without whim, this is not possible. All table and drinking songs, in which whim does not breathe, are ugly. Comedy can also play with natural instincts ironically. It can jokingly exaggerate the passion for sensual pleasure, as if for humans and even for gods nothing higher and more important existed. Thus the ancient comedians have represented

[151] German has one word, *sinnlich*, for English 'sensuous' and 'sensible'. One result is that puritanical arguments against sensuousness are more closely linked in German to the senses in general and their subject matter (the 'sensible'). We alternate the words according to context, but the fact that German has one word should be kept in mind.

Heracles as a vagabond of unquenchable appetite. Aristophanes ridiculed these Hanswurstiads, but preserved their manner, for instance in *The Frogs*. Of the satyr plays only the Euripidean *Cyclops* has been preserved, which presents to us the colossal crudeness of Polyphemus. In *Gargantua and Pantagruel*, the learned and worldly doctor Rabelais held up to the Parisians a mirror image of their immoralities, by portraying drinking and eating as serious study, with which the heroes occupy themselves at the university with the zest of thorough researchers. In Immermann's *Münchhausen* we meet the well-served Karl Buttervogel [Butterbird!], who only feigns a burning love for the gracious Fräulein von Posemuckel because he wishes to be regaled by her with fatty buttered breads and other victuals.—For the comic handling of sexual instinct that situation is most amenable, wherein the necessity of nature [**230**] is roundly denied and in false pride opposed to an imagined naturelessness, only to be surprised by the power of nature and forced to a half-involuntary recognition of it. This comic spirit trembles through the ancient Indian stories of those penitent kings who threatened to become dangerous to the gods through their force and to whom they thus sent one of the most charming Apsaras [cloud and water deities] to seduce them in their holy solitariness. The same spirit enlivens many medieval tales, which have imagined the contrast contained in them most delicately in those stories like that in which Alexander sends Aristotle a courtesan, and the philosopher is flattered down from the height of his abstractions, so that crawling on all fours he lets himself enjoy carrying her ample burden on his back, a graceful occupation in which the laughing Alexander surprises him. What saucy stories of Boccaccio and Wieland rest on this element, is well enough known.

Although the instinct of self-preservation, like that of reproduction only become aesthetically possible through moral blessing or humour, it is nevertheless interesting to see how as a natural consequence of its satisfaction, conditions can come up which may seem to us aesthetically even cruder. Nature, for instance, forces the human like the animal to void the superfluous, and indeed in a much more urgent manner than in the eating or drinking of the same, which is why we in German name this common necessity by the particular word *Notdurft* [literally base necessity, or more familiarly nature's call]. The organism frees itself thus from what it could not use in its life, [**231**] which it separates from itself as something relatively dead, something inorganic produced by an organism, a being killed by life. This externalization is, however necessary it may be, ugly, because it makes the human appear in the lowest dependence on nature. For that very reason he seeks to hide the carrying out of nature's call. The animal is naturally careless in relation to this act, and only the neat cat, who is always licking and cleaning itself, buries its excrement after depositing it in vacant places. The child does as the animal at first, and the impropriety of the dear little one, opposed to the closure of conventional forms, can bring forth very uncomfortably delightful contrasts. The representation of nature's call is thus in all cases unaesthetic, and only humour can make it tolerable. Potter has painted a 'pissing cow' which was finally sold to Petersburg for an enormous price; but had Potter not been such a good animal painter, the most exact copying of the animal in that state precisely would not have heightened the value of the work of art. We confess that we could well do without the pissing of the cow and that no aesthetic satisfaction accrues in us out of it.

Nevertheless we may not apply the measure of man to the animal, and that is the reason why a 'pissing cow' does not offend us. We must say here the reverse: *quod licet bovi, non licet Jovi* [what a bull may do, Jove may not do]. In Brussels a well-known fountain, by which the flood of the fashionable world flows, is called *Mannekenpiss*, because a ribald boy pisses out the water. But this Netherlandish comedy is hardly comical, for water should be pure, should indeed be water, and something repulsive mixes itself [232] into the thought of ladling out and drinking water produced in such a manner. When Rembrandt on the other hand paints *Ganymede*, carried up into the air by the eagle, as amidst the surprise he pees in fright in the manner of children—that is really funny [cf. Figure 1, where, however, the urine is not reproduced]. The plump boy still holds a grape bunch in the left hand, which he had been enjoying, as the bird of thundering Zeus above seized him and, with its claws, pulled up his shirt to reveal his round behind. How Aristophanes brought even nature's call on stage has already been mentioned in a different connection. The *Pfaffe von Kalenberge* [Parson of Kalenberge], the *Pfaffe Amis* [Parson Amis] and the *Eulenspiegel* swarm with such coarse jokes. Also the ugly, cynical *Morolf* with his whole Italian kin belongs here.[152]

The excessive satisfaction of the feeding instinct can as a consequence make a shape portly, paunchy, and thus ugly, a deformity that humour exploits ever again to unfailing effect, even if Aristophanes complains in this regard that the comic writers, in order to secure laughs, make things too easy for themselves with fat bellies. The fat belly, which brings too many inconveniences with itself, because of which the owner can no longer see his feet, which so maliciously deprives the poet of the ethereal, the priest of the spiritual, the fat belly, which one must carry before oneself and which is more likely to be visible on the street-corner than is its carrier, has been a favourite of low humour up to the pointed belly of the roguish Punch. Without brains, without wit, without irony, the ridiculousness of a fat belly is nevertheless very thin; in a Falstaff, however, it becomes an inexhaustible repository of humoristic wit. [233]

Drunkenness can appear amiable, as long as it enhances the freedom of the person and only does away with the inhibitions which otherwise constrain him. As an enthusiastic drunkenness it can then even transfigure the visage, like the festive frenzy of the heavens-gazing maenads. Silenus has indeed been robbed of the use of his feet by the Bacchic fire; one must help him onto the donkey; only his thoughtful smile shows that the godly drunkenness has focused his mind more intensively, rather than destroying it. The passage of the drunken from level-headedness into unconsciousness is the witness stand for scurrility, and even for the higher humour, when it represents someone as 'tipsy'.[153] But if drunkenness reaches a level that robs the person of all

[152] Rosenkranz is referring to the Middle High German poem *Salman und Morolf*, a comic-epic adaptation of the story of Solomon and his pagan wife; the real hero is the king's brother Morolf, an Odysseus-like trickster. The *Pfaffe* poems mentioned just before are from the same epoch; all are rated highly by Rosenkranz in his literary historical writings, e.g., *Handbuch einer allgemeinen Geschichte der Poesie*, vol.3 (Halle: Eduard Anton, 1833), 327. Rosenkranz is daring in making international comparisons with what were supposed purely Germanic works: at *Geschichte der deutschen Poesie im Mittelalter* (Halle: Anton & Gelbcke, 1830), 351, he compares Morolf to Sancho Panza.

[153] Rosenkranz has *bespitzt* in double quotes, indicating this is unusual slang in his time—'high' would give the more appropriate tone, though the substance meant is alcohol.

self-awareness, it becomes necessarily ugly. In many books on aesthetics indeed drunkenness is discussed without further ado as if it were unconditionally ridiculous. This is by no means the case, for the decline of personal freedom that brings the person near to the animal can only appear ugly. This state can only be ridiculous so long as it represents freedom in vain struggle with nature and so long as we spectators turn a blind eye to all moral reproach. The slurring and stuttering of the drunk, his swaying, his unguarded babbling of secrets, his monologues, his dialogues with persons not present, his criss-crossing jumps from A to Z are funny, as long as they still reveal a certain self-control. Already the drunk can do no other, than to fall victim to chance and arbitrariness, but he would still like otherwise, and this appearance of his freedom going down into the fog of unconsciousness is funny for us. Because of this [234] inevitability of mimicry and tone-painting, only pantomimes and dramatists can really use this state successfully, which they have also done so frequently that we can dispense with examples.

Flatulence is under all circumstances ugly. But because, against the freedom of the person its outbreaks assert something non-arbitrary, because they to his dismay often surprise him in the wrong place, escaping unnoticed on the occasion of a quick movement, they have the quality of a mischievous kobold, who unannounced, *sans gene* embarrasses one. Comedians have therefore always used it in their grotesques and burlesques, at least in allusion. The most ridiculous scenes can be brought forth through this 'ringing impropriety', among which of the well known the anecdote of the forester and his dog is certainly the most delightful. Karl Vogt tells it also in his *Bilder aus dem Thierleben* [Pictures from Animal Life] (*NOTE 46).—Because we humans, however we differ in age, education, affluence and rank, meet in this non-arbitrary humbleness of our nature, the allusions to it seldom fail to elicit a laugh from the public, and low humour loves extraordinarily all relevant boorishness, scurrility, and oafishness. Even the most elegant circus produces it in its clowns ever again. Without wit, or at least without caprice, they are eminently shallow, paltry, repulsive, indeed quite repulsive; but the Bengal fire of wit is capable of endowing with brains even these cynicisms. In Paris a dog groomer had two dogs sniffing each other's rears painted on his sign. But under this he had [235] the words written: *Au bon jour des chiens!* ['a good dog-day!'] and all the world laughed.

Of these natural occurrences, which can happen even to the most cautions person, ἄτοπος καὶ ἀκαίρως [*átopos kaì ákairos*, out of time and place], the commonness of *obscenity* differs in being shameless. Shame is holy and beautiful, for it expresses the feeling of the spirit that in accordance to its essence it is something over and above nature; it cannot be natureless, but it should be nature-free. Nature does not know shame and the dear beast, as one says in German, is not ashamed; but the person, becoming aware of his difference from nature, is ashamed. Obscenity consists in the intentional infringement of shame. Already an accidental and unintended exposure awakes embarrassment, maybe a distressingly funny moment, but it is not obscene. With children, unselfconscious bathers, with beautiful statues or pictures that represent the naked body in its totality, no one will speak of obscenity, for nature too is godly and the genitals are in themselves just so much natural, God-made organs as the nose or the mouth. But fig leaves stuck to the privates of statues already bring off obscene

effects, for they draw attention to them and isolate them. One ought not to understand this as if I meant to say that art does ill to be chaste; we only wish to make clear that chastity and prudery are not the same. Obscenity begins first with a sexual bond; because the sexual feeling excites the member of the man and gives it an ugly form, which in this state enters into a false proportion to the rest of the body. The female is handled more modestly by nature, but [236] the menstrual cycle forces her to conceal her shame. All representation of shame and sexual relations in picture or word, which is not made in a scientific or ethical spirit, but only out of wantonness, is obscene and ugly, for it is a profanation of the holy mysteries of nature. All that is *phallic*, though holy to religion, is, taken aesthetically, ugly. All phallic gods are ugly. Priapus in the rectilinearity of his stiff member is ugly. The masks of the ancient and the *Mohabazzin* or street actors of the modern Egyptians, which with movable members play an obscene game; or the dwarf figures of the Romans with their colossal male members, the Sannio, the Morion, the Drillops, are ugly, for the penis of such a figure is nearly as large as its owner (* NOTE 47).—If already the ostentation of the genitals in itself is ugly, the ugliness must be amplified if the sexual relation emerges determinately, as, for instance, in the Indian lingam, which represents the phallus as stuck in the Yoni, that is, the female genitals, which indeed in the Indian context is meant religiously. How many people in Europe also share this Indian standpoint, how strongly the fantasy of the crowd is stained with phallic pictures, one can see in every city, where a wall, a gateway only needs to be painted freshly, to be daubed within a day with such figures. In the Middle Ages it was even common for a period to give sugary confections eaten for dessert phallic forms.—All priapic pictures, poems and novels are thus ugly, however great the expenditure of fantasy, [237] wit and technical virtuosity with which they might be made. One can examine the survey of the extensive pertinent novelistic literature in O.L.B. Wolff's *Geschichte des Romans* [*History of the Novel*] (* NOTE 48). In painting the pornographers, who represent the various τρόποι τῆς Ἀφροδίτης [*trópoi tes Aphrodítes*, themes à la Aphrodite], began in the time of Alexander; for the modern world, the well-known pictures of Pietro de Arezzo and the figures drawn by Giulio Romano and engraved by Raimondi have laid the groundwork for such representations. In the novel, Petronius with his *Satyricon* laid the fundamentals for such obscene-lustful depictions with a certain greatness of purview that is missing in his followers. Nothing indeed is more characteristic for this notorious genre than the fact that Sade, the so-called King of the Galley Slaves, has become the noblest classic among them. The jaded nerves of those libertines, who have enjoyed their way through everything, tickle their fantasy at least with such further refinements. A sad phenomenon of the present, that such obscene writings and pictures find an ever greater public and, as the tourist Kohl tell it, in the streets of London even find their way into the hands of youth. Our modern ballet too is infected with such elements, and thus so aesthetically impoverished that it no longer aims to represent the passion of love symbolically, but rather the convulsions of lust. These pirouettes and windmill-shapes, these shameless heaven-defying stretching out of the legs and disgusting couplings of male and female dancer are held as the triumph of art. Ideal beauty and grace are no longer at issue there, only common tickling. The *chahut* and *cancan* are in the dance of today's [238] society the inevitable consequences of such a standpoint, which can only be surpassed

by the naked and half-naked bodies in the living pictures (*tableaux vivants*) of Quirinus Müller. The Frenchman Chicard was until a short time ago the zenith of this obscene tendency. A. Stahr, *Zwei Monate in Paris* [Two Months in Paris], 1851, vol.2, p. 155 describes him as follows: 'No sense of being absorbed in the tumult of the senses and of the blood, in that drunkenness of passion that carries its justification in itself; no exuberance of youth, which lets the excess of force rejoicing in wild rhythms of the body. No, here was nothing but cold, conscious, reflected refinement of the ugly and mean. This Chicard was the genius of the police-morality ironizing itself. The police guards who stood at his side served only as foil, heightening the brilliance of his triumph. For all interest was invested essentially in seeing how far he would try to push the representation of the abominable and the immoral before these defenders of morality thought themselves legally justified to interrupt his artistic productions, and remove him bodily from the stage of his triumph. It was the ridicule of uniformed moral, of liveried, sabre-carrying decency, the guard of virtue rented by the hour, that constituted the whole interest of this dance. Chicard dared the most extreme, and he went forth as victor.' This piquant report is nevertheless very one-sided; for it should be compared with the detailed representation of Chicard by Taxile Delord in the *Français peints par eux mêmes*, Vol.2, 361–76 (* NOTE 49).—The Greeks, with their deep, ethically true sense of art, softened the [239] obscene by attributing it in large part to half-human beings like the satyrs and the fauns. If such individuals, who present below with goat's feet, also behave goatishly, it will hardly make us wonder. Many Pompeian pictures show us satyrs in the woods sneaking up on a nymph who has just stretched out her snow-white limbs most luxuriously on the mossy cushion. The beauty normally sets herself up in a half-rear view, and is often covered with a veil, which the pleasure-seeking satyr lifts. With lust-shaken limbs, lost in the rigidity of sensuous intoxication, animal ugliness stands before half-slumbering beauty. How different these luxuriant, obscene-elegant pictures are to look at from the erotic scenes from the *cubiculis Veneris* [little rooms of Venus, probably the erotically decorated bedchambers—eds.] of Pompeian houses, where lovers in manifold positions carry on the work of nature, and generally a slave stands nearby who has served the aphrodisiac drink and whose presence first really provokes the vivid sensation of the obscene. Disgusting!

To soften obscenity, the mind applies the cunning of ambiguity, that is, of the more or less covered-up or hidden allusion to inevitable cynical activities or to the sexual relations of people. Ambiguity is an indirect view of that which provokes shame in us. It clearly originates from this shame, in that it at the same time contradicts it by going into sexual relations, but it veils this shamelessness through forms which at first seem to comprise another sense, but which nevertheless allow easy translation into another version. The play of fantasy [240] can thus really rear its head here in humorous analogies. If one considers what Schopenhauer says on the relation of the two sexes (* NOTE 50), one will be able to comprehend why through all cultures and classes in all epochs, sexual ambiguity, the amphiboly *par excellence*, has been one of the favourite activities of humanity. With civilization grows the enjoyment of the same, so long as out of it a still higher, purer, ideal education is born. The religions in their obscenity do not at all veil sexual relations, and what a phallus, lingam, or priapus is, is not to be explained for the first time by symbolic interpretation. The religions recognize there

the divine, holy force of nature and defuse through their openness the attempt to play with it. In the pictures, reliefs, and gems of antiquity (* NOTE 51) that represent sacrifices brought by young women to Priapus, one will find nothing lustful, but much rather a strict observance. Sculpture and painting can, however, be lustful and obscene, only they are less vulnerable to corruption through ambiguity than is mimicry or poetry. Music is not capable of it at all. Ambiguity employs our fantasy and our common sense at the same time, and is through its allusion not exactly the same as ribaldry, which for its part can also be ambiguous, while on the contrary an ambiguity need not be ribald. Ribaldry shows a roughness, rudeness, crudeness, from which ambiguity in the service of wit distances itself. Ribaldry, a main element of so-called low humour, plays by preference with the expressions of nature's call. It laughs at the human being, that it as such a privileged [241] being nevertheless cannot do otherwise than to empty his bladder and pass his stool. How Rabelais bubbles over with ribaldry, how sparing he is with ambiguity! How rich Shakespeare is in ambiguities, how thin on ribaldry! In Rabelais it is quite in the spirit of ribaldry that his hero, for instance, busies himself with the profound research which kind of toilet paper (*torcheculs*) is best, and for this purpose sets up a long series of experiments, which are conscientiously recounted in a catalogue that ends with the result that the rump of young chickens, those that have just crawled out of the egg, is most comfortable to our behind. It is obvious that Rabelais through the treatment of this theme intended incidentally to satirize what is sterile in science, which so rigorously deals with nothing. From satire, ribaldry can be turned more generally into a corrective against prudery, reminding delicacy through its natural robustness that its angelic nature is a lie. If the tastelessness of puritanical rigorism in North America forbids the use of the word 'shirt' or 'underpants' in the presence of a lady, the expression *inexpressibles* proves best that one knows well enough what pants are. The title of a novel like *Die Hosen des Herrn von Bredow* [The Pants of Mr. von Bredow] by W. Alexis would have made the author eternally unfit for polite society in North America. Much depends on how the ribaldry is prepared for, an art wherein Heine excels. Recall his polemic against Platen in the *Reisebilder* [Travel Album]; or his *Memoiren des Herrn von Schnabelowopski* [Memoirs of Mr. von Beakowopski]; or the end of his *Winter's Tale*, as his feisty Hammonia orders the night throne of Charlemagne [242] covered up. Ambiguity on the other hand moves mainly in the domain of more or less hidden sexual allusions. The seventeenth and eighteenth centuries have gone into this especially. Ronsard, Voltaire, Crébillon, Gresset and others belong here. A work of Diderot is always presented as a maximum of the equivocal French literature of that time: *Les bijoux indiscrets* [The Indiscreet Jewels]. But one would be making a great mistake, if one placed the latter book in the class of Sotadic inventions, as is routinely done. Literary historians reproduce desperate judgements without knowing their object. A banal phrase sticks to a book as stereotypical predicate. The *Bijoux indiscrets* are, objectively speaking, a sequel to Montesquieu's *Persian Letters*, a satire on the boundless licentiousness and political corruption of the time, a moral tribunal on the secret sins and vices of that society, executed with all the spirit of a Diderot, but, it cannot be denied, not without a certain frivolous feature, a certain delight in erotic scenes. Diderot has juxtaposed tactfully in the Sultan Mongogul and his favourite Mirzoza the tenderest feelings and the most extravagant cynicisms, which

are unveiled by the magic ring of the wise Cucufa; he has strictly separated love and tenderness from lust and commonness; he never oversteps a certain limit, but breaks off where an author dedicated to the excitement of sensual stimulation would really have gone in depth; through the whole book he makes tangible the bitter realization summarized by the sultan in his own words [243] (*Œuvres de Denis Diderot*, ed. [Jacques André] Naigeon [Paris: Deterville, 1800], Vol.10, p. 126): 'What horrors! a spouse dishonoured, the state betrayed, citizens sacrificed, these faults ignored, rewarded even as virtues: and all this for a jewel.'[154] And nevertheless the book makes an unpleasant impression, because the fundamental fiction of unmasking the depths of human passion is plain ugly. The meanness of this premise works itself out similarly in the whole series of stories, just as in Ben Jonson's *Epicœne, or The silent woman* (translated by Tieck and collected in his *Sämmtliche Werke*, vol.12), the basis of the piece, that a marriage contract should be recalled *porter frigiditatem* [due to frigidity].

A curious grouping of the ugly is represented by representations that are not shameless in the sense of lasciviousness or ambiguity and yet injure the sense of shame deeply, because they want to make poetic a content that we would accept with unprejudiced seriousness coming from the muse of history. There is an openness of corruption that becomes an inverted innocence. One cannot object to certain representations that they made lust more piquant through veiling or on the contrary that they made a particular effort to corrupt the senses. Their fidelity in the painting of physical and ethical baseness, their embarrassingly precise anatomy of commonness, does not allow us to raise the objection against them that we are seduced by half-betrayed stimulations or overpowered by coquettish colours; only, precisely because this excuse is absent, the effect of such products is all the more disgusting. When a Suetonius or a Tacitus with their objective love of truth [244] report such things, we shudder over the brutality to which humanity can be misled; but when we find the same horrors offered with the pretension of finding poetry in them, we feel ourselves destroyed ethically and aesthetically. Beaumont and Fletcher often made this error; it is also Lohenstein's error in his dramas; it is the error of so many products of the new French hyperromanticism, as in the recent *Dame aux Camélias* [Lady of the Camelias, 1851] of the younger Dumas; the error of Sue in many parts of his *Mysteries of Paris*, for instance in the medically correct description of *amor furens*;[155]—all fantasy is not enough to purge the terrible prosaicness of such material. Even Diderot has produced an exemplar to scare people off in his *Réligieuse* [The nun]. From a cultural historical viewpoint, this book is certainly one of the great legacies of the eighteenth century, for in intimate knowledge of the horrible secrets of the cloister it exceeds even the story of the Black Nun of Montreal in Canada. And what a simple, entrancing account! From an aesthetic standpoint however the story is thoroughly objectionable, for a fat, lustful abbess who forces her nuns to lesbian sins is an unpoetic horror. Admittedly Diderot

[154] 'Que d'horreurs! un époux déshonoré, l'état trahi, des citoyens sacrifiés, ces forfaits ignorés, récompensés même comme des vertus: et tout cela à propos d'un bijou.'
[155] Literally, frantic love, the Latin term for erotomania, a phenomenon first described in 1610 by the French doctor Jacques Ferrand, after whom Sue named one of the characters in his novel.

could say why pretension drove him to have made a novel, a work of art; indeed he himself, as Naigeon (* NOTE 51) reports, became convinced independently of such an aesthetic claim, that his representations were dangerous, and he wanted even to castigate them, wherein he was hindered by the illness of which he died. In *Jacques le fataliste* as well we find folded a kind of excuse for the rudeness that [245] is found in it.—Romantic literature has a fixation on the lubricious, obscene, ambiguous, lascivious, which already stretches from the Middle Ages to the *contes* and *fabliaux*, to the gallant adventures of the Knights of King Arthur, all the way to the *Chansons* of a Béranger, an author whom, when one thinks of his Frétillon, it is hard to acquit of the specific enjoyment of the sensuous frivolity of the French, however temperamentally and gracefully he may be able to handle ugly material. The fiction of a certain fatalism of love, which we already find in the Tristan saga and which are turned in Goethe's *Wahlverwandschaften* [Elective Affinities] into the tragic and thus the moral, was made by the French into an inadequate excuse for very ambiguous representations. One of their most beloved novels remains Prevôt d'Exiles' *Manon Lescaut*. Two lovers are there somehow magically chained together, and remain true to another through all, often through very rough changes of fate, until death. But how? When her outer necessity becomes very great, the beautiful, amiable Manon regularly resorts to the expedient of throwing herself, with the approval of her lover, into the arms of a rich man, exploiting him properly, and then, with the riches earned through prostitution, once again to lead a carefree life with her lover. Manon remains true to her lover, so true, that she prostitutes herself for him. And he, the Sir Knight Desgrieux? He makes his living through cheating at cards! Certainly these situations are piquant, and certainly they are French, as the many, still ever new editions of *Manon Lescaut* prove. But [246] certainly they are ethically and aesthetically mean and low as well. That the lovers finally move to America, there become very virtuous and come to a moving end, the model for Chateaubriand's *Atala*, is no justification, but ethically and aesthetically an error, for this Manon and this Desgrieux on American soil are not longer the same persons. George Sand has led herself be misled to the point of wanting to deliver in her *Leone Leoni* a counterpart to Manon, with the difference that Julie is chaste and that she doesn't know the occupation of Leoni, also a card cheat. But she is wholly caught up in ugliness, for what in Prevôt d'Exiles through the open agreement of the lovers becomes, as we said above, a perverted innocence, becomes here through the viciousness and force of Leoni against Julie, whom he sells to an Englishman in the most brutal way, unbearable. The fidelity of Manon has nothing unnatural, but the passionate dependence of Julie on a moral monster, who wanted to lower her to a means of commerce and also deceives her in the most dishonourable manner, is detestable (* NOTE 53).

This whole region of sexual meanness can only be aesthetically liberated by humour. The ethical side must be ignored in this case and only the factual contradiction that lies in the situation as such, must be held on to. Humour must only turn to the happenings as such for a deeper sense would disturb it. Byron in his *Don Juan* has practised this humour in very piquant scenes, which make us laugh without getting us up in arms. Julia, the opulent Spanish woman, stuffs Don Juan under the bedcover when her husband brings the alguazils [constables] into her room, and holds a fulminating [247]

sermon, over how one could be so shameless to intrude on her in bed. The whole bedroom is searched and nothing suspicious found, while the guilty party sweats in bed. Or Don Juan is bought as slave by the Sultana in Constantinople, disguised as a girl and stuck in the harem, but since a bed for him is still missing, he is placed provisorily for the first night with an odalisque, who then dreams such a strange and vivid dream, that her shouts bring the whole dormitory into animation. In these cases, humour must, as I said, abstract from all moral critique, only the possibility of this abstraction must lie in the whole complex of the other conditions, as for instance here, in a harem, with Don Juan disguised as a girl and through no effort of his own assigned an odalisque as bedfellow, we do not find the forgetting of the ethical postulate surprising. Byron never paints in his *Don Juan* with lustful colours in the way that Wieland does, enjoying the taste of the sensual. Among contemporaries, Paul de Kock above all has preserved a fresh carelessness in this genre, without which it is repulsive through and through. One feels in him that despite all, the ridiculous in the situation is the main point, and the sensuous may indeed be handled lasciviously, but without ulterior motives. He thus lets an old maid fall for the notion that all sexual immorality stems from the fact that so many ladies don't wear pants. She thus tolerates no female being in her house whose legs are not clothed. If she hires a maid, the maid has to swear that she will wear pants. Once inside the house, she must appear, raise her skirt, [**248**] and show that she is decently pantalooned. She takes a niece into her house. The young girl must immediately, before all things, put on *calençons*,[156] for wearing pants has become for this honourable lady identical with decency and morality, and she addresses long speeches to the young girl concerning the importance of this ethical principle. One day then the niece sits with her male cousin on a bench in the garden. The bench tips over, the young people fall off, and through this accident the cousin discovers that his cousin wears the most attractive pants. Unhappy discovery, for one sees in advance that it may have consequences quite opposed to the sublime intentions of the wise old pedagogue. We have already said that Paul de Kock through his humour in general, because this tends toward the grotesque and the burlesque, is far less dangerous than some other authors. He has unfolded this jovial mood with particular success in a novel, *La maison blanche* [The White House; Ghent: Vanderhaeghe-Mava, 1840]. Of the many truly funny situations we would like to introduce just one to illuminate our theme. Robineau, a parvenu, has bought a castle in the province and organizes there a rustic feast. Among other entertainments there is also a *Mât de Cocagne* [Greasy pole]. All the hotly competing boys slide down the smooth pole, and it already appears as if no one will win the prize. Then comes the earthy cook, pulls up her skirts, climbs both elegantly and efficiently, seizes the prize and begins the descent. Only, in the meantime her clothes have gotten hooked, and unexpectedly bunch up over her head, so that the public gets to see the rough, pantless buttocks of the winner. [**249**] This highly ridiculous situation is presented by Kock in a quite unforced way.

The concepts so far examined as forms of crudeness have in common the dependence of freedom on the sensible. From them *brutality* distinguishes itself

[156] Probably *caleçons*, an old term for long hose or harem pants.

through the pleasure it takes in impeding the freedom of another by force. Majestic action can also make others suffer, only, it only does so when justice demands it; majesty is more sublime still when its mercy can forgive. Meanness, on the other hand, achieves its crudeness through the fact that it satisfies its egoism by bringing about suffering in others. The word 'brutal' characterizes itself already through its etymological origin, although the beast itself, precisely because it is beast, cannot be brutal. Only the human being can become brutal, because out of its freedom it can lose itself in a violence that takes on a beastly character. When a tomcat or a boar eats its young, it is unnatural, only it is not brutal, because the animal is not capable of family feeling.[157] The recklessness with which animal compulsion acts is indeed really the essence of the brutal; the animal obeys it unconcerned; but the human being should subject it to its will. Brutality is crude, because it acts with violent arbitrariness, thus *cruelly*, and because at the same time it feels *pleasure* in this conduct. In the brutal, cruelty turns to lust and lust to cruelty. The more calculated the violence in its cruelty, the more refined the debauchery in its lust, the more brutal they become—and aesthetically the uglier, for then the excuse of an overhurried application of affect all the [250] more falls away, and the brutal appears all the more clearly as a work of a self-consciously free will. Brutality misuses the violence of the stronger against the weaker, of man against woman, of the grown-up against the child, of the healthy against the sickly, of the free against the imprisoned, of the armed against the helpless, of the master against the slave, of the guilty against the innocent. The coercion those who have the upper hand in their egoism practise on the weak is what is outrageous in brutality.

With respect to form, however, brutality can be at times *rougher*, at times *subtler*. It is rougher when the suffering it brings about takes on direct sensible expression, as in animal baiting,[158] bullfights, executions, tortures and the like; it is subtler when suffering consists more in psychological coercion. The previous form flourishes in criminal dramas, in knightly and bandit-novels, in proletarian stories, in slave narratives. After Eugène Sue wrote his *Secrets of Paris*, what brutalities of the roughest sort did his imitators pile up! Sue had an extraordinary talent for the portrayal of the brutal; he is often lurid, but from time to time also genuinely plastic. His story of Gringalet and Coupe-en-deux in the *Mysteries* is a masterpiece. This Coupe-en-deux is after the manner of Bluebeard, a dark madman-type of feudal extraction. He had gathered together a menagerie of helpless small children, whom he sends out during the day, one with a tortoise, the other with a monkey; woe betide them, if they return at night without plentiful proceeds; [251] obscenities, mishandling, beating, hunger await them then with the most dreadful cruelty.—The finer form of brutality, psychological coercion, has probably had no deeper development than in the drama of Calderón, whose dialectic of faith, love, and honour brings out the most unheard-of torments

[157] We usually render *Pietät* as 'filial piety': since in English that word is used to refer to the feelings of the younger for the elder, the broader 'family feeling' seems better here.
[158] Philosophers of the Enlightenment attacked this public entertainment, wherein wild carnivores or packs of dogs fought large bovines. Vienna's *Hetztheater* (1755–1796) is immortalized by a disapproving footnote in Schiller's *Letters on Aesthetic Education*, where it is suggested that a nation's morality can be read from its favourite pastime.

even in others; for the agony that one applies to oneself cannot be called brutality, even if it should consist in self-castration, as in the case of Origen, in the wearing of a spiked belt, as in Suso's case, in sleeping on a wooden cross, and so on. The great fantasy of the Spanish poet and the Catholic religious interest that it is bound to have in any case very much repressed the acknowledgment, even the noticing of a brutal element in the reception of his works. That said, we too possess a work that has taken pains to document, to show through Calderón's dramas with much thoroughness the abominable inhumanity in which the dialectic of faith, honour and love may degenerate. We mean Julian Schmidt in his *Geschichte der Romantik im Zeitalter der Reformation und der Revolution* [History of romanticism in the era of Reformation and Revolution; Leipzig: Herbig], 1848, Vol.1, 244–302. We only wish to draw out from the conclusion of this perceptive treatment the passage relevant to our theme on pages 290–1. Julian Schmidt (*NOTE 54) says: 'Behind this mythology of honour, of faith, and of love, these richly blooming dreams of fantasy hide a coldly calculating, abstract egoism.—The external service to God leaves all natural forces free, and the dim appeal of superstition upturns life into a deserted stomping ground of evil spirits. Whoever admires the abundantly creative [252] fantasy of Calderón ought not to forget that in this fantasy the word of the mystery hides itself, whose corruption has swept Spain. This richly blooming language celebrated with the same finery the acts of faith of the Inquisition, it overlay with its sweet whispers the howls of burning heretics, it spread like the odour of Arabian incense, concealing the dishonourable sacrificial altars of fanaticism.—The essence of fanaticism is to realize[159] itself in an abstraction which as absolute negativity turns on all that is concrete. Thus life is a dream in the fullest sense of the word, dreamed by an abstract being. Reality is cast at the mercy of the moment, because it is not recognized by the absolute. But it is also not constrained by it; it knows no moderation. Nature breaks out in the fire of passion, thoughtless and without rein, roaring from the dark source of an unholy mind, and destroys today what it loved yesterday. Nothing is solid but the afterlife. In all forms this passion plays, this subjectivity concentrated on itself, unbroken by the holiness of abstraction; the individual is unbounded in hate as in love, in generosity as in malice; the fire of life, not fed by any substantiality, burns with correspondingly unbounded violence in a person's interior. Man's justification is that he abstracts from himself and reality: once he has emptied the cup of earthly pleasure to the dregs, through a miracle he swings onto the wings of abstraction into the bliss of heaven.—That the salvific effect of this blind force enters by an exterior way, without interior rupture, man in his naked natural [253] wildness goes untroubled and thoughtless in pursuit of this arid destiny. On one side the tiger's taste for blood, the thoughtless rabidity raging all around, on the other holiness, which has already accomplished all abstraction from the world and moves in pure supernaturalness. All these figures are abstractions, because they are without rupture and without development; they appal our feeling, for the animal or the divine asserts itself as nature over mind. If man aims for the knowledge of the absolute, he

[159] Schmidt's *veräussern* means in financial jargon to sell, to divest, to expropriate or alienate. In Hegelian terminology the latter is dominant, suggesting (as does the prefix *ver-* before *äussern*), 'to externalize' a flawed coming into concrete being of a concept.

reaches for magic; if a rebirth takes place, it is through a miracle.'—What Schmidt calls abstraction in Calderón we call psychological compulsion, for the motivation of acts is always taken from a calculation, whether life is to be set after love, or love after honour, or honour after faith. When in *La niña de Gomez Arias* [The Daughter of Gomez Arias] the wife, after the horrifying mishandling of her by her husband, who even sells her as slave to the Moors, nevertheless forgives him, it is the power of love that as absolute womanly passion allows her to subordinate honour. When in *El medico de su honora* [The Doctor of his Honour], a play that has become well known among us, Don Gutierre murders his wife cruelly on the mere suspicion that she has injured fidelity through an affair with a prince, and on discovering the invalidity of his suspicion he remains calm, indeed marries another, it is the man's passion for honour that orders him to sacrifice love to honour. When in the *Príncipe constante* [The Constant Prince] the Infant Fernando in prison, though beloved by the daughter of the Moroccan king, though he has the possibility of freeing himself by handing over Ceuta, [**254**] nevertheless suffers the most extreme infamy and even dies thus, that is because the faith demands of him as a Christian to regard love, freedom, and life as nothing against its splendour. In this dialectic the brutality of dishonour, of murder, of mishandling, of a martyr's death finds its method.—Some of our newest tragedies are also infected with this fine brutality of psychological compulsion, as for example [Friedrich] Halm's *Griseldis* [Vienna: Gerold, 1837] (* NOTE 55). The comparison of this play with the treatment of the same theme in Shakespeare's *Cymbeline* can help us grasp that neither for Parzival nor for Griseldis can true love cause such tragic pathos to arise, for then Parzival could by no means have progressed to such cruel brutality in the torture of his wife, and Griseldis in her devotion to him could not have sunk to such demeaning humiliation. The thrill of the most refined language and the escalation of the tests by which the arrogant Parzival examines the fidelity of his spouse fascinate us without elevating us.

When the crudeness of violence mishandles innocence, the brutality of its force becomes the more ugly, the more innocence is either that of a child, who has not yet settled into the confusion of history, everywhere stained with guilt, who has not yet become guilty by any act of one's own; or even more if the innocence is the self-conscious grandeur of morality that has freed itself from the general corruption. Among these belongs, for instance, the *Massacre of the Innocents* [*Bethlemitischer Kindermord*, literally Bethlehem Infanticide], which the painters have so loved to paint, and which Marini sang. Something similar can represent itself in the form of a finer barbarity, as [**255**] Sue in his *Mathilde* renders the vicious torments with which Mademoiselle de Maran martyrs the little Mathilde, all under the pretence of giving her a conscientious, careful upbringing. How boundlessly brutal is that monster in the scene wherein, lying in bed, she cuts the beautiful hair of the little one! In the notorious Chouette of the *Mysteries of Paris* Sue has only given an already caricatured, roughly executed copy of this diabolical egoity.[160]—A contrast of brutality with the majesty of

[160] The neologism *Egoität* seemed worth preserving, given the text's link of egoism with ugliness, announced on the first page of the book and reaching its culmination here.

self-conscious freedom is made the object of art above all in the *Passion story* of Christ. In ancient art this opposition did not yet appear. Niobe, Dirce, Laocoon were guilty of hubris;[161] Oedipus and Orestes through unintentional free action; Marsyas, in his turn offending a god through his hubris, can provoke in us pity by the means of his punishment, because it injures our contemporary feelings that a god himself, even if he is in the right, would carry out such a punishment as skinning his defeated opponent with a knife. Ancient representations on reliefs therefore soften this brutal image by having Apollo, knife in hand, only begin to step toward Marsyas, who is tied to a tree trunk. But in the Passion of Christ we gaze on a diametrical opposition of innocence and brutality, which confronts it in finer and in rougher forms. Painting has taken hold of this contrast early, and the older German school above all took an interest in giving the Pharisees, scholars, and soldiers truly brutal, diabolical physiognomies (* NOTE 56). From the story of Christ, this contrast entered the narratives [256] of martyrs and saints and was developed further in every direction. In a thousand shadings they repeat the mocking of Christ by the soldiers who struck him with switches, crowned him with thorns, and forced him to carry his cross. The pinching with glowing pincers, the nailing to the cross, in the case of Peter even with head downward, the roasting on a grate, the flaying of the skin, the tearing out of innards, the beheading, the dismemberments on the rack, the boiling in oil, the burying alive, and so on, are brutalities that deserve an aesthetic as much as an ethical anathema. However much the genius of the artists struggled to reconcile this material with the demands of beauty, it really succeeded very seldom. One ought not to reply that a battle painting just as often offers us in manifold guises the scene of murder and of deadly torment. In battle violence meets violence; the warrior fights the warrior; the attacker is at the same time the attacked. Nevertheless the painter will be economical with the horrors of war; he will paint us wounded and dying of all kinds, but he will scruple not to offer to our sight certain mutilations. Ancient painting too had no reservations about representing terror, but only that which is necessary, of which Goethe in his observations on the Philostratian paintings[162] says that it is what is appropriate. In Vol. 39, p. 65 he has this to say about the tearing apart of Abderos[163]: 'In these pictures we never find what is important being avoided, but on the contrary brought powerfully before the spectator. Thus we find the heads and skulls, hung by highway robbers on an [257] old tree as

[161] Niobe, who claimed her children more beautiful than Apollo and Artemis, had to watch them be killed by the latter's invisible arrows; Dirce, who tortured and tried to kill her beautiful niece Antiope (impregnated by Zeus), was herself tied to the horns of a bull and so killed; Laocoon, who warned the Trojans against the Greeks' wooden horse and was killed by water snakes, is said by some commentators to have insulted Athena (who wanted the Greeks to win) or Apollo (according to Apollodorus), or Poseidon (Servius, recounting Euphorion). Of course the attribution of any guilt to Laocoon is controversial, but for an argument that would have pleased Rosenkranz, see S.V. Tracy, 'Laocoon's Guilt', *American Journal of Philology*, Vol. 108, No. 3 (Autumn 1987), 451–4.

[162] Philostratus of Lemnos (or less likely his father, Philostratus of Athens) wrote the first volume of *Eikones* (in Latin *Imagines*), a description of many ancient paintings; his son (or grandson) Philostratus the Younger, wrote a second, even more didactic volume. Interestingly, given some of the subject matter, the intended reader was a 10-year-old.

[163] By the carnivorous horses of Diodemes, in the eighth labour of Hercules.

trophies; just as little are the heads of Hippodamia's suitors[164] missing, stuck on [the columns in] her father's palace; and how should we react to the rivers of blood in some of the pictures, that mix with dust and flow again and curdle. And thus we may say that the highest principle of the ancients was to show what was significant, the highest result of a happy execution on the other hand was beauty. And with us moderns is it not the same? For wherever we turn our eyes in churches and galleries, unfinished masters oblige us to look on some rather repugnant martyrdoms thankfully and with satisfaction.' The brutality that prepares choice sufferings for the defenceless saint can only become an aesthetic object insofar as the representation makes visible the victory of inner freedom over outer violence. Therefore, the hangmen must have muscular bodies, hard faces without feelings, smirky looks, to be in line with their damnable business, while the figure and the visage of the saint must attract us through dignity and beauty. The powerlessness of brutality over freedom must appear indubitably through the transfiguration of the physiognomy, through the nobility in the bearing of the martyred. The self-assured majesty of faith must not just scoff at the bands and the pains of death and ridicule, for that would imply a certain timidity, a finitude of opposition, but rather it must be entirely over it and triumph in its suffering and feeling of pain. In looking on such sublime peace the horrors of the brutal act must disappear as a nothing. Without this decline of the dreadful in the greatness and power of [258] a divine disposition, the view of mere hangman's work becomes intolerable, and with this sight of horror we are tormented also by those painters and sculptors who represent Christ, the Apostles, and the saints as Iroquois, who delight in opposing to the pains with which their enemies martyr them the defiance of an abstract callousness. The immortality of the spirit that is happy to sacrifice itself for the absolute truth must consume the cruelty in itself. And yet such scenes through their effect-rich contrasts are still better for visual art than for poetry, for the picture or sculpture group gives us once and for all that which, dragged on through the length of a description, could touch us even more repugnantly. This seems to violate the Lessingian canon, only, whoever knows those medieval legends wherein the martyrdoms of the saints are described with protocol-like precision, will be compelled to agree with us; there is hardly anything more boringly ugly. Some materials of this region have always been extraordinarily beloved of painters, for they offer occasion for lurid contrasts, but they stand on a dangerous border and for this reason descend into ugliness often enough in the execution. How some painters have distorted the Massacre of the Innocents into a repulsive butcher's shop! How some have painted Herodias, not as if she carried in her bowl the bloody head of a martyr, but rather a bouquet of flowers, or even a delicious dish! The Middle Ages felt here a gap, that youth, beauty, love of the world, frivolity could confront dignity, abnegation, devotion to God, persistence so unfeelingly, and thus they invented a love story of the beautiful [259] dancer and the prophet, who spurned her and against whom she wished to be avenged through his death.

[164] Fearful of death through a son-in-law, Oenomaus challenges suitors to chariot races, and kills them; Pelops defeated (and killed) him by conspiring with the charioteer.

In order to subdue the crassness of the phenomenon of brutality, a connection of the violent with justice will always remain advantageous, for it moves thought away from mere arbitrariness and chance. We already pointed out how ancient art held on to the black thread of guilt in such cases. The sculptors Apollonios and Tauriskos, in the famous group of the Farnese Bull that is now found in Naples, have represented Dirce as she is bound by Amphion and Zethos to the horns of a bull that already rears in preparation for a limb-crushing charge. How beautiful is this woman! But her beauty does not move the forceful youths. These also do not take pleasure in their brutal work, but rather they exercise in accordance with ancient concepts the obligation of avenging their mother. They do the same as Apollo and Artemis in killing the children of Niobe. Lack of so-called *poetic justice* is thus felt by us as an irresponsible brutality. Modern French tragedy, in accordance with its principle, *le laid c'est le beau* [the ugly is the beautiful], has also not been deficient in this respect. In a tragedy, *Le Roi s'amuse* [The King Amuses Himself; Brussels: Louis Hauman, 1832], Victor Hugo has, for instance, made this mistake. He has opposed to the majesty of a beautiful and knightly king, François I, an ugly and bowlegged fool, Triboulet. He has, however, degraded the king to a real rascal, who courts every skirt and disguised runs after the most common serving girls in the dirtiest pubs. Such a king is no king, for [260] starting from the orgy where we first meet him to the most disgusting adventure in the drinking hole where he is to be murdered, there is not a trace of noble being to be discovered in him. But this Triboulet, who launches poisonous impromptus at everyone, who gives such malicious advice, who ridicules the unhappy St. Vallier for the fact that the king dishonoured his daughter, he should all along be an affectionate father and beside his folly, which he only carries out as a profession, should possess a thoroughly humane, even priestly, consciousness. Unfortunately he has a beautiful daughter, and the king likes her. The king, who has seen her in church, does not know that Blanche is the daughter of his court jester. In disguise he creeps after her. Courtiers insulted by Triboulet's sarcasm waylay her, gag her, rob her and lead her to the king, who, while she cries and begs, takes her into his cabinet, closes the door and rapes her *con amore*, while the same door is guarded by the courtiers and defended against the suspicious Triboulet. Can one imagine a more brutal situation? The jester then wishes to have the king murdered by a gypsy, Saltabadil, for twenty gold pieces, but by accident and confusion he kills Triboulet's daughter, who loves the king, although he robbed her of her honour. Saltabadil sticks the body into a sack; Triboulet assumes that the body is that of the king and wants to throw it into the Seine. Nevertheless, to properly confirm his vengeance, he wants to see the murdered king one more time. In the pitch-black night this would indeed be impossible, only the accommodating poet at once lets a storm gather, so as to provide intermittent light with its thunderbolts. Triboulet [261] slits the sack open with a dagger and recognizes his daughter, who still lives a little, and, with half her body stuck in the sack, holds a few moving speeches more, full of sentimental passion for the king, who should have been murdered in the pub, where he had stolen to in order to spend the night with the sister of the gypsy, Magelone. With this she dies; a hurrying surgeon explains to the father with professional firmness that his daughter is finally and truly dead, upon which Triboulet does not even kill himself, but only loses consciousness, while the king, saved from death by Magelone, unaware

of the happenings around him, trills around in a well-rested voice as he passes by! The lack of punishment is obviously the most arrant brutality in this play, which is indeed a handbook of villainies. It would take us too far to enter into other dramas by this poet, and so we content ourselves with the observation that since Victor Hugo the injury of poetic justice by the French has become less seldom. One of Rachel's[165] most brilliant roles is the *Adrienne Lecouvreur*, which Scribe wrote especially for her. Adrienne, an actress courted by the Marshall of Saxony [Maurice, Count of Saxony], receives from the jealous lover of the same, a married duchess, a poisoned bouquet, which kills her thoroughly while the duchess gets off free. The real point of this piece however is not even this dissonance, but the pathologically exact representation of the death of the unfortunate. All phases of the poison's effect are only too correctly presented in their dreadful transitions, up to the exhalation of the last sigh. Also in the *Lady of the Camelias* [**262**] of the younger Dumas, the faithfully rendered death of Lorette becomes an interesting brutality for the public.

Although it is our task to develop the concept of ugliness, still we must admit that for us, in spite of all scientific courage, it is impossible to delve into that form of brutality that comes about through the connection of cruelty with lust, and through the unnaturalness of lust. The annals of art history are unfortunately over-rich in such products. It is enough to recall, in German literature, [Daniel Casper von] Lohenstein's *Agrippina* [Breslau: Fellgibel, 1665] (* NOTE 57). Rape, of the cruder and finer variety, is naturally the favourite brutality in this domain.

The brutal can also be turned into the humorous. This turn will most usually take the form of parody, as in recent times the Munich *Fliegende Blätter* [Flying Pages] have so delightfully parodied the brutality of minstrel ballads in small tragicomic actions, and the parody of the marionette theatre in Paris and London (* NOTE 58) has deliberately scourged the unnatural situations and the bookish false pathos in which tragedy falls for whole epochs. But the comic turn can become possible without parody as well. The *Abduction of the Sabines* is in itself an act of violence; the sudden ambush of the young women is brutal; however, in that here the fundamental relation between the sexes intervenes, fear and terror are tempered! Sculptors and painters have thus been very happy to represent this incident, because through it they have the chance to beautify frightened faces with the expression of sweet trepidation, the reluctance of modesty with involuntary [**263**] devotion; to be abducted by the bold Romans is in the last analysis not too unpleasant. The same happens with the *Abduction of Proserpine*, with the *Abduction of Europa*, and so on.[166] When Reinecke (Reynard the Fox) rapes

[165] Elizabeth-Rachel Félix, better known as Mademoiselle Rachel (1821–1858), leading French actress of the mid-nineteenth century, famous for revivals of the classic French theatre of Racine and Corneille. Adrienne Lecouvreur (1692–1730) was herself a famous actress of classic French theatre, and at the end of her life a friend of Voltaire.

[166] The standard English art-historical terms here are *Rape of the Sabines*, *Rape of Proserpine*, even *Rape of Europa*. Rosenkranz has *Entführung* for the latter, but *Raub* for the other two, which is robbing or plunder more generally, as is the original English *rape*, from Latin *rapere*. Though of course these mythic abductions ended in more or less forced sexual intercourse, given what Rosenkranz has just said about sexual brutality (for which he uses the archaic but unambiguous word *Nothzucht*) here he is concerned with abduction. But the separation of topics is not absolute: see the next sentence.

Isengrim's wife before his eyes on the ice, it is certainly brutal, but becomes humorous under the circumstances (* NOTE 59). There are also certain actions that are violent, but which one would not call brutal; these can only become an object of art as humorous acts; there belong all those pictures of the Dutch School (see Figure 6) which represent *tooth-pullers*[167] messing with simple youths, who cry wildly, or with peasants, who line up like poor sinners for an execution.—

We have thus far investigated the obscene and the brutal as forms of crudeness, which leaves one more form: the *frivolous*, which contradicts the sublime insofar as that is the sacred through its absolute arbitrariness, thus questioning the inner grip of the universe. Nature and history in the end only have a sense on the presupposition of the truth of morality and divinity. Someone is not frivolous in negating the existence of this truth because he cannot convince himself of it, but he who ridiculed faith in the sacred out of groundless insolence. The sceptic who becomes an atheist need not be frivolous; but the egoist for whom the sacred becomes a farce because the reality of its existence makes him uncomfortable is frivolous. Arbitrariness outrages with its ridicule the being that is itself the ground of all freedom and necessity, whereas scientific atheism, which is possibly the sad [264] result of honest efforts, can be stamped with the imprint of religious despair. Frivolity is ugly, because it is the ape of divine majesty, which lends nature and history all the majesty they display. It sets itself as the absolute. For nature then this form of ugliness is impossible, for as nature, without consciousness, it cannot laugh at its own necessity. Among the arts poetry is the best suited to representing the frivolous, because through language it is able to delve into our thoughts. Frivolity surrenders the sacred to laughter as something intrinsically null and void; piety in marriage, friendship, patriotism, religion are for it bigotry and weakness, above which the strong mind rises above the prejudices of the multitude. This strength of mind is however nothing but arbitrariness, which out of its subjective convenience despises divinity as a nullity of pure imagination and thus really declares mean that which among the peoples makes the objective claim to be honoured as the venerable and the highest.

It is very useful to distinguish between human belief in the existence of the absolute and the errors to which they may fall prey in the same belief, because they are free and because it would be opposed to the essence of the divinity to force belief on humans from the outside. In particular, people will by no means always have absolute truth as the content of their faith; they will mix up truth and delusion and even deify the latter into a false religion. The religions have [265] individually differing contents, but they are identical in being religion and in placing humans in relation to the absolute; the true Buddhist, Jew, Muslim will die just as cheerfully for the truth of his religion as the true Catholic, Lutheran, Methodist, and so on. Also in particular customs[168] the peoples differ, but to each his customs are holy. The savage goes to great lengths, from his moral

[167] *Zahnbrecher*, literally toothbreakers, the German term for early fairground dentists.
[168] The word *Sitte* can mean moral or more or custom, whereas *Sittlichkeit* is unambiguously morality. For the young Hegel, who wrote a *System der Sittlichkeit*, and for his followers, the link between morality and culture was crucial in taking a historical view of reason.

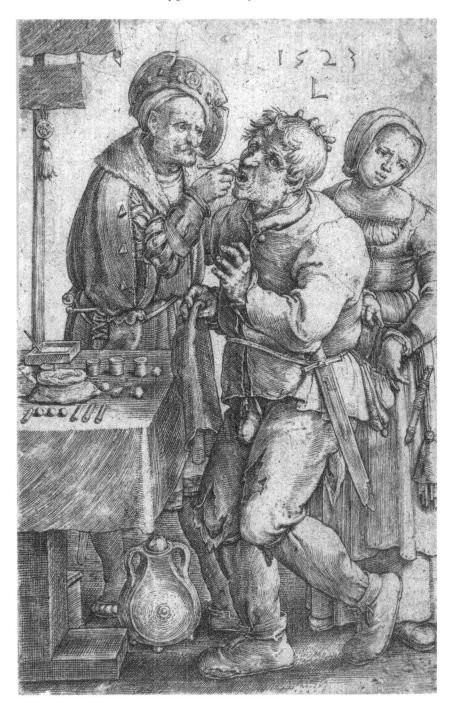

Figure 6 Lucas van Leyden, *The Dentist*, 1523, engraving, Rijksmuseum, Amsterdam.

standpoint, to offer his guest his daughter or his wife to sleep with, which another standpoint would hold to be a dishonour.[169] The customs of the same people vary at different times, and as late as the eighteenth century one would have taken it as a frivolous undermining of authority among us if children had dared to call their parents 'you', which in the meantime is even done by the members of noble families. Because the custom is the form that the will of a people takes in its habituation, the peoples respect each other's customs, as divergent as these may be from one another, and it is rightly taken as frivolous to ridicule the individual for being born and raised in its general necessity.—A conflict with custom, with the faith of a nation is also very well thinkable, which is by no means frivolous but can even be caused by the deepest morality and religion, as this in the case of all great reformers.—Frivolous is only the lack of seriousness which reveals a delight in representing the respect for a custom, the faith in a divinity, as absurdity and fraud, as delusion and self-deception. Frivolity is not the holy struggle of that sublime skepsis which springs from the innermost truthfulness of the spirit; it is [266] the unclean pleasure of intellectual debauchery, which has emancipated itself from the absolute as a stupid ghost, and is now really satisfied, for chance and arbitrariness as sole factors of what occurs fundamentally allow nothing but an ephemeral life of enjoyment. Frivolity thus characterizes itself aesthetically through the cruel lust with which it tickles itself in destroying faith as a limitation, and custom as a perversity.

With regard to the concrete phenomenon, however, the judgement that something is frivolous will often be difficult, because in the history of spirit, knowledge of the truth in conflict with what is recognized as false and the exercise of virtue in conflict with privileged vices can take on the appearance of frivolity. The in and for itself justified polemic of the eternally true and good against triviality and wretchedness, which hold themselves to be the former, will often be denounced by them as frivolous. It is natural that this polemic will not always be able to wear on its brow the melancholy air of infinite sorrow over the moral and spiritual misfortune of mankind; being human, it will not be able to dispense with breaking out into laughter over the pretension of its opponents, or of meeting it with satire, which will then inevitably be scolded as frivolity. Here for the concrete case fine new boundaries are generated, for the in itself earnestly meant polemic can very easily be carried along through the pleasure of wit to utterances that themselves already carry a frivolous aftertaste. The crushing quickness to anger of an Aristophanes is at the same time filled with the contentment that flows into it from the ridicule of his opponents, and the comic element pulls him along to occasional [267] formulations that, from the Greek standpoint, breathe a caustic frivolity (* NOTE 60). The laughter aimed at the immorality and the faithlessness of his opponents strikes inadvertently at moral and faith itself. Heine becomes through the same fault so mean that he cannot resist the craving to sacrifice to wit the sacred itself with irresponsible crudeness and thus to become really frivolous. His poetry without these frivolous offshoots would be that

[169] The example, and the moral drawn from it, are due to Diderot's *Supplement au voyage de Bougainville*, in *Œuvres de Denis Diderot*, ed. Naigeon, Vol. 3.

much more poetry (* NOTE 61). The truth in frivolity is characterized by a certain brutality with which what is holy for a person or a nation is destroyed, and it feels joy in the degradation of the sacred to a ridiculous grimace. The concept of frivolity is thus indeed in general fully determinate, in particular cases, however, it is a *relative* one, as we see this quite positively through the diversity of legislation that punishes its uses. What still counts as frivolous and can be justly indicted from a limited standpoint, no longer has the same meaning from a higher, freer standpoint. We only have to consider the *aesthetic* side of the issue here, which consists in the fact that the truly beautiful can only perfect itself in unity with the truly good, that therefore an aesthetic product that contradicts this axiom is also not able to be truly beautiful, and thus will be more or less ugly. That a custom or a belief from another standpoint appears ridiculous, is not yet a frivolity; first, when one ridiculed those who hold to a custom in their observance, or those committed to a belief in their faith, would one become frivolous. We mentioned above[170] that [268] in Dahomey and Benin everyone, even a minister or a general, who receives a gift from the king, must dance publicly before him. As ridiculous as this seemed to the French ambassador Boué, he did well to restrain himself from laughing. When the Russian hetaerae give themselves to someone, they take care to cover the image of St. Nicholas with a veil, for they are ashamed [to appear thus] before him. Who would dare in their presence to laugh at this expression of the sacred feeling of shame, as ridiculous as it might appear to us? One can hardly be careful enough with one's judgement and behaviour in such delicate matters. If one, however, wished to deprive humour of its entitlement to treat the customs of foreign nations or bygone times, religious conceptions of other peoples or outmoded forms of culture as ridiculous contradictions of the truth and freedom of spirit, then one must understand that not only art but also science would have to prepare for itself a Trappist way of life. The joke has as much to suffer from the stiff-necked bourgeois as from the dumb, bigoted practitioner of piety, because the short-sightedness of both sees in its mobile play a dangerous assassination attempt on the moral good and right belief. If it were entirely up to them, we would have to suffocate in a stagnation of home-baked prose. From this standpoint nothing has done more harm to the unprejudiced appreciation of poetic artworks than the isolation of individual passages, the praise of single words. The history of poetry has in its possession concerning such conflicts extremely curious documents in the trials to which Béranger was subjected under the Restoration, and wherein Marchangy and Champanhet [269] pressed the charges with as much wit as Dupin, Barthe, and Berville answered them with the interesting reference to the history of the chanson in France. If we only had the concept of the frivolous to deal with here, nothing would stop us from going deeper into this; for us however the frivolous is only a moment in a much larger totality (* NOTE 62). We limit ourselves to illustrating the discussion up to this point through a few examples. When Heine in his poem 'Disputation' lets the monk reply to the Rabbi in defence of Christian faith,

[170] In Rosenkranz's Introduction to this volume, R 28.

I can defy your apparitions,
Your dark hellish buffoonery,
For in me is Jesus Christ,
I've tasted of his body.

there is nothing to be said against it, under the circumstances given to us, on Spanish soil in the Middle Ages. But when he has the monk continue,

Christ is my favourite dish,
Tastes much better than Leviathan
With the white garlic sauce,
Cooked probably by Satan.

the expression 'favourite dish'[171] is simply frivolous and not to be justified by the meanness of the fanaticism that is supposed to be depicted here.—One cannot demand of Heine that he make the sacrament of the Last Supper to a moment of his own faith; only poetry may demand from him that he does not shower with ridicule what is holy to thousands of the hearers he addresses. The dryness, the doctrinaire simplicity with which he expresses himself amplifies the insult. In the *Romances* **[270]** *of Vitzliputzli,*[172] which are so rich in poetic beauties, his hatred against Christianity, against the Last Supper, breaks out in the following verses:

'Human sacrifice', the piece is called
Ancient is the material, the fable;
In the Christian adaptation
The play is not so gruesome,

For the blood became red wine,
And the corpse that turned up there,
Became a harmless, thin one
Wheat flour porridge transubstantiated—

We abstract here wholly from the religious standpoint; we only apply the aesthetic yardstick and according to this we condemn these verses as bad verses, for what in them should be poetic? Do they not sound as if they had been copied in their

[171] There is a pun on the German for 'favourite dish', *Leibgericht*, meaning literally 'body dish', so that the monk can go from tasting Christ's body to Christ being his 'body dish'.
[172] Heinrich Heine's last book of poems is in fact called *Romanzero* (Hamburg: Hoffmann & Campe, 1851). *Vitzliputzli*, the German name for the Aztec hummingbird-god Huitzilopochtli, features in a three-part poem closing the first section of the book, the *Historien* (this passage, p. 104). The 'Disputation' quoted above is on page 281.

woodenness from Daumer's notorious treatise on Christian anthropophagy?[173] Heine utters no word of disgust, of disapproval; he lectures like an accurate historian; but what immeasurable frivolity lies in these cold words, which pass over a religious mystery as if it were a culinary object!

A poet can, as we noted, be treated very unjustly if one does not take him in context, and saddles him with a frivolity where one only appears to be present. In the verses quoted the second verse could be removed entirely and the poem would lose nothing, indeed it would gain much. But we also want to give an example of how Heine might be treated unjustly. In his poem 'Der Schöpfer' [The Creator] he tells the story of how God created the sun, stars, oxen, lions, cats, and continues thus: [271]

To populate the wilderness
Man he afterward creates;
After man's image propitious
He went right on to the apes.[174]

Satan watched him work and laughed:
Hey! The Lord copies himself!
After the picture of his oxen
He makes in the end the calf!

Anyone recognizes at once in these verses the satire on religions in which animals are worshipped, on the Golden Calf, which even the Israelites danced around. One could indeed find Satan laughing at God frivolous: but the poem consists of four smaller ones; in the second God answers:

And God said to the devil
I the Lord copy myself,
After the sun I make stars,
After the oxen I make calves,
After the lion with its paws
I make little, lovely cats,
After the person I make the ape
But you cannot anything make.

[173] Robert Steegers, *Heinrich Heines "Vitzliputzli": Sensualismus, Heilsgschichte, Intertextualität* (Stuttgart: Metzler, 2006), 184, has found actual citations of Daumer in Heine's conversations of May 1850. Hans Christian Daumer, *Die Geheimnisse des christlichen Alterthums*, 2 vols. (Hamburg: Hoffmann & Campe, 1847), was a dubious piece of biblical archaeology, arguing that the early Christians were cannibals practising child sacrifice; Heine may have known Daumer through their common publisher.

[174] Heinrich Heine, *Neue Gedichte* (Hamburg: Hoffmann & Campe, 1844), 129–30, 'Schöpfungslieder' [Creation Songs]. Rosenkranz must be citing from memory: instead of 'right on to the apes', Heine has 'interesting apes'.

Satan deserves this answer and must be taken as the godly negation of his ridicule. And now to really grasp the Heinian malice, one has to look at the conclusion of the whole; in the fourth poem of this small cycle, wherein he keeps going from the large to the small, he has God say at last:

> Creation itself is just vain movement,
> Which gets bungled in no time at all. [272]
> But the plan, the reflection,
> That really shows who's an artist.

> I have no less than three hundred years
> Daily thought about it,
> How one best makes doctors of law
> And even the smallest flea.

The target is Goethe, who wrote a legal discourse about the flea, printed in Berlin in 1839.[175]

Frivolity will naturally bind together for mutual support religious and ethical nihilism. Most works of obscene literature are at once materialistic and atheistic. A certain blunt, dim apathy, the straightest opposite of a noble melancholy, settles atop them and often ruffles their desperate reflections to half-madness, as this is the case above all in the notorious novel *Thérèse philosophe*. French literature must take the blame of having taken farthest the union of fornication and godlessness. Voltaire's *Pucelle d'Orléans* is the beginning, Évariste Parny's *Guerre des dieux* [War of the Gods; Paris: Debray, 1808] the summit of this development. One can grant to both writers the ridicule of sanctimony, of the excrescences of monastic life, of the perversities of superstition and clerical fanaticism; but against the way they tear to pieces the very faith in God and the fundamental ideas of Christianity one will always be able to press the charge of frivolity. The virtuosity of their elegant language, their shrewd wit, the fullness of their ridiculous-infernal inventions, the correctness of their drawing, are not able [273] to cancel out the feeling of meanness with which they degrade us. Parny has the Greek gods fight with the persons of the Christian Trinity, who are almost defeated by the brutally gigantic Scandinavian gods. He made fun of the pagan gods, but only the better to ridicule the Christian mythology. That he presents Christ as a lamb, decorated with a blue ribbon; that the Holy Spirit is a delicate dove; that Mary is a 'sweet Lady', as the Middle Ages called her; all that is naturally to be expected, for the contradiction of the sensible element with the concept of God gives his [Parny's] abstract ratiocination rich sustenance. God the Father he represents as a somewhat

[175] The attribution to Goethe is a hoax. Otto Philipp Zaunschliffer (1653–1729) printed his eroto-comic discourse on fleas' rights pseudonymously as Opizius Jocoserius, *Dissertatio juridica, de eo, quod justum est circa spiritus familiares foeminarum: hoc est, Pulices* (Amsterdam, 1684). A German edition was printed as *Göthe's juristische Abhandlung über die Flöhe (de pulicibus)* (Berlin: Alexander Duncker, 1839).

narrow-minded Jewish god, who occasionally shows signs of the weakness of age. He must, in order to see the earth clearly, put on a pair of glasses; his thunder is somewhat used up; his arm is no longer sure. Once his son sees a robber who is about to kill a priest; the son demands that he intervene with lightning; he throws the deadly ray, but instead of the robber hits the priest, and so on. The Christian gods, being new, attract more and more the attention of the old, who in order to get to know them invite them to a dinner on Olympus. On this occasion the curious Mary ogles the Olympians' palace, Apollo slinks after her, and rapes her. Rape is Parny's passion; in the most diverse situations he delights in it; amidst the battle of the gods he has the angel Gabriel rape Artemis. This unclean mind lets him dwell at length on the old apocryphal tale according to which Christ is the illegitimate son of Mary and the [274] Roman soldier Pantheras;[176] this provokes from him the fiction that Priapus and the satyrs let themselves be baptized in order to live a plump, lubricious life as monks, and so on. If a faun wrote poetry, he would write like Parny, for through Priapus he finally achieves peace between the gods, once under Constantine so many people had weaned themselves off the Olympians and turned to the Christian gods:

> Here one pleads, and one judges over there:
> Man has judged: good or bad, it doesn't matter.

With this, however, Parny is not satisfied; in order to be really methodical and thorough in his frivolous ridicule, in his epilogue he takes on the features of a holy singer, pure of heart and loud of tongue, renders the end of the world and the judgement of the Lord in the most lively colours, finally setting himself in Paradise:

> As for me, being wiser, I believed without thinking,
> To radiant paradise I arrive:
> I enter; and while behind St. Genevieve
> I am seated in the celestial Eden,
> Hell receives our reckless soldiers,
> Who scolded the vicars of Jesus,
> The scoffers of the cult of our fathers,
> And the lovers of the daughters of our mothers,
> And the rebels of my sincere rhymes,
> In *saecula saeculorum*; amen!

One will have to be content with this one example of real frivolity, for we are loath to move further on a field wherein wit shrivels to the poverty of the dullest punch lines, and beauty to the stereotyped [275] nudities of a true bordello fantasy. We Germans have certainly at times tempted frivolity, but compared to the French we remain ever dumb students of the same; even when we display the most barren rationalism and the

[176] The polemicist Celsus apparently held that Mary was turned out by Joseph for bearing a child by the Roman soldier Panthera, a claim disputed in Origen, *Contra Celsum*, I.32.

most doctrinaire atheism, we cannot help letting the mind assert itself in naïve inconsistencies, like a mountain lake whose clear surface seems to stagnate while subterranean tributaries in the deep maintain a secret life. A younger poet, Rudolph Gottschall, has for instance sung the *Goddess*, that is the *deésse de la raison* [goddess of reason] of the French Revolution [in *Die Göttin*; Hamburg: Hoffmann und Campe, 1853]. But how chastely, how romantically, how tragically the poet handles this material; how he has been at pains to immerse himself in the goddess of reason through a long, painful experience, so that she does not appear merely as a pretty phantom of the senses, but much rather aspires with mind and heart to the name of a goddess and in inevitable disappointment with this delusion, as Robespierre decrees faith in God as the highest being, she collapses in mad despair; how the poet has rendered truly German her step of exposing herself to the whole people, motivated by love of her husband, whose death she thus hopes to prevent. Philosophically this poet stands, as is well-known, in the standpoint of Feuerbach, only his anthropologically revolutionary pathos is broken in itself and loses itself partly in the softest elegiac tones, partly in dithyrambic outbursts of sceptical madness. His goddess of reason Marie unites the beauty of foam-born Aphrodite with the nobility and interiority of a Madonna, for [**276**]

> on her noble features,
> Which carry Hellas' stamp,
> Dreaming circumspection
> Has thrown a dark mantle—
> How Madonna-like lustre
> Makes a halo round her head,
> Signalling the tortured thought,
> Desperate life and pain of heart.

The frivolous can turn into the humorous when it is backed up by truth, that is, only apparently a sacrilege against the holy. It then exposes the contradiction that can be present between the essence and its [sensible] form. Works that originate this way can appear frivolous to those who are touched polemically by them, without being so. They will indeed attack incongruence in the representation of the divine, but they will never sin against morality. Lucian has one of his great strengths in the cheerful way with which he mercilessly exposes the inner contradictions of the ancient Olympus. For us, his parodies of the gods become a necessary moment in the dissolution of paganism, to a Greek of that time however they could also seem frivolous. In his *Tragic Zeus* he lets the stoic Timocles dispute publicly with the epicurean Damis about the existence of the gods and their providence. The stoic brings out the expected teleological arguments, complains vigorously over the nefariousness of his opponent, but in the end, after his comparison of the world with a ship steered by a pilot has suffered shipwreck in the dialectic of Damis, he can only retreat to the inference that as long as there are altars, there must be gods as well. Zeus takes [**277**] great interest in this dispute, because the sacrifices that people bring him decrease with the increase in enlightenment. Hermes must thus invite all the gods, even the barbarian ones, to a conference. They come and are seated according to the value of the materials out of

which their cult statues are built, so that the gold and silver barbarian gods take precedence over the beautiful but only marble or iron gods of the Hellenes. The most diverse suggestions are discussed, and in their refutation the weak side of the divinity of these gods is ridiculed, in the case of Apollo the obscure ambiguity of his oracular pronouncements, in the case of Heracles the crudeness of his physical force, and so on. As the disputing Athenian philosophers resume their controversy, the father of men and gods knows no better remedy against fear over its conclusion than to ask the gods to pray with him for the defender of their existence, Timocles, who seemed to have lost his composure. 'Thus we should at least do what is in our nature and—pray for him, but

Only among us and silently, so that Damis does not hear!'

––––––––––

B. The Repulsive

Involuntarily, in the representation of the final determinations of the concept of the mean we have already had to mention the concept of the repulsive as something that in comparison with the mean results in even aesthetically uglier forms. The positive opposite of sublime beauty namely is pleasant beauty. [278] The sublime strives into infinity, while the pleasant settles itself comfortably in the limitations of finitude. The former is great, powerful, majestic; the latter is cute, playful, charming. The negative opposite of the sublime, the mean, opposes to the great the petty, to the powerful the feeble, and to the majestic the low. The negative opposite of pleasant beauty is the repulsive, for it opposes to the cute the clumsy, to the playful the empty and dead, to the charming the hideous. Pleasant beauty invites us to its enjoyment in that it meets us in advance, bringing to light, not unintentionally, all its sensuously agreeable aspects. The inapproachability of the sublime tears us out of common bounds, filling us with awe and admiration. The thrill of the pleasant draws us to it in order to enjoy it and flatters all our senses. The repulsive on the other hand repels us from itself, in that it awakes distaste through its clumsiness, horror through its deadness, and disgust through its hideousness. A lack of unity of form, symmetrical articulation, harmonic eurhythmy, is ugly, but not yet repulsive. A statue, for instance, may be marred and then restored. Should this restoration not be felicitous, bringing a strange feature to the form, its dimensions disproportionate to the original artwork, the restored parts differing too luridly from the original remains, the resulting quality will not be beauty, only it may still have a long way to go to being repulsive. It would first become this should the restoration roundly cancel out the original idea. A form can also [279] be incorrect and more or less contradict the normality that should be expressed in it, only this is not yet enough for it to be repelled by itself. Great incorrectness may even be balanced to the point of being forgotten altogether by great beauty coordinated with it elsewhere in the work. Incorrectness will first become repulsive when it chops to pieces the totality of the form, when it betrays a thorough incompetence, whose presumption offends us, in case it does not become ridiculous. Meanness is ugly, because in its

pettiness, feebleness and baseness it represents unfreedom that might exceed its boundaries, but instead remains within the flatness of chance and arbitrariness, in the poverty of powerlessness, in the baseness of the sensuous and the crude. Meanness is unbeautiful, but it is not yet for that reason repulsive, and frivolity even strives to capture us through sensuous magic, to make its ridicule of the sacred really palatable through its formal amiability.

The repulsive generates itself out of pleasant beauty as its negative opposite. As positive opposite of the quantitatively sublime,[177] the pleasant is that small [entity], which is easily regarded in its totality, delicately worked out in its parts, and which in German we call *niedlich* [in English we call it cute]. The small in itself, a small house, a small tree, a small poem and so on is not yet for this reason cute, but only that small thing that shows in its fine parts delicacy and cleanness of conception. How cutely nature has constructed certain snails' houses and mussel shells! How thoroughly cute are the leaves and flowers of many plants, because in [280] their smallness their particular relations also display themselves, delicate and varicoloured. How cute are Alexander parrots, canary birds, goldfish, Bolognese dogs, *Affenpinscher* [a type of terrier], marmosets and so forth, because these little animals are multiply articulated and precious in their details.—As the positive opposite of the dynamic sublime, the pleasant is the playful. The sublime as power expresses its infinity in creation and destruction of the great, and one can say without injustice that in the absolute freedom of its doings it plays in a way with its own power, as theologians and poets have described the creation of the world itself as a game of divine love. The sublime in itself is serious, and the expression 'play' applied to it should characterize only the absolute lightness of divine production. To play as mere play belongs a movement deprived of the seriousness of a purpose, as the wind plays with the clouds, waves and flowers. In play, the unrest of change moves from form to form merely for the sake of change. It is only accidental movement, which changes nothing in the substance; it preserves the sweet, half-dreaming pleasure of the surface of being, while this remains the same in its foundations. The process of playing must thus exclude danger from itself; a storm that bends and shatters the giant trees of a forest only seems to be playing with them in terrible seriousness, whereas a mild, caressing West wind really plays around the flowers; waves of the crashing sea that raise ships to the clouds only to throw them again into yawning abysses, only seem to be playing with them, whereas the mild wave slapping the beach really plays with the sand on the shore. All play, that as devoid of purpose and danger [281] is a pleasant one, flirts with change, in that it takes back every change that it brings about immediately, cheerfully, as a nothing. This is so even when it frightens, because it only provokes delight, indeed laughter, as especially in those grotesque mummeries that the savage peoples, no less than the civilized, love so passionately. The playful is beautiful because it shows us the various sides of a being in the guise of a change whose back and forth leaves the unity of the same untouched.

[177] Rosenkranz gives the Kantian distinction between quantitative and dynamic sublime his own terms (the great, the powerful); they are followed by his third category, the majestic.

Finally, the positive opposite of the majestic sublime, within pleasant beauty, is the charming.[178] The cute, the playful, can of course also be charming; the charming as such will, however, unite the delicacy of form with the cheerful play of movement. It is strange what prejudice against the charming may be found among some aestheticians. They often despise it because through its sensuousness it mixes a practical demand into the aesthetic. We hold this accusation for unjust, for in a cynical sense, for the unclean mind even the most ideal beauty, even a Madonna, can become charming. In any case, the sublime makes the sensuous disappear in the infinity of its effect, even when it belongs to nature, whereas the charming presents us the sensuous side of the phenomenon of beauty with seductive grace. But can this charm not be an innocent one? Must the sensuous be directly identical with evil? Is there no harmless enjoyment of sensuous beauty? It seems that many are only capable of thinking about the charming in the manner in which Delacroix painted a naked beauty, [282] who combs her flowing hair before a mirror, while behind it, in the mask of a man of means, superfluously equipped with elegant horns, the devil spies, piling up a tower of gold coins. How repellently the painter has poisoned the whole picture thus! Had he without prejudice displayed the beauty in the charm of her body, one would have delighted in the pure, noble forms. Through that grimace cowering in the darkness, a piece of vulgar allegory no doubt holding itself to be virtuous in accordance with French bad taste, he forces us to think of the lust of desire, of the fact that innocence can be bought. The great painters and sculptors have represented the charm of naked beauty *sans phrase* [without a word], and have thus been chaste; they have at the same time known how to bring sensuousness into a situation wherein it concedes the superiority of the intellect. For instance, Titian has painted Philip II with his mistress resting completely naked on a sofa;[179] he sits behind on the edge of the same; the scene opens on a free, beautiful landscape. But how has he drawn the lovers? They make music; he plays the guitar and looks after her tenderly, giving her the sign to fall in, while she has the sheet music beside her on the pillow and raises the flute. This painting is infinitely charming, but its free, open charm excites no desires, for the sensuous side of beauty, as strongly as it steps forth here, remains nevertheless subordinate to the mind and the spirit of the lovers. If the sensuous becomes tendentious in its effort to capture us only through the sensuous, charm is disturbed in its simplicity, and some products wobble badly in this way, above all those of contemporary Parisian painting. [283] Ingres' famous *Odalisque* is such a picture (see Figure 7).

The form is just as unforgettable as the execution, but the whole situation breathes only sensuousness. A closed, narrow bedchamber; heavy silk pillows and curtains, no sight of free nature; on a carpet near the mattress upon which the amply slender, velvet-skinned beauty stretches with nothing to do are jams, fruits, glasses; before her, leaning against the wall, an opium pipe. The Venus of the Harem has just smoked! Ingres can

[178] The German *Reiz* is a broad word, ranging from a mechanistic notion of stimulation and irritation (*Nervenreiz*) to personal charm and physical allure. The latter is particularly relevant to the discussion of sexuality that ensues, but to avoid giving the sense that sexuality alone is at stake, we opt for 'charm' and 'charming' throughout.

[179] The word *Lotterbett* also has erotic connotations: the dishevelled bed in a bordello.

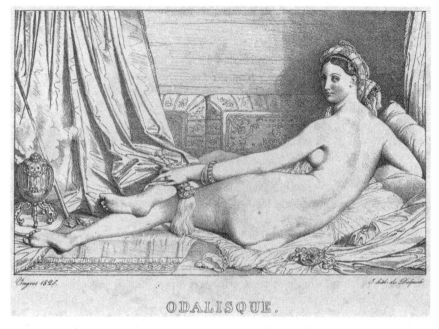

Figure 7 After Jean Auguste Dominique Ingres, *Odalisque* [1814], lithograph, 1826, The British Museum, London.
Source: © The Trustees of the British Museum.

say that he has painted everything very accurately according to the custom of the Orient; to be sure, only this will not brush away from the picture the claustrophobic impression that it only shows us a slave, not a free beauty. This odalisque is only a beautiful wild human,[180] captured and caged; when she does something, for in general she does nothing at all, then she eats, drinks, smokes. O how full of wit, how beautiful compared to that opium pipe is the flute in the hand of Philip's mistress!—The charming, as one of the necessary forms of beauty, binds itself naturally to all others and unfolds in very different degrees, for which reason we extend the use of the word 'charm' so widely and call the cute and the playful charming without any second thought. With greater precision we will, however, only acknowledge charm where the sensuous factor of beauty dominates, just as in the opposite case sublime majesty grows, the more it retreats into the depths of the spirit, in absolute freedom, for which reason we find spring, youth, woman more charming than autumn, age, or man. Charm loves the colourful, with which it amplifies sensuous energy, above all [**284**] contrast, as, for example, a white marble statue stands out the more charmingly against the green of a garden background. Covering also amplifies charm insofar as it shows it to us with

[180] The wordplay of *Menschenwild* suggests human 'game' (*Wild*), as in game animals.

a certain *agaçerie* [allure] by hiding it, rather like the ancient Roman poets found that beauty is all the more charming when she flees.

The negative opposite of pleasant beauty is repulsiveness, namely 1. as negation of the cute, clumsiness; 2. as negation of the playful, the empty and the dead; 3. as negation of the charming, the hideous. The clumsy is a lack of articulation, of developed beauty of the parts; the dead is absence of movement, undifferentiated being; the hideous is active destruction of life through a negativity that appears in ugly form. With respect to the sublime, the plump is opposed to magnitude; the dead to the powerful; the hideous to the majestic. The nobility of the sublime excludes from it all meanness, whereas the repulsive takes it in itself; the sublime transfigures what is finite in the ideality of its infinity, whereas the repulsive immerses itself in the dirt of the finite; the sublime stretches us with godly forces to the edge of heroism, whereas the repulsive with its formlessness and powerlessness relaxes us to the point of hypochondria.

I. The Clumsy

Cuteness applies to something small which we like through its delicateness; clumsiness is something that displeases through the nonform (*Ungestalt*) of its mass or through the awkwardness of its [285] movement. Because the cute is carefully worked out in its parts, we also call it the fine, just as we call the clumsy, due to the lack of development of differences, the rough. The clumsy is then not formless; it has form, but an ill-suited one, in which mass rules. It can also move itself, but its movements are *inept*, careless, klutzy. A fat willow trunk deprived of form by having its branches cropped looks clumsy. The crocodile, hippopotamus, sloth, sea lion, and so on, are animals whose movement is clumsy, because their mass lacks articulation and elasticity.[181] Neither the magnitude of the mass nor the simplicity of form are causes of clumsiness, but rather proportion and nonform. An Egyptian pyramid is a great, very simple mass without any clumsiness; the Asiatic Dhagopas (or stupas) on the other hand, in whose domes one wished to imitate the world bubble, seem through their massive, stumpy proportions clumsy.[182] The Kabirian gods with their fat bellies, their short, broad feet, their lack of a neck and their crouching postures are clumsy. Force stands always in danger of falling into the clumsy in the expression of its energy, as visual art has found with Heracles and Silenus. The rough also reaches its limit, as can be seen at times in Rubens. Side by side with his vigorous heroic figures it is true that his female figures too had to take on something of the Flemish type, broad backs, full breasts, swelling hips, well-rounded loins and arms, but in the overflowing fullness also an inwardness of life, an articulation, direction, nervous tension, which [286] still fends off decided clumsiness. To become aware of this, we need only compare him to Martin de Vos, in whose forms the paunchy, excess

[181] Rosenkranz is not alone in these odd claims: on the sloth, whose laziness 'contradicts' the necessary liveliness of animals, see Hegel, *Ästhetik*, vol.1, 166; the crocodile, a prize target of Theodor Vischer's, was still being discussed by Hermann Lotze in 1868.

[182] On the shift in receptivity to Indian architecture and its proportions, see Partha Mitter, *Much Maligned Monsters*, 2nd edition (Chicago: University of Chicago Press, 1992), 184–8.

growth of flesh obscures the articulation, so that the proportions seem pressed and awkward.

The clumsy as movement is naturally bound first of all to the form that is clumsy in itself. Of a hippopotamus, crocodile, penguin, polar bear, of an ungainly klutz we can only expect clumsy movements. But a clumsy motion may also be brought forth from a being intrinsically beautiful, even delicate, which being in contradiction with it must appear all the uglier; just as, on the contrary, the delicate movement of an intrinsically clumsy mass, for instance of an elephant dancing on a wire, as the Romans trained him to do, will necessarily reduce the impression of clumsiness in the form. The more an element justifies us to [expect to] see it unfold fineness of form, lightness, even elegance of movement, the more repulsed we feel when instead crudeness and roughness are disseminated. This is primarily so in the element of the humorous and the comical. A clumsy joke, clumsy humour, are ugly, because lightness lies already as an essential predicate in the concept of the joke and of humour as play. The meanness of a Morolf for instance expresses itself in such clumsiness.

The clumsy is often called the *rustical*. One would however err greatly in conflating it with the *rustic*.[183] The rustic can be rough, forceful, only it need not be ungainly. In the scale of a stratification by classes, the aristocracy will hold every [287] form of manners of the classes subordinate to it to be clumsy and inept. But the peasant is originally identical with the rural nobility; where he steps forth as a free landowner, he is indeed forceful as the ruler of nature, but in his morals and his decency he is anything but clumsy, but much rather in the self-consciousness of his force, his ability, he is filled with natural dignity, as is shown by the free peasants of Norway, of the North German marshlands, of Westphalia, of Switzerland;[184] as Voß has rendered the peasants of Holstein in his idylls, or Immermann the Westphalians in his *Münchhausen*. Immermann's village-Schulze shows us the full dignity of man, who sits in court with the sword of Charlemagne, and his daughter Lisbeth shows us the whole grace and moral fineness of a peasant girl, who knows very well how to rake, milk, sew, spin, cook, without injuring with such activities either the nobility of her demeanour or the amiability of her conduct. Rightly the author emphasizes in his Schulze that he wished to do everything *con maniera* (as it should be), that is, with moral measure, with the rhythm of the decency demanded by the nature of the material. George Sand too in her peasants des Berry in *Meunier d'Angibault*, in the *Jeanne*, in the *Péché de M. Antoine* and so on, has very rightly felt through what is conventional in their essence in a characteristic manner. Inapt is only the neglect of manner. The peasant can be called ἄγροικος [*ágroikos*, dwelling in the fields], *rusticus, rustre*, rustical, as opposed to *Urbanitas*, to the practised refinement and well-spokenness of urban manners. But his form and appearance first became aesthetically repulsive when the feudal nobility [288] overburdened and bent it, sucking out its marrow through exaggerated feudal duties, when it made it hard and raw through hard and raw treatment, as it alienated it

[183] *Bäuerisch* vs. *bäuerlich*, a contrast analogous to that between childish and childlike.
[184] It should be remembered that at the time Rosenkranz was writing serfdom was still in force in the Habsburg and Russian empires, and that its reform in Germany was slow.

from itself through its pride. Thus the peasant became stiff; thus he became rustical, being ridiculed as maladroit and failed; and the high name 'peasant' [*Bauer*, in German literally 'builder'], who builds up God's earth with his hands and thus builds up the foundation of the entire civil society, became a bad word, above all in the frivolity of the bureaucratic and financial nobility. Insofar as the concept of the rustical hangs together with that of the low, we have to point to the treatment of this concept above.

In this context we also discussed how the lack of manner becomes ridiculous in the grotesque and the burlesque. The clumsy is one of the main driving forces of low humour; but the unruliness of the massed form and the awkwardness of movement must remain within certain bounds in order to be funny; it may not become brutal. The child discovers the humorous opposition of the clumsy and the adroit on the street, in bears and monkeys. How ridiculous it seems to the child when the wild animal on two legs, like the child, rides on a stick, when like a maid going to get water, he puts a wooden balance over his neck! And how clever and delicate by contrast he finds the red-jacketed monkey, which on the back of the bear crashes the cymbals, munches nuts, shoots a little rifle! Comics have always had great success in contrasting the clumsy with the graceful. They have, particularly in transitional phases, always compared the provincial and small-towner [289] with the courtier and the urbanite, the petit bourgeois with the haute bourgeois, the recruit with the experienced soldier, the inferior subaltern bureaucrat with the top dog, and so forth. *L'homme de province* among the French, is due to the centralization of their education in Paris in all his variations a stereotyped comic figure. Aristophanes in his comedies has enlarged the clumsiness of the Spartans, tribals and such in that, contrasted with the fineness of Attic language, he lets them speak their dialect. All mimic arts have in the clumsy an infallible means to get effects. In Gluck's *Iphigenie auf Tauris* the Scythian dance, compared to the Greek, is incomparable in its effect. Gluck has depicted in the music to the same scene the awkward unsociability of the great, naturally vigorous force of the barbarian people in both melody and the instrumentation, in the most genial fashion. Acrobats and riding masters often apply plumpness as a grotesque shell, in order to surprise all the more through the contrast of an ethereal motion breaking out from it. Thus the Parforce riders present themselves normally at first as dumb, clumsy devils who are unable to ride at all. But once they sit on the back of the horse, they outdo all with their cheek and neck-breaking playfulness.

II. The Dead and the Empty

To life stands opposed death, and in life the cheerfulness of play is opposed to the seriousness of work. Aesthetically, to the purposeless unrest of the playful the dead [290] and empty is the opposite, the expression of lack of life and free movement.

The dead as such is not yet without any further ado ugly; indeed death can even result in an increase in the beauty of human features. From the furrows of suffering, from the scars of the struggle, the childhood features of the primordial face of the deceased smile to us once more. Dying too, though it is the passage to death, need not be ugly in itself. Lessing, in his essay *Wie die Alten den Tod gebildet* [How the ancients

pictured death, 1769] says very rightly: 'To be dead has nothing frightful [in itself]; and insofar as dying is nothing but the step to being dead, dying too can have nothing that is frightful. Only to die so and so, right now, in this spirit, after this or that [act of the] will, with cursing and martyrdom, can be frightful and becomes frightful. But is it then dying, is it death, that is the cause of fright? Nothing of the sort; death is the wished-for end to all this fright, and only the poverty of language is to blame if it names both of these conditions, the condition which leads inevitably to death, and the condition of death itself, with one word.'[185] The Greeks, as Lessing further shows, distinguished the sad necessity of having to die, which they called *Kere*, from death itself. The former they pictured as a horrible woman with voracious teeth and claw-armed hands, the latter as a graceful genius who extinguishes the lowered torch, as the brother of sleep. But they also represented in the chopped-off head of Medusa the eloquent, soul-stealing gaze of death. From the head of the dying sprang [291] in addition Pegasus, and Athena affixed the snaky locks to the *aegis*, for it was she, the warlike goddess of thought, who in fact killed the sole mortal Gorgon-daughter.[186] We have above, in a different context, counted the Medusa among those forms with which the Greeks were so fortunate as to build up the terrible into the noblest beauty.[187] This powerful head with the forceful, cramp-afflicted lips, with the imperial chin, with the forehead that, only a bit lower, recalls that of Zeus, with the large, brokenly rolling eyes, with the dark adder-hair: even killed, it beams death and destruction. The later Medusa-ideal has wonderfully blended a peculiar melancholy with the force of the features. In a Medusa-picture that [Wilhelm] Ternite has reproduced faithfully in colour in his *Wandgemälden* [*aus Pompeji und Herculaneum*; Berlin: Reimer, 1839], vol.2, the grey, green, and pale yellow tones of the dying visage are gripping in their effect; for all the most perfect psychological truth, for all the sublime greatness of the whole conception, the gruesome has been attenuated to delight.—Christian art went even further, for its whole worldview sees true life as mediated through right dying. The God-man, deceased but arisen again to eternal life, is its centre. The dead body of Christ must, despite all truth of death, allow the immortal spirit that dwelt in him and will dwell in him again to shimmer through it. These closed eyes will open again, these bleached, inert lips will tense once again, these stiff hands will once again bless and break the bread of life. This possibility may not be represented by the sculptor or painter as [292] life remaining in the corpse, for that would be only an apparent death, but rather, it must appear as the miracle which exists only in this corpse; undoubtedly the most difficult task of all of visual art, to which only the greatest forces of genius are adequate. Faith indeed has nothing directly to do with these aesthetic postulates, and on its lower levels of education it may even be that a really crass expression of Christ's death is very appropriate to it; a really emaciated, wound-covered, pain-wrecked corpse will be more compelling for the masses, precisely through its gruesomeness and through the contradiction of seeing the saviour of the world present in such a form. The aesthetically perfected artworks are, as is well-known,

[185] In *Sämmtliche Schriften*, ed. Karl Lachmann, vol.8 (Berlin: Voß, 1839), 247.
[186] That is, through her agent Perseus.
[187] Rosenkranz is referring presumably to the Medusa Rondanini, cited in his Note 14.

not those that perform wonders; these are rather those strange, often decidedly ugly figures that with their lurid forms possess a magically binding force of attraction for the superstitious. The type of the dying and dead Christ has been naturally extended to Mary, and further to the Saints. Life out of death is here everywhere the fundamental thought, the precise reversal of the death-gazing Medusa head that Perseus, as several wall paintings of Pompeii show, only dared to show to Andromeda reflected in water.—Death as personification, as skeleton with a merciless scythe, the Christian metamorphosis of the old Kronos, is actually not ugly either. The human skeleton is beautiful; it is only the side imaginings of having to die, of the darkness of the grave, decay, judgement, which have surrounded it with its familiar terror. Only relatively to blooming life is the sack of bones (*Gerippe*—literally ribcage, but see his comment), as one puts it with a derisory expression, ugly. In the [293] *Dances of Death*, thus, painting too has been able to individualize death as the life-ending power to the highest degree of liveliness. The pathos of destruction tenses the bones of the fleshless skeleton with indomitable force, which overtakes life in all classes, ages and situations and forces it into the grave (* NOTE 63). This idea does not let death appear by itself, but in contrast with the multiplicity of life, in struggle with which it becomes terribly beautiful.

In none of these cases can we really speak of the dead and the empty, as it concerns us here, insofar as it constitutes the abstract negation of life, which in its exuberant play goes beyond natural necessity. In all becoming, in all change, in all struggle there is already charm. But once life is excited with playful purposelessness by the happiness of its pleasure-quickened self-feeling, it first really comes to enjoy itself as life. When water murmurs down garrulously over the pebbles, when flowers silently spread their scent of offering and butterflies flap about their swinging bowls, when the swallow atop the gable twitters its greeting, when the doves draw their glowing circles untiringly through the blue of the sky, when dogs tumble in a bratty manner on green lawns, when girls throw the ball, when boys try the strength of their vigorous limbs in wrestling, when girls and boys let the overspill of pleasure peal out in song or break out in dance,—then, then life enjoys itself in cheerful play. How sad, how ugly appears by contrast a drought-dried, crawling stream, a stagnant swamp, a scorched, dusty lawn, a grey sky, a soundless wasteland, the [294] mechanical service in a machine factory, the silence interrupted only by sighs in a military hospital!

The ugly dead consists in the lack of self-determination, which unfolds in a multiplicity of distinctions. It therefore encloses more or less in itself the presupposition of life, which through its lack of difference it contradicts. And indeed this can take place in different ways. One time the scheme might be brilliant, but the execution dull and hollow;—as this tends to be the case when a great genius has begun a work but not carried it through, and a lesser talent takes over its completion. Here the plan of the whole is blameless, but the representation does not reach the heights of its intention and leaves us cold, like Schiller's *Demetrius* and the version by Maltitz and so on.[188]—Or

[188] *Demetrius* is the fragment of a play by Schiller that Hebbel and others tried to complete. Franz von Maltitz's version appeared in Karlsruhe and Baden: D.R. Marx, 1817.

the scheme is frosty and the extraneous richness of the execution is expected to hide this inner poverty. The discrepancy between the original deadness and the luxury of the exoteric paraphernalia only helps increase the impression of emptiness, as in Bernini's deformation of the building style originated by Palladio a richly built up ornament is unable to hide the lack of soul in the genuine architectonic invention. Or one may recall that army of endless epics, which in hexameters, stanzas or Nibelungen-strophes allowed the most vacuous contents to loll out in irresistible breadth, like Kunze's *Heinrich der Löwe* [Henry the Lion] (* NOTE 64), or Bodmer's *Noachide,* wherein a comet on God's command approaches so near to the Earth as to cause the raising of the floodwaters. What a profusion of water, what profusion of misery of every kind, what profusion of bad [**295**] hexameters—and what excess of poetic emptiness! One may recall those thoughtless odes, which through the decorative piling up of traditional big words affect enthusiasm; those modest songs, which always repeat to us the command, that we should drink and sing and sing and drink; those trivial tragedies, whose unholy stupidities and beggar pathos one could put an end to if it were allowed to throw ten dollars from the orchestra to the miserable people onstage; those unsalted comedies, wherein an invention blameless in itself is exploited until the spectators despair. How dead, how empty they are.—Finally however deadness can inhere in the lack of form as well as in the lack of content. Better said, deadness of conception can come together with deadness of execution to a frightening harmony. This is the case with many *allegorical* products, which attempt to replace the lack of truly poetical insight through the personification of vices and virtues, of arts and sciences, and through a laboriously thought-together symbolism, a species to which, excepting several passages, the *Roman de la rose,* so beloved in the French Middle Ages, belongs (* NOTE 65).—This is also the case with many works that make art only the means to some *tendency.* We belong by no means among those who reject tendency out of hand, for the artist cannot escape the currents of the time to which he lives; tendencies contain also ideas in themselves; but they must not be confused with the closed-off *dogma of one party.* The tendency of our time, for instance, [**296**] of mediating the opposition of aristocracy and democracy in all its forms through genuine education, from the inside out, has fructified two of our best novels, the *Engelchen* [Little Angel] of Prutz and the *Ritter vom Geiste* [Knights of the Spirit] of Gutzkow. These authors, however, have only reached their great success by rising from the tendency to the ideal. If the tendency on the other hand sinks to making the exclusive party point, it inevitably kills the poetry through this prosaic intention. Tendency in this limited sense has similar consequences as does allegorizing. The forms become already in the conception victims of the concept whose victory or defeat it concerns.—Further, the stillbirth of content and form enters many works of sculpture and painting through *academic* schooling, through the unfree clinging to the poses of the models and the folds of the phantom. Instead of becoming works of art, they become nothing but made-work. The expression of such academic forms gives the feeling that they are only distorting themselves for its sake. But something similar can be observed in music and poetry, when merely *imitative,* intrinsically unproductive mediocrity prostitutes its inability in fruitless, hollow, wooden repetitions of the ideas of great predecessors. What was a play of fresh life in the original becomes in the copy

of the imitator a dead make-word, the desolate aggregate of a sterile eclecticism. Living invention bursts from mysterious sources and falls like a mountain current with joyful sound; the imitation crawls silently away like a diverted watercourse in enclosed canals. The inventor becomes himself enthused by the revelation of the idea; the imitator is first enthused by this enthusiasm. [297] Should the imitator be at the same time a dilettante, all that enters the scene which we drew attention to in the section on correctness. The creative genius is filled by the power of the idea with a freedom that feels itself one with the necessity of the thing, and from within which he in the newness, greatness and daring of his composition will likely transgress empirical normality and the rules of technique. The imitator, in whom is active the taste for the work already made, which for him becomes an empirical ideal, a surrogate of the idea, can have no truly productive pathos, even should he delude himself into feeling one. Imitation exaggerates in its dependency not just the errors, but routinely also the virtues of its original, and perverts through this disproportion the very virtues into errors. Through this the remains of original life that he had still taken from the original are fully killed.

As we name the living differently according to its different aspects, so we do with the dead, in that we call it the empty, hollow, bald, dry, desolate, deserted, frosty, cold, wooden, leathery, insensitive, indifferent, and so on, and bind these synonyms for the qualitative characteristics of the repulsive variously among one another, as Heine sings in *Atta Troll*:

Drones the sound of the great drum,
And the tone of the copper kettle,
Where the hollow with the empty
Connect so pleasantly.

The passage to humour of the dead proceeds through the boring. The dead, hollow, cold becomes through its lack of free distinction, of spontaneous [298] development without interest, boring. The boring is ugly or rather the ugliness of the dead, empty, tautologuous generates in us the feeling of boredom. Beauty makes us forget the time, because as something eternal and self-sufficient it transports us to eternity too and fills us with bliss. Should the emptiness of an experience become so great that we notice time as time, we come to feel the contentlessness of pure time, and this feeling is boredom. This is itself thus by no means humorous, but the turning point to humour, when namely tautology and boredom is produced as self-parody or irony, and a truly terrible ballad consists only in these words:

Eduard and Kunigunde,
Kunigunde, Eduard;
Eduard and Kunigunde,
Kunigunde, Eduard!

———————

III. The Hideous

When beauty unites the amiability of the delicate form with the graceful play of movement, it becomes charming. It is not necessary that this game be an agitated one; the greatest calm may rule within it; it must however represent the soulful expression of the freedom of life. If we recall one of those sleeping nymphs, as the ancients, as Titian, Netscher, or Rubens painted them, here sleep is by no means death; in the sleeper too the fullness of life stretches the soft skin, raises and lowers the breasts, ebbs and flows through the barely opened [299] mouth and contracts the eyelids. In this play of life the delicate form becomes charming. If we take that all away, the dead form would also remain delicate, for after all nothing would have changed in the proportions of the same, only it could no longer be called charming. [Alexandre] Décamps has painted a beautiful young girl as a corpse, covered by a thin veil, through which her noble features shimmer, lying on a trestle in an empty attic.[189] No one will speak here of charm, for charm resides only in the living. Or assume that the form is not beautiful; then we also do not find it charming. An old woman, an *anus libidinosa*, as Horace says, also breathes in her sleep, her wilted breasts also rise and sink, and so on, but it will only seem the uglier to us. The charming, however, demands also the delicacy of form, for if we imagine a sublime beauty, the force of her limbs and the strength of her forms will have rather something repellent than inviting to pleasure, which the Greeks expressed in the myth that Hera, to arouse Zeus's love, had first to borrow from Aphrodite her grace-giving belt.

Opposed to the charming is the hideous as non-form, which in its ugly motion always only brings about new mis-forms, dissonance [literally 'mis-sounds'], and mis-words. The hideous does not hold us as does the sublime at a respectful distance, but pushes us away from itself; it does not pull us seductively to itself, as does the pleasant, but makes us shudder before it. It does not satisfy us, like the perfectly beautiful, through absolute consolation in the innermost of our being, but rather digs around the [300] depths of the same to bring about the most outward rupture. The hideous above all is that ugliness that art cannot do without, because it cannot dispense with the representation of evil and move within a superficial and limited worldview, whose goal is only comfortable entertainment. The hideous is in turn: 1. in ideal form the tasteless, the negation of the idea in the purely senseless; 2 in real form the disgusting, the negation of all beauty of the sensuous appearance of the idea; 3. in ideal-real form, evil, the negation both of the idea of the concept of the true and the good as well as of the reality of this concept in the beauty of appearance.[190] Evil is the climax of the hideous as the positive, absolute Non-Idea. Art not only is allowed to make use of all these forms of ugliness, but rather it must do so under certain conditions. We gave the general conditions in the introduction; they are those without which the representation

[189] Alexandre-Gabriel Decamps famously painted a *Suicide* (1836, now in the Walters Art Museum), but this is a painter (as one can see from his cast-away easel) who has done himself in with a pistol. Rosenkranz may have confused the picture with another.

[190] Rosenkranz has 'the negation both of the concept of the idea ...' but the parallel with the 'reality of the concept' suggests that he is opposing evil both to idea and reality.

of ugliness is not permissible at all. The hideous may never thus be an end in itself; it may not be isolated; it must be brought forth by the necessity of rendering freedom in its totality, and in the end it must be idealized just as much as any appearance. Let us see then wherein the particular conditions of its aesthetic possibility consist.

a) The Tasteless

The hideous in general conflicts with reason and freedom. As the tasteless it represents this conflict in a form that insults above all reason through the unmotivated negation of the law of causality and fantasy through the resulting [301] lack of consistency. The tasteless, absurd, inconsistent, senseless, silly, insipid, crazy, mad, or however else one might care to name it, is the ideal side of hideousness, the theoretical, abstract basis of the aesthetic rupture present in it. Not the contradiction as such is absurd, for it can be a rationally justified one, as we saw in elucidating the concept of contrast. Good rightly contradicts evil, truth the lie, beauty ugliness. But indeed the so-called *contradictio in adjecto*[191] is a self-destroying contradiction, and such comprises the content of the tasteless. Logic distinguishes contradiction from contrariety (thus: a contradiction is only a simple, undetermined negation of a predicate on the part of the speaker ἀντιφατικός ἀντικείμενον [*antiphatikós antikeímenon*, contradictory opposite], while a contrary is the positive negation of a predicate through one that is immanently opposed to it ἐναντίος ἀντικείμενον [*enantios antikeímenon*, contrary opposite]).[192] Neither that kind of contradiction nor contraries are absurd, but rather that kind of contradiction which negates the subject itself through the predicate, as for instance if I wanted to say 'white is black', or 'good is evil', and so on.[193] In any case this in itself perfectly correct determination of common sense is not the last word, for extremes can turn into one another, as every housewife unself-consciously will say of the white sheets that they have turned black;[194] as justice, in itself a good, can become cruel, and thus evil, through abstract stubbornness; as ugliness through correct handling within an aesthetic totality can take on the significance of beauty, not indeed of ugly beauty, but rather of a beautiful ugliness, and so on. [302] Mere common sense considers much to be absurd that is in fact the epitome of reason. We have to keep in mind this dialectic that lies in finitude, in order to precisely recognize the bounds of the tasteless, and to understand its affinity to the ridiculous.

It should already be clear from what was said that the fully senseless without deeper motivation, a pure chaos of accidental contradictions, is objectionable in art. Who should take an interest in it? At best the psychiatrist, as for instance [Karl] Hohenbaum in his fine treatise on *Psychische Gesundheit und Irresein in ihren Uebergängen* [Psychic health and insanity in their gradations, Berlin: Reimer], 1845, p. 54ff, enumerates absurdities taken from a teacher given to distraction. This man often misspoke, and

[191] Contradiction in the adjective or predicate, like 'round square'.
[192] See Aristotle, *De Interpretatione*, 17b17 and 17b4 respectively.
[193] The complaint is that of Socrates in Plato's *Parmenides* 129b, that showing things to be both alike and unlike is not to show 'that the like is the unlike'. Incompatible attributes are not ascribed to objects, but concepts are themselves said to be their opposites.
[194] She means, presumably, that they are dirty.

said, for instance: 'Jerusalem was at this time in the enemies of the Turks.—Take a look, this sentence is obviously complicated, at the same time there is nothing complicated in it.—Hannibal bound the river to its left bank and had sand poured on it, so that the elephants could better cross.—The Empress died and left behind an unborn child.— The Lakedaemonians wore at that time a *Pileus* on their hats.—Ajax took a stone and threw it so hard on Ajax's head that he died, etc'. In such things, as I said, not aesthetics but psychiatry takes an interest. It cannot be denied, that a not inconsiderable part of the poetic literature of our century belongs in fact only under this category. On the side of Reaction become bigoted and superstitious, as well as on the side of Revolution, become atheistic and libertine, there have appeared in England, France and Germany enough products, namely **[303]** novels, which only deserve attention as symptoms of the mood of the times, from the side of politics and psychology, not however as artworks. The raggedness of the scandalized spirits has progressed to the confusion of dementia, and [Karl] Mager, in his [*Versuch einer*] *Geschichte der Französischen National-Literatur neuerer und neuster Zeit* [Essay in the History of Modern and Contemporary French National Literature, Berlin: Heymann], 1839, vol.2, p. 374, has not hesitated to propose precisely the category of *crazy novels*.

One must thus not confuse the absolute unintelligibility of this babbling absurdity with that contradiction which the fantastic world view opposes to reason, for this, in playing with the bounds of finitude, does try to bring to mind the essence of the idea. Here belongs the *wonderful*, which negates the law of objective causality in order to represent in fantastic form a higher idea, the freedom of spirit from nature. The true wonder can be distinguished from the bad *miracle* through the infinity of its ethical-religious content, whereas the miracle makes absolute nonsense as such, absurdity itself. We have this distinction before us in two mythologies, the Greek and the Indian. The thaumatic (wondrous) moments in the myths of the former are always connected with the deepest ideas, so that for educated humanity they have become the most beautiful and universal symbols of the same ideas, whereas the myths of the latter are too thoroughly covered by absurd climbing plants to allow the depth present in their conception as well to become visible. In the same way one can distinguish the wonders told in the canonical Gospels from those of the Apocrypha, which are more or less absurd. Also in **[304]** legends we find this same double tendency. The wondrousness of *fairy tale poetry* does indeed lose itself in the strange and adventurous and descends in places wholly into the absurd, but as long as it still possesses a truly poetic content, it will have even in its thaumatic element that symbolic truth which we had to vindicate in the section on incorrectness. This symbolism, the reflection of the idea in the soft childhood fantasy, will be combined into a unity by the true fairy tale, instinctively, with the great powers of natural and moral life, whereas the fairy tale so often fabricated by our pedagogical entertainers or gilt-edged-duodecimo-salon-tea-table-poets falls away from such powers and seeks its strength in the *childish*. The more absurd, these corrupters of youth seem to think, the more poetic. Because in this undisciplined fantasizing, which pushes a Callot-Hoffmann tendency to its extreme, all true causality finally disappeared without a trace and finally even ordinary furniture arose to think and speak, the manner of *Struwwelpeter*[sic!]-Hoffmann made an extraordinary impression, because it knew again somehow how to present its hair-raising nonsense

naively with a kind of lapidary poetry and fresco painting, thus making ironic the elegant, thoughtless whining of the fairy-tale poets. This explains why the grown-ups read the Struwwelpetriads just as happily as the children, until the swarm of imitators naturally degraded its manner in turn to the childish.—But back from this digression to the concept of the absurd: that element within the fairy tale, and the myth, which in fact contains the root of [305] inconsistency, is *magic* as the in-itself conceptless realization of fantasy's absolute arbitrariness. Magic is a tasteless act, for it brings about effects through causes that stand in no proportion to them. The magic-maker turns a ring—and an obedient spirit appears; he touches a raging tiger with a wand—and it hardens into a statue; he pronounces a senseless word, which he himself does not understand—and a palace rises out of the earth. Because in magic pragmatic causality is thus cancelled, it is consistent enough that all its procedures, formulas, conspiracies, explorations are without any sense. Nevertheless one will find here the same double tendency which we earlier identified as the difference we have given between the true wonder and the miracle, the true fairy tale and the sickly pseudoproduct of a weak-nerved, crazy fantasizing. If magic is given the tendency of placing humans in a higher spiritual realm, should it wish to open the gates of an unknown beyond, then on the threshold of the same it will find a certain frightful seriousness indispensable, for in such occasions there lies a kind of sublime boldness. But should the goal of magic be futile, vicious, pettily egoistic, even immoral, then it is in order that its means become silly, mad and grimacing. When Goethe's Faust calls up the Earth Spirit, it is a sublime moment corresponding also to the sublime of the phenomenon cited. But when the same Faust lets a witch brew him a drink, through which he sees Helen embodied in every woman, we notice [306] immediately in the witch's kitchen the absurd, which soon confronts the philosopher.

In craziness, the incoherence of the thoughts, the tastelessness of the images, the senselessness of the actions become sad reality. Painting and music can only represent this condition relatively. Donizetti in his opera *Anna Boleyn* has tried to express the incipient madness of the heroine especially through tremulous, whimpering, suddenly screeching tones that then expire in low notes. Only poetry can dare to do this thoroughly. But it will only be able to use the absurd as a means of representing brokenness of mind symbolically, as it were. The quodlibetarian combinations, the leaps, the impossible syntheses in the outpouring of the crazed intelligence are in themselves terrifying. With a timid shudder we turn from a precipice, out of which absurdity yawns at us. Poetry must show us madness as the result of a monstrous fate, so that we see in the unconnected burbling of the insane person the fury of the powerful contradictions to which humans are prey. We take fright not merely at the raggedness that bubbles at us out of such nonsense, but also at the powers that have been able to cause such cruel rupture. Lessing has famously said that whoever does not lose his understanding over certain things must have had none to lose. But he did not speak of reason, but hinted that it is much rather reasonable to lose one's understanding over certain things, an understanding that cannot grasp the monstrous, which overwhelms all its bounds, the nonexistence of reason in a concrete case, [307] so that reason as unreason drives understanding crazy. Those certain things—what can Lessing have meant by them, if not the existence of contradictions that seem to destroy the reality of the idea itself?

Only apparently, for art must hold on tightly to the truth of the idea and still manifest in the chatter of the insane its positive background, which Shakespeare names the method in the madness.[195] Art must grasp this in connection with the essence of genius, which Schopenhauer has sketched so aptly (* NOTE 66). Aesthetically then we will be able to demand that in the adventurous utterances of the madman a shimmer of the idea still gleams through, that in the dismembered sentences, in the counterintuitive confusion, in the elliptic interjections and the strange gestures of the same, as if in a distorting mirror, reason still illuminates itself and thus remains possible in the unhappy. The absurd in a craziness brought about only through somatic causes, such as concussion, encephalitis and so on, cannot for this reason become an aesthetic object, because it is lacking the ingredient of reason. Just as little can the mad rapture (*Raptus*) generated by petty causes and common passions become an aesthetic object. Both states are simply ugly. But if the contradiction of a powerful destiny, or the nemesis resulting from dark deed, pushes a person into insanity, the inverted actions and confused speeches will still permit reason to flash through them. If reason is in the world, and a God lives: should the horrific, the unnatural, the diabolical be possible, is it permissible for innocence to be ridiculed as guilt, justice ridiculed as injustice, and [308] viciousness idolized? The real poet lets the unhappy one, mutilated by experience of the reality of such horrible things, pronounce the most monstrous sacrilege against humans and gods. What a person otherwise hides to himself, moved by piety, moral, law, faith, what he represses in himself as a godless sacrilege, what in the context of a lasting and recognized world order is foolishness and silliness, all that is said out loud by the anarchy of an intelligence ruptured in itself, with zest and remarkable rudeness. Tragic madness turns away from the world order, for after what it has met, the absurd must deserve the throne. Friend betrays friend, seduces his wife away; the lover is unfaithful; wife poisons husband; the guest, who is at once master and king, is killed by one who should have defended him with his blood; the father is rejected by the children for whom he sacrificed everything, and so on. Such deeds, black as the night, do they not shake the eternal laws of the universe? And yet there they stand in sharp, blank, defiant actuality, and seem to ridicule as a fool whoever is weak enough to still believe in the sacredness of the good and the power of reason. Art may not give madness the last word. It must represent in it the curse of the nemesis striding through the darkness, or it must dissolve this in a higher totality. It was a dangerous deviation of the more recent romantics to drive their opposition against enlightenment and common sense, their irony, as they called it, so far that craziness, dream, foolishness came to be seen as the real truth of the world; a view crazy in itself, [309] which could only have ugly products as consequence. The madman has the privilege of voicing with unbridled *parrhesia* [courage of speech] thoughts which otherwise can only be tolerated in philosophical scepticism, or would only pass through the dreams of the most preciously clever souls as revolutionary manifestos. But to be beautiful, this madness bringing all things out of order must have an individualizing centre, which does not allow the pressure of the eccentric thoughts to float in an absolute vacuum, but rather lets them gravitate toward it. The poet must give the madman a

[195] Polonius's phrase, 'Though this be madnesse, there is method in't.' (*Hamlet*, II: 2).

generally interesting theme for his absurd rambling variations. Thus Gretchen's madness in the prison has a centre in the thought that through the love for a man she has transgressed against that for mother and child; thus Augustino in *Meister* in the thought of fatalism; Lear in the injured authority of king and father, and so on. The representation of madness is thus endlessly difficult, and only the greatest masters are successful, for instance Shakespeare, Goethe, G. Sand, among painters Kaulbach in his *Madhouse*, and so on. Of the recent French theatre, which is not otherwise sparing in disharmonies, a piece by Scribe and Melesville, *Elle est folle!* [She is mad!] deserves to be mentioned not only because it is psychologically most exact, but also because it dissolves the madness again in the end. A man is struck with the insanity of thinking his wife insane; but he himself is insane, because he fancies that he has pushed someone into the sea and thus killed them. If an incompetent sets out on the difficult task of rendering madness, the most hideous silliness comes to light, who is normally so miserable with its many exclamation [310] marks and dashes that one cannot even laugh about it, but withstands the uneasy proximity of imbecility.

We can say that tragedy has to do with the rupturing of reason, comedy with the contradictions of common sense. The latter can thus make a positive, very happy use of the tasteless. For it the silly, mad, crazy, incongruous cannot be absurd enough, as Calderón in such funny excess of foolishness travestied his own drama *Zelos aun del ayre matan* [Being Jealous, Even of the Air, Can Kill] in the burlesque *Cefalo y Procris*. The mere absurd is however not yet ridiculous; it first becomes so in its cancelling itself out in certain relations that make it impossible in itself, but seemingly real all the same. Madness in itself can often be sublime, as is that of a Don Quixote, and yet in its elaboration it can become humorous; foolishness however can also, as babbling, distraction, and bizarre imagination, be very humorous. The *fools* are privileged favourites of humour; the overconfidence of intelligence can also play with the absurd. Here belong also those concatenations of the heterogeneous which in Old German were called lying tales (*Lügenmärchen*) or miracle tales (*Wundermärchen*), and are today called blooming nonsense, in French *coq à l'âne* [cock and donkey, rather like English cock and bull]. Here belong the crowliads (*Krähwinkliaden*), Jew jokes, the sillinesses of Hanswurst, namely those he produced as Turlupin with the Wonderdoctor. On the Parisian fairs he played a leading role (* NOTE 67). In an old *coq à l'âne*, this kind of tastelessness, a constant *contradictio in adjecto*, is called an *almost rambling* [French *radoter*] (O. L. B. Wolff, *Altfranzösische Volkslieder* [Old French folk songs], Leipzig [Fleischer], 1831, 118):[311]

I went to Bagnolet,
Where I found a great big mule,
Who was planting some carrots.
My Madelon, I love you so,
That I almost ramble on.
I went on a little long,
Found a bunch of Foing,
That was dancing the gavotte.
My Madelon, I etc.

The Gascognades of the French are in any case such cheerful absurdities as can be found gathered together loosely in the old, beloved farce transplanted to us as well from the French, the *Lügner und sein Sohn* [The Liar and his son].[196] Father and son compete with one another in silly inventions. Mr. von Erat has planted a punch tree, in that he injected a rice grain with lemongrass, and watered it with rum; the son tells of having owned a hunting rifle with which he could shoot crosswise around corners, and so on. Among us such strands were concentrated earlier in *Eulenspiegel*, later in Bürger and Lichtenberg. Münchhausen wants to climb to the moon on a beanstalk, and to pull himself out of a swamp by the hair. His horse is cut in half by a closing gate; the front half of the horse stands peacefully there and drinks from a fountain endlessly, because the water keeps running out of the back. A hunting dog runs his feet down and metamorphoses from a hound to a kind of terrier. He shoots a deer in the head with a cherry pit. The next year he meets it and the deer carries between [312] the horns a cherry tree, and so on. Senseless, we call on hearing such hunter's lies, but we entertain ourselves wonderfully. Immermann in his Münchhausen has let fall the parody of hunter's one-upmanship, but to make up for it he gave the baron a delicious slice of universal mendacity in the spirit or much rather non-spirit[197] of our times, which with its puffs and humbugs speculates greatly, as when Münchhausen convinces the old Baron of Posemuckel to build an air-stone factory, for as he reasons, all that is material consists of the four chemical elements; since these are also to be found in the air, one has in the air the best, most available, ever-present material to make stones!—Low humour naturally makes use of the absurd to an extraordinary extent, in stuttering, in mistakes of speech, in mistakes of hearing, in breaking a foreign language on the wheel, especially also in ridiculing the absurdities of magic. Caspar in the puppet theatre of Faust is from this standpoint one of the most delightful creatures. He parodies the whole study of necromancy and magic; he doesn't let the devils impose on him, but rather he harasses them with his *perlippe, perlappe* in his cruelly funny way.

b) The Disgusting

The tasteless is the ideal side of the hideous, the negation of common sense. Disgust is the real side, the negation of the beautiful form of an appearance through a non-form originating in physical or moral decay. According to the old rule *a potiori fit denominatio* [the name follows the principle], we call also the lower levels of the repulsive [313] and the mean disgusting, because all that causes us disgust, which through the dissolution of form injures our aesthetic sense. For the concept of disgust in the narrower sense, however, we must add to this the definition of decay, because this contains that becoming of death, which is not a wilting and dying, but rather the *decomposition*[198] *of*

[196] A printed version of the farce by Colin d'Harleville was published in Vienna by Wallishäuser in 1837: but a playbill in the Thüringische Staatsarchiv (2029 / Blatt 139) indicates that the farce was played in the Hoftheater, Weimar, in August 1820.

[197] Since *Geist* is also a normal German word for mind, *Ungeist* also suggests the silliness Rosenkranz has in mind here.

[198] *Entwerden*, a word the Grimms complain is 'obscure, oscillating between 'cease', 'exit', 'perish' and 'escape'. In this context, it suggests decay, a process opposed to change in life.

the already dead. The appearance of life in what is dead in itself is what is infinitely repulsive in disgust. The absurd in its illogical tangle also provokes repugnance, as long as it is not turned into the humorous, only due to its intellectual element the effect is not so strong as that of disgust, which dares our senses with the enjoyment of a being hostile to them, and which one could call the sensuously absurd. In the absurd, even if it is a pile of splinters of intelligence, one can still take a critical interest, whereas disgust outrages our senses and simply pushes us away from it. The disgusting as a product of nature, sweat, slime, dung, abscesses and the like is something dead that the organism separates from itself and thus gives over to decay. Inorganic nature too can become relatively disgusting, but only relatively, namely in analogy or in connection with the organic. In itself, however, the concept of decay is not applicable to it and for this reason one cannot by any means call stones, metals, earths, salts, water, clouds, gases, or colours disgusting. Only relatively, in connection with our smell and taste organs can one call them so. A mud volcano, the very opposite of the majestic theatre of a fire-spitting mountain, becomes repulsive for us because the eruption of cloudy liquids analogically reminds us of water, [**314**] and here instead of it a liquid, opaque solution of earth, perhaps mixed with dead, decaying fish, in some ways a decaying earth seems to present itself. One can examine the representation of such a mud eruption in A[lexander] von Humboldt's *Vues des Cordillères* [Paris: À la Librairie Grecque-Latine-Allemande, 1816]. Thus is also the swampy water in city canals, where the runoffs from gutters gather, where plant and animal parts make a hideous amalgam with rags and other remnants of cultured decay, extremely disgusting. If one could take a large city like Paris and turn it upside down once, so that the bottommost came to the top, so that not merely the sludge of the sewers, but also the light-avoiding animals were brought to the light, the mice, rats, toads, worms, who live from the decay, it would be a terrifyingly disgusting picture. That in this connection smell possesses a superior sensitivity is certain. The bad smell of excrement makes it appear in its naturalness still more repulsive than it would as a mere shape. For instance, coprolith, the fossilized dung of antediluvian animals, no longer has anything disgusting about it, and we have it lying peacefully in our mineralogical collections beside other petrified objects. Among the wonderful pictures of the Campo Santo in Pisa we also see a proud hunting party riding by an open grave in which the body may be seen and holding their noses with their hands; we see this well enough, but we don't smell it. The sweat of work, which runs off the forehead, that drops liks pearls off the chest, is indeed very honourable, only not aesthetically. Should the sweat get mixed even in the pleasure, it is straightforwardly disgusting, as when Heine for instance [*Der Salon*, vol.1 (Hamburg: Hoffmann und Campe 1834), 192] sings the nuptials of a young couple: [**315**]

God save you from overheating,
All too strongly pounding heartbeats,
All too odorously sweating,
And from overstuffing bellies.

Dirt and excrement are aesthetically disgusting. When the dying Emperor Claudius called out: *Vae! Puto concacavi me!* [Woe, I think I've shat myself!], he destroyed all his

imperial majesty. When [Wilhelm] Jordan in his *Demiurgos* [Leipzig: Brockhaus], 1852, 237, motivates the separation of Heinrich from Helen thus, that he once saw his wife on the toilet, it is so unboundedly disgusting, common, shameless, that one barely comprehends how an indisputably versatile poet can become so tasteless, even if he lets Lucifer laugh long over this overfine *delicatesse*. This mystery is decked out with cynical manifestations of the most lurid sort; we want however to resist the temptation to give further examples of disgust out of it. The roughness of popular speech, it is true, loves excrement as the *ultima ratio* in cursing, in order to express the absolute nullity of something and to indicate the maximum of one's repugnance, in the same manner for instance in which Goethe excuses the ignoring of his opponents in the Xenien:

> Tell me about your opponents, why don't you want to know of them?—
> Tell me if you set your foot there in the street where there was s— — —

Poetry, however, can only make use of it for grotesque humour, as we have already cited Blepyrus from Aristophanes' *Ekklesiazusen*, or as Dr. [Heinrich] Hoffmann in an Aristophanic comedy, *Die Mondzügler* [The Moon Jugglers; Frankfurt: Jäger], 1843, [316] ridicules the dialectic of modern philosophy by giving the disputing philosophers the task of defining the *fundamental concept of dirt*. The one want to prove, for example, that one has never understood the sense of dirt, because one has never grasped its genus rightly:

> *Subject* and *object*, absolutely identical are the two,
> A is the same as B and not to be distinguished,
> B, the object, is the dirt. But is that the pure truth?
> That I am A, the subject, is evidently clear.
> And with that, I am myself the dirt, I myself, I am identical.
> It is a proved truth, this, even if it is counterintuitive!
> If someone only hypothetically produced the dirt for you,
> It follows from this that the man has just produced himself.
> Now I call such a mode of reproduction really nonsexual,
> And if I say: *he*, and if I say: *she*, it is incorrect.
> Much rather, to grasp this whole deduction in one word,
> So I may from now on only grant the validity of *it (dirt)*.

One could say of decay that through the Christian religion it has nonetheless become a positive object of art, in that painting has attempted the *raising of Lazarus*, of which the text itself reported that he already stank. Above all things, one should not forget that painting does not represent this smell and thus that for this reason one only has to think of a superficial beginning of decay. The genuinely positive in this theme remains ever the experience of how death was overcome through the divine life radiating from Christ. Lazarus, coming out of the opened grave wrapped in his shroud, contrasts most picturesquely with the group of the living [317] standing about the grave. Lazarus must, however, reveal in his somewhat schematic form and in his pale features that he

has already been a victim of death, but he must at the same time show how the power of life has already cancelled out the death in him.

Illness has already been treated in the introduction. In itself it is not necessarily repulsive or disgusting. It only becomes so when it destroys the organism in the form of decay and especially when vice is the cause of the illness. In an atlas of anatomy and pathology for scientific purposes the most hideous is naturally justified, for art on the other hand disgusting disease is only representable under the condition that a counterweight of ethical or religious ideas is posited with it. A Job covered in sores steps under the light [Reverbère] of divine justice. The *Arme Heinrich* [Poor Henry] of Hartmann von der Aue is indeed a nearly brutal object that makes it hard to understand why the Germans have reprinted him so frequently and offered it to the youth a thousandfold, in original and the most diverse forms of adaptation; that said, there is in it, albeit in quite repulsive side circumstances, still firmly the idea of the free sacrifice. *Le lépreux de la ville d'Aosta* [The Leper of the City of Aosta; Paris: Delaunay, 1823] by Xavier de Maistre, a very gripping portrait of human loneliness, is based on the idea of absolute resignation. The ancient Philoctetes suffers from his foot, because the snake bit him at the altar raised by Jason in Chryse on the island of Lemnos, as punishment for his showing it to the Greeks, etc. Disgusting illnesses with immoral causes must be rejected by art. Poetry prostitutes itself [318] when it represents such things, as Sue in his Parisian Mysteries gives a medically precise description of St. Lazare, and a German woman writer, Julie Burow, in a novel, *Frauen-Loos* [Woman's Fate; 2 vols., Königsberg: Adolph Samter, 1850] has recorded the exact description of the syphilitic station of a lazar-house. These are mistakes of a time that holds its sickly pathological interest in corruption and the misery of demoralization for poetic. Illnesses that are indeed not infamous but only have the character of a curiosity, which make themselves known through strange deformities and growths, are also not aesthetic objects, as for instance elephantiasis, which makes one arm or leg swell up like a tyre, so that its own form is quite lost.

Art, however, has every right to represent illnesses that like an elemental power afflict thousands, to whom they can appear in part as a mere natural force, in part as a divine judgement. In this case, the illness takes on, even when it includes in itself disgusting forms, even a frightfully sublime character. The masses of the ill give an immediate impression of the extraordinary, and picturesque contrasts of sex, age and class ensue. Taken aesthetically, however, the Raising of Lazarus will give the canonical type for all such scenes, and life as the eternal power of death will have to appear triumphant over the process of dying.[199] The sight of mass death alone, as it occurs in Raffet's picture of the typhus outbreak of the French republican army in Mainz (see Figure 8), would only depress us, but the ray of life emerging from the divine freedom of spirit makes [319] it possible to overcome pestilence and deathly pain.

Thus painters have rendered the Jews in the desert, as in the grip of illness they look upon the brazen serpent that Moses set up for their cure at Jehovah's command. Here illness is punishment of their complaining against God and Moses, just as the healing

[199] This is an obscure passage: Rosenkranz may be saying that (eternal) life is the firm unchanging principle visible in death, regarded morally or religiously, as opposed to the pathos and process of dying (see the discussion of Lessing above).

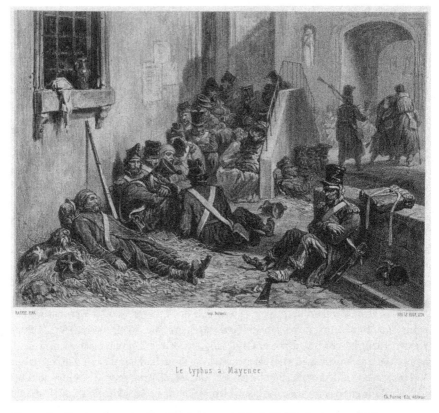

Le typhus à Mayence

Figure 8 Eugène Leroux after Denis-August-Marie Raffet, *Le typhus à Mayence*, lithograph, second quarter of the nineteenth century, Wellcome Library, London.

from the bite of the fiery snake is reward for their repentance. In the picture of Rubens showing St. Rochus healing the pestilent, the passage from death to life is the poetry that frees the terror of the hideous illness from disgust. A fine picture in this sphere is that of [Jean-Antoine] Gros, *Napoleon among the pestiferous at Jaffa*. How gruesome are these patients with their boils, with their livid colour, with the green-blue and violet skin tints, with the drily burning gaze, with the distorted features of desperation! But they are men, warriors, French: they are the soldiers of Bonaparte. He, their soul, appears among them, fears not the danger of the most malicious, horrifying death; he shares it, as in battle he shared with them the rain of bullets. This thought delights the good. The dull, muffled heads are raised; the half-extinguished or feverishly glittering eyes turn to him, the limp arms stretch enthusiastically toward him, and after this treat, a blissful smile plays on the lips of the dying—and right among these forms of horror, the giant human being[200] Bonaparte stands straight, full of compassion, and lays his

[200] Rosenkranz must mean this metaphorically, for Gros places Napoleon among giants.

hand on the boil of one of the ill, who has arisen half-naked before him. And how beautifully Gros has painted, that one looks out of the vault arches of the lazar-house upon a landscape, that one has city and mountain and sky to relieve the view of the humidity of the sickbed. Similarly [320] at the end of *Hamlet*, as the poisoned corpses of a house fallen into decay lay twisted all about, Shakespeare lets the forceful trumpet blast and the young, cheerful, pure Fortinbras step forth as the beginning of a new life. Lazar-houses wherein only the wounded lie lack the disgust of such scenes and are thus often painted without any offence.

Vomiting too has been mentioned earlier. Whether it is an innocent pathological affection or the result of gluttony, it is always most disgusting. Painting can suggest it through mere position, although Holbein in his *Dance of Death* did not scruple to let the gourmand discharge right in front of the feasting table.[201] In their fairground and tavern scenes, the Dutch have also not been stupid about it. The permissibility of such repulsive features depends very much on the other aspects of the composition and the style in which it is carried out, for even a humorous turn is possible, as in Hogarth's *Punch Party* [*A Midnight Modern Conversation*, 1733][202] or in that painting on a Greek vase wherein Homer, stretched on an upholstered bed, vomits into a vessel set on the floor. A female form, poetry, holds his godly head. Around the vessel there is a multitude of dwarfish figures, who eagerly ingest what has been vomited. They are the later Greek poets, who nourish themselves from the cynically thrown away excess of the great poet. Yet another Apotheosis of Homer (* NOTE 68)! But if poetry goes so far as not only to tell the tale of vomiting but to bring it onstage, this is an overstepping of aesthetic bounds, which cannot [321] even function comically. This Hebbel has overlooked in his *Diamant* [Diamond]. The Jew who has swallowed it vomits it out again onstage, and does not simply vomit it out, but even sticks his finger in his throat for this purpose. That is too repulsive! Birth as a necessary act of nature does not have this offensiveness, even when, as in Hans Sachs' *Narrenschneiden* [1534] and in [Robert Eduard] Prutz's *Politische Wochenstube* [Political Nursery, 1845], it is given a comic turn.

The disgusting also becomes aesthetically impossible when it is mixed with the *unnatural*. Bored epochs of nations as well as individuals tickle limp nerves with the most intense and thus not seldom also the most disgusting means of stimulation. How hideous is the newest fashionable entertainment of London's leisure class, rat baiting![203] Can one conceive anything more disgusting than a mass of rats defending itself in deadly fear against a bestial dog? Surely, some will say, the bettors who stand around the brick-lined pit with watch in hand. Only Pückler Muskau, in his first, immortal *Briefe eines Verstorbenen* [Letters of a Deceased Man] tells of something more disgusting,

[201] This is not among Holbein's 49 *Totentanz* illustrations, and indeed does not quite fit the rationale of the genre, which show the deaths of persons of various classes, careers, and age groups, not of particular sinners. Rosenkranz may be recalling Holbein's King or Rich Man, both of whom sit at tables, the one set for feasting, the other displaying gold.

[202] On punch parties and their objects, see the interesting recent article by Karen Harvey, 'Ritual Encounters: Punch Parties and Masculinity in the Eighteenth Century', *Past & Present* 214:1 (2012), 165–203.

[203] A fashion arising in part as a result of the Cruelty to Animals Act of 1835, which imposed fines on traditional entertainments like bear-baiting and cockfighting.

namely how in Paris on the Boulevard Montparnasse he saw the philistine petty bourgeois shooting at a rat they had tied to a crooked board, so that it ran back and forth desperately in the narrow space. To shoot at a rat for pleasure! Infernally disgusting. Petronius has a certain grandiose nakedness, a certain roughness akin to Juvenal's, which gives his representations of bored depravity a sombre charm. A scene in his Feast of Trimalchio [the middle portion of the *Satyricon*] renders to an extent symbolically the deepest falsity[204] of [322] such a world. A living pig is first shown to the guests, then after a short time served. But it has not been disembowelled. Furious, the host has the cook appear, and asks him to lay his head at his guests' feet for such forgetfulness, for such insult. At a gesture from the host the cook undertakes the disembowelment, and: what are these disgusting intestines? One discovers in them the most exquisite sausages, which however were kept in the form of natural intestines. All are enthused. The host is complimented on having such a cook, and the cook gets to keep not only his life, but is presented with a silver crown and a bowl of Corinthian iron. Make the pig's intestines to delicacies and you will be a great man for such disgusting times. A Paetus[205] it will execute, but you it will crown with laurel (* NOTE 69)!—The cynicism of sexual relations opens up between nature and decided unnature a further playing field for disgusting lustfulness, which we do not want to get into here (* NOTE 70). Humour itself, though it may push the same phenomenon into burlesque through the use of ribaldry, cannot eliminate the ugliness in it. We count here for instance the in itself very funny scene in Aristophanes' *Lysistrata* wherein Myrrhine heightens the desires of Kineas to the utmost and then lets him hang (* NOTE 71). Should age be added to such situations and sensations, repulsiveness rises. Horace has rendered them in the eighth ode of his *Epodes* (* NOTE 72). Unnature as the perversion of natural law through independence or better insolence of human will is thoroughly disgusting. The sodomizing, the pederasty, the wanton [323] refined modes of copulation (among the ancients, for instance, ἅρμα, [*árma* [union, love], φιλότης [*philotes* friendship, sexual love]), and so on, are hideous. The pornographers also represented erotic scenes called *libidines* or *spinthria* and about which one may read in the learned-elegant explanations of Raoul Rochette to the *Musée secret* of Herculaneum and Pompeii by Ainé and Barré (Paris, 1840). According to the report of Pliny, for instance, Tiberius bought for an outrageous sum a painting of Parrhasius to hang in his bedroom. This picture represented Atalanta as she is going about Meleager in disgusting, obscene ways with her mouth. To see a parody there, as Panofka does (* NOTE 73), seems to us awkward.

c) *Evil*

The tasteless is the theoretically hideous; the disgusting is the sensibly hideous, which however, as we have recognized, in its unnatural extremes already hangs together with

[204] *Ungeist*, according to the Grimms a Romantic neologism used to decry inauthenticity. Cf. Note 197.

[205] Among the many Roman politicians with this name, the relevant Paetus is Aulus Caecina, participant in a conspiracy against Emperor Claudius, who was executed in 42 C.E. His wife Arria famously insisted on dying with him, uttering the brave last words 'Paete, non dolet', an anecdote recounted by Pliny the Younger and beloved of neoclassical art.

the practically hideous, with evil. The evil will is the ethically ugly. As will for itself it falls within pure inwardness. To become aesthetically possible, it must in part reflect itself symbolically from the inside out in the ugliness of form, in part it must out itself in an act and become crime. Homer already rendered Thersites thus, by giving his quarrelsome nature a conforming shape. The *Iliad*, Book II, 214 reads [in Voß's edition]:

> Always perversely, against order, at odds with the princes,
> Where something appeared to him ridiculous among the Argives
> The ugliest man before Ilion, he was come
> Squinty was he, and lame in the one foot, and the shoulders [**324**]
> Humped, against the narrow chest, and above there rose
> A pointed head, the crown sown with this wool.
> Repulsive he was above all to the son of Peleus and Odysseus.

For our investigation we have to put the aesthetic standpoint before the ethical. One should not thus await here a treatise on the concept of evil; this belongs to ethics; aesthetics has to assume it, busying itself with the form of the phenomenon, insofar as the same is capable of expressing morally ugly content in an adequate manner that is also compatible with the laws of beauty. Here the concepts of the *criminal,* the *ghastly*, and the *diabolical* are relevant. The criminal is namely the empirically objective reality of evil will. But this reality is, compared with the idea of the will as something good, at the same time the unreality of its concept. Real as a phenomenon, its essence is the nothing of a non-essence. The certainty of this nullity in the acting person is his evil conscience. From the guilt of evil one cannot separate the consciousness of having brought about through the positive injury of the idea of the good something that is void in itself, and this appearance-being of evil in itself is the ghastly. The criminal's imagination creates from his guilt the image[206] of an uncanny, otherworldly, dark, vengeful being. Finally, if the will knows itself as evil in principle, behaving as the creator of a world of nothing and taking its repulsive pleasure therein, it thus becomes diabolical. Such a will is in its negativity demonic, and this demonic quality is in its appearance the ghastly. [**325**]

α) *The Criminal*

That in its deepest ground the beautiful is one with the good is not just an idiosyncrasy of the flowery Plato, but rather the full truth. It is just as true that ugliness in and for itself is identical with evil, namely insofar as evil is the radical, the absolute, the ethically and religiously ugly. If one however stretches this identity so far that the cause of the ugly in general is supposed to lie in evil, that is an overloading of its concept, which inevitably must lead to untrue and violent abstractions; for as it was shown in the introduction, ugliness can arise in many other ways out of the freedom of being generally. One confuses ugliness as such with the maximum of its appearance, which in any case can first be brought about through evil, since this is the deepest contradiction

[206] Both 'imagination' and 'image' in this sentence translate the German word *Vorstellung*, but the first refers to the faculty of imagining, the second to its product.

of the idea with itself. Evil as the primordial lie of spirit can be interesting for fantasy and common sense, but will necessarily, even in this form, cause the deepest revulsion. The evil will gives itself an objective existence through the evil act, whose groundless arbitrariness breaks through the absolute necessity of freedom, for whose sake the whole universe is there. Crime cannot scrape from itself its correlation with necessary freedom, for it is only crime through its self-conscious rebellion against the same. Through this correlation it becomes possible as an aesthetic object, for with it its immanent opposite, true freedom, must also be brought out, revealing the hollowness and lying nature of crime. This correlation also justifies [326] the demand so often repeated since Schiller that crime, in order to become possible aesthetically, must be great, because it then requires courage, cunning, cleverness, force, persistence in more than usual measure and thus at least contains the formal side of freedom.

The concepts sketched here have been treated so often since Aristotle's *Poetics*, and lately so amply by Vischer, that probably no point of our theme has been worked out to the same degree and is so familiar to the general reader. We will thus restrict ourselves here to a few observations.

With reference to content, all those crimes are incapable of being aesthetic objects which due to their everydayness and triviality and due to the small expenditure of intelligence and will required to commit them fall into the category of the meanness of the common. The petty egoism that drives them and only feeds the files of the police and the correctional court is too subordinate to deserve to occupy art. Its crimes are often hardly to be called deeds, so often do they arise from a circle of crudeness and lack of education, of laziness and need, of limitation and rascality become habitual.

Accessorily, in connection with higher motives, as episode, as side member in a larger chain of events, the common crime becomes aesthetically possible, because it then appears in a wider context as a moment in the history of morals. Hate, vengefulness, envy, addiction to gambling, ambition, are already more aesthetic than theft, forgery, fraud, coarse incontinence, even than murder for no purpose than to have and to enjoy. [327] They thus take an enormous space in epic and dramatic entertainment. Crime in itself is naturally worthy of execration, only that through cultural-historical, psychological and ethical intertwining in which it appears, it gets from us a higher interest. The English have been the masters in this genre since time immemorial. Already in their old ballads we meet the criminalistic aspect. The theatre before and after Shakespeare's time is crawling with such dramas, among which even some whose authors are unknown, such as the tragedy *Arden of Feversham* (* NOTE 74).[207] Later on the novel took on this mission among them, and the foremost authors have not deemed it below them to work in a genre that has been hardly touched by our classics. [Edward] Bulwer[-Lytton]'s *Paul Clifford, Eugene Aram, Night and Morning*, and so on, or Boz' [that is, Dickens'] *Oliver Twist*, are such material. In *Pelham*, Bulwer has rendered the most fashionable aristocracy, but also the most extreme depravity of systematic theft

[207] The play, in which an Agamemnon-like husband is murdered by ruffians hired by his wife and lover, based on a real sixteenth-century case, was first printed in 1592, and has been variously attributed, e.g., to Shakespeare, Christopher Marlowe, and Thomas Kydd.

and robbery in expansive dimensions. After the English, the French have come to such motifs since the July Revolution. The brilliant tyranny and the court conspiracy, love and licentiousness as fine gallantry as well as orgy, were until then its favoured themes. First with the consciousness of the world-historical entrance of the proletariat has the tendency to poetizing treatment of crime developed in them as well, with accelerated pace, and indeed, in accordance to their social nature, first in the drama and then in the novel. Casimir Delavigne, Alfred de Vigny, Alexandre Dumas, Victor Hugo and Eugène Sue [**328**] have become the classics of this tendency, to which however a great mass of dramatists of the second and third rank affiliates itself, which works for the boulevard theatre, especially for those of the Porte St. Martin and Ambigu comique: Dumanoir, Pyat, Melesville, and others. *D'Arlington, Le docteur noir, Le pacte de Famine, Marie Jeanne, Le marché de Londres, Le chiffonier, Les deux forçats on le Moulin de St. Alderon, Marie Lafarge, La chambre ardente, L'homme en masque de fer*, and so on, are this kind of horror pieces, wherein the most lurid contrasts test the nerves of the public for hours at a time. Hardship up to starvation, casual crime, but also out of the most coldblooded calculation, false play, double-cross, murder in all its forms including poisoning and self-murder, debauchery, cruelty, child abduction, incest, adultery, betrayal, atrocities of the most brutal disposition are represented in these dramas, which have been largely incorporated into the German repertory as well. In that the Germans however have not wanted to leave the *horreurs* of evil-doing[208] in their full French nakedness, adaptation has given rise to far more fatal products, for the infernal motivation of the sinister plots, which in German are abbreviated if not suppressed altogether, gives them a more psychological justification, and the extremity of infamies one gazes upon first gains an interest through the entirely wretched, original way it is carried out. The so-called social novel of today's French, which under the July Monarchy has brought forth so many poisonous flowers: we have had to touch upon it from so many side and so often, that we may just mention it here. [**329**] The most frightful product of this sphere, *Le nom de Famille* [The Name of the Family; Brussels: Jamar, 1842] of Auguste Luchet, is fortunately, as far as we know, not translated into German. The childish greed of the Germans (which over the last decade has descended into what for a large nation must be regarded as a scandalous competitiveness) to translate English and French novels while they are still appearing[209] and before a judgement of ethical and aesthetic worth is possible, might explain the weakness we ourselves show in this domain. Only in knight and robber novels do we ourselves commit the most offensive crimes with a certain naïve originality, which is however too tasteless to excite the interest of the French and English and make them want to translate us (* NOTE 75).

If we leave behind the sphere of bourgeois society, crime may become more aesthetic through motives taken from the higher spheres of religion and the state, for with such a rationale the individual is torn out of the insular circle of petty egoistic drives and subordinate contingencies. The crimes committed are materially the same as those of the bourgeois sphere: betrayal, adultery, violence, murder. Only, insofar as they have

[208] Rosenkranz self-consciously uses here the French term *forfaits*.
[209] It should be kept in mind that long fiction was then routinely published in serial form.

their origin in more general conditions, they win for themselves the right of a certain necessity, and our participation [i.e., interest] increases insofar as large changes of the state and society are directly linked to the lives of distinguished and especially aristocratic personalities. Through the involvement of great powers conflicts become possible that make the individual guilty, while at the same time he is not [330] guilty in the sense of the common criminal. Here three cases are possible. First, the crime may not be committed as a crime; there is guilt, but only in the sense that it was committed, not in the sense that it was carried out as a crime. Second, the crime may be committed in full consciousness that it is vicious. Third, guilt can consist in innocence being sacrificed to brutality. For the first case a well-known example is the Sophoclean *Oedipus*, for the second, Shakespeare's *Richard III*, for the third Lessing's *Emilia Galotti*.[210] We have thus arrived at the tragic, whose essence does not require a particular explication here. Crime becomes aesthetically possible in the first case because, though it is a *work* of the freedom of the individual, it is not really an *act*. It is brought to fruition really by the necessity of the pragmatic causal nexus, and precisely this takes from the crime its personal ugliness. In the second case, the crime becomes aesthetically possible through the exact opposite, namely through its perfectly conscious freedom. Naturally, evil can only awake revulsion in us through the content of its doings; but through the form of its action we see freedom from its formal side, namely as self-determination, at the peak of its virtuosity. That such a villain, in the entire complex of the circumstances, may even become an organ of divine justice through his intrinsically unjust actions does not make him aesthetically more tolerable. But his extraordinary intelligence and the gigantic strength of his will make a demonic impression, for the virtuosity of subjective [331] freedom in contrast with its negative content allows us to judge here, as Christ does regarding the unjust steward, that in itself it would be worthy of imitation.[211] In the third case, the cancelling out of ugliness in crime is effected by the fact that purity, virtue, and innocence are its victims. The ugliness of crime appears here the more horrible the more vainly it storms the freedom of innocence. The victorious self-certainty of the latter, even in its final demise, is what allows us to exhale freely when facing crime. Tragedy in this case excludes from its purview some things that are permissible in epic, because the latter can take on the whole breadth of mediation, while the drama must go to work in epitomizing and epigrammatic fashion. Let us clarify this through an example as well. Shelley has shown in his *Cenci* a rare art for representing a highly despicable material with a poetic air, only, it remains unsuitable for the drama. The old Cenci, the tyrant of his own, hears at a banquet of the death of two of his sons and publicly thanks heaven for it. All draw away appalled. He decided to violate his daughter Beatrice, in order to corrupt her body and soul. Beatrice and her

[210] In the 1772 tragedy, the angelic title character has her father stab her rather than endure the attentions of the tyrannical Prince Gonzaga, who had had her fiancé murdered.

[211] The parable of the unjust steward (Luke 16:1–9), who offers discounts to get debts to his master paid back, is very puzzling, as it is followed by the passage contrasting God and mammon (wealth) as two masters who cannot both be served. Protestants, following Luther, tend to see in the parable approval of practical wisdom, consistent with faith.

brother Giacomo, in league with their stepmother Lucretia, have bandits kill him. The murder is discovered and the guilty are executed. This is in few words the main content of that well-known grisly story. This material is not suited for drama, not only due to its unnaturalness, because the diabolical father wants to violate the daughter, but also because only a recounting can set forth all the hideous minor circumstances that [332] make the whole situation of these unhappy people an absolutely exceptional one; those of the tortures, with which the old Francesco martyred his own, putting them into a hell without equal; those that led to the discovery and led the Pope, despite the appeal of so many distinguished Romans, to confirm the death sentence for Beatrice, Lucretia and Giacomo. Shelley has had to content himself with suggestion on all these points, making the third act, which motivates Beatrice's decision to murder her father, into a very embarrassing affair. For the same reason painting may not bring to our sight certain crimes that remain possible in epic delivery. The ancients praised the painter Timomachos for painting Ajax after the blood frenzy of his madness, and Medea *before* the murder of her children, as one of the Herculanean paintings also portrays her. The children sit at a table playing dice under the care of the pedagogue, while she gazes darkly, struggling with herself, standing aside, jerking the fateful sword into her hands. If it be granted to the painter to represent a series of scenes that help explain one another, a certain kind of epic thus becomes possible to him, as in Schinkel's frescoes carried out by Cornelius in the atrium of the old Berliner Museum or in Hogarth's picture of the idle and the industrious prentice. This is a genre-pictorial novel, wherein we understand the individual moments through their context. Hogarth, after his manner of carrying the characteristic to extremes, has omitted nothing on the side of the lazy [333] apprentice, and has painted the misery of the criminal in the most naked colours, as for instance in that scene, where the lazy boy lies in bed with a whore in a dirty attic room, a chamber pot standing amidst the remains of a meal, a cat jumping down from the chimney after a rat who flits by the bed so that the lazy boy is startled, while the whore regards the stolen earrings with obtuse glee.

Typically when aesthetics books get around to the concept of the tragic, only tragedy is discussed, but it is right that its epic representation, which has taken on such large dimensions in the ballad and the novel, be attended to as well. Even so, in the tragic one customarily finds a certain circuit of the frightful, whereas the latter is incomparably larger and more many-sided. With regard to the criminal, we first distinguished the mean and plainly prosaic, from which even through the most careful psychology there is hardly any interest to extract, as [Berthold] Auerbach has tried in his new *Dorfgeschichten* [Village Stories; Mannheim: Bassermann, 1848]. Second, we distinguished the form of crime emerging from the extrications of bourgeois society, from the passions of egoism. Third, there is tragic crime, namely that which in public conditions of society, the state and the church gains a certain justification, which we cannot deny to a Richard III or Macbeth. The deeper a crime is fused with the great interests of society, the state, and the church, the more terrible indeed it will be in its consequences, which affect thousands, only, the more ideal too it will be, losing through this pathos [334] some of its ugliness. It seems less the intention of a limited egoism, more the work of an error that has forced itself out of the circumstances of the heroes,

as in the case of Fiesco, Wallenstein, Macbeth, Pugachev, and so on.[212] Taken materially, the crimes of high tragedy are the same as in the sphere of the common bourgeois tragedy; there is also robbery, murder, adultery, betrayal. Why then do they appear noble? Or, if this expression should say too much, in any case distinguished? Why is the theft of a crown something else than the theft of a pair of silver spoons? On no other grounds, obviously, than that the nature of the objects makes necessary a whole other pathos, and, involving a struggle of life and death, brings us into relations that we would not have in the case of petty private passions.

That which is immoral in crime cannot be turned into humour, unless one abstracts away from its ethical significance and its happening is represented from other points of view. Only the intellectual element must be emphasized, as for instance the lie occurs as the exaggeration of an uncontrolled fantasy, as a white lie, as waggishness and jest, for in this case the gravity of the ethical element has been removed in advance and we delight in it solely from the side of the understanding. The soldierly braggart, as he is found in Plautus and Terence, commits no crime, when he as an intrinsically harmless subject amuses us with the clumsy inventions of his boasting, which do themselves in through their contradictions. The lie is and remains amoral, but as [335] an innocuous farce, as it appears in the case of a Falstaff, a Münchhausen and similar figures, it becomes ridiculous. [Roderich] Benedix has very successfully based a comedy, *Das Lügen* [Lying, 1852], on the situation that a very truth-loving man, who catches his wife in a few small lies after female fashion, finally out of pure caprice tries out lying himself for once, and brings forth a seemingly indifferent untruth. But this nothing, namely having ridden into a little wood one evening on a white horse, brings the roughest consequences in its train, so that there is even an attempt to imprison him. Finally he insists that he has simply invented that ride, only, since everyone knew him as the strictest friend of the truth, no one wishes to believe him at first that he had really lied this time. If someone lies through a penchant for carelessness, without wishing to harm others, as in [Friedrich] Schmidt's comedy *Der leichtsinninge Lügner* [The careless liar; Stuttgart and Tübingen: Cotta, 1813], the lie appears more as a natural product than as a moral offence. It becomes what we call a flaw of temperament.—Betrayal, to become humorous, must be handled like the lie, being only a waggish traitorousness. The intrigue plays a deception in order to catch weakness and vanity, false self-certainty and hypocrisy in their own nets. When Madame Orgon hides her husband under the table and appears receptive to the insistent declarations of the hypocritical Tartuffe in order to convince her spouse of the infamy of the falsely pious, we are gratified ethically and aesthetically by this exposure. Old tutors, who for the sake of the inheritance [336] want to force their young and beautiful nieces to marry, like Doctor Bartolo in the *Barber of Seville*, deserve like him to be duped, and we sympathize right away, in opposition to the greedy old character, with all the cunning that brings his vile plottings to grief.—Adultery, as real adultery, allows no comic handling, only a tragic

[212] All rebels who had classic pieces of literature written of their adventures: by Schiller for Genoese conspirator Fieschi (1522–47: *Fiesco*, 1783) and Thirty Years' War general Wallenstein (three plays, 1798–9), by Pushkin for Cossack pretender Pugachev (1742–1775).

one (* NOTE 76). In myriad medieval stories, French contes, Italian novellas (* NOTE 77), and German drolleries, adultery is only represented from the side of common sense, namely of the overcoming of the obstacles faced by the lovers. The moral moment is entirely ignored, and through such abstraction in any case makes a certain comic possible. Kotzebue has indeed in his play *Menschenhaß und Reue* [Misanthropy and remorse; Berlin: Himburg, 1790] represented adultery in a way that is not tragic and also not comic. Namely, it is, as in the empirical way of the world, forgiven— because of the children. Meinau and Eulalie see each other again after four years. Their coming together ends with the distressing decision of a renewed separation. Just then hurry the children, these real heroes of Kotzebue—and keep mother and father together. Kotzebue has thus only expressed a very sad, but very ordinary fact, namely that many marriages, hollow on the inside, would collapse on the outside as well, but for the thought of poisoning the children's filial piety with the public admission of guilt, which keeps the parents in tolerable apparent harmony. This motivation for breaking the barb of tragic resignation is indubitably why this play has enjoyed such unprecedented success throughout Europe, and among the ladies even brought into fashion the Eulalie-hats. [**337**]

Murder finally can only appear funny in parody. It is exaggerated to a farcical play, as we have recently heard it sung in so many gruesome, ghastly murder ballads in the Munich *Fliegende Blätter*, in the *Musenklängen aus Deutschlands Leierkasten* [Sounds of the Muses out of Germany's Lyre-Boxes], in the Düsseldorf *Monatshefte*, and so on. If the word were not too good for them, one could call them tragicomic.

β) The Ghastly [213]

Life dreads its nature after death. The dead has already been handled above. It becomes the ghastly when, against its nature, it appears again as the living. The contradiction, that the dead should nevertheless be living, constitutes the horror found in the fear of ghosts. Dead life as such is not ghastly. We can keep watch over a corpse unaffected. Should, however, a gust of wind move the sheet, or the flickering of a torch make his features uncertain, thus would the mere thought of life in the deceased, which otherwise could be very comfortable for us, have at first something very ghastly in itself. With death, this world is closed for us; the opening of the beyond through a being that has already died has the character of a terrible anomaly. The deceased, belonging to the beyond, seems to obey laws we do not know. With the revulsion before the deceased as a being that has fallen into decay, with the reverence before the dead as a consecrated being, the absolute mystery of the future mixes itself. We have to hold apart for our aesthetic purposes the idea of *shade* and *ghost*, [**338**] as the Romans distinguished

[213] *Das Gespenstische* is literally 'the ghostly', but this puts us in the awkward predicament of having to use as a term of ugliness a word that in English is rather used to modify beauty. There is such an element in Rosenkranz too (see the long Goethe quote), but we have chosen a term that is univocally negative in English while retaining a conceptual link to ghosts. 'Spooky' and 'ghoulish' were not available, as they crop up in the text.

lemurs and larvae.[214] The image of *ghosts*,[215] which originally belong to another order of beings, indeed has something extraordinary, even daunting, in itself, but nothing ghastly. Demons, angels, kobolds are what they are innately, they do not become so through death. They stand over the shade. Between the ghost and the living stands the strange idea of vampirism. The *vampire* is imagined as a dead person who leaves the grave for a time in the appearance of full liveliness, seizing young, warm life and sucking out its blood. The vampire is already dead, and yet lusts, against the essence of death, after nourishment, indeed after flourishing life itself. Through Goethe's *Braut von Korinth* [Bride of Corinth], through Byron's story and Marschner's opera *The Vampire*, this grave fantasy has become sufficiently well known among us as well. As legend, it corresponds among the Greek and Serbian peoples to that of the werewolf (*loups garoux*) among the Romance. In the tales of the *Thousand and One Nights* there appears also the idea of persons who take pleasure in eating corpses, that is, to satiate life with the decay of the dead, the so-called *ghouls*. These Oriental Lamias[216] are even more repulsive than the vampires, because even less natural.

The dead as simple shade can make in its appearance an impression of strangeness, but by no means need it be ugly. It can retain essentially the same form it had in life, only somewhat blurring into paleness and colourlessness. In the *Persians*, Aeschylus has the [339] shade of Darius brought forth from the underworld by the lamentations of the chorus, and as he appears before it and Atossa, the poet lets the chorus (verse 690) say only:

> I am seized with dread before the sight,
> I am seized with dread by the salutation,
> O you old honourable king!

The chorus, however, does not make it known through any word that in the apparition as such there is anything repulsive. The same is the case with the shades in the *Odyssey*, which come from Hades to crowd round the sacrificial pit of Odysseus. So it is with the shade of Samuel, whom the witch (literally necromancer: *Todtenbeschwörerin*) of Endor presents to Saul. In the observation on *Der Tänzerin Grab* [The Dancer's Grave] (*Werke*, vol.44, 194ff.), which is very important for our purpose, Goethe treated the essence of the shadowy and the lemur-like so splendidly that we cannot resist quoting the following. There are [on the grave] three pictures, a cyclical trilogy. 'The ingenious girl appears in all three, and indeed in the first, inspiring the guests of a prosperous man to delight in

[214] It is not clear if these terms for malevolent ghosts were in fact distinguished strictly by the Romans: Augustine in any case discusses both in *City of God*; Linnaeus expressly named the lemur family in accordance with the supposedly slow movements of the *lemures*, not their facial decorations, which might better match the mask-like *larvae*.

[215] *Geister* means both spirits in a general sense, as Rosenkranz explains it in the next sentence, and ghosts in the vulgar sense (it also means, applied to living things, minds).

[216] In Greek mythology (Aristophanes' *Wasps, Peace*, Diodorus Siculus) a lover of Zeus and queen of Libya who, through Hera's ill will (she either killed or stole her children, all except Scylla) became a mad child-eating monster. The word became generic for female vampires or witches, but John Keats' 1820 poem brought the original back into fashion.

life; the second show how in Tartarus, in the region of decay and half-destruction, she pitifully continues with her art; the third shows her to us apparently revived, having reached that eternal shadow-bliss.' The first panel represents the dancer at a banquet in the role of a bacchante, provoking the admiration of every age group. The second picture catches her in the passage from the upper- to the underworld. If in the first [picture] the artist appeared to us rich and lively, sumptuous, mobile, graceful, wave-like and fluent, here we see her in the sad lemurian empire, the opposite of all that. [340] She indeed stands on one foot, but she presses the other one against the thigh of the first, as if it sought support. The left hand rests on the waist, as if it did not have in itself sufficient strength; one finds here the unaesthetic cross-form, the limbs go in zigzags, and to the curious expression even the upraised right arm is forced to contribute, which otherwise sets itself in motion for what would have been a graceful position. The supporting leg, the resting arm, the closed knee, all gives the expression of the stationary, of the mobile-immobile: a true picture of the sad lemur, to whom enough muscles and sinews remain that it can move itself pitifully, so that she does not quite appear as a transparent skeleton and then collapse. But even in this repulsive condition the artist must continue to work on her present public in an enlivening, attractive, ingenious manner. The desire of the crowd that rushes by, the applause granted her by those quietly watching, are symbolized here deliciously in two half-ghosts. Each figure for itself, as well as all three together compose wonderfully and work in a sense as one expression.—But what is this sense, what is this expression? The divine art, which knows how to ennoble and to raise up everything, is not able to reject even the repulsive and the abominable. Precisely here it wishes to exercise forcefully its monarchic right; but it has only one means to achieve this: *it cannot become master of the ugly, unless it handles it comically;* as indeed Zeuxis is supposed to have laughed to death over his ugly Hecuba.—If one dresses this current lemurian monstrosity with female, [341] youthful musculature—one will see one of the comic postures with which Harlequin and Colombine have always been able to delight us. If one proceeds the same way with the two side figures, one will find that here the rabble is meant, which is most drawn to such performances.

I hope I may be forgiven for having become more long-winded here than perhaps necessary; but not everyone would grant me, on a first look, this antique stroke of humoristic genius, whose magic establishes a *lemurian farce* between a human play and a spiritual tragedy, a grotesque between the beautiful and the sublime. Nevertheless I admit gladly that I do not easily find something more worthy of admiration than the aesthetic juxtaposition of these three states, which contain all that man can know, feel, imagine, and believe about his present and future.

The last picture, like the first, speaks for itself. Charon has brought the artist into the land of shades, and he already looks back to see who might stand there waiting to be picked up next. A deity that is partial to the dead, who thus protects them also in that realm of forgetting, looks with pleasure on an unrolled parchment, whereon might be listed the roles in which the artist was admired during her life.[217]—Cerberus is silent in

[217] Rosenkranz combines two paragraphs, omitting the last sentence of one and the first of the next: 'for as one made monuments for poets, which beside their form listed the names of their tragedies, should the practical artist not enjoy such advantage? / But especially this artist, who like Orion with his hunts, here takes up and completes her performances.'

her presence, she finds already new admirers, perhaps even former ones who preceded her to these hidden regions. Just as little does she lack a servant; here too one follows her, continuing her former functions, and holding the shawl[218] for her mistress. [342] These surroundings are grouped and disposed in wonderfully beautiful and significant ways, and yet they make, as on the previous panels, the frame into the real picture, to which shape here as everywhere forms itself decisively. Forcible it appears here, in a maenad's movement, which may well be the last, with which such a Bacchic representation could close, for beyond it is only distortion. The artist seems amidst the enthusiasm of her art, which animates her here as well, to feel the difference between her current state and that which she has left. The position and expression are tragic, and she might as well be presenting here a despairing being as one powerfully inspired by God. If in the first picture she seemed to tease the spectator through an intentional turning away, here she is really absent; her admirers stand before her, applaud her, but she pays them no mind, withdrawn wholly from the external world, thrown deeply into herself. And so she closes her performance with a truly pagan tragic conviction, which despite being silent is as pantomime more than clear enough, and which she shares with Achilles in the *Odyssey*, that it is better to carry an artist's shawl as servant among the living, than to count as the most splendid among the dead.' (* NOTE 77b)

The shade is, as its name already tells us, intangible. It is indeed visible and audible, only not to be touched and therefore undeterred by material boundaries. It comes and goes—everywhere—and is, in terms of time, hardly bound to the favourable dark of the night. The dismally painted imagination sees the grave-like mirrored in it, as the ballads especially love [343] skeletons and burial shrouds, but at times, as for instance in Bürger's *Lenore*, the shade is allowed to appear also in the form of a full reality. The non-colours black, white, grey are among all peoples the colours of the shadow world, for all real colours belong to life, to the day and the world. The shade turns to ghost, *larva*, when an ethical context still connects it with this world, and thus in the interest of history calls it back from the beyond, where it should find peace, into the bustle of ours. Absolute, free rest, bliss, can only be found by a spirit that has overcome history. If a person has not yet lived out his history,[219] fantasy lets him return from his grave to carry out the finale of its drama in the upper world. It does not save the conclusion of the remains of his history for the indefinite time of a general last judgement, but resolves it here already in the form of poetic justice. The deceased then has done something or had something done to him, which as something begun must be concluded, or else guilt must be atoned. Externally, death has torn him out of a historical context, but the unity of inner necessity does not let go of him and he reappears, seeking his right, his atonement. At night, when sleep befalls the living, he creeps from the earth's bosom, which cannot yet keep forever one who has not been justified; he approaches the beds of the dreaming, the half-awake. He shows the spouse or the son his bleeding wounds, cut into him far from them by vicious hands; he disturbs the

[218] Twice in this text, Rosenkranz oddly misspells Goethe's Anglicism 'Shawl' 'Shwal'.
[219] Throughout this passage Rosenkranz plays both on history and story, for which German has one word, *Geschichte*. Historical context is thus also the context of a story.

murderer himself through the agony of his gaze; he demands [**344**] that his own avenge him for the infamy committed; he waves, wishing to be followed to places where he has left for the living important proofs or treasures; or he reveals crimes he committed secretly and pleads to be absolved of his guilt, or that one helps in his atonement. For the deceased is already bodiless and powerless, and fearing light he cannot anymore intervene in reality by light of day; he can only stand, conjure, direct, so that justice and love of the living for him do not wither away. Fully silent the spirit of the deceased can show to the living his guilt, as does Banquo's shade in sitting down at Macbeth's table; or he can speak with muffled wails, as Hamlet's father does, and so forth. What then is the ghost? It is the reflex of the consciousness of guilt, the lack of peace caused by one's own rupture, that projects itself in the image of the pressing spirit, as a painter once ingeniously painted the *arrest warrant* as the double portrait of the murderer himself, whom it persecutes. The murderer flees in murky night, gigantic, the warrant hurries after him; this warrant is, however, when one looks more closely at it, the murderer himself, it is the endless reverberation of his guilt; he flees from himself and writes a warrant for himself. This ethical moment gives the ghastly an ideal consecration; in his shadowiness the weight of that necessity must be felt that rests on the eternal ground of the moral powers. In the ghost an interest must be manifested, that is above all opinion, above all ridicule and attack by the living, as the spirit of the defeated Commendatore stands so high above the flippantly sacrilegious Don Juan. [**345**]

The representation of the ghastly is thus extraordinarily difficult. Lessing, in numbers X–XII of the [*Hamburg*] *Dramaturgy*, has given the aesthetic theory of the ghastly. 'The seed for belief in ghosts lies in all of us, and most abundantly in those for whom he (the dramatic poet) composes. All that matters is his art in getting these seeds to sprout; only certain tricks, which through speed impart an élan to the grounds for believing in their reality. If he has these in his command, we may believe what we will in our ordinary life; in the theatre we must believe what he will.' Lessing compares Voltaire and Shakespeare, the former as one who misses the essence of the ghost, the latter as one who understood it aright and represented it with mastery, in which according to Lessing he is almost alone and unique. Voltaire in his *Semiramis* lets the shade of Ninus step forth from his grave in broad day amidst a congress of the estates of the empire, accompanied by a thunderbolt. 'Where did Voltaire hear that ghosts are so cocky? Every old woman could have told him that ghosts shun sunlight, and indeed do not enjoy paying visits to large companies. But Voltaire certainly knew that as well; only he was too timid, too disgusted, to use these common circumstances: he wanted to show us a ghost, but it had to be a ghost of a noble breed, and through this nobility of breeding he ruined everything. The ghost who presumes to do things that are against all convention, all good manners among ghosts, seems to me to be no proper ghost at all; and everything that does not promote the illusion damages the illusion here.' Lessing confines himself to a comparison [**346**] of Ninus with Hamlet's father. He makes the fine observation that the ghost of the latter does not really have its effect of itself, but through the way Hamlet expresses the effect of the apparition on himself.[220]

[220] This is strikingly like Lessing's account of the successful depiction of beauty in poetry: we feel it in the poet's description of its effects on others (*Laokoon*, section XXII).

The ghost of Ninus has the purpose of preventing incest and exercising revenge against his murderer. He is only there as a poetic machine, to deal with the knot; Hamlet's father on the other hand is a genuinely acting person, in whose destiny we participate, and which arouses shuddering, but also compassion. Voltaire's main error according to Lessing consists in the fact that he sees in the appearance of the ghost an exception from the laws of world order, a wonder, whereas Shakespeare sees in it a perfectly natural occurrence, 'for it is surely much more decent of the wisest being that he does not need these extraordinary means, and that we think of the reward of good and the punishment of evil as caught up in the orderly chain of things.'[221] This is what we were after above with words to the effect that the necessity of the eternal moral powers is first needed to give the ghastly an ideal consecration. The spirit's own driving force must break through the usual bounds of the grave from the inside out.—But we may permit ourselves a small observation against Lessing. He has here left unnoticed the difference between shade and ghost. He did not recall that Banquo's spirit takes its place at the table in bright light, in the same poet whom he otherwise, with perfect right, calls the master in the rendering of the ghastly in all its horror. He criticizes as a clumsiness in Voltaire the appearance of a ghost before the eyes of a great multitude. [347] 'All at once, on seeing the same, all of them must express in different ways fear and horror, if the scene is not to have the frosty symmetry of a ballet. Well, then, let one train up a herd of dumb extras to this feat; and when one has achieved this as well as possible, one may consider how much this manifold expression of the same affect divides attention and draws it away from the protagonists.' And if Lessing had only thought of the spirit of Darius in Aeschylus' *Persians*? Does he not appear to the whole chorus, beside Atossa? But Darius in fact does not appear as ghost; there is no talk of any guilt between him and Atossa, it only wants to cry out to him, the great king, its immeasurable sorrow. The ghost, and here Lessing is right, can only be related to one or a few persons, for it has a definite relationship with them. Shakespeare has always observed this exclusionary relation with deep psychology. Hamlet sees the father's spirit, the mother does not. Banquo is seen by Macbeth, not by the guests. From the tent of Brutus one after the other leave; only a boy remains, but he is overpowered by sleep; Brutus is alone and now there appears to him, the murderer, at the dawn of the decisive battle, the spirit of Caesar.

Should the ethical and ethereal nature of the ghastly be handled with clumsy hands, it sinks to a lower level, the *spooky*, as it is namely beloved in the German knight- and robber-novels: Pantolino or the terrifying ghost at midnight; Don Aloyso or the unexpected apparition at the crossroads, and so on.[222] The spooky on average [348] is just as absurd in content as it is in form. It apes the living through uncanny, senseless things that coquet with the seriousness of the beyond more than really belonging to it. Our Romantic School has let the ghastly devolve primarily in this direction. The

[221] Lessing is only criticizing Voltaire in the paragraph from which this passage is quoted: Rosenkranz does not intend to give an impression of supernaturalism in Shakespeare.

[222] Rosenkranz is mangling book titles facetiously: one of them is *Pontolino der furchtbare Räuberhauptmann oder die Schrecknisse der Teufelsgrotte* [Pontolino the Terrible Robber Chief or the Terrors of the Devil's Grotto], 2 vols. (Quedlinburg: Basse, 1823).

strangest tomfoolery, the most grotesque craziness was considered genius. One could only hold on to the ethical consistently, insofar as one thought about it at all, as fatalism, and then only in a horrifying form, as for instance in Heinrich von Kleist's *Familie Schroffenstein* the chopped-off child's finger. When in the *Oresteia* Clytemnestra appears with the dagger in the wound struck by her son, the phantom shocks through its truth; when, however, as in Werner's *Februar*, one has to murder with a knife because murder has already been committed with it, that is an irrational, spooky state of affairs. This tendency has for the same reason a great preference for dolls, nutcrackers, automata, wax figures and so forth. Hoffmann's *Nutcracker* dragged a whole pile of similar spook figures after it, so that Immermann in *Münchhausen* could still interweave a satire on it in the figure of the great, swaggering Ruspoli. The more hollow and poorer in content such inventions became, the more fantastic they were taken to be. It was fortunate that through popular fantasy one found some elements already worked out in advance, wherein at least the terrifying side of the spooky was grasped more correctly and with the echo of an idea. Thus for a while through Arnim golems became fashionable, clay figures to whose foreheads one affixed pieces of paper with incantations of the spirit prince Salomon [**349**], giving them life apparent. The highest in this region has probably been contributed by Shelley's wife [Mary Wollstonecraft Shelley] in an expansive novel called *Frankenstein or the modern Prometheus*. This novel deserves to be mentioned here all the more, since it has also worked out the idea of ugliness in an interesting way. A natural scientist has completed a human automaton after prolonged effort. The great moment has come for the machine to pass over to autonomy, to see, hear, speak, and move itself. Its creator cannot endure this drama; he stumbles off to his bed and falls asleep from exhaustion despite his feverish excitement. As he finally awakes and returns to his atelier, he finds it empty. The automaton namely had really come to life and as a perfectly formed human being he has gone through the whole scale of sensations, as Condillac depicts them in his famous story of the statue turned sensitive.[223] In the moonlight, with a suit of Frankenstein's, it comes out of the room into the open air and loses itself in the solitude of the mountains, in the undergrowth of the forests, avoided by people and even by animals as a purely heterogeneous being. Although according to the intention of his creator he is not only strong but beautifully formed, living he nevertheless appears a repulsive monster (see Figure 9).

The movements of life make all its forms and features into ghastly distortions. Finally it takes an interest in the isolated family of a preacher, which it observes in secret. The need arises to express sympathy and it does this by bringing wood at night. As winter begins the benevolent monster, which solely through its [**350**] concealed eavesdropping has learnt not only to speak but also to read, is perceived, and they are horrified by him, burn down the house and move away by night. We refrain from any psychological criticism, for although Mistress Shelley applies herself at great length

[223] Etienne Bonnot de Condillac, *Traité des sensations* (Paris: De Bure, 1754), 5–6: 'Let us imagine a statue whose interior is organized like ours, animated by a spirit deprived of all idea.' The senses are then added, one by one, over the course of the treatise.

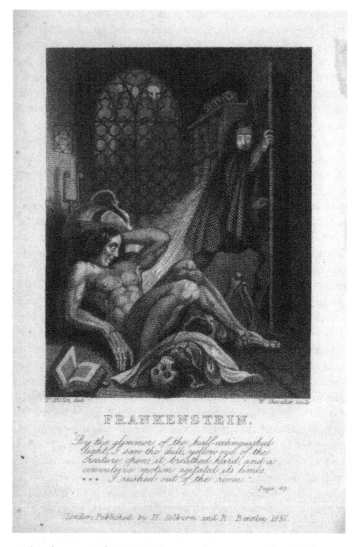

Figure 9 Theodor von Holst, Frontispiece steel engraving, Mary Shelley, *Frankenstein*, 3rd edn. (London: Colburn Bentley, 1831).

particularly to the psychology, a serious reflection on the causal nexus cannot be said to belong in a work that rests from beginning to end on a fiction and whose story has more of a symbolic character.[224] We remain silent therefore concerning other aesthetic shortcomings as well, and continue with our report. From a letter in Frankenstein's

[224] Rosenkranz here registers a deeper objection than he realizes, not just to philosophical fiction but to thought experiments generally: what conclusions about causality (say, about the turn from good to evil) can we draw from such fantastic or frankly impossible cases?

clothes, in which it escaped, the monster discovers—for why else has it learned to read?—the secret of its birth. Vengeance against his creator, who has made it so miserable, drives it to the murder of Frankenstein's son. In the mountains he meets Frankenstein by himself, drags him into a cave and forces from him the vow to create a female being suited to it by virtue of the same ugliness, or else it would murder all his loved ones. The modern Prometheus gets to work and is again close to finishing, as the terrible thought arises in him that through the female a terrible race might come into existence. Since he knows himself to be watched in his work by the secretive, creeping, spying eyes of the monster, an infinite rage breaks out in him, wherein he again destroys his creation, packs the pieces of his automaton into a basket, puts this in a boat and rows to the middle of the lake. Here he sinks his work, and although only a machine-woman, he has nevertheless the feeling of having committed a crime. In the further very [351] fantastic development, which does not belong here, the monster murders Frankenstein's lover and disappears then in the fogs of the North. This confused, femininely overinflated composition has some boldness and depth that makes it attractive. The most mature product of human technology, when it wants to rival the wondrous act of the Creator, becomes a monster precisely through the artificial life it achieves, for in its absolute isolation, naturally unrelated to any being, it feels itself deeply miserable. Just in the moment that Frankenstein approaches the triumph of his tedious work, he is shaken by his creation, flees the one time, destroys it the other. And in this destruction he is not frightened only by the consequences for his wellbeing, but he is thrilled to his core as by a murder. In this feeling the rendering of the spooky culminates here, for the spooky consists not only in the fact that the dead moves as a living thing, but primarily in the fact that dead things, broom sticks, knives, clocks, pictures, dolls come to life and, raised to a higher power still, in the fact that curious tones sound, harbouring strange mysteries that have never before been heard or spoken of; for when a certain ethical context is still there, as in Kleist's *Bettelweib von Locarno* [Beggar-woman of Locarno], where from the corner of a room at a certain time a wheezing, penetrating sound is heard, because here a poor beggar-woman was once allowed to die miserably, whose dying sigh has been heard since at the same hour as a dreadful, solemn warning to have pity, there is still far too much reason there. The wholly contentless tone hovering in the air is for these Romantics *à la* Hoffmann really Romantic only when the flower is not rose and violet, [352] but is 'the blue flower' itself. The more abstract, the more enigmatic. Shelley's wife then really has the deeper fantasies. How grandly in Frankenstein does the thought come to her, that through the race he has called into existence an ineradicable and permanent rupture in the human race would be founded, namely that between the God-created natural humans and the artificial humans made by calculation. How deeply the necessity is motivated to grant the ugly man also the ugly woman and thus to set ugliness as the norm, as the ideal of the species!

It is superfluous to report how easily the spooky can turn humorous, for satire involving ghost seers busies itself with this subject often enough (NOTE 78). But even outside of satire, art has used the ghastly and the spooky often enough to prepare the most ridiculous complications, of which the last canto of Byron's *Don Juan* surely contains the most elegant, and the scenically and psychologically most consistently

executed representation. Don Juan has decided to see the monk who haunts the castle. An antiquely furnished gothic room, moonshine; two pistols on the table; midnight; strange rustling in the corridor; it nears; there he is, the monk! Two fiery eyes glare from a dark hood. Don Juan springs to his feet; the monk runs back down the dark corridor; the knight follows, grasps the phantom, wrestles with him—and

> The ghost, if ghost it were, seem'd a sweet soul
> As ever lurk'd beneath a holy hood:
> A dimpled chin, a neck of glory stole [**353**]
> Forth into something much like flesh and blood:
> Back fell the sable frock and dreary cowl,
> And they reveal'd—alas! that e'er they should!
> In full voluptuous, but *not o'er*grown bulk,
> The phantom of her frolic Grace—Fitz-Fulke![225]

γ) *The Diabolical*

We first considered evil in the form of the criminal. As purely negative attitude, without expressing itself in a deformed shape or objectively in an action, it could not be an aesthetic object. But we have chosen the label of the criminal also for this reason, because we wanted to suggest that the human being, through a hybrid affect or through passion, through the conflict of circumstances, can be carried away into committing an evil act without being through and through or even in principle evil, without being diabolical. Oedipus, Orestes, Medea, Othello, Karl Moor, and so on, commit crimes, without that one can attribute to them malice, or pleasure in evil. We let the ghastly follow on the criminal because it is essentially mediated by some guilt-laden context. We have distinguished it from the realm of demons; we have also distinguished it from the realm of shades in general. The appearance of a spirit, like the Earth Spirit of Goethe's *Faust*, of a shade, like Darius in Aeschylus' *Persians*, can arouse dread, but at the same time be sublimely beautiful. The shade first becomes a ghost when the deceased has not yet lived out his history, and thus is still caught up in the pragmatism of what is taking place. Out of caution, we also made use here of a broader [**354**] definition, so as not to exclude phenomena which are not directly called forth by evil. Namely not through evil as something inherent in them, for Banquo himself for example is by no means evil, nor criminal, and yet he appears. We emphasized the restlessness of the deceased, who is still pulled back by some important interest in this world. Insofar as the ghastly turns spook, it still does not quite step into the territory of evil as such, but rather in the region of the absurd, which we have investigated earlier. The ghastly as the reverberation of inner rupture can even becomes aesthetically beautiful, in that, as Lessing rightly says, it arouses fear and yet also pity. As connected with the ideas of death, of decay, of guilt, of evil, it provokes loathing in us; it is repulsive;

[225] Rosenkranz uses the version in *Lord Byron's Sämmtliche Werke*, ed. Johann Valentin Adrian, vol.7 (Frankfurt am Main: Johann David Sauerländer, 1831), 184. It makes no difference to the argument, but Adrian is more explicit in his descriptions than Byron: his Duchess of Fitz-Fulke in the penultimate line has 'ample breasts and full calves'.

but as connected with ethical interests, as a representation of the honour of justice, which reaches out even over death, it is freed from ugliness, as the shadow-form of the Commendatore in Mozart's *Don Giovanni* shows so incomparably. Madness has in its self-forgetting undoubtedly something ghastly in itself. The insane person is, however, unlike the deceased, alienated by an image; the ghost namely returns from the beyond to this world; it has made the giant leap from the one to the other; the insane on the other hand still lives, but is deprived of reality by his madness, so that for the living interests of positive reality he is pathologically dead. The immeasurable greatness of Shakespeare, who knew the human heart in all its heights and depths, gives us here too the most fitting examples. His Lady Macbeth, as she [355] gets up from bed at night and in sleepwalking wants to wash the bloodstains from her small hands, is an apparition standing very near to the ghastly, freezing the blood in our veins. Consciousness of guilt, sleepwalking, and the beginning disruption of the mind mix here to a terrific effect. His King Lear, as he wears a crown of straw, resting on a tree branch, bubbling with insane speeches on the open heath, makes a ghastly impression. But in these scenes there is always still reason through the powerful context in which they stand. The spooky on the other hand turns into the silly and the uncanny. Nevertheless it would be very one-sided to deny to it its aesthetic right. Fantasy has known how to derive a wonderful beauty from it as well, partly in the fairy tales of the peoples, partly in the literary poems of the great masters, as in Tieck's wonderful *Phantasus* tales of the blond Eckbert, of the Runenberg, of the goblet, among others.

This development should make obvious the false one-sidedness of that conceptual definition which identifies the ugly with the ghastly and this in turn with evil. Weiße, in his theory, has been carried away by the idea of hell in the religious fantasy of various peoples to the error of identifying ghosts with the denizens of hell, *vulgo* devils, which aesthetically is not defensible. *Ästhetik*, vol.1, 188: 'The forms of this abyss are the *ghosts*, which *lie*[226] a self-sufficient, or objective existence separated from the subjectivity of fantasy, and through this lie they threaten the finite spirits [i.e., living humans—eds.] to whom they appear, and each of whom unfolds in endless particularity, with the same [356] abyss of depravity.' Page 196: 'Thus as general attribute of all ugliness, that it is something *ghastly* and *uncanny*; expressions which one may oppose to the *mysterious* or *secretive*[227] nature of beauty. As this ghastly nature, ugliness intrudes into all the formations of beauty, and disturbs these so that instead of their true significance, which assigns to each its particular dialectical position, it foists the contentless meandering of a fantasy setting itself in the place of the highest. Furthermore, because this stepping out of ghastly fantasy from the sphere of its being, that is, of its nothingness, into the higher spheres of aesthetic reality is a fragmentation of the forms wherein the idea of beauty essentially consists, so the final and sufficient cause of this occurrence is to be found not within, but without or beyond this idea, namely in the essence and the

[226] In Weiße's curious wordplay, ghosts *lie* (*lügen*) rather than *live* (*leben*). This is an elementary blunder, since one must exist in order to lie: but it is typical Young Hegelian practice to thus exchange predicate (the lie concerns ghosts) with subject (ghosts lie).
[227] Another wordplay: *unheimlich* (uncanny) ugliness vs. *heimlich* (secret/ive) beauty.

concept of *evil.* We have nothing against, indeed we agree entirely with the notion that in evil can be seen the absolute lie and *insofar* in it also a *ghastly moment,* only, to take the ghastly only as a lie and the ugly only as the ghastly seems to us a confusion of the aesthetician, whose falseness can be seen in its full light in his follower Ruge and then again in his colouring-book popularizer Kuno Fischer (* NOTE 79).

While we can now go on to the diabolical, we must deal with one more philosopher, Hegel, for according to a detailed and very insistent passage in his *Ästhetik,* vol.1, p. 284ff, evil as such is incapable of arousing an aesthetic interest. Given the importance of the [357] matter in itself and the degree to which we value Hegel's opinions, it shall hopefully be allowed here to quote his own words and to accompany them with some remarks. Hegel says: 'The reality of the negative can indeed correspond to the negative and its essence and nature, but if the inner concept and purpose in itself is already null and void, the already inner ugliness permits even less a real beauty in its outer reality.' That the negative cannot have the form of the positive is natural. So is that its inner nature, an ugly one, must reflect itself externally in a corresponding form. But aesthetically, a difference enters the picture. Namely, if art constructs the exterior in accord with the interior, then in the case of the bad this exterior may not and cannot indeed be beautiful in the sense in which this is the case for the good and the true. But shall we not have to judge that the artist who brings the negative to visibility perfectly in accordance with its essence does so beautifully? Not beautiful through sublime or pleasant, but through mean and repulsive forms, which however he has known to find, combine, and design just so, that they indeed represent the inner negative unmistakably as something ugly. Is then the drawing of evil so easy, that every bungler can succeed at it?—Hegel continues: 'Sophistry can indeed attempt to bring positive aspects into the negative through dexterity, strength and energy of character, but we retain nevertheless only the impression of a whitewashed grave. For the only-negative is in itself in every case matt and flat, and for this reason leaves us empty, or pushes us back, whether it is used as the motive of an [358] action or merely as means of getting someone's reaction. The cruel, unhappy, the roughness of violence and the hardness of superior force, may be held together consistently in an idea, if it is itself sustained and supported by a contentful magnitude of character and purpose; but evil as such, envy, cowardice and perfidy are only repulsive, *and the devil for himself is therefore a bad, aesthetically useless figure,* for he is nothing but the lie in itself, and therefore a highly prosaic person.' Let us stop here a moment. That evil is ethically and religiously deplorable goes without saying. The Neo-Platonists, after all, irrespective of its empirical existence, have even taken it as non-being. That evil is aesthetically repulsive we too affirm to such a degree that our whole discussion of the repulsive culminates in the concept of evil and the diabolical. But is evil therefore aesthetically useless? In the world of phenomena, is the negative not connected[228] with the positive, evil with good in such a way that the essence of the one is always illustrated by the appearance of the other? Indeed Hegel says, not without caution: the devil *for himself* is a bad, aesthetically useless figure. The

[228] Rosenkranz has *Comrex,* certainly a typo—but for what? The Reclam ed. has *Konnex* (connexion, old sp. *Connex*), but *Commerz* (commerce) is nearly as plausible.

devil for himself, however, seems to mean something like the devil alone, torn loose from the entire context of the world, as isolated object of art. Against this there is nothing to object. We already showed in the introduction that evil and ugliness may only be thought as infinitesimal[229] moments of the great divine world order. Only, within this requirement, is the devilish there also so [359] thoroughly unaesthetic? Whoever wants to assert this must demand only moral exhibitions from art, he cannot demand that its products so mirror the picture of the world that we could look through the struggle of phenomena and see on the other side the eternally self-same ground of the purely affirmative idea. It is true that evil leaves us cold, that it pushes us away from it; it is true that sophistry of passion cannot conceal the inner hollowness of the bad. But the representation of the bad, which allows such a judgement to *come into being* in us as a *result*, can it not be aesthetically interesting? Is the formal mind that develops evil hypocritically, is the formal energy, with which it pursues its goals, is the tyrannical greatness, with which it recklessly piles crime upon crime, is that all aesthetically useless? How does it come about that the entire dramatic art of the Middle Ages could be raised on the 'prosaic' element? How does it also come about that England's classic stage could only pass from the mysteries to the morality plays and from these to genuine comedy and tragedy by means of the metamorphosis of the devil and his joker ('the Vice')?[230] Though we may moderate our questions, for perhaps there are answers to come. Hegel continues: 'Just the same, the Furies of hate and so many later allegories of the same kind are indeed powers, but without their own affirmative sufficiency and standing, and unpromising for ideal representation, although also in this respect for the individual arts, and for the means by which they bring their object before the intuition or not, a great difference in what is allowed and what is forbidden may be observed.' [360] If the 'Furies of hate' should indeed refer to the Eumenides, then Hegel would certainly have made a mistake, for the same, as guardians over blood guilt, are essentially affirmative powers, who avenge the transgression of justice and sacred duty. In their fearsomeness they are pictured as sublimely beautiful, even if the god of light [Apollo, in Aeschylus' *Eumenides*–eds.] calls them night-fiends [and] monsters. At the same time, he [Hegel] may have thought here less of the Greeks than of the Romans and the French, for instance, Voltaire's *Henriade*, which is richly outfitted with such allegorical figures, which make up a kind of mythology. If however such allegories seem aesthetically dull and barren, is the reason not rather to be found in the nature of the allegory? Are the virtues, expressed in allegorical isolation, any better off than the vices? Is not the most fruitful, form-prodigal genius, like that of an Albrecht Dürer or a Rubens, hardly able to counter the prosaic nature of allegory? Hegel does admit something, namely that the individual arts may well behave differently in this regard. Certainly, but for this very reason poetry is capable of representing evil in thoroughly interesting fashion, because it is able to show the peculiar insanity that brings it about in its ultimate genesis. Unlike visual art, it need not help itself to allegorical and

[229] Not 'vanishing' in the sense of invisible or absent (which goes against what Rosenkranz has just said about the interweaving of good and bad in the world), but shrinking, as in the old interpretation of the calculus, so that within the divine order they are insignificant.

[230] In English in the original. Rosenkranz may be alluding to Marlowe's *Doctor Faustus*.

symbolic means, but rather it can let the negative depth of the evil self-consciousness speak for itself. Is not the greatness of Goethe's Mephisto to be found in the very ironic clarity with which the rogue who ever negates expresses himself? Our philosopher continues: 'Evil however is in general barren and contentless in itself, because from the same nothing other than negativity, destruction and unhappiness emerges, [**361**] whereas real art should offer us in itself the sight of harmony.' We once again accept the general assurance of the contentlessness of evil, but the explanation through its consequences we reject. May unhappiness and destruction not come about in manifold ways as a result of the good as well? Is the harmony of an artwork hemmed by unhappiness and destruction? Does not every tragedy contain endless misery, and does this hinder its aesthetic harmony? Hegel is of the opinion that 'primarily, viciousness is despicable, in that it originates in envy and hatred toward the noble, and does not scruple to pervert even a power justified in itself to its own bad or shameful purpose. The great poets and artists of antiquity do not, for this reason, give us the sight of malice and depravity; Shakespeare on the other hand, for instance in Lear, presents to us evil in all its grisliness,' etc. Hegel goes on to chide the old man for being so foolish as to divide his realm and misjudge Cordelia, and finds it consistent that such crazy behaviour should have as its final result craziness itself. We prefer to set aside here the question whether the great Homer did not already give us in Thersites a sight of that viciousness that originates in envy and hatred toward the noble.[231] But should we believe in earnest that Hegel wished to contrast Shakespeare with the great poets of antiquity in this way, that with the presentation 'of evil in all its grisliness' he made himself guilty of an aesthetic error? [**362**] This opinion would be contradicted by the countless passages of his *Aesthetics* wherein he cannot do enough to express his admiration for Shakespeare, and for the present case [*Lear*] the definite statement is that at Vol. 3, 571ff.[232] What then should we think? Incontrovertibly we have to admit that Hegel found incomparably more poetic those plots, wherein the collision of thoroughly morally justified affirmative powers occurs, than those wherein the negative is used for leverage. In his boundless admiration of *Antigone*, he declares the play for this very reason the 'finest, more satisfying artwork' of all (*Aesthetics*, Vol.3, 556). We must further admit that he is the declared enemy of all straw-man moralizing, namely of the sophistic chatter of the flabby, forgiveness-craving moral of an Iffland or a Kotzebue, but nevertheless and even for this reason he was a man of the greatest ethical gravity, for whom immorality, in a sense related to the genius of Plato, was outrageous to the point of intolerability, and thus lacked a sense for the humorous handling of evil that developed during the Christian Middle Ages. The irony of the Romantic School essentially also fell apart for him in 'flat jests'. Dutch genre painting alone enjoyed the privilege of being allowed to abstain from high and noble content, which he otherwise inevitably demanded. The ancients, whom Hegel also accentuates here, could not yet,

[231] Rosenkranz may be citing here Lessing's discussion of Thersites in *Laokoon* XXIII.
[232] For example, 'Thus in Shakespeare's *Lear* the initial foolishness of the old man rises to madness in the same way as Gloucester's mental blindness turns to real bodily blindness, wherein his eyes are finally opened to the true difference in the love of his sons' (571).

because of the idea of fate, represent evil in free subjective form; as Hegel elsewhere explains very well, the moderns, because of the idea of freedom, which drives their worldview through the mediation of Christianity, [363] by necessity had to take up evil in the cycle of their representations, because the subjective side of freedom manifests itself as exclusive precisely in evil, and with its negativity prepares the fate of demise through the affirmative powers of the good itself. The viciousness of envy, which Hegel finds so repulsive, belonged for the ancients to the φθονερόν [*phthonerón*, envy][233] of the gods themselves, for Christians to the devil. Otherwise, why should precisely the great artists—Orcagna, Dante, Raphael, Michelangelo, Pierre Corneille, Racine, Marlowe, Shakespeare, Goethe, Schiller, Cornelius, Kaulbach, Mozart—have been so diligent in rendering evil not just in the form of the criminal and the ghastly, but also of the devilish! (* NOTE 80)

From the evil of a single passion, of a particular wickedness, of a passing affect, evil as the diabolical distinguishes itself in that it hates the good on principle, makes negation an absolute goal, and takes pleasure in the production of ill and evil. This conscious opposition to the good, inseparable from its concept, also makes it the transition to caricature. It is only possible as the self-conscious distorting mirror of what should be the divine image originally within it. It reminds us instantly of the good whose destruction is its pleasure; it grins at the good as its absurd opposite; it bares its teeth at the good—but it cannot escape it, for if there were no good, it would be nothing itself; evil is to this extent insane. The diabolical repeats the criminal in the idea of persons who are possessed by devilish demons and are forced by them to hideous acts. The *possessed* rages [364] passionately, plays, drinks, curses and sinks to the outright bestiality of the man-animal. The real agent in him, so the idea goes, should be the demon or indeed the multiple demons who have taken possession of him. But more truly still it is the person itself who does this all, for the idea does trace the unfreedom of its condition back to its freedom, in that it committed some error, that he granted access to some demon, be it tyranny, lust, etc., to which then, for as it is well known, the vices are among themselves as sociable as are the virtues, others soon came. Being possessed thus remains the liability of the person who does not as he should keep evil away through his freedom and for its sake.—The diabolical repeats the element of the ghastly in *witchcraft*. So-called black magic aims through the sacrifice of true freedom and bliss to force the power of the hellish demons to its service in order to satisfy all the frivolous desires of a hideous egoism. In magic, a person does not lose the subjective freedom that perishes in the state of possession. He wants evil with clear consciousness, and signs contracts with the devils.—We may call the diabolical in and for itself, as it frankly knows and wants and affirms itself, and as it takes its delight in the sneering disruption of the divine world order: the *satanic*.

Let us not forget that we are not approaching these conditions psychologically and ethically or even from the standpoint of the philosophy of religion, but aesthetically. In the idea of [365] being possessed there is still a dualism of the human and the devilish.

[233] For example, in Herodotus (*History*, I:32), the wise Solon tells his host, the Persian king Croesus, that 'the divine is entirely grudging and troublesome to us' (Godley trans.).

The possessed is imagined as a being over whom demons have taken possession and over whom they exercise arbitrary control. Such a duality of distinct personalities in the same organism naturally cannot be beautiful; on the one hand there is present the peculiarly passive form of the possessed, on the other the eccentric mobility produced by the violence of the possessing demons. Should painting or poetry bring to view a rupture of this sort, they must somehow artificially distinguish between the natural form and that made by the demons.[234] That nevertheless the demons could not have taken possession of the human, had he not opened the path for them, the distinction is in principle invalid. All religions agree in this attitude. Even the Indian religion presupposes the guilt, that is to say the freedom of the person, in such a case. Nala, the Lord of Nishada, Damayanti's brilliant husband, aroused the envy of the gods through the fortune that the great beauty preferred him to the gods. Long do they lie in ambush to do him some harm, for the Indian gods are no less envious and vengeful than the Greek. The nobleman, however, fulfils strictly all the obligations of his caste. Finally after twelve years he once urinates, forgets the prescribed purification, steps with the foot in the urine-drenched grass—and thus gives the evil demon a chance to enter him. Kali, who had been insidiously shadowing him all along, takes possession of him and seduces him first to gambling. The argumentative may want to dispute over the absurd rules set by this religion. [366] The German translator of *Nala and Damayanti*[235] has also, without any justification, left out the genuine Indian catastrophe. Bopp in his 1838 version mentions it modestly in the notes, but since even there a lady's eye might mistakenly wander, he does so with Latin words: 'Qui fecerat urinam et eam calcaverat, crepusculo, sedebat Naishadus, non facta pedum purificatione; *hac occasione* Calis cum ingressus est.'[236] Bodily cleanliness is, however, not in fact something so insignificant, that religions aiming to educate the whole person should not place great weight upon it. And the fulfilment of duties demands the realization of all duties. In that the Indian poet in fact lets Nala transgress the law only infinitesimally, he wants to convey to us nothing but the holiness of the hero, for he is indifferent to nothing, not even to the smallest observance, and at the same time he wants to put in Nala's account the fact that he fell only into the lightest sin, a real *pecatillum.*—Art can convey the liberation from demons with greatest effect in that moment when through the intervention of a saving power, the brokenness of life, the madness of the gaze, the cramped limbs, the darkened mind, the mild dawning of a spirited, loving consciousness begins to shine through; the eyes are still half-veiled, but the mouth already opens to admit the escaping demon. With him the ugliness of distortion disappears. Thus have Rubens and Raphael handled this motif. In Raphael's *Transfiguration*, one sees on the height of the mountain the floating light-drenched form of the saviour; below, at the

[234] Anyone familiar with William Friedkin's 1973 film *The Exorcist* will admit the justice of Rosenkranz's observation: on one hand, a contrast between victim and demon is made there by having the victim sleep frequently, on the other through hokey green make-up.

[235] Rosenkranz reviewed Franz Bopp, *Nalas und Damajanti, eine Indische Dichtung, aus dem Sanskrit übersetzt* (Berlin: Nicolai, 1838), in the *Jahrbücher für wissenschaftliche Kritik*, June 1839, 878–9. After criticisms, he compares the poem to the Nibelungenlied.

[236] 'Having urinated and stepped in it, at dusk Naishadus [Nala] sat down without having purified his foot; *on which occasion* Cali entered.'

foot of the mountain there is a group around a demonically possessed boy, [367] who is brought by his relatives and his mother, who kneels in the foreground, to the apostles, who point him upward, toward the one who alone is truly able to liberate.

In the diabolical there is also a ghastly feature, because it opposes itself on principle against the affirmative world order. This feature takes on a specific form in witchcraft, which one must distinguish from magic in general. Magic, as we saw earlier, brings with it the absurd, and as such it can even be reconciled with the beauty of the magic-maker, indeed with useful intentions and with good purposes, and can be imagined as wise magic, as a high science, whose art makes possible a jump over middle links in the chain to which ordinary action finds itself bound. Thus Pater Baco of Robert Greene, thus Prospero in Shakespeare's *Tempest*, thus Merlin in the Arthur legends, Malagis of the Carolingian saga,[237] thus Elberich in Otnit, thus Virgil in the Roman-Italian legends, and so on. That magic as such can also be carried out cheerfully as a delicate affair, as some women are shown doing in the *Thousand and One Nights*, as Lucius's hostess in Lucian's story of this name very charmingly turns herself into a bird in order to fly to her lover, whereas he, through the use of the wrong salve, is turned into a donkey. Witchcraft is something entirely different. In a broad sense we must understand so-called black magic as belonging to it, namely because it aims to get the help of evil, hellish spirits for evil works. This magic wants evil consciously and calls the demons up to cooperation in its dark deeds. [368] Weakness opens the way for the demons unconsciously or half-consciously, always without wanting it; but he who devotes himself to witchcraft tears himself self-consciously out of the circle of the humans and allies himself with the powers of the abyss. We find this idea already in the ancients, but through the dualism of the Christian Middle Ages it came to be worked out as a formal system of the most hideous fantasies. In the Orient and with the ancients, the malicious old woman, the haggish counterpart to the honourable matron, had already become the type of the witch, who with her evil eye, her potions, and her incantations brought about mischief. The word *hex*[238] is supposed to come from Hecate, the old goddess of night. The evil old woman, as Aristophanes so often portrayed her in the *Thesmophoria, Ekklesiazusen* and the *Lysistrata*, is horrendously ugly, not alone because her cheeks sag, her forehead is covered with wrinkles, and her hair is blanched, but rather because she appears as the wicked envier of youthful happiness and beauty, because as procuress she corrupts fair virginity with satanic glee, because she, in spite of her age, is still tormented by impure desires and still looks to their satisfaction. The evil hag exercises through procuring a hideous revenge against natural freshness, which she sees as her natural adversary, and through magical coercion she tries to achieve a pleasure which nature no longer tends to grant her willingly. This, one may well say, infamous person

[237] Malagis the wizard is the protagonist of fifteenth-century German translations of the Middle Dutch epic *Madelgijs*, hence perhaps Rosenkranz's description of the material as 'Carolingian' (*Kerlingisch*). First printed in 1885, a good modern edition is *Der deutsche Malagis nach den Heidelberger Handschriften Cpg 340 und 315*, ed. Annegret Haase, Bob Duijvestijn, Gilbert de Smet and Rudolf Bentzinger, with preparatory work by Gabriele Schieb and Sabine Seelbach (Berlin: De Gruyter, 2000).

[238] *Hexe* is German for witch. In English the verb form has survived.

constitutes the foundation of the witch. To this is added the idea that she has taken up with devils, indeed, with the devil himself. The orthodox fantasy of the catholic as well as the protestant [369] church forms witchcraft as a *diabolical rite*. The gatherings of the Waldensians on lonely mountain peaks gave the first provocation to the idea of the *witches' Sabbath*, which in France was also called *Vauderie*[239] and which north German myth places on the Brocken. Here, in the *synagoge diabolica*, the whole Christian liturgy is supposed to be parodied with the most disgusting cynicism. Satan, indeed in human form, but with a ram's head, with clawed hands and goose or horse feet, is ceremoniously adored. His genitals and buttocks are kissed. Baptism and Eucharist are satirized, in that toads, hedgehogs, mice and so on are baptized; what the devil offers instead of the Host resembles a shoe sole, is black, rough, and tough; what he gives to drink is similarly black, bitter, and disgusting. To a certain extent Satan also sacrifices himself in order to parody Christ's sacrifice, by having himself burnt as a ram, with a great stink. The devilish church celebrates its devotions in the orgy, in lustful dances and embraces, which nevertheless have the peculiarity that the devils' semen is cold, for as God-accursed subjects they are not productive, and thus first must sleep with a sorcerer in assumed female form as a *Succubus* in order to be inseminated, in order then to be able to satisfy the beastly lust of their female lovers in the male form of the *Incubus*. Arid feasting and gluttony and fornication of all kinds, systematic perversion of the godly order, self-conscious disavowal of God, art has thus tried to express in the forms and physiognomies of witches, as Teniers but above all A[lbrecht] Dürer has drawn them. In Vienna in the collection of [370] drawings of the Archduke Karl there are some invaluable sheets of Dürer's (see Figure 10), upon which witches, with their whirling hair, rheumy eyes, their udder-like animalized breasts, their crumpled, stump-toothed mouths and an expression of equal parts malice and unbridled lechery, arouse our horror.[240]

Poetry has worked through witchcraft especially in the older English drama, in the *Witch* of Middleton; in the *Witch of Edmonton* composed together by Rowley, Decker, and Ford; in Shakespeare's *Macbeth* and in Heywood's *Witches of Lancashire* (* NOTE 81). This last piece contains in a sense a gallery of all the forms of mischief through which the witches disrupt society. They see to it, for instance, that in a family the entire moral order is reversed. Mother and father fear the son and daughter, the son fears the valet, the daughter the maid, etc. Heine has taken up what is essential to the witches' Sabbath in his dance-poem *Faust* [Hamburg: Hoffmann und Campe, 1851]. The groundlessness of the assumption of real witches and especially the terror of the witch trial is represented most vividly in a superior German story, *Veit Fraser*, which can be found in the *Nachtseiten der Gesellschaft, eine Galerie merkwürdiger Verbrechen und Rechtsfälle* [Dark sides of society, a gallery of remarkable crimes and court cases; Leipzig: Otto Wigand], 1844, Vols. 9–11. We can spare ourselves greater prolixity over the witchlike, since in the last few decades the many commentators of

[239] After *Vaudois*, the French name for the Waldensians.
[240] Perhaps Rosenkranz saw some of Hans Baldung Grien's drawings, often taken for Dürer's. Or perhaps he saw a print: the Albertina also has the engraving we reproduce.

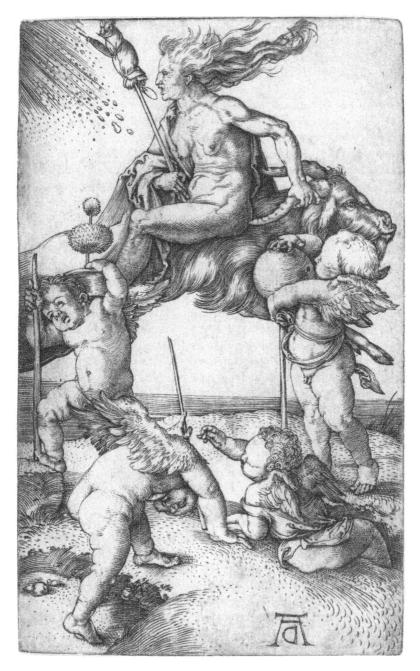

Figure 10 Albrecht Dürer, *A witch riding backwards on a goat, with putti carrying an alchemist's pot and a thorn apple plant*, c.1500, engraving, National Gallery of Art, Washington, DC.

Goethe's *Faust* have not been lacking in diligence in gathering numerous notices and observations on magic, witches' kitchens and Walpurgis Night on the Blocksberg; this is done most thoroughly in Eduard Meyer's 1847 *Studien zu Goethe's Faust* [Altona: Hammerich]. **[371]**

Although in fact, taken aesthetically, one cannot conceive anything more hideous than the witches' Sabbath, the design of the diabolical as the *satanic* goes still deeper intellectually. Witchcraft with its ludicrous paraphernalia plays mainly in a cycle of coarsely sensuous desires, in the sphere of lustful, malicious women, in a fantastic world of appearances. The satanic is indeed the centre of its rite, but more as a parody of the church liturgy; the intellectual content is thin. The truly satanic by contrast emphasizes the consciousness of its indignation. Not out of weakness, like the possessed, determined by relatively foreign powers; not driven to devotion to evil through spiteful pleasures, like the witch; it finds its greatest pleasure in the self-conscious, free production of evil. That said, in accordance with its concept, absolute evil is also the absolutely unfree, for it consists only in negating true freedom, in willing the non-willing of the good, which is why we have already called its will an unwill, being the will that wills nothingness.[241] In this abyss of substanceless willing alone does he feel free, if one may put it this way, because he feels only himself, only his quite exclusive egoism. The good as divine ground of all things only reminds him to shatter all God-made boundaries, to root out all natural order, to destroy with derision all propriety and modesty of spirit. With right then we can expect here the maximum of ugliness, only, as paradoxical as it may sound, it is nevertheless true that the metaphysical abstraction that lies in this standpoint in turn softens its ugliness. The satanic subject has a certain enthusiasm of **[372]** depravity, which despite all hideousness lends his appearance a certain formal freedom that allows it to become a more aesthetic object than one might think at first. The devil, as much as he might strain to set himself in God's place, is, however, incapable of creating anything, other than the monstrous wonder of his yes-no, his absolute contradiction, and he is, thanks to the a priori futility of his effort to be original, in the end only a grimace, whose arrogated majesty instantly reverts into the humour of the 'poor and stupid' devil. Fantasy has [thus] represented the devil as 1. *superhuman*, 2. *subhuman*, and 3. *human*.

Superhuman as the member of a higher spiritual world, belonging to the true God, from which he fell out of envy and pride. Religious fantasy has imagined such satanic subjects in colossal form. In the lower nature religions the power of evil is still attributed to the highest gods, and the form of the idols is thus calculated to instil through its monstrousness fear and terror. How horridly the Mongolian Ghangor and the Mexican Huitzilopochtli glare at us! How terrifying these lurid eyes that stare at us, how bloodthirsty this brutal tongue that pants from this maw, how threatening these sharp teeth that grin at us, how bestially these unruly paws that show us their blind irresistibility, how disorienting the body appears as a chequered conglomerate of

[241] *Willen, der das Nichts will* (will that wants nothing[ness]) anticipates Nietzsche's concluding sentence of the *Genealogy of Morals: lieber will noch der Mensch* das Nichts *wollen, als* nicht *zu wollen* (man would rather will nothing[ness], than not will at all).

human and animal forms, how chilling the ornament of human skulls and crushed corpses! In more advanced religions this predator physiognomy disappears. *Lies, envy* and *arrogance* appear as basic features of the satanic, *murder* first as [373] a result. The spiritualization of the image makes the form less distinct and works it out more in evil actions, as in the Indian Kali, the Parsee Eschem,[242] the Egyptian Set, who is represented with a fat belly and a hippopotamus head, and was called by the Greeks Typhon. Among the Greeks, evil was grasped as the negation of natural and moral measure, but not concentrated in a specific individual. The ugliness of negativity was distributed to distinct subjects according to distinct moments (*NOTE 82). The many-limbed hekatoncheira, reminiscent of the Indian gods, struggled with the new gods as titanic powers, but they were not evil. The hulking, one-eyed Cyclopes were not so much evil as coarse. The Graiai (literally, grey sisters) were beautiful-cheeked girls with greying hair, Phorkyas one-toothed, the Harpies disgusting, the sirens beautiful-breasted virgins ending in fishtails,[243] the Lamias and Empusas lusted after the blood of handsome young men whom they seduced, the satyr, devoted to drink and to lust, was goat-footed—but none of these fabulous beings were in our sense evil. The children of night, whom Hesiod in the Theogony enumerates after the portrayal of Chaos, were terrible but not evil. The origin of ill, but not truly of evil, is represented in the Promethean myth.[244] Enough: for all the moral depth we encounter in the Greeks, we must judge that the idea of the satanically evil was foreign to them. Their ἀσέβεια (*asébeia*, impiety) does not suffice by far for this wickedness. In Scandinavian mythology on the other hand, the idea of evil in Loki is already much more concentrated. Loki hated in genuinely satanic fashion the good [374], friendly Baldur. In the exuberance of happy play, the gods decided to shoot at him. But all things were first made to swear not to hurt him; only a mistletoe switch was excepted thanks to Loki's deviousness. It became the fateful dart of death. Loki gave it to the blind god Hödur to shoot at Baldur.[245] The gods indeed punished only Loki,[246] in that they chained him to a rock and had snakes dribble down painful poison on him. With the death of Baldur the good the catastrophe of the world was begun, hurrying to its fall with the great struggle of the race of the Asen.[247] This thought, that the world can not longer subsist after the

[242] In Zoroastrianism, the evil principle, Ahriman, rules over personified vices or *dev*, of which Eschem, envy, is the most prominent. Rosenkranz may be relying on the founder of comparative religion, Georg Friedrich Creuzer, *Symbolik und Mythologie der Alten Völker, besonders der Griechen*, 3rd ed. (Leipzig and Darmstadt: Leske, 1837), I: 204.

[243] This is the modern confusion with mermaids—though Homer does not describe their bodies, most ancient Greek accounts and vase paintings give them birds' bodies or feet.

[244] Rosenkranz distinguishes here *das Übel* from *das Böse*, which are generally given in English interchangeably as 'evil'. His point is that Prometheus embodies a revolt against the gods, and punishment (thus evil in the sense of hurt, harm, ill), but not vicious intent.

[245] Rosenkranz assumes the reader's familiarity with this story, which is probably why his retelling is so confusing. Some details: Hödur is Baldur's twin. Baldur having foretold his death in a dream, his mother Frigg, wife of Odin, demands the oath not to harm him from every object, except the mistletoe, which seems harmless. The gods, knowing Baldur's immunity, make sport of pelting him with objects, and Loki thus sees his chance.

[246] This is not quite true, as Vali, the one-day-old son of Odin and the giantess Rind, avenges Baldur's death on Hödur as well (though he survives).

[247] Odin's martial family of gods, as opposed to the older nature gods, the Wanen.

death of the good god that has been sacrificed through malice, is uncommonly beautiful and deep.—In Hebraic monotheism, Satan, who receives from Jehovah the mission of tempting Job, is only an angel, and by no means a diabolical being torn loose from God. Only later did the Jews take from Parsism [Zoroastrianism] the idea of Eschem the fly-god, and so on. In Islam also Eblis is on a good footing with Allah. He swears to him to seduce to evil all persons that do not convert to Mohammedanism, so that he may damn them all to hell. The Karagöz (*gargousse*) of the Turks and the whole of North Africa, even the main character in the Chinese shadow play, is indeed a devil, but only a cheeky, buffoonish subject (* NOTE 83).—Only with the Christian religion with its absolute depth of freedom does evil also perfect itself in the form of an absolutely negative self-consciousness growing lonely in itself. Faced with a God appearing as a human, absolute evil can also only step forth anthropologically, even if [375] at first in the form of a powerful winged angel, who can only be distinguished from the other angels through his grey, shadowy colour. Thus Satan appears in Abraxas[248] and the old miniatures. The diabolical has also been shown as a trinity of evil, in three identical, harnessed, crowned, sceptre-carrying, tongue-wagging, repulsive persons, as illustrated by Didron in his *Iconographie chrétienne* (see Figure 11) (* NOTE 84).

Later the painters conceive the wings very handily as bat wings, as in the Campo Santo Pisano, until the striving after energetic contrasts led art to seize on other animal forms as well. Dante in the *Inferno* has made use of a multitude of fantastic conceptions. The anthropological formation, which is the dominant tendency even in the superhuman conception, also gave occasion in the Middle Ages to the myth of Merlin, in that the devil, imitating God, also wanted to beget a son. He thus slept with a very pious nun at Carmarthen [in Wales] without her knowledge, to thus unite the powers of good with those of evil.[249] Merlin, the fruit of this union, conceived and born of a holy virgin, was supposed, as the devil's son, to destroy the realm of the Son of God. Naturally the opposite took place. The Old French story of Merlin has been translated into German in a well-known version by Friedrich Schlegel (* NOTE 85). A delicious drama, the *Birth of Merlin* of Shakespeare[250] and Rowley (* NOTE 86), has rendered the devil splendidly, not without a certain infernal seeming-majesty, which, however, does not prevent the son from meeting the father very roughly, a real foil to Scribe's sentimental treatment of the son by the father, which we have already criticized several times, [376] in *Robert le diable*. [Carl] Immermann's *Merlin* [Düsseldorf: Schaub, 1832] has not grasped the idea of the devil deeply enough; the poet has not penetrated sufficiently into the Christian sense of the myth and has remained standing too much with the cosmogonic fantasies of the Gnostics.

The subhuman conception of the satanic is essentially derived from the antique *satyr masks*, of which the simple ram was probably the simple consequence. The evidence for this has been given by F[erdinand] Piper in his *Mythologie und Symbolik*

[248] Rosenkranz may have had in mind Abraxas-stones taken to depict Gnostic deities in Enlightenment anthropologies from Bernard de Montfaucon to Pierre d'Hancarville.

[249] According to the twelfth-century *Vita Merlini* by Geoffrey of Monmouth.

[250] The play, first printed in folio in 1662 as *The Birth of Merlin, or, The Child Hath Found his Father* under both names, is now believed to be exclusively by Rowley.

Figure 11 After a fourteenth-century French miniature (MS Paris BNF fr.96 [Anc.6770]), line engraving in Adolphe Napoléon Didron, *Iconographie chrétienne* (Paris: 1843).

der christlichen Kunst von den ältesten Zeiten bis in's sechzehnte Jahrhundert [Mythology
and symbolism of Christian art from the most ancient times until the sixteenth
century], Vol.1 [Weimar: Landes-Industrie-Comptoir], 1847, pp. 404–6. Nicola Pisano
represented Beelzebub[251] in his Last Judgement on the Pulpit of the Pisa Baptistery of
1260 as a satyr. Until then, this formation had rested. In the fourteenth century we then
find it again in the Campo Santo Pisano in the story of San Ranieri,[252] and from here
on its application grows rapidly. Also the *lion* and the *dragon* (*le cocodrill*, worm, orm,
lindworm) became symbols of the satanic. Furthermore, the artists blended in not only
animal forms, but dead things like barrels, beer mugs, and cooking pots with human
heads and human forms in the strangest way. In such mosaic compositions they wanted
to epitomize the endless absurdity and rupture of evil. What a wealth of curious,
bizarrely grotesque grimaces Hieronymus Bosch, the Bruegels, Teniers and Callot have
created in this domain! Such fantastic informality was also applied to the representation
of the temptation of saints by demons that wanted to take possession of them, and no
less on the representation of Hell to make visible the torments of the damned. [377]
One was inexhaustible in symbolic representations of the vices and their punishments.
Dante still has much that is antique in his hell, which stares one in the face in the
drawings to the *Inferno* by John Flaxman. Here rules still a plastic art of seeing and
grouping. Conversely Brueghel has transferred elements of the Christian hell to the
antique Tartarus in his *Arrival of Proserpine*.[253] In the beloved temptation story of Saint
Anthony, the swarm of kobolds, larvae, devils and she-devils, which are supposed to
objectify for us the inner struggle of the saint, are given a central point in the figure of
the devil who tries to tempt the recluse to lust in the form of a beautiful woman. This
seductive beauty is, however, supposed to betray her true home in small traits: thus the
horn that rises from the mass of curls, thus the tail that peeks out from the train of her
velvet dress, thus the horse's hoof that profiles itself through the skirt. But more than
such symbolic attributes, bodily position, gestures, features, and the woman's look as
she offers the hermit a cup allow one to recognize the sham-being of infernal beauty,
which harbours death and misery in itself. Callot (* NOTE 87) has shown in his
handling of this subject an exuberance of crazy inventions (see Figure 12).

He has painted a great rock fissure, which in the distance offers the view of a world
molested by fire and flood. In the right foreground, forced into a corner, we see Saint
Anthony defending himself against the vices, who would like to clap him in chains and
take him away. He seems just about to assert his victory over the devil of lust. In a dark
corner [378] of the rock face a rat-like animal rears its head, with spectacles on its
snout, and cocks a gun, with the vicious intent of shooting from its hiding place. On a

[251] Rosenkranz gives the less common spelling for the demonic name, originating perhaps from an
honorific name for the god Baal. Corruptions of the more common spelling Beelzebub have been
interpreted as the 'Lord of the Flies' which inspired not just William Goulding, but Rosenkranz's
comment on Eschem a few paragraphs earlier.

[252] The frescos by Andrea Bonaiuti and Antonio Veneziano are in a fragmentary state after a fire swept
the Pisan Camposanto as a result of Allied bombing in July 1944.

[253] Rosenkranz may have meant Jan Brueghel the Elder's 1594 *Orpheus Singing before Pluto and
Proserpine* in the Palazzo Pitti, Florence. Pieter Brueghel the Younger also painted the *Rape of
Proserpine* with fiery effects reminiscent of his father.

Figure 12 Jacques Callot, *The Temptation of Saint Anthony* [second version], 1635, etching, National Gallery of Art, Washington, DC.

spur of the rock above the hermit's cave a strange community has gathered.[254] A naked, birdlike creature with a fat belly, long neck and an inhuman and yet human face reads out of a missal. One cannot imagine anything more hypocritical. Around this fat parson[255] gather all kinds of devils, no two of them alike, and yet alike in possessing the repulsive features of the most common sensuousness and hypocrisy. One folds his hands. Another, kneeling on the back of a traveller's donkey, seems to announce a discharge.[256] Some play clarinet on their long noses; others have an anus instead of a face, upon which they drum. On the far left of the picture we see a cliff face which bulges upwards with several recesses. On a ledge stands an entirely eccentric, martially attired being, which looks upwards, opening its grinning gullet to allow a mass of faeces to fall into it. It feels itself beatified by this condescending transmission. Right in the foreground stands a largish four-footed animal composed entirely out of pieces of

[254] There is an earlier etching (1617) with cliffs; the second (1635) version plays in a ruined basicila. Rosenkranz must have had the second version, as is clear from the dedication he mentions in his note, as well as various figures he describes.

[255] *Pfaffe* is a pejorative term for cleric unlike anything in English (its nearest paraphrase might be 'fat parson'). It is beloved of Mephistopheles in Goethe's *Faust*.

[256] Rosenkranz's memory may have played tricks on him in this obscure passage: it is the parson figure who kneels on a donkey's back, while the nearby figure holds a trumpet to its anus and carries the missal on its back: the company is in fact gathered to sing.

armour and weaponry, from whose opened jaws guns, lances, arrows, and projectiles of all sorts shoot, because a careless chap has lit the creature's hind parts with a fuse. Before this, an obscurantist crab runs forward with a lantern that spews smoke. But in the middle of the whole a hideous triumphal procession appears. On the neck and head of an animal skeleton sits a naked shape with a mirror. Is it supposed to be Venus? Two highly remarkable [379] beings pull the skeleton-wagon, the one crooked and wizened, a real beast, the other with an elephant-like foot and a claw that holds a crutch. And over all this spawn of unfettered fantasy there floats a hell-dragon, spitting out devilish beings which immediately multiply in the air, as an evil thought brings forth innumerable others.

The superhuman conception of the satanic is fundamentally as simple as the subhuman one is manifold. As fantastically as the latter might ramble, it cannot do without some connection to the human, because its subject is always human freedom, captured in its fall from its divine necessity. Painting has for this reason even given to the snake in paradise, who teaches the first pair its sophisms from its seat in the tree of knowledge, a human head with a flattering, clever, maliciously friendly physiognomy. Since for us no other form but the human exists wherein we can see the personality of the spirit, it is only an inevitable consequence of art that it represents the diabolical too in simple human form. After all, the form of the devil as an evil angel can be no other. In our fantasy the idea that the devil may take on any form, thus human form as well, is another passage to humanization. It seems that in art there were at first two different starting points; the one represented the satanic in the form of a monk, the other in the form of a hunter; the former was the clerical, the latter the worldly, national form. The former [380] meets us for example among the pictures of Boisserée's collection in a *Temptation of Christ* by [Joachim] Patinir,[257] wherein the frocked devil retains as symbol only the clawed hand, and the remaining energy of diabolical expression has gone into the individualization of the body and the physiognomy, naturally a much more difficult achievement than a representation resting on the clarification of attributes. Thus also the Dutch painter Christoph van Sichem painted Faust (see Figure 13) with the devil as a Franciscan monk, a squat form with a forceful round face full of sensuousness and malice and with a small hand that is unpleasant through the shortness of its fat, fleshy fingers (* NOTE 88).

The Mephistopheles of the old Faust legend commits with the Doctor much speculative theology about the origin of the world, the orders of spirits, the essence of sin, all the secrets of the beyond, and for all these profundities the monk figure fits nicely. Heine in his dance-poem *Faust* notes on page 87 that this side of the old legend, which is still visible in the 1604 tragedy *Doctor Faustus* of the Englishman Marlowe, must have been unknown to Goethe, and that he must have borrowed the elements of his *Faust* from the puppet play and not from the *Volksbuch*: 'Otherwise he would not have let Mephistopheles appear as such a piggish, comical, cynically sterile mask. He is

[257] The painting, once in the collection of Cologne's Boisserée brothers, who did much to promote Flemish and German 'primitives', is now in Upton House, Warwickshire. The monk has in fact perfectly human hands but a glaring white claw on his dark right foot.

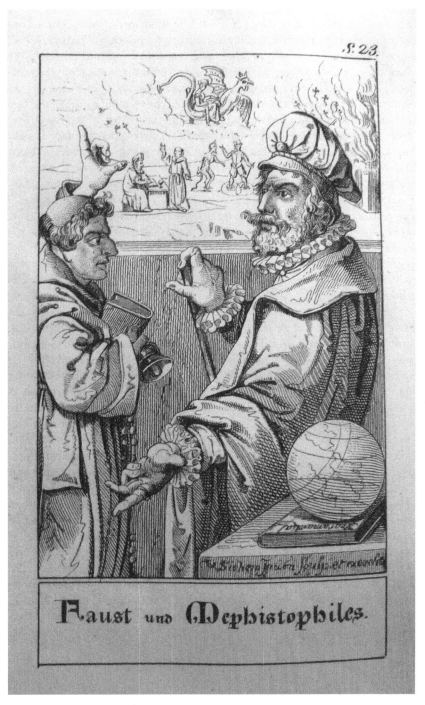

Figure 13 After Christoffel van Sichem I, *Faust and Mephistopheles* [c.1601–1624],
engraving, Johann Scheible, *Doctor Johann Faustus* (Stuttgart, 1846).

no ordinary rascal of Hell, he is a *subtle* spirit, as he calls himself, very elegant and noble and highly placed in the underworldly hierarchy, in the hellish government, where he is one of those statesmen out of whom one can make a Prussian chancellor.' This criticism is certainly wrong, for Mephisto does indeed lack the [**381**] doctrinaire theology, but by no means a metaphysical aptitude.—The other worldly starting point seems to lie in the idea of the wild hunter, who can be seen in pictures of the Upper German school in tight green hunting gear with pointed hat with a wood-grouse feather in it, and that pale, leathery, thin, pinched, pointed, satyr-like face, as well as those longish, hard hands and thin, skeleton-like limbs, who in the pictures of [Moritz] Retzsch, Ary Scheffer and the theatrical representations that follow them has become a stereotypical mask among us [Germans], and whose 'Baron with false calves'[258] [Engelbert] Seibertz in his illustrations to Goethe's *Faust* has also not managed to overcome. Since the wild devil in popular belief about devils is in fact Odin, this form of anthropomorphism was quite natural. In Calderón's *Magico prodigioso* the demon who wishes to kidnap Saint Cyprian appears in perfectly human form. In religious epics, Satan is naturally presented in superhuman form, in Milton as a warlike lord of Hell, in Klopstock's *Abbadonnah* as a demiurge overcome with melancholy feelings.

From this anthropomorphic incarnation of the devilish one must again distinguish the form it receives in that the human being itself becomes a devil, which should not be possible at all according to a shallow moral and a stupidly good-tempered theology, but in fact happens all too often. Indeed, it is terrible but true that we humans rise up against our divine origin and can be insatiable in our hunger after I-ness.[259] Not single moments [**382**] of evil come into play here, as in the case of lust, tyranny and the like, but the abyss of absolute, conscious selfishness. From this form, one direction concentrates more on actions, another more on satanic artiness. In the former vein, art generates characters like Judas, Richard III, Marinelli, Franz Moor, the Secretary Wurm, Francesco Cenci, Vautrin, Lugarto, and others, in the latter category, ruptured souls like Roquairol, Manfred, and so on. In the active villains there is still a certain naïve health of negative principle, but in these contemplative devils evil transforms through the sophistic play of a bad and hollow irony into hideous decay. Out of the restlessly exhausted, greedily impotent, overfull and bored, elegantly cynical, pointlessly educated, flippantly corrupt person of today, who obeys every weakness and flirts with pain, an *ideal of satanic jadedness* has developed, who in the novels of the English, French and Germans steps forward with the demand to be considered noble, especially since these heroes tend to travel much, eat and drink very well, are well-groomed, smell like Patchouli and have elegant man-of-the-world manners.[260] But this noblesse is nothing but the newest form of the anthropological hypostasis of the satanic principle. The 'beautiful disgust' of this diabolic style, which throws itself intentionally into sin in

[258] That is, the form in which Mephistopheles courts Gretchen's neighbour Marthe.

[259] Rosenkranz's term *Ichheit* is a neologism in German as well.

[260] Rosenkranz's list is not just timely but prophetic: the extreme forms of this kind of amoral dandy, from Huysmans to Gide, were a half century in the future.

order to then enjoy the sweet shivers of remorse, the contempt for humanity, the devotion to evil, only to wallow in the arid feeling of universal depravity, the genius of insolence which leaves morality to the philistines, the fear before the possibility of a true story, the disbelief in a living God who reveals himself in nature [**383**] and history, this entire ugliness of the torn and slurred world-weary one has been splendidly characterized by Julian Schmidt in his *Geschichte der Romantik* [History of romanticism], 1848, Vol.2, 385–9. He finds the beginning of this aesthetic Satanerie in Lovelace.[261]

The dissolution of the diabolical in humour lies already in an original contradiction. Its project of trying to ground a state of exception in the universe seems so much the more foolish, the greater the formal reason and will are that are at work in it. Against the sublimity of divine wisdom and omnipotence, devilish intelligence and force profiles itself as nothing more than a duodecimo-all-knowingness and miniature-omnipotence. The means it applies for its ends help in the end to realize the opposite. This is the angle from which Christian art has principally grasped the representation of the devil. The Middle Ages developed their humour essentially thus. Vice was attributed to the devil as to a fool, and from him the later clown and lout developed. The devil always comes up short, despite his great efforts, and is in the end the butt of laughter, after he has prepared embarrassments for others. The people in its legends make him out to be *poor and dumb*, but also the *funny* devil. In Ben Jonson's *Dumme Teufel* [The dumb devil, really called in English *The Devil is an Ass*] (translated by [Wolf Graf von] Baudissin in *Ben Jonson und seine Schule* [Leipzig: Brockhaus, 1836]) the devil is deceived by everybody and finally is brought to prison, from which Satan must free him. In the English puppet show, Punch beats the devil and sings:

Yoohoo! Gone's the despair
For even the devil is dead![262] [**384**]

In the Middle Ages the figure of the devil, whose power the Christian religion knew to be overcome, was granted a licence to critique that which otherwise was frowned upon. Later this humour had to be laid down in concrete human individualities, as simultaneously the dark side of evil was laid down in real humans. Thus the devil eventually became superfluous in art. He has shrunk, even in humour, to an allegorical person who is only allowed a certain poetry in baroque and burlesque compositions, as for instance, Grabbe in a comedy[263] has the grandmother of the devil come up with the bright idea of scrubbing hell clean. His highness the son is sent for to the upper world for the duration. But since there it happens to be cold, the devil, spoiled by the warmth

[261] Rosenkranz must be getting this from Schmidt, 385, who writes: 'Since Lovelace, novel writers have made efforts to create an aesthetic villain.' He must be referring to the villain of Samuel Richardson's *Clarissa* (1748), who rapes the titular heroine.

[262] The couplet differs only in its first word (the Latin *Vivat*, 'live long!' instead of the childish *Juch he*) from that cited by the great traveller and eccentric Prince Hermann von Pückler-Muskau, *Briefe eines Verstorbenen*, vol.3 (Stuttgart: Hallerberger, 1831), 152.

[263] *Scherz, Satire, Ironie und tiefere Bedeutung*, in Dietrich Christian Grabbe, *Dramatische Dichtungen*, vol.2 (Frankfurt am Main: Johann Christian Hermann, 1827), 53–190.

of hell, promptly freezes and lies down in this state on the roadside. A very enlightened village teacher, who has long emancipated himself from belief in the devil, finds him, considers him a *curiosum naturae* [curiosity of nature] and takes him home, very cheered over such a rarity. Here the devil thaws, which gives rise to very ridiculous situations. The Parisians have also known how to make of the devilish element very charming and graceful sketches, the so-called *diableries*, fantastic shadow-pictures in the manner of the *ombres chinoises*. They also make a variant of the Brueghel-Callot-Hoffmann manner of distorted image, which the French have capriciously decided to take for real romanticism. At the end of this short aesthetic phenomenology of the devil we would like to describe such a *diablerie* by Nicolet, which has become available to us Germans as well thanks to [August] Lewald's *Europa*, 1836, Vol.1, Supplement to the first volume. We [385] find ourselves at a brilliant ball, which presents to us enamoured pairs in the most manifold attitudes. Suddenly, in the colourful press of dancers there appear three horrifying devils, who sit one upon the other and start up a hideous concert with barrel organ, French horn, Turkish drums and triangles. After them comes a funny thing with large bells in its hands. After it comes a devil that beats the rhythm with a cooking fork and chains; other devils amplify this orchestra by drumming on kitchen pots, using casseroles instead of kettledrums, and blowing on funnels. Three crazy, wild witches, who are indeed not unpleasant to look at, laughingly pull a foul, bristling, howling devil after them into the hall. They have laid a rope around the body and tie him up properly. Hardly has he reached the middle of the hall, that all women press forward to beg him that he practise the benevolent procedure of rejuvenation on them. The devil grabs the women, locks them in a great basket and puts in the middle of the hall a colossal mortar, from which a pipe leads into an adjacent receiving dish. A devil proceeds to throw the women into the mortar, wherein the grisly chief devil mashes them with wild, derisive laughter.—A masked procession follows, as it can only be conceived by the most uncurbed fantasy. First a devil on stilts; then a Chinese smoking tobacco, riding on a dwarf skeleton; an Amazon on an ostrich walking on stilts; a delicate little whore carrying a devil piggyback; an old venerable gentleman with *paraplui* [umbrella] and dagger, trotting in quite elegantly on a hoopoe bird, and finally a long series of bird-, ape-, and dog-devils, skeletons, spray-devils, airy figures. Amidst [386] this crazy haunting there appears a thick Beelzebub with a champagne coupe in his hand; a giant skeleton in rider's boots takes up a post across from him brandishing a champagne bottle; the cork shoots into the air and flies, scorpions, snakes, little devils, bedbugs, fleas bubble out of the bottle and land in the proffered glass. In the end a sylphide enters and dances a delightful solo. But suddenly a devil jumps forth with a hunting whip. The sylphide loses her wings and receives arms instead. The whip cracks and the dancer must now stand, walk, and dance on her arms. Everywhere similar sylphides float in the air, driven by hellish bellows and air-devils, whom one sees standing on dagger's points one moment, jumping through hoops the next, until finally the devils swing onto scaly dragon-ghosts, which in turn grab the dancers in their claws and fly forth:

'That is the fate of beauty on this earth.'

C. Caricature

Beauty appears either as the sublime or the pleasant, or as the absolute, which reconciles the opposition of the sublime and the pleasant in itself to a perfect harmony. Not so transcendent as the sublime, not so comfortably accessible as the pleasant, in it the infinity of the former becomes dignity, while the finitude of the latter becomes grace. Dignity can however be at the same time graceful, and grace dignified. Ugliness as the [**387**] second-born[264] is in its concept dependent on beauty. It perverts the sublime into the mean, the pleasant into the repulsive, and absolute beauty into caricature, in which dignity becomes bombast and charm becomes coquetry. Caricature is insofar the peak in the conception of ugliness, but for that very reason, through its definite reflexive relation to the positive counter-image it distorts, it constitutes the transition to the comical. In every form of ugliness a point has been revealed to us where it can become ridiculous. The formless and the incorrect, the mean and the repulsive, can create through self-destruction a seemingly impossible reality and with it, the comical. All these determinations pass over into caricature. It too becomes formless and incorrect, mean and repulsive through all the gradations of these concepts. It is inexhaustible in chameleonic turns and connections of the same. Petty magnitude, feeble strength, brutal majesty, sublime nullity, clumsy grace, delicate coarseness, sensible nonsense, empty fullness and a thousand other contradictions are possible.

Insofar, we have also indirectly discussed the concept of caricature in all that came before. More precisely, however, this consists in the *exaggeration* of one moment of a form to formlessness. But this definition is still too narrow, even if it is right in general. Exaggeration namely has a limit. In itself it is the quantitative change, be it increasing or decreasing, of a quality as a determined quantum, a change that is connected to the essence of the quality itself.[265] Measureless change, as endless increase or decrease, ends up by issuing in the destruction of the [**388**] quality of the quantum, because there is an inner relation between the quality and the quantity. Quality is itself the boundary of quantity. We thus find it ridiculous that a quality in its simplicity should have a comparative.[266] Relatively indeed it can contain degrees in itself, but absolutely it can only be one. Gold as such cannot be more golden, marble not more marble-like, omniscience cannot be more omniscient, a triangle more triangular, and so on. A Sunday hunter goes to a grocer to buy buckshot. This one offers him various sorts; one is much pricier, but also superior. Such a gradual difference is possible here. Should the grocer, however, recommend one sort for the reason that it shoots *deader*, the comparative is ridiculous, for no dead thing can be deader than dead. That said, it depends on the more precise circumstances, which can make this comparative, ridiculous here, appear in an entirely different light. If among the Russians, who have

[264] Rosenkranz has *secundogenitur*, that is, what follows the primogeniture or first-born.

[265] This formula seems to be saying that the unit of exaggeration is determined by the quality at issue: thus, a nose, as protrusion from the face is exaggerated by being made more protrusive (or less in the case of a stub nose).

[266] I.e., we compare two colours, but not colour with sound, at least not quantitatively, in the absence of a common unit of measurement (the so-called *tertium comparationis*).

abolished the death sentence, a person is sentenced to several thousand blows and the soldiers in the end are striking only a corpse, which is pulled through their ranks on a condemned man's cart,[267] so is this deadly beating of a dead man, only in order to carry out the sentence, certainly not something ridiculous. Exaggeration as enlargement and amplification, as miniaturization and weakening as such, is thus not yet caricature. The athletic enhancement of bodily force is so little a distortion, as the waning force of an invalid. A fortune of Rothschildian proportions is as little a caricature as a massive debt. Swift's giant people of Brobdignac and his dwarf people of Lilliput are fantastic beings, [389] but no caricatures. The diseased organism exaggerates the activity of a suffering organ, the passionate exaggerates his feeling for the object of his affection, the licentious, his dependence on a bad, reprehensible habit. But no one will call tuberculosis a distortion of leanness, patriotic self-sacrifice a distortion of love of fatherland, or prodigality a distortion of generosity. Exaggeration alone is an indefinite, relative concept. If one were to stop with it, then floods, hurricanes, firestorms, plagues and so on would also have to be caricatures. To ground caricature, then, to the concept of exaggeration there must be added another, namely that of the *incongruity* between one moment of a form and its totality, thus a cancellation of unity that should exist according to the form's concept. For instance, if the whole form were enlarged or shrunk uniformly in all its parts, the proportions in themselves would remain the same, and thus, as in those figures of Swift, nothing really ugly would result. But should one part come out of the unity in a way that cancels out the normal proportion, which persists unchanged in the remaining parts, a displacement and slanting of the whole emerges which is ugly. The disproportion forces us again and again to perceive subliminally the proportional form. A forceful nose for instance can be a great beauty. Should it become too large, however, the rest of the face disappears behind it. Involuntarily we compare its size with those of the other parts of the face, and judge that it should not be so large. Its excessive size [390] makes not only it, but the face to which it belongs, into a caricature, as Grandville in the *Petites misères de la vie humaine* [Small miseries of human life; Paris: Fournier, 1843] so delightfully drew the social embarrassments of such an oversized nose.—Exaggeration will thus have to lead to disproportion. Only, here too another qualification is necessary. A mere misunderstanding namely could also result in a simple ugliness, which could not yet by any means be called a caricature. Anything that is mean or repulsive would otherwise be able to claim this designation, being in general as it is a distortion of the beautiful. That in daily life we talk this way and also the simply ugly is berated as caricature, is no reason not to handle the concept more rigorously in science. Here only that misform can be called caricature, which reflects a determined positive opposite, and deforms its components into ugliness. But not an isolated anomaly, disorderliness, or failed relation is sufficient; much rather the exaggeration that distorts a form must work dynamically, affecting negatively the totality of the form. Its disorganization must become organic.

This concept is the secret of the generation of caricature. In its disharmony, through the *false dependency* on a moment of the whole, a certain harmony ensues nevertheless.

[267] Rosenkranz's *Armensünderkarren*, literally poor-sinner's cart, is one of a series of such colourful words in German (e.g. *Armensünderstühl*, the chair of the accused).

The crazy tendency, so to speak, of one point creeps into the other parts as well. A false centre of gravity develops, towards which everything in the form begins to gravitate, thus bringing about a more or less thorough distortion of the whole. Acting in *one* perverted direction, this [391] soul of deformity produces not merely one single, especially conspicuous ugliness, but rather penetrates the whole with its abnormal disfigurement. In general, we will recognize here a double means of deformation, *usurpation* and *degradation*. The former pushes a phenomenon into a higher form than can be assigned to it by virtue of its essence; the latter brings it down into a lower form than should be assigned to it by virtue of its essence. Usurpation screws up an existent being to the contradiction of seeming more than its genuine being allows it to be. It affects an essence not originally belonging to it. Degradation throws an existent being into the contradiction of entering a sphere that according to its primitive standpoint it has already surpassed. Usurpation and degradation are thus not identical with potentiation and depotentiation. *Potentiation* is normal augmentation. The medieval legend of *Gregorius auf dem Steine* [Gregorius on the stone], for example, which Hartmann von Aue adapted into German, and which continues to circulate as a chapbook, is a Christian potentiation of the ancient Oedipus legend, but by no means a caricature of it.[268] In the same way, Euripides' way of dealing with the material of the Oresteia and the Oedipody is compared with the Aeschylean treatment of the former and the Sophoclean of the latter a poetic depotentiation, but by no means a caricature of either of them. Another determination is thus necessary to make the too high or too low aim of deformity into caricature, and this will be the *determinate comparison* which distortion must provoke. All determinations of ugliness, as reflective concepts, contain [392] in themselves a comparison with those positive concepts of beauty that they posit negatively. The petty has in the great the measure in which it is reflected, as does the feeble in the strong, the low in the majestic, the clumsy in the cute, the dead and the empty in the playful, and the hideous in the charming. Caricature on the other hand no longer has its measure only in a general concept, but rather demands the determinate relation to an *already individualized concept*, which can have a very general significance, a great scope of application, and yet must come out of the sphere of mere conceptuality.[269] The concept of the family, of the state, of dance, of painting, of greed, etc., cannot as such be caricatured. In order to see the prototype in the distorted image, there must step in between its concept and the distortion at least that individualization which Kant in the *Critique of Pure Reason* called the *schema*.[270] The prototype cannot remain the merely abstract concept, it must have taken on a form that is in some way already

[268] The Middle High German epic by the knight-poet Hartmann von Aue (c. 1190), adapted from an unknown French source, tells the tale of a child of incest who makes his heroic way home and unwittingly weds his mother, then does seventeen years of penance chained to a rock. Christianity comes in not only through the characters' acts of remorse (the brother-father dies in a crusade, and the mother undergoes repeated penance), but also through the happy ending: the mother is forgiven and Gregorius elected Pope.

[269] In other words, it is concepts for *specific objects* that lend themselves to caricature.

[270] Kantian 'schematism' is nearly the opposite of how the word is used today (i.e., to mean abstraction and simplification): it is the making concrete of the pure categories of reason so that they may apply to objects of perception in space and time.

individual. But what we here call the prototype for the distorted picture is not to be taken in an exclusively ideal sense, but rather in that of a *positive background* as such, for it may itself be a thoroughly empirical phenomenon. Aristophanes in his *Clouds* ridicules non-philosophy, sophism, the unjust Logos. As distorted image of the philosopher he deploys Socrates. This Socrates, who steals cloaks on the Palestra, who calculates the flea's leap, who teaches how to make the crooked straight, who in order to be closer to the ether, floats through the air suspended in his study, which is a cheese basket, who dupes his disciples, is indeed not the same Socrates with whom he celebrated enthusiastic [393] symposia. But from one point of view he *is* the same Socrates, for his form, his bare feet, his staff and beard, his manner of dialecticking, all this Aristophanes has borrowed from him and thus created a real caricature. Philosophy, in general, cannot be caricatured, a philosopher on the other hand, very well. The most general, eminent, and for the public the most familiar form of appearance of philosophy, a philosopher, his dogmas, his method, his way of life; as Palissot in his *Philosophe*[271] caricatured Rousseau's nature gospel, and [Otto] Gruppe in his *Die Winde* [The winds][272] caricatured Hegel's lectern-style. For Aristophanes, Socrates was the schema, the transition to poetic individualization. Socrates possessed sufficient philosophy and urbanity to attend the premiere of the *Clouds* and even to stand up in the theatre, so as to make the comparison easier for the public. Had Aristophanes only devised an abstract sophist, his figure would have lacked the individual depth.

Be that as it may, we must immediately recognize a distinction between caricatures that belong to the world of real phenomena, and those belonging to the world of art. The real caricature also represents for us the contradiction of a phenomenon and its essence, be it through usurpation or degradation. This is however a very involuntary caricature. All those knights of industry,[273] precocious children, pedants of learnedness, pseudo-philosophers, pseudo-reformers of the state and the church, pseudo-geniuses, forced-amiable beauties, eternally eighteen-year-old girls, overeducated intellectuals, and so on, as they perpetually arise out of the corruption of every culture, all works that comprise only the realization of the [394] contradiction of their concept, all these existences are certainly caricatures. Only, as empirical existences they are so interwoven with reality in every direction, that they contain in themselves also a quantity of very different, often highly respectable relations. Thus one must distinguish from them aesthetic caricature as the *product of art*, which is purified of the contingencies of empirical existence and that pithily emphasizes that one-sidedness around which everything turns. The standpoint of art for its creation of caricature is therefore the *satiric*. All concepts that belong to satire belong consequently to caricature. All modifications of tone that are possible for satire are also possible for caricature. It can

[271] Charles Palissot de Montenoy, *Les Philosophes: Comedie* (Paris: Duchesne, 1760).

[272] In full: *Die Winde, oder ganz absolute Konstruktion der neuern Weltgeschichte durch Oberons Horn, gedichtet von Absolutus von Hegelingen* (Leipzig: Haack, 1831).

[273] *Industrieritter*, the German for *chevalier d'industrie*, combines two frauds typical of the epoch: a self-made man affecting aristocracy, and a confidence man affecting wealth. See 'Nomen Nescio: Die Industrieritter. Nach dem Franzosen Arago', *Morgenblatt für gebildete Leser*, vol. 27, No. 78 (1 April 1833), 309 and No. 81 (4 April 1833), 323.

be cheerful and bleak, sublime and low, sharp and mild, rough and polite, clumsy and witty. But it would be a false limitation to seek caricature only in the works of painting, as happens to Paulin Paris[274] in his introduction to the *Musée de la Caricature en France* [1834], when on page 1 he says: 'Caricature is, on its most expansive construal, the art of giving to the imitation of nature and the expression of sentiments and habits the character of satire. This art cannot be much later than the invention of painting. As soon as one had grasped the ideal in its relations to beauty, one has felt a need for the ideal to be related to physical and moral ugliness. Nevertheless the word *caricature*, of Italian origin, is a quite new French word. Admitted since the sixteenth century into the language of the arts, it is only in our days that it has become academic and that as such it has taken its place among the ordinary expressions of conversation.'[275] **[395]** This limitation to painting is promptly disproved factually by Paris himself, in that he discusses the novel *Fauvel, Le pélérinage de la vie humaine* [The pilgrimage of human life] and *La danse macabre* as satirical works, from which miniature painting took the material with which manuscripts are decorated. Poetry is as capable of caricature as painting, indeed due to its more intellectual means of representation it is able to achieve this with far broader scope and more incisive depth. *Die Geschichte der komischen Literatur* [The history of comic literature] of C.F. Flögel, 1784, 4 vols., contains especially the history of satirical literature and with it of poetic caricature. As for the word 'caricature', we Germans have picked it up from the Italians by French side-paths. In Italian it is derived from *caricare*, to overload; the French have for caricature the similar word *charge* in circulation. We Germans earlier had for caricature the expression after-picture (*Afterbildniß*).[276] Among painters, long before Hogarth, Leonardo da Vinci had an especial inclination to the observation of the ugly as a means of caricature and his drawings in this vein, mostly head studies, have been frequently published since Caylus.

Of nature one can only say figuratively that it brings forth caricatures. When its reality does not reach its concepts, ugliness and under specific conditions even humour can result, as we convinced ourselves earlier, but a real caricature would presuppose the possibility that the deformation could have been caused by freedom. We call the ape a distorted picture of man, only we know very well that this can only be said in jest. **[396]** The ape is no ugly, degenerate human, and it is impossible to write a satire on the ape, because, for one thing, it cannot be otherwise than it is, and because we cannot demand from it that it be less ape and more human. But the satire of a depraved man can very

[274] The famous medievalist Alexis Paulin Paris (one pronounces the final 's') was a bitter opponent of Grimm's German school of medieval studies, insisting that French narratives like Reynard the Fox had been dumbed down in their Dutch and German adaptation.

[275] In the original: 'La caricature est, dans son acception la plus étendue, l'art de donner à l'imitation de la nature et à l'expression des sentimens et des habitudes le caractère de la satire. Cet art ne doit pas être de beaucoup postérieur à l'invention de la peinture. Dès qu'on a compris l'idéal dans ses rapports avec la beauté, on a dû sentir le besoin de l'idéal dans ses rapports avec la laideur physique et morale. Cependant le mot *caricature*, d'origine italienne, est d'un Français assez nouveau. Admis, depuis de seizième siècle, dans la langue des arts, c'est de nos jours seulement qu'il est devenu académique et qu'à ce titre on l'a vu prendre rang parmi les expressions ordinaires de la conversation.'

[276] *After* means rear or anus as well, but *Afterbild*, according to Grimm, relies on a defunct usage identical to the English, according to which it means a weak imitation. A scatological connotation, however, is not to be discounted in modern German.

well degrade him to an ape, because he, against his concept, degrades himself to one. Of the cretin it can already be said with more justice that he is a caricature of the human, because he, according to his essence already human, according to appearances is sunken into animality, whereas the ape, approaching the human in form, remains distinct in essence. If some animals appear as total distortions of their type, there is mixed up with this usually the compulsion humans exercise upon them, and this compulsion again cancels out all aesthetic freedom. When in a livestock show we see pigs, or in the Parisian mardi gras oxen, who suffocate in their fat, we find such masses of flesh only ugly, or perhaps comical, but they are not genuine caricatures. To see a horse, who once whinnied along martially to the fanfares of the regimental bugler, as a run-down nag, having to pull the garbage-collector's cart through the streets: it is a sad sight. A pug dog, who through a sybaritic indoor life has become fat and shameless, who through the pampering of ladies has become demented in his dog nature, will represent for us a hideous unnature, but we will only improperly call it a caricature.

Art, however, will indeed make especial use of the animal world in order to express satire of humans through travestying and parodic caricature. Satire [397] ridicules the null and void in itself through its own exaggeration, with which it covers up its impotence and thus turns into ridiculousness. The animal is very fit to represent, very decisively, certain imbalances and vices. The higher, nobler characteristics of man are less adequately expressible through the animal analogy than the stirrings of a limited, selfish egoism. But the animal realm is sufficiently large and varied to be able to bring into play good characteristics and virtues as well, in order to be able to offer a rather complete counter-picture of human activities. The Orient, antiquity, the Middle Ages, and modern times have all equally loved their reflections in an animal mask. The *Batrachomyomachia* [Battle of Frogs and Mice] of the Homerides is one of the oldest and greatest of these works. Old Comedy made use of such animal masks in its choruses, as the *Wasps* and *Frogs* of Aristophanes still bear witness. Among the small genre pictures of Pompeiian wall painting there are many grotesque animal scenes that shade into the satirical. A hoopoe proudly drives a *biga* [two-wheeled Roman war chariot], which is pulled by goldfinches, butterflies and gryphons. A duck hurries toward a barrel, eager to drink; a bell jar hinders it, and it stands there full of disappointed expectation, and so on. An exquisite picture mocks the pious Aeneas, as he leaves behind the burning ruins of Troy with his father Anchises on his shoulders and the little Ascanius holding his hand. Aeneas and Ascanius are represented as dog-headed apes, Anchises as an old bear.[277] Instead of the patriotic Penates, the latter has rescued from the flames a game of dice. The interpretation of this picture as a [398] satirical caricature on the imperial family, and incidentally on Virgil, as Raoul Rochette attempts it in *Musée secret de Pompéi*, p. 223–26, seems to us too far-fetched. For why should not the *pius Aeneas* as such be already open to ridicule, since the ancients in such pictures did not spare even the gods? The sculpture of the Middle Ages has applied in the churches a quantity of

[277] Rosenkranz probably saw a print (in Panofka, his note 68) of the fragmentary mural: Anchises is in any case of the same species as Ascanias, and Aeneas's pronounced snout is that of a baboon. He and Ascanias are also outfitted with prominent phalluses.

similar grotesques to ridicule the Jews and parsons. In the wolf and fox fables, poetry has summed up the parody of the world and its ways through the animal form into a universal picture, which in our days through the genius of Kaulbach has not just been illustrated in painting, but intensively further composed.[278] He has drawn the animals true to nature and to the same extent humanly true, developing in the process an admirable humour, which emerges in autonomous inventions. How delicious is the great banquet, where the elephant pours a bottle of champagne down its gullet! How delicious the still-life of the royal family (see Figure 14), with the mother lion lying in

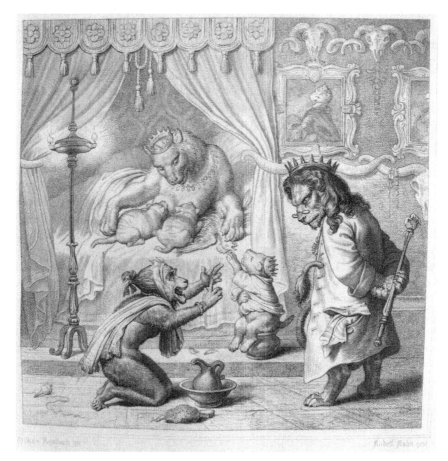

Figure 14 Adrian Schleich after Wilhelm von Kaulbach, *Reynard Fox (the Royal family)*, engraving in Wolfgang von Goethe, *Reineke Fuchs* (Stuttgart: Cotta, 1846).

[278] History painter Wilhelm von Kaulbach (1805–1874) drew 36 illustrations and many vignettes for Cotta's 1846 edition of Goethe's 1794 hexameter adaptation of the *Reynard* story, *Reinecke Fuchs*, to which Rosenkranz's example refers. The edition was a success, especially after an inexpensive printing in 1857, that is, after the *Aesthetics of Ugliness*.

bed, King Noble with spectacles on his nose pacing anxiously and the little crown prince at the very moment sitting on the chamber pot!

Among the French, Grandville has achieved extraordinary results with his *Political Animals* and his illustrations to Lafontaine's *Fables*. His art of melding human form and clothing with animal form is inimitable. He paints, for instance, two cocks as peasants, who throw punches at each other, but nevertheless the peasants remain cocks, for he has set cock's heads on their heads and strapped spurs on their feet.

Another, no less effective means of parodic caricature are since time immemorial the *marionnettes*, [**399**] as one can convince oneself from Charles Magnin's *Histoire des Marionnettes en Europe depuis l'antiquité jusqu'à nos jours* [History of marionettes from antiquity to our days], Paris, 1852. The marionettes on the fairs of St. Germain and St. Laurent, whose chronicles Magnin has excerpted at p. 152–169, parodied not only high tragedy, like the Oresteia, Merope, and so on, but also high comedy, for instance Molière's *Médécin malgré lui* [Doctor in spite of himself].

Between *parody* and *travesty* there is the difference that parody only perverts the general, travesty also the specific. Travesty is thus every time parody as well, but parody is not also travesty. Shakespeare's *Troilus and Cressida* parodies the heroes of the Iliad, but does not travesty them. The noble princes appear as sensuous, brutal, stage fighters, Helen and Cressida as loose, ambiguous whores. The shabby, nagging Thersites makes with his satiric observations the humorous chorus to the intellectually impoverished goings-on of the famous heroes. Shakespeare has exaggerated the characteristic features found in Homer, and with this *charge* has made the heroic pathos of Homer ridiculous. The pride in strength of Ajax, the ruling office of Agamemnon, the cockiness of Menelaus, the friendship of Achilles for Patrocles, the knightly addiction to adventure of Diomedes are dissolved in boastful phraseology, and the immoral in all these circumstances is mercilessly exposed. This caricature is parody. The travestying caricature on the other hand pursues the content also into detail in order to pervert it, as Scarron and Blumauer have done with Virgil's *Aeneid*, and Philipon and Huart with Sue's *Juif errant* [The Wandering Jew]. In nine small books they have summarized the complex [**400**] novel, telling its major events once more step by step, in the meanwhile exposing every mistake in its composition, unmasking all the contradictions and improbabilities and very delightfully underlining the ugliness in its persons through exaggeration. The animal tamer Morock, the old soldier Dagobert, the ethereal Adrienne de Cardoville, the bow-legged Mayeur, the Indian prince Djalma, but especially the brutal-energetic Jesuit Rodin, who is cleverer than all, become in the drawings of Philipon the most hideous-ridiculous grimaces. This is also parody, but travestying (* NOTE 89).

Concerning the concept of the grimace, Kant seems in his *Beobachtungen über das Gefühl des Schönen und Erhabenen* [Observations on the Feeling of the Beautiful and the Sublime, 1764] to have extended it too far, when he says: 'The quality of the terrible-sublime, when it becomes entirely unnatural, is adventurous. Unnatural things, insofar as the sublime is meant in them, whether it is achieved only little or not at all, are grimaces.' 'I want to make this—through examples—somewhat more comprehensible, for the reader missing Hogarth's burin must make up through descriptions what he lacks in graphic expression. The bold undertaking of dangers for our own rights, those of the fatherland, or those of friends is sublime. The crusades, the old knighthood were

adventurous: the duels, miserable remains of the latter on the basis of a perverted concept of honour, are grimaces. Melancholy withdrawal from the noise of the world out of a justifiable surfeit is noble; the reclusive devotion of the old hermits was adventurous: cloisters and analogous tombs to lock up living saints in are grimaces. Overpowering of one's passions through principles is sublime: self-chastisements, [401] vows, and other monkish virtues are grimaces. Holy bones, holy wood and all similar junk, the holy faeces of the great Lama of Tibet not excluded, are grimaces. Of the works of wit and of fine feeling, the epic poems of Virgil and Klopstock fall among the noble, those of Homer and Milton among the adventurous: the *Metamorphoses* of Ovid are grimaces, the fairy stories of French lunacy are the most miserable grimaces ever hatched. Anacreontic poems are generally near to foolishness.'[279] This treatment of the grimace-like as something unnatural, but ostensibly sublime, particularly from the moral point of view, certainly goes too far beyond the borders of the aesthetic determination of this concept. According to Kant, there is little to stop us from having to call all that is fantastic a grimace. We would only give this name in part to those distortions that turn into the undulistic, in part to those that disfigure normal or noble forms into a repulsive ugliness. In the first form, the grimace can be very humorous, as for instance in Töpffer's brilliant drawings and in quite a few of Jean Paul's figures; in the second form it can also arouse our laughter or at least a smile in virtue of other relations, and yet have an uncomfortable aftertaste that does not let us come to rest pleasantly with such forms, but hurry away from them to others. In a small conversational novella, *Die guten Weiber* [The Good Women], Goethe has treated this point (*Goethe's Werke*, Vol.15, 263ff).[280] He here has a social gathering argue for and against ugliness. Fantasy and wit would be better justified in busying themselves with ugliness than with [402] beauty. Out of ugliness much could be made, out of beauty nothing.[281] The latter could make something out of us, the former could destroy us, and caricature could leave an indelible impression that is thoroughly deplorable. One of the interlocutors asks: 'But why should pictures be better than we are ourselves? Our spirit seems to have two sides, which cannot subsist the one without the other. Light and darkness, good and evil, high and deep, noble and low and so many other oppositions seem, only in variable portions, to be the ingredients of human nature, and how can one blame a painter who has painted an angel white, light and beautiful, and then the idea comes to him to paint a devil black, dark and ugly.

> *Amalie.* Against that there would be nothing to say, if the friends of uglification did not pull into their territory that which belongs in better regions.
> *Seyton.* In that they act quite rightly, it seems to me. For the friends of beautification also pull over to them what can hardly belong to them.

[279] In Rosenkranz's edition of Kant's writings, *Sämmtliche Werke*, Vol.4 (Leipzig: Voss, 1839), first passage at pages 407–8, second passage at page 408–9.
[280] *Goethe's Werke. Vollständige Ausgabe letzter Hand*, vol.15 (Stuttgart and Tübingen: Cotta, 1828), 263–296.
[281] Ibid., 264. The two sentences are spoken by the character Seyton, who introduces caricatures to the company. The next sentence compiles a reply on the same page by Armidoro (up to 'destroys us'), a defence of caricature by Henriette, and a critique by Amelie (p. 265). The long quotation (p. 266–7) begins with a speech by Seyton.

Amalie. And yet I will never forgive the distorters the fact that in their pictures it is mainly people that they so infamously disfigure. Whatever I try, I have no choice but to think of the great Pitt as a stump-nosed broomstick, and Fox, who in some respects is quite worthwhile, as a comfortably sagging pig.

Henriette. That's just what I said. All such grimace-pictures make indelible impressions, and I do not deny that I sometimes amuse myself by calling up these ghosts in my thoughts and distorting them even worse.' [**403**]

If caricature develops through overloading, we may view grimaces as the extreme of caricature, through which exaggeration is exaggerated and turns into the undulistic or nebulous, as this transition is correctly identified in the final passages just quoted from Goethe. The grimace as such is in any case ugly, but through its bizarre and grotesque design it can become a supreme tool of humour. How rich Shakespeare is in such grimaces! In *Henry IV* and in *The Merry Wives of Windsor* the Corporal Nym, Bardolph, Doll Tearsheet,[282] [Justice] Shallow, and the recruits, in *The Two Gentlemen of Verona* the servant Lance,[283] in *Love's Labour's Lost* Nathaniel, Holofernes, Dull and Costard, in *Much Ado About Nothing* the magistrate and constable,[284] and so forth, are nothing but grimaces, which, however, make us laugh heartily. Gargantua and Pantagruel in Rabelais as well as in Fischart are grimaces. Tieck and Boz [i.e., Dickens] are extravagant in their grimaces. Painting too has spawned countless funny grimaces. We recall only the compositions of Brueghel and Teniers. Even that fine art which seems to withstand the grimace entirely has in fact cultivated it in various forms. Those monstrous figures we have already mentioned so often, wherein medieval masons let loose their satire, what are they but the strangest, most tremendous grimaces! [Jean-Pierre] Dantan's statuettes of Nisard, Ponchard, Liszt, Brougham, and so on are grimaces. The humour of the pantomime cannot do without them. The figure of the ravenously large-mouthed, shaky, blundering, simple-mindedly clever, beat-up Pierrot, whom Domenico[285] of the Comédie Italienne in Paris put together from the costume of [**404**] Polichinelle and the character of Arlecchino, is essentially a grimace.

We distinguish caricature into the involuntary and that which art brings forth intentionally. It would however be a misunderstanding to take this distinction to mean that in the products of art there cannot be such that, without wanting to be caricatures, that is to say involuntarily, are nevertheless really caricatures. This is so far from being the case that, on the contrary, a great many artworks lose themselves in caricature against their intentions. The reason for this phenomenon lies in the essence of absolute beauty, which balances in itself the extremes of the sublime and the pleasant. To bring

[282] A prostitute and friend of Mistress Quickly who appears in the second play of *Henry IV*.

[283] Spelled 'Launce' in the original.

[284] Rosenkranz is probably referring to Constable Dogberry and his sidekick Verges, who is headborough, a kind of constable's assistant.

[285] Domenico Biancolelli (1636–1688) played Arlecchino and chronicled the Comedians' improvisations in his *Zibaldone*. Rosenkranz is wrong about Biancolelli playing Pierrot; the character, after his introduction in Molière's *Dom Juan* (1665), was played at first by the Italians Giuseppe Geratoni and Fabio Antonio Sticotti. For details, see Robert Storey, *Pierrot: A Critical History of a Mask* (Princeton, NJ: Princeton University Press, 1978).

forth the genuinely beautiful requires a depth of conception and a force of production that are very rare. Mediocrity has feeling enough for beauty, but not enough originality to bring it forth independently. For this reason it is principally mediocrity that enjoys itself in a pseudo-idealism, fancying itself to be immersed in the ideal through hollow nobility of tone and formal purity of execution. This idealism produces forms that at bottom possess only an allegorical universality, whereas they lay claim to the validity of truly living existences. It would be better if they were only allegories, for then they would not contradict themselves. They would then be only abstractions. Instead of this they demand from us recognition as natural forms full of their very own liveliness, and with that they fall into ugliness; for they deceive us with the appearance of genuine ideality. The absence of all positive incorrectness, the application of known noble forms here and there, the [405] containment of every extravagance, the domesticity of the chosen expression, the negative cleanliness with which detail is polished away deceives us over the contentlessness of the interior, and does not lead the artist to suspect that he has only brought to light ideal caricature. We have just said, and intentionally, that it is mediocrity which falls into this error, of realizing the true ideal in such bloodless shadows. Even the genius is however by no means assured of avoiding this detour, for absolute beauty really excludes from itself every extreme, and the necessity of absolute harmony can produce the impetus to a levelling that can dissolve all fresh force and peculiarity in a false refinement, in a thin play with forms, in a diseased noblesse of design.

This *fine* mode of distortion, which brings forth so much unfruitful beauty, which so often in the guise of a *eunuch-ideal* leads astray the productive forces and generally, after it has exhausted and emaciated them for a while, calls up in its wake the reaction of a wild, primordial, raw, empirical *Storm and Stress* period—this demands a particular critical attention, for it apparently offers the highest achievement. Each art naturally specifies this ideality according to the medium of its representation. To go into detail here must be left to more specialized art theory. But we want to give a few examples for the sake of clarification. As ancient art fell into disrepair, it lapsed into the *construction of hermaphrodites*, which in the end is nothing but caricature. Only in the difference of the sexes can the peculiarity of beauty perfect itself to the ideal, as Wilhelm von Humboldt showed so carefully in his excellent essay [406] on the male and female form, printed in Schiller's *Horen* in 1795[286] and now in his *Gesammelte Werke*, Vol.1, 1841, 215ff. Only in man can honour, only in woman can grace rise up to absolute purity. In its youthful period the male form, as ephebe, can take on a certain female softness, while in the period of old age the female form, as matron, can take on a certain male severity, without in any way impairing the individual truth of the sexual type. But to put together out of the male and the female ideals a third ideal, which is supposed to be neither male nor female, but rather shemale, is a temptation of fallacious reflection that inevitably leads to distortions. It remains an unnatural beginning that could only

[286] 'Über den Geschlechtsunterschied und dessen Einfluß auf die organische Natur', *Die Horen*, vol. 2 (1795), 99–132, and 'Über die männliche und weibliche Form', *Die Horen*, vol. 3 (1795), 80–103 and vol. 4 (1795), 14–40. Rosenkranz seems to cite only the latter.

flatter a race sunken into pederasty. Sculpture and painting have made a great effort to render homage to this pseudoideal, but even in works of the highest virtuosity it remains caricature. The beauty of these hybrid forms has in itself, precisely because it must have pretensions to absolute, exhaustive beauty, an almost ghostlike terror, indeed a disgust-inducing ugliness. Should an Amazon cut a breast off the better to stretch her bow, she remains nevertheless woman, indeed, like a Penthesilea, she remains capable of love. Should a man be violently castrated, he is unhappily feminized. But a hermaphrodite, who should be at once male and female, is a monster.[287] Among Pompeiian pictures we find some hermaphrodites, but also one wherein the disgust of healthy nature before such an ambiguous ideal is represented fitly: *Musée secret*, plate 13, p. 68. A [407] hermaphrodite with female headgear, with earrings, with breast-like swellings of the chest and broad hips, lies supine in a landscape upon a mound of pillows. A satyr, deceived by the appearance of femininity, has pulled away a blanket. Lustfully the hermaphrodite looks up at him, but the satyr, who has not found a nymph as he expected, flees aghast, dares not turn around and stretches the arms back defensively.[288] Art may not leave off individualization if it does not want to give up true poetry. It should represent the essence, but as a concrete phenomenon. The general as general is a subject of science, not of art. This must consequently be on guard against such generalizations that absorb the individual. In the sequel to *Consuelo*, in the *Countess of Rudolstadt [La comtesse de Rudolstadt*, 1842–44], for instance, George Sand fell into this noble but inartistic distortion. Consuelo as Zingara and her husband as Trismegistus become finally pure humans, *humans as such*. Trismegistus cried: 'Am I not *man?*[289] Why should I not say what human nature demands and thus also realizes? Yes, I am *man*, thus I can say what *man* wants and what he will achieve. Whoever sees the clouds rise can predict lightning and the hurricane. I know what I carry in my heart and what will come of it. I am *man* and stand in relation with the *humanity* of my time. I have seen Europe . . ', etc.[290] Pure, prosaic abstraction! Such works can be noble, they can be beautiful, only, their nobility like their beauty are on a detour of distortion leading to [408] the abstract. We recall here the great reputation that a statue by the sculptor [Auguste] Clésinger made in the Parisian Salon of 1847, because out of lack of a mythological or other kind of situation it was hardly permitted into the exhibition, and made a great furore. It consisted of a voluptuous woman, who lunged in lustful dreams on a rose-strewn bed. This was the reality, which one however did not quite wish to admit. What did the critics do? They claimed Clésinger had beaten an entirely

[287] This rather shrill condemnation of hermaphroditism should be contrasted with J.G. Herder's soliloquy on 'Bacchic dream and hermaphroditism' in the *Plastik* (Riga: Hartknoch, 1778), 97, inspired by the Borghese Hermaphrodite. The romantic ideas of Humboldt and Schiller proved, in their rigid contrast of the sexes, conservative.
[288] The hermaphrodite in fact lies upon a leopard skin (bolstered by one large pillow), and so may be a maenad. The lustful satyr prior to the discovery is Rosenkranz's addition.
[289] Rosenkranz writes *der Mensch*, 'the human being', true to Sand's '*l'homme*.' What is implied is not a sole human being, but something between the concept and 'all people'.
[290] George Sand, *La comtesse de Rudolstadt*, vol.4 (Brussels: Alphonse Lebègue & Sacré Fils, 1844), 154. Rosenkranz gives a fair sense of the drift, though one should complete the sentence: 'I have seen Europe and know what storms are brewing in its breast.'

new path. Friends had counselled the sculptor to have a snake coil around one of the crossed legs, so as to preserve the decency of the catalogue, since one could then think of a Cleopatra or a Eurydice, and the statue received the title *La femme piquée par un serpent* [Woman stung by a serpent]. Critics enumerated how this masterpiece was no goddess, nymph, dryad, oread, napee,[291] oceanid, 'but very simply a woman. He found, this audacious man, this fool, this madman, that here this was a sufficient subject.'[292] 'You will be struck and ravished by this type, which is neither Greek nor Roman, and which is charming, by this half-open mouth, by these dying eyes, by these passionate nostrils, by this convulsive and sweet physiognomy, which is agitated by an unknown sentiment, by this voluptuous fainting caused by the drunkenness of poison, perfidious potion, rising from the heel to the heart, and which freezes the veins in burning them.' Even with the help of the fiction of the poison, it is said openly enough that the rapture is a lustful one. 'A meticulous mind might well ask: what did she express—before the addition of the serpent? We would not know anything to say in reply. Well, perhaps! She has received squarely in her breast one of the golden arrows from the quiver of Eros.' Finally **[409]** the newness of direction that is here followed is supposed to be articulated, but this amounts only to a generality, which reveals to us clearly the danger attending to the representation of *tout bonnement une femme*, a *woman as such*.[293] 'Clésinger has through this statue given proof of an incontestable originality. The antiquity of Athens or Rome has nothing to do in his work: nor does the Renaissance. He no more starts with Phidias than with Jean Goujon; it does not resemble in the least David, nor Pradier, that belated pagan: it could be, that with the best of wills, one would find in him some connections with Coustou or Clodion, but it is far more male, spirited, and violent in its grace, far more enamoured of nature and truth. No sculptor has grasped reality in a closer embrace! He has resolved this problem of making beauty without cuteness, without affectation, without mannerism, with a head and body of our time, wherein *every man* [*chacun*] could recognize his mistress, if she is beautiful!'[294]

It is very plausible that the distortion of abstract idealism takes as its object genius and its struggle with the world. Genius is itself an ideal power. Where could then the ideal unfold more brilliantly than in a representation of genius itself? This inference appears so valid that we owe it a quantity of poems, novellas, novels, and dramas whereof the story of artistic creation constitutes the content. But since this creation is in itself something silent, mysterious, invisible, a condition, there is nothing to do but to place artists in circumstances that give them the opportunity to register their feelings, their efforts, their powerful **[410]** will through words. And how could one achieve this better than through unfavourable conditions, lack of recognition, distress, poverty,

[291] ναπη, the nymphs that live in wooded valleys, rather like oreads (mountain nymphs).

[292] Rosenkranz quotes the French of Théophile Gautier, *Salon de 1847* (Paris: J. Hetzel, Warnod, 1847), 202. The list of negations before the quote is likewise from Gautier, as is the account of the sculptor's friends. The two quotes that follows are from Gautier, 206.

[293] This is a repetition of Gautier's phrase translated above as 'quite simply a woman'.

[294] Gautier, 206-7. Though Rosenkranz comments no further, it is obvious that Gautier's strange conditional generalization—that *everyone* (naturally, gendered male in standard French) should recognize his mistress in the work, *provided* that she is beautiful—is taken to reveal a problematic vagueness in the work, or at least in its interpretation.

social exclusion and the like. Thus comes one sad opportunity after the other to speak to the unthankful world, which is not in fact worthy of possessing such geniuses, the truth and thus to satisfy the pride of the indignant spirit which is nevertheless not so proud as to renounce the applause of the thus deeply despised world. Since Goethe's *Tasso* and Oelenschläger's *Correggio* it is hard to find one somewhat renowned artist who has not been poetized into one world-weary ideal or another, and which is only one line away from caricature, insofar as it doesn't fall right into it. One of the most discussed of such noble distorting pictures is the *Chatterton* of Alfred de Vigny, after whose premiere in the Theatre Français Jules Janin wrote the following in [August] Lewald's *Allgemeine Theaterrevue*, Vol. 2, 1836, 218: 'This Chatterton is a kind of talented fool, whose vanity throws him into perdition. Instead of going to work with self-consciousness and courage, like a man who sees a future for himself, Chatterton begins to complain about people and the world. One fine day he kills himself, because he doesn't want to wait any longer. In any case this is deplorable, but at the same time it is a sad example that should never have given the material to a pathetic elegy. One simply doesn't say this enough to young people: that society doesn't owe anything to those who haven't done anything for it. The moment they feel a few verses or some prose in their heads, they believe the world should approach them with open arms and open purses, whereas it is they who should approach the world. [411] According to its nature, genius is patient; the more immortal it is, the better it knows how to wait. Where in the world is there a genius who has not waited staunchly, like old Horace, until he was next in line? Do you not drive these young impatient spirits to indignation, who do not see that youth itself is already a great good and are unthankful to heaven in not feeling happy to be young? Do not promote through your immoderate laments, through your fraudulent complaints the attempts at suicide. The death of Guilbert, Malfilatre, Chatterton has already done much evil.—From this point of view, Alfred de Vigny's *Chatterton* is a deplorable and murderous composition. Imagine a poet who goes around for five acts declaiming against society, because he has no robe and no bread. But work he has; why does he not work? Which privilege does he have, that one should go to him before one knows him by his works? A merciless creditor wants to have Chatterton thrown into prison. Why doesn't he go to prison? There he would be fed and housed and can compose poetry at will; greater poets than Chatterton lived in chains, and less comfortably. Sheridan himself, was he not a prisoner of the *Os alienum*, and was he for this reason less Sheridan?[295] The Lord Mayor offers to Chatterton the position of his first secretary, and Chatterton refuses. J. J. Rousseau was less proud; he wore the livery and was still Jean Jacques, and if he killed himself,[296] he did so secretly, in hiding, after having written *Heloïse, Emile,* and the *Contrat social.*' [412]

[295] Richard Brinsley Sheridan (1751–1816), noted author of *The Rivals* and *The School for Scandal*, MP and owner of Drury Lane until its destruction by fire in 1809, spent time in a 'spunging-house', the precursor to a debtors' prison, in 1815. See Thomas Moore, *Memoirs of the Life of The Right Honourable Richard Brinsley Sheridan*, vol.2 (London: Longman et al, 1826), 442–4. 'Os alienum', the mouth of another, is very out of context: it is from a sermon of St. Bernard praising Christian modesty: 'laudet te os alienum, sileat tuum' [let the stranger's mouth praise you while you are silent].
[296] A hypothesis advanced by Madame de Staël in her *Lettres sur Rousseau* (1788).

So much for the distortions brought about by artists under the belief of having through them realized the ideal of beauty itself. So much for the more hidden form of these caricatures and the delusions that can afflict even criticism in dealing with them. So much for the almost inevitable caricature that is imposed through the material itself. For all these reasons it follows, however, that the very same is possible for the production of intentional caricature. Since as an artwork the caricature obeys the general laws of beauty, even though its form is negatively correlated to the same laws, it follows, naturally, that there can be *bad* caricatures as well. They are the ones that get stuck in tendentious malice and ugliness of form, without raising themselves to the mirth of playful mischief. They are the ones that, in service of a prosaic bitingness, do not break loose from the finitude of a limited intention to annoy or to injure. But they are also those that do not reflect their features sufficiently sharply in the assumed counter-image, that is, that do not come off funny enough, and in their bluntness give rise to an uncertainty of reference or a difficulty of interpretation. Further there are those that must make up for the weakness of their drawing by surrounding themselves with the superficialities of symbolic padding, and through this overload run the same danger of missing the right target. Finally, those caricatures are bad, which cannot hold onto, or even hardly know how to find, the point from which the distortion of the form departs, developing from the inside out as the real irony of the concept, which in fact should be there. One hears caricature [413] spoken of as if it is a very subordinate achievement of art, as if only minor talents could busy themselves with it and as if occupation with it must corrupt one's taste. This banal opinion only has a point with regard to bad caricature, for the good kind is in truth just as hard as—all that is good and beautiful. We have to consider that, as Plato says already in the *Symposium*, the best tragic poet is also the best comic poet, that is, that the comic and the tragic spout from the same depth of spirit and demand the same force. The ancient tragedians themselves composed the customary satyr drama that concluded their trilogies. The bulk of these plays is lost. We have left only one, Euripides' *Cyclops*. It suffices to show us that caricature was the soul of this genre. Whoever then thinks poorly not of bad caricature, but of caricature as such, ought to let pass over him the names of the ancient tragedians, the names of Aristophanes and Menander, the names of Horace and Lucian, of Calderón and Shakespeare, of Ariosto and Cervantes, of Rabelais and Fischart, of Swift and Boz, Tieck and Jean Paul, Molière and Béranger, Voltaire and Gutzkow, the names of Brueghel and Teniers, of Callot and Grandville, of Hogarth and Gavarni, and let him then ask himself if he could still have the courage to regard the creation of real caricatures as a thus subordinate achievement? Indeed, without ideal content, without wit, without freedom, without boldness or delicacy, without humoristic elasticity, then indeed caricature is only a repulsive, tormenting grimace and just as boring and intolerable as any other bad work of art. [414]

Caricature must represent the idea in the form of the non-idea, the essence in the perversion of its appearance, but it must reflect this non-idea and this perversion in a concrete medium. In other words, it must understand the art of individualization. Caricature is the contrary of true beauty, carrying its satisfaction in itself and satiating itself in the euphony of its own forms. Caricature points restlessly beyond itself, because with itself it represents at the same time something else. It is a form ruptured in itself,

but within this rupture it is relatively harmonious with itself. The *empirical mediation* from which it departs can be an *infinitely varied* one. Conditions, actions, cultural tendencies of every format can provoke it. We see that *neighbouring peoples* sum up their characteristics in distorting pictures. The Frenchman caricatures the Briton, the Briton the Frenchman, and so on. Outstanding cities produce distorting pictures out of themselves, wherein they laugh ironically over their peculiarities. The type of the Roman Attelans[297] for instance has been inherited by the more recent Italian masks, to which the various leading cities of Italy have made their contribution. The Arlecchino is the old Roman Sannio; Pantalone the Venetian merchant; the Dottore is from Bologna; the Beltramo is from Milan; the Scapino is the impish servant of Bergamo; the Spanish Capitano and [his descendant] Scaramuccia is from Naples; Pulicinella the Apulian joker is from Acerra, the Maccus of the ancients; Tartaglia the stutterer [is from Naples];[298] Brighella the cheat and pimp from Ferrara;[299] Pascariello, the garrulous dandy from Naples; Gelsomino, the sweet little lord of Rome and Florence, and so on. The Mezzetino and Pierrot [415] are adaptations of Italian masks in the Italian Theatre of Paris. These masks are in many respects the most perfected caricatures. They contain all nuances of the ugly, dissolved in humour. They parody everything, but they parody it in a concrete individualization, which has a historical basis. Great cities, like London, Paris, Berlin, parody themselves in their *cockneys, badauds*, and Buffeys. The perpetual corrosion of society in these centres of culture is inexhaustible in distorting materials. Mayhew in his endlessly important work on the London poor has carried out the thought of daguerreotyping the characteristic figures of the street life and dives of London, so that one can see in his work frighteningly faithful reproductions of the ghostly Hades of Londoner civilization; the proletariat of this city consists almost entirely of caricatures, and these caricatures consist almost entirely of grimaces, which have just that peculiar sensuous feature that repels us in the distorting pictures of Cruikshank and Phiz. The neglected children namely make an appalling impression, for in the precociousness of an existence devastated by need, misery, crime, drink, and occasional debauchery they make an entirely senile impression. Some forms are nobler, but only that much more gripping, like for instance that Hindu beggar, who on a corner sells Christian pamphlets. This dark, slender form with its subtle bony framework, with its quietist limitation, with its movingly melancholic face, from which nevertheless a higher mind still looks out, as if from a memory not quite erased in the fogs of London!—The French have brought forth a work [416] that seems to copy reality with

[297] The Attelan farces, known according to Livy since the fourth century BCE and supposedly imported from the Tuscan town of Attela: the rhymed satiric verses and burlesque non-plots (originally improvised, become a literary genre in the Imperial period) are plausibly connected here to the modern commedia dell'arte, which underwent similar refinement.

[298] Rosenkranz gives just the name with no derivation. For information on the characters, see Allardyce Niccoll, *The World of Harlequin: A Critical Study of the Commedia dell'Arte* (Cambridge: Cambridge University Press, 1963), 95–116, or more recently John Rudlin, *Commedia Dell'Arte: An Actor's Handbook* (London: Routledge, 1994), 134–59.

[299] The consensus is that he is from Bergamo, like Arlecchino. Of course commedia characters are 'from' somewhere *within* the play, as part of their stock character: but there is no guarantee, as Rosenkranz seems to suppose, that the character originated there.

a faithful stylus, without hiding the caricatural element wherein so many types of today's society are immersed. We mean *Les Français peints par eux-mêmes: Encyclopédie moral du dix-neuvième siècle* [The French painted by themselves: moral encyclopaedia of the nineteenth century; Paris: Curmer, 1841–50]. This work, outfitted with the most splendid drawings by France's leading artists, and written by its classic authors, appeared in eight quarto volumes starting in 1841 and deserved to be much better known by psychologists, moralists, poets, clerics and statesmen, than seems to be the case. Three volumes of this work contains provincial types. The articles on the army, the *Forçats* [chain-gang workers], St. Lazare and the like are written with the most thorough scientific spirit. The *Diable à Paris* or *Paris et les Parisiens*, which appeared in 1845 in two quarto volumes, can be seen as a sequel, which however is already more nearly devoted to entertainment, and occupies itself almost exclusively with the caricatures delivered by the finer and the coarser proletariat, down to the beggars and the prostitutes.

Like peoples and cities, we also see the various *classes* of society caricature one another. The peasant, the soldier, the schoolmaster, the barber, the shoemaker, the tailor, the grocer, the man of letters and the streetcorner-poet, the doorman, the waiter, and so on are fixed in distorting pictures which metamorphose from epoch to epoch but always renew the same direction.

Finally the varieties of *sex* and the *ages* give the material for caricature. One can also count among them the *passions*, as Theophrastus in his *Characters*, and after [417] him La Bruyère and then Rabener have portrayed them, which make up the content of the comedy founded by Menandros [Menander] and Diphilos.

We have to distinguish such states of affairs from plots or action as such. They make up the content of genuine *historical* caricature, which satirizes the contradictions that come to light in the public actions of peoples and administrations. Periodic works of caricature, like the London *Punch*, the Paris *Charivari*, the Berlin *Kladderadatsch*, thus become the chronicles of political and ecclesiastic perversions.

Trends in education give the material to much and often to very interesting caricature, and indeed in a double way, one through the parody of a trend as such, then through the parody of the conflicts developing between culture and non-culture, between culture and hyperculture. A trend as such can be caricatured insofar as its novelty can be limited by satire to one-sidedness and exaggerated in the process of this fixation. It lies in the nature of the matter, however, that education delivers the most felicitous material for distortion in the imperfection of its beginnings or in the overripeness of its final stage. The caricatures that lie on either side are generally generated everywhere where highly cultured peoples meet primitive peoples.[300] From another standpoint, they can often provide for us a very painful sight, in that we see how a strong, relatively beautiful existence is seized by a foreign cultivatedness, destroyed and miseducated into a horrible, ridiculous grimace. Catlin in his *North American Indians*[301] (German edition of Berghaus, p. 306ff), gives [418] the illustration

[300] See the editors' note concerning the terms *Naturvolk* and *Culturvolk* at R 45.
[301] The full title of George Catlin's work is *Letters and Notes on the Manners, Customs, and Condition of the North American Indians*, 2 vols. (New York: Wiley & Putnam, 1841).

and story of an Assineboine chief Wi-jun-jon, who came to Washington in the full regalia of his magnificent national costume. But how did he return to his own after a longer stay in the cities of the union?[302] 'As he appeared on the foredeck of the steamer, he wore a coat of the finest blue, trimmed with gold lace; on his shoulders two immense epaulettes; round the neck a shining black stock, and his feet were forced into a pair of waterproof boots with high heels, which made his gait shaky and unsure.—On his head was a high-crowned beaver hat, with a broad silver lace band, with a red feather two feet high. His coat collar stiff with lace came higher up than his ears, and down his back flowed his long hair in plaits and decorated with red paint. A large silver medal was suspended from his neck by a blue ribbon, and across his right shoulder passed a wide belt, supporting by his side a broad sabre. On his hands were a pair of white kid gloves, in the right he held a large fan and in the left[303] a blue umbrella. In this fashion was poor Wi-jun-jon decked out[304] on his return from Washington!' Catlin gives a picture of this caricature (see Figure 15).

The sabre drags between the hero's legs; he puffs at a cigar and from the opening of both coat pockets the neck of a whiskey[305] bottle peeps out. But the real caricaturing first took place when he arrived back home, where his own held him for a liar due to the reports he made of the Yankees.[306] [']One day after his arrival, his wife made for herself from the coattails, that is, the superfluous elements of the coat, a pair of [419] leggings, and from the silver hat-band a pair of garters. The coat, thus shortened, was worn from then on by his brother, while he himself appeared with bow and quiver, but without coat, so that his astounded friends could admire his shirt with its precious studs. The sabre continued to assert its place, but already about noon he traded the boots for moccasins, and in this attire he sat, by him a little keg of brandy, telling stories to his friends.[...] One of his lovers had fixed her eyes on his beautiful silk braces, and on the next day he was seen, whistling Yankee Doodle and the Washington's Grand March, with the whiskey keg under his arm, swaggering toward the hut of his old acquaintance. His white shirt, or that part of it that had been flapping in the wind, had been shockingly abbreviated [*Catlin*: tithed]; his pantaloons of blue, laced with gold, were turned into a pair of comfortable leggings; for all that, his bow and quiver were slung, and his broad sabre, which trailed on the ground, had taken a position between his legs, and served to some degree as a rudder to steer him surely over the "earth's

[302] Rosenkranz quotes from *Die Indianer Nord-Amerikas und die während eines achtjährigen Aufenthalts unter den wildesten ihrer Stämme erlebten Abenteuer und Schicksale*, ed. Heinrich Berghaus (Brussels and Leipzig: Carl Muquardt, 1848), 307. Catlin's original is droller: 'He had in Washington exchanged his beautifully garnished and classic costume, for a full dress "en militaire". It was, perhaps, presented to him by the President. It was broadcloth, of the finest blue, trimmed with lace of gold; on his shoulders were mounted two immense epaulettes: his neck was strangled with a shining black stock, and his feet were pinioned in a pair of water-proof boots, with high heels, which made him "step like a yoked hog"...' (Vol. 2, 197). We have restored the original where possible, unless the German text (which is quite loose) deviates notably.

[303] The specification of which hand held which item is the translator's invention.

[304] Catlin has 'metamorphosed'.

[305] Rosenkranz has *Brantwein*, brandy, here and throughout the following.

[306] The following paraphrase is nearly verbatim Berghaus, 308 (hence our bracketed quotation marks). As above, we restore Catlin's original, except for notable changes.

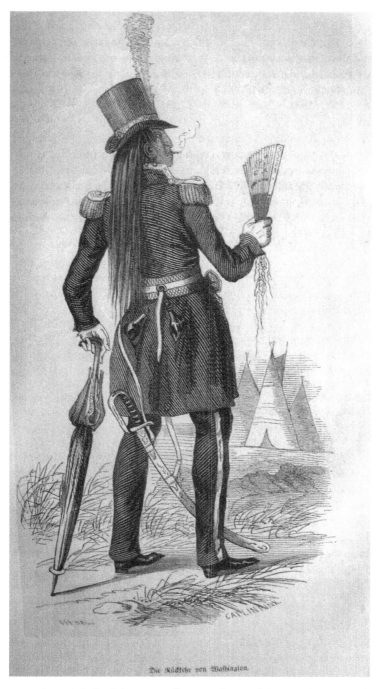

Figure 15 George Catlin, 'The Return from Washington', in *Die Indianer Nord-Amerikas*, translated into German by Heinrich Berghaus (Leipzig: Carl Muquardt, 1848).

troubled surface".—In this way two days passed, the keg was empty, and of all his fine attire only the umbrella remained, to which his heart's strongest affections still clung and which he carried in all sorts of weather, while for the rest he wore leather![']

If art should handle such contradictions, it must have the irony to ridicule the shortcomings of culture itself. The French for instance, after taking possession of the Marquesas Islands, published a suite of caricatures in this spirit. They painted the tattooed [420] savages in European suits, just like that Indian chief, disfiguring themselves into the wildest caricatures; or how, to their great astonishment, they were favoured by the window tax;[307] how the progress of French civilization is revealed to surprised fathers in white-coloured children, and so on.[308] On one sheet (Figure 16) we indeed see a noble Marquesan in boots, but otherwise only in a shirt, carrying a club, and intending to come out of a hut through whose door he sees his wife, outside, in a tender *tête à tête* with a French fop. But another Frenchman holds him back and tries to remove his club. 'Unhappy man! What would you do?

- Parbleu! One swipe at my wife's lover.
- That would be to ruin your reputation. Follow European fashion, send a card to your rival, tomorrow morning you draw on the field, the gentleman will blow out your brains—and at least you will have complete satisfaction!'[309]

On another sheet we see a victim of fashion, forced into white stripped leggings, yellow *gilet* (waistcoat), stiff collar, and a tight frock. 'But, tailor, it is impossible for me to move arms or legs in this outfit you are putting on me.

- That's what it takes. That's precisely what it takes. In Paris, the rich people do not dress any differently; the more uncomfortable one is in one's clothes, the more one promenades, to be at one's ease!'[310]

More versatile, naturally, is the material that offers miseducation as hyperculture, in false sentimentality, false courtesy, false learnedness, the craziness of political reasoning, the madness of sectarian fanaticism, the tastelessness [421] of luxury, the rivalry of modish medical cures, and the confusions of art. These caricatures are usually already the expressions of the reaction through which the spirit tries to overcome such illnesses. Thus the *Basblue* (bluestockings) as satire on writerly ladies; thus *Monsieur Prudhomme* as satire on the critic who always knows better; thus *Monsieur Mayeux* in uniform, the great busby [hussar's cap] on his head, the conservatory spectacles on his nose, as satire on the national guards; thus *Jean Patûrot à la recherche de la meilleure des républiques*

[307] The *Loi sur l'impôt sur les portes et fenêtres*, passed in November 1798 and repealed in 1926, like similar laws in Britain, taxed a property according to the number of windows.

[308] *Le Charivari*'s 1843 suite *La Civilisation aux Iles Marquises*, drawn by several authors.

[309] Rosenkranz gives the original: 'Malheureux! qu'allez-vous faire? / Parbleu! une volée à l'amant de ma femme. / Ce serait vous perdre de réputation. Suivez la mode européenne, envoyez un cartel à votre rival, demain matin vous tirez sur le terrain, ce monsieur vous brûlera la cervelle—et au moins vous aurez eu complète satisfaction!'

[310] 'Mais, tailleur, il m'est absolument impossible, de remuer bras ou jambe dans les vêtements, que vous m'apportez là. / C'est ce qu'il faut. C'est justement ce qu'il faut. A Paris les gens riches ne s'habillent pas autrement ; plus on est gêné dans ses habits, plus on passe, pour être à son aise!'

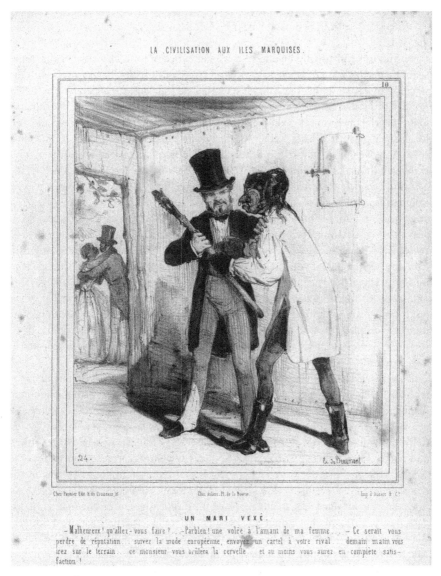

LA CIVILISATION AUX ILES MARQUISES.

UN MARI VEXÉ.

– Malheureux! qu'allez-vous faire? . . . –Parbleu! une volée à l'amant de ma femme – Ce serait vous perdre de réputation . . suivez la mode européenne, envoyez un cartel à votre rival . . demain matin vous irez sur le terrain . . ce monsieur vous brûlera la cervelle . . et au moins vous aurez eu complète satis-faction!

Figure 16 Édouard de Beaumont, *Un Mari vexé*, lithograph, part of *La Civilisation aux Iles Marquises*, 1843, The British Museum, London.

Source: © The Trustees of the British Museum.

[Jean Patûrot in search of the best republic] as satire on the socialists and communists, and so on. Such caricatures are sometimes quite personal, for instance when A. W. Schlegel ridiculed Kotzebue's poetry, or how the efforts of Countess Hahn-Hahn to find the right man in her novels is so ingeniously parodied in [Fanny Lewald's] *Diogena*. After having tried in vain with a whole series of men, even with a North American Indian chief, she finally finds the right man in—a Chinese.

In handling, caricature must follow the general laws of art. It can portray, symbolize, idealize.

Portraiture will usually belong to personal caricature, which originates in satire against a particular individual. But since this trajectory usually hangs closely with the struggles of parties in the state, church, and art, hate will play a great part within in. The result of this is that the aesthetic execution of the distorting picture will be subordinated to its material interest of expediting a poisoned arrow at the opponent. One is satisfied for this reason with a [422] certain likeness of figure and physiognomy. It must only suffice as envelope for the satiric attack. The art value of all caricatures of this kind is extremely limited. One should look through a mass of such caricatures, such as the *Musée de la caricature en France*, wherein distorting pictures are taken after the originals from the time of the Fronde, of the Huguenot wars, the Law money racket,[311] and so on, up until the first Revolution; one should look at the caricatures, also taken after the originals, from the history of the Revolution itself in the *Histoire-musée de la république Française depuis l'assemblée des Notables jusqu'à l'empire*, by Augustin Challamel, Paris, 1842, 2 vols.; one should look at the caricatures in the journal *London und Paris*, which Böttiger edited in Weimar at the end of the previous and the beginning of this century; one should compare with such pictures the analogous satirical writings, pasquinades, songs—and see if one does not everywhere meet a rough, sharp, prosaic tone, preoccupied above all with striking a blow at the opponent in public opinion. For this reason, certain techniques of delivering the enemy to laughter are even repeated in these circles.

This misery of means is a result of the egoistic standpoint of the personal satire, which seldom rises to cheer and harmlessness. The second kind of aesthetic handling distinguishes itself from portraiture by the fact that it takes the distortion already as a general one, as a type, one that represents a genus and insofar conveys a symbolic value to the individuals that belong to it. Here the bitterness of the direct reference vanishes, and poetry [423] gains great room to play. This symbolic representation follows the twists of history in order to render the decline of its more important forms in the contradictions that gradually develop out of their empirically inevitable limitations. Thus for instance our German chapbook of the *Schildbürger* or *Lalenbürger* [1597] is such a caricature, which, without any personal reference, scourges with real humour the ridiculousness of the petit bourgeois immersed in his bigotry. Thus in Wernher's Middle-High German poem *Helmbrecht*, the dissolution of the peasant and knightly life in an arid, slovenly robber existence is splendidly portrayed. Thus the period of the July Monarchy brought forth the type of *Robert Macaire*, that is, of the generally organized fraud. Macaire, with his comrade Bertrand, is everywhere, in the tribune, in the stock exchange, in the salon, at the betting table, in the doctor's consultation room, in the cabriolet, and so on, Macaire full-bodied, Macaire frocked, Macaire in a shiny

[311] Scottish economist John Law (in French, Jean Law), French minister of finance 1715 to 1720, and founder of the first state bank in Europe, bankrupted in 1720 as a result of the 'Mississippi Bubble'. Shortly after Rosenkranz's *Ästhetik*, French statesman and historian Adolphe Thiers published a detailed study, *Histoire de Law* (Leipzig: Hetzel, 1858).

hat, with a fat silk cravat, bejewelled tie-pin, as ingratiating as can be; his accomplice Bertrand with a plain cap and threadbare clothes, long baggy pockets for pilfering[312] every sort of thing, with shaky gait and a bare hard neck, and a confected expression full of roguish innocence. The pictures that the nations make of one another in every epoch belong here as well, as when we speak of Brother Jonathan in America,[313] of John Bull in England, of Michel in Germany, and so on. In China even the government makes use of symbolic caricature to persecute opium smoking, by having represented in pictures every stage of the decline of the unfortunate, who through the enjoyment of opium is finally alienated from all human feeling, all [424] sense of duty, all reality, and emaciated to a hideous skeleton.

The ideal style of handling caricature may also be called the fantastic. The immoderateness of exaggeration makes the distorting picture into an end in itself, representing the ugly sometimes as harmless accident, sometimes as the highest necessity. The distortion destroys itself, because it steps outside the boundaries of common reality and plays itself out in a fairy-tale freedom. Only great artists possess enough genius to bring about this wonderful metamorphosis of ugliness, which through its humour works in us such bliss, as only absolute beauty otherwise can. Freedom and greatness of handling overcomes in its comic nature the negativity of form as of content. The fantasy of this standpoint stands to the reasonableness of the first as the young Deburau did to his older brother, as he exposed the latter to the most capital danger in Constantinople. Deburau's father was supposed to produce his athletic and acrobatic arts before the sultan. He was thus led one day into a great hall, which, however, was entirely empty; here, before a silk curtain, he executed with his family the most neck-breaking stunts. Among other things, the older brother takes a ladder on his teeth and the younger climbs up it. Happily having reached the top, he forgets to come back down, because from the highest rung he suddenly sees the sultan's entire harem, who sat behind the curtain. The brother gave sign after sign and almost succumbed, before the youth up there awoke from his astonishment and climbed down. This story, told by Jules Janin in his *Deburau, histoire du théâtre* [425] *à quatre sous* [La Hane: Vervloet, 1832], in the third chapter, is itself a symbol. Below the calculating, balancing reason, then the bare, unbeautiful ladder as the means, but above rapturous fantasy, forgetting itself in the contemplation of beauty.

Caricature as a product of painting will very often and happily take on the help of the word in order to speak its intentions clearly. Out of this connection have emerged gradually not just isolated *picture-jokes*, but whole *suites* of caricatures, indeed whole consistent stories of picture-words and word-pictures. Gavarni is an extraordinary genius in this double art, but Töpffer exceeds him in humour. The *Œuvres choisies de Gavarni, etudes de moeurs contemporaines*, four quarto volumes, 1846, present us with the *enfants terribles*, the lorettes, the students, carnival, the *débardeurs*,[314] the actresses,

[312] There is a typo in the original: *Einfuppen* for *einpuppen*, 'wrap up', 'steal'.

[313] The top-hatted figure, eventually displaced by Uncle Sam as a national symbol, is still sometimes evoked as the personification of New England, often with reference to Jonathan Trumbull, governor of Connecticut before and after the American Revolution.

[314] Something like 'shirt-sleeves': women dressing as men during the Parisian carnival.

Clichy, Paris in the evening, and so on, always funny, but caustic. Töpffer on the other hand in his delicious *Histoires en estampes* bubbles with that cheerful wantonness that made Shakespeare create his Falstaff, Jean Paul his Dr. Katzenberger, or Tieck his scarecrow Ledebrinna. [Theodor] Vischer has characterized this whole genre so excellently in an essay on Gavarni and Töpffer in Schwegler's *Jahrbücher der Gegenwart*, 1846, 554–66, that we have to refer to it, since we could only repeat him (*NOTE 90).

Fantastic caricature strips from distortion all ethical danger. It grants the advantage of springing over common reasonableness from the start and parodies itself. Now, it could seem as if such exuberance would either fully cancel out the exaggeration of the [426] characteristic or amplify it to such an extreme that outer ugliness must be the result, because ugliness negates all measure, as already Plato in the *Sophist*, 228a, calls it, τό [τῆς] ἀμετρίας πανταχοῦ δυσειδές [ἐν]όν γένος, the everywhere misformed race of the ugly. But this would be a mistake. The immoderateness of fantasy namely generates again in itself a new measure, in that within its exaggeration the forms must nevertheless enter into a certain proportional relation to one another. Through this an extraordinary freedom, boldness, but also grace of handling become possible, so that caricatures reflect themselves not only in a finite medium, but rather in the infinity of the Idea itself, in the beautiful and the true and the good in and for itself. As the Old Comedy of the Greeks achieves such admirable results in this ideal fantasy, so could we Germans, given our aptitudes, bright forth immortal contributions in this direction, if to a certain extent more national force, more unified collaboration were present among us, and the best efforts did not often deteriorate into marginal forms of existence and entirely local ephemera. We do not hesitate, beside acknowledged masters in this domain, Jean Paul and Tieck among others, to hold the Leopoldstädter Theatre in Vienna, founded by Stranitzky,[315] as that institution which most brilliantly displayed a vocation to move caricature into the purest heaven of humour, and, freed from all one-sided sharpness of common sense, to make the 'whole misformed race of the measureless' into a source of the purest source of pleasurable laughter. [Adolf] Bäuerle represented already its approaching decline; with [Ferdinand] Raimund it swung itself once [427] more to its highest glory; with [Johannes Nepomuk] Nestroy it hurried to its doom. This subject would very well deserve its own treatise, which we cannot give here, where we have only to say farewell to caricature and suggest its further development into the ridiculous. We thus dispense with further exposition and give only a few strokes for the sake of better comprehension. In the *Lindane*,[316] a mousy shoemaker is supposed to accomplish a great act in the realm of the fairies. Fate had selected him, as uncomfortable and repulsive as it might seem to him, to play a hero. He must go through a wood. His fearfulness is caricatured, but how? In an entirely fantastic manner. He takes a shotgun and his elder journeyman with him. As they come

[315] Rosenkranz confuses his chronology: the actor Josef Anton Stranitzky (1676–1726), notable for adapting *commedia dell'arte* to Viennese taste, leased the Kärntnerthor-Theater in the city centre a generation before Karl von Martelli (1745–1803) had a theatre built expressly for his troupe in Vienna's Jewish quarter, Leopoldstadt (1781).

[316] Friedrich August Kanne, *Lindane, oder die Fee und der Haarbeutelschneider* [Lindane, or the Fairy and the Wigcutter], 1824, one of the most successful Viennese farces.

into the wood, he becomes very scared. There is in fact no definite danger present. That makes no difference. The wood as such, the fear as such, are reason enough to undertake something in defence against possible dangers. The journeyman thus has to shoot. But where?, since nothing suspicious ever shows itself. He shoots randomly into the air, while the shoemaker frightens himself endlessly. And look here—this is really what is fantastic in the execution—something falls down out of the air. But the bird really does not look like a bird; it has four feet; and it doesn't have proper feathers, but bristles; enough, the bird is a pig! Impossible, but there it lies, really. We laugh, naturally, but the shoe-maker is only that much more afraid. Or in Raimund's *[Der] Alpenkönig und [der] Menschenfeind* [The Alp-King and the Misanthrope], Herr von Rappelkopf, through the Alp-King, with whom he has traded form, sees himself speak, act, rumble, rant. But now [**428**] he finds this doppelganger exaggerated. The Alp-King, he thinks, caricatures him too much! How true, how deep, how philosophical, we want to say, is this humour! If we all could see ourselves once so truly objectively, would we not also be of the opinion that we indeed appear to ourselves, but not quite how we really are, rather a trifle exaggerated?

[429] Conclusion

The Olympic gods were the most beautiful figures human fantasy ever conceived. And yet they had among them the limping Hephaistos, and this limping god not only married the most beautiful goddess, the foam-born Aphrodite; he was also the sensible god of the fine arts, who knew how to contrive the most beautiful things. And although the gods were so beautiful, and immortal to boot, they did not think it beneath them now and then to break out in a laughter which Homer calls unquenchable, such as that which broke out when Hephaistos caught his own wife with Ares in the net. Thus does Greek mythology recognize the affinity between beauty, ugliness, and the comical. But it does so also in a particular myth, to which Bohtz draws our attention in his book *On the Comical and Comedy* (1844, p. 51), and which is to be found in the *Deipnosophist* of Atheneus (XIV, 2). Parmeniskos has been in the cave of Trophonios and seen its horrible wonders. Afterwards he could no longer laugh, so he consulted the oracle of Delphi, which replied that only mother in her house could restore the capacity for laughter. On arriving in Delos, Parmeniskos sought the image of the god's mother, Latona. This was shown to him in a shapeless log; having expected a fine statue, he was overtaken by a [**430**] robust fit of laughter. So the oracle kept its word. The mother of the god Apollo and a log seem to us to be heterogeneous things, but these irreconcilables were really conjoined, and this conjunction which should not have been possible was ridiculous. Is this myth not the history of the bond between the ugly, which silences us, and the comic, which shakes us with laughter?

We first sought ugliness in the concept of the negative, of imperfection in general. It proved by no means fundamental, only a secondary quality, finding in beauty the precondition of its existence. We then convinced ourselves that in nature, ugliness is realized partly through purely natural forms, partly through the intervention of illness

or mutilation. From natural ugliness we distinguished intellectual ugliness, under which we could not assimilate error, ignorance, or awkwardness, but only madness and evil. It seemed a contradiction that art, the progenitor of the beautiful, should be able to make ugliness its object. Not only the possibility of this construction proved itself, but its necessity: on the one hand, in the universality of art's content, which reflects in itself the panorama of the world of appearances, on the other hand in the essence of the comical, which cannot do without ugliness as a tool. Since the arts vary qualitatively in mode of representation as they differ in medium, we found a varying relation to the possibility of bringing forth ugliness, of which music and architecture have the minimum capacity, sculpture a moderate one, painting [431] and poetry the maximum. Indeed, in the pure possibility of falling short of the ideal or of mangling it, the arts are all on a par; but architecture, sculpture, and music are somewhat insulated against uglification by their technical means.

All beauty that depends on figuration consists of general proportions of unity, symmetry, harmony. For this reason, ugliness begins with the formless, which prevents unity from achieving closure, or dissolves it into the shapeless, giving rise to a muddle of non-shapes in disharmonious contradiction.

And yet it is not just in general that ugliness is hostile to proportion. Rather it is in the specific that ugliness most clearly functions as the negative of normal form as it is brought forth by the practice of culture, either as a natural constant or as the conventional yardstick of aesthetic activity, definite taste, which we also call correctness. The negation of this normality is the incorrect, and is to be found especially in the individual arts and historical styles.

This negation of proportions and that of physical and conventional norms, have their grounds first in disfiguration, in a negative inner process which only makes perceptible its dissolution through the irruption of outer deformity. The freedom of being, of life, of the spirit can transform the sublime into the banal, the pleasant into the repellent, the beautiful into the deformed. Not in the sense that the sublime, the pleasant, the beautiful as such are not sublime, pleasant, beautiful; but rather, that the objective measure of the petty is to be found in the great, of the feeble in the powerful, of the lowly in the majestic, of the clumsy [432] in the cute, of the dead in the playful, of the hideous in the charming. At the pinnacle of hideousness appeared evil, this free self-destruction of the good. In the guise of the diabolical, evil revealed itself to be a maximum of ostensible freedom, consciously negating the good, and vainly seeking satisfaction in the abyss of its own torment.

Evil gave us the transition to caricature, insofar as it essentially contained a reflection on the form and content of its opposite. The image of the devil is the image of absolute caricature, for he represents the lie as fictive destruction of the truth, non-will as the will of nothingness, and ugliness as the positive eradication of beauty. But caricature dissolves disgust into ridiculousness, in that it tends to absorb all forms of ugliness, and of beauty as well. That it becomes beautiful in its deformity, and full of immortal cheer, is nevertheless possible only thanks to the humour that it exaggerates into the fantastic. The unchained exuberance of humour, whose compassionate cockiness, also partakes in the grimace, does not preclude the purest of reflective thought; it resembles the maenad who, having climbed the mountaintop, throws her head boldly to the stars,

driven by the god's rapture, as if she already wished to flee the earth and return to the divine ether from which everything is descended.

[433]

Notes [434]

[435] [The italicized page numbers refer to the original pagination, given by us as [x], eds]

1. *Page 5.* If we reckon rightly, we shall notice that here as in many other things Lessing made a real beginning, namely in *Laokoon*, whose Chapters 23 through 25 deal with the ugly and the nauseating. The credit for having consciously introduced into science a notion of ugliness as organic moment of the idea of beauty goes to Chr[ristian] H[ermann] Weiße in his *System der Ästhetik*, first part, Leipzig [Hartmann], 1830, 163–207.

2. *Page 5.* But Weiße has understood the non-idea (*Unidee*) of the ugly too spiritually, and this one-sidedness, which consists in an attention primarily on the moral moment as the lie of the ghastly, the evil, the devilish, has been transferred to his followers. Among these was Arnold Ruge, particularly in his *Neue Vorschule der Ästhetik*, Halle [Waisenhaus], 1837, 88–107. Ruge, an agile mind impatient to set down the various naïve impressions excited by a reading of Hegel's writings, which were new to him, was fortunate indeed in some formulations, leaving however much to wish for from the point of view of clarity. He says on page 93: 'When the finite spirit stands firm and asserts itself in its finitude against its truth, the absolute spirit, then this spirit which wants to be self-sufficient becomes, as knowledge, *untruth*, as will, which secedes and only intends itself, *evil*, and in both forms, when they come to appearance, *ugliness*.' The upshot of this narrow setting of boundaries is that when Ruge describes ugliness, he thinks almost exclusively of the poetry of Hoffmann and Heine.— [August Wilhelm] Bohtz, *Ueber das Komische und die Komödie*, Göttingen [Vandenhoeck und Ruprecht], 1844, 28–51, takes the concept of ugliness somewhat more freely and expansively, but still as 'perverse Spirit', as 'beauty turned on its head'. Kuno Fischer once again entirely follows Weiße and Ruge in his *Diotima oder* [436] *die Idee des Schönen*, Pforzheim [Flammer und Hoffmann], 1849, 236–259. Ugliness for him, as the flipside of the sublime, enacts the decisive contradiction of sensuous existence against the ideal; the tendency to ugliness is possessed according to him only by *moral* spirit, and only in the human world is it for him an aesthetic truth. Thus page 259: 'The frivolous Romans and the sclerotic Jews are the final expression of the lifeless primordial world, just as the lecherous monks and the effete Caliphs are the triumph of ugliness over pious Catholicism and brave Islam. It is so that in the blink of an eye ugliness becomes the fate of the sublime within the concept of beauty, as in the history of mankind.'

3. *Page 9.* [Hermann] Hauff, *Moden und Trachten. Fragmente zur Geschichte des Costüms*. Tübingen and Stuttgart [Cotta], 1840, 17–23.

4. *Page 17.* According to Howard's theory, even the most fugitive cloud formation can be deduced from certain basic forms. We have here in mind the aesthetic impressions of clouds which travellers and poets have so often and so variously described, among them the excellent passage in Novalis' *Heinrich von Ofterdingen, Schriften,* vol.1, 3rd ed. [Berlin: Realschulbuchhandlung], 1815, 238: 'They—the clouds—pass and want to take us up and away with their cool shadows, and when their form is soft and gaudy, like one of our inner wishes exhaled, then their clarity, the fine light that then rules over the earth, is like the omen of an unknown, ineffable glory. But there are also dark and serious and frightful clouds, in which all the terrors of the ancient night seem to lurk: the sky never seems to want to cheer up, the bright blue is destroyed, and a livid copper red against a gray black ground arouses horror and fear in every breast.'

5. *Page 18.* Of the names here mentioned, Oersted[317] has in the last few years become known to our greater public as well, and the Germans' mania for foreign enthusiasms has called forth a bevy of competing translations of his popular works. Bernardin St. Pierre is indeed familiar enough among us as a name, since his narrative *Paul et Virginie* has long dominated the bestsellers, and copperplates, not to speak of ballets, disseminate this material and the author's name widely enough. But the book we mean is his *Ètudes de la nature,* 3 Tomes (in the Parisian edition which we have before us, 1838, *chez Desbleds*), a book whose hypotheses are made impracticable by the polar zone, but which [**437**] otherwise contains a treasury of multifaceted observations and nature-paintings, and which seems to be used and enjoyed by few. Friedrich Theodor Vischer's *Abhandlung über das Naturschöne* [Treatise on Natural Beauty] can be found in his *Ästhetik,* vol.2, First Part, 1847, and is one of the most distinguished works in this field that we possess. Had the Germans recalled this work, or even the portion of Kant's *Kritik der Urtheilskraft* [Critique of Judgment] that deals with teleology, they would not have fancied that they encountered something entirely new in Oersted.

6. *Page 18.* F.A. Schmidt, *Mineralienbuch, oder allgemeine und besondere Beschreibung der Mineralien* [Mineral Book, or General and Specific Description of Minerals], with 44 colour plates, Stuttgart [Hoffmann], 1850, 4. Animals and plants are illustrated frequently enough, minerals seldom. And so this book is a hopeful sign of progress. The author claims with justice: 'It is no easy task to illustrate a mineral, and quite vigorous artists who have attempted it left the work unfinished. The rigid, lifeless forms oppose the artist's instinct, each change of viewpoint calls forth fleeting reflections, if not wholly new color tones, and it is plainly impossible to convey the degree of lustre. The patience of good painters at such work, when it is not driven by an inner motive, is not too great, and certain colors of this gnome's world remain, despite all diligence, entirely out of reach. The difficulties encountered even in selecting the objects of such an undertaking are thus easy to imagine.'

[317] The Danish physicist and natural philosopher Hans-Christian Ørsted was generally called Oersted in other languages.

7. *Page 18.* One should see the images of these remarkable places in the steel engravings published at Karlsruhe as *China: historisch, romantisch, malerisch* [China: historical, romantic, picturesque]. Since neither the title page nor the introduction bear a date of publication, we cannot give one either.[318]

8. *Page 19.* The treatise by [Johann-Friedrich-Ludwig] Hausmann which we intend here is called 'Die Zweckmäßigkeit der leblosen Natur' [The purposiveness of lifeless nature], and can be found in a little volume with the modest title *Kleinigkeiten in bunter Reihe*, Göttingen [Dieterich], 1839, vol.1, 20–226. The preceding treatise, 'Über die Schönheit der belebten und unbelebten Natur' [On the Beauty of living and lifeless Nature], is also excellent. Both are model pieces of writing, real ornaments of our national literature, although our literati, who now fabricate histories of our 'national literature' by the dozen, know nothing of it. Noble Hausmann, were you only a foreigner, had you only emigrated through bad translations – then one would know of these beautiful studies.—The aesthetics of landscape geography, founded among us by [Alexander von] Humboldt's *Ansichten der Natur* [Views of Nature, Tübingen: Cotta, 1808], [**438**] has advanced greatly since. But here too is a deplorable lack of awareness, that brings us Germans to higher summaries and to doing the same thing, everything, a hundred times. There is a very fine treatise on *aesthetic geography*, which remains too little known among aestheticians and even geographers, and which with consideration to visual art must be regarded as among the best that we have. It appears in a collection and has not been much noticed. We mean G[eorg Ludwig] Kriegk, *Schriften zur allgemeinen Erdkunde*, Leipzig [Engelmann], 1840, 220–370. The aesthetic accounts of the Earth's physiognomy in Humboldt's *Kosmos* [Stuttgart and Tübingen: Cotta, 1845], [Matthias Jacob] Schleiden's *Die Pflanze und ihr Leben* [The plant and its life, Leipzig: Engelmann, 1850], [Hermann] Masius's *Naturstudien* [Leipzig: Brandstetter, 1852], etc. have become better known. To them one should add [Franz Thomas] Bratranek, *Beiträge zur Aesthetik der Pflanzenwelt*, 1853 [see note 29 for bibliographic information and a quote—eds.].

9. *Page 19.* The aesthetics of plant form was in fact founded by [Adrien de] Jussieu in his exploration of the family type [in German as *Die Botanik*, Stuttgart: Scheible, 1848]; thereafter A[lexander] v. Humboldt, *Ideen zu einer Physiognomik der Gewächse* [Ideas for a physiognomy of growths], Tübingen [Cotta], 1806, 8. A copperplate handbook of poisonous plants, where one can gain an oversight of the noblest among their sometimes bewitching forms and colors, is the *Giftpflanzbuch* of [Friedrich] Berge and [Adolf] Riecke, Stuttgart [Hoffmann], 2nd ed. 1850, 4. That poisonous plants should reveal themselves through a repulsive odor is also only a very limited truth; violets, cherries, laurel, which contain such strong poisons, smell wonderfully. – With regard to the primeval world (*Urwelt*), there is the same difference between animals and plants, so that its plants are beautiful, if not sublime. Compare [Franz] Unger's *Die Urwelt* [*in*

[318] A version of Thomas Allom, *China Illustrated* printed by Heinsius in 1843. The book must have been pirated from the English, hence the anonymity.

ihren verschiedenen Perioden, The primeval world in its different periods, Vienna: Beck, 1851] containing images he commissioned from [Joseph] Kuwasseg, of which I have given an overview in [Robert] Prutz' *Deutsches Museum* [Leipzig: Brockhaus], 1852, vol.1, 62–9.

10. *Page 21.* Grandville in his *Fleurs animées* [The animated flowers, Paris: Gabriel de Gonet, 1847] first picked out the comical expression of the mangold beet and the sugarcane, then [Amédée] Varin applied it to the *Cucurbitaceae* [pumpkins] and beets, though, it seems to us, with unequal success.

11. *Page 22.* The aesthetic observation of animals in still very much behind that of plants. Aside from the already-mentioned treatise of Vischer's, I can hardly name a work of consequence that has ascended to more general views on this topic. Scheitlin's *Versuch einer allgemeinen [vollständigen] Thierseelenkunde* [Attempt at a General Psychology of Animals, Stuttgart and Tübingen: Cotta], 1840, 2 vols., still seems to me the best that natural scientists themselves have done, unless I went all the way back to Aristotle's natural history.
[439]

12. *Page 24.* [Carl] Daub, *Judas Ischarioth oder das Böse in Verhältniß zum Guten* [Judas Ischarioth, or Evil in Relation to Good], Vol.2, Part 1. Heidelberg [Mohr und Winter], 1818, 350ff. A key passage on page 352: 'The violent death, for instance, of the entire animal kingdom drowned by the flood is not less *violent,* and thus not less *unnatural,* because perhaps it took place as if experimentally, intentionally and with premeditation, making place on earth, after the waters had found their channels and their pools, for another, perhaps for the human, race—giving you all, however, the opportunity to satisfy your curiosity with the skeletons of those primitive animals, and to sharpen your wit on their teeth. For, in that instead of spending their lives, they drowned, suffocated, or were killed in some other way, and with justice; their death remains none the less *murder,*[319] which took place through that which is unnatural in nature, but not through nature itself, to say nothing of the Deity. The same malicious power, which there (See Luke 8:33) drives a herd of sows into the water so that they drown, poured waters over your mammoths and cave bears, over your Megatheriums [giant sloths—eds.] and other such beasts; and precisely this power, which seems to lie in ambush in every element, without being that element, and through which, as for instance earthquakes, local floods and other calamities teach, the lives of animals, of people, and even of that earthly king endowed with freedom and reason [Prospero—eds.], are still and ever at risk, for 'What do the roaring waves in the storm ask for the name of a king?'[320] Nature has its terrors, but that which provokes terror in it is neither nature,

[319] Daub's *Ermordung,* more active than just *Mord* (murder) usually means 'assassination', which in German as in English suggests a person suffering assassination—Daub's intent.
[320] Daub's German rendering of the Boatswain's words early in *The Tempest:* 'What cares these roarers for the name of King?' First Folio (1623), Act 1, Scene 1.

itself a work of eternal love—nor the supernatural, itself eternal love; and if you have no faith in divine Power, which threatens[321] the wind and the sea, so that it is still (Matthew 8:26), will your opinion of the physical necessity of so-called *physical* evil replace Him? Or do you perhaps know so certainly that these terrors are none for you?' I have attempted a refutation of this theory in my essay on the transfiguration of nature ['Die Verklärung der Natur'] in my *Studien*, vol.1 [Berlin] 1839, 155ff, touching on the point of ugliness, insofar as it is relevant here, at pages 185–92.

13. *Page 41.* Goethe, *Werke*, Vol.28, 118–19 [The Italian Journey]. We want to isolate from the follies of Prince Pallagonia the elements of his madness, as Goethe expresses himself. Page 115: '*Humans*: beggars, female beggars, Spaniards, Spanish women, Moors, [**440**] Turks, the bow-legged, all types of the conjoined, dwarfs, musicians, Pulcinellas, antiquely costumed soldiers, gods, goddesses, people dressed in ancient French costume, soldiers with ammunition pouches and spats, mythology with hideous additions: Achilles and Chiron with Pulcinello. *Animals*: only parts of the same, horse with human hands, horse's head on human body, deformed apes, many dragons and snakes, all sorts of paws on figures of all sorts, doublings, exchanged heads. *Vases*: all kinds of monsters and curlicues, which stretch downwards to the belly of the vase or the foot.—If one only thinks of such figures manufactured in a hurry (*schockweise*— literally, 'shock-like') and produced entirely without sense or reason, and put together without choice or intention, if one thinks of these plinths, pedestals, these non-forms in an incalculable sequence, one will also feel the uncomfortable feeling that would befall anyone persecuted by these lashes of insanity.

The preposterousness of such a tasteless style of thinking shows itself however in its highest degree in the fact that the cornices of the little houses hang entirely askew in one or another direction, so that the feeling of the water level and the pendulum,[322] which actually makes us human and is the source of all eurhythmy, is torn and tortured in us. And so these rows of roofs are also embellished with hydras and small busts, with music-making choirs of apes and similar insanities. Dragons alternating with gods, an Atlas who instead of the world supports a wine cask.—If one however should intend to save into the castle that which, having been built by the father, has a relatively reasonable exterior appearance, one would find not far from the gates the laurel-crowned head of a Roman emperor and a dwarf figure sitting atop a dolphin.'

14. *Page 43.* According to Levezow's essay on the Gorgon ideal,[323] the development of the latter had three moments. First it was an animal face; then a mask with bleating tongue; finally a human face, whose beauty however eventually lost all character, indicating the Medusa-like only attributively through the hair and wings. The φοβερά χάρις (*phobera charis*, fearful grace) we admire in the Medusa Rondanini was last to disappear.

[321] Luther writes 'threatened'; The King James Version has the more decorous 'rebuked'.
[322] *Perpendikel*, a pendulum used to establish a vertical line perpendicular to the ground.
[323] Konrad Levezow, *Über die Entwicklung des Gorgonen-Ideals in der Poesie und bildenden Kunst der Alten* [On the Development of the Gorgon Ideal in the Poetry and Visual Art of the Ancients] (Berlin: Königliche Akademie der Wissenschaften, 1833).

15. *Page 44.* Anselm Feuerbach, *Der Vaticanische Apollo. Eine Reihe archäologisch-ästhetischer Betrachtungen* [The Vatican Apollo. A series of archaeological-aesthetic observations] Nürnberg [Friedrich Campe], 1833. Feuerbach, who is already deceased,[324] takes it as a decisive external confirmation of his views that most works in pliable bronze, which could have asserted the full freedom of the master, have been lost. Page 75: 'Were the bronze statues of athletes [441] and wrestlers still preserved, which populated the Altis [sacred precinct—eds.] of Olympia, or only the marble originals of the Thyades and female dancers, whose weak shadows in reliefs and mediocre frescos still captivate our eyes, there would open here another wholly new source for our admiration; we would be astounded by the mastery of those artists, who in the full feeling of their sureness were permitted to dare the utmost, and in fact dared it. We would be thankful to them that they did not, still and deliberate and avoiding every freer movement, remain within the four posts of the purest plastic art; we would gladly follow the artist upon the vertiginous path to the utmost peak of his art, putting down the chisel only when the distorted picture of lifeless non-nature makes him recoil, or, as constructor (*Bildner*) of his gods—grace, this nemesis of art, orders him to pause. Nothing lay outside of the domain of the Greek artist, but the death of Egyptian repose.[...]'[325]

16a. *Page 44.* Stimulated by the drawings of the brothers Riepenhausen,[326] Goethe went to great trouble to sort out Polygnotus' pictures in the Athenian Poikile[327] and the Delphic *Lesche* [council]. They show a kind of epic panorama. Out of the descriptions that have come down to us, as imperfect as these are, one recognizes the content of the paintings, and from these, that these did not exclude anything terrible. The usual images gathered from Winckelmann and Lessing of the delicacy with which visual art avoided ugliness are insufficient here. I will pass over the dismembered bodies that one saw strewn among the straw in horses' mangers, and so on; from Pausanias' report of the pictures in the Delphic *Lesche* which represent Odysseus' visit to the underworld I only want to quote some of the les frightful passages: 'on Charon's bark, a patricidal son is throttled by his own father. [...] Then a temple robber is punished. The woman to whom he is consigned seems to know very well every medicine, as well as every poison with which one kills people. [...] Above these one sees Eurynomos, who is counted among the gods of the underworld. It is said, he devours the flesh of the dead and leaves only the bones. Here he is shown as blue-black. He shows his teeth and sits on the fur of a predator, etc.'[328]

[324] The book is by philologist Joseph Anselm Feuerbach (1798–1851), not his son, painter Anselm Feuerbach (1829–1880), whose career was beginning as Rosenkranz wrote.

[325] The passage quoted (75–6), does not end where Rosenkranz sets a full stop, but adds after a comma: 'whether it created for the enjoyment of extended seeing, or gathered up all of life and the fullness of the soul in one single moment, for one ravishing instant.'

[326] Franz (1786–1830) and Johannes (1787–1860) Riepenhausen, Romantic devotees of Raphael. Their drawings were published as *Gemälde des Polygnotus in der Lesche zu Delphi; nach der Beschreibung des Pausanias gezeichnet von F. und J. Riepenhausen* (Göttingen: Dieterich, 1805). Goethe's article appeared as 'Polygnots Gemählde in der Lesche zu Delphi', *Jenaische Allgemeine Literatur-Zeitung*, (Jan-March 1804) 9–24.

[327] The ποικίλη στοά (*poikíle stoá*, or painted porch), on the north side of the Agora, a treasury of monumental paintings; Zeno's teaching there lent the Stoics their name.

[328] Rosenkranz translates freely passages from Pausanias, Book X, Ch.28. See, e.g. *Beschreibung von Hellas*, ed. Ernst Wiedasch (München: Fleischmann, 1830), IV: 264–7.

16b. *Page 53.* This should in fact be note 17. By mistake 16 is repeated [by the printer—eds.]. The passages mentioned in the text are indeed often enough printed, but we could not dispense with this important authority. [**442**] Aristotle, *De Poetica*, V: 'Comedy, as we said, is a mimesis of inferior people, not indeed in the full sense of the word bad, but the laughable is a species of the base or ugly. It consists in some blunder or ugliness that does not cause pain or disaster, an obvious example being the funny face[329] which is ugly and distorted but not painful.'[330] And Cicero, *De Oratore*, II, 58: 'The place or province, so to speak, of the ridiculous, is just the base or the ugly; for we laugh solely, or mainly, at things that remark upon and point out the base in no base manner.'[331]

17. *Page 69.* Plato's principal text on this difference will always remain the *Philebos*. In other places he shows that the beautiful is more than just a *useful desire*; more than *what provokes love*; more than the *useful*; but in this dialogue he comes to positive definitions. *Proportion* is his basic concept here. The nature of Zeus must be inhabited by a kingly soul and a kingly reason due to the power of the cause. From spirit and finally out of Zeus's kingly soul thus springs every order and each ordering thing has its origin, so that we cannot be embarrassed in defining the homeland of proportion, of number, of determination (πέρας, *peras*), of the concept or the ideas of things, since proportion, μέτρον [*metron*], is for Plato here the first; the second, founded on this eternal ground is for him [that] *the symmetrical and the beautiful and the perfect and the sufficient are all as many species of that same genus.*[332] The ugly (δυσειδές, *duseides*) he thus calls in a different place that everywhere, πανταχοῦ [*pantachou*], belongs to the species of ἀμετρία [*ametria*, disproportion]. Compare A. Ruge, *Die Platonische Aesthetik*, Halle, 1832, 22–60, and Eduard Müller, *Geschichte der Theorie der Kunst bei den Alten* [History of art theory of the ancients], Vol.1, Breslau [Josef Max], 1834, 58–72. The latter draws particular attention with regard to the concept of harmony and anharmony that according to *Philebos* 25de and 26a, the γένεα τοῦ πέρατος [*genea tou peratos*, the species of the limit], the ἴσον [*ison*, the same, the equal] and διπλάσιον [*diplasion*, the double], and the union of opposites, *the right combination of the limited and the limitless*[333] must be distinguished from the simple concept of proportion.

18. *Page 72.* In this essay, 'Der Sammler und die Seinigen' [The collector and his circle], *Werke* vol.38, Goethe has basically taken up the dispute of the idealists and the partisans

[329] Some translators read this as 'comic mask', but that seems an unwarranted limitation.
[330] Rosenkranz quotes the Greek [Bekker no.1449a]: 'ἡδέ κωμῳδία ἐστίν ὥσπερ εἴπομεν μίμησις φαυλοτέρων μέν, οὐ μέντοι κατά πᾶσαν κακίαν, ἀλλά τοῦ αἰσχροῦ ἐστι τό γελοῖον μόριον. τό γάρ γελοῖον ἐστιν ἁμάρτημα τι καί αἶσχος ἀνώδυνος καί οὐ φθαρτικόν, οἷον εὐθύς τό γελοῖον πρόσωπον αἰσχρόν τι καί διεστραμμένον ἄνευ ὀδύνης.'
[331] Rosenkranz quotes the Latin: 'Locus et regio quasi ridiculi turpitudine et deformitate quadam continetur: haec enim ridentur vel sole, vel maxime, quae notant et designant turpitudinem aliquam non turpiter.'
[332] Rosenkranz quotes *Philebos* 66b: τό σύμμετρον καί καλόν καί τό τέλεον καί ἱκανόν καί πάνθ' ὁπόσα τῆς γενεᾶς αὖ ταύτης ἐστίν.
[333] ἡ ὀρθή καί πέραιος καί ἀπείρου κοινωνία, not in *Philebos*, perhaps Rosenkranz's gloss.

of the characteristic, as one expressed oneself at that time, and as a result of the back and forth of debate, he set up the following schema:

1. *Seriousness* alone; individual inclination: Manner. a) Imitators. b) Character-students. c) Little masters. (or also a) Copyists, b) Rigorists c) Miniaturists) [**443**]
2. *Play* alone; individual inclination: Manner. a) Phantomists. b) Undulists. c) Sketchers (or also a) Imaginists b) Snakists c) Designers)
3. *Seriousness and Play* bound together; Education in the universal; Style. a) Artistic truth. b) Beauty. c) Perfection.

19. *Page 82.* In the text there is a typographical error. The castle is called Meilhant, not Meilhart.[334] This curious castle is reproduced on five pages of Jules Gailhabaud's *Denkmäler der Baukunst* [Monuments of architecture], in collaboration with Franz Kugler and Jacob Burckhardt, ed. Ludwig Lohde, vol.3, Monuments of the Middle Ages, Part 6. This intrinsically instructive and elegantly executed collection is unfortunately conceived from the narrowest French standpoint. The Celtic, Roman, medieval Romanesque, and Italian building styles are disproportionately favoured in it. In contrast, extraordinarily important links in the development of art, for instance German architecture, are wholly neglected. Castle Meilhant is quite interesting, but cannot even remotely compare with Marienburg Castle, which one seeks in vain.

20. *Page 95.* In the field of *opera* we could have gleaned a most fruitful compilation of the most repugnant sillinesses of poetic composition, or rather decomposition, for 'to enjoy wistfully life's foolishness'[335] is nowhere the case so much as in our current *Opera seria* and *mezza*.[336] Since however Richard Wagner in his three-volume work *Oper und Drama* [Opera und Drama, (Leipzig: J.J. Weber, 1852)] has sufficiently honoured the anti-poetic ugliness of modern opera texts, and especially the badness, indeed the nonsensicality, of their translations, we have limited ourselves to this one example.

21. *Page 99.* The Marienburg Castle is not built up gradually, so that one could explain such infringement of purely symmetrical forms through temporal heterogeneity and the arrival of other styles. Rather it was built originally in few years after one plan, which thus proves that the high aesthetic sense of the architects allowed itself, out of the fullness of harmony, such liberties with subordinate aesthetic demands and architectonic joints.

22. *Page 102.* H[ermann] Hettner, *Vorschule der* [actually, *zur*—eds.] *bildenden Kunst der Alten*, Oldenburg [Schulz], 1848, vol.1, 307f.

[334] We do not silently apply Rosenkranz's corrections as the Reclam ed. does inconsistently (e.g., note 16b). We do, however, complete names of authors and bibliographic details.

[335] Rosenkranz quotes a famous anonymous rhyme, apparently first printed in an 1825 obituary: 'Des Lebens Unverstand mit Wehmuth zu genießen / Ist Tugend und Begriff ...' Rosenkranz left out the conclusion, 'is virtue and wisdom.' See *Der Baierische Landbote* 14 (1 February 1825), 60, and *Regensburger Zeitung* 49 (26 February 1825), n.p.

[336] While uncommon, *opera mezza* must mean half-serious, as in *mezzo carattere*.

23. *Page 107.* The prostitute (*La Goualeuse,* really the street singer) tells the story herself: 'I no longer knew how to live. They took me. They made me drink brandy!—There you have it.' [**444**]

'I understand', said the murderer (*Le Chourineur*).

Sue continues: 'By a strange anomaly (indeed!—[Rosenkranz's interpolation, eds.]), the traits of *La Goualeuse* offer us one of these angelic, candid types, conserving their ideality amidst depravity, as if the creature was powerless to efface through her vices the noble impression that God made on the forehead of some privileged beings.'[337] This kind of sophistry in the *Mystères de Paris* deserved the severe criticism that Paulin Limeyrac devoted to it in the *Revue des deux Monde,* 1844, vol.1, p. 74. The aesthetic critique of this novel, so important for the concept of ugliness in its caricatural manner, is even more sharp in Albert Schwegler's *Jahrbücher der Gegenwart,* 1844, p. 653ff. In the same year's volume there is however also Wilhelm Zimmermann's contribution, pp. 199–219, which defends the cultural-historical significance of this novel.

24. *Page 109.* A[ugust] Hennenberger, *Das Deutsche Drama der Gegenwart* [Greifswald: Koch], 1853, p. 54ff. This small book is one of the most reasonable, impartial, and substantial that we possess on this subject.

25. *Page 121.* Cf. the collection of [Jean Baptiste] Seroux d'Agincourt, *Paintings,* Vol.1, Plate 40ff.[338]

26. *Page 122.* This statue is now found in the Museum of Nîmes. The form has much that is flattering. Of it, French critics could and should have said: 'It is grace itself, and life, and youth, and dancing-rhythm.'[339] But we criticize the head, or rather the chin and eyes.

27. *Page 128.* [Georg Gottfried] Gervinus, *Shakespeare,* vol.4, [Leipzig: Wilhelm Engelmann] 1850, p. 36: 'Even today we must still recognize the truth of this position, which is not threatened by the repeated suggestion that Shakespeare made English burghers and proletarians out of the Roman people; since the moving masses are the same everywhere, and especially in two such politically similar peoples, this criticism is much rather praise. We would not like to repeat literally what has been said on the other side as praise, namely that in these works the character, the destinies, the

[337] Eugène Sue, *Les Mystères de Paris,* vol.1 (Bruxelles: Hauman, 1843), 25. Rosenkranz quotes the French: 'Par une anomalie étrange, les traits de la Goualeuse offent un de ces types angéliques et candides qui conservent leur idéalité meme au milieu de la dépravatin, comme si la creature était impuissante à effacer par ses vices la noble empreinte que Dieu a mise au front de quelques êtres privilégiés.'

[338] The German ed.: *Sammlung von Denkmälern der Architektur, Sculptur, und Malerei vom 4. bis 16. Jahrhundert,* 4 vols., ed. Ferdinand von Quast (Berlin: Müller, 1840).

[339] Rosenkranz gives a French phrase, apparently his own: 'C'est la grâce elle même, et la vie, et la jeunesse, et le rhythme-dansant.'

patriotism the martial glory, the real attitude, the public life of the eternal city is brought back to life; but it is true that the faithful adoption and lively adaptation of the little that Shakespeare could get from Plutarch for the characterization of Roman life is worth more that the most precise rendition of the time out of the most strained antiquarian studies.'
[445]

28. *Page 135.* [Clemens] Brentano's *Godwi* appears in Bremen, 1802, in 2 vols. Brentano named himself Maria on the title page and wrote characteristically enough on the same: a novel gone wild. In the collected edition of Brentano's works, this curious book, a hyperromantic parhelion of [Goethe's] *Wilhelm Meister*, is not to be found, only a small fragment is printed in the fifth volume.[340]

29. *Page 135.* In [Franz Theodor] Bratranek's *Beiträge zu einer Ästhetik der Pflanzenwelt* [Contributions to an aesthetics of the plant kingdom, Leipzig: Brockhaus, 1853], the *Fleurs animées* are justly given their own chapter, and Bratranek says aptly on p. 396 [and 397]: 'Already in his scenes from the private and public life of animals Grandville showed how one could conjure up again the original felicity of symbolizing from the highest level of reflexion, in that he either emphasized the animal side in humans, or in animals the echo of human conditions and relationships, and in the animal-human world gathered together a faithful likeness of all the mis-realities flowing from society. Thus also he proceeds in his *Fleurs animées*; as he did there from images that had become typical, here he starts with the originally or traditionally or conventionally established significance of the plant, and transfers it into womanly expressions, gestures, and clothing. The ensoulment that a plant receives from human interiority through symbolism is now lent by the artist a human form corresponding to the vegetation type—they are flowers become human before us, whereas symbolism only pronounced the human in flowery form. Always, everywhere and in all forms, Grandville knows how to illuminate for us in such *human-plants* even the genius of the landscape.'

30. *Page 137.* Lucian, in the translation of [August] Pauly [*Lucian's Werke*, vol.4, Stuttgart: Metzler and Vienna: Mörschner und Jasper, 1827], says at the end of his preface to the *True Stories* [p. 686]: 'I admit that all these people, as many of them as appeared to me, could hardly be accused by me of lying, for I saw how common lying is even among men who carry the title of philosopher: I could only wonder over the fact that the latter imagined readers would not notice that in their stories (Homer, Iambolos, Ktesias) there is no true word. At the same time I was vain enough to want to leave the world a little work from my pen, so as not to have to be the only one to renounce the right and freedom of making myths. For I had nothing true to tell (what I experienced in my life is hardly worth mentioning); and so I had to decide to lie [446], but in such a way that I went to work a little more sincerely than the others. For

[340] 'Fragment aus Godwi', in *Clemens Brentanos Gesammelten Schriften*, ed. Christian Brentano (Frankfurt am Main: Säuerländer, 1852), vol. 5, 285–326.

I say at least *one* truth: *I am lying.* Through this free confession I hope to evade all criticisms of the content of my story. Thus I declare solemnly: ["]I write about things which I neither saw myself, nor experienced, nor heard of from others, and which are just as little *real*, as they are *possible.*["] Well, let he believe them who feels like it!'

31. *Page 149.* Kant in the *Kritik der Urtheilskraft* [Critique of Judgement], Analytic of Beauty, §17, about the ideal, distinguishes this from the *normal idea.* 'This [the ideal] is not derived as definite rules from proportions taken from experience, but only according to it do rules of judgement first become possible. It is that picture for the entire genus floating between all the discrete and somehow different experiences of individuals, and it is what nature used as a prototype for its productions in the same species, but seems not to have fully reached it in any individual. It is by no means the prototype of *beauty* in this genus, but only the form, which constitutes the necessary condition of all beauty, hence purely the *rightness* in representations of the genus.'[341]

32. *Page 156.* Dr. Franz Kugler, *Ueber die Polychromie der Griechischen Architektur und Sculptur und ihre Grenzen* [On the polychromy of Greek architecture and sculpture and its limits], Berlin [George Gropius], 1835, 4.

33. *Page 161.* H[ermann] Ulrici, *Ueber Shakespeare's dramatische Kunst [und sein Verhältniß zu Calderón und Göthe]* [On Shakespeare's dramatic art and its relation to Calderón and Goethe]. Halle [Eduard Anton], 1839, 146 and 174.

34. *Page 163.* See the introduction to [Friedrich Wilhelm] Genthe's *Geschichte der macaronischen Poesie und Sammlung ihrer vorzüglichsten Denkmale* [The history of macaroni poetry and collection of its finest monuments], Halle [& Leipzig: Reinicke], 1829.

35a. *Page 168.* Weiße, in his *System der Ästhetik*, pt.1, says on page 177: 'Insofar as abstract definitions like beauty, ugliness, etc. do not remain entirely empty, but are supposed to mean something, even then they must be brought into this position of contradiction among each other, so that abstraction does not rob them of their dialectical truth and liveliness.'[342]

35b. *Page 172.* I will also cite the passage from the translation of Droysen, who is more decorous than Voß:

— — *it is knocking already*
Old man stool mutters at the back door —

[341] Rosenkranz quotes the German text as established in his edition of Kant, *Immanuel Kant's Sämmtliche Werke*, vol.4 (Leipzig: Leopold Voss, 1838), 85. Rosenkranz notes that Kant originally (in the first ed.) was concerned with differing *ideals* of beauty among the races, but changed the subject decidedly in later edition to differing *normal ideas.*
[342] Christian Hermann Weiße, *System der Aesthetik als Wissenschaft von der Idee der Schönheit*, 3 vols. (Leipzig: Hartmann, 1830). I: 178. The quoted text appears a page later than Rosenkranz indicates.

This little underdress I must take from my wife,
Set out, quickly, in her little Persian shoes!
(Gets up, puts on female dress). **[447]**
But where will I find a little place, where unseen
Lovers meet? Ah, in the night all cats are gray.
(Goes forward on the proscenium).
Here no one will see me lay down my little pile.[343]

36. *Page 177.* [Friedrich] Schiller had quarrelled with Fichte. Fichte had sent him for his journal [*Die Horen*] an essay on spirit and letter.[344] Schiller did not want to print it as it was, because he found the delivery wanting. Fichte defended himself with great pride, and Schiller persisted in the demand that, for an aesthetically satisfying exposition, *concept* and *picture* should stand in *reciprocity* to one another. This controversy, which is now available to us as a printed exchange of letters,[345] likely led Schiller to compose his essay 'Über die nothwendigen Grenzen beim Gebrauch schöner Formen' [On the necessary limits of the use of beautiful forms] of 1795, wherein, in a footnote it is true, the words cited by me in the text may be found.[346]

37. *Page 178.* Ruge, *Neue Vorschule der Ästhetik*, 75–77. Fischer in the *Diotima* follows him, 198ff: 'What we usually call sublime in nature is much rather the expression of affect than aesthetic conviction. Nature does not elevate[347] us, it only imposes on us.'

38. *Page 186.* Voltaire in the Prologue to *Pucelle* gives in one move the entire direction followed in the poem. He praises the miracles of bravery and faith that Jeanne performed:

Jeanne d'Art had a lion's heart:
You will see, if you read this work.
You will tremble at her new exploits;
And the greatest of her rare works
Was, *to guard her virginity a year.*[348]

39. *Page 197.* According to Goethe's famous words in *Faust*, law and rights are inherited like an eternal disease.[349] But judgements over people and books are also inherited like

[343] *Des Aristophanes Werke, Uebersetzt von Johann Gustav Droysen*, 3 vols. (Berlin: Veit, 1838), vol.3, 334.
[344] 'Über Geist und Buchstabe in der Philosophie. In einer Reihe von Briefen. 1794', *Philosophisches Journal*, Vol.9 (1798), 199–232, 292–305, reprinted in *Johann Gottlieb Fichte's Sämmtliche Werke*, ed. J.H. Fichte (Berlin: Veit, 1846), 270–300.
[345] *Schiller's und Fichte's Briefwechsel*, ed. J.H. Fichte (Berlin: Veit, 1847).
[346] *Die Horen* Vol. 3, No.9 (1795), 99–125, the note is on pages 103–4; Rosenkranz cites the first sentence, on page 103 (see the bracketed quotes in the text at R 177).
[347] In German, 'sublime' (*erhaben*) literally means 'elevated', as in Longinus' Greek.
[348] Rosenkranz gives the French: 'Jeanne d'Arc eut un Coeur de lion: / Vous le verrez, si lisez cet ouvrage. / Vous tremblerez de ses exploits nouveaux; / Et le plus grand de ses rares travaux / Fut, *de garder un an son pucelage.*'
[349] Mephistopheles' words to the pupil in the scene in the study: 'Es erben sich Gesetz' und Rechte / Wie eine ew'ge Krankheit fort.'

an eternal disease. Diderot and his books belong among the objects on which ignorant and prejudiced people cool their little bit of courage, in that they brand with harsh words the abominableness of this atheist, this editor of the *Encyclopédie*, this author of indecent novels, without knowing Diderot or his works. It is held to be decided once and for all that one may only mention him and them in a tone of moral indignation. I have tried earlier and elsewhere to introduce among us as well a greater favourableness in the judgement of Diderot. I drew attention to how [**448**] Lessing, Goethe, Schiller, Varnhagen, Moritz Arndt think about him. About *Jacques* I only want to note here that Diderot defends himself against the accusation of cynicism in the book itself, *Oeuvres*, ed. Naigeon, vol.11, 333f. One errs in the opinion that in *The Fatalist* only cynical stories are told. The tragic story of the Marquise de la Pommeraye, told by the landlady, takes up a third of the whole. It was translated by Schiller under the title 'Merkwürdiges Beispiel einer weiblichen Rache' [Curious example of female vengeance] in the *Rheinische Thalia*, vol.1, 1785, 27ff. Its theme, namely the idea of fate, of an objective connection of circumstances, is already declared in the first words of the text, which can only be called a novel very figuratively (*uneigentlich*). 'Jacques said, that his captain said, that all that reaches us of good and evil down here is written up there.

The Master: That is a great word, there.

Jacques: My captain added that every bullet that left a musket had his ticket.'[350]

40. *Page 206.* [Eduard Kaspar] Hauser's[351] *Massacre of the Innocents* shows us only a gathering of unhappy mothers, who stare at the corpses of their children, from whose wounds the blood trickles. This monotony gives the beautifully painted picture something highly sad, indeed boring. How differently old Le Brun handled the subject! With him one also sees murdered children, mourning mothers, but one also sees mothers who try to save their children, who throw themselves upon the warriors, who fight them. One sees that motherly love does not make it easy for the soldiers, who even leap around on horseback and thrust at the children with spears, to carry out the terrifying order. Above all this one sees a broad deep space. A great open square, in the background a bridge, upon which soldiers and fleeing women crowd, manifold groups. In Hauser, a prison-like closure.

41. *Page 211.* Hegel, *Ästhetik*, vol.3, 1838, 123: 'We see therefore no common sensations and passions before us, but the peasant-like and nearness to nature in the lower classes, which is happy, roguish, and comical. In this carefree exuberance itself lies here the ideal moment: it is the Sunday of life, which makes everything equal and removes all badness; people who are so whole-heartedly joyous cannot [**449**] be bad and vicious

[350] Rosenkranz gives the French: 'Jacques disoit, que son capitaine disoit, que tout ce qui nous arrive de bien et de mal ici bas étoit écrit là haut. / Le Maître: C'est un grand mot que cela. / Jacques: Mon capitaine ajoutoit, que chaque balle, qui partoit d'un fusil, avoit son billet.'

[351] A Swiss artist working in Rome, his *Massacre* is praised by the poet Heinrich Wilhelm Stieglitz, *Erinnerungen an Rom* (Leipzig: Brockhaus, 1848), 122–3, who thinks it influenced the version of the Nazarene painter Franz Overbeck. Oddly, though Hauser's studio was in Rome, Rosenkranz speaks as if he had seen the painting, not a reproduction.

through and through. From this standpoint it is not indifferent whether evil emerges as only momentary or as a basic feature of a character. Among the Netherlandish [artists], the comic cancels out what is bad in a situation, and to us it becomes immediately clear that the characters can also be something other than as they at this moment stand before us. Such cheer and humour belongs to the inestimable value of this painting. If one on the other hand wants to be piquant in the same kind of pictures today, one usually represents something plainly common, bad, and evil without reconciling humour. An evil woman, for instance, scolds her drunken man out of the tavern, and that quite snappily; there shows itself, as I already mentioned earlier, nothing but that he is a miserable chap and she a poisonous old female.'—[Heinrich Gustav] Hotho, *Geschichte der Deutschen und Niederländischen Malerei*, Berlin [Simion], 1842, vol.1, 137ff: 'The artist who concentrates on this circle of common everydayness and interestless appearance, taking from it his only norm and wanting forcefully to draw out its degrading enthusiasm, would even in the presence of the highest grade of formal dexterity have done nothing else but to have stepped outside of the sphere of art itself.'

42. *Page 214.* W[illibald] Gringmuth, *De Rhyparographia. Disputatio philosophica* Vratislaviae [Bratislava: F. Hibt], 1838, octavo. This industrious and interesting treatise has had the fate of most academic dissertations of rotting unknown and unnamed. Gringmuth has gathered together in the introduction various definitions of ugliness, opts rather for the Weißian standpoint, cannot, however, come to any kind of peace with the comical, and concludes his view with Goethe's verses:

Then in the end it is inevitable
That the poet some things hates;
What insufferable is, and ugly,
He lets not live like beauty.[352]

43. *Page 218.* On Peire Vidal see Fr[iederich] Diez, *Leben und Werke der Troubadours*, Zwickau [Gebrüder Schumann], 1829, 149ff. Lichtenstein's insanities are well enough known through his *Frauendienst* [Women's prayer].[353]

44. *Page 222.* Concerning the grotesque it should also be said that Lessing in a small essay traces its origin to the Egyptians. But its origin in and of itself lies in the nature of the thing. One could just as well derive it from the Chinese or [**450**] the Indians. The book cited in the text is called *La Passion de Notre Seigneur J. O. en vers burlesques*, and it appeared in 1649. This book was poetically bad, but meant quite seriously, not parodically as it might seem. The burlesque verses were only a bookseller's gimmick for greater sales.

[352] *West-Östlicher Divan* (Stuttgart: Cotta, 1819), 15.
[353] Handily available in Rosenkranz's time in a critical edition, *Ulrich von Lichtenstein, mit Anmerkungen von Theodor von Karajan*, ed. Karl Lachmann (Berlin: Sander, 1841).

45. *Page 224.* Farce has made rich use of these means in all times, in all peoples. It is true that a certain aesthetic overpoliteness looks down on the farcical with scornful looks, but this has as much its right as so-called fine or high humour, which recently has become so fine among us that one would more rightly call it boring.

46. *Page 234.* Carl Vogt, *Bilder aus dem Thierleben* [Pictures out of animal life], Frankfurt am Main [Rütten], 1852, p. 433: 'Does one perhaps not know the really true story of the friend of the forester, who thought himself alone in the room, allowed himself to be guilty of a ringing impropriety, and to his astonishment saw how suddenly the dogs who were lying under the tables and the chairs broke out in loud pained howling, and among all signs of fear jumped out of the windows of the ground-floor apartment into the garden? The Forester, as he came in again, guessed immediately the case of the sudden madness of his dogs. Every time one of the beasts thus stank up the room, he beat the entire animal society as punishment, since he neither wanted to, nor could he find the guilty party.'

47. *Page 236.* Compare their illustrations in Raoul-Rochette, *Musée secret*, Plate 37, 40, and 42.

48. *Page 237.* O. L. B. [Oskar Ludwig Bernhard] Wolff, *Allgemeine Geschichte des Romans von dessen Ursprung bis zur neuesten Zeit* [General history of the novel from its origin to the present], Jena [Mauke], 1841, 324ff.

49. *Page 238.* T[axile] Delord derives Chicard from the vendages of Burgundy. He interprets the song and dance of Chicard as parody of love. Page 371: 'It is not at all a dance, it is once again a parody; parody of love, of grace, of the old French politesse, and, admire just how far the ardour of derision can go among us! parody of voluptuousness; everything is reunited in this licentious comedy which is called *le chahut*. Here the figures are replaced by scenes; one does not dance, one acts, the drama of love is represented in all its promenades, everything that could contribute to the success of the dénouement is put to work; to aid in the truth of his pantomime, the dancer, or rather the actor, calls his muscles to his aid; he agitates himself, he dislocates himself, he drums his feet, all his movements have one sense, all his contortions are emblems; that which the [451] arms have indicated, the eyes succeed in saying; the hips and the loins have in turn their own rhetorical figures, their eloquence. It is a frightful assemblage of strident cries, of convulsive laughing, of guttural dissonances, of unimaginable contortions. A dance that is loud, frantic, *satanic*, with its clapping of hands, its revolving arms, its stirring hips, its thrilling kidneys, its tapping feet, its attacks of gesture and voice; it jumps, glides, folds, curves, rears; wanton, furious, sweat on her brow, the eye fiery, the face delirious. Such is this dance, which we are trying to gesture at, but no pen can trace its lascivious insolence, its poetic brutality, its spiritual wantonness; the verse of Petronius would not be wide enough to contain it; it would even alarm the verve of [Alexis] Piron.'[354] But even then, in 1841, Delord thought that

[354] We do not reproduce the original of Rosenkranz's nearly page-long French quotation.

Chicard had reached the moment of his maximal glory. 'He believes himself so powerful that he fails to recognize his popular origin; for a while now he has turned in deplorable fashion toward the aristocracy; he plays the famous man, the artist, the lion.—Chicard is going!' Stahr only saw his frosty decline.

50. *Page 240.* See Arthur Schopenhauer, *Die Welt als Wille und Vorstellung* [The World as Will and Representation], Leipzig [Brockhaus], Vol.2, 1848, 531–64. This 'metaphysics of sexual love' is indeed here and there somewhat cynical, but full of attractive observations gleaned from nature and life.

51. *Page 240.* In the Gallery of Florence, among the copperplates of the pictures from the Palazzo Pitti, a great many gems are represented, enlarged and excellently engraved. Very many of these superb works contain offerings by young women and girls, who appeal to the force of nature, but with a chastity and grace that expresses the absence of every thought but the religious.[355]

52. *Page 245.* The repetition of Note 51 on page 244 is again an erratum. Naigeon, in the twelfth volume of his Diderot edition, inserted on page 255–66 a vindication of why in dealing with Diderot's so-called novels he has kept 'the scandal of the text in all its purity', without suppressing anything, because otherwise the public, as literary history at any rate shows, would then be mystified with even more troublesome things and in worse style in the name of Diderot. On page 263 he tells how he often gave Diderot to think about the dangers that could lie in wait for fantasy in those books: 'and I [452] may say here, to excuse in this respect the philosopher, that, struck by reasons on which I expressed my opinion, he had become determined by decency, chastity, and moral convention, to sacrifice a few cold pages, insignificant and fastidious for even the most dissolute man, and revolting or unintelligible for the honest woman. It is certain that the work thus purified would have lost nothing of its effect.'[356] Already Lessing, who in the [*Hamburger*] *Dramaturgy*, no.84, for the year 1768 translated a section of the *Bijoux indiscrets* and thus at that time first made the existence of this book known to the German public, says in agreement with Naigeon: 'This book is called *Les Bijoux indiscrets*, and Diderot no longer wishes to have written it at all. In that Diderot also does very well; but be that as it may, he has written it, and must have written it, if he does not want to be a plagiarist. It is also certain that only such a young man could have written this book, who would at some point be ashamed of having written it.'[357]

53. *Page 246.* In this judgement I agree with J[ohn Colin] Dunlop, *The History of Fiction* [3rd. ed., London: Longman, 1845], translated into German by F[elix] Liebrecht as *Geschichte der Prosadichtungen*, Berlin [Müller], 1851, 397. The French are still

[355] See Ornella Casazza and Riccardo Gennaioli, eds., *Mythologica et Erotica: Arte e Cultura dall'antichità al xviii secolo* (Florennce: Sillabe, 2005), 74–5, on ancient erotic gems from the Palazzo Pitti that were reproduced in the eighteenth century and later.
[356] Rosenkranz quotes this passage in French.
[357] *Gotthold Ephraim Lessings Sämmtliche Schriften*, ed Karl Lachmann, Vol.7 (Berlin: Voß, 1839), 376.

enthusiastic about the book. We think that St. Beuve is a very noted name as a critic even among us, and St. Beuve says in the *Critiques et portraits littéraires*, ed. de Bruxelles [C.J. de Mat], 1832, vol.2, 176ff so much that is flattering as is possible. He calls it a small masterpiece, *whose freshness without makeup is immortal.*[358] 'Manon Lescaut endures forever, and despite the countless revolutions of taste and fashion, which eclipse the true reign, it can retain at bottom, as its own fate, this playful, languid indifference which one knows so well at it.'

54. *Page 251.* J[ulian] Schmidt's work contains just as much that is interesting about Shakespeare, Racine, Voltaire, and German Romanticism, derived from real study of the sources. If it remains little known, this likely has its cause in two factors: first, that the author does not hold on to one real historical trajectory, but rather, as it appears to us, follows an artificial grouping that is inaccessible to the reader who approaches the work with a glimpse of world history; second, that the author takes no pleasure in any of the figures he observes. A certain discontented tone, which glowers at all the phenomena of history, reaches through the whole book. J. Schmidt has the talent to grasp the negative side of phenomana sharply, [453] to portray them vivaciously, but he tends too much in this in the Ruge-Bauer[359] manner to see the process of becoming only in the bleak colours of dissolution. He is really the opposite of Valentin Schmidt, who was so catholically, glowing enthused for romanticism and whom, as is known, we owe the first complete survey and taxonomy of Calderón's dramas in the Viennese *Jahrbücher*.[360] Schmidt was a hero in his knowledge of medieval literature. I cannot pass by the opportunity to ask again a question I have already raised from time to time. We Germans print in vain such vast quantities of paper with repetitions. Consider for instance our myriad anthologies, which have organized themselves for a formal, decent reprint business. Consider the myriad translations of foreign novels. Why do we not print Schmidt's work on Calderón, his still important, because positively supplementary review of Dunlop's *History of Fiction*, his work on the Decameron, his contributions to the history of romantic literature, together in one volume for once? How thankful all would be who study literature. I know from experience how difficult it is to acquire the relevant numbers of the *Wiener Jahrbücher*. Only the *Beiträge* are printed as separate little pamphlets. The critique of Dunlop runs through four issues of the *Wiener Jahrbücher*.[361] The work on Calderón is indeed only to be found in the journal's newssheet.

[358] Rosenkranz quotes the French of Saint-Beuve, 108: '*dont la fraîcheur sans Fard soit immortelle.*' The explicit quotation that follows, also in French, is on page 109.

[359] Arnold Ruge (1802–1880), whose aesthetics Rosenkranz criticizes in Note 2, was a left Hegelian, and a correspondent of both Marx and Rosenkranz. Bruno Bauer (1809–1882), likewise a left Hegelian, is best known for his attempts to demystify Christianity, and for his 1843 *Judenfrage* [Jewish question], which provoked Marx's first famous polemic.

[360] Valentin Schmidt, 'Kritische Uebersicht und Anordnung der Dramen des Calderón de la Barca', *Jahrbücher der Literatur* (1822), *Anzeigeblatt für Wissenschaft und Kunst*, Vol.17, 21–31, Vol.18, 1–38. The journal was routinely called the *Wiener Jahrbücher*.

[361] To be precise in vols. 26 (1824), 29 (1825), 31 (1825), and 33 (1826).

55. *Page 254.* [August] Henneberger, *Das Deutsche Drama [der Gegenwart* (Greifswald: Koch, 1853] [Contemporary German Drama], 8: 'The poet could perhaps answer that Griseldis, through her rejection of Parzival on finding out that it had all been a game, throws a counterweight into the scales.' But—'is this then, what we are sold here as love, really the true love of a woman? Can we forget that such a devotion, which gives up the right to one's own personality, and to a certain degree human dignity itself, brushes up against animal dependency rather than freely given love, which must heighten the lover's feeling of his or her own dignity?'

56. *Page 255.* Hotho in his *Geschichte der Deutschen und Niederländischen Malerei*, 160, distinguishes [phases of] a progress from van Eyck to J. Bosch, from Bosh to Schongauer (Martin Schön). Page 212: 'In his dandified executioners, in his maliciously snarling boys and whipping henchmen, Martin Schön proves a study wholly true to nature. He only augments, often, the observed [454] features with solicitous energy. The amplified malformation of the trunk-like muzzles, the ram-like heads and bony bodies are to demonstrate more clearly the inner and outer perversity.' Cf. [Franz] Kugler, *Handbuch der Geschichte der Malerei* [Handbook of the History of Painting], vol. 2, Berlin [Duncker und Humblot], 1837, 84ff.

57. *Page 262.* See J[ohann] B[aptist] Rousseau, *Dramaturgische Parallelen*, München [Fleischmann], 1834, vol.1, 189ff. As Oloaritus finally pulls out the dagger on Agrippina, she cries:

> Stab, murderer, through the limb, that owes such treatment,
> Stab through the breast milk that fed such a child,
> Stab through the naked belly, that bore such a worm
> etc. [Rousseau, 195]

58. *Page 262.* Ch[arles] Magnin, *Histoire des Marionettes en Europe*, Paris [Michel Lévy Frères], 1852, 147ff.

59. *Page 263.* Mrs. Gieremund [Greedymouth—eds.], craving fish, was frozen solid.

60. *Page 267.* This infection of Aristophanes with the same element he combats is well established in Th[eodor] Rötscher, *Aristophanes und sein Zeitalter*, Berlin [Voss] 1827.

61. *Page 267.* Heine can cause real pain through the levity with which he suddenly and quite superfluously cuts a capriole,[362] making a grimace in mid-stream of the most noble feelings, and he has seduced a whole flock of boyish little poets to mistake these prosaic punch lines for his true poetic moments. See [Robert Eduard] Prutz, *Vorlesungen über die Deutsche Literatur der Gegenwart* [Lectures on contemporary German literature], Leipzig [Gustav Mayer], 1847, 238ff.

[362] French for 'goat's leap', the most difficult jump performed by horses in classical dressage.

62. *Page 269.* See the *Œuvres completes de P.[ierre] J.[ean] de Béranger, edition illustrée par Grandville et Raffet*, Paris [Fournier Aîné], 1837, vol.3, 195–380. Inestimable documents for the history of that time.

63. *Page 293.* On the *Dances of Death* or *Danses macabres* there is now available a very substantial literature. There is just as little lack of astute reflections. Yet I cannot hold back the observation that the last of the Dances of Death (I do not mean Rethel's woodcuts[363]) has remained unnoticed in Germany and seems not to have been brought into relation with the earlier ones. It is painted in oil, mainly by a painter called Becher; a long row of rather large, often not at all uneven paintings, composed after the taste of the bourgeois ballad in the main [455] corridor of the Augustinian abbey in Erfurt in the middle of Germany during the eighteenth century. If one begins with Basel's Dance of Death, and on moves across Erfurt to Lübeck, where another Dance of Death can be found, one can in fact draw a diagonal. The Erfurt cycle, however, deserves at least for the sake of completeness a lithograph. I have given an analysis of Holbein's Dance of Death[364] in *Zur Geschichte der Deutschen Literatur*, Königsberg [Gebrüder Bornträger], 1836, 25.[365]

64. *Page 294. Heinrich der Löwe, Heldengedicht in 21 Gesängen, mit historischen und topographischen Anmerkungen von Stephanus Kunze. 3 Thle* [Henry the Lion, heroic poem in 21 lays with historical and topographical notes by Stephanus Kunze, 3 parts], Quedlinburg, G. Basse, 1818, octavo.

65. *Page 295.* See J. L. Ideler, *Geschichte der Altfranzösischen National-Literatur von den ersten Anfängen bis auf Franz I* [History of Old French Literature from its Beginnings until Francis I], Berlin [Nauck, 1842], 248ff. This pale allegorizing incidentally ruled Europe generally from the fourteenth to the sixteenth century.

66. [*Page 307.*] A. Schopenhauer, *Die Welt als Wille und Vorstellung* [Leipzig, Brockhaus], 1819, 262ff.

67. *Page 310.* Turlupin was also called Tabarin, Gaultier was Garguille, Gros was Guillaume and now Grosboyaux. Emile de la Bédollière, in a rendering of today's *Banquistes* [that is, saltimbanques—eds.], *Les Français peints par eux memes*, Tome 1. de Province, 150ff, has given many samples of today's nonsense, which has however often been passed on from time immemorial. Only a sample of the song of the Paillasse [straw mattress]:

Three little pigs on the manure
Amuse themselves like carriage porches.

[363] Alfred Rethel (1816–1859), German history painter whose 1848 *Dance of Death* cycle probably annoyed Rosenkranz, as it does T.J. Clark, with its reactionary propaganda.

[364] A suite of 33 woodcut executed in 1526 by Hans Holbein the Younger, perhaps inspired the older Dance of Death frescos on the inner wall of the Dominican graveyard in Basel.

[365] In fact, pages 25–9. See also the admiring account of Holbein's sinful nun, pages 32–3.

I told him: starling, my pretty,
I'd like to have a pound of butter.

I'll put oil on your sabots
To curl up your candy wrappers.
My vest is pierced at the knees
Ah, give me back my candle end.[366]

68. [*Page 320.*] Reproduced in [Theodor] Panofka, *Parodieen und Karikaturen auf Werken der klassischen Kunst*, Berlin [Königliche Akademie der Wissenschaften], 1851, quarto, plate 1, fig.3.[367]

69. *Page 322.* Whoever cannot or does not wish to read the scene in Burmann's edition of Petronius,[368] for it is among the rarer books, can find it in the *Begebenheiten des Enkolp* [Episodes of Enkolp] [**456**], which [Wilhelm] Heinse translated from the *Satyricon*, supposedly in Rome, 1773, vol.1, 132ff.

70. *Page 322.* How much there would be to say here! Material belongs here that painting in particular has colonized, and for whose view habit has hardened us, which however at bottom can only be called disgusting. The Shunamite woman [Abishag] procured for the elderly King David, Lot in the mountain cave, made drunk by his daughters so that he will sleep with them, and so on. But also a whole mass of repugnant bedroom acrobatics[369] and infamous paintings of the most repulsive voluptuousness, of which one hardly would like to talk, belong here. I will only give one example. In 1823 I found in the collections of the University of Göttingen a picture, hidden under a sliding panel that showed something else, and which our guide pointed out as something particularly notable. Louis XIV had made a bet with Madame Pompadour that she could not piss through a ring. The picture represents Pompadour, as she tries this experiment, while His Majesty kneels on both knees and holds the ring himself with lecherous curiosity!

71. *Page 322.* I would like to set down from Droysen's *Aristophanes* [*Werke*], vol.2 [Berlin, Veit], 1838, 204 the beginning of the terribly foppish Kinesias's monologue, which certainly is meant to parody also the dithyrambograph Kinesias:

Destroyed, this woman has destroyed me!
Of all things [*Zu allem Andern*], thus unsheathed she lets him stand!

[366] Rosenkranz gives the French, whose wordplay is memorable: 'Trois p'tits cochons sur un fumier / S'amusaient comm' des portes cochères. / J'lui dis: Sansonnet, mon petit, / J'voudrois avoir un liv' de beurre. / / J'te mettrai d'huil sur tes sabots / Pour faire friser tes papillotes. / Ma verste est percé aux genoux / Ah' rendez moi mon bout d'chandelle.'

[367] Panofka does not reproduce the poets on the vase exterior. Also, Panofka (same page, fig.7) erroneously gives the parody of Aeneas (R 397) dog rather than baboon heads!

[368] *Titi Petronii Arbitri Satyricôn Qvae Supersunt . . . Curante Petro Burmanno* (Utrecht: Guil. Vande Water, 1709).

[369] Rosenkranz has *klinopanic symplegmae*, bed-exercise body combinations. The latter term, derived from boxing, is used in German as a euphemism to describe orgies.

Oh how I feel! Oh! How I pour myself out,
By the sweetest woman, so cruelly tricked!
etc.[370]

72. *Page 322. Horatii Epodon liber*, VIII, 'In anum libidinosam' [On the lustful hag[371]]:

You rot, to ask interminably,
What unnerves my virility!
With your black tooth and old furrowed
Brow plowed by senility;
Gaping repulsive between arid buttocks
Your anus like a bloody cow.
But your chest and putrid breasts incite me,
Like the teats of a mare;
Soft paunch, and thin thighs
Conjoined to swollen calves [**457**]
Bless you! a funeral and images too
Triumphantly carried for you;
Let no wife with rounder
Pearls weighed down walk by.
What? What if Stoic pamphlets in silk
Cushions love to nestle?
Illiterate, are my nerves less stiff?
Any less languid my amulet?
To provoke my proud one from his groin,
Your mouth must work its charms.[372]

I confess I cannot find the least spark of poetry in this abominable narrative.

73. *Page 323.* Panofka, op. cit., 4, sees here a parody of virginity, because Atalanta should embody its character *par excellence.* Concerning ἅρμα (*árma*: union, love) and φιλότης (*philótes*, friendship, affection) there is still to say that they may also mean copulation,

[370] Myrrhine had delayed sex to bring a mattress, a blanket, a lotion, another, only in the end to run off altogether when Kinesias hesitated in promising to vote for peace.
[371] The infamous 8th Epode, like the homosexual 12th, was routinely left out of Horace editions, or when included left untranslated, until the twentieth century.
[372] Rosenkranz quotes the Latin: 'Rogare longo putidam te saeculo / Vires quid enervet meas! / Cum sit tibi dens ater et rugis vetus / Frontem senectus exaret; / Hietque turpis inter aridas nates / Podex, velut crudae bovis. / Sed incitat me pectus, et mammae putres, / Equina quales ubera; / Venterque mollis, et femur tumentibus / Exile suris additum. / Esto beata; funus atque imagines / Ducant triumphales tuum; / Nec sit marita, quae rotundioribus / Onusta baccis ambulet. / Quid? Quod libelli Stoici inter Sericos / Jacere pulvillos amant? / Illiterati num minus nervi rigent? / Minusve languet fascinum? / Quod ut superbo provoces ab inguine, / Ore adlaborandum est tibi.'

coitus. After Plutarch, however, they have the side meaning intended here, described by Lucretius Carus, *De rerum natura*, IV, verse 1259ff [in fact, 1263–7][373]:

And in what way smooth pleasure itself is done
This very many say: *after the manner of beasts*
On all fours, as the magic rite generally is done.
The women conceive, for thus placed they can take,
With breasts down the seed into raised loins.

Following which Lucretius goes on with natural-philosophical explanations in his manner.

74. *Page 327. Arden of Feversham*, translated in Tieck's *Vorschule Shakespeare's* [eds.— the real title is *Shakspeare's Vorschule* (sic), Leipzig, Brockhaus], 1823, vol.1, 113ff.

75. *Page 329.* The thoughtless translation-mania of the Germans with respect to English and French novels and novellas is a cancer of our literature, indeed of our life. One ought to compare statistically how much we translate of the English and French in this domain, with what they translate of ours. The most miserable scraps of less than mediocre authors are immediately translated into German, and if one surveyed the catalogues of lending libraries, one would almost think Paul de Kock, d'Arlincourt, Alexandre Dumas, Feval, James,[374] etc. are our classics. One ought to ask whether there wouldn't be ten translations if foreign literatures had brought forth novels like Max Waldau's *Nach der Natur* [After nature, Hamburg: Hoffmann und Campe, 1850], [Berthold] Auerbach's *Neues Leben* [New life, Mannheim: Friedrich Wassermann, 1852], Gutzkow's *[Die] Ritter vom* [458] *Geiste* [The Knights of the Spirit, 9 vols., Leipzig: Brockhaus, 1850–2], [Robert] Prutz's *Engelchen* [Little angel, Leipzig: Brockhaus, 1851], Adalbert Stifter's *Studien* [6 vols., 1844–50]. One should ask oneself whether one of these books is translated into French or English.[375] One should recall that even among the older recognized classics of our nation still very little, even by Tieck, who has done more light entertainment, only a few novellas, *Le livre bleu*[376] and such, has been translated. And added to this, consider that a third of the Germans can

[373] Rosenkranz quotes the original: 'Et quibus ipsa modis tractetur blanda voluptas / Id quoque permagni refert: nam *more ferarum*, / *Quadrupedumque magis ritu*, plerumque putantur. / Concipere uxores, quia sic loca sumere possunt, / Pectoribus positis, sublatis semina lumbis.'

[374] This is George Payne Rainsford James (1799–1860), author of historical novels, the best-known of which remains *Richelieu: A Tale of France* (1929). Paul Féval (1815–1887) and Victor d'Arlincourt (1789–1856) were minor followers of Victor Hugo.

[375] With the exception of Stifter's, these books remain untranslated. That some might deserve better is suggested by the calibre of some of their readers: Arthur Schnitzler, for instance, read Waldau. See his *My Youth in Vienna* (New York: Holt, 1970), 106.

[376] Ludwig Tieck, *Das alte Buch und die Reise ins blaue hinein* (1835), an untranslatable title (one try might be 'the old book and the journey into the blue'). We have not located the translation Rosenkranz mentions, but just in this style of mixed light entertainment is the Paul Gavarni-illustrated Tieck novella *La Réconciliation*, Paris: Curmer, 1842.

understand English or at least French well enough to read those novels in the original (of the Brussels, Berlin, and Leipzig reprints, that is), whereas only few English and French learn German; one will have to admit that the relation has become blatantly dysfunctional. One cannot do anything about it through police interventions, they are too superficial and only generate lust to obtain the forbidden pleasure by a detour. Only from the inside out, through better education, through strengthening of national feeling, through respect for ourselves, through real love for our fatherland (instead of the ironic position that we usually take to it and which withers all our forces, the moral included, at the root), can something real be done against it. But the knight and robber novels mentioned in the text are proof of how arid and fantastic things are in the lower classes of our nation. Only one thing should not be forgotten, that they possess a certain wild poetry, a lurid adventurousness, which is able to captivate the uneducated and the half-educated, and that the wooden, if also well-meaning moralizing tomes that so insistently preach the economic worth of time and money, books like the *Käserei auf den Vehfreude*[377] of J[eremis] Gotthelf and the like simply cannot compete with the intrinsically shoddy products of Pastor Leibrock, etc. [that is, of the swashbuckling authors—eds.].

76. *Page 336.* On adultery, see my essay in *Studien*, vol.1, Berlin [Jonas], 1839, 56–90. ['Die poetische Behandlung des Ehebruchs', The poetic handling of adultery]

77a. *Page 336.* See on this topic v. Bülow's [*Das neue*] *Novellenbuch* [The new novella book, Leipzig, Brockhaus, 1834–6], 4 vols., or with reference to Italian novellas the splendid selection of translation given by Adalbert Keller in his *Italienischen Novellenschatz* [Italian novella treasury], Leipzig, [Brockhaus], 1851, 6 vols.

77b. *Page 342.* I should have put this delicious description of Goethe's in the notes, for it takes up so much space. Only, I thought that at the end [of the book] only few will bother with the notes, and that I would therefore do well in forcing the reader upon it in the text. One should not reply that I could have done better simply by referring to Goethe's works, for how sluggish we are [459] in looking things up—and who always has the works to hand! Without reproaching my honoured readers, I am moreover certain that most of the same have known nothing of this grave of the dancer in Goethe until the moment that brought them here, because these little works of Goethe's are in general seldom read.

78. *Page 352.* There is a whole group of comedies and operettas that are based on this. Viennese farce, for instance in *Der rosenfarbenen Geist* [The pink ghost],[378] makes a particularly comical and cheerful use of it. Among other things a funeral procession

[377] *Käserei in der Vehfreude* (Berlin: Julius Springer / Zürich: Höhr / Bern: Huber, 1850), a proto-Heidi-esque 'Swiss tale' set in a rustic dairy.
[378] Carl Meisl, *Der rosenfarbenen Geist oder: Liebesqualen eines Hagestolzen*, Vienna, 1825, music Wenzel Müller.

appears onstage. The deceased, dressed entirely in pink, walks as a ghost with a hymnal and sackcloth in the hand among the pallbearers, mourns himself, and so on.

79. *Page 356.* Ruge's *Neue Vorschule*, 106: 'All ugliness of poetry and other art, of disposition and act, obtains in fact only an apparent being, an apparent reality of spirit, the apparent existence of the ghost. The ghost is appearance, but not the true and real appearance of spirit, therefore in fact not appearance', etc.

80. *Page 363.* Goethe too, in the fifteenth book of his autobiography, says that the titans are the foil of polytheism as the devil is the foil of monotheism, and that *the devil is no poetic figure.* But precisely as foil he *becomes* what he is not in himself, a moment of poetry and art. All ugliness, as such, is unbeautiful, unpoetic, unartistic. But within a certain context, under certain conditions, it *becomes* aesthetically possible and effective. Cain, for instance, the fratricide, is for himself abominable; Lucifer, who sophistically tricks him, for himself abominable; but in Byron's mystery-play *Cain*, Cain *becomes* poetic through Abel, Adah and Zillah, and Lucifer becomes so through Cain. In addition, the Satanology of Christianity is a wholly different one than that of simple monotheism.

81. *Page 370.*[379] Translated in Tieck, *Vorschule Shakespeare's*, vol.1. Ulrici, *Über Shakespeare's dramatische Kunst*, 221, says very rightly of the witches in Macbeth: 'His witches are hybrid creatures, half naturally mighty beings belonging to the night side of earthly creation, half fallen, common, human spirits sunken in evil; they are the *echo of evil*, that from the breast and the spirit realm of evil answers the evil in the human breast, calls it forth, helps it develop and instructs it to decision and act.'
[**460**]

82. *Page 373.* See F.A. Märcker, *Das Princip des Bösen nach den Begriffen der Griechen* [The principle of evil according to Greek concepts], Berlin [Ferdinand Dümmler], 1842, 58–162. At pages 151–56 Märcker discusses the ugly, τό αἰσχρόν [*to aischrón*] in distinction from and in context with κακόν [*kakón*, the bad]. Very important is the passage on σοφία (*sophia*, wisdom) he cites [on page 154] from Plato's *Hippias major* 289b: 'the same beautiful maiden set beside the gods would be ugly',[380] namely insofar as the divine powers, also justice, would be imagined as terrible.[381]

83. *Page 374.* An illustration of the shadowplay *Kara-geuz* is found in the *Illustration universelle*, Paris, 1846, No.150, page 201. M.F. Mornand in his 'Souvenirs de voyage en

[379] Rosenkranz erroneously refers the note back to page 371.

[380] Rosenkranz has written: 'τήν καλλίστην παρθένον πρός θεῶν γένος αἰσχράν αἰσχράν'

[381] Rosenkranz seems to have been confused by Märcker, who cites the text merely to assert the beauty of 'deity and wisdom' while emphasizing their terror. But this seems unrelated to the relative beauty of a girl, unless Rosenkranz read *prós*, the comparative 'beside', as asserting that a beautiful girl, set among the terror-inducing gods, would herself come to seem ugly or perhaps be scared into an ugly expression.

Afrique'[382] says of this devil: 'Grotesque summary of all the vices and turpitudes, he combines the diverse types invented among us to frighten children, amuse the populace, draw the silent attention of old women listening to exaggerated stories on winter evenings, or, in political storms, to distract the suspicious vigilance of the masses from the approach of a coup d'État, or then again to feed that source of original folly that so constitutes the merit of our fashionable men. Garagousse is Arlequin, Paillasse, Polchinelle, Croquemitaine, Bluebeard, Cartouche, Mayeux, the Robert-Macaire of northern Africa; but with these qualities, he excites no more than a feeble admiration among the spectators; it is as a model of obscenity that he takes all their praise. In this role, he puts onstage all that is most repulsive and more horrible in cynicism; his words, his actions, are of a disgusting crudity. Outraging the modesty of nature, he parodies even the monstrosities which fable attributes to Parsiphae.'

84. *Page 375.* [Adolphe Napoléon] Didron, *Iconographie chrétienne*, Paris [Imprimerie Royale], 1843, quarto, page 545. In the place of the organ of procreation there is another head, which sticks out its tongue. In addition, the miniature painters of the Middle Ages thought they were completing a pious work when they painted the devil as really repulsive, because in their pious madness they assumed that it would annoy him—and to annoy the devil, well, that always amounted to some service.

85. *Page 375.* Also in his *Sämmtliche Werke*, Vol.7.

86. *Page 375.* Translated in the second part of Tieck's *Vorschule Shakespeare's*.

87. *Page 377.* I own a large copperplate of this *Temptation of St. Anthony Abbot*, engraved by P. Picault. Callot [**461**] has dedicated this remarkable picture to the Abbé Antoine de Sever, *prédicateur ordinaire du Roy* [the king's confessor], with the [Latin] motto: *If armed camps should stand against me, my heart would not fear.*[383]—Concerning the name *diablerie* I want only to add that in the Middle Ages those mysteries were called *grande diablerie* wherein at least four devils played.

88. *Page 380.* Reproduced in Scheible's *Doctor Faustus*, Stuttgart, 1844, 23 (also as Pt.2 of the series *Das Closter* [The Cloister])[384].—On the hunter type see also F. Kugler in the *Geschichte der Malerei*, vol.2, 79, who discusses such figures with an 'Italian' face by Hans Holbein.

89. [*Page 400.*] The aestheticians have the same kind of trouble with the concepts of parody and travesty as the logicians do with the concepts of induction and analogy.

[382] First published under the initials A.F. as 'Souvenirs d'Afrique: Garagousse', *Le Navigateur: Revue maritime*, vol.5 (1838), 163–9, this quote 163–4; Rosenkranz saw it probably in *L'Illustration*, vol.6 (1846), where it appeared with engravings as 'Algérie: Ombres Chinoises—"Garagousse (Kara-Geuz)"', 301. We don't print the long French.

[383] 'Si consistant adversus me castra, non timebit cor meum.' Psalm 26:3 in the Vulgate.

[384] Rosenkranz is more bibliographically careless than usual here: the book is vol. 2 of Johann Scheible's *Das Kloster, Doctor Johann Faust*, Stuttgart, Scheible, 1846.

What one calls parody, the other calls travesty, and vice versa. The basic definition of travesty will remain that it is also parody, but not just in general; rather, as the name hints, it disguises the same content in a different form, and thus qualifies that content differently. A parody can also be serious, a travesty is always ridiculous.

90. [*Page 425.*] Vischer, op. cit., has compared Gavarni with Töpffer and characterized splendidly the humour of the latter. Töpffer's drawings are just hurried pen drawings; often they seem to be nothing but little blots and strokes, but one has to add to them the stories, these delicious stories about Mr. Jabot, Jolibois, Mr. Pencil, and others. Töpffer's manner has become almost popular among us through its application by Schneider and Braun in the Münich *Fliegende Blätter*. To characterize it, we take the liberty of taking just a few words out of Vischer's account. Vischer stresses as key moment the *epic* quality of Töpffer's procedure, which also invites him to pursue the individual *episodes*: 'If the astronomers in Dr. Festus are rescued from the water, we also have to learn what happenend to their wigs, and that results in another long, interesting story. Madame Crépin puts on a pitch-plaster[385] and loses it; it wanders on through various hands, until it ends its circulation on the skin of the former educator of her children, henceforth customs policeman (*Zolljäger*) Bonichon.[386] Thus he exhausts the main motifs as well with epic elaborateness. The way he reels them out, he reels out to the last threads. Finally, Töpffer's whole method may be called successive, one has fully the impression of edging away (*Fortmachen*), going forth, the extended sequence, as in storytelling, which however, [462] in order not to tire, stops at resting points from one stretch to another—as in the *Histoire d'Albert*, where each new phase of this prodigal son ends with a kick in the pants administered by his father, whereby one only sees the foot of the one and the *posteriora* of the other; just so the recurring moments, where Mr. Jabot takes his stance again, Mr Vieux Bois changes his shirt, and more of the same kind. But Töpffer prefers to handle the successive in his fantastic way thus: he shows the same action in multiple fields separated by strokes to form multiple moments that follow one another directly. Albert becomes among other things first a travelling salesman for a wine merchant, then for a bookseller, who in turn edits a *Metaphysique pittoresque*. One sees him enter the door of a family and annoy them with his intrusiveness (*assassine*). Now Töpffer divides the rest of the paper through strokes in eleven narrow strips; on the first one still sees Mr. Albert in full figure, making a compliment: *Il assassine au rez de chaussée* [he assassinates on the ground floor][387]; on the second only the half-figure: *à entresol* [on the mezzanine]; on the third only his rear and feet, always bowing more deeply: *au premier* [on the first floor]—and so on with grace *in infinitum*, until at the end one only sees a disappearing point. Mr. Pencil draws beautiful nature. As soon as he is finished, he looks on his work with the deepest

[385] A very sticky medicinal bandage made of pitch, wax, or resin, used well into the mid-nineteenth century to combat infection.
[386] A gag updated with a modern adhesive plaster in Hergé's Tintin comic, *L'Affaire Tournesol* (Brussels: Casterman, 1956). Vischer's account of 'the successive' which follows is perhaps the first definition of the many-panelled modern comic.
[387] The captions are Töpffer's.

satisfaction. Again a picture: he looks at it from the other side and *il est content aussi* [he is just as content]. He looks at it over his shoulder and is just as satisfied; he turns it all the way around, looks at the empty backside and *remarque avec plaisir, qu'il est encore content* [remarks with pleasure that he is again content]. Töpffer knows his business so well as to repeat the words just so in the text. Thus the furiously jealous Jolibois in *Mr. Pencil* is always introduced with the parenthesis: *car hélas la passion aveugle* [because, alas, passion blinds].—Now we must also emphasize the insane play of chance, the fantastic cancellation of natural laws, which begins as soon as the main subject steps out of the first exposition into the interlacing of his destiny, into entanglement. The racing wheel of a crazy world grabs him by the little finger, by the coattail, and swings him unrelentingly away with it. The impossible is handled as if it were self-evident. In several of these volumes, almost the whole story takes place in the air, in which heights a mischievous zephyr has blown several persons. The persons are properly equipped with indestructible bodies; a hundred times they must have been crushed to dust, squashed to a pulp, wheezed to death, dissolved in sweat, were they not comic gods, immortal beings on the Olympus of folly. There is no longer any gravity; but yet [**463**] there is one still, one sweats and pants under its burden, but one firm jolt and the impossible is done. There is no longer any need; but yet there is one still, it is only a matter of overcoming it through great effort: some persistence and one can fast, thirst, hole up in empty tree trunks for days or weeks, navigate the air in giant telescopes, or take walks in a locked suitcase, through whose holes one can get both one's arms free. Töpffer is not fantastic in the way of Aristophanes, Callot, and many modern grotesque draughtsmen; he composes no absolutely impossible forms, frog-people, bird-people, and so on. The modern sphere of his material already would not tolerate this. But through a transition creeping up through motifs that seem entirely coherent, so that the impossible will become possible, and when one grants just the first inch over the line, unnoticed it becomes miles, he dissolves the laws of gravity and want, the limits of human strength and human delusion, and has conjured us, before we noticed it, in a world of his own, a cloud-cuckoo-castle, where we are just as much reminded at every moment of the most ordinary things, of all the indispensables of life, as we are spirited over them and away. Through this the freedom and purity of the comical is perfected, the proper, whole and absolute world of humour. Also because of this the bitterness and viciousness of satire vanish, because we find ourselves tricked into this second, free world of impossibilities become possible.'

Additional Texts on Aesthetics

Karl Rosenkranz

I Excerpts from: Review of Hegel's *Ästhetik*, vol. 1, *Jahrbuch für wissenschaftliche Kritik (Berliner Jahrbücher)*, January 1836, 1–15, 17–20 (here 6–20); and March 1839, 363–90 (here 387–9). Reprinted in Rosenkranz, *Erläuterungen des Hegelschen Systems*, 1840, 177–216.

Editors' introduction

A generous but critical appraisal of Hegel's posthumous *Aesthetics*, edited by H.G. Hotho, we excerpt the portions stressing Hegel's contribution and Rosenkranz's broad criticisms of it. Rosenkranz objects that Hegel, as a passage not reproduced here puts it, 'often does violence to peoples and arts to fit them into his ideal forms' (377/204). Beyond this empirical complaint lies the deeper point that Hegel takes his theoretical divisions—symbolic, plastic (erroneously called classical), and romantic—to correspond precisely and exclusively to epochs, a problematic move if, as Rosenkranz believes, these modes are available in all places and times, or even just in more than one. This aspect of Hegel's thought, immortalized in Heinrich Wölfflin's aphorism that 'not all is possible at all times' is orthodox today beyond art history (and endorsed by readers as different as Rosalind Krauss and Michel Foucault), so Rosenkranz's critique is of broad interest. Also interesting, coming from a Hegelian who counted among his friends Hegelian art historians (Hotho and Franz Kugler) but rejected history as a guide to metaphysics, is his concluding call for a 'philosophical art history'. Bold page numbers are from the journal, italics from the 1840 reprint. The conclusion of the first review (in angle brackets), and the emphases were not reprinted. The *Berliner Jahrbücher* were a Hegelian organ, but unlike the *Hallesche Jahrbücher*, they were also an interface between the Hegelians and the learned world: a discussion of Bunsen's work on arsenic was printed cheek by jowl with the 1836 Hegel review. This context explains also the detailed and ironic defence of Hegel against common opinion: the form of this satire in turn depends on the *Jahrbücher* appearing in weekly instalments. We therefore indicate the issue breaks of the journal.

No. 1

...*[182]* Certainly the timing of Hegel's life was very favourable for the production of an *Aesthetics*, insofar as it embraced all the stages of the development of this science

among us until a few years ago. For his youth held still the excitement caused by Lessing's *Laokoon*, as the eve of his life saw the fierce debate over irony. Hegel thus had with all turns of the science between these two points that salutary familiarity that springs from living through a crisis. He is at home everywhere, even in those nuances that the speeding stream of time has already begun to [7] efface. Hegel was not indifferent to any phenomenon, but rather, as one can see above all in his miscellaneous writings, he lived through the life of peoples and literature in all their breadth, down to the least significant. In such many-sided partaking and attention, his inner strength proved itself. *[183]* As a great general also takes notice of common soldiers, and such penetration of the totality heightens the certainty of his actions, thus Hegel too had an interest for the numerous *Dii minorum gentium* [the gods of the smaller nations] of literature. But nowhere did he remain a passive mirror. By all devotion to what the day brought, he retained his individuality without thinking about it. His impartiality was the force of his reaction. As much as he devoted himself completely to the productions of his time, he knew how to blow a breath of life into all of them. In the *Aesthetics* he knows also how to give what was long familiar around him the charm of newness, in part through the special position that it receives in the context of the whole, in part through his energetic, striking mode of expression, as is so surprisingly the case with, e.g., the concepts of fable, metaphor, and the like. Objects about which he has much argued a long time ago, for example, Jacobi's *Woldermar*, appear in a fresh light. He uses the old judgement and yet adds another, because Hegel never took up something ready-made from memory, but rather made everything from scratch out of the material itself. Even threadbare controversies, like the superiority of Voss's *Luise* over Goethe's *Hermann und Dorothea*, over the historical fidelity of dramatic representation, and so on, crop up in new connections. In moderation, H. is a completely singular person. He is full of deep admiration for Goethe, Schiller and Shakespeare, but not a trace of mania is in him; he does not ignore their faults. His enthusiasm is always only that of reason. Where reason does not smile back at him, he remains unmoved. As fiery as his soul is, when he is allowed to greet in a work of art like Goethe's *Iphigenia* the real spirit of beauty, so magically his pithy speech then flows, so unreservedly, so naïvely and dryly in the opposed case does he utter [8] his criticism. He then does not shy away from using words such as 'trivial', 'coarse', 'barbaric', 'flat', 'tasteless' and the like against those favourites, as a partisanship that seeks the appearance of depth in unqualified praise and justification is alien to him. With incorruptible eyes he recognizes the object as that which it is, and with chaste seriousness he pronounces the knowledge acquired. *[184]*

Of all that Hegel taught, the aesthetics was probably that part that remained most obscure to a larger public. The public held in general the opinion that it might indeed understand what is logical and moral-religious in works of art, but that the true mysteries of beauty would remain closed to it. Only an agile mind, a warm, poetic sense would be open to the science of divine and free art; the force of arid scholasticism could never befriend it. But Hegel, the protector of the dialectic, the enemy of all blessed immediacy, whose Gorgon-head threatens everything individual with destruction, is supposed to be the driest of all philosophers. Thus was established the prejudice that the Hegelian aesthetics is not interested in beauty when it comes to art, but only in science artificially cloaked. It is supposed to grant no specific domain to

beauty, but sees in it only the skilful masking of logical, ethical, and theological categories.[1] The duty of science is supposed to be the destruction of such an illusion; it thus raises the mind from the lower, earthbound forms of imagination and experience that captivate it in art, to the sunlit heights of speculative thought. Every work of art, even the worst, that is, the most clumsy, because it contains general determinations in itself, would therefore have to let itself be legitimated as imbued with reason, to use a favourite expression of the Hegelology.[2] Since, however, according to Hegel and his School, the world spirit has finally ascended the peak of the cultural pyramid in his philosophy, one simply does not understand why an artistic life should continue to exist after it. It is after all fully doing one's bit to have helped communicate the birth of the speculation that knows itself to be all the truth there is.

No. 2

[9] We are convinced that through the *Aesthetics*, that are now finally available, the public will be fully disenchanted of this view, born of misunderstanding and spread by spitefulness, and that furthermore it will quietly be ashamed of how it could have once attributed to Hegel's genius this and that absurdity that it was not reluctant to believe.

If we were to finally state what is peculiar to the Hegelian aesthetics in general, we would begin by emphasizing the *form*. *[185]* Hegel's mastery in exposition is to be admired anew here. H. was to the highest degree the master of dialectical development. But with the enormous richness of material he possessed, it was really the pleasure of this passionately thorough man to put to the test abstract, general definitions through all-round application to the concrete, through following the dialectic into the tapering of the individual, so to speak. The fidelity and care with which the individual is handled in the *Aesthetics* must delight. He is here so accessible, mild and colourful, as, in contrast with the cheerful play of detail, he is rigorous and sublime in the contours of the whole. The pleasure of expression, from which nothing escapes, which delves into the innards of things and reveals them, arose out of his intimacy with the subject, out of his ruthlessness towards all that is otherworldly to it. Born of unmixed German stock, he has a store of most fitting antiquated words, and through the suppleness and force of his fantasy a multiplicity of new combinations, without him trying, flowed out of every [10] experience. Latin and French expressions too he knows to use with ease. Some contemporary writers want through a mixture of French words to give us a feeling of their fine Parisian education; they want to throw us rude Germans a few crumbs of their salon life. Of such vanity H. knows nothing. If he uses a foreign word, one must almost always agree with him because of its specific value, namely when he intends comic effects or expounds most academically and esoterically.[3] If in the writings of the School, as it cannot be otherwise, an unmistakable type rules due to him, if here necessarily certain catchphrases and constructions return, still in Hegel

1 Still a widespread misunderstanding of Hegel's *Aesthetics*. But is there *no* truth to it?
2 Rosenkranz, in this parody, invents the term *Hegelianik*, which suggests that Hegel is a Messiah.
3 Rosenkranz here uses a more esoteric word for 'esoteric' himself: *acroamatically.*

there is always another view open, where, we'd like to say, he exceeds himself, where he mints new gold coins, which from then on can no longer be done without in literary intercourse and for that reason find their way even into the enemy camp. *[186]*

Moving on, we would like to emphasize in the content the *moral dignity* that permeates these lectures with wonderful majesty. Hegel's impartiality, his tough objectivity, were made just for seeing clearly and steadily art's position relative to all other domains, without doing any of it injustice through preference. In the most fervent enthusiasm for art, we nevertheless encounter nothing of the dithyrambic drunkenness that has been in fashion for some time, which tears apart as unworthy of the mysteries of spirit whoever is not ready to sacrifice himself to beauty as the unconditionally highest. As much as he recognizes the divinity of art, still, its grounds, the holiness of religion and the truth of science are higher for him. We must only add right away that this rising sequence of the beautiful, the good, and the true has in him the [11] sense of expressing in its totality the moments of the one absolute spirit, thanks to which the charge of an abstract subordination of the one moment under the other falls away. It will sound more than a little strange to many when we report that H. quite earnestly embarks on an investigation as to whether art deserves scientific observation. This distrust of art, the question whether thought is not wasted when it sets itself to work with it, has perhaps in our century only occurred to H. It is not the concern of saintliness, which over the colourful, amiably present heaven of art fears that it will lose serious eternity, which, as in the German Middle Ages, feared in the beautiful gods the disguises of infernal demons: it is much rather speculative sobriety, which in this way raises itself from the prejudice of the day, from the frenzy of dilettantism, from the preconizings[4] of the parties, the mists of droll criticism, to the clarity and dignity of the concept.

Hegel's basis is not the bare non-difference of the real and the ideal, but the *idea of spirit. Freedom* is therefore the lover to whom H. turns everywhere with the deepest yearning. Therefore, in investigations of nature his blatant delight is when he can show how it still runs riot in hybrid forms, how it still obeys external necessity, *[187]* and its companion, chance, while spirit, in the fullness of its self-confidence, knows itself reconciled to necessity as its own, as posited by itself. Therefore also his compulsion to parade in a work of art first of all the intellectual content, which even tempts him into error, namely that of encroaching too much on politics and the philosophy of religion. Therefore a serious tone, which meets narcissistic moralism as cuttingly as it does aesthetic effeminacy. Therefore finally the free breadth of his mind, which always feels the individual in consonance with the spirit of a people, with the general state of the world, and nonetheless along with all its plastic, almost solemn morality is again harmless enough to enter tamely, with childlike devotion, in the whole surface of appearance.—This sympathy of Hegel's for objective [12] morality explains his inclination toward a *historical* conception of art. Prior to him, among the authors already discussed, as earlier among [Friedrich] Bouterweck, [Lazarus] Bendavid, Kant, [Gottlob] Eberhard, [Georg Friedrich] Meier, [Henry] Home, and [Charles] Batteux, aesthetics had been principally the theory of beauty and of art, and the historical was taken up mostly from the standpoint of the *example*. In H. the matter seems almost

⁴ Preconization, from Latin *praeco*, herald, is the Pope's appointment to a high office.

inverted. Indeed, he too starts with the idea as such, only in his execution the historical development presses itself constantly as the element that he takes as the starting point of his classification, because the idea comes to *concrete determinacy* in it. The judgement of our time on H. is in this respect inconsistent. With regard to the logical idea one has namely said that, gathering all earlier standpoints of pure speculation in itself, it was only a skilled conglomeration of ready-made definitions, a certain illusion of necessity dressing up an arrangement of principles that others had discovered, while H. himself had not invented anything truly progressive. One thus objected to the logic that it is too historical, that it is a *history of speculation corseted into the form of a system*. On the other hand, one claimed with reference to history that H. tyrannized it through his logic. He is supposed to have put in it the abstract *[188]* schemata under which he accommodates the empirical material, well or badly, through which he makes history into a *shadow play of logical concepts*. The truth is that H. was just as precise and conscientious in the logical and in the historical, and through his familiarity with the one as with the other element he could illuminate the one through the other. In his logic, the definitions are of such sharpness and purity, that one wanders through a truly transparent crystal temple. But in his historical exposition every succulent local colour delights, which seems somehow still perfumed by the atmosphere of its soil of origin. The exhaustive pithiness, with which he draws world-historical epochs, individuals, and works of art is also one of the many extraordinary talents, which God has granted this wondrous man. In the *Aesthetics*, the great discovery that he makes in a historical **[13]** vein is the distinction of symbolic, plastic, and romantic styles, a division that corresponds in history to that of oriental, antique, and modern.

The idea of beauty is the ideal in the determination of the artistically beautiful. But the ideal must distinguish itself in itself; it is no abstractum.[5] Through its individuation the afore-named basic forms of all artistic representation are generated. For the determination of the individual, however, the specific individualization is still necessary, which is produced through the individual arts, through the difference of the representing material in architecture and sculpture, in painting, music and poetry. Thus result three parts of the aesthetics.

The first, which therefore deals with the ideal, studies (1) the beautiful in and for itself; (2) the naturally beautiful; and (3) the ideal itself. The *beautiful* is the idea, but not the idea as logical, as in the abstract element of thinking, it is the true and good in itself, but rather as it exists in the objective reality of sensuous appearance. The interior of the concept and its exteriority are inseparable in it. It is interesting to notice how aesthetics in its origins, from the Platonic standpoint, posited beauty still as abstractly identical with truth and goodness, whereas modern aesthetics since Baumgarten in contrast *[189]* began with reflection on the sensible, on outer appearance.—The immediate being of beauty is in any case the *naturally beautiful*, for natural life has the concept as its soul. The particular forms are here on one hand the abstract determinations for the *relation of the parts* of a form: regularity, symmetry, law-likeness, harmony; on the other hand it is the unity of sensuous matter *in itself*, that is the purity of colours, tones, and so on. But

[5] The confusing talk of an idea distinguishing itself from itself in Hegel and his disciples relates precisely to the doctrine of the unity of the concept and a reality falling under it.

as much as natural form may delight, it is nevertheless, because its interior remains an interior, incapable of granting spirit a final satisfaction. The soul as the liquid binding of all limbs shines through only dimly to the exterior, which is constantly dependent on other exteriors, on chance circumstances, through which beauty is incessantly impaired and stunted. Even the most beautiful organism, the human, is subjected to the pressure of naturalness. [14] Because of this defect, the spirit must go beyond the naturally beautiful and create a beauty which is not wrested only from the fluctuating condition of the natural through durability, but in general is freed from the inappropriateness that the idea has in itself as a natural life, as only exteriorized and not returning to itself from exteriority. This development, of which we barely give a full description here, is worked out by H. with an uncommon love; he has gone through all natural forms from the crystal through to vegetation and the animal kingdom; also the elementary in landscape beauty is not forgotten.—That therefore absolute beauty is not found in nature, it must be made by spirit itself. The *ideal* is beautiful individuality, which has cast off the neediness of the natural state and in its exterior represents only the idea, nothing else, so that the sensuous is fully permeated by the spiritual. In the determinacy of the ideal there must be distinguished (1) the ideal in itself; (2) the action; (3) the exteriority, wherein the ideal represents itself in an adequately corresponding way. The *ideal* in itself is a carefree, *serene* beauty that is only possible to the immortal *gods*. Where individuality as *[190]* it is born on earth gets mixed up in an opposition that demands action, the blessed serenity disappears. Action, however, is *a*) necessitated by the *general state of the world*. In the *heroic* epoch, the individual by himself decides his own actions and also takes all the consequences of the same upon himself unrepentantly. But in times wherein a people has developed into a state through the distinctions of classes and administration, the individual is inhibited in his doings by a thousand obstacles. Each act of the same must orient itself according to generally valid norms. All is controlled. The mechanism of the whole destroys the poetry of the individual, and action is all the more excellent, the more prosaic it is, for prose is nothing but practical reason worked out in the form of laws and principles, which regulate the doings of the individual. Art thus will have a natural inclination to the heroic age, or at least happily seek circumstances that place the manifold limitations of the conventional state of things in the [15] background, which is why princely houses have the advantage, because from them the self-sufficiency of action, its comprehensive significance, immediately stands out. *b*) Through the determinate relation of the individual to the general state of the world, the *situation* of the latter results. Where the substantial in and for itself is represented, there is no situation at all. Where it is grasped in a play of action without consequences, as is often with the Greek gods, there the situation is harmless. *(to be continued)*

No. 3

[17] Only starting with *collision*, that is with the opposition and tension of individuals through one and the same interest, do we come to the turmoil of the true situation, whose contradiction *c*) can only be cancelled out through *action*. The individual receives its energy from the general, partly affirmative, partly negative, powers of

morality. In the genuine unity with one of them, the individual has its *character*, which expresses itself in affect as *pathos*. Without such substantial content, with which the subject is entirely merged, true pathos is impossible.—With this interiority of disposition, the outer environment, the appearing *expression* must now also correspond, not merely with relation to time, place, *[191]* drapery, but rather, in order to bring the reflex of spirit to view concretely, to make it singular. The *artist*, who brings the ideal forth for the public in a work of art, must therefore have the idea straightaway in sensuous form before him. He must be able to pour himself fully into the matter that he wishes to represent, wherein alone true *originality* lies, which cannot consist in individual strangeness, bizarre whim, or abstract idiosyncrasy, but in *objectivity* itself.

This superb discussion is followed by the second part, the development of the ideal to the *particular forms* of the artistically beautiful. The symbolic *seeks* to represent the idea in ways appropriate to it. But because it seeks, content and form remain apart. The form only signifies content, is not in concrete unity with it. The plastic *reaches* this unity. Form and content meld **[18]** entirely into one another. Significance breaks through everywhere; the interior is in the exterior; the exterior itself is thus no longer an exterior against the interior, but itself the interior, and the interior is also no longer anything for itself, but has entirely abandoned itself to the surface. With relation to art, this identity is the highest. But spirit, if it makes itself into content in its absolute self-consciousness, if therefore individualizing particularity is exploded, can leave form behind in its depth. It *exceeds* it. Then the opposite takes place, like in the symbolic. The symbolic imagines the interior in the exterior,[6] while it itself continues to seek the concept of the interior. Here the concept, the idea, is already present, but no vessel suffices any longer to take it into itself. This form is the romantic form of art, the last thinkable.

The published part of the *Aesthetics* conceives only the development of the *symbolic* form of art. H. distinguishes (1) the *unconsciously* symbolic, that is, that which does not yet separate the content which should be represented externally from the means of representation as a sign for the thing, like the rather unartistic Parsees [Zoroastrians], for whom natural light flows together immediately with the ideas of the true and the good. More separation is contained already in the fantastic symbolism of the Indians. *[192]* But highest here stands Egyptian symbolism, because it, not being so arbitrary and lacking in proportion as the Indian, contains a more precise congruence of the meaning and the objects standing for it. (2) Should one become conscious that intrinsically infinite substance cannot be exhausted by any exterior objectivity,[7] then there arises a symbolism of *sublimity*. On one hand this symbolism is pantheistic, mirroring the universe in the individual, as it has manifested itself in the Indian, **[19]** Islamic, and even in the Christian culture. On the other hand it is monotheistic, contrasting the earthly and finite with the divine and absolute, and becoming conscious of the infinite not so much in affirmation, but also in negation, in the disappearance of

[6] Rosenkranz's singular phrase, *bildet das Innere dem Äußeren ein*, gives the verb 'imagine' (*einbilden*) more objects than it normally takes: another way to read it, which would not essentially alter his account of the symbolic, would be 'builds the inner into the outer'.

[7] Essentially, when one realizes that the infinite cannot be represented, it comes to be suggested in sublime forms. Rosenkranz, in the *Aesthetics*, deviates more from Kant in asserting an objective correlate of the sublime: see our Introduction.

the finite, in the dependence and fear of the human. (3) Finally, the symbolic can fix the opposition of picture and thing so that, *conscious of the difference*, it uses both *comparatively* to *refer* to one another. Should it in the process start *a*) from *exteriority*, in order to involve it in spiritual content, fable, parable, proverb, apologue,[8] metamorphosis come to be. If it starts *b*) the other way round, from the *significance* and establish a more or less consistent exteriority, there ensues the riddle, allegory, metaphor, picture and analogy.[9] *c*) Through the *separation* of the matter and the picture representing it, however, the essence of the symbolic must be destroyed, for the identity of the object and that which the subject intuits and thinks of it become obviously ever looser. The unity, as an ultimately wholly *arbitrary* relation, falls apart. In the didactic poem the ruling thought uses the picture only as decoration; in descriptive poetry, on the other hand, thought and feeling are only brought in to enliven the given object. In the epigram, finally, the thought is so sharpened for itself, that the object on which it leans is reduced to a mere frame of the intellectual content.

It is obvious that Hegel is mistaken in this last development. In itself it is indeed consistent, but does not belong here, where the symbolic form of art was to be investigated quite generally, but in poetry, which naturally must be investigated also in the kind of composition found in the various forms of art. <Much else that seems to us in part dubious, in part incomplete, must await the appearance of the second part. At the moment, critique would be premature.—

I want to also mention in the most thankful way possible what my friend Hotho has done for these lectures. Indeed it would be unnecessary to the extent that he himself has discussed the matter so carefully in the preface, and everyone who has read in the preliminary studies on life and art published by him [20] the masterful character study of Hegel will grant him the greatest fitness for such work. I am also an incompetent judge insofar as I did not myself hear Hegel lecture.[10] I did, however, have the opportunity in Berlin three years ago to see the material from which this so finely styled, so well-interlinked work, originated. Without the notebooks, which diligent listeners caringly kept and which were amiably conveyed to Hotho, without his own notes the enterprise would indeed have been impossible. A rough pile of folio pages of various sizes lay before me. Here was for a whole page the most voluble development. Suddenly it broke off. Fragmentary sentences followed, single words stuck together only through [single] letters. Right on top lay a piece of paper that contained the same thing, but in another order, or somewhat more explicit. There was a little mark, indicating where a note was to go, which found itself lost in some corner known really only to himself. With Hegel's irrepressible force of thought was paired a bee-like diligence, which in the *Aesthetics* made itself visible through the compilation of carefully chosen examples, cited *ad paginam*. Back and forth they were solidly inscribed. It was the most charming, brilliant, suggestive confusion. But what a self-sacrificing,

[8] Like a fable, but even more moralistic.
[9] *Gleichnis* is routinely translated as 'parable' (already on the list), but then again, in German Plato's cave is the '*Höhlengleichnis*', and it is never called 'the Cave parable' in English. What is essential, perhaps, is the basic notion of comparison, hence our suggestion, 'analogy'.
[10] That is, on aesthetics. According to his autobiography, Rosenkranz did hear Hegel lecture on other philosophical topics, in the late 1820s and again shortly before his death in 1831.

tedious work to bring together these *disjecti membra poëtae*[11] to such an organic whole that nothing was lost, that the plod of private repetition is avoided, and that Hegel nonetheless would have to recognize himself in the arrangement and expression, and it should not be forgotten, as Hotho also emphasizes, that Hegel did not write as he spoke!>

Review of Vols. 2 and 3, 1839:

... [387] *[213]* Looking back now on the whole, we must pay our admiring respects to the already often discussed basic thought of Hegel's, the concept of the ideal, just as much as his all-round, thorough and fine presentation; but what caused reservations in us can be summed up briefly in the following points:

First of all, Hegel has given in his development too wide a scope to the element of the *philosophy of religion*. Nevertheless this drawback would be effaced entirely if we consider that we have here only lectures, in which such misunderstandings easily creep in. But the further question is how Hegel had thought through the position of aesthetics generally in the domain of absolute spirituality. In the *Encyclopaedia*, art is the first moment, revealed religion, the second, science, the third. In this *[214]* sense the present work also contains several pronouncements concerning the transition of art into the 'regions freer from sensuousness' of religion and philosophy. *In fact*, however, H. proceeds here in every case thus, *as if the concept of religion had already been treated*. Pantheism, monotheism, and so on, as well as world history, are here presuppositions that point in a backward rather than in a forward direction.[12] Art appears as the *exegete of religion*. What exists in concentrated simplicity as the immediate feeling of religiosity, art brings firmly into view, to decided sensation, to separated image. It procures the feeling of *definiteness* and develops the differences of its content in a form that is *congenial* to piety, and readily accessible to it. Just in this way it brings spirit to consciousness of its religion. It *exhausts* [388] gradually the *fantastic* design of the same and thus prepares the precinct of thought. Once art is finished, then thinking, the grasping of religion become a *necessity*. The final products of art become themselves ever more abstract, lose themselves ever more in generality and appear ordinarily to be frosty allegories, for spirit has already moved on to philosophy.[13] The main question here would be how the status of religion in the *Encyclopaedia* is justified, and how the art of revealed religion relates to the art of other religions. But for now these suggestions suffice.

[11] The phrase from Horace's *Satires* I.4, which gave our more familiar *disjecta membra*.

[12] This aphoristic phrase, though intuitively clear, is tricky to put into words: it might mean that these presuppositions, like pantheism, assume less the events of history to come (e.g., modernity), but rather the nebulous primeval stages of human development.

[13] The question of how Hegel's 'abstract art' relates to the century or so of art after Hegel is a live one in scholarship: see Stephen Houlgate, 'Hegel and the "End" of Art', *The Owl of Minerva* 29 (Autumn 1997), 1–19, and Robert Pippin, 'What Was Abstract Art? (From the Point of View of Hegel)', *Critical Inquiry* 29 (Autumn 2002), 1–24. One point that Hegelians today seldom note is that the 'advanced' or 'avant-garde' art of Hegel's time in Germany, Nazarene painting, was allegorical in its use of Renaissance subject matter. Rosenkranz offers a useful question: whether the crisis of allegory announced since Winckelmann is art's fault or, so to speak, an artefact of philosophy becoming less visual.

A second point was that Hegel gives the development of the concept of *beauty* as such too little space, working rather toward the difference of the ideal forms, and thus is misled into attributing *wholly general conditions*, which apply *uniformly* to all ideal forms and arts with only quantitative differentiation,[14] with violence to one or another ideal form, to the one or another art *in particular*, as for instance where poetry is supposed to be a romantic art. This generates a *mixture* of heterogeneous points of view that should be rigorously kept apart in a dialectical system. I find in the history of contemporary philosophy of Michelet[15] in the exposition of Hegel's system (vol. 2, p. 747) the attempt, already in logic, to derive the idea of beauty from the unity of the theoretical and practical idea (whereupon the true, good, and beautiful are presented in the reverse of the order they assume in the sphere of absolute spirituality in the form of art, religion, and philosophy), a thought which certainly does not belong to Hegel himself, but is only lent to him, like so much else, by Michelet, but which nonetheless gives some proof that the idea of beauty is only shakily systematized in Hegelian philosophy. The works of Vischer and Ruge too, into which I cannot go here, are evidence for this.

Just for this reason Hegel did not come to terms in every particular with the *history of art*, however much he wanted a reconciliation between theory and the empirical, and however indubitably with his concept of the ideal forms [389] he grasped the eternal foundations of all philosophical research in art history. It has already been noted that he proceeds very unevenly in this respect, very historically in architecture, only half so in sculpture and painting, not at all in music, in poetry mostly historical, but with a dispersal of the historical process in the various genres. Here, if aesthetics did not want to regress to the earlier exemplary use of artworks, philosophy would have to engage seriously in a philosophical art history.[16] [...]

II. 'Beauty and Art', in Rosenkranz's *System of Science*, 1850
Karl Rosenkranz, *System der Wissenschaft: Ein philosophishes Encheiridion* (Königsberg: Gebrüder Bornträger, 1850). 'Das Schöne und die Kunst', 562–74, and notes, 613–15.

Editors' introduction

The aesthetic in Rosenkranz's system fills a gap by starting with his view of beauty. If the pedantic numbered lists are a bit dry, the concluding sections on the individual arts are aphoristic, and build on one another, culminating in the theatrical *Gesamtkunstwerk*,

[14] In the part of the review we do not print (376/204), e.g., Rosenkranz insists that Chinese, Indian, and Greek art had significant painting, so that Hegel's identification of painting with Christian art can only be justified as a matter of degree.
[15] Karl Ludwig Michelet, *Geschichte der letzten Systeme der Philosophie in Deutschland von Kant bis Hegel*, 3 vols. (Berlin: Duncker und Humblot, 1838).
[16] We omit the end, which first mentions work in this vein, and finally praises Hotho for his modesty as an editor. Rosenkranz dedicates to him what he thinks is a verse from the Koran (in reality, an embellished version of an Arab proverb, see, e.g., Jon R. Stone, ed., *The Routledge Book of World Proverbs* [New York: Routledge, 2006], 190, though it may originate from Surahs 6:59 and 20:90): *What you have done, throw in the sea / If the fish don't see it, the Lord will.* This seems a good justification for art in general.

and a plea for world art history. Even better are the endnotes: in brief criticisms of Hegel and F. T. Vischer, Rosenkranz announces his aesthetic project, then still conceived as an Aesthetics of Caricature and intended to be richly illustrated. And, more boldly than in the finished book, Rosenkranz declares humour the basic concept in the 'metaphysics of beauty'—because it can generate all others in its transformations.

[562] Beauty and Art

§825

The absoluteness of spirit asserts itself immediately as beauty, that is, as harmonious-appearing freedom of spirit in sensuous form.

Beauty is thus to be grasped (1) in its concept as the abstract measure of every concrete beauty;(2) as the bringing forth of beauty through the activity of spirit, which we call art; (3) as the result of this activity, as the artwork, as it presents itself variously according to the means of representation.

The science of beauty and of art we have called for a hundred years (Baumgarten's *Aesthetica* having appeared, as the first, precisely in 1750) by the essentially unsuitable but by now habitual name of aesthetics.[17]

A. Beauty

§826

Beauty is (1) positively the harmonious-appearing freedom of spirit in sensuous form; (2) negatively the disharmonious-appearing non-freedom and rupture [563] of the spirit in sensuous form; (3) the cancellation of this non-form through its reduction to a play of the freedom of spirit. Beauty is therefore the simply beautiful or the ugly or the humorous.

I. *Beauty in itself*

§827

Beauty is that measured and harmonious representation that freedom of spirit gives itself in the element of sensuousness. Nature can for this reason be beautiful as well, because the spirit is which created it, and to which in turn it gives, in its forms and motions, the reflection of its freedom.[18] Natural beauty is essentially symbolic, namely in landscape expression and in the human form.

[17] Rosenkranz already comments on the disadvantages of the word in his history of Kantian philosophy. There, however, he finds a silver lining to the artificiality: in not knowing precisely what "aesthetics" means, we are not misled into assuming what it is.

[18] This difficult sentence seems to say that spirit creates nature, and nature in its embodiment gives spirit (back) a reflection of its (spirit's) freedom. Given Rosenkranz's habits of thought and the account in the *Aesthetics*, however, it is conceivable that the author wrote quickly and erred, having intended rather to say that spirit lends nature its freedom.

Beauty is as representation of freedom in sensuous form bounded by itself, for freedom is its own necessity, and nature, through whose mediation freedom appears in sensuous form, is everywhere ruled by immanent determination of proportion. All logical determinations of the concept of proportion apply in turn to beauty, just as much as all determinations of natural proportion.

Eurhythmy, symmetry and harmony are the abstract foundations of all beautiful design and movement.

§828

If design frees itself from the measured boundary and becomes immoderate, it is *in this transition sublime*; if it turns rather to individualization and miniaturization of proportions, it becomes *pleasant*.

§829

Beauty in and for itself is the perfected unity not only of spiritual and sensuous, but also of proportions, [564] in that the sublime in it becomes *honour*, the pleasantness *grace*.

II. Ugliness

§830

In freedom lies the possibility of the negation of proportion, as well as of the necessity of nature and of spirit itself. Thus ugliness is born. It inverts the beauty of proportions into the *formlessness* either of the formless, or of the unformed and unproportioned.

Sublimity, on the other hand, finds its opposite in *meanness*, pleasantness in *repulsiveness*.

Ugliness perfects itself in *caricature*, wherein the *contradiction* of freedom and its essence are expressed through the *misshapenness* of form and movement.

III. The Humorous

§831

Neither the beautiful in itself nor the ugly as such are comic. The humorous is the *dissolution* of ugliness, in that it *destroys itself*. The distortion of proportions and of expression in caricature make possible the transition to beauty through the cheerful play of frolicking exaggeration of contradictions.

§832

Design and motion become *grotesque* and *burlesque*. Expression becomes *ridiculous* if a tense expectation dissolves in a harmless nothing. *Travesty* and *parody* ridicule disproportion and disharmony.

[565]

§833

In exposing the *nullity* of the *appearance* of the Idea that spreads itself out in place of its positive appearance, humour becomes *satirical, ironic, humoristic*. Humour is the perfected restoration of the Idea of beauty in its unity with the Idea of the true and the good, and indeed so, that it takes in itself the whole depth of the rupture between empirical existence and the essence of spirit, affirming the optimism of absolute freedom and representing the reconciliation of spirit with itself, also in suffering, in unhappiness, in lack, in finitude generally, as the work of a subjectivity infinite in itself. Even the ugly is no obstacle for its all-conquering magic, only that, in being precisely the outermost possibility of beauty, it stands ever at the boundary of its measure.

B. Art

§834

Beauty exists as natural as well as artistic beauty. In nature beauty is, however, accidental to the extent that nature does not have as its goal beauty as such, but life. The beautiful as such is brought forth by the spirit, which uses nature as a means and represents the truth of its proportions after its own free concept, independent of empirical chance and pressure. Spirit asserts beauty (1) as ideal; (2) determines the ideal through its specific formation, style; (3) realizes it as a single relatively finite work. [**566**]

I. The Ideal

§835

The Idea of beauty becomes an ideal insofar as the representation of freedom in the element of sensuousness, which constitutes the essence of beauty as such, is referred to as its *bringing forth* through the spirit. Without this reference, the Idea remains in its concept; with this reference, it leaves its theoretical serenity and enters the tension of what should be.

§836

The ideal distinguishes itself in its varieties according to the moments of sensuousness and spirituality, which are identical in the Idea of beauty. The abstraction of these elements from one another produces the distinction into objective and subjective ideals, and the unity of the ob- and subjective in the absolute [ideal].

1. The *objective* ideal contains the idealization of *sensuousness*. It does not copy nature, but it determines itself through the *realism* of empirical appearance. Psychologically, the artist who strives to realize it starts with experience (*Anschauung*), but does not

stop there, but raises reality to the truth of its concept. We call the objective ideal for this reason also the *naïve*.[19]

2. The *subjective* ideal contains the realization of *the thought*. It does not, however, express the thought as thought, purely ideally, but it determines itself through the *idealism* of abstraction from the essence of the phenomenon. Psychologically, the artist who strives to realize it [the thought], as symbol, as sign, as allegory, starts with the *idea*, but does not stop there, but immerses its content in manifest visualization. We call the subjective ideal for this reason also the *didactic*.

3. The *absolute* ideal contains the realization of the representation of freedom of spirit in the element of sensuousness in [**567**] such a way, that *freedom as absolute necessity* pierces through sensuous appearance, and in this ensoulment, as the decisively irresistible power, reaches out with the victorious force of subjective idealism over objective reality. This ideal thus, like humour, reaches to the boundary of art and stands on the edge of letting its transcendental transfiguration of appearance fall into abstract transcendence. We call the absolute ideal for this reason also the *sentimental*, so as to mark freedom's path back into itself from its appearance.

§837

Taken historically, in the sphere of peoples that constitute the group of nation states, because they are based on natural individuality, the objective ideal rules and with it the riches of the visual arts. In the sphere of the theocratic states, which are based on an abstraction of reason, the subjective ideal rules and with it poetry, the word, the fullness of musical speech. Finally in the sphere of humanistic states, whose principle is the self-conscious concept of spirit, the absolute ideal rules and with it the equal cultivation of all arts, only thus, that they can no longer directly express the depth of spirit, whence the effusiveness of content and the underselling of form that Goethe, in contrast to the objective ideal, labelled as downright pathological.

II. Style

§838

The ideal realizes itself within each art and within each nation that applies it to an art, in all its directions, for it strives ever after its absoluteness, and with this striving, in its realization, the [**568**] one-sidedness of its distinctions also becomes relatively apparent. But the ideal, as concrete realization of the idea of beauty, includes in its formation also distinct stages of particularization: style.

Style is determined (1) through the distinction of the moments of the idea of beauty; (2) through nationality; (3) through the peculiarity of an epoch, a school, an artist.

[19] This nomenclature goes back to Schiller's distinction between naïve and sentimental (Romantic) poetry, the former being represented above all by Homer and the Greeks.

§839

1) The distinction of the moments of the idea of beauty realizes itself in the formation of the idea thus, that a) the sublime serves as basis of the *severe* style, which concentrates itself in the hardness and brittleness of the form and the roughness of movement; b) the pleasant manifests itself in the *soft* style, which rounds the design and tames movement; c) beauty in and for itself determines the *beautiful* style, wherein the purest proportions unite themselves with the innermost expression of freedom.[20]

This full beauty, wherein spiritual content reaches its really adequate form, the inner thus really is found in the outer, we also call the *classical*.

It dissolves when it separates itself into its elements, dignity and grace, and exaggerates either, so that a) the element of dignity becomes the *colossal* and b) the element of grace becomes the *piquant*. The former flirts with sublimity, the other with pleasantness.

§840

2) These differences, grounded in the concept of the idea of beauty, receive their particular colouring through *nationality*, whose individualization penetrates all levels of a style. Insofar we speak quite rightly of an English, Spanish, Chinese, Greek ideal, and so on. If we compare the very similar works of art of different nations, there is revealed immediately despite all other analogy the [569] difference of national character, which runs through everything else, for instance, in the pyramids and palaces of Anahuac[21] and those of Memphis.

§841

3) The nationality of style perfects itself in the *manner* with which an epoch, school, or master carries out the realization of the ideal in a nation. This peculiarity can go as far as the idiosyncratic, but has nevertheless a solid base in the distinction of manner into *high, middle,* and *low* style.

III. *The Work of Art*

§842

All these determinations of the idea and of style flow into the concrete existence of individual artworks brought forth by the genius and talent of the *artist*. The artwork is *divine*, for though it is mediated by the individuality of the artist and his nation, it is nevertheless an expression of the idea of beauty in and for itself. Only as *enthused* by this

[20] Readers of Winckelmann will recognize from his *Geschichte der Kunst des Alterthums* (Vienna, Akademischer Verlag, 1776), pp. 469–501, the three styles (high or severe, beautiful, soft, all prefaced by the 'older style') of Greek Classical art, a historical schema of progress and decline quite unlike Rosenkranz's.

[21] A Nahuatl word for the Mexican basin: Rosenkranz is referring to Aztec pyramids, probably the destroyed but often described Templo Mayor in Mexico City (Tenochtitlán).

does the artist succeed in setting up the work in free self-sufficiency, so that it carries and holds itself, and he can step back modestly from it, after it has received his soul immortally, and he can leave it to the enjoyment of others, the *devotion* of their *delight*. [570]

C. The System of the Arts

§843

The artwork distinguishes itself intrinsically through the material with which the artist realizes the ideal. This realization comprises a whole closed in itself, a system, in which the various arts determine one another and each art excites all the others, because it is in itself only one moment of the aesthetic totality.

The work of art is 1) the *spatial*, which forms matter for the eye *plastically*; 2) the *timely*, which forms sound for the ear *musically*; 3) the *ideal*, which forms [mental] images for the intelligence *poetically*.

I. Plastic Art[22]

§844

Plastic art arranges matter in space for our view 1) as building; 2) as statue; 3) as picture.

1. Architecture
Architecture forms mass as the meaningful casing of an interior separated from it, which it assumes to be the aim of its enclosure, whether it is a corpse, the statue of a god, a religious or political or sociable action. Spatial enclosure opposes floor and ceiling. In order to carry the ceiling, it requires a vertical intermediary member. In the specification of this as wall, pier, column, all of architecture develops itself. [571]

2. Sculpture
Architecture assumes life. Sculpture, on the other hand, represents life, and indeed, since it can only capture it in one moment and it can only represent the phenomenon in immutable sameness, it does so according to its whole *perfection*. The work of sculpture must also bring into view the intense, painful emotion with ideal restraint, because it must raise it to an intrinsically infinite present. The naked human form in the ideal repose of a general situation therefore remains its centre, from which, however, it can venture into athletic mobility, groupings, portraiture and representations of animals. The architectural column is already a preface to sculpture, the relief, a preface to the picture.

3. Painting
Sculpture represents life in its full reality, but due to the rigidity and monochromy of its material nevertheless only in an ideal transcendence. Every statue has something

[22] We translate *Plastik* thus rather than as 'sculpture', for which it is a common German word and also a fit translation of Herder's 1778 *Plastik*, because Rosenkranz includes painting and sculpture under plastic art, whereas Herder opposed the two.

ghost-like, supernatural, about it. The picture does not have the palpable fullness of the statue, for it represents only on the surface, but it manages to represent through colour the whole pithiness of *immediate* life, all the violence of individual characteristics, the whole soul of the beaming eye, the whole illusion of sensuous phenomena. Painting therefore excludes nothing that can become visible. From the flower it ascends to the landscape, from the still-life to genre, from portrait to a historical situation, or even, from the din of a battle scene, of elaborate sensuousness, to the transparency of the aesthetic *morbidezza* [tenderness] of a dying god.
[572]

II. Music

§845

The picture already pronounces the individuality of things, plants, and people, as it appears in light. Only the interiority *as interiority*, the undistorted utterance of the individual soul, is first expressed in sound. Sound reveals the secret of life. It is open and yet mysterious. It manifests specificity without ambiguity, and yet it is inscrutable. Music, which gives this fugitive, through length and brevity, through duration and interruption, through alternation of heights and depths, through the harmony of the sound that drones in cymbals and drums, shivers in strings, bursts from horns, streams from the human breast, an infinitely manifold form, music is the art not only of expressing everything that the spirit understands, but also that which remains obscure in it and in words as yet unsayable. The symbolism of tones can also articulate the approximate.

III. Poetics

§846

This wonder is, however, also the shortcoming of music. Poetry combines musical interiority with plastic visibility, in that it binds together the mobility of sound, but as human sound, with the constancy of the image in the ideal space of intelligence. Language as the means of poetic representation exceeds in clarity every other form of manifestation of spirit. The revelation of language stands higher still than the revealed mystery of sound in itself.

[573] As reproduction of the essence of visual art, namely of experience, poetry becomes *epic*; the reproduction of the essence of musical art, namely immediate mental excitements through sound, poetry becomes *lyric*; as the unity of epic and lyric poetry, as the view of an action, but one immediately present, spoken individually by those acting in the stages of the process, it becomes *drama*.

The difference between *tragic* and *comic*, which one usually only observes in drama, goes through all these forms uniformly.

Poetry strives to represent the others in each of its forms. Epic poetry can be purely epic, in that it represents a past action fully objectively, but it can also take on a lyric accent and a dramatic construction, in the same way that lyric can take into itself the

element of vision or dialogue and the dramatic can subordinate pathos to the march of events in epic fashion, or let the action disappear lyrically in the fullness of pathos. The truly drastic drama will represent the equilibrium of action and the pathos of those acting. All poetry presses toward drama, because it makes possible *theatrical* art as that wherein the human being in accordance with his *totality* brings to the human being the essence of spirit to immediate view, making possible the melting together of all arts into a harmonious total effect.

§847

Beauty is brought forth by art as the sensuous formation of the absolute. It is divine and proves this divinity also empirically by the fact that works of art, though they are produced by the intrinsically limited spirit of the nations, the various epochs of its destiny and the individual force of genius, nevertheless make us [574] forget this particular origin and are able to offer themselves to the enjoyment of all nations, all times and cultures. A people standing at a higher stage of development can appropriate the works of art of all nations and epochs that have come before. The real works of art are laid down by the spirit on the altar of humanity as a global offering to bind the people. For instance, not just the dramas of the Englishman Shakespeare and the Spaniard Calderón, as individual as they were born, but also the Medea of Euripides and the Antigone of Sophocles still stalk our stages, and there is nothing to stop this happening also with Kalidasa's *Sukuntala* or *Urwasi!*[23]

But art is still dependent on nature and humans. This dependence is cancelled out (*aufgehoben*) in the purely spiritual relation of spirit to absolute spirit. Religion[24] takes on art as the organ of its observance, in itself it is, however, initially indifferent to the beauty of form.

Notes: [613]

On *beauty* and *art*, §825ff, I note that I have stated my fundamental difference with Hegel at length in the review of his *Ästhetik* in the *Berlin* yearbooks,[25] reprinted in my *Kritische Erläuterungen des Hegelschen Systems* [Critical Elucidations of the Hegelian System], Königsberg [Gebrüder Bornträger], 1840, pp. 177–216.

This fundamental difference consists in the fact that Hegel (1) lacks a *metaphysics of beauty* and (2) that not only does he *identify* the *symbolic, classical*, and *romantic* with Oriental, Greek, and Christian art *per se*, but that he furthermore uses these as a classification in which to *subordinate* the system of the arts.

[23] The fifth-century Indian poet Kalidasa's *Shakuntala* was the first Indian verse play to be translated into English and German, to great acclaim (including by Goethe). The second play Rosenkranz refers to is generally called *Vikramōrvaïyam* [*Urwashi won by Valour*]. Rosenkranz's interest in Indian poetry is manifest in his review of Franz Bopp's translation of the story of Nala and Damayanti, on which see our note to R 366.
[24] The section on religion follows in the *System*.
[25] *Jahrbücher für wissenschaftliche Kritik*, 1936 and 1939, translated in this volume.

Concerning the first point, the fault is widely admitted. Hegel allows the ideal, but not the idea, [**614**] to come into its rights. From this spring other errors. Vischer has already remedied this flaw in his splendid treatment of aesthetics, in the first volume [*Ästhetik oder Wissenschaft des Schönen. Erster Theil: Die Metaphysik des Schönen*], Reutlingen and Leipzig, [Carl Mäcken], 1846, just as in the second volume he has treated the concept of *natural beauty* in a thorough and as yet unsurpassed way. That nevertheless I often cannot agree with Vischer in particulars will already be obvious from the short sketch here. The main difference between him and me is that he takes the comic for the opposite of the sublime. He constructs thus:

1. Simple beauty.
2. Beauty in the conflict of its moments;

 α) The sublime;
 β) The comical.

3. The beautiful on its return from these concepts to itself.

I construct thus:

1. Beauty in itself;
2. Ugliness;
3. The comical.

Ugliness seems to me to be the true opposite of beauty, *negative beauty*, which is why we can fight over whether something is ugly *or* beautiful. The true opposite of the sublime, however, does not seem to me to be the comical, but the pleasant, so that to the great the cute, to the powerful the playful, to the majestic the charming are opposed. The comical, however, presupposes ugliness. From the sublime to the ridiculous is but one step, but this must lead through a moment of ugliness, as Weiße rightly saw, when in his 1830 *System der Ästhetik als Wissenschaft*, Leipzig, 2 vols., he first earned the merit of installing ugliness into aesthetics *systematically*, after everyone from Aristotle to him had handled it only occasionally. But he narrows his concept through the juxtaposition with the sublime, instead of with [**615**] beauty as such, and through an identification of ugliness with evil. As it happens that one tends to interest oneself most energetically in the upbringing and education of neglected subjects, so I confess that was the case for me with ugliness, since I recognized how much it is still neglected. My goal has become a very determinate one, an *Aesthetics of Caricature*, for which I have been collecting pieces for years, but always delaying its composition until the perhaps quieter times of a more advanced age, particularly since I would like to illustrate it with an *atlas*, in order to properly put an end to delicate sensibilities through the mediation of the visible as well. In this occupation, which I quietly allow to go on in the company of more important things, I have learned to some degree to survey with an astounded gaze the enormous extent of ugliness in art, but also I have recognized ever more clearly its intimate connection with the comical. I therefore hold the concept of *humour* for the *ultimate* in the metaphysics of beauty, because in my view humour, with divine

cheer, *plays* also with seriousness, but in this play it can again run through all the steps of beauty up to the sublime.

As for the second point, I hold the symbolic, classical, and romantic to be entirely general determinations of the development of fantasy as such, which can emerge in *all the arts* and among *all the peoples*, and on this I refer to my *Psychologie*, 2nd edn, p. 287ff.

Bibliography

Note: Under 'Sources cited by Rosenkranz', we expand and correct the bibliography contained in the Reclam editions, which limited itself to 'the scholarly sources', meaning to exclude fiction and poetry, which however it did inconsistently. That list also proffered modern editions for canonical works cited by Rosenkranz from memory. We have not followed this practice, giving only the author and customary name of the work where Rosenkranz quotes, and leaving classics mentioned but not quoted to the index.

Sources cited by Rosenkranz

Aeschylus, *The Persians*.

Alexis, Willibald. *Die Hosen des Herrn von Bredow* (Berlin: W. Adolf, 1846).

[Allon, Thomas, published anonymously] *China: historisch, romantisch, malerisch*, 12 vols ([Karlsruhe:] Heinsius, 1843).

Anthus. *Vorlesungen über die Eßkunst* (Leipzig: Wagand 1838).

Aristophanes. *Aristofanes. Von Johann Heinrich Voss*, 3 vols (Braunschweig: Friedrich Vieweg, 1821).

Aristophanes. *Des Aristophanes Werke, Uebersetzt von Johann Gustav Droysen*, 3 vols (Berlin: Veit, 1838).

Aristotle, *De Poetica, De Interpretatione*.

Von Arnim, Ludwig Achim. *Armuth, Reichthum, Schuld und Buße der Gräfin Dolores*, ed. Wilhelm Grimm, 2 vols (Berlin: Veit, 1840).

Auerbach, Berthold. *Dorfgeschichten* (Mannheim: Friedrich Bassermann, 1848).

Auerbach, Berthold. *Neues Leben. Eine Erzählung* (Mannheim: Friedrich Bassermann, 1852).

Baggesen, Jens. *Adam und Eva* (Leipzig: Göschen, 1826).

Balzac, Honoré. *Le Livre des doleurs*, vol. 4: *Séraphita* (Paris: Hyppolite Souverain, 1840).

Barthélemy, Jean-Jacques. *Voyage du jeune Anacharsis en Grèce: vers le milieu du quatrième siècle avant l'ère vulgaire* [1788] (Paris: Didot, 1843).

Baumgarten, Alexander Gottlieb. *Aesthetica* and *Aestheticorum pars altera* (Frankfurt an der Oder: Johann Christian Kleyb, 1750–8).

Becker, Wilhelm Adolph. *Gallus oder Römische Scenen aus der Zeit Augusts*, 3 vols (Leipzig: Friedrich Fleischer, 1838; second rev. ed. 1849).

Becker, Wilhelm Adolph. *Charikles, Bilder altgriechischer Sitte*, 2 vols (Leipzig: Friedrich Fleischer, 1840).

Benedix, Roderich. *Das Lügen. Lustspiel in 3 Aufzüge* (Köln: Langen, 1852).

Béranger, Pierre Jean. *Oeuvres completes de P. J. de Béranger, edition illustrée par Grandville et Raffet*, vol. 3 (Paris: Fournier Aîné, 1837).

Berge, Friedrich and Adolf Riecke, *Giftpflanzbuch*, 2nd ed. (Stuttgart: Hoffmann, 1850).

Blumauer, Aloys. *Virgils Aeneis traverstirt von Blumauer*, 4 vols (Vienna: Rudolf Gräffer, 1784–8).

Bohtz, August Wilhelm. *Ueber das Komische und die Komödie* (Göttingen: Vandenhoeck und Ruprecht, 1844).

De Boyer, Jean-Baptiste (Marquis d'Argens). *Thérèse philosophe* (Paris, 1748).

Bratranek, Franz Theodor. *Beiträge zu einer Ästhetik der Pflanzenwelt* (Leipzig: Brockhaus, 1853).

Brentano, Clemens. *Godwi, oder das steinerne Bild der Mutter: ein verwildeter Roman*, 2 vols (Bremen: Wilmans, 1802).

Brentano, Clemens. 'Fragment aus Godwi', in *Clemens Brentanos Gesammelten Schriften*, ed. Christian Brentano (Frankfurt am Main: Säuerländer, 1852), vol. 5, 285–326.

Bülow, Eduard. *Das neue Novellenbuch*, 4 vols (Leipzig, Brockhaus, 1834–36).

Bürger, Gottfried August. *Lenore. Ein Gedicht* (London: S. Cosnell, 1796).

Burow, Julie. *Frauen-Loos*, 2 vols (Königsberg: Adolph Samter, 1850).

Lord Byron, George Gordon. *Sardanapalus, A Tragedy. The Two Foscari, A Tragedy. Cain, A Mystery* (London: John Murray, 1821).

Lord Byron, George Gordon. *Lord Byron's Sämmtliche Werke*, vol. 10: *Sardanapal, Werner, Der umgestaltete Ungestalte*, ed. Johann Valentin Adrian (Frankfurt am Main: Sauerländer, 1831).

Lord Byron, George Gordon. *Lord Byron's Sämmtliche Werke*, vol. 7: *Don Juan. Zwölfter bis sechszehnter Gesang. Die Insel*, ed. Johann Valentin Adrian (Frankfurt am Main: Sauerländer, 1831).

'Lord Byron, George Gordon'. *Irner*, translated Gustav Jördens (Leipzig: Lauffer, 1823).

Calderón de la Barca, Pedro. *El príncipe constante, Zelos aun del ayre matan, Cefalo y Procris, Magico prodigioso.*

Catlin, George. *Die Indianer Nord-Amerikas und die während eines achtjährigen Aufenthalts unter den wildesten irher Stämme erlebten Abenteuer und Schicksale*, ed. Heinrich Berghaus (Brussels and Leipzig: Carl Muquardt, 1848).

Challamel, Augustin. *Histoire-musée de la république Française depuis l'assemblée des Notables jusqu'à l'empire*, 2 vols (Paris, 1842).

Cicero, *De Oratore.*

Condillac, Etienne Bonnot de. *Traité des sensations* (Paris: De Bure, 1754).

Constant, Benjamin. 'Réflexions sur la tragédie', *Revue de Paris* 7 (1829), 5–21, 126–40.

Daub, Carl. *Judas Ischarioth, oder das Böse in Verhältniß zum Guten*, 2 vols (Heidelberg: Mohr und Winter, 1816–18).

Daumer, Hans Christian. *Die Geheimnisse des christlichen Alterthums*, 2 vols (Hamburg: Hoffmann & Campe, 1847).

Delavigne, Casimir and Eugène Scribe. *Robert der Teufel, Nach dem Französischen des Scribe und Delavigne von Theodor Hell, Musik von Meyerbeer* (Munich: J. Rösl, 1834).

Le Diable à Paris. Paris et les parisiens: mœurs et coutumes, caractères et portraits des habitants de Paris, 2 vols (Paris: J. Hetzel, 1845–6).

Diderot, Denis. *Les bijoux indiscrets* in *Oeuvres de Denis Diderot*, vol. 10, ed. Jacques André Naigeon (Paris: Deterville, 1800).

Diderot, Denis *Jacques* in *Oeuvres, Oeuvres de Denis Diderot*, vol. 11, ed. Jacques André Naigeon (Paris: Deterville, 1800).

Didron, Adolphe Napoléon. *Iconographie chrétienne* (Paris: Imprimerie Royale, 1843).

Diez, Friederich. *Leben und Werke der Troubadours* (Zwickau: Gebrüder Schumann, 1829).

Dumas, Alexandre (fils). *La dame aux camélias* (Paris: Alexandre Cadot, 1848).

Dunlop, John Colin. *Geschichte der Prosadichtungen*, translated Felix Liebrecht (Berlin: Müller, 1851).

Feuerbach, Anselm. *Der Vaticanische Apollo. Eine Reihe archäologisch-ästhetischer Betrachtungen* (Nürnberg: Friedrich Campe, 1833).

Fichte, Johann Gottlieb. 'Über Geist und Buchstabe in der Philosophie. In einer Reihe von Briefen. 1794', *Philosophisches Journal*, vol. 9 (1798), 199–232, 292–305, reprinted in *Johann Gottlieb Fichte's Sämmtliche Werke*, ed. J.H. Fichte (Berlin: Veit, 1846), 270–300.

Fichte, Immanuel Herrmann, ed. *Schiller's und Fichte's Briefwechsel* (Berlin: Veit, 1847).

Fischer, Kuno. *Diotima oder die Idee des Schönen* (Pforzheim: Flammer und Hoffmann, 1849).

Flögel, Karl Friedrich. *Die Geschichte der komischen Literatur* (Liegnitz and Leipzig: David Siegert, 1784–7).

Flögel, Karl Friedrich. *Geschichte des Groteskekomischen: ein Beitrag zur Geschichte der Menschheit* (Liegnitz and Leipzig: David Siegert, 1788).

Fourier, Charles. *Théorie de l'unité universelle*, 4 vols (Paris: Société pour la propagation et la réalisation de la théorie de Fourier, 1841).

Les Français peints par eux-mêmes: Encyclopédie moral du dix-neuvième siècle (Paris: Curmer, 1841–50).

Gailhabaud, Jules, with Franz Kugler and Jacob Burckhardt, ed. Ludwig Lohde. *Denkmäler der Baukunst*, 4 vols (Hamburg: Johann August Meissner / Leipzig: Julius E. Richter, 1852).

Gautier, Théophile. *Salon de 1847* (Paris: J. Hetzel, Warnod, 1847).

Gavarni, Paul *Oeuvres choisies de Gavarni, etudes de moeurs contemporaines*, 4 vols (Paris: J. Hetzel, 1846).

Genthe, Friedrich Wilhelm. *Geschichte der macaronischen Poesie und Sammlung ihrer vorzüglichsten Denkmale* (Halle & Leipzig: Reinicke, 1829).

Gervinus, Georg Gottfried. *Shakespeare*, 4 vols (Leipzig: Wilhelm Engelmann, 1849–50).

Glaßbrenner (Glasbrenner), Adolf. *Das Paradies* (Berlin, year unknown).

Goethe, Wolfgang. 'Polygnots Gemählde in der Lesche zu Delphi', *Jenaische Allgemeine Literatur-Zeitung* (Jan–March 1804), 9–24.

Goethe, Wolfgang. *West-Östlicher Divan* (Stuttgart: Cotta, 1819).

Goethe, Wolfgang. 'Die guten Weiber' [1800], in *Goethe's Werke. Vollständige Ausgabe letzter Hand*, vol. 15 (Stuttgart and Tübingen: Cotta, 1828), 263–96.

Goethe, Wolfgang. *Italienische Reise*, [1789/1813–17], in *Goethe's Werke. Vollständige Ausgabe letzter Hand*, vol. 28 (Stuttgart and Tübingen: Cotta, 1831).

Goethe, Wolfgang. 'Der Sammler und die Seinigen' [1799], *Goethe's Werke. Vollständige Ausgabe letzter Hand*, vol. 38 (Stuttgart and Tübingen: Cotta, 1831), 51–139.

Goethe, Wolfgang. 'Der Tänzerin Grab' [1812] and 'Über den sogenannten Dilettantismus oder die praktische Liebhaberey in den Künsten' [1799], in *Goethes Werke. Vollständige Ausgabe letzter Hand*, vol. 44 (Stuttgart and Tübingen: Cotta, 1833), 188–95, 255–85.

Goethe, Wolfgang. 'Diderots Versuch über die Mahlerei' [1798–9], in *Goethe's sämmtliche Werke in vierzig Bänden*, vol. 29 (Stuttgart and Tübingen: Cotta, 1840), 384–443.

'Goethe, Wolfgang' [Otto Philipp Zaunschliffer]. *Göthe's juristische Abhandlung über die Flöhe (de pulicibus)* (Berlin: Alexander Duncker, 1839).

Gotthelf, Jeremis. *Käserei in der Vehfreude* (Berlin: Julius Springer / Zürich: Höhr / Bern: Huber, 1850).

Gottschall, Rudolf. *Die Göttin* (Hamburg: Hoffmann und Campe, 1853).

Grabbe, Dietrich Christian. *Scherz, Satire, Ironie und tiefere Bedeutung*, in *Dramatische Dichtungen*, vol. 2 (Frankfurt am Main: Johann Christian Hermann, 1827), 53–190.

Grandville, J.J. *Petites misères de la vie humaine* (Paris: H. Fournier, 1843).

Grandville, J.J. *Un autre monde* (Paris: H. Fournier, 1844).

Grandville, J.J. *Les Fleurs animées* (Paris: Gabriel de Gonet, 1847).

Gringmuth, Willibald. *De Rhyparographia. Disputatio philosophica* (Bratislava: F. Hibt, 1838).

Gruppe, Otto. *Die Winde, oder ganz absolute Konstruktion der neuern Weltgeschichte durch Oberons Horn, gedichtet von Absolutus von Hegelingen* (Leipzig: Haack, 1831).

Gutzkow, Karl. *Mahaguru* (Stuttgart: Cotta, 1833).

Gutzkow, Karl. 'Der Prinz von Madagaskar,' *Novellen*, vol. 2 (Hamburg: Hoffmann und Campe, 1834), 91–256.

Gutzkow, Karl. *Blasedow und seine Söhne: Komischer Roman*, 2 vols (Stuttgart: Verlag der Classiker, 1838).

Gutzkow, Karl. *Dramatische Werke. Richard Savage. Werner* (Leipzig: Carl Lorck, 1845).

Gutzkow, Karl. *Uriel Acosta* (Leipzig: Carl Lork, 1847).

Gutzkow, Karl. *Die Ritter vom Geiste*, 9 vols (Leipzig: Brockhaus, 1850–2).

Von der Hagen, Friedrich Heinrich. *Geschichten, Mährchen, und Sagen*, ed. with E.T.A. Hoffmann and Henrich Steffens (Breslau: Josef Max, 1823).

Von der Hagen, Friedrich Heinrich. *Erzählungen und Mährchen* (Prenzlau: Ragoczy, 1826).

Halm, Friedrich. *Griseldis* (Vienna: Gerold, 1837).

[D'Harleville, Collin]. *Der Lügner und sein Sohn. Posse in 1 Akt nach Collin d'Harleville frei bearbeitet* (Vienna: Wallishäuser, 1837).

Hartmann von Aue. *Die Lieder und Büchlein und Der arme Heinrich*, ed. Moriz Haupt (Leipzig: Weidmann, 1842).

Hauff, Hermann. *Moden und Trachten. Fragmente zur Geschichte des Costüms* (Tübingen and Stuttgart: Cotta, 1840).

Hausmann, Johann-Friedrich-Ludwig. *Kleinigkeiten in bunter Reihe*, 2 vols (Göttingen: Dieterich, 1839).

Hebbel, Friedrich. *Maria Magdalene. Ein bürgerliches Trauerspiel in drei Akten* (Hamburg: Hoffmann und Campe, 1844).

Hebbel, Friedrich. *Julia. Ein Trauerspiel in drei Akten* (Leipzig: J.J. Weber, 1851).

Hegel, G.W.F. *Vorlesungen über die Ästhetik*, ed. H.G. Hotho, vol. 10 of *Hegels Werke*, 3 vols (Berlin: Duncker und Humblot, 1835–8).

Heine, Heinrich. *Der Salon*, vol. 1 (Hamburg: Hoffmann and Campe, 1834).

Heine, Heinrich. *Neue Gedichte* (Hamburg: Hoffmann and Campe, 1844).

Heine, Henrich. *Atta Troll. Ein Sommernachtstraum* (Hamburg: Hoffmann and Campe, 1847).

Heine, Heinrich. *Romanzero* (Hamburg: Hoffmann and Campe, 1851).

Heine, Heinrich. *Der Doktor Faust. Ein Tanzpoem, nebst kuriosen Berichten über Teufel, Hexen und Dichtkunst* (Hamburg: Hoffmann and Campe, 1851).

Heinrich der Löwe, Heldengedicht in 21 Gesängen, mit historischen und topographischen Anmerkungen von Stephanus Kunze. 3 Thle (Quedlinburg: G. Basse, 1818).

Henneberger, August. *Das Deutsche Drama der Gegenwart* (Greifswald: Koch, 1853).

Hettner, Hermann. *Vorschule zur bildenden Kunst der Alten*, 2 vols (Oldenburg: Schulz, 1848).

Hoffmann, E.T.A. *Sämmtliche Werke in einem Bande* (Paris: Baudry, 1841).

Hoffmann, Heinrich. *Die Mondzügler* (Frankfurt am Main: Jäger, 1843).

Hohenbaum, Karl. *Psychische Gesundheit und Irresein in ihren Uebergängen* (Berlin: Reimer, 1845).

Hölderlin, Friedrich. 'Der Tod des Empedokles. Fragmente eines Trauerspiels,' in *Gedichte* (Stuttgart and Tübingen: Cotta, 1826), 198–226.

Homer, *Homers Ilias von Johann Heinrich Voss*, 3rd rev. ed. (Tübingen: Cotta, 1806).

Horace, *Epodes*.

Hotho, Heinrich Gustav. *Geschichte der Deutschen und Niederländischen Malerei*, 2 vols (Berlin: Simion, 1842).

Howard, Luke. *Essay on the modifications of clouds* [1803] (London: Harvey and Darton, 1832).

Hugo, Victor. *Le Roi s'amuse* (Bruxelles: Louis Hauman, 1832).

Humboldt, Alexander. *Ideen zu einer Physiognomik der Gewächse* (Tübingen: Cotta, 1806).

Humboldt, Alexander. *Ansichten der Natur*, 2 vols. (Tübingen: Cotta, 1808).

Humboldt, Alexander. *Vues des Cordillères* (Paris: À la Librairie Grecque-Latine-Allemande, 1816).

Humboldt, Alexander. *Kosmos. Entwurf einer physischen Weltbeschreibung*, 3 vols (Stuttgart and Tübingen: Cotta, 1845-50).

Humboldt, Wilhelm. 'Über die männliche und weibliche Form', *Die Horen* 3 (1795), 80-103 and 4 (1795), 14-40.

Ideler, Julius Ludwig. *Geschichte der Altfranzösischen National-Literatur von den ersten Anfängen bis auf Franz I* (Berlin: Nauck, 1842).

Immermann, Karl. *Merlin. Eine Mythe* (Düsseldorf: J.C. Schaub, 1832).

Immermann, Karl. *Münchhausen. Eine Geschichte in Arabesken*, 4 vols (Düsseldorf: J.C. Schaub, 1839).

Janin, Jules. *Deburau, histoire du théatre a quatre sous* (La Hane: Vervloet, 1832).

Janin, Jules. 'Das Theater in Frankreich in den letzten 6 Monaten des Theater-Jahres', in *Allgemeine Theaterrevue*, ed. August Lewald, vol. 2, (Stuttgart, 1836), 201-63 [218-20 on Alfred de Vigny].

Jonson, Ben. *The epicœne, or The silent woman*, translated in *Ludwig Tieck's Sämmtliche Werke*, vol. 12 (Vienna: Leopold Grund, 1817).

Jonson, Ben. *The Devil is an Ass*, translated by Wolf Graf von Baudissin as *Der Dumme Teufel* in *Ben Jonson und seine Schule* (Leipzig: Brockhaus, 1836).

Jordan, Wilhelm. *Demiurgos* (Leipzig: Brockhaus, 1852).

De Jussieu, Adrien. *Die Botanik* (Stuttgart: Scheible, 1848).

Kanne, Friedrich August. *Lindane, oder die Fee und der Haarbeutelschneider* (Vienna, 1824).

Kant, Immanuel. *Kritik der reinen Vernunft*, vol. 2 of *Immanuel Kant's Sämmtliche Werke*, ed. Karl Rosenkranz (Leipzig: Leopold Voss, 1838).

Kant, Immanuel. *Kritik der Urtheilskraft* and *Beobachtungen über das Gefühl des Schönen und Erhabenen*, vol. 4 of *Immanuel Kant's Sämmtliche Werke*, ed. Karl Rosenkranz (Leipzig: Leopold Voss, 1838).

Keller, Adalbert. *Italienischen Novellenschatz*, 6 vols (Leipzig: Brockhaus, 1851).

Kleist, Henrich. *Die Familie Schroffenstein. Trauerspiel in 5 Aufzüge* (Bern and Zürich: Heinrich Geßner, 1803).

Kleist, Heinrich. 'Das Bettelweib von Locarno', in *Heinrich von Kleists gesammelte Schriften*, ed. Ludwig Tieck, vol. 3 (Berlin: Reimer, 1826), 219-22.

Klopstock, Friedrich Gottlieb. *Abbadonnah*, 2 vols (Leipzig, 1804).

De Kock, Paul. *La maison blanche* (Ghent: Vanderhaeghe-Mava, 1840).

Kohl, Johann Georg. *Land und Leute der Britischen Inseln*, 3 vols (Dresden and Leipzig: Arnold, 1844).

Kotzebue, August. *Menschenhaß und Reue* (Berlin: Himburg, 1790).

Kriegk, Georg Ludwig. *Schriften zur allgemeinen Erdkunde* (Leipzig: Engelmann, 1840).

Kugler, Franz. *Ueber die Polychromie der Griechischen Architektur und Sculptur und ihre Grenzen* (Berlin: George Gropius, 1835).

Kugler, Franz. *Handbuch der Geschichte der Malerei*, 2 vols (Berlin: Duncker and Humblot, 1837).

Kurz, Heinrich. *Geschichte der deutschen Literatur mit Proben aus den Werken der vorzüglichsten Schriftsteller*, 3 vols (Leipzig: B.G. Teubner, 1851-3).

Laube, Heinrich. *Moderne Charakteristiken*, vol. 1 (Mannheim: Löwenthal, 1835).
Lessing, Gotthold Ephraim. 'Untersuchung, ob man in Lustspielen die Charaktere übertreiben sollte?' in G.E. Lessing and Christlob Mylius, *Beyträge zur Historie und Aufnahme des Theaters*, vol. 1 (Stuttgart: Metzler, 1750).
Lessing, Gotthold Ephraim. *Laokoon* [1766] in *Sämmtliche Schriften*, ed. Karl Lachmann, vol. 6 (Berlin: Voß, 1839), 372–546.
Lessing, Gotthold Ephraim. *Hamburgische Dramaturgie* [1767], in *Sämmtliche Schriften*, ed. Karl Lachmann, vol. 7 (Berlin: Voß, 1839).
Lessing, Gotthold Ephraim. *Wie die Alten der Tod gebildet* [1769], in *Sämmtliche Schriften*, ed. Karl Lachmann, vol. 8. (Berlin: Voß, 1839), 210–63.
Levacher de Charnois and Hilliard d'Auberteuil, eds. *Costumes et annales des grands théâtres de Paris* (Paris), 1786–9.
Levezow, Konrad. *Über die Entwicklung des Gorgonen-Ideals in der Poesie und bildenden Kunst der Alten* (Berlin: Königliche Akademie der Wissenschaften, 1833).
Lewald, August. 'Der Sylversterklub. Eine Laterna-Magica,' *Europa, Chronik der gebildeten Welt*, ed. August Lewald, vol. 1 (Leipzig and Stuttgart: J. Scheible, 1836), 1–8.
Lewald, Fanny. *Diogena. Roman von Iduna Gräfin H* (Leipzig: Brockhaus, 1847).
Lichtenberg, Georg Christoph. *Vermischte Schriften*, ed. L.C. Lichtenberg and Friedrich Kries, vol. 4 (Göttingen: Dieterich, 1844).
Lichtenstein, Ulrich. *Ulrich von Lichtenstein, mit Anmerkungen von Theodor von Karajan*, ed. Karl Lachmann (Berlin: Sander, 1841).
Limayrac (Limeyrac), Paulin. 'Simples Essais d'histoire littéraire. IV. Le roman philanthrope et moraliste. *Les Mystères de Paris*', *Revue des Deux Mondes* 14(5), 1 January 1844, 75–97.
Lohenstein, Daniel Casper. *Agrippina* (Breslau: Fellgibel, 1665).
London und Paris, ed. Karl August Böttinger, vols. 1–24 (Weimar, 1798–1810).
Luchet, Auguste. *Le nom de Famille* (Bruxelles: Jamar, 1842).
Lucian, *Lucian's Werke*, translated August Pauly, 15 vols (Stuttgart: Metzler and Vienna: Mörschner und Jasper, 1827–32).
Lucretius, *De rerum natura*.
Märcker, Friedrich August. *Das Princip des Bösen nach den Begriffen der Griechen* (Berlin: Ferdinand Dümmler, 1842).
Mager, Karl. *Versuch einer Geschichte der Französischen National-Literatur neuerer und neuster Zeit* (Berlin: Heymann, 1839).
Magnin, Charles. *Histoire des Marionettes en Europe* (Paris: Michel Lévy Frères, 1852).
De Maistre, Xavier. *Le lépreux de la ville d'Aosta* (Paris: Delaunay, 1823).
Maltitz, Franz, and Friedrich Schiller, *Demetrius* (Karlsruhe and Baden: D.R. Marx, 1817).
Marmier, Xavier. *Lettres sur l'Amérique*, 2 vols (Ixelles: Delevigne and Callewaert, 1851).
Masius, Hermann. *Naturstudien* (Leipzig: Brandstetter, 1852).
Mayhew, Henry. *London labour and the London poor*, 2 vols (London: Charles Griffin, 1851–2).
Meisl, Carl. *Der rosenfarbenen Geist oder: Liebesqualen eines Hagestolzen*, Vienna, 1825.
Meißner Alfred, *Das Weib des Urias: Tragödie in fünf Akten* (Leipzig: Herbig, 1851).
Mélesville (Anne-Honoré-Joseph Duveyrier) and Philippe Dumanoir. *Les vieux péchés* (Paris: Barba / Berlin: Schlesinger, 1833).
Meyer, Eduard. *Studien zu Goethe's Faust* (Altona: Hammerich, 1847).
Möser, Justus. *Harlekin: oder Vertheidigung des Groteskkomischen*, second rev. ed. (Bremen: Johann Heinrich Cramer, 1777).

Möser, Justus. 'Harlequins Heirath. Ein Nachspiel,' in *Justus Möser's sämmtliche Werke*, ed. B.R. Abeken, vol. 9 (Berlin: Nicolai, 1843), 107–36.

Mornand, M.F. (alias A.F.). 'Souvenirs d'Afrique: Garagousse', *Le Navigateur: Revue maritime*, vol. 5 (1838), 163–9, reprinted in *Illustration universelle* 6 (1846), No. 150.

Müller, Eduard. *Geschichte der Theorie der Kunst bei den Alten*, 2 vols (Breslau: Josef Max, 1834).

Musée de la caricature en France, ou, Histoire pittoresque de la satire, de la malice et de la gaieté françaises pour servir de complément a toutes les collections de memoires (Paris: Au Bureau de la France pittoresque, 1834).

'Nachtrag zur Kritik der Mystères de Paris von Eugène Sue', *Jahrbücher der Gegenwart*, ed. Albert Schwegler (Tübingen: Fues, 1844), 655–74.

Nalas und Damajanti, eine Indische Dichtung, translated by Franz Bopp (Berlin: Nicolai, 1838).

Novalis. *Heinrich von Ofterdingen, Schriften*, vol. 1, 3rd ed. (Berlin: Realschulbuchhandlung, 1815).

Palissot de Montenoy, Charles. *Les Philosophes: Comedie* (Paris: Duchesne, 1760).

Panofka, Theodor. *Parodieen und Karikaturen auf Werken der klassischen Kunst* (Berlin: Königliche Akademie der Wissenschaften, 1851).

Parny, Évariste. *Guerre des dieux* (Paris: Debray, 1808).

La Passion de Notre Seigneur J. O. en vers burlesques (1649).

Pausanias, *Description of Greece*.

Petronius. *Titi Petronii Arbitri Satyricôn Qvae Supersunt. . .Curante Petro Burmanno* (Utrecht: Guil. Vande Water, 1709).

Petronius. *Begebenheiten des Enkolp*, translated Wilhelm Heinse (Rome, 1773).

Piper, Ferdinand. *Mythologie und Symbolik der christlichen Kunst von den ältesten Zeiten bis in's sechzehnte Jahrhundert*, 2 vols (Weimar: Landes-Industrie-Comptoir, 1847–51).

Platen, August. *Die verhängnißvolle Gabel* (Stuttgart and Tübingen: Cotta, 1826).

Plato, *Hippias Major, Philebos, Sophist, Symposion*.

Pontolino der furchtbare Räuberhauptmann oder die Schrecknisse der Teufelsgrotte 2 vols. (Quedlinburg: Basse, 1823).

Prévost d'Exiles, Antoine François. *Histoire de Manon Lescaut et du Chevalier de Grieux* [1731] (Paris: Ménard et Desenne, 1818).

Prutz, Robert Eduard. *Karl von Bourbon. Historische Tragödie in 5 Akten* (Hannover: Kius, 1845).

Prutz, Robert Eduard. *Die Politische Wochenstube. Eine Komödie* (Zürich and Winterthur: Verlag des literarischen Comptoir, 1845).

Prutz, Robert Eduard. *Vorlesungen über die Deutsche Literatur der Gegenwart* (Leipzig: Gustav Mayer, 1847).

Prutz, Robert Eduard. *Das Engelchen*, 3 vols (Leipzig: Brockhaus, 1851).

Pückler-Muskau, Hermann. *Briefe eines Verstorbenen*, 4 vols (Stuttgart: Hallerberger, 1831).

Raoul-Rochette, Désiré. *Herculanum et Pompei – Recueil des Peintures, Bronzes, &c.*, ed. Roux Ainé and Barré, vol. 8 (*Musée Secret*) (Paris, 1840).

Redwitz, Oscar. *Märchen vom Tannenbaum* (Mainz: Kirchheim, 1850).

Riepenhausen, Franz and Johannes Riepenhausen, *Gemälde des Polygnotus in der Lesche zu Delphi; nach der Beschreibung des Pausanias gezeichnet von F. und J. Riepenhausen* (Göttingen: Dieterich, 1805).

Rötscher, Theodor. *Aristophanes und sein Zeitalter* (Berlin: Voß, 1827).

Rosenkranz, Karl. *Zur Geschichte der Deutschen Literatur* (Königsberg: Bornträger, 1836).

Rosenkranz, Karl. 'Die poetische Behandlung des Ehebruchs (1835)', in Rosenkranz, *Studien* (Berlin: Jonas, 1839), 56–90.

Rosenkranz, Karl. 'Über die Verklärung der Natur (1836)', in Rosenkranz, *Studien* (Berlin: Jonas, 1839), 155–205.

Rosenkranz, Karl. 'Über Ungers Urwelt', *Deutsches Museum. Zeitschrift für Literatur, Kunst, und öffentliches Leben*, ed. Robert Eduard Prutz, vol. 2 (Leipzig: Hinrichs, 1852), 62–9.

Rousseau, Johann Baptist. *Dramaturgische Parallelen*, vol. 1 [only one published] (Munich: Fleischmann, 1834).

Rückert, Friedrich. *Gesammelte Gedichte*, 2 vols (Erlangen: Carl Heyder, 1836).

Rumohr, Carl Friedrich von (alias Joseph König). *Geist der Kochkunst* (Stuttgart and Berlin: Cotta, 1822).

Ruge, Arnold. *Die Platonische Aesthetik* (Halle, 1832).

Ruge, Arnold. *Neue Vorschule der Ästhetik* (Halle: Waisenhaus, 1837).

Sainte-Beuve, Charles Augustin. *Critiques et portraits littéraires*, 5 vols (Bruxelles: C.J. de Mat, 1832–9).

De Saint-Pierre, Bernardin. *Études de la Nature*, 5 vols (Basel: Tourneizen, 1797).

Sand, George. *La comtesse de Rudolstadt*, vol. 4 (Brussels: Alphonse Lebègue & Sacré Fils, 1844).

Scheible, Johann. *Das Kloster. Doctor Johann Faust* (Stuttgart: Scheible, 1846).

Scheitlin, Peter. *Versuch einer allgemeinen vollständigen Thierseelenkunde*, 2 vols (Stuttgart and Tübingen: Cotta, 1840).

Schiller, Friedrich. 'Über die nothwendigen Grenzen beim Gebrauch schöner Formen', *Die Horen* 3(9) (1795), 99–125.

Schlegel, Friedrich. 'Über das Studium der griechischen Poesie' [1795–6], in *Fried. v. Schlegel's sämmtliche Werke*, 2nd ed., vol. 5 (Vienna: Ignaz Klang, 1846).

Schlegel, Friedrich. *Geschichte des Zauberers Merlin*, in *Friedrich Schlegel's sämmtliche Werke*, vol. 7 (Vienna: Jakob Mayer, 1825), 9–188.

Schleiden, Matthias Jacob. *Die Pflanze und ihr Leben* (Leipzig: Engelmann, 1850).

Schmidt, Friedrich. *Der leichtsinnige Lügner* (Stuttgart and Tübingen: Cotta, 1813).

Schmidt, F.A. *Mineralienbuch, oder allgemeine und besondere Beschreibung der Mineralien* (Stuttgart: Hoffmann, 1850).

Schmidt, Julian. *Geschichte der Romantik im Zeitalter der Reformation und der Revolution*, 2 vols (Leipzig: Herbig, 1848).

Schmidt, Valentin. 'Kritische Uebersicht und Anordnung der Dramen des Calderón de la Barca', *Jahrbücher der Literatur* (1822), *Anzeigeblatt für Wissenschaft und Kunst*, vol. 17, 21–31, vol. 18, 1–38.

Schmidt, Valentin. Review of John Dunlop, *The History of Fiction, Jahrbücher der Literatur*, vols. 26, 29, 31, 33 (1824–6).

Schopenhauer, Arthur. *Die Welt als Wille und Vorstellung* (Leipzig, Brockhaus, 1819).

Schopenhauer, Arthur. *Die Welt als Wille und Vorstellung*, 2 vols (Leipzig: Brockhaus, 1848).

Schopenhauer, Johanna. *Johann van Eyck und seine Nachfolger*, vol. 1 (Frankfurt am Main: Wilmans, 1822).

Scribe, Eugène and Edouard Mazères. *Vatel, ou le petit-fils d'un grande homme* (Paris: Pollet, 1827).

Scribe, Eugène and Ernest Legouvé. *Adrienne Lecouvreur. Comédie-drame en cinq actes* (Berlin: A. Asher, 1850).

Semper, Gottfried. *Über Polichromie und ihren Ursprung* (Brunswick: Friedrich Vieweg, 1851).

Seroux d'Agincourt, Jean Baptiste. *Sammlung von Denkmälern der Architektur, Sculptur, und Malerei vom 4. bis 16. Jahrhundert*, 4 vols, ed. Ferdinand von Quast (Berlin: Müller, 1840).

Shelley, Mary Wollstonecraft. *Frankenstein, or the Modern Prometheus*, 3 vols (London: Lackington, 1818).

Shelley, Percy Bysshe. *The Cenci, A Tragedy in Five Acts* (London: Ollier, 1821).

Stahr, Adolf. *Zwei Monate in Paris*, 2 vols (Oldenburg: Schulze, 1851).

Stifter, Adalbert. *Studien*, 6 vols (Pest: Heckenast / Leipzig: Georg Wigand, 1844–50).

Sue, Eugène. *Mathilde; memoires d'une jeune femme*, 6 vols (Paris: Charles Gosselin, 1841).

Sue, Eugène. *Les Mystères de Paris*, 4 vols (Bruxelles: Hauman, 1843–4).

Sue, Eugène. *Le juif errant*, 10 vols (Paris: Paulin, 1844–5).

Ternite, Wilhelm. *Wandgemälden aus Pompeji und Herculaneum*, 3 vols (Berlin: Reimer, 1839).

Tieck, Ludwig. *Phantasus: Eine Sammlung von Mährchen, Erzählungen, Schauspielen und Novellas*, 3 vols (Berlin: Realschulbuchhandlung, 1812–17).

Tieck, Ludwig. *Shakspeare's Vorschule*, 2 vols (Leipzig: Brockhaus, 1823).

Tieck, Ludwig. *Ludwig Tieck's Gesammelte Novellen*, vol. 7: *Das alte Buch und die Reise ins blaue hinein – Der Alte von Berge* (Breslau: Josef Max, 1838).

Tieck, Ludwig. *Ludwig Tieck's Gesammelte Novellen*, vol. 8: *Eigensinn und Laune – Die Gesellschaft auf dem Lande* (Breslau: Josef Max, 1838).

Töpffer, Rodolphe. *Monsieur Pencil* (Paris: Cherbuliez, 1840).

Töpffer, Rodolphe. *Histoire d'Albert* (Geneva: Kessmann, 1846).

Ulrici, Hermann. *Ueber Shakespeare's dramatische Kunst und sein Verhältniß zu Calderón und Göthe* (Halle: Eduard Anton, 1839).

Unger, Franz. *Die Urwelt in ihren verschiedenen Perioden* (Vienna: Beck, 1851).

Baron von Vaerst, Eugen. *Gastrosophie*, 2 vols (Leipzig: Avenarius and Mendelssohn, 1851).

'Veit Fraser,' in *Nachtseiten der Gesellschaft, eine Galerie merkwürdiger Verbrechen und Rechtsfälle*, ed. A. Deitzmann, W. Jordan, and L. Meyer, vols. 9–11 (Leipzig: Otto Wigand, 1844).

Vischer, Friedrich Theodor. *Ästhetik oder Wissenschaft des Schönen*, vols. 1 and 2 (Reutlingen and Leipzig: Carl Mäcken, 1846–7).

Vischer, Friedrich Theodor. 'Über Gavarni und Töpffer,' *Jahrbücher der Gegenwart*, ed. Albert Schwegler (Tübingen: Fues, 1846), 554–66.

Vogt, Carl. *Bilder aus dem Thierleben* (Frankfurt am Main: Rütten, 1852).

Voltaire. *La pucelle d'Orléans. Poëme. Divisé en quinze livres* (Louvain, 1755).

Waldau, Max. *Nach der Natur* (Hamburg: Hoffmann und Campe, 1850).

Wagner, Richard. *Oper und Drama*, 3 vols (Leipzig: J.J. Weber, 1852).

Weiße, Christian Hermann. *System der Aesthetik als Wissenschaft von der Idee der Schönheit*, 3 vols (Leipzig: Hartmann, 1830).

Welcker, Fridericus Theophilus (Friedrich Gottlieb), ed. *Philostratorum Imagines et Callistrati Statuae. Textum ad fidem veterum librorum recensuit et commenarium adiecit Fridericus Iacobs* (Leipzig: Dyck, 1825).

Werner, Zacharias. *Der vierundzwanzigste Februar. Eine Tragödie in einem Akt* (Leipzig: Brockhaus, 1819).

Wolff, O.L.B. *Altfranzösische Volkslieder* (Leipzig: Fleischer, 1831).

Wolff, O.L.B. *Allgemeine Geschichte des Romans von dessen Ursprung bis zur neuesten Zeit* (Jena: Mauke, 1841).

Zimmermann, Wilhelm. 'Der Roman der Gegenwart und Eugène Sues Geheimnisse,' *Jahrbücher der Gegenwart*, ed. Albert Schwegler (Tübingen: Fues, 1844), 199–219.

Sources cited by the Editors

Adorno, Theodor Wiesengrund, *Ästhetische Theorie*, ed. Gretel Adorno and Rolf
 Tiedemann (Frankfurt: Suhrkamp, 1970).
[Arago, François.] 'Nomen Nescio: Die Industrieritter. Nach dem Franzosen Arago',
 Morgenblatt für gebildete Leser, 27(78) (1 April 1833), 309 and 27(81) (4 April 1833),
 323.
Austin, John L. 'A Plea for Excuses', *Proceedings of the Aristotelian Society* 57 (1956–57),
 1–30.
Baechtold, Jacob. *Gottfried Kellers Leben: Seine Briefe und Tagebücher, 1850–1861* (Berlin:
 W. Hertz, 1894).
Barthes, Roland. 'L'Effet de Réel', *Communications* 11 (1968), 84–9.
Baudez, Claude-François. 'Beauty and Ugliness in Olmec Monumental Sculpture', *Journal
 de la Société des Americanistes* 98(2) (2012), 7–31.
Bauer, Axel. 'Der "Weichselzopf" in medizinhistorischer Perspektive. Eigenständige
 Hautkrankheit oder mythologisches Konstrukt?' in *Aktuelle Dermatologie* 30 (2004),
 218–22.
Blier, Suzanne Preston. 'Meeting the Amazons', in *Human Zoos: Science and Spectacle in the
 Age of Colonial Empires*, ed. Pascal Blanchard, Nicolas Bancel, Eric Deroo, and Sandrine
 Lemaire (Liverpool: Liverpool University Press, 2009), 159–64.
Blier, Suzanne Preston. 'Mort et créativité dans la tradition des amazones du Dahomey',
 Ethnocentrisme et creation, ed. Annie Dupuis (Paris: Éditions de la Maison des sciences
 de l'homme, 2013), 67–80.
Bosanquet, Bernard. *A History of Aesthetic* (London: Swan Sonnenschein / New York:
 Macmillan, 1892).
Briese, Olaf. *Konkurrenzen: Philosophische Kultur in Deutschland 1830–1850. Porträts und
 Profile* (Würzburg: Königshausen & Neumann, 1998).
Byron, George Gordon. *The Deformed Transformed; A Drama* (London: J. and H.L. Hunt,
 1824).
De Caroli, Steven. 'The Greek Profile: Hegel's Aesthetics and the Implications of a
 Pseudo-Science', *Philosophical Forum* 37:2 (2006), 113–51.
Cardwell, Richard, ed. *The Reception of Byron in Europe*, vol. 1–2 (New York: Continuum,
 2004).
Carter, Alan. 'Biodiversity and all that Jazz', *Philosophy and Phenomenological Research*,
 80:1 (January 2010), 58–75.
Casazza, Ornella and Riccardo Gennaioli, eds. *Mythologica et Erotica: Arte e Cultura
 dall'antichità al xviii secolo* (Florennce: sillabe, 2005).
Catlin, George. *Letters and Notes on the Manners, Customs, and Condition of the North
 American Indians*, 2 vols (New York: Wiley & Putnam, 1841).
Creuzer, Georg Friedrich. *Symbolik und Mythologie der Alten Völker, besonders der
 Griechen*, 2 vols., 3rd ed. (Leipzig and Darmstadt: Leske, 1837).
Dippie, Brian W. *Catlin and his Contemporaries: The Politics of Patronage* (Lincoln:
 University of Nebraska Press, 1990).
Dummett, Michael. *Frege: Philosophy of Language*, 2nd ed. (London: Duckworth, 1981).
Eliot, T.S. *Prufrock and Other Observations* (London: The Egoist Ltd., 1917).
Esau, Lotte. *Karl Rosenkranz als Politiker* (Halle: Max Niemeyer, 1935).
Fischer, Karl Philipp. *Speculative Charakteristik und Kritik des Hegel'schen Systems*
 (Erlangen: Carl Heyder, 1845).
Flashar, Helmut. *Inszenierung der Antike* (Münich: C.H. Beck, 1991).

Frege, Gottlob. 'Der Gedanke', *Beiträge zur Philosophie des Deutschen Idealismus*, 1(2) (1918), 56–77.

Funk, Holger. *Ästhetik des Hässlichen: Beiträge zum Verständnis negativer Ausdrucksformen im 19. Jahrhundert* (Berlin: Agora, 1983).

Galet, Pierre. *Cépages et vignobles de France; L'amphelographie française* (Montpellier: C. Déhan, 1990).

Gaussail, Adrien Joseph. *De L'influence de L'hérédité sur la production de la surexcitation nerveuse, sur les maladies qui en résultent, et des moyens de les guérir* (Paris: Germer-Baillière, 1845).

Gibbon, Edward. *The History of the Decline and Fall of the Roman Empire* [1776–88], ed. David Wormsley (London: Penguin, 2000).

Golt, John. *The Life of Lord Byron* (London: Henry Colburn and Richard Bentley, 1832).

Goodman, Nelson. *Languages of Art* (Oxford: Oxford University Press, 1968).

Gottlieb, Marc. 'The Painter's Secret: Invention and Rivalry from Vasari to Balzac', *Art Bulletin*, 84(3) (September 2002), 469–90.

Gottschall, Rudolf. 'Glossen zur Aesthetik des Hässlichen', *Deutsche Revue über das gesamte nationale Leben der Gegenwart*, 3 (July–September 1895), 38–54.

Hamburger, Jeffrey. ' "To make women weep": Ugly art as "feminine" and the origins of modern aesthetics', *RES: Anthropology and Aesthetics* 31 (Spring 1997), 9–33.

Haase, Annegret, Bob Duijvestijn, Gilbert de Smet and Rudolf Bentzinger, eds. *Der deutsche Malagis nach den Heidelberger Handschriften Cpg 340 und 315*, with preparatory work by Gabriele Schieb and Sabine Seelbach (Berlin: De Gruyter, 2000).

Harvey, Karen. 'Ritual Encounters: Punch Parties and Masculinity in the Eighteenth Century', *Past & Present* 214(1) (2012), 165–203.

Hegel, G.W.F. *Wissenschaft der Logik* (Nürnberg: Schrag, 1812).

Hegel, G.W.F. *Enzyklopädie der philosophischen Wissenschaften im Grundrisse* (Heidelberg: August Oswald, 1817).

Hegel, G.W.F. *Wissenschaft der Logik*, 2nd ed. (Berlin: Duncker und Humblot, 1841).

Hegel, G.W.F. *Enzyklopädie der philosophischen Wissenschaften*, ed. Karl Rosenkranz (Berlin: Heimann, 1870).

Heraclitus, *Fragments*, ed. T.M. Robinson (Toronto: University of Toronto Press, 1987).

Hinrichs, H.F.W. *Das Wesen der antiken Tragödie* (Halle: Ruff, 1827).

Houlgate, Stephen. 'Hegel and the "End" of Art', *The Owl of Minerva* 29 (Autumn 1997), 1–19.

Humboldt, Wilhelm. 'Über den Geschlechtsunterschied und dessen Einfluß auf die organische Natur', *Die Horen*, vol. 2 (1795), 99–132.

Jauss, Hans-Robert, ed. *Die nicht mehr schönen Künste. Grenzphänomene des Ästhetischen* (München: Wilhelm Fink, 1968).

Jung, Werner. *Schöner Schein der Häßlichkeit oder Häßlichkeit des schönen Scheins* (Frankfurt: Athenäum, 1987).

Kant, Immanuel. *Kritik der Urtheilskraft*, 3rd ed. (Berlin: Lagarde, 1799).

Kirk, G. S. *Heraclitus. The Cosmic Fragments: A Critical Study* (Cambridge: Cambridge University Press, 1962).

Kliche, Dieter. 'Pathologie des Schönen: Die "Ästhetik des Häßlichen" von Karl Rosenkranz', in Karl Rosenkranz, *Ästhetik des Hässlichen*, ed. Dieter Kliche (Leipzig: Reclam, 1990), 401–27.

Künne, Wolfgang. 'Goethe und Bolzano', in *Abhandlungen der Akademie der Wissenschaften zu Göttingen*, vol. 18 (Berlin and Boston: Walter de Gruyter, 2012), 77–118.

Lach, Donald F. and Edwin J. Van Kley, *Asia in the Making of Europe. Volume 3: A Century of Advance. Book 4: East Asia* (Chicago: University of Chicago Press, 1993).

Lichtenstein, Hinrich. *Reisen im südlichen Afrika*, 2 vols (Berlin: Salfeld, 1811–12).

MacIntyre, Alasdair. 'Hegel on Faces and Skulls', in *Hegel: A Collection of Critical Essays*, ed. Alasdair MacIntyre (Notre Dame: University of Notre Dame Press, 1976), 219–36.

Manget, J.-J. *Bibliotheca chemica curiosa*, 2 vols (Geneva: Chouet et al., 1702).

Michelet, Karl Ludwig. *Geschichte der letzten Systeme der Philosophie in Deutschland von Kant bis Hegel*, 3 vols (Berlin: Duncker und Humblot, 1838).

Mielke, Laura. *Moving Encounters: Sympathy and the Indian Question in Antebellum Literature* (Amherst: University of Massachusetts Press, 2008).

Mitter, Partha. *Much Maligned Monsters*, 2nd ed. (Chicago: University of Chicago Press, 1992).

Moeser, Justus, *Harlequin: or, a Defence of Grotesque Comic Performances*, translated Joachim and Friedrich Warneke (London: W. Nicoll, 1766).

Moffat, Robert. *Missionary Labours and Scenes in Southern Africa* (London: John Snow, 1842).

Moore, Thomas. *Memoirs of the Life of The Right Honourable Richard Brinsley Sheridan*, 2 vols (London: Longman et al., 1826).

Niccoll, Allardyce. *The World of Harlequin: A Critical Study of the Commedia dell'Arte* (Cambridge: Cambridge University Press, 1963).

Panofsky, Erwin. *Three Essays on Style*, ed. Irving Lavin (Cambridge, Mass.: MIT Press, 1997).

Pippin, Robert. 'What Was Abstract Art? (From the Point of View of Hegel)', *Critical Inquiry* 29 (Autumn 2002), 1–24.

Pop, Andrei, and Mechtild Widrich, eds. *Ugliness: The Non-Beautiful in Art and Theory* (London: I.B. Tauris, 2014).

Pop, Andrei, 'The Coexistence of Beauty and Ugliness', in *Ugliness*, ed. Pop and Widrich, 165–79.

Quérard, J.-M. *La France Littéraire, ou Dictionnaire Bibliographique*, vol. 1 (Paris: Firmin Didot, 1827).

Riegl, Alois. 'Das Denkmalschutzgesetz', *Die Neue Freie Presse*, 27 February 1905, 6–8.

Riehl, Wilhelm Heinrich. *Land und Leute* (Stuttgart and Augsburg: Cotta, 1856).

Röcke, Werner. 'Karl Rosenkranz (1805–1879)', in *Wissenschaftsgeschichte der Germanistik in Porträts*, ed. Christoph König, Hans-Harald Müller and Werner Röcke (Berlin: Walter de Gruyter, 2000), 33–40.

Rose, Margaret A. 'Karl Rosenkranz and the "Aesthetics of the Ugly" ', in *Politics, Religion, and Art: Hegelian Debates*, ed. Douglas Moggach (Evanston: Northwestern University Press, 2011), 231–52.

Rosenkranz, Karl. *Geschichte der deutschen Poesie im Mittelalter* (Halle: Anton & Gelbcke, 1830).

Rosenkranz, Karl. *Handbuch einer allgemeinen Geschichte der Poesie*, vol. 3 (Halle: Eduard Anton, 1833).

Rosenkranz, Karl. Review of Hegel's *Ästhetik*, vol. 1, *Jahrbuch für wissenschaftliche Kritik (Berliner Jahrbücher)*, January 1836, 1–15, 17–20; and March 1839, 363–90.

Rosenkranz, Karl. Review of Christian Heinrich Weiße, *Kritik und Erläuterung des Goethe'schen Faust*, in *Jahrbücher für wissenschaftliche Kritik*, October 1837, 599–619.

Rosenkranz, Karl. Review of Franz Bopp, *Nalas und Damajanti, eine Indische Dichtung, aus dem Sanskrit übersetzt* (Berlin: Nicolai, 1838), in *Jahrbücher für wissenschaftliche Kritik*, June 1839, 878–9.

Rosenkranz, Karl. *Studien* (Berlin: Jonas, 1839).
Rosenkranz, Karl. *Kritische Erläuterungen des Hegel'schen System* (Königsberg: Bornträger, 1840).
Rosenkranz, Karl. *System der Wissenschaft: ein philosophisches Encheiridion* (Königsberg: Bornträger, 1850).
Rosenkranz, Karl. *Die Topographie des heutigen Berlin und Paris* (Königsberg: Bornträger, 1850).
Rosenkranz, Karl. *Aus einem Tagebuch: Königsberg Herbst 1833 bis Frühjahr 1846* (Leipzig: Brockhaus, 1854).
Rosenkranz, Karl. *Wissenschaft der logischen Idee*, vol. 1: *Metaphysik* (Königsberg: Bornträger, 1858).
Rosenkranz, Karl. *Wissenschaft der logischen Idee*, vol. 2: *Logik und Ideenlehre* (Königsberg: Bornträger, 1859).
Rosenkranz, Karl. *Epilegomena zu meiner Wissenschaft der logischen Idee. Als Replik gegen die Kritik der Herren Michelet und Lasalle* (Königsberg: Bornträger, 1862).
Rosenkranz, Karl. *Hegel als deutscher Nationalphilosoph* (Berlin: Duncker und Humblot, 1870).
Rosenkranz, Karl. *Von Magdeburg bis Königberg* (Berlin: Heimann, 1873).
Rosenkranz, Karl. *Politische Briefe und Aufsätze 1848–1856*, ed. Paul Herre (Leipzig: Dieterich, 1919).
Rosenkranz, Karl. *Briefwechsel zwischen Karl Rosenkranz und Varnhagen von Ense*, ed. Arthur Warda (Königsberg: Gräfe und Unzer, 1926).
Rosenkranz, Karl. *Briefe 1827 bis 1850*, ed. Joachim Butzlaff (Berlin: Walter de Gruyter, 1994).
Rudlin, John. *Commedia Dell'Arte: An Actor's Handbook* (London: Routledge, 1994).
Russell, Margarita. 'The Iconography of Rembrandt's *Rape of Ganymede*', *Simiolus* 9(1) (1977), 5–18.
Schasler, Max. *Kritische Geschichte der Ästhetik*, 2 vols (Berlin: Nicolai, 1882).
Schiller, Friedrich. *Gedichte* (Stuttgart and Tübingen: Cotta, 1852).
Schiller, Friedrich. 'Von der ästhetische Größenschätzung', in *Schillers Sämmtliche Schriften. Historisch-kritische Ausgabe*, vol. 10: *Ästhetische Schriften*, ed. Karl Goedeke (Stuttgart: Cotta, 1871), vol. 10, 187–206.
Schmidt, Julian. Review of Karl Rosenkranz, *Ästhetik des Hässlichen*, in *Die Grenzboten* 28 (July 1853), 1–9.
Schnitzler, Arthur. *My Youth in Vienna*, translated by Catherine Hutter (New York: Holt, Rinehart and Winston, 1970).
De Staël, Germaine. *Lettres sur les ouvrages et le caractère de J.J. Rousseau* [1788], 2nd ed. (Paris: Charles Pougens, 1798).
Steegers, Robert. *Heinrich Heines "Vitzliputzli": Sensualismus, Heilsgschichte, Intertextualität* (Stuttgart: Metzler, 2006).
Stieglitz, Heinrich Wilhelm. *Erinnerungen an Rom* (Leipzig: Brockhaus, 1848).
Storey, Robert. *Pierrot: A Critical History of a Mask* (Princeton: Princeton University Press, 1978).
Tieck, Ludwig. *La Réconciliation* (Paris: Curmer, 1842).
Thiers, Adolphe. *Histoire de Law* (Leipzig: Hetzel, 1858).
Torberg, Friedrich. *Die Tante Jolesch; oder, Der Untergang des Abendlandes in Anekdoten* (Munich: Langen-Müller, 1975).
Tracy, S.V. 'Laocoon's Guilt', *American Journal of Philology* 108(3) (Autumn 1987), 451–4.
Turner, James. *Schooling Sex: Libertine Literature and Erotic Education in Italy, France, and England 1534–1685* (Oxford: Oxford University Press, 2003).

Widrich, Mechtild. 'The Willed and the Unwilled Monument', *Journal of the Society of Architectural Historians* 72:3 (September 2013), 382–98.

Widrich, Mechtild. 'The "Ugliness" of the Avant-Garde', *Ugliness*, ed. Pop and Widrich, 69–81.

Winckelmann, Johann Joachim. *Geschichte der Kunst des Alterthums*, 2nd ed. (Vienna: Akademischer Verlag, 1776).

Zerner, Henri. 'The Sense of Order: An Exchange', *New York Review of Books* (28 June 1979), 62.

Index

Note: Though there are a few general discussions in Rosenkranz, readers should keep in mind that under, e.g., 'concept', there are mainly discussions of the concept of ugliness. Italicized page numbers refer to the editors' notes and introduction. Bold page numbers refer to images. The letter 'n' marks the number of one of Rosenkranz's endnotes.

Töpffer (Toepffer), Rodolphe, 241, 255–6,
 284–5n90
torture, *see* brutality, martyrdom
tragedy, the tragic, 48, 75, 79–80, 188–9,
 200–2
 French classical, 95, 104
transition, transformation, 34, 37–40, 50,
 64–5, 70, 85, 110–11, 118, 183,
 185, 233, 255
 see also becoming, perishing
translation(s), *20–1*, 199, 261n8, 266n20,
 275n54, 280–1n75
travesty, 125, 137, 240, 283–4n89
trend, *see* tendency
truth, 48, 50, 58, 92–5, 164–6, 172–3, 189,
 256, 258

Ulrici, Hermann, 269n33, 282n81
uncanny, the, 197, 208, 213
unconsciousness, 149–50
underworld, *see* hell
undulistic, 65, 130, 241–2, 266n18
unfreedom, 42–3, 45, 59, 116–20, 147
Unger, Franz, 261–2n9
unit(y), 58–9, 63–5, 70, 81–2, 233–4
 see also harmony
unnatural, *see* supernatural
urine, urination, *14*, 51, 148–9, 218, 278n70
usurpation, 111, 235–6

Varin, Amédée, 262n10
Vatican Apollo, *see* Apollo Belvedere
Von Vaerst, Eugen, Baron, 32
vampire, 204
Van Eyck, Jan, 50, 94, 112, 276n56
Varnhagen von Ense, Karl August, *5, 8*,
 271n39
vaudeville, 144–5
Veit Fraser, 220
Veronese, Paolo, 51
vice, 42–4, 129–31, 215, 217, 231
Vidal, Peire, 142, 272n43
Vienna, *71, 157*, 220, 256–7
Vigny, Alfred de, 199, 246
violence, 39, 57, 60, 116, 126–7, 157, 233–4,
 271n40
 see also rape, murder, martyr

Virgil, 219, 241
 parodies of, 125, 238–40
virtue(s), 35, 42–4, 61, 182, 215, 217, 235
Vischer, F.T., 26, 38, 59, *177*, 198, 256,
 260n5, 262n11, 284n90, 296, 305
Vogt, Karl, 150, 273n46
volcano, 126, 191
Voltaire, 76, 78, 83, 104, 125, 139, 153,
 170, 207–8, 215, 247, 270n38,
 275n54
vomit(ing), 51, 118, 195
De Vos, Martin, 177–8
Voss (Voß), J.H., 67, 178, *197*, 269n35b, 288

Wagner, Richard, 266n20
Waldau, Max, 125, 280n75
Waldensians, 220
war, *10*, 95, 103, 131, 160, 194, **192**, *202*
Weiße, Christian Hermann, *14*, 116,
 213–14, 259n1–2, 269n35a,
 272n42, 305
weak(ness), 126–9, 230
 see also feeble(ness)
weapons, 64, 69, *85*, 93, 95, 143, 152,
 160, 201, 209, 212, 227–8,
 250, 271n39
Welcker, F.G., 140
Werner, Zacharias, 209
Wernher der Gartenaere, 254
Wieland, Christoph Martin, 148, 156
Wi-jun-jon, *see* Catlin, George
will, the, 42–4, 58–9, 197, 220
 unwilling, 129, 222, 258
Winckelmann, J.J, 26, *108*, 264n16a, *295,
 301*
witches, witchcraft, 217, 220–2, **221**,
 282n80
Wolff, O.L.B., 134, 151, 189, 273n48
wonder(s), 186–7, 208
work(ers), 26, 97, 115–16
writer(s), 26–7, 83, 98, 149, 280–1n75, 289

Zerrbild (distorting/distorted picture), 60,
 217, 248–9, 254–5
Zeus, 172–3, 180, 184
Zeuxis, *91*, 205
Zimmermann, Wilhelm, 267n23

Made in the USA
Coppell, TX
06 May 2021